Fifty
Years
of
Great
Art
Writing

Fifty Years of Great Art Writing

HAYWARD GALLERY PUBLISHING

FOREWORD
BY RALPH RUGOFF

Encompassing a wide range of perspectives and diverse styles of writing, the essays collected here – all of which originally appeared in exhibition catalogues produced by Hayward Gallery Publishing – span a period stretching back half a century. Their authors include eminent scholars and critics as well as leading artists and novelists, curators of contemporary and modern art, and a number of individuals who wear more than one professional 'hat'. Many are hugely influential figures who have made major contributions to our understanding of art, while some have even expanded art's possibilities. Bridget Riley, Britain's most original post-war painter, shares her insights into the delicately nuanced work of Paul Klee. Rasheed Araeen reflects on the art of historically neglected Afro-Asian artists in Britain, while James Turrell reveals the roots of his pioneering use of light in works that probe our perceptual process. Groundbreaking art historians and theoreticians including Michael Fried, Lucy Lippard, Dawn Ades, Dore Ashton, Homi K. Bhabha and Kaja Silverman provide revelatory conceptual frameworks for looking at artists ranging from Anthony Caro to Agnes Martin and Anish Kapoor. In other essays, some of the most innovative contemporary art curators from the past 30 years – among them Lynne Cooke, James Lingwood, Chrissie Iles and Matthew Higgs – reveal the thinking behind critical thematic and group exhibitions. Reminding us that writing on art can also draw on the qualities of literature, award-winning novelists like Dave Eggers, Ali Smith, Rick Moody and Will Self confront the work of their contemporaries with vivid language and wit.

Many of the essays in this volume seem as timely and relevant as the day they were written; others offer fascinating takes on the critical temper and burning issues of particular moments from the past. They vary greatly in their use of language, which should not be too surprising given the diverse backgrounds of the authors represented here. From the intimate and evocative voices of fiction writers to the measured and analytical precision of more scholarly essays, this selection presents a cross-section of literary voices and a variety of approaches to informed and perceptive writing about art.

Originally published in exhibition catalogues, all of these texts were commissioned to provide interpretation and context for the work of artists featured in particular shows organised by Hayward Gallery and the regional touring programmes it supervises. While they vary widely in tone and approach, these essays comprise a distinct type of art writing. Typically, catalogue essays are partisan undertakings: the author is almost always writing about the artist(s) under consideration from an appreciative standpoint. In the case of essays written about thematic or historical group shows, the author also outlines the argument or proposition that the exhibition seeks to formulate. In illuminating a neglected dimension of art history or the shared concerns of a new generation, such essays frequently look askance at commonly held ideas and the biases they reflect. At their most extreme, texts in this category can share something of the character and spirit of manifestos.

The occasion for publishing this anthology is Hayward Gallery's 50th anniversary. Rather than produce a book commemorating the Hayward itself, we chose to make

these valuable writings – most long out-of-print – available again for today's readers. Over the course of its existence, Hayward Gallery Publishing has produced over 350 catalogues, most containing multiple essays; the present selection, which represents a fraction of this output, was arrived at over several months of discussion between the Hayward curatorial and publishing teams, with some helpful suggestions from a number of artists, writers and curators who at one time or another played a role in Hayward exhibitions. The overwhelming focus on white male artists, and on art from North America and Europe, reflect biases that shaped much of the Gallery's programme in its first 40 years – and not, of course, just the Hayward's programme, but that of most major Western art galleries and museums during this same period. Happily that situation has changed, and the Hayward is committed to an increasing presence of female voices and worldwide perspectives.

It is my hope that these texts will be engaging and informative to all who read them, and that they will be particularly instructive for anyone who ever takes the opportunity to put into words their own thoughts about art. The American comedian and painter Martin Mull once remarked that writing about music is like dancing about architecture. Many have applied this dictum, with its implied sense of absurd futility, to writing about art as well. How is it really possible, after all, to accurately translate our non-verbal encounters with art into words? And yet for all the difficulty of doing so, the authors here demonstrate that writing can indeed enhance our experience of artworks by illuminating their complex layers of resonance as well as their historical connections.

Not so long ago I participated in a public discussion meant to address the state of art criticism, during which a fellow panelist – a critic who was also an artist – preemptively declared that criticism was completely superfluous. Art would continue to exist without it, he maintained, whereas without art there would be no criticism. Point taken – and yet, as artists like Marcel Duchamp have long pointed out, an artwork is hardly a complete statement or self-contained proposition. Works of art do not convey specific messages in and of themselves. But while they do not mean anything in particular, we can nevertheless find meanings for them. Interpretation, in other words, is part of the work that an artwork generates. The writing in this volume embodies this spirit of exploration, taking into account not only the artist's intentions but also the author's own responses. It scrutinises how an artwork plays with existing traditions and conventions in ways that disrupt our habitual patterns of seeing and thinking. It looks at how art manages to affect us and how it draws on different contexts in doing so. Ultimately, such writing forms a crucial and vital component in the collective conversations, dialogues and responses that artists provoke.

All of us at Hayward Gallery are grateful to the contributing authors who have allowed us to reprint their work here. We are also thankful for the crucial support of Joe and Marie Donnelly, without which this publication would not have been possible. My personal thanks go to the excellent Hayward Gallery Publishing team led by Rebecca Fortey, especially to Project Manager Diana Adell, who steered this complex project

through to completion. Finally I wish to acknowledge the indispensable contributions made by former Hayward Chief Curator Stephanie Rosenthal, Senior Curator Cliff Lauson and Exhibitions Interpretation Manager Lucy Biddle in helping to conceive the book and in the difficult task of selecting the essays.

Ralph Rugoff
Director of Hayward Gallery, London

MICHAEL FRIED
ON ANTHONY CARO

Anthony Caro
1969

In 1969 Hayward Gallery staged the first retrospective exhibition of the work
of British sculptor Anthony Caro. Taking over the entire gallery, as well as
the three outdoor sculpture terraces, the exhibition featured more than 40
works, including large-scale works such as Early One Morning *(1962) and*
the artist's smaller 'table sculptures'. Caro was the first living British sculptor
to have a one-man exhibition at Hayward Gallery, which in the seven months
since it opened had held exhibitions of the work of Henri Matisse, Emil Nolde
and Vincent van Gogh. For Edward Mullins, who reviewed the exhibition
for the Sunday Telegraph, *Caro's solo show was '...one of the few really*
important events in the history of British sculpture'. The American critic
and art historian Michael Fried, an early admirer of Caro's work, curated
the exhibition and wrote for the accompanying catalogue.

I

Anthony Caro's sculptures have always been intimately related to the human body. This is clearly true of the figurative works which he modelled in clay or plaster of Paris and cast in bronze throughout the mid and late 1950s, until his visit to the United States in the autumn of 1959. But it is just as true of the wholly non-figurative sculptures which he began making on his return to England late that year and which (with three exceptions) are the subject of the present exhibition. I do not mean that Caro's conversion to abstraction was other than the most decisive event in his career. For one thing it is only since that occurred that Caro has produced work of major quality. Furthermore it is my conviction that the changes that took place in his art in late 1959 and early 1960 have already proved decisive for sculpture itself. What I want to insist upon, however, is that they were not the result of any shift of fundamental aspirations. Rather it was his determination to take whatever steps were necessary to realise those aspirations that led him, at a critical moment in his development, to give up both modelling and representation and in general to transform his art.

Even in his figurative bronzes Caro was not chiefly concerned with the appearance of the body, its external form. Above all he seems to have wanted to render sculpturally his innate sense of the human body *as actually lived* – as possessed *from within* so to speak. For example, the experience that seems to lie behind sculptures like *Man Taking Off His Shirt* and *Man Holding His Foot* is that of being brought up against the limits of one's body by the performance of an ordinary action (for example, reaching, bending). Similarly, the small *Woman Waking Up* should be seen as an attempt to render that particular act of repossessing the body from within. The desire to find sculptural equivalents for what might be called the *livedness* of the body impelled Caro to the often extreme departures from verisimilitude that characterise these and other works of the period. In *Man Taking Off His Shirt*, for example, the disproportion between the small head and the heavy arms seems to

have been intended as an equivalent for the figure's concentration upon an action in which the arms do all the work and the head is mostly in the way.

Towards the end of the 1950s Caro seems to have grown more and more dissatisfied with expedients of this sort. Perhaps he began to suspect that his aspirations might not, or might no longer, be realisable by modelling and casting; that whatever distortions he imposed upon the image of the human figure in an attempt to project the livedness of the body, to find plastic correlatives for its possession from within, the finished sculpture was experienced as a solid, somewhat massive object whose illusory internal state had as it were to be inferred from its external form and which as a result was distanced, held at arm's length, from the start. (This at any rate is how Caro's dissatisfaction appears in retrospect.) At the very least he came increasingly to feel that the traditional placement of the sculpture on a base or pedestal reinforced its apartness, its isolation as a special – conventional – kind of physical thing. In one piece, *Woman's Body*, now destroyed, Caro went so far as to seat the figure on an actual steel bench, which rested directly on the ground and was conceived of as part of the sculpture. But he quickly recognised that simply altering or even taking away the usual base did not and could not give him the new, more direct connection between sculpture and beholder that he was seeking. That would require the radical transformation of the sculpture itself, a step he was now prepared to contemplate for the first time. Significantly, the works that Caro made during the spring and summer of 1959 departed drastically, though not entirely, from the image of the human figure. But because the basic premise of his art – the shaping of an apparently solid, obdurate mass – remained the same, the sculptures in question wholly failed to resolve the problems that had come to obsess him.

II

It was at this critical juncture that Caro visited the United States. He spent just over two months there (and in Mexico), travelling, meeting artists and critics, looking at pictures and sculptures. In particular he was impressed by the work of two painters just starting to be recognised, Kenneth Noland and Morris Louis, as well as by the few Pollocks then in New York museums; he saw at least one sculpture by David Smith, whose work he knew from reproductions, and met Smith briefly; and he became friends both with Noland and with the critic Clement Greenberg, whom he had met in London the summer before.

On his return to London Caro began making sculptures which in obvious respects differed sharply from anything he had previously done. In fact it may seem that pieces like *Twenty-Four Hours*, which he made in March 1960 and which now appears to mark his breakthrough to major accomplishment, or the superb *Midday*, the first of his masterpieces, which he finished in August or September of that year, are simply discontinuous with his previous work. And as far as their physical means are concerned – they were made by bolting and welding large sections of steel to

MICHAEL FRIED ON ANTHONY CARO 15

one another and painting the final ensemble – this is true enough. Moreover these sculptures, unlike the bronzes of the mid and late 1950s, are not figurative; the image not just of the human body but of any recognisable thing is absent from them even as a basis to be departed from with virtual impunity.

I have already claimed that these differences, important as they undoubtedly are, do not signify a change either of basic aspiration or of essential content. Now I want to suggest that the transformation that took place in Caro's art in late 1959 early 1960 was impelled by his discovery that it was possible to express the livedness of the body more directly and convincingly by juxtaposing a number of discrete elements than by the techniques of modelling and casting that he had used until that time. The sources of that discovery seem to have been partly American. His choice of physical means was almost certainly inspired by the steel sculpture of the late David Smith. And the paintings of Caro's exact contemporary, Kenneth Noland, may have helped speed him to the recognition that an abstract art based on apparently simple relations – in Noland's pictures, between concentric rings or radiating armatures of intense colour – could achieve the richness and complexity of human content that he had always sought in his work. Noland's content differs from Caro's in that it is radically *dis*embodied. (If the central concept for understanding Caro's art is that of the body, the central concept for understanding Noland's is that of personal identity, of the self.) But the essentially relational mode of expression that one finds in Caro's first abstract sculptures is in deep accord with that of Noland's paintings of the late 1950s. The presence in *Twenty-Four Hours* of a large metal disk, which happens also to have a dark ring painted around its centre, suggests that Caro may actually have had Noland's work in mind at this time. But whether or not he did, the crucial development in that sculpture, the single step which seems in retrospect to contain the germ of virtually everything Caro has accomplished since, had no precedent in Noland or anyone else: I mean his decision to lean the flat rectangular plate at the rear of the sculpture backwards, to inflect it *up*. Caro was not, of course, the first to place an element at an angle to the vertical. He *was* the first to make such an apparently simple placement assume the intense, if ultimately ineffable, expressive significance of the one in *Twenty-Four Hours*.

III

What gives that particular placement, or any other in Caro's work, that kind of significance is its role in the totality of relations which the sculpture in question comprises – its function in what I have elsewhere called the *syntax* of the piece.[1] Roughly, each of Caro's sculptures establishes a structure of mutually reinforcing norms, against which various inflections make themselves felt with the force and nuance of natural gesture but with a freedom from the actual limits of the body that goes beyond anything previously achieved in sculpture. This is not to say that in a given sculpture the individual elements simply and unequivocally state either norms or inflections; rather they simultaneously and in different ratios *imply both:* the

MICHAEL FRIED ON ANTHONY CARO

normativeness and inflectedness of every element are experienced in relation to the normativeness and inflectedness of every other. In *Twenty-Four Hours*, for example, the flatness and rectangularity of the rearmost element are normative, just as the shape of the front element is experienced, if not actually as an inflection, at any rate as responsive to the inflectedness of the other. In an essay published in 1965 Clement Greenberg discussed the importance of the rectilinear in Caro's sculpture up to that time: 'Almost all surfaces and edges are rectilinear, and almost all their changes of direction are strictly rectangular [...] But the relationship of the rectangular details in Caro's sculpture, while necessarily angular, are themselves only sparingly *rect*angular: it is as if the rectangular were set up in one aspect only to be the more tellingly countered in another.'[2] In general I think it can be said that rectilinearity is a fundamental norm of Caro's art, along with frontality, axiality, horizontality and certain kinds of forthright symmetry. None of these is of interest to Caro in its own right; indeed I do not mean to suggest that he works with them consciously at all: it would be truer to say that they simply end up being crucial to sculpture after sculpture. This, however, is not to imply that they are only incidentally related to Caro's aspirations as I have tried to describe them. On the contrary, I want to claim that they are nothing less than fundamental to the realisation of the latter – that the virtual omnipresence of these and related norms in Caro's art is at least partly the result of their having been put there by his enterprise as a whole. Here the question arises: why should these particular norms have been called for by those particular aspirations? What is the nature of the connection between them? The answer I want to propose is one that I cannot prove, namely, that the connection between them has essentially to do with what might be thought of as the natural history of the norms themselves, by which I mean their rootedness in certain basic facts about being in the world and in particular about possessing a body. In other words I am suggesting that it is *our* uprightness, frontality, axiality, groundedness and symmetry – as these determine our perceptions, our purposes, the very meanings we make – which, rendered wholly abstract, are the norms of Caro's art. If this is right it helps explain not just the recurrence of these norms but their extraordinary, otherwise inexplicable ability to confer the most profound expressive significance upon the slightest and least dramatic inflections: the deep expressiveness of the inflections is a direct function of the primordial depth, the essentiality, of these and related norms in our lives, in our experience of our bodies and of the world, in our common humanness. Not that any work that shares these norms will have this sort of depth. It is only because their recurrence in Caro's art is compelled by the needs of individual sculptures – only because each time they return it is as the result of the discovery of their essentiality to a particular content – that they possess the kind of significance I have claimed for them. And this means that Caro's enterprise, fully as much as any other aspect of their history, gives these norms the kind of depth and essentiality as sculptural conventions I have claimed they have.

It is probably already clear that the relations that comprise a given Caro concern not just the position but, equally important, the physical character of the various discrete elements juxtaposed in it. Those relations are comprehensive, even exhaustive, in

a way never before seen: the sheerly physical qualities of the individual elements are themselves *fully* subsumed in them, with the result that physicality as such is rendered wholly relational. It is in this sense that Caro's sculptures may be said to consist *entirely* in their syntax: a state of affairs which Greenberg has observed amounts to 'an emphasis on abstractness, on radical unlikeness to nature'.[3] (This is the obverse of their emphasis on meaning. on radical likeness to natural forms of expression.) Greenberg continues: 'No other sculptor has gone as far from the structural logic of ordinary ponderable things.'[4] The obduracy with which Caro's bronzes of the 1950s adhered to precisely 'the structural logic of ordinary ponderable things' – and therefore were distanced by the beholder – contributed, I have suggested, to his ultimate dissatisfaction with modelling and casting. In any case, by displacing that logic with one of pure and exhaustive internal relation Caro achieved the new, undistanced connection with the beholder which he had been seeking since before his American visit. The elimination of the base or pedestal by placing the sculpture directly on the ground was concomitant with these developments and received from them its decisive significance. By itself the removal of the base would have been trivial, a step of no artistic consequence, like the motorising of kinetic 'sculptures' and similar novelties. Compelled by the exigencies of the revolution which Caro was bringing about in the body of his sculpture – above all by the need to defeat the objecthood of his previous work – it was an event of revolutionary importance.

Caro's use of colour should be seen in this context as well: as a means of neutralising the material or surface character of the individual elements. It is as though Caro's sculptures make a distinction between sheerly physical qualities on the one hand, which are wholly subsumed in a given piece's syntax, and merely material or surface qualities on the other, which are not so subsumed and must be dealt with separately. Naturally, applied colour cannot displace surface; it is itself surface; but because it is, it can guarantee a kind of uniformity which is first and foremost the impalpable one of hue and only secondarily the material one of texture, skin, surface as such.

Anthony Caro, *Early One Morning*, 1962. Installation view, *Anthony Caro*, 1969

It may seem contradictory to claim that Caro's abstract sculptures are experienced as profoundly physical but not, or not essentially, as physical objects. The contradiction eases, however, and the continuity of his enterprise becomes fully clear, when it is recognised that this exactly characterises the physicality of the body as actually lived. In Caro's art the physicality of the body is *itself* liberated from the body's limits.

IV

That Caro's sculptures consist entirely in their syntax (and their colour) is a basic difference between them and the work of the late David Smith. This is worth stressing for two reasons: first because it was Smith's example that led Caro to take

MICHAEL FRIED ON ANTHONY CARO

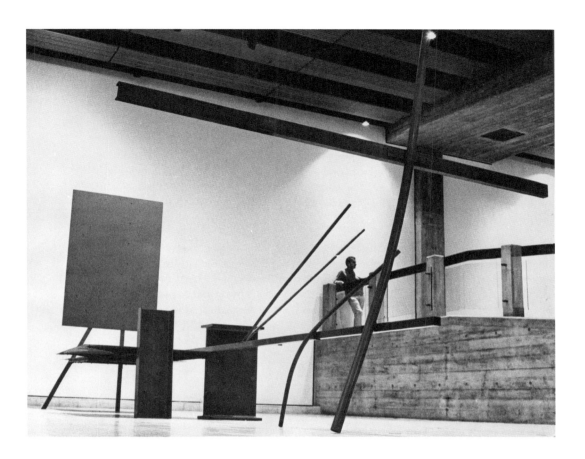

up welding; and second because it is above all in comparison with Smith's art that the decisive originality of Caro's fully emerges. More radically and consistently than any sculptor before him, Smith opened sculptural form to the space it occupies. But from the perspective of Caro's work, the physicality even of Smith's most open, 'optical', apparently dematerialised pieces is that of ordinary objects. The relationships between the different parts of a single sculpture, however informal or gravity-defying they may seem to be, are essentially object relations; and the sculpture itself can be described as a single compound thing in a way that a larger, physically more massive piece by Caro finally cannot. Smith's pieces, at their most abstract, striding or attenuated, stand and confront us like traditional statues; they have that kind of uprightness, robustness, monumentality. In this connection it is significant that Smith never found it necessary, or possible, to eliminate the base despite the fact that it seems often to have been problematic for him. Caro's sculptures in contrast neither stand nor lie: they open, or rise, or suspend, or spread, or turn, or bend, or stretch, or extend, or recede... understood as characterisations of the abstract meaning of individual works, not of anything that

might be called their literal presence. A sculpture by Smith can also be described as a single compound image, whether representational or non-representational, whereas the abstractness of Caro's sculptures is resistant to images of any kind. Even in those pieces in which something like an image appears (for example, the frame-like element in *Span*, the table-like plane in *Trefoil*), the implicit physicality of the latter is itself subsumed in the syntax of the sculpture as a whole. Most of the time, however, there is nothing that can properly be called an image in the first place: there are, I want to say, *only* the relations among the elements, relations whose presentness to the senses is not that of an object or image. They cannot be looked at in the same way, though of course they can be, and are, seen. (One might say that Caro's sculptures reveal the extent to which an image as such is a kind of object; and that the visual initiative his pieces call for is more like *listening to* than like *looking at*.)

These differences do not mark a difference in level of accomplishment. Throughout his immensely productive career, right up until his death in 1965. Smith found in a logic of object and image the conviction for an art of supremely high quality. And it was Caro's admiration for Smith's work, together with his own intense preoccupation with the livedness of the body, that led him to transcend that logic in one of pure and exhaustive internal relation, and by so doing to alter profoundly the history not just of sculpture but of abstraction.

V

The radical abstractness of Caro's sculptures is also a crucial difference between them and work which can be described as essentially theatrical. By theatrical I mean, among other things, situational: work that in one way or another makes the beholder aware of the situation in which it is encountered, a situation that includes not just the space (or room) in which it is sited but the physical presence of the beholder himself.[5] The current fashion known as minimal art, for example, has been described by one of its foremost practitioners as taking relationships out of the work and making them a function of the physical circumstances in which the work is met – for example, the shape, size, bareness of the room in which it is placed, its position relative to all of these, the precise management of the lighting, etc. – as well as of the viewer's field of vision, which changes as he moves.[6]

Clearly, Caro's work is the antithesis of this. *All* the relationships that count are to be found in the sculptures themselves and nowhere else. Even the relation of his sculptures to the ground is not to the actual ground, the literal floor beneath our feet but to the ground as conceived abstractly, in purely relational terms. Though precisely because this is so, Caro's sculptures have changed forever the ground on which we stand; while theatrical work, by including the actual ground and the actual beholder in the situation which it determines, leaves both unaltered, unilluminated.

MICHAEL FRIED ON ANTHONY CARO

It is as though the beholder bears no literal relation whatsoever to Caro's work; as though within the grip of a given sculpture, in the spell of its presentness, everything that has to do with the beholder's merely literal circumstances – his situation as opposed to his nature, essence or condition – is abrogated, suspended, as never before. Hence the description of the new relation between the work of art and the beholder that Caro broke through to in 1960 as *undistanced*. I suggest in fact that what disturbed Caro about the sculptures that he was making just before his American visit was their nascent theatricality, stemming from the fundamentally situational nature of our relation to ordinary ponderable things, to physical objects. Caro's attempt to undo the distancing by then inherent in that relation by seating a sculpted figure on a real bench simply made things worse. It provided the wrong kind of immediacy – the literal, situational immediacy of a direct confrontation – and thereby heightened the incipient theatricality which I am suggesting Caro already sensed and wanted to avoid. The immediacy of his sculptures since 1960, like everything else about them, is wholly and radically abstract. They are as immediate to one as one's own body.

VI

Exactly why theatricality became an issue in the mid 1960s need not concern us here. Partly it was the result of developments within painting and sculpture, especially painting, which reached a head roughly at that time. In any event the need to defeat theatre, to overcome the literal and situational, has I believe rapidly become perhaps the central imperative of ambitious painting and sculpture. This is not to say that Caro conceives of his enterprise in these categories. The thinking that goes on in painting and sculpture is not, or does not have to be, conceptual. But it *is* thinking, in Caro's case thinking of the highest order, and one of the tasks of criticism is to make this clear. Caro's enterprise consists in discovering radically abstract, and therefore anti-theatrical, terms for the recreation in sculpture of different aspects of being in the world. It is as though with Caro sculpture itself has become committed to a new kind of cognitive enterprise: not because its generating impulse has become philosophical, but because the newly explicit need to defeat theatre in all its manifestations has meant that the ambition to make sculpture out of primordial involvement with being in the world can now be realised *only* if anti-literal – that is, radically abstract – terms for that involvement can be found. Not only is the radical abstractness of Caro's art not a denial of our bodies and the world: it is the only way in which they can be saved for high art today, in which they can be made present to us other than as theatre.

If there is a single assumption behind Caro's work it is that anything the body does or feels or undergoes can be made into art. Indeed nothing reveals the scope of Caro's ambition, as well as the depth of his imagination, more than the fact that within the past few years he has been able to render wholly abstract various actions and states that are themselves paradigmatically situational: for example, being led up to something, entering it, perhaps by going through or stepping over something else,

being inside something, looking out from within. Caro did not set out to deal with these particular experiences; he works intuitively, without aiming at a particular expressive end – which perhaps makes the fact that experiences of this kind have come to play a more important role in his art than ever before all the more significant. Sculptures like *The Window* and *Source*, for example, are at least partly about being enclosed, as in a room or by a screen; but this is accomplished abstractly, without literally enclosing the beholder. Caro's use of metal grid has been instrumental in these and other pieces, enabling him simultaneously to define and to open the same plane and thereby to give the beholder access to an 'inside' or a 'beyond' that remains literally inaccessible to him. In fact one is never allowed to enter a Caro sculpture: not because he is uninterested in the experience of entering as such, but because allowing the beholder to do so would be tantamount to establishing a literal, situational connection between the beholder and the piece.

Similarly, in the table sculptures which Caro has been making since the summer of 1966 he has deliberately engaged with the physicality of objects, in particular their graspability and their apartness. The use of handles in many of the pieces explicitly acknowledges their graspability; while at the same time the subsuming of those handles in the syntax of the individual sculptures makes graspability itself into an abstract quality. There is also in the table pieces a more powerful sense of the separateness of elements, as of physical objects lying or standing apart from one another, than can be found in the work of any previous sculptor. This is achieved, characteristically, not by literally separating the elements, but on the contrary by connecting them, often with handles, in ways that separate them abstractly. Finally, the fact that all these sculptures go off the table and below the level of the table-top at one or more points acknowledges that they do not rest on the ground. And that keeps them from being experienced simply as small or table versions of larger sculptures – it gives them what might be thought of as a sheerly abstract smallness, independent of their actual size.

At another extreme from these pieces the great *Prairie* of 1967 goes further towards completely revoking the ordinary condition of physicality than any other sculpture in Caro's oeuvre. In the grip of the piece one's conviction is that the horizontal poles and corrugated sheet are suspended, as if in the absence of gravity, at different levels above the ground. Though once again this is done, not by hiding the physical means by which these elements are supported from below, and thereby seeming literally to suspend them in mid-air, but by acknowledging the means of support in such a way as to accomplish the abstract suspension not just of the elements in question but of gravity itself. The result, as in other sculptures by Caro, is something deeper, more radical, more abstract than illusion.

BRYAN ROBERTSON
ON BRIDGET RILEY

*Bridget Riley: Paintings
and Drawings 1951–71*
1971

Bridget Riley was the first contemporary painter to have a full-scale retrospective at Hayward Gallery. The exhibition, organised by the Arts Council as part of a European tour, featured the artist's black and white works, alongside her lesser-known colour paintings, early drawings and sketches. The retrospective took place ten years after the artist's first solo exhibition at Gallery One, London, and three years after Riley represented England at the Venice Biennale, where she won the International Prize for Painting. The influential writer and curator Bryan Robertson – Director of London's Whitechapel Gallery between 1952 and 1968 – was commissioned to write the essay for the accompanying catalogue. In London, the exhibition was extremely well received. In a letter to Robertson, the Arts Council's Director of Exhibitions Norbert Lynton wrote that 'a gratifying number of people told me that they thought the Hayward had never looked better'.

The eye is the first circle.
RALPH WALDO EMERSON, 'CIRCLES', 1841

In Bridget Riley's art, any definition of identity is confronted immediately by a paradox: for although her work is plainly her own, and nobody else's, there is one aspect of all her painting which defies identity in the conventional sense of surface texture or personal handling of pigment. The surfaces of these paintings are anonymous. This is not so unusual: a puritan strain in the imagination of many artists can be self-effacing in the expression of objectively constructed imagery. But Riley's plans for each painting are executed by assistants, under the artist's constant and strict supervision. The surface of a Riley painting remains entirely impersonal. Its identity springs from the visual perception, crystallised as an idea, that detonates or releases the essence of a new sensory experience.

There are practical reasons for work being carried out by assistants, for without them the artist would not be able to keep pace with her ideas. But the over-riding reason for employing assistants is because the nature of Riley's vision eschews painterly handling and instead demands immaculate execution. Only methodical application is needed, virtually automatic in physical reflexes and discipline.

We are accustomed to this approach to work from sculptors, who employ assistants as well as machinery, but it is still a comparatively new practice for the public to accept from a painter. Frank Stella and Roy Lichtenstein are two painters in America, among others, who employ assistants in their studio and Victor Vasarely provides, of course, an obvious example in France. But in Riley's case the absence of a uniquely personal surface may touch a raw nerve in our receptiveness because if her intentions could not possibly be confused with those of Stella or Lichtenstein, they are wholly different, in their lack of didactic impetus, to those of Vasarely. By nature Riley is a far more

BRYAN ROBERTSON ON BRIDGET RILEY

romantic artist than Vasarely, intent upon visual 'situations' and 'events' that are more traditionally pictorial in their roots, however remote this premise may seem when we see what they engender, compared with the decorative character (in the finest sense) and, above all, architectonic mainspring of Vasarely's work. It is quite new for a romantic artist like Riley to jettison the sacrosanct ingredient of personal touch, to abandon entirely the idiosyncrasies of a sensuously variable tactile surface. In oral terms, the result is like hearing unfamiliar music played by invisible instruments.

Vasarely has in addition a particular attitude towards art, technology, computers and society which makes it possible for him to produce multiples, with other activities, that deny the autonomy of the single painting. He has said that he continues to paint only because of the necessary prestige and financial reward obtained by the exercise, which enable him to continue his researches. Riley does not share this attitude and is a painter who creates paintings because she must, because of unknown territories that remain to be explored, because of the demands of painting perceptually conceived as an activity from which sensuality and the fullest imaginative achievement can only be seen and sensed *after* the completion of each work. She believes also in the uniqueness of a work of art as something transcendent, not as a prototype or as marking a stage in 'research'.

Riley's lodestars include, centrally, the impressionism which culminated in Seurat, Monet and Van Gogh, Mondrian, and the Futurists. She is concerned consistently with the physical expression of states of psychic ease, tension, repose, or disequilibrium; with thesis, antithesis and synthesis; with revelatory disruptions of ordered progression; with trapping and utilising certain units *as elements* in relation to each other in order to divulge the physiology of other, unseen, factors which, in their atmospheric complexity, disclose a fresh climate. In all this, and above all in releasing dormant or previously invisible energies from colour and light, the additional weight of personal handling would act only as a distracting veil between the spectator and these energies, certainly as a qualifying barrier.

What I have called the 'romantic' impulse behind Riley's work touches on another aspect of her painting. Although the artist mainly works within the prescribed boundaries of a progression of inter-related ideas, or plans paintings *en série*, there are occasional departures from this principle. A single work or a group of paintings may suddenly materialise at a tangent from what has preceded them. There are phases of recapitulation. At least one aspect of her work has not yet been fully exploited, in which oval shapes were deflected at minutely varying angles horizontally, diagonally, vertically, or in a spiralling centripetal or centrifugal tilting movement across the surface. In this group of paintings, colour was first explored and summoned forth (where, in essence, it did not exist) as warm or cold greys modified by infinitesimally progressive degrees of refinement until they culminated in the coldest grey, seen as 'blue', or the warmest grey, seen as 'pink', to counterpoint the equally subtle pace of their direction as well as the structure of their movement. Riley works intuitively: in this instance she felt impelled to move on to other regions because the complexities

of all these implications were holding her back from other ideas. She does whatever she can to confirm her intuition by classical disciplines and studied progression. Loose ends are picked up eventually and expanded later; but in general her work is self-generating, tightly so, in its momentum.

In referring to 'ideas' and their expression we arrive at the next stage in describing Riley's identity. An idea is conceived; but Riley's art is primarily perceptual, both in its driving force and in its physical realisation: its 'presence'. Vasarely intellectually explores formal concepts, even if they involve distortions, as vigorously as Riley discovers unexpected visual relationships and their offspring as a natural sequence of events in her strict adherence to perception prompted by instinct and induction. Vasarely is a dramatist, and a fine one; while Riley allows visual phenomena to speak for itself.

Perception may be common to both artists, but where Riley is most strikingly different to Vasarely is in her use of space. Vasarely confines his use of space to the picture plane. Whatever obtrudes from that plane or recedes into it is implied by *perspective within that picture plane*. His roots are in cubism, constructivism and the Bauhaus. In Riley's case, the spaces are white intervals; or vacant arenas to be inhabited by whatever is expelled – or exhaled – by the interaction of adjacent colours.

Riley's true space, the quintessential and most dramatic space of all, is not confined to the picture plane: it is the *distance between the spectator and the canvas*. This is the real arena of dramatic confrontation, the receptacle for transmissions from that picture plane which, with Riley, serves primarily as a sounding board or a magnetic field in reverse: transmitting colour and light, or light as colour, which do not exist in themselves on the actual surface of her paintings. They come into being, incorporeal and always unexpected, unpredictable, at a precise stage in their journey toward you. There is an ideal viewing-point; the paintings also demand active exploration from many distances. It is equally important to study them in close-up, formally, and as their basically resolved sources of energy. The paintings 'work' at many levels [...]

Installation view, *Bridget Riley: Paintings and Drawings 1951–71*, 1971

If Vasarely stems from constructivism and the Bauhaus and is concerned with architectonic principles, Riley is attempting to extend, by means of perceptual equations which are both rational and intuitive, the supposed climax arrived at by the impressionists. But the impressionists were intent upon recording, with the utmost plastic expressiveness in their use of paint as well as light and colour, the external realities of nature. The divisionism and pointillism discovered by Seurat did not serve as a basis for departure by his contemporaries but were pegged down by them to objects, to substances, intrinsically to pigment. Riley has freed these and her subsequent discoveries from 'matter' or substance, and dematerialised them as clouds of coloured light floating in the space between an already depersonalised surface and the spectator. What Riley's paintings are about is quite different to what, on close inspection, their apparently unyielding surfaces suggest.

BRYAN ROBERTSON ON BRIDGET RILEY

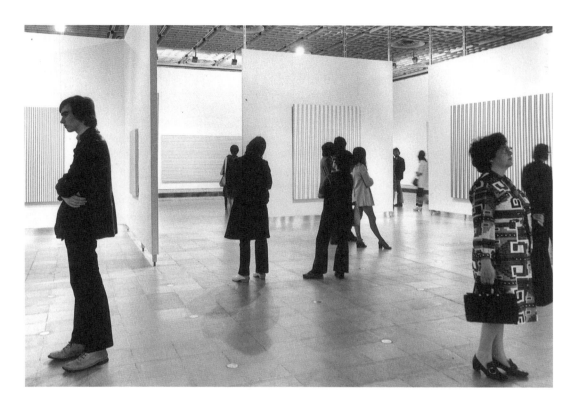

Like the way in which a man may be released, through analysis, after being inhibited from being fully himself or true to his inherent personality by the interference of an enforced role, thrust on him by the suppositions of society, so Riley is intent upon laying bare with absolute accuracy the fundamental energies to be found in the convergence or divergence of lines, or opposed masses; the expansion or contraction of parallel bands of colour and their parallel or diagonal subdivision; or to demonstrate the way in which one colour may invade and alter the characteristic function of another. All these preoccupations are freed from outside, extraneous demands of a descriptive or emblematic kind. She has released much else that can be described later, but it is essential now to understand that hers is an act of perception made concrete by conceptual speculation 'behind the scenes'. If her painting can only achieve perfect life when it inhabits, by transmission, space beyond itself, the eye provides the focal point in an especially exact and concentrated sense. Nothing is left to chance, though the imaginative qualities of the paintings radiate beyond that optical encounter and pass through to another dimension.

The artist should here be allowed to speak for herself: 'There are vast reserves of energy in everything and if you allow them to operate freely, relieved of pressures, concepts, malfunctions, distortions or perversities, or remove them from the burden

of carrying or embodying a projected character, you are nearer to stimulating or unleashing a truly creative power.'

It is at this point that another facet of Riley's identity may be described: the vivid, astringent freshness of her perception and the physical vitality in her work that keeps the conceptual aspect not only subordinate but totally invisible. Even in close-up, her paintings have their own perceptually aesthetic autonomy as abstract structures. Henry James once complained that 'certain creative works nowadays arrive so surrounded by explanation and built-in critical commentaries that one's approach to any one of them is like opening the door to a guest arriving for dinner to find him on the doorstep accompanied by policemen'. Riley's paintings travel farther than the usual terminal point and their climax occurs, in its dematerialised physical impact, beyond the frontier of the picture plane. But the paintings arrive alone, on their own terms and without arguing issues. They are unaccompanied by extraneous factors.

Occasional analogies with nature are fortuitous, though the starting point of Bridget Riley's work may sometimes spring from direct observation of nature. The artist has referred to her reactions in France to the apparent disintegration of rock by light, with pin-pricks of light flashing back from the invisible rock surface; to the heat-haze transfiguring a plain in the Italian landscape; or the regular geometry of a pavement asymmetrically transformed by a shower of rain. In her studies for paintings, these observations of natural phenomena have given place to abstract graphs of light and dark, movement and stillness, and other oppositions in nature from which the artist may have isolated one principle in particular with which to animate the forms on a canvas or the *behaviour* of colour which, in Riley's hands, stabilises itself into the controlled condition of *conduct*. It is significant that in the final paintings there is no sense of a 'graph' or chart: the progress has come full circle and the paintings suggest the unfragmented authenticity of a natural experience.

It is sometimes supposed that because Riley's paintings 'pull the eye', and seem to stretch or disorder our accepted perceptual sensations to the degree of straining our optical reflexes, that her intention is implicitly aggressive. But all art that breaks new ground, from Uccello to Picasso, attacks accepted modes of perception and actively destroys traditional standards of what is visually tenable in art. There is no doubt that Riley's paintings directly challenge our optical vision at the sharpest pitch but this does not restrict her to being an 'optical' painter in the accepted sense since she is not interested in even the most abstract *trompe l'oeil* effects. Glare or dazzle or the feeling of vertigo induced by tautly converging lines are all by-products of her central preoccupation: these disquieting feelings are not her main intention. Riley does not want to 'deceive' the eye; her work requires only an accurate eye as a receptive vehicle.

The optical challenge in Riley's work, given time, is tonic, bracing, and relates to new physical conditions or facts, received optically, which stimulate the imagination as much as they extend our knowledge of nature. If the challenge seems initially to strain our optic nerves it is really because they have become flabby and unexercised through

BRYAN ROBERTSON ON BRIDGET RILEY

the comforting familiarity of what they habitually encounter. We have a very narrow idea of 'nature'. We are creatures of habit and rarely fully stretched. Riley's paintings are alive with potentiality; they disrupt visual complacency and do not provide us with any opportunity for evasion or rest. If one of the dominant characteristics of the best twentieth-century painting is its freedom from nostalgia, then Riley's work shares ground with this new freedom in the continuous present […]

Riley's work confronts us, constantly, with new optical and imaginative sensations but to associate it with aggression is to misconceive the artist's purpose. If we continue to see her work as aggressive, then each new proposition put forward by any artist must be seen, by implication, as an act of violence – as indeed it usually has been seen in the past until familiarity removed the sense of threat. We should look elsewhere in contemporary art for the themes and conditions of sado-masochism, implemented most recently in the more extreme modes of conceptual art. The truth is that we are not used to such *active* paintings as Riley's, which extend so precipitously into space from tightly reasoned premises, and advance at such electric speed to meet us. We have become accustomed to painting as an identifiable surface, with any content or movement confined to a flat plane so that the dynamics are reassuringly distanced, like an animal behind bars.

But if her attempt to extend the colour and light functions of impressionism, and Seurat's pointillism, can be understood as historical evolution, it is necessary also to realise that the innate tensions of her work, embodied by formal relationships or oppositions in terms of black and white, or as colour which serves as a harmonically constructive vehicle at such insistently ordered intensity that it becomes transformed, are equally relevant and cannot be disregarded. These tensions provide the underlying strength and positive force in all Riley's work in the same way as the 'stabilisation' of a Mondrian grid painting, with its locked units of red, blue and yellow signalling the climactic intersections of his vertical and horizontal structure of black lines, gives to his equilibrium a dynamic urgency through the exorcised expressionism behind [his] sustained act of refinement […]

The tensions in a painting by Riley set off an 'expressiveness', in addition to the light/colour which blazes or glows from the surface, not dissimilar to that in a painting by Mondrian. The compacted expressionism of Munch and Van Gogh also affected Mondrian just as much as the structure of organic growth. And the seeds of expressionism sown by Van Gogh as well as the dynamics of the divisionism of Seurat have affected Riley in a similar way, giving her abstract work a loaded compression and energy in the impact of each painting that does not come only from its concentration on essentials and the reductive distribution of their component parts.

Riley is also intent upon climax, but as crescendo: with slow, fast or abrupt colour transitions as contributory movement; with changes of tempo; drastic convergence or divergence, and other near-organic issues touched upon earlier in this text. It is

not possible to deal, in Riley's terms, with any of this phenomena without invoking and establishing an expressiveness that exists beyond the boundaries of her final, clearly stated abstract paintings. The expressiveness stops far short of the wilful deformations of expressionism; but the measures adopted by Riley release formal and harmonic energies in the toughest and most radical, certainly the least ingratiating way. They combine together to make a new plasticity which exerts a special force in her paintings as well as the colour/light transmissions. If these paintings seem aggressive, then light refracted from the surface of a crystal must also be seen as an act of aggression.

Given Riley's early allegiances to Van Gogh, it is useful to recall that Van Gogh's drawings, as his most direct statements, employ a marvellously orchestrated and decorative calligraphy, alive with tensions, to register all the accents and nuances, in their essence, of the structural energies in landscape: from rocks and water to grasses, trees, clouds and sky. This point of departure for Riley, with the analogous structurally articulated deluge drawings of Leonardo, has been aptly indicated by David Thompson, the artist's most scrupulous interpreter, in his film for television on Riley's painting called *Fall*, of 1963. In this film, which avoids the usual falsifications of the media, Thompson makes many other comparisons, from natural events like the movements in deep grass agitated by the wind, to the amalgam of complementary elements of colour in paintings by Seurat which, close-up, strike off a friction until they become submerged within the totality of the object depicted: distanced as a rock, the sea, or part of a human body.

Riley stays with the friction and ignores the object; or, rather, allows the friction to occur and manifest itself at a new altitude in her pursuit of formal conclusions. The friction is spontaneously set in motion as a new basis for coherence and is retained, involuntarily, because the constituent parts of each formal or harmonic synthesis are left exposed like raw nerve ends. Nothing is submerged or concealed. Each move in the process of dissection and reassembly is evident, as well as the final resolution in formal and optical terms. It is within the total character of this final resolution that Riley's identity resides.

Is her identity dispersed or submerged by method and rule? Seurat's art was of course conditioned by theory; but it should be noted in passing that although Riley is patchily aware of the history of colour theory from Newton and Goethe through to Chevreul, and Seurat's contribution to colour analysis, her own grasp of theory, of any sort, is elementary. The artist has described her intentions in this way:

> I have never studied 'optics' and my use of mathematics is rudimentary and con-
> fined to such things as equalizing, halving, quartering and simple progressions.
> My work has developed on the basis of empirical analyses and syntheses, and
> I have always believed that perception is the medium through which states
> of being are directly experienced. (Everyone knows, by now, that neuro-
> physiological and psychological responses are inseparable.)

BRYAN ROBERTSON ON BRIDGET RILEY

It is absolutely untrue that my work depends on literary impulse or has any illustrative intention. The marks on the canvas are the sole and essential agents in a series of relationships which form the structure of the painting. They should be so complete as to need, and allow of, no further elucidation. The basis of my paintings is this: that in each of them a particular situation is stated. Certain elements within that situation remain constant. Others precipitate the destruction of themselves by themselves. Recurrently, as a result of the cyclic movement of repose, disturbance and repose, the original situation is re-stated.

I feel that my paintings have some affinity with happenings where the disturbance precipitated is latent in the sociological and psychological situation. I want the disturbance or 'event' to arise naturally, in visual terms, out of the inherent energies and characteristics of the elements that I use.

Other polarities which find an echo in the depths of our psychic being are those of static and active, fast and slow, or warm and cold. Repetition, contrast, calculated reversal and counterpoint also parallel the basis of our emotional structure. But the fact that some elements in sequential relationship (the use, for example, of greys or ovals) can be interpreted in terms of perspective or *trompe l'oeil* is purely fortuitous and is no more relevant to my intentions than the blueness of the sky is relevant to a blue mark in an abstract-expressionist painting.

It also surprises me that some people should see my work as a celebration of the marriage of art and science. I have never made use of any scientific theory or scientific data, though I am well aware that the contemporary psyche can manifest startling parallels on the frontier between the arts and the sciences.

And elsewhere, regarding her attitude to the space in which the situations in her paintings have to occur, the artist has said:

My conception of space is 'open' space, shallow space, a multi-focal space, as for example in Pollock, as opposed to a focally centred space. Nevertheless, I use occasionally a concept of space which has two counterpoint centres. But on the whole I tend to work with open-area space. Mondrian used this and it demands a shallow push-pull situation and a fluctuating surface.

As essential to Riley as the multi-focal, shallow space that she describes is *scale*. And here it must be stated that whereas American painters have used scale as an expression of freedom from the cabinet picture, and as a romantic gesture as well as one perfectly attuned to the full possibilities of physical gesture, as in Pollock's work, Riley's painting demands always the scale that is precisely relevant to the energies supported by her chosen units. Scale in Riley's work is indivisible from content and is generated and set by that content. A big painting by Riley is not a 'heroic' or grandiose statement: it is very large because the units contained by it would not function properly in any other scale.

In response to questions about tempo in her paintings, and changes of speed, Riley has stated one of the most important conditions of her recent work:

> A lot of my notations for recent paintings are written down in this way (for example, the figures 'seven, three, one', that might represent a sequence of colours or forms which control an optical speed), and one might think that I had selected seven and three, for example, because of some arcane or scientific relationship independent of vision, but I am in fact experimenting in visual tempi. For example, a slow movement of 'seven' looks right with a fast movement or 'three'. If I try 'six' against 'five' it may not be discernibly different but in the case of 'eight' against 'two' the jump is too big visually. By the time I have reached the point of writing down seven with three, I have drawings pinned up around the studio with other pairs of relationships explored from which I have chosen seven and three as right for my purpose.

> But there are two types of tempo. There is the overall tempo of the picture and there are the different rates of movement, the separate tempi, of the units within the work. I think the first time that I became conscious of this was in starting to use grey. Grey is midway between black and white, and clearly this relationship is encompassed in the three stages: white, mid-grey, black. But you can make a progression in five beats, seven beats, twenty-four and so on, and all the time you are in fact changing the tempo. I became very interested in this question of visual time. I worked through a series of paintings using this concept: it led to my trying to pitch this type of tempo against structural tempo with axial movement.

In general, although Bridget Riley has read and admires a few works such as Rudolf Arnheim's *Art and Visual Perception* and Stravinsky's *The Poetics of Music*, her reactions to theory are best expressed in her own words: 'In general, I cannot be opened up or stimulated by the printed page unless it serves as a mirror to reflect or extend an already existing strand of thought, evolution, or line of enquiry.' [...]

To return to what is physically perceived by Riley, as opposed to conceptual development: around 1960–61, the artist noticed for the first time that in Cézanne's watercolour studies, what had been called 'corrections' along the contours, in his drawings of tree trunks, were in actuality graphic notations for light hitting a surface, i.e. the tree trunk. Movement could have been extracted from this; but Cézanne was too firmly rooted in impressionism, as embodying the physical vibrations of light on natural surfaces, and had, too strongly, an accompanying allegiance to a robust strength and stillness of construction in still life or landscape derived from classical models, to push through into the further degree of kinetic abstraction implied by these factors. It was left to the cubists, but far more radically to the Futurists, to take the wholeness of Cézanne's understanding of form, at once constant in structure and fugitive through the shifting emphases of light, and to create a new form of simultaneity [...] Ultimately, it is the work of the Futurists, Boccioni and Balla, that

BRYAN ROBERTSON ON BRIDGET RILEY

interests Riley most because cubism solidified space or turned space into another aspect of form: space or spatial form had become too circumscribed, consumed by perspective, and localised, whereas the Futurists extended form spatially as movement across the picture plane.

And as the most radical space in a painting by Riley is the space *between* the canvas and the spectator (while the other spaces in the painting are intervals, or blank areas to be occupied by the interaction of adjacent colours) it could also be implied that Riley's work is a personal extension of the 'figure in a landscape' tradition. Throughout the development of this tradition, the figure has either been subordinate to the landscape: emanating from it, as it were, as an imaginatively sympathetic projection; or the figure has dominated the landscape in such a way that the landscape becomes an imaginatively and psychologically apt commentary on the figure, or an aesthetic extension of the *persona* of the figure. Only rarely have figures and landscape existed on equal terms. Modern art allows the figure to be consumed by the landscape, or vice versa, and emerge as an abstract structure with disguised but implicit references. The same is true of the abstract dialogue or ambiguity between interior and exterior space, in other modern paintings.

With Riley, the figure is completely removed from any context – it is obviously not landscape in Riley's case – within the picture plane and becomes, *as the spectator himself*, a fulcrum for the energies contained by the painting. In this sense, Riley could be considered as one of the most acute and direct environmentalists at work today, since the spectator is pulled into an active participation with the painting, without special props, which goes far beyond the customary involvement, under the purest and most stringent optical conditions. The only space concerned in this involvement is an extension of the pictorial space. There are no extraneous references of any kind: *all* the spatial relationships are purely formal and exactly determined by the painting.

One final observation by the artist: 'Our bearings still suffer from the concept or suppositions of Renaissance theory, which is "man as the measure of all things". But man is part only of a bigger whole and this whole is neither centripetal nor centrifugal. It is much more open and egalitarian; and the structure of this whole, as opposed to a circle (Renaissance) is an infinitely subtle grid.' Riley is not familiar with the work of Lévi-Strauss and his structured theories of behaviour and evolution among primitive societies, but there is possibly a correspondence of thought here, also.

Riley's interest in behaviour, or its abstract principles, can be found in her titles. which are not poetic indulgences or arbitrary labels. Even the more recondite titles, such as *Byzantium* (1969), *Persephone* (1970) or *Gamelan* (1970) are allusive to 'states of being' rendered in optical terms: *Gamelan*, for example, is in visual terms the equivalent of a hard and sudden percussive sound in the swift pace of graded movement in its colour-and-light resonance. *Breathe* (1966), by contrast, is a painting in which movement, by expansion and contraction, is deliberately slow; *Fall* speaks for itself; *Late Morning* (1967), is the first large work in which an unusually wide

spectrum of eleven colours (red, blue, green and eight hues between blue and green, blue-green, turquoise, etc.) combine to produce an extreme sharpness and brightness at the outer extremities of the canvas which softens toward the centre and registers a pale-yellow glow across the canvas that is pure illusion, released by the serial interaction of red and green. The pale-yellow glow is invoked light emanating from the surface of the painting when seen at a certain distance.

Attention should also be paid in other paintings to the way in which colour widths vary, adjoin each other or white voids, or are super-imposed over each other in different widths leaving variable borders of the subordinate colour which thus alternate in dominancy or acquiescence. And it is important to trace the basis and repercussions of the movement when one colour traverses another as an attenuated *diagonal* band and thus sets up a different sensation, beginning with one of the *Banner* paintings, *Banner 2* (1968), and culminating in *Persephone*, a high pitched painting, cool and spring-like, in lilac-magenta, blue and green; and *Orient 4* (1970), in which cerise, olive and turquoise produce a duskier, more subdued yellow glow of light and, in musical terms, achieves a deeper and warmer sonority than almost any other painting made so far. A different, if equivalent resonance, in terms of colour-space momentum gathering speed and thrust and broadening in definition as it swells toward the centre, can be found in *Chant 1* (1967) and especially in *Chant 2* (1968) and later, more coldly and abruptly, almost as a detonation, in *Gamelan*. These three paintings employ only parallel bands of colour, which are not traversed by others to form attenuated triangles. The earlier use of black and white in Riley's paintings has no symbolic overtones, except as oppositions: black and white from the beginning are used as colours, or in the artist's own words: 'as surrogates for colour'.

But in a general sense, every colour in a Riley painting is a surrogate whose influence extends beyond itself to invade and modify, by appearance, its adjacent colour: either simply, in pairs, or in a more complex structure through serial progression and inversion. A central, balanced grey can be reached in two ways: either by simple pigmentary mixture or through eventual fusion of polarities such as turquoise and vermilion. This occurs in *Cataract 3* where the central pairing of vermilion and turquoise (exact complementaries) arrives at grey, by implication, which equates with the pigmentary, non-illusionary, grey seen at the top and base of the painting. The main characteristic of this painting is a controlled situation of flux between these two routes to grey.

In the most recent work, patches of pale light are released at what seem to be irregular intervals right across the surface of the painting through the distribution of colour in bands. In *Rise 2* (1970), for example, these multiple and asymmetrically distributed 'flashes' occur, and individual bands of colour change into quite different colours, most spectacularly, when seen from a certain distance. Violet, yellow, green, pink, and strong red all materialise from ascending bands of cerise, blue and golden-brown, in differing alternations of three, which are 'spaced' regularly with white. And in *Apprehend* (1970), the opposing elements of rising and falling are shown simultaneously through

progressively widening or narrowing bands of grey and black, enriched by flashes of coloured light along the edges of the blacks and greys which are not, on close inspection, where they appear to be at a distance: in this very discrepancy, the 'colours' of the blacks and greys, which are in fact constant, seem to change and pass through another spectrum. The spatial interplays in this painting are extremely complicated and the painting, a culmination of many years of work, must be considered one of Riley's most powerful inventions.

Finally, if the artist has spoken of a human condition in nature which is neither centripetal nor centrifugal, it should be noted that the edges all round her paintings are both important to observe and surprising in what they disclose, notably in *Arrest 3* (1965) and *Drift* (1966). The paintings make a complete statement; there is no suggestion, certainly no intention, of trapping a fragment from a condition of flux extending outside the picture plane. But the terminal points around the edges of Riley's paintings here have a freedom, and random unpredictability, implying a situation inside each canvas that is arrested between centripetal and centrifugal movement.

The toughest and earliest expression of this situation, possibly, is *Kiss* (1961), in which a curved and a square black shape confront each other in dynamic tension, both in terms of hairsbreadth proximity and the way in which the stable, solid, black rectangular-base-shape is confronted by or almost supports an unstable, tilted segment of a black circle shape. Both parts co-exist, impartially; the segment of a solid black circle is stable in itself and yet implies that the centre of the circle is high out of range, above the boundary of the top left corner of the painting. The blank white area between the black masses is made to assume the active role of a third protagonist through the way in which it is caught and squeezed by the black shapes with such intensity of compression at the off-centre focal point that the white appears to be bulging outward, beyond the picture plane, at each side of the painting.

Kiss is clearly a turning point in the artist's evolution: a state of pressure is shown in the clearest and most monumental terms; but its parallel with other works is useful to follow. *Chill* (1964) goes through the same motions but in reversed conditions and in multiple dispersed spatial and tonal units. The beginnings of an approach to colour in the manipulation of formal units with white as a space to be occupied by optical 'blink', or transference, are stated in both these paintings as well as in *Breathe*, which foreshadows the later crossing of vertical bars of colour by diagonal, narrower, bands of colour exemplified in the *Banner* paintings of 1968.

Few artists in recent years have progressed with such measured, frugal restraint and certainty of purpose; or deployed counterpoint as units of colour or shape as well as movement in such a deceptively simple manner. Riley has steadily denied herself the luxury of the spectacular set-piece: every painting is the inexorable result of the one preceding it. There are no sudden eruptions, no extravagances, no evasions of the issues as they are disclosed, no digressions or self-indulgent respites from the central direction of her work which continuously gains in elusive richness,

although some paintings appear, by hindsight, to be anticipatory and others seem to recapitulate earlier themes – which is, of course, true of most artists' work. Like life or any supposed progress, an artist's work does not advance in totally logical order. Organic evolution is not a straight line from a to z, but some kind of circular equation.

We are left with the question of identity: which brings me back to the aesthetic of the work again, but this time as an object for contemplation rather than analysis. What are the true characteristics of Bridget Riley's painting? The sheer visual intelligence of this artist is obvious. The flow of vitality throughout the work is constant, unswerving, and consistently eliminates the toxic qualities from whatever she reveals so that the tonic energies, in exactly calculated quantity and degree, survive unscathed in pristine force. If this seems clinical as an approach to art, it should also be granted that such an attitude presupposes not only a goal but an ideal; certainly the generalised motives of purification and idealism. Furthermore, each painting in impact is a joyous celebration of truth: these paintings are optimistic affirmations of what an alert, fluent relationship between the eye and the imagination can release.

But a painting by Riley is also, unquestionably, a visual spectacle which passionately seeks our direct, involuntary participation and sensory response. Riley's work may utilise physical evidence dispassionately but there is often a great tenderness in what her paintings suggest; an empathy with colour and its full nature, in selective instances, which affects our imagination to the same extent as it imaginatively informs the structure of the painting. Perception cannot be indiscriminate; selection is instinctive and determinate. Mallarmé did not speak the whole truth when he told Degas that poems were made only with words.

In any painting by Riley, the confluence of precisely stated physical conditions gives place to a total presence of etherealised colour and light but the vibrations behind that presence change structurally as the eye moves across the surface of the painting from different angles. Formal subtleties, at more than one level, have to be sought out: the potentialities of a Riley painting do not subside at easily defined frontiers. Its presence is imaginatively alive, charged with action and unpredictable flux: constant under stable conditions of lighting and most radiantly discharged in full daylight, which implies that Riley's paintings are as free of artificiality, in a negative or contrived sense, as they are devoid of extraneous factors. At their best, they are like spontaneous acts of nature. Riley is showing us what we did not know before, and here she is an innovator because she brings these 'acts of nature' into existence.

This is an abridged version of the original essay, published in full in 1971.

ANNE SEYMOUR
ON BRITISH
CONCEPTUAL ART

The New Art
1972

The New Art was the first institutional survey of British conceptual art. The curator Anne Seymour, who was at the time a young Assistant Keeper at the Tate Gallery, sought to address work by British conceptual artists who had frequently exhibited abroad, but rarely in the UK. The exhibition had originally been intended as a survey of British contemporary art – the first in a series of 'Hayward biennials' – but under Seymour's direction became more focused, featuring just 14 artists including Michael Craig-Martin, Barry Flanagan, Gilbert & George and Richard Long. This landmark exhibition received mixed reviews in the press. While Richard Cork in the Evening Standard *praised Seymour's 'courage, intelligence and care', Marina Vaizey, writing for the* Financial Times, *criticised the artists for making 'arrogant and elitist noises'.*

Faced with the disproportionate size of the entire field of current British art and 18,000 square feet of the Hayward Gallery, my first consideration was where is information needed most? And it seemed that even after six or seven years of getting accustomed to it, there was still a really bad area of mystification surrounding the kind of work which has recently extended the historical continuum of art a little further. Land art, conceptual art, arte povera, process art are some of the labels which have been allotted to parts of it. I have taken it to include a rather wider range of things, but basically work which does not necessarily presuppose the traditional categories of painting and sculpture – involving written material, philosophical ideas, photographs, film, sound, light, the earth itself, the artists themselves, actual objects. However, the ideas and attitudes contained in the work are equally if not more important than the media. I felt if I could explore and collect together some of the criteria concerned I would be making a more useful contribution than I would by attempting an all-over view of an incredibly diverse situation.

The situation of a particular area of art crying out for attention is probably peculiar to the present time. But it also seemed justifiable to single it out for reasons of its international connections, the somewhat uneasy bed it has made for itself in art schools in this country, its lack of representation in its more radical forms in public museums and art galleries. The present moment also seemed to be a good time for a backward look at a ripple in the waters of art which has been moving outwards on the basis of impetus received more than half a decade ago. To leave things much longer could mean that we might only be able to see these ideas in a purely historical context. As it is, we can, I think, see the distinct phases through which the ideas have passed while at the same time get some feeling of what issues are at stake. It also looks as if we are catching things at a moment of rethinking, expansion and change.

Clearly the exhibition constitutes a broad and personal selection. It probably includes only a fraction of the number of people working in somewhat similar ways in this

country. It also doesn't include some people I would have liked it to. Bruce McLean, whose area of operations might be defined as somewhere between Richard Long and Gilbert & George, has recently renounced his status as artist and he felt it would be inappropriate in the circumstances for him even to allow his previous work to be exhibited in an art context. (The designation was his, not mine.)

Although this kind of thing has long been featured in art magazines and things have snowballed in the field of written and photographed information since 1969 (the famous *Conception* show was held in Leverkusen that year), in Britain we have actually *seen* very little of it. Landmarks have been the *When Attitudes Become Form* exhibition from Berne, partly organised by Charles Harrison at the ICA, and the (entirely his own) *Idea Structures* show at the Camden Arts Centre the following year. Commercial galleries, such as the Lisson Gallery, Nigel Greenwood, and recently Situation have had relevant shows. Richard Long exhibited briefly at the Whitechapel Gallery last year and the Tate had a fill-in show of some of the artists earlier this year. The Rowan Gallery supports Barry Flanagan and Michael Craig-Martin. But there has certainly been no real acceptance in this country of the fact that art may never be the same again since the artists, British and foreign, who showed in these exhibitions appeared on the scene.

The situation has been rather different abroad. Many of these artists in this show are in constant demand in other parts of the world and some have become very selective about where they exhibit. (A number of them will be at the Documenta exhibition in Kassel this year.) Britain is a quiet place to work, but New York, Dusseldorf, Paris and Turin are where they sell and display their ideas.

Although charity must begin at home, in view of the straitened exhibition and gallery circumstances in this country, it would of course have made most sense to have seen this work in an international context. It would have thrown into relief precisely how these manifestations of a world-wide upheaval are very specifically British in their eschewal of aesthetic mumbo-jumbo, in the ways they discuss the paradoxical nature of the work of art (whether indeed it matters very much what it's called as long as it makes sense), how we see and think we see reality, the kind of time and space and specific content it is possible to put into a work.

Among the artists in this show there is no question of transatlantic or continental influence in some cases and very specific instances of it in others. For example, the approach of Robert Morris, Ad Reinhardt and of American minimal sculpture in general is widely evident in work by many of these artists in the mid 1960s: Keith Arnatt, Michael Craig-Martin, Victor Burgin, for example. That Joseph Beuys has been an important figure is acknowledged by Keith Milow – no doubt he has been influential in other cases.

However, in 1965 (the year of Robert Morris's *Mirror Boxes*) Richard Long had already done his first pieces out of doors. This was also before he went to St Martin's and

before he saw the Whitechapel Gallery 'New Generation' sculpture show that year (David Annesly, Michael Bolus, Phillip King, William Tucker et al.) which adjusts the popular misconception which distinguishes this kind of work as 'post-New Generation' sculpture.

It is nice for chauvinism that English artists were up at the front. But as Carl Andre has said, around that time, 'They [himself, Robert Morris, Michael Heizer, Robert Smithson, Dennis Oppenheim in America, Jan Dibbets in Holland, Richard Long in Britain] all reached the same objective state and their subjective reaction was somehow to work in similar ways'. The same goes for the situation when Terry Atkinson took the first written pieces by himself and Michael Baldwin to America in 1966 in search of some likeminded thinking, though he seems to have found himself somewhat further beyond what has been termed 'the object-barrier' than any of the people he visited at the time.

That these artists belong to an international intellectual context is vital, but it is clearly a source of worry to some of them that it is easy to misconstrue that context by singling out parts of it for attention without recognising that it represents a complete worldwide consciousness in time and space.

Richard Long, *Three Circles of Stones*, 1972. Installation view, *The New Art*, 1972

One might perhaps say that there seem to be two poles of principle within the criteria which motivate them. There is the one which is most obviously recognised in the Art-Language group which has deliberately, by dint of philosophy and common sense, expanded its work beyond the aestheticism of so-called 'modernist' art. Its systems and weapons are logic, mathematics, information theory, philosophy, history, cybernetics – almost anything with a solid basis of thought is grist to its mill.

On the opposite side of the coin you have an approach, as exemplified by the work of Long and Hamish Fulton, which repudiates not only aesthetic discussion of art, but emphasises that it is necessary to work according to no preconceived philosophies, as far as possible from the great art history machine. Long's concern is with things at their rawest, their simplest, their most pure. His work is a quiet connection, private, a philosophical dialogue between the artist and the earth. For all its complexity, it has that concentrated inconsequential, incontrovertible conviction of the man in the Samuel Beckett story who has 16 stones in his pocket and simply moves them round inside the pocket; it seems the right thing to do.

Basically, Long's attitude has much in common with Gilbert & George's, but they have taken their practice right out into the public domain and given it a deliberately ambivalent, precarious role in art, between sophistication and naiveté. There is nothing new about this, nor about art where everything has purpose and no loopholes are left, but in extending the idea in time and space to include a way of life, Long, Gilbert & George and Fulton seem to counter the breath-taking freedom suggested by adopting moral obligations against which careless spectators can stub their toes.

ANNE SEYMOUR ON BRITISH CONCEPTUAL ART

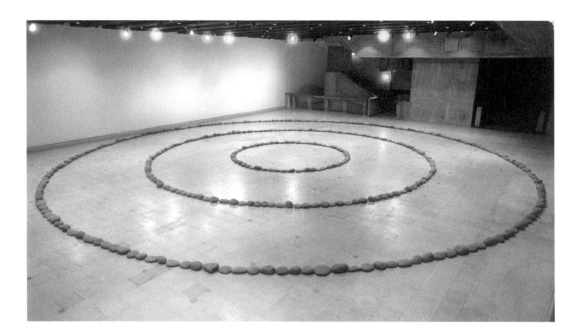

It is symptomatic of this situation that neither Long nor Fulton have permitted explanatory material to be published about their work in this context, and that David Tremlett who works with similar considerations has allowed only material to be used which is largely outside the usual area of art writing. (Indeed all the artists have checked and often revised the material collected in the second part of the catalogue which was based on a series of interviews during the early part of this year.) That this new art presents particular problems for art writers is already evident in art magazines. The difficulty with the language orientated work is the amount of pre-reading which is necessary, but other kinds of work also demand a much more detailed kind of thinking than perhaps seemed necessary before. In the absence of such miracles, Long and Fulton continue to work in peace – at their express request.

If principle is the backbone of Long's work, the material side of things is equally important as flesh. It's the touching of the earth and the meaning of the touching that matters. There is much the same feeling in Barry Flanagan's attitude to materials in Keith Milow's use of processes to build layers of reference into a work. In all cases materials are used with straightforward functional implications and in a basically undisguised form. Michael Craig-Martin has used ready-made easily purchasable objects. Gerald Newman creates a complex interweave of sounds by banging a bottle with a hammer (though you wouldn't know that was what it was), to get an effect physically rather like a Barnett Newman painting. The systems into which the 'materials' are fitted are arbitrary, quasi-mathematical, always self-contained, often constructed directly out of the materials themselves.

Among other things John Hilliard uses photography to discuss photography, David Dye, film to discuss film, Art-Language, philosophy to discuss philosophy, Long, landscape to discuss landscape.

The political and social significance of work which may be made of ephemeral or unimportant materials and may operate as much in time and space as immediately in the eye of the beholder, has perhaps turned out to be less forceful than was originally hoped in financial respects: instead of being quite unusable within the sinister structure of the art market an enormous amount of money has been made out of conceptual art. However, the moral and the physical results remain. Although perhaps we shall never know if the shafts aimed at real estate and at the need for a thinking rather than a materialistic or neurotic approach to art have gone home, since the need for such criteria comes from outside as well as inside art.

To me one of the most important things this work has done is to open the field to history again. It has become possible to consider not simply as reference, connections between Terry Atkinson and Hegel, Richard Long and Beckett, Keith Milow and Rauschenberg, Gerald Newman and John Cage, to consider matters of current interest outside art (as well as inside it) in terms of mathematics, logic, information theory, and so forth. Being able to do so has also shed new light on the work of more traditional means, but just as radical approach, that preceded and now runs parallel to this sort of thing.

Richard Smith's great series of paintings, *A Whole Year, Half a Day*, Bernard Cohen's white pictures, Beckett's 'Imagination Dead Imagine', Richard Long's first pieces out of doors when the whole world suddenly became open to work with – all of them appeared at the same time, around 1965–66. To speculate why is to speculate about the history of collective consciousness.

If there is any single attitude which binds the artists in this exhibition together – and they certainly shouldn't be seen as any kind of group – I would say it was their ability to look reality in the eye, deliberately to see things in proportion. If there is any look which their work has in common it is to do with a very straight use of materials and images and facts.

Reality has always been strong medicine, perhaps because it is generally taken for granted. But reality doesn't have to be a nude lady of uncertain age sitting on a kitchen chair. It can also be a Balinese 'monkey dance', a piano tuner, running seven miles a day for seven days, or seeing your feet at eye level. It can mean that the artist can work in the areas in which he is interested – philosophy, photography, landscape, etc. – without being tied to a host of aesthetic discomforts which he personally does not appreciate. This doesn't mean he can do without structure. As (approximately) John Cage has said, structure without life is dead and life without structure unseen.

ANNE SEYMOUR ON BRITISH CONCEPTUAL ART

JOHN RUSSELL
ON LUCIAN FREUD

Lucian Freud
1974

By the early 1970s, despite being one of the UK's best known and most respected artists, Lucian Freud had not yet received a comprehensive showing of his paintings and drawings. Hayward Gallery staged Freud's first retrospective in 1974, when the artist was 50 years old. The exhibition, which featured more than 120 works, covered his entire career, from his early works in 1937, through to his portraits and still-life paintings and drawings of the late 1940s, and the larger than life-sized works that Freud began in the late 1950s. More than 90,000 visitors attended the retrospective during the London showing, after which a smaller version of the exhibition toured to venues in Bristol, Birmingham and Leeds. John Russell, art critic of the Sunday Times *and later the* New York Times, *contributed the following biographical essay to the exhibition catalogue.*

I n the paintings of Lucian Freud there has been developed over more than 30 years a particular kind of steadfast scrutiny. That scrutiny involves a long, slow stalking of the thing seen; but as much could be said, as we know, of a lot of work which in its final effect is pedestrian and unillumined. In Freud's case there is the stalking *and something else*: and as to the exact nature of that something else our best analogy from the past is probably not drawn from another painter at all, but from a sculptor. One of Lucian Freud's few possessions is a bronze by Rodin, and it was an important day for him when he came across, in Bernard Champigneulle's book on Rodin, a reported conversation with the great man on the subject of just how he used the model.

'I do not correct Nature', Rodin had said. 'I incorporate myself within it. It is my guide. I can only work with a model. The sight of the human form sustains and stimulates me. I have an unbounded admiration for the naked body. I worship it. I can tell you flatly that when I have nothing to copy I don't have an idea in my head. But as soon as Nature shows me shapes l find something worth saying – and worth developing, even.'

Not long ago Lucian Freud said something about his own procedures which, though in many ways comparable, was informed by the keener self-awareness which is a part of his generation's inheritance. 'I am never inhibited by working from life. On the contrary, I feel more free; and I can take liberties which the tyranny of memory would not allow. I would wish my work to appear *factual*, not *literal*.' Now the notion of fact, or the definition of facthood, is something that varies with all of us from year to year. Our notion of rigour varies, likewise. Young men differ, in such matters, from men in middle life, and any individual human being will modify his opinions many times over in the course of a lifetime. Lucian Freud in life is a paragon of alertness and speed of response; and if this should seem to contradict the ordered adagio of his working methods the truth is that the two aspects of

JOHN RUSSELL ON LUCIAN FREUD

him are not mutually contradictory. They interlock, rather, with results that have varied continuously since he first came to notice soon after the outbreak of the war.

It was in April 1940, to be precise, that Lucian Freud's name was put before the public in the third issue of Cyril Connolly's magazine *Horizon*. Both the look and the contents of the magazine were somewhat tentative, at that time. It had not yet developed that readiness to irk and to outrage, that determination to have the very best, no matter how sombre the state of the world outside, which marked its greater years. Art for once ran ahead of literature, under the guidance of the magazine's backer, Peter Watson, and the issue in question included Clement Greenberg's *Avant-Garde and Kitsch* as well as the first published drawing (a self-portrait) of Lucian Freud. Freud was then 17 years old. Among those who were on, or close to, the magazine at that time he exerted a considerable fascination. Like Tadzio in *Death in Venice*, he was the magnetic adolescent who seemed by his very presence not only to symbolise creativity but to hold the plague at bay. Like the naked youth who crosses the stage at the end of Busoni's *Doktor Faust*, he was the visitor from another world who rounded off a long and painful story. Everything was expected of him. Opinion was divided as to whether he would have a career comparable to that of the young Rimbaud, or whether he would turn out to be one of the doomed youths who cross the firmament of British art like rockets soon to be spent.

Appearances may well have deceived, in this context. We can see from a photograph published in John Lehmann's magazine *New Writing* that as late as 1943 Lucian Freud had a bushy, untouched, still-adolescent look. But in reality he was what he is now: a man of iron and leather, not at all to be deflected from his purposes. Doubtless this was innate, but it had been reinforced by the experience of a European education of a kind peculiar to the late 1920s and early 1930s. He was born in Berlin in December 1922. His father, a son of Sigmund Freud, was an architect who had also, in his student days in Vienna, been quite an accomplished artist in the style of the Secession. His mother's father was a grain merchant in north Germany with an estate near Potsdam and it was there that Lucian Freud acquired the lifelong love of horses which belies his urban nature. In the summer the family went to a house on the Baltic, not far from the island of Rügen, where Caspar David Friedrich painted some of his most visionary pictures, and the island of Hiddensee, well known to readers of early Isherwood. For the rest of the year they lived in Berlin, near the Tiergarten, in what was distinctly one of the *beaux quartiers* of the German capital. When Lucian Freud first went to school it soon became clear that his was a privileged family – so much so, in fact, that when he had a short illness in Berlin no fewer than 50 of his schoolmates in the country wrote to him, individually, to wish him a rapid recovery.

From the age of seven he led, none the less, a double life. The street-scene of Berlin from 1929 onwards was a hard school of life, in which the children of the rich could graduate on equal terms with the children of the poor. Both were free to parody the hideous pastimes of their elders – lighting fires, chalking emblems on the wall,

looting and ransacking when occasion offered, operating in packs, picking quarrels and following them through, and in general subverting and disrupting the patterns of bourgeois life. It was in these circumstances that Lucian Freud learned to outrun, outfight and outsmart the future leaders of the Berlin underworld; and the lesson was not lost upon him.

When his father and mother left Germany in 1932 and started a second life in England, Freud adapted himself with the celerity, and with the insubordination, which are fundamental to his nature. Where other young refugees would flounder, bemused by the longing for acceptance, he was in and out of schools almost before the bursar had written down his name. He was in no hurry to declare himself an artist (at Dartington he did not even bother to take art, but chose riding instead) but he did turn his own unmatched fixity of attention on the life around him. The unformed faces of his English contemporaries were portrayed, when he came to draw them, through the eyes of someone who had seen inhumanity in full cry in the streets of Berlin and had stood, as a small boy in short trousers, to watch the Reichstag on fire.

At the age of 19, in 1941, Freud smuggled aboard a merchant ship which was outward bound from Liverpool, thereby substituting for the indolent and quizzical Peter Watson and his friends the company of a shipload of Liverpool Irishmen. After five months, most of them spent on convoy duty, he was invalided out of the Merchant Navy and was free to work full-time, as he has done ever since, as an artist. He remembers with great gratitude the art school in Suffolk which was run by Cedric Morris (in his view one of the best painters in England) and Lett Haines; but in general it was difficult in wartime to see very good pictures in England. However, there also Freud was lucky. It happened, for instance, that he took down to Brighton, by train, one of the finest of all Picasso's paintings, the *Weeping Woman* of 1937; the ease with which the picture dominated its surroundings and was manifestly more real than so-called real life, was something that remained with him for ever. Some Soutines owned by the painter Adrian Ryan came across with an emotional immediacy which was the more striking by contrast with the fine-drawn reserve of our English graphic tradition. From Peter Watson he learned what it meant to have 'a collection' that ran from Poussin to Picasso, De Chirico and Roger de la Fresnaye – and, perhaps more important, what it meant to use collecting creatively. Watson had mastered what might be called the expressive use of money: the antithesis of a hoarder or a miser, he used money as the instrument of liberty in a way which has guided Freud ever since.

Still, it was one thing to have such perceptions and another to act upon them. Freud at that time was conscious – and in fact had been conscious since he was 15 – that he had an almost total lack of natural talent. He determined to make up for this by observation, and by working in a graphic tradition. Drawing continually, as he did, he gradually became aware that he used drawing as a means of keeping painting at bay. Feeling the difficulty of painting most acutely – to a point at which he was

barely able to get the paint to cohere at all – he was also intimately aware of its superior potency. Paint was for later.

In the circumstances it is not surprising that in more than one of Freud's wartime works he now looks to have been even younger than he actually was. *The Refugees* (1941) was intended, so he says, to be 'like a satirical snap' – a box-Brownie's view of a group lined up as arbitrarily as Hogarth lined up his servants – and it also has in many of its details an urchin's sharpness. Freud at this time was distinctly a graphic artist: uneasy with oil-paint, he was at home with the drawn line that moved, taut and tense, across the surface of the page with only a minimal suggestion of depth. If there was 'a background', as in the *Man with a Feather* of 1943, it was carefully laid out in terms of flat rectangles. If there was a subject that called out for deep space, as happened with *Lochness from Drumnadrochit* in the same year, Freud composed the picture in terms of frieze-like terraced forms that spread laterally across the paper. The pictures were predominantly linear, and they were also distanced in feeling, as if Freud were using the sharp point of the pencil to keep something of himself at bay. Sketchbook drawings of this period have the look of an artist who was holding on to the expressive range of childhood until something more weighty, and more fully committed, should present itself.

It was in 1945 that Lucian Freud began to handle oil-paint in a specifically adult way. This was due to a new density of involvement with individual human beings. His subject-matter had almost always been autobiographical, in so far as it was related either to objects that he particularly liked – Chelsea buns, for instance – or to his own immediate surroundings. But he had led until then a life un-anchored to specific attachments; and when he portrayed his environment it was with something of the intent but still childlike enjoyment with which a very clever small boy will make an inventory of his toys. His concern was always with the particular, never with the general; and although he was befriended in first youth by Graham Sutherland, and was to that extent aware of the climate of the times, his own preoccupation was still with what was immediately to hand. There was nothing of the times, for instance, in the *Woman with a Tulip* of 1945; if it had affinities, it was rather with the kind of portrait which had been perfected by Clouet, and by Corneille de Lyon, 500 years earlier. Only the dimension of disquiet – the broody, unresolved, divided look – was peculiar to our age.

The circumstances of the work thereafter became, not secret, but private. Lucian Freud puts this with his habitual firmness and plainness. 'My work is purely autobiographical', he said a year or two ago. 'It is about myself and my surroundings. It is an attempt at a record. I work from the people that interest me, and that I care about and think about, in rooms that I live in and know. I use the people to invent my pictures with, and I can work more freely when they are there'. Only after death do his sitters lose the privilege of anonymity; Christian Bérard, John Minton and John Deakin are named, whereas most of the paintings are titled with a bareness which is the despair of the archivist. But then what is portrayed is as much the act

of looking as the appearance of a nameable individual; and the act of looking has a unique intensity when it is also an act of love – and, as such, private.

Not that all the work of the late 1940s, or of any later period, can be so classed. There are triumphs of objectivity, like the portrait of Christian Bérard. It is difficult to convey to a younger generation quite how compelling was the personality of Bérard when he came to London with the prestige of a man who had made magic on the stage, over and over again, without apparent effort. But Lucian Freud got him down on paper, entire, and missed no detail of the pouchy, well-indulged look of a man who had rarely or never eaten a bad meal in dull company.

Like most people who had spent the greater part of the war in England, Freud in 1946 had arrears of curiosity to make up. Today no one could be less of a traveller – 'My travelling is downwards, rather than outwards', he will say – but when Peter Watson gave him the chance to go to Paris he jumped at it, and in July to August 1946 he went on to Greece, where John Craxton was then living, and stayed there, at a time of great civil strife, until February 1947. He liked to gut a new city as a fishmonger guts fish – so energetic were his explorations of Paris that his bicycle broke in half beneath him – and he brought to Paris, in particular, something of the loving inquisitiveness which marks Giacometti's posthumous book of lithographs, Paris *sans fin*; but fundamentally he felt then as he feels now – that 'All my interest and sympathy and hope circulate round the English' – and when *Time* magazine suggested that he had spoken disloyally of his adopted country he brought an action for libel against them and won it. He might possess, and on occasion paint, a *Zimmerlinde* – the miniature limetree with which refugees refreshed their memories of central Europe – but fundamentally he was at one with London and had no wish ever to leave it.

Everybody has their own London, of course, and the London of Lucian Freud's paintings is highly particularised. It has primarily to do with an area within a mile or so of Paddington station. At the time he first went there, towards the end of the war, and for some years afterwards this was a neighbourhood worthy of an updated *Lower Depths*. The law was not so much disobeyed as disregarded. People came and went without regular hours or avowable occupations. Identities were changed like number-plates. As a background, there were the great run-down porticoed terraces, the dank and silent canal, the bizarre, overbearing, unvisited Victorian parish churches, and the blank spaces rubbed out at random by German bombers. When Freud was invited to contribute a large painting to an Arts Council exhibition in 1951 his *Interior near Paddington* gave a glimpse, brief but cogent, of all this. Nothing was spelt out; but there was a violence implicit in the bull-neck, and in the instinctively clenched fist, of the principal figure, just as there was a sense of dereliction in the scabbed stucco of the houses across the way and the small boy who looked up from the street.

By the end of the 1940s Freud had quite lost the carefree, vagrant curiosity which first brought him to notice. What had been dispersed was unified. What had been detached was concentrated. Perhaps *The Painter's Room* of 1944 was already the

last painting in which Freud took his surroundings apart and put them together again in the wry, aloof manner of someone whose real life was yet to begin. (When E.L.T. Mesens saw that painting he mistook the zebra's head for an irrational image which might herald a conversion to surrealism; but in point of fact the head is a real head – a stuffed one which Freud brought home from Rowland Ward's as a substitute for the live horses whose company he had grown to love while living in the country.) By 1947–48 he had entered a world of total commitment, in which whimsicality played no part.

In the paintings of that period the seamless enamel of the paint has a European ancestry, as do the emblematic passages of still-life – a held rose, or a daffodil laid flat on the table. There is no symbolism in Freud's paintings, and there are no 'meanings' to be un-riddled. Everything 'is what it is', as in philosophy, 'and not another thing'. But, at the same time, there is in these portraits a fullness of realisation and a manifest severity in the choice of auxiliary detail which puts them in a tradition which runs from Botticelli's portrait of Giuliano de' Medici, with its turtle-dove perched on a dead branch, to the portrait of Theodore Duret which Manet embellished, almost as an afterthought, with a half-peeled lemon and a glass. Freud here moves into the European tradition as Noah moved into the ark.

This was as much a matter of feeling as of fact. In the attitude to painting which these pictures reveal there is a solemnity of commitment which parallels the commitment to the person portrayed. The question 'What can painting still do?' runs in tandem with the question 'How much can one know of another human being?' For ten years and more Lucian Freud answered both questions in terms of a tight, primarily linear form of expression which on many occasions was quite startlingly exact. There was a price to be paid for this, and when he put himself in the picture as he did in *Hotel Bedroom* (1954), he looked as if he had been skinned alive with his own hand; suddenly we realised that there is a point beyond which interrogation and torture are one and the same thing. But from what had initially seemed to him a point of total incompetence he had arrived at a degree of proficiency-plus-poetic-insight which has been rivalled rarely, if at all, in modern painting.

Most of these paintings were quite small. 'Lifesize looks mean', he used to say. It was as if he could only arrive at maximum intensity by scaling the image well below the true dimensions of what was being portrayed. Possibly, also, certain things had to be writ small, lest they should get out of hand. There came a time, in any case, at which the tight, inflexible procedures which had served him so well began to seem to him a limitation, rather than a hard-won asset. In such circumstances, he said later, 'You long to do something that doesn't look like your own work – something that frees you from your own nature'. Towards the end of the 1950s he began to work on more-than-life-size heads that had no point of focus and were, on the contrary, so truly dispersed, so explicitly all-over in their handling, that it was sometimes quite difficult to take any particular passage of paint and decipher the subject at all. The looser, more fatty to-and-fro of the brush marked a complete break with

the perfected enamel of a year or two before; Lucian Freud was engaged with what Yeats called 'the fascination of what's difficult'.

Sometimes it worked; sometimes it didn't. The image, which had so recently been hugged too tightly for his liking, was suddenly not hugged at all, but allowed to inch its way across the canvas, patch by wristy patch. The paint, once dosed to the thickness of the next millimetre, had suddenly a well nourished, almost a Soutinesque look. Textures which had been rendered to perfection – fur, velvet, linen, rose-petals, cheap carpeting, a raincoat ten years overdue at the cleaners – were subordinated to the undisguised motion of the brush. These were radical changes, and not everybody approved. But Lucian Freud believes, with Arnold Schoenberg, that 'the middle road is the only one that never leads to Rome'.

Eventually he withdrew from this position. But he never returned to the meticulous execution of 1947–57. There was, moreover, a new freedom of conception in the major paintings of the 1960s. There were giddying viewpoints, compositional schemes that were the visual equivalent of epigram (notably the mirror, suspended in a window-frame, in which the painter sees himself in *Interior with Hand Mirror* [1967]), and strange conjugations of subject-matter. These last mostly took the form of what might be called metropolitan pastoral. They were urban interiors, that is to say, into which he usually introduced one of the large and indomitable plants which follow him from one painting to another. To this was allied a human figure, in a way pioneered by the *Interior near Paddington* of 1951. There was, once again, no question of symbolical meaning; but even so there was something not of the everyday world about the child who lay sleeping beneath the majestic foliage in *Large interior, Paddington* (1968–69). Nor do I see much of the *petit train-train* of everyday about the extraordinary image in which Lucian Freud himself is glimpsed, like a shipwrecked mariner grown hard of hearing, at the back of the overgrown plant in *Interior with Plant, Reflection Listening* (1967–68). The way in which, in this latter painting, the plant seems to have outgrown the canvas is one of his most remarkable inventions.

Lucian Freud
*Reflection with Two Children
(Self-Portrait)*, 1965

It often happens in the course of a long career in art that ideas which originally functioned in one given context later turn up in quite a different one. The over-life-size heads had, as I said earlier, a de-focused look. Each area in them was the equal of every other area: none was favourite. Between 1970 and 1972 Lucian Freud applied this same principle to quite different subjectmatter, and to a mode of execution which was nearer to the patient, inch-by-inch naturalism of his earlier paintings. The pictures in question were *Waste Ground, Paddington* (1970), *Waste Ground with Houses, Paddington* (1972) and *Factory in North London* (1972). The first two had in common the presence in the foreground of what must be the ultimate in unselected, un-posed urban subjects: a rubbish-heap. This he painted with an impartial curiosity which ruled out any notion that any one object was more

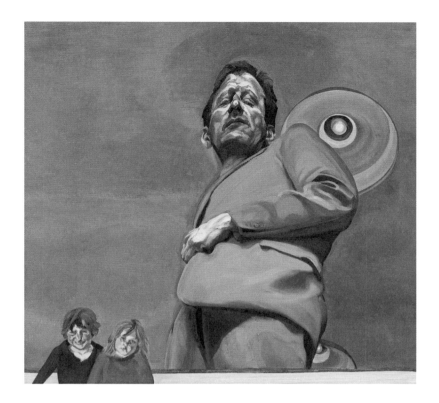

or less important than any other. Above, the same curiosity was extended: brick by brick, window by window, chimneystack by chimneystack. There was nothing, in the brushwork, of the eloquent sweep which had so lately unified the paintings. Everything had to be played for, all or nothing, with each touch of the brush. Nor was there on our side the instinctive sympathy, the longing for the picture to come out right, which we feel when the naked body is in question. We were to be won over by the sheer strangeness of the undertaking; and we were.

It should also be said that in the 1960s Lucian Freud was willing for the first time to admit ambiguity to his images. It is really very difficult for anyone who has not been prompted to know that the mysterious substance which fills the background in *Red Haired Man on a Chair* (1962–63) is a heap of old rags brought up from a neighbouring rag-and-bone shop. In such passages Freud deliberately throws away that absolute lucidity, that taut hold upon our attention, which is the mark of his conversation and was once plotted into his pictures. Just what is happening in *Reflection with Two Children* (1965) is also not easy to guess at a first scrutiny, for at that time he was experimenting with the acrobatics of the reflected image. Disdaining to make things easy for himself, he risked an incoherence which 15 years earlier would have seemed to him quite unthinkable.

Noctambular by choice, and by disposition, he paints a great deal in the unvarying, ever-reliable dead of night. His nudes, in particular, are night pictures, as sealed off from the light of day as from the distractions which day brings with it. A favourite painting of his – until it was cleaned – is the so-called *Death of Procris* by Piero di Cosimo, in the National Gallery. Procris was accidentally killed, as we know, by her husband Cephalus; and even if the title once given to the painting is not the right one there is something akin to Freud's own undeceived view of the world in the sight of the hapless bloodstained girl, her limbs so revealingly awry. It is as if her body had taken on, in death, its definitive expression. In his later nudes Freud tries for something of that same definitive expression, but in life: in the living, breathing body which eventually will get up from its narrow pallet and walk down the stairs and out of the house.

There has lately been a change in the nature of his figure-paintings. In particular, the nature of the person portrayed has been allowed to participate, as it were, in the look of the picture. When asked about this, Lucian Freud said 'I get my ideas for pictures from watching the people I want to work from moving about naked. I want to allow the nature of my model to affect the atmosphere, and to some degree the composition. I have watched behaviour change human forms. My horror of the idyllic, and a growing awareness of the limited value of recording visually-observed facts, has led me to work from people I really know. Whom else can I hope to portray with any degree of profundity?'

The picture, once started, still goes very slowly; and whereas in earlier days Freud never overpainted, he will now take the image out and start all over, time and time again, till it has the inevitable look that he wants. This inevitability has nothing to do with the notion of the well-made picture, which he abhors, and indeed he now often takes out the image if it seems to him too immaculate. A new kind of reality – sometimes awkward, sometimes incomplete – is there for the trapping.

It is Ingres, as much as anyone, who stands behind his late nudes: Ingres who had the gift of perpetrating the most outrageous distortions and persuading us to accept them as quite natural: Ingres, again, who had the courage to come to terms with even the wildest of his fancies and to enlist the female body in their service. But as Lucian Freud's name is linked in this present exhibition with that of Edvard Munch it is worth remarking that the last picture of all has, at first glance, a Munch-like subject: an old woman and a young one, in the same room, each walled up in her thoughts. Lucian Freud's intention was not to make a facile comparison between youth and age, but to get two completely unassociated figures to work together on the same canvas. He reworked the head of the reclining figure 20 and more times until the scale satisfied him; and with other, smaller amendments to the given scene he tried to meet the challenge which is continually present to him – that of those images from the past which in his own words are 'so powerful that one cannot imagine how anyone could have made them, or how they could ever not have existed'. That is the kind of ambition for which this exhibition speaks.

DORE ASHTON
ON AGNES MARTIN

Agnes Martin: Paintings
and Drawings 1957–1975
1977

Agnes Martin's solo exhibition at Hayward Gallery in 1977 was the first major exhibition of the artist's work outside the United States. It took place four years after a major retrospective of her work at the Institute of Contemporary Art, University of Pennsylvania (1973), and a year after she represented the US at the Venice Biennale. The exhibition featured 49 works: 20 paintings, 27 watercolours and drawings, and two constructions. Writing of the exhibition in the Telegraph, *the critic Michael Shepherd stated that Martin's works transformed Hayward Gallery into 'a very contemporary temple of contemplation'. American writer, critic and scholar Dore Ashton, responsible for book-length studies of abstract expressionism, including* The New York School: A Cultural Reckoning *(1973), wrote for the catalogue, which also included notes from a lecture given by Martin at Yale University, entitled 'We Are in the Midst of Reality Responding with Joy'.*

AGNES MARTIN AND NATURE

Years ago when her paintings were close to their sources and her thinking about them less arcane, Agnes Martin often recalled the place of her birth, Saskatchewan, and her childhood in Vancouver. Her father's wheat farm and the sealike vastness of wheat fields were not forgotten. The great prairies had endowed her with an undying hunger for spaces. With time, Martin's relationship to nature, once so direct, has become more oblique and the metaphors have changed, but the sites in her imagination are ineffable.

In the late 1950s when she first exhibited at Betty Parsons's gallery, those sites were still in her thoughts. She spoke of her youth in Canada, of her exploration of the Indian culture there, and – proudly – of her work with mining and logging companies. (Not too long ago, at a friend's country house, she proved herself a true daughter of the wilderness by splitting logs with great expertise.) Martin thought of herself in those days as distinctly American, in the romantic pioneering sense: 'I've never been to Europe, never thought about it, and I suppose the only other place like Vancouver is the Russian tundra.'[1]

Martin's taste for the large horizons hadn't prevented her from spending enough time in New York to take a Master's degree from Columbia University, but it drew her back to the Southwest in the 1940s where she settled for a time in New Mexico. It was the New Mexican experience which resolved her attitudes toward art and nature. As she said, 'The land is effective there'. The experience included exposure to Hopi and Navajo artifacts; the incomparable New Mexican light; the expansive mesas and the magnificent mountains of Taos. It was while trying to paint those mountains that Martin discovered her need for symbolic means.

The paintings that emerged then were pale evocations impregnated with the sands of the desert. Their symbols drew upon the common fund developed at the time by

DORE ASHTON ON AGNES MARTIN

such painters as Clyfford Still (whose earliest memory was also of Northwestern wheat fields), Adolf Gottlieb, Mark Rothko and Arshile Gorky. There were memories of pictographs, and remote stylisations of the human form based on vice-like interlocking signs. Above all, there were attempts to suggest the immemorial in the ambiguous, no-man's-land environments.

When she came to New York in 1957 and settled in Coenties Slip, an enclave of artists' lofts hard by the great shipping waters of New York Harbor, the images of New Mexico lingered, but they were slowly being transformed. During the late 1950s and early 1960s Martin frequently recalled the loam browns, deep siennas, clay yellows and near-blacks of tundras, mesas and prairies. She called her paintings *Wheat, Tideline, Earth* and *Desert Rain*. The recurring motifs at the time were dark circlets that seemed to burrow into the earth and there were insistent symmetries. Martin's relationship to nature continued to shift. The regularity of certain figures, and her increasing interest in steady rhythms indicated the onset of a certain maturity in which an intuition of natural laws and universal harmony began to crowd out the occasional and specific experience.

In a city loft or in the desert or mountains, Martin's temperament inclined her to solitude. During her decade in New York from 1957 she did encounter younger artists such as Ellsworth Kelly and Jack Youngerman who had studios at Coenties Slip, and she did see how many other artists were grappling with pure abstraction in the lean ways following abstract expressionism. But her dialogue with nature took its own course. A meditative painter, the question as to what painting can be never left her in peace. Gradually something in the work began to transcend nature, but in the Chinese manner: assuming that nature is always there to be transcended. In recent years she has said that her work is anti-nature, but she has also alluded frequently to the Oriental ways of thinking about painting. And they are effective ways to approach her work of the past decade, for it is very important to understand that what Martin calls 'art work' is a work in the active sense that Chinese painting is a work and not a product. Martin's fondness for philosophical parables, which she herself sometimes writes with her friend Ann Wilson, is quite like the Chinese way of talking about painting.

Take Ching Hao's conversation on method of around 900 AD.[2] He begins by saying that he is a farmer who went up to the mountains to take a look. As 'the air was pleasant and with a sense of life and growth' he went the next day again with a brush. 'I must have done several ten thousand copies before I caught the spirit', he recounts. The following Spring he met an old man who asked him what he was doing. 'Do you know the painting technique?' No, answers Ching Hao, 'I am an uncultured peasant. How would I know about painting technique?'

The old man proceeds to enlighten him. He outlines the six essentials: spirit (*ch'i*), mood and atmosphere (*yün*), thought (*sze*), the scene (*ching*), brushwork (*pi*) and ink-work (*mo*). The young man answers, 'To paint is to give the external appearance. We just want the true likeness. Why all this?'

The old man then warms to his subject and reads his pupil a lesson on how to think about painting. 'There is an external appearance which may not be mistaken for the true reality (*Chen*). Take the appearance as appearance and the reality as reality. Unless this is understood, one will draw a mere likeness, but not capture the real essence.' When asked what a likeness is, he firmly answers: 'A likeness is what you get when you portray a thing's form and miss the spirit (*ch'i*). *Chen* (reality, real essence) means when you have captured both the form and the spirit. When the spirit is left out, the form is dead.'

Martin's understanding of the painter's relationship to nature is very close to that of the ancient Chinese sages, as her poem-note shows:

The underside of the leaf	In silence
cool in shadow	This poem,
Sublimely unemphatic	like the paintings,
Smiling of innocence	is not really about nature
	It is not what is seen –
The frailest stems	It is what is known
Quivering in light	forever in the mind [3]
Bend and break	

It behooves us to remember that the Chinese were so sophisticated that they carried their meditations on the negative (what these things are not, as Martin instinctively says) to the point of establishing such a noun as the not-not.

AND FORM...

The extensive technical talk about Martin's decisive shift, around 1962, to what is known as the grid formation, with all its citations of measurements and repeated shapes, always seems tedious when we are confronted with the paintings. Perhaps even misleading. If everything remains perfectly flat, Paul Klee said, we might under certain circumstances have a good carpet. Even at her most extreme – when, for instance, in 1972 she produced 30 serigraphs with the intention of rendering grids and parallels in an absolutely mechanical way – Martin is not talking about carpets.

In fact her discourse has many affinities with Klee's. In both her ecstatic utterances and her more practical discussions of 'art work', Martin is capable of many Klee-like hermeticisms. She can exhort, and sometimes her exhortations are strikingly similar to Klee's when he raises his voice to say:

Fellow man, arise! Learn to appreciate this *villégiature*; a change of air and viewpoint, a world that distracts you, and gives you strength for the inevitable return to work-a-day grey. And this is not all. Let it help you shed your shell; try, for a moment, to think of yourself as God. To look forever forward to new holidays when the soul will sit down to feed its hungry nerves [...] Let yourself be carried to this life-giving ocean along broad rivers and delightful brooks. [4]

Martin is always summoning her listeners to festivals of the soul. Her published lectures abound with allusions to happiness, freedom from the distracting world, and something she specifically calls the 'holiday state of mind'. Still more striking is the fact that Martin's formative principles, as revealed in the work since the 1960s, are rooted in meditations very similar to Klee's. Nothing could come closer to Martin's excursions via form into the Platonic realm than Klee's own discussion of structural rhythms of 1922.

Klee recognised the power of repetition and the phrasing that numerical regularity can produce. 'I often count without noticing it during my work', he told his students. Almost algebraically he analysed the kinds of form in symmetrical structures. Those with regular structures such as 1+2+1+2, etc. he called dividual, their characteristic being that 'parts can be taken away or added without their rhythmic character, which is based on repetition, being changed. Thus the structural character is dividual, i.e. divisible.' On the other hand, the individual he defines as a form in which 'one cannot take anything away without disturbing or even destroying the function of the whole. Nor can anything be added.' These he equated with a higher form of rhythmics, opposing it to primitive rhythmics such as pure ornament which 'has no rhythmic relation to the inner creative drives of man'.

Martin's 'inner creative drive' which, it is true, led her to explore the very limits of the rhythmic domain, always draws up short before the deadening prospect of total order. The individual was and remains paramount. There were many drawings during the early 1960s in which the insistent beat of repeated rectangles might have seemed endlessly dividual to a hasty eye. But not one of these drawings, figured with dots, arching lines, triangles, circles or rectangles, lacked the slight disorder which gives back the dimension of nature – its element of chaos.

In the paintings, individual intonations are even more pronounced. While it is true that sometimes, as Lawrence Alloway wrote, 'the area of the grid extends to the edges of the canvas, making a single, undifferentiated tremor of form, or a plateau of non-form',[5] we must still talk about these canvases as paintings and not as grids. The just phrase 'tremor of form' describes an element among others that go to make Martin's paintings real paintings. Between 1964 and 1967 when Martin left New York again, her paintings did in fact make use of repeated vertical and horizontal divisions that stressed above all their rhythmic unity. Occasionally they were so composed that the comparison with music was unavoidable, even to certain drawings that might have been references to music paper. The musical analogy holds for an analysis of her paintings of around 1965–66, many of which were 72 inch square. Martin frequently laid down a delicate tone – sometimes as smooth as ivory, sometimes slightly flecked with light as in mica, sometimes fragile white like rice-paper – that served much as the *continuo* serves in music. Above this *continuo* lifts the rhythmic melody, in which the very close harmonies are sometimes as indistinguishable to the eye, as overtones in instrumental music are to the ear. Yet the composer not only knows they are there but composes in relation

to them. What the 'tremor of form' (the almost, but not quite, even intervals and repeats) create is a sense of wholeness which carries with it, inevitably, a sense of the articulated individual parts.

Because of the regularities visible in these paintings, Martin was often linked with artists who could authentically fit newly designated categories of 'systemic', 'cool' and 'non-hierarchical' approaches to art. But precisely the irregularities in Martin's paintings struck her viewers – the intuitive stresses, pauses, accents, modulations and cadences. The sense of form at work here does not generate grids (which are, after all, utensils, either practical or theoretical) but rather, visual illusions that express a confluence of emotional values. If Martin calls a painting *Mountain* we are prepared to believe that she is creating an analogue. If she makes her analogue in a certain key – the tone of ivory with all its secreted light – and then scores her canvas with double lines of differing intervals, including some lines of diminishing value, these spaces may well be read as an inner-eye scanning of mountains, the *chen*. The line may be the always tremulous and interrupted line that a pencil on canvas produces, or it may be freely drawn in white paint with its own flickering intensities. It is line that responds to nuance, and tells of process, time and deep concentration. The slightest change, even occasional drips of paint, must be taken as a shift in focus, a shift in space, a *formal* accent.

Martin thinks of herself as classicising. Her attraction to classicism (let's not cavil about meaning, we know what she means) intensified somewhere along the line after her departure once again for New Mexico in 1967. There was, by her own testimony, a long period of hesitation during which she did not paint at all. This was remarked with some incredulity in the art world, although writers have long known such periods, witness Rilke and Valéry. Anyone who seeks to characterise the oceanic intuition is subject to long suspensions and drifts. Martin says the 'ocean is deathless' and the prolonged pause in her creation did not alarm her. Such preoccupations always unfold in Bergsonian duration and not in clock time. Just as Mondrian closed in on his intuitions in the *Pier* and *Ocean* series, so Martin closed in on hers in the works which seem to constitute a period between 1957–67 and the current set between 1972 and the present. The form her painting has taken since 1972 is a report back from experiences that only a meditative painter can have.

Agnes Martin
Mountain II, 1966

After building her studio on a New Mexican mesa Martin gathered her forces and painted a group of canvases, again 72 inch square, in which the condensation impulse that governed the delicate works of the 1960s is seen in a different light. Literally. Something akin to Cézanne's impulse in the late oil sketches and watercolours governs these new paintings. There are breathing apertures. Surfaces are surpassingly thin, allowing gessoed grounds full right to radiate interior light. When Cézanne spoke mysteriously of the 'passage' he spoke on two levels. One had to do with the practical problem of a painter who must indicate the third dimension with a minimum of obscuring detail. The other had to do with the strange experiences he had as he

DORE ASHTON ON AGNES MARTIN

shifted his gaze, ever so slightly, so that his faithful hand followed certain absences that light and atmosphere create. Such absences, laden with pictorial meaning, inform Martin's paintings of 1974–75, and paradoxically bind them into unique organisms. Just as Cézanne slowly evolved a set of principles which represented to himself his own innate classicism, and just as he increasingly clarified his own rules of the game, so Martin performs certain ritual reductions in order to honour fresh responses to colour and light.

For these paintings she limited herself to two basic colours plus white. The colours range in accent from rose-to-ochre-to-orange, the natural colours of the mesa, and from azure-to-turquoise-to-milk-blue. Each painting is endowed with a distinct climate and emotional tenor. The limits of specific spaces vary greatly, although Martin limited herself just as strictly as before to rectangular shapes that spanned her canvases in differing positions. In the way she measured out her colours, or broadened or lessened the white of canvas, she was able to describe the character of specific experiences. At times the bands of ochre or blue were broad, almost exuberant, stretching in a broad horizontal gesture. At times they were more confined, vertically aligned, broken by a delicate single horizontal: an absence that creates a plane, which in turn creates other planes, and reminds us, as she says, that 'anything is a mirror'. Within her strictly

observed ritual rules, Martin is able to speak of many things, requiring only that the viewer is sensitive to light and measure. The problems so many abstract painters encounter in holding and sustaining their vision while wielding a technique is foreign to Martin. These emotionally precise paintings are executed with the greatest finesse. Their surfaces, almost veils of thinned acrylics, are full of vitality achieved with an economy of means that defies words.

In Martin's most recent paintings the hues are still more etiolated, running from bluish pinks to salmon pinks, and the cadences are less robust, the pencilled lines restored to greater prominence. The forms – the ultimate fusion of her reduced painterly means with a specific content – can still be read in terms of acute condensation. The ritual function of rhythm presides and the whole is irradiated by a splendour of light equal to but different from the works of 1975. These paintings are all mornings.

AND CONTEXTS…

Martin likes to read Chuang Tsu. Perhaps she read: 'Tao cannot be conveyed by either words or silences. In that state which is neither speech nor silence its transcendental nature may be apprehended.' In the long way from Taos, and the mortal attempt to record its towering mountains, to these recent paintings, often not even titled, Martin has found the spaces of the imagination, and specifically, the spaces between words and silence. I think it is what she is painting. But never can we separate her from that mesa and the radiance, harmony and measure that emanates from it. This is not the desert of sagebrush and Indian arrowheads and *kivas* and coloured bluffs in bizarre shapes. This is the desert whose light is between words and silence and whose image resides in the imagination. Martin paints about the desert as Baudelaire wrote about *clarté*. Baudelaire's *clarté* is an abstraction that suffuses his poems, and synopsises all the morning lights he has ever imagined. He created *clarté* and the Petit Larousse will never be able to sift it out of his poems and distil it as a definition. Such, I think, is the light of Martin's paintings.

In spite of the patent duality of Martin's thoughts, and her misprision of the notion of analogy, she is gifted with an aptitude precisely for analogy. Her concentration, so apparent in the slightest waver of a pencil line, brings her always to the kind of expansive imagery that analogy, as opposed to homology, sponsors. The error of those who rationally analyse that part of Martin's scheme that has to do with repetitions (and therefore homologues) lies in taking the rules of the game for the game itself. These symmetries are of a different order. Anyone who has ever known children's games, and the framework of rules children spontaneously invent, will understand that it is in the revisions and deviations from the rules that the game lies.

Martin's 'art work' does not lie within the context of the discourse of the 1960s but rather in the tradition of analogy diffused throughout the 19th century, filtered through such masters as Mondrian, Kandinsky and Klee, and winding up, for the

nonce, in Martin's animated deserts. Wittgensteinian strictures are to be avoided. Although Martin's pictorial language is stripped to a few intense expressions, the demon of analogy flits among them. 'If a poem is a system of equivalences, as Roman Jakobson has said – rhymes and alliterations which are echoes, rhythms which play with reflections, identity of metaphors and comparisons – then French poetry as a whole becomes a system of systems of equivalences, an analogy of analogies.'[6] So writes Octavio Paz of modern romantic poetry, and so, with a slight transliteration, could one write of Agnes Martin's oeuvre.

This would honour her own emphasis on qualities of mind, what she calls 'adventures of the mind.' In her mind beauty exists, and it is even, she says, unattached, but it is beauty rooted in the great tradition of recall. At its classical boundaries it goes back, and back. To Leon Battista Alberti: 'The judgment which you make that a thing is beautiful does not proceed from mere opinion but from a secret argument and discourse implanted in the mind itself.' And it goes forward to Le Corbusier and Amédée Ozenfant: 'Art has to be the expression of the invariable.' And back again to Blake, of whom Martin says: 'Blake's right about there's no difference between the whole thing and one thing.'

LEON KOSSOFF
ON FRANK AUERBACH

Frank Auerbach
1978

63

This solo exhibition of the work of Frank Auerbach, selected by the artist himself, brought together the artist's paintings and drawings of the past 25 years and featured 130 works in total. Alongside this short lyrical text by the painter Leon Kossoff, a contemporary of Auerbach's, the accompanying catalogue featured an interview between the artist and the exhibition organiser Catherine Lampert. Speaking of his work in that interview, Auerbach stated: 'It's always a process of invention... of suddenly seeing a unity in the disparate things one's trying to hold together'.

THE PAINTINGS OF FRANK AUERBACH

Sickert said, 'Perhaps the chief source of pleasure in the aspect of a nude is that it is in the nature of a gleam – a gleam of light and warmth and life.' (*A Free House!*, 1947)

The same could be said of the paintings of Frank Auerbach. Out of darkness, drawn from unknown areas of the self, the landscapes, the heads and the nudes remain with us, gleaming in the mind – a gleam of light and warmth and life.

Sometimes in the presence of a work from the early days, where the painting, from continuous effort, has become thick and heavy and the ochre still seems wet enough to slide off, we become aware of the nature of this activity and, in spite of the excessive piling on of paint, the effect of these works on the mind is of images recovered and reconceived in the barest and most particular light, the same light that seems to glow through the late, great, thin Turners. This light, which gleams through the thickness and finally remains with us is an unpremeditated manifestation arising from the constant application of true draughtsmanship. Whether with paint or charcoal, pencil or etching needle, it is drawing that has constantly engaged Frank Auerbach.

Drawing is not a mysterious activity. Drawing is making an image which expresses commitment and involvement. This only comes about after seemingly endless activity before the model or subject, rejecting time and time again ideas which are possible to preconceive. And, whether by scraping off or by rubbing down, it is always beginning again, making new images, destroying images that lie, discarding images that are dead. The only true guide in this search is the special relationship the artist has with the person or landscape from which he is working. Finally, in spite of all this activity of absorption and internalisation the images emerge in an atmosphere of freedom. This is the nature of true draughtsmanship and it is out of this spirit that the paintings of Frank Auerbach grow, glimmering towards the light.

Frank Auerbach
Head of Leon Kossoff, 1954

LUCY LIPPARD
ON GENDER AND
CONTEMPORARY ART

Hayward Annual '78
1978

Hayward Annual '78 was the second in a series of annual exhibitions at Hayward Gallery which set out to present a 'cumulative picture of British art' as it developed. Each exhibition was selected by a small committee of artists and critics. In 1977 the committee consisted of curator Michael Compton and artists Howard Hodgkin and William Turnbull. Hayward Annual '78 *was selected by five female artists: Rita Donagh, Tess Jaray, Liliane Lijn, Kim Lim and Gillian Wise. Of the 23 artists in the exhibition, 16 were women and seven were men. At the invitation of the selection committee, American critic and curator Lucy Lippard – an early champion of conceptual and feminist art – contributed the introductory essay to the exhibition's catalogue, in which she traces the roots of this 'Women's Annual' back to Hayward Gallery's male-dominated 1975 exhibition* The Condition of Sculpture.

THE ANATOMY OF AN ANNUAL

Why don't we have a show of good English art that is selected from studios, not address books? There has never been such a thing.
TIM HILTON, *TIMES LITERARY SUPPLEMENT*, 5 AUGUST 1977

As for the abjectly trendy idea of having an all-woman jury
[for the 1978 Annual] as if everyone is up for rape, words fail me.
JOHN MCEWEN, *ART MONTHLY*, SEPTEMBER 1977

I. BACKGROUND

I f the first Hayward Annual (HA) of current British art was an 'art-political event'[1] this second one should be still more so. While it is of course primarily an art show, it was also chosen with an overtly political goal in mind: to 'bring to the attention of the public the quality of the work of women artists in Britain in the context of a mixed show.'[2]

Its history begins in 1975, when a feminist protest against a Hayward sculpture show including 36 men and four women raised general consciousness. Later in the year one of the five eventual selectors of HAII – Liliane Lijn – approached the Tate Gallery with a proposal for a women's art exhibition. The Tate, selected because its frequent contemporary art shows included no women, soon deemed itself 'not feasible' and the idea was passed on to the Arts Council, then considering the import of the comprehensive international historical women's exhibition organised by Linda Nochlin and Ann Sutherland Harris at the Los Angeles County Museum.[3]

Lijn first suggested a complement to the LA show consisting of British work made after 1950. In February 1976 she was notified that the LA show was not coming to England because of a conflict in dates and that the chances for any women's show

were 'much diminished'. Nevertheless, she, Tess Jaray, Kim Lim and Gillian Wise Ciobotaru submitted a detailed proposal for an exhibition of fifteen contemporary women artists – five selectors each choosing two other artists; they also offered the possibility of an historical show, beginning with Vanessa Bell and Gwen John, though still focusing on 'the contemporary working scene'. These proposals *per se* were not accepted, but in September 1976, the Arts Council suggested that the 1978 Hayward Annual should be chosen by Lijn, Jaray, Lim and Wise Ciobotaru, who then asked Rita Donagh to join them.

II. FOREGROUND

What, then, is the point of a 'national' art survey, and to whom is such a show directed?

A national group show – if it is indeed a survey of the art being made rather than a summary of the art already being shown – should include artists of varied age, political and aesthetic persuasion, geographical location and – yes – sex and race. There should be something for everybody. There probably is to *some* extent in even the most homogenous exhibitions – a fact the Arts Council must be banking on which is certainly encouraged by different artists' juries. The Hayward Annual was instigated partly by artists, and is conceived as a platform where British art can be seen developing over the years, where an artist can see his (and finally her) work in relation to that of other artists. HAI, attacked in the press as being the 'clannish' product of a charmed circle of 'old boys' exhibiting art already familiar from the leading London galleries, was in fact chosen from the famous to give the Annual itself initial status. Controversy is the fate of all group shows, and may constitute their major virtue.

Ideally, and presumably, it is towards the general public that such a survey show is orientated, though the opinions and composition of this mysterious audience are rarely made known. Also ideally, even the specialist, for whom such shows represent only a fraction of the year's viewing experience, will be confronted by art s/he has never seen before. I tend to agree with those critics who saw the initiation of a new British annual exhibition as a 'political event'. HAI was clearly more remarkable as a whole – as the idea of an annual – than it was in its rather predictable parts. How the art got there seemed more interesting to many than what art got there.

If the Hayward Annual were planned simply as a routine summary of the commercial galleries' seasonable offerings, it could be selected by almost anyone, and reviewers could pass immediately to the art. (Paradoxically, although HAII has a more overtly political *raison d'être*, it may provoke more commentary on the art than HAI, if only because its contents are relatively fresh and unfamiliar and writers cannot take for granted their public's acquaintance with new work.) If, however, the Hayward Annual is in fact an honest attempt to broaden the boundaries of and to show in a different light that which takes place in *and* out of the galleries, then the means by which it is organised and the choice of selectors is crucial. This in turn leads one

to hope that these will not be the last women to select a Hayward Annual, since other combinations of women, and of women and men, will bring other opinions and tastes to bear. The differences between the first and second annuals make these points clear.

Installation view, *Hayward Annual '78*, 1978

If selection is crucial, what then are the options? I was amused by a suggestion that the Annual's selection be 'impartial' – a contradiction in terms. Does that mean chosen at random? Chosen by established reputation (which in turn often seems to have been chosen at random)? The alternative to the irrational maze of 'rational aesthetic criteria' taken by this year's selectors was 'merely' personal conviction or aesthetic integrity. How else are such decisions made, even when disguised in the rhetoric of 'objectivity'?

There seem to be a limited number of possibilities open to the selecting of the selectors:

a. One or a few respected artists, critics, or curators choose what they like – hopefully not limited to what they know; artists, being most biased with best reason, probably make the best selectors.
b. The same but with a specific theme or limitation imposed either by the Arts Council or by the selectors themselves; this narrows the focus and also broadens it, in the sense that more 'outside' or 'unknown' work can practically be considered.
c. The same but selected each year by the previous year's selectors in a 'chain' governed by artists rather than by administrators.
d. A similar 'chain' chosen collectively from among the exhibitors of the previous year or by them from submitted slides and studio visits; this is an awkward but effectively educational process.
e. An artist's organisation or group as selector.
f. A well-advertised juried show open to all professional artists, and finally,
g. An entirely open show in which everyone who submits has a guaranteed amount of wall or floor space – hardly the Hayward's *forte* but also often an eye-opener as well as a crowd-pleaser.

This last possibility suggests that such a show might have to expand into the streets or at least into the South Bank malls, or maybe into different neighbourhoods... which in turn suggests a Hayward Annual which is not a Hayward Annual at all but takes place simultaneously in various community art centres, parks, and available spaces all over London – all over England... Fantasy is preferable to logic in desperate situations.

Of course not everybody thinks the international art scene can be described as a desperate situation. Yet few would deny that it suffers from irrelevance to a general public and is constantly in need of new blood. New blood is always resisted by those securely nestled in the status quo. The economic infusion of a few new artists each year – the number for whom berths in the establishment have been made available

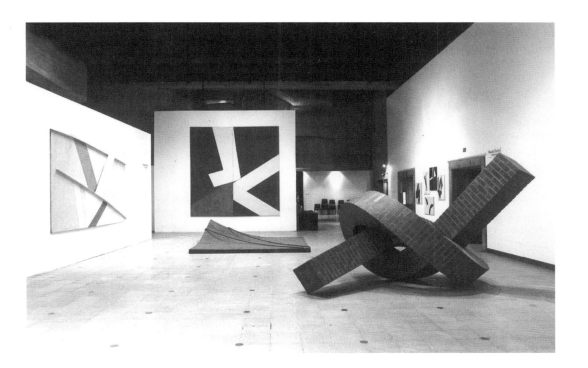

by death or failing powers – is not enough. One cure could be the broadening of the base – not only of the audience for contemporary art but of the artists who participate in the system as it stands. The burden of this responsibility falls on publicly-sponsored group shows like the Hayward Annual.

The 1970s are a period of confusing pluralism in the arts – a pluralism which simultaneously emphasises the decadence of today's consumer-oriented art world and offers a healthy alternative to the successive one-movement bandwagons that prevailed in the 1960s. As the middle class grows larger, the art public grows apace, and the cramming of greater numbers of people into the same limited showing spaces threatens to discourage all but the most enthused from trying to look at art ever again.

Museums, with their steadfastly institutional guise borrowed from courthouses, banks and office blocks are not the most welcoming places in which to experience pleasure, culture, intellectual provocation or entertainment. Maybe they should be left to the charmed circles. Maybe the next British art exhibition should be a survey of potential energy and outreach rather than of rarefied aesthetics – if for no better reason than providing an antidote. Maybe such a show would not convey to the lay audience 'Here is the Best of British Art passed – down – to Lucky You', but would instead leave the audience to make up its own mind and imply instead 'Here are the various ways in which these artists are trying to communicate. Which ones do you think succeed?'

Given, therefore, the context of public and specialised dissatisfaction with virtually all large group shows, it appears that there is no better way to utilise the medium than to redress some of the wrongs inherent in the current system of showing art – wrongs which inevitably reflect the broader social situation. I suspect other 'minorities' are badly represented in art world shows for the same reasons that the few small women's shows in London have so far been left up to independent and undersubsidised groups like the Women's Free Arts Alliance. Under the present conditions and prejudice against women *making* art rather than being the subject of art by men or keeping house for men's art (in curatorial and critical as well as in basic domestic roles) has become a feminist cliché.[4]

This is not merely a British problem. In 1970, when feminist organisations besieged the Whitney Museum of American Art – seat of New York's only 'national' survey annual[5] – we were told that race, creed, colour and sex were invisible to the selectors and that in any case there were 'no women sculptors' (the annual that year being for three-dimensional work). Under the pressure of publicity and weekly picketing, threats of human rights legislation, and the visual proof of the existence of a great number of unknown women sculptors whose studios had never been visited by the museum's staff, the Whitney hastily amended its list to include over 20 per cent women artists – up from 4.5 per cent in the previous year's painting show; an amendment which, according to their public statements, should have been impossible. A small women's show also followed.

Thus, elsewhere in the world, shows, magazines and galleries representing women only have been found necessary to open up the art institutions and marketplaces to the work of women artists. The fact that this year's Hayward Annual is a mixed show (though it is already known as 'the women's show' regardless of the facts) means that this step is being skipped in England. It remains to be seen whether such a process will be as effective for British women who want to enter the system as 'separatism' has been for women in America.

In fact, this controversial entrance of women artists into the 'mainstream' (which amounts to fishing rights in a private brook) may be better for the British art world and public than for the women themselves. It has taken some courage to organise a mixed show while admitting to a bias in favour of women. All-male shows selected by all-male juries have never stated their prejudices so openly. This year's selectors have gone out of their way to offer a different kind of show. Not everyone will like it. It will not finally look so different from other contemporary art shows. But the *spirit* with which it was approached seems to me to be absolutely necessary to the making of a national group show. Both selectors and exhibitors are aware of an element of risk, and risk is usually accompanied by passion.

LUCY LIPPARD ON GENDER AND CONTEMPORARY ART

ROGER CARDINAL
ON OUTSIDER ART

*Outsiders: An Art Without
Precedent or Tradition*
1979

*In May 1977 the poet and filmmaker Victor Musgrave approached the Arts
Council with the suggestion of mounting an exhibition of outsider art – a
'large exhibition' that would include 'photographs and large objects, as well
as paintings and drawings.' The result – two years later – was an exhibition
of over 400 works by 42 artists from France, Switzerland, Germany, Austria,
England and the United States. For Musgrave,* Outsiders: An Art Without
Precedent or Tradition *was an exhibition of work that was by turns 'lyrical,
powerful, delicate' and 'violent', carried out by 'individuals of prodigious
talent whose work and even existence is usually unknown to each other, and
for the most part little known even to the "official" art world'. The exhibition
was co-curated by Roger Cardinal, a writer, curator and academic who is
credited with introducing the term 'outsider art', and published the first
English-language book on the subject in 1972.*

SINGULAR VISIONS

The streets are well lit in the centre of the city. Here lies an elegant square
with a triumphal arch and statues of shiny marble; all about rise the
citadels and pagodas that house the standards and traditions of the
academic arts. There is no trace of disorder, no hint of hesitancy in the
smooth running of affairs. Each inhabitant of the city centre knows
his place, and each newcomer must submit to polite but scrupulous testing of his
credentials before being allotted a position. It is true that there are problems of
space, and squabbles may arise between those with rival claims. But on the whole
disputes are rare and restricted to mandarin questions of status and precedence.
The inhabitants collaborate to enshrine the past and to ensure that what comes after
shunts neatly into place without hiatus. Nothing disturbs the sense of fairness and
exactitude in these proceedings. And nobody who has attained a position within
this sedate arena feels at all inclined to query the fact that a few streets away the
lights begin to dim.

Walk into these streets and you find agitated movement. Figures scurry about
haggard-faced: these are the impatient men who feel their time is long overdue. They
are magnetised by the thought of one day entering the central square in triumph. Are
they not constantly grooming themselves in readiness, even though they sometimes
sport a self-protective attitude of bohemian disdain for success? Soon they too will
press forward into the light and gain the approval of the authorities.

But walk further. Pass through the suburbs of the city and listen to the noises in the
night. Something is stirring, an anonymous ferment. As you walk, the light fades
and things become incoherent. Further still and the streets peter out into grassy
lanes, the dwellings become spaced out and decrepit. Beyond the limits of the city,
a sombre landscape stretches forth into apparent emptiness. You lean forward

ROGER CARDINAL ON OUTSIDER ART

across the boundary line, ragged and ill defined. The authorities occasionally speak of fencing in the city, but thus far have not exerted themselves in this task. They seem to have every confidence in their invulnerability to challenge from without.

These territories which lie beyond are off limits to those who inhabit the city centre. No one in his right mind would venture here. Yet somewhere in this vast space there are wanderers, hermits and isolated squatters. They do not belong to the city. They have no official papers, and yet seem indifferent to the fact. They scarcely glance at the glow in the sky which marks the centre. Living outside the jurisdiction of the system, they are happy as they are and the work they do, carried out in conditions of secrecy and isolation, carries its own justification, They have no desire for promotion or recognition, so often another name for supervision. They work to their own specifications and, curiously, none seems to know that the others exist, so engrossed is each in his own activity. These are the Outsiders, dwellers in the zone of darkness upon which anyone coming from the central light can only dimly focus. Only if you strain your eyes can you make out the astonishing shapes looming out of the uncertain night.

Who are these Outsiders who seem so unconcerned about the splendours of the Cultural City? Where do they come from and what can they be thinking? Until we know their background, how shall we know what to make of them? They are not entered in the records of the central authority. They possess no official qualifications as artists. They have attended no classes, gained no diplomas. They are not subsidised nor even recognised. They seem to work on their own, for themselves, for the fun of it. They know nothing of the trend and snobberies of the cultural centre, with its beflagged museums and smart contemporary galleries. They work to no commission, without links or debts to the Establishment. Many are social misfits; all prefer the rule of the imagination to the strictures of officialdom. Deprived of the blandishments enjoyed by the professional artist, the Outsiders create their works in a spirit of indifference towards, if not plain ignorance of the public world of art. Instinctive and independent, they appear to tackle the business of making art as if it had never existed before they came along. What they make has a primal freshness: it is the product of an authentic impulse to create and is free of conscious artifice. It has nothing to do with contrivance and academic standards, everything to do with passion and caprice.

It was in the years just after the Second World War that the French artist Jean Dubuffet, himself a professional painter at odds with his cultural milieu, began collecting the works of those who, in his phrase, showed themselves to be 'immune to the polarisations of culture and the copycat spirit of cultural art'. He was convinced that, as the surrealists had also asserted, inspiration is not the special property of an elite, but can be found among all men. His first researches took him to psychiatric clinics in Switzerland, whence he speedily drew forth an abundance of material. He had correctly guessed that people who are socially and psychologically nonconformist might be in a position to produce especially inventive work. Later he

discovered that non-aligned creativity springs up in all sorts of settings – principally, though, along or beyond the borders of social conformity. He concluded that what was rare was not so much the faculty of invention as 'the boldness to give it free rein. For to be truly inventive is to lay oneself open to certain mockery and disapproval'.

An instinctive recalcitrant himself, Dubuffet sympathised with those whose inner life set them at odds with the routines of day-to-day social existence, and indeed theorised that artistic invention has no worse enemy than other people, whose mere presence can set up implicit expectations concerning subject and style, inhibiting the creative impulse at its very inception. Creativity, he decided, was incompatible with social approval, and even, at the limit, with communication. The criteria Dubuffet established for assessing what he called the authentic 'raw purity' of creativity were rigorous ones. His term 'art brut' refers to those forms of extra-cultural creativity which arise from internal promptings, the spontaneous expression of personal resources untainted by outside influences. In this spirit, he built up his Collection de l'Art Brut in a deliberately secretive manner, gathering works which would represent an alternative corpus of material to the works of academic art, and ensuring that the outside world knew as little about it as possible. For years his collection was stored in a private house in Paris and could only be viewed by special appointment. His aim was to develop a circle of people who really appreciated the significance of this art without precedent: to allow it to become public property would be tantamount to offering the cultural system the chance to reassert its ascendancy by classifying, evaluating and in due course marketing the works of art brut.

Apart from some modest early exhibitions in the late 1940s and a single large-scale show in 1967, Dubuffet's collection remained effectively closed to the public gaze until, following its transfer to Lausanne, it opened its doors as a public museum in 1976. Even then Dubuffet took steps to protect the corpus he had so carefully assembled over a period of some 30 years from the kinds of misapprehension that might distort and devalue its significance. Thus he has stipulated that no item from the Collection shall be removed for display elsewhere: hence there is no risk that a work of art brut will be seen next to any work not of art brut, or displayed in any way that will impair its extra-cultural status. The Lausanne Collection is in this sense a symbolic foundation: it asserts the value and potency of art brut while ensuring its safety from contamination and misinterpretation.

The question of how to protect the authenticity of this outsider art is clearly a delicate one. In an extreme view, it might seem better not to let anyone learn of its existence. For it thrives on its obscurity, and is by definition incompatible with popular acclaim. Yet those who appreciate this form of art and are dissatisfied with the offerings of the cultural establishment, feel an urge to make it manifest, if only in the form of sporadic and more or less polemical exhibitions. As Alain Bourbonnais suggests, such public displays should be intermittent, and interspersed with periods of relative seclusion. Too much publicity can only jeopardise the natural spontaneity of Outsiders still at work, and falsify our perspective on art brut at large.

The criteria adopted for the present exhibition are broadly congruent with those expounded in Dubuffet's many writings on art brut. But Dubuffet himself recognised that art brut is not a territory which lends itself to definitive mapping. Rather it is an 'ideal pole', defined as the mobile contrary to the fixed point represented by conformist academic art. 'The fact is that Art Brut, savagery and freedom cannot be conceived of as places, still less as fixed places, but as directions, aspirations, tendencies.' Any artist must inevitably take up a position on one of the lines which lead outwards from conformity in the directions of individual inspiration. Distance from the centre is the index of his creative originality.

Yet no artist is ever graced with complete immunity to culture. Indeed Michel Thévoz, the present curator of the Collection de l'Art Brut, contends that 'in the extreme, a production totally estranged from culture would be simply imperceptible'. That is, any creative work which achieved absolute independence of a context would simply lie beyond all hope of recognition, and be invisible to us. All we can ask for is an art which as far as possible is resistant to its surroundings. Outsider art is a force in motion which contests the authority of the central establishment and maintains a posture of dissidence in the face of influences to which it is subject.

Given that an infinite number of points exist on the lines radiating out from centralised conformity into the unmapped regions of originality; given that even the most truculent outsider cannot be expected to stay put on one spot, but most inevitably shift at different times either towards or away from the centre; given, finally, that the Lausanne Collection exists as a conclusive demonstration of Dubuffet's criteria at their strictest; it seemed reasonable to the selectors of the present public show that they should follow principles slightly less rigid than those on which Dubuffet insists. If art brut lies totally outside the city limits, there are still transitional zones where interesting things can happen. Terms like outsider art, the singulars of art, isolate art, grass roots art, art extraordinary, fringe art or marginal art are attempts to identify areas which, arguably, overlap all the time with art brut. While the present show comprises works which are indisputably fully proof art brut, it also encompasses works whose potency is adulterated by the fact that they have been made by people whose imperviousness to culture has not been so extreme. Alongside such originals as Adolf Wölfli, Madge Gill and Martin Ramirez, this exhibition features creators like Alain Bourbonnais, Denise Aubertin and Louis Soutter. Now Bourbonnais is a professional architect: he is cultured, and conscious of the fact. What he tries to do is to adopt a stance of resistance to culture, thrusting himself away from the magnetic pull of conformity and agitating his sensibility in such a way that he shakes off, if only in temporary bouts of creative work, the impediments of cultural awareness. Denise Aubertin started out as a writer in a country where literature is a central pillar of the cultural order. When she tried to disown her inheritance, she found ways to subvert the notion of being a producer of the legible word. Still claiming to be a writer, she now makes books which 'tell everything at once' – book-objects whose literary value is highly dubious, yet whose expressive impact is considerable. Soutter was a man of undoubted culture, a trained

architect, painter and musician, who only late in life felt the urge to throw off that training and to assert his creativity in pictures whose wild energy and strangeness testify to a wholehearted effort to work *against the grain*. Creators of this kind are, then, inevitably less free of influence than someone like Wölfli, who was uneducated, socially deprived, and isolated in an institution from which he could never gain access to libraries or museums. But their capacity to resist is no less telling, their faculty for deliberately 'forgetting' what they ought to remember no less admirable.

A quarter of a century prior to Dubuffet's researches, the German psychiatrist Dr Hans Prinzhorn had put together a collection of works by mental patients from many different hospitals, the material on which he based his pioneering study of the artistry of the mentally ill. In the conclusion to his book, he voices ideas similar to those of Dubuffet when stating that 'a primal creative urge belongs to all human beings, but has been submerged by the development of civilisation'. Prinzhorn explained the rare and astonishing creativity of those patients he analysed in detail – creators like Joseph Sell, August Neter, Johann Knüpfer and August Klotz – in terms of a sudden activation of resources which normally lie dormant. 'To explain the cause of this, we would need to consider the inner development or transformation of the patient, his withdrawal from the world around him, his autistic concentration on his own person; together with the change in his external existence and his milieu, and especially his removal from the activities and countless little stimuli of life outside.' Prinzhorn and psychiatrists after him have insisted that artistic talent is not something which mental illness automatically implants in every patient. In fact the statistics show that madmen are comparable to any other section of the population, in that only a minority are artistically inclined. On the other hand, it may be surmised that those patients who *are* drawn to create will, by virtue of the special circumstances which Prinzhorn outlines, be likely to produce work which is not subject to conformist pressures. In other words, the psychosis can act in certain cases as a facilitating agency, enabling the creator to by-pass culture at a stroke and tune in directly to his latent creative resources. Given the possibility of confusion on this point, let me repeat: the outsider is not by definition psychotic, far from it! – there are plenty of creators in this exhibition who have never been considered as mentally unbalanced. And what is interesting in the art of those who *are* thus certified is not the madness itself, but the exciting art that comes out of it.

Installation view, Outsiders: An Art Without Precedent or Tradition, 1979

Another group of fascinating creators who are also mental patients – a group including such intriguing artists as Johann Hauser, Oswald Tschirtner, Philipp Schöpke and Max, not to mention the schizophrenic poet Ernst Herbeck – has emerged in recent years at a clinic in Austria whose director, Dr Leo Navratil, has shown himself to be unusually sensitive to the paradoxes and nuances implicit in the situation. These are people whose work shows astonishing independence of aesthetic and cultural reference points. Their free artistic self-expression is viewed by Navratil as a valid mode of therapy. It should be noted that Navratil dissociates himself from art-therapy as practised in many contemporary hospitals in that he

imposes no guidelines, makes a minimum of intervention in the creative process and holds up no standards of achievement to the patient. What therapeutic value there is to the activity derives from this atmosphere of non-constraint. Something of an anomaly arises in the cases of Hauser and Tschirtner, in that encouragement seems necessary before they will actually put pencil to paper. Tschirtner in particular will only draw on request, the subject of his picture being given by the doctor. However, the undeniable singularity of Tschirtner's style, its remoteness from pictorial models (confirmed, rather than compromised, by those drawings based on newspaper cuttings, which disengage themselves so triumphantly from their sources) – these factors seem to cancel out any sense that he is an 'assisted' and therefore inauthentic outsider. We may even speculate that Tschirtner's reliance on his doctor represents a ritual which by now has been integrated into the creative process and is of no more significance than the preparatory sharpening of the pencil.

Fascinating though they often are, the individual biographies of the Outsiders are by no means the real reason why one feels drawn to their work. Recognition of a work as outsider art does not depend on one's ticking through a checklist of criteria. It would go against the spirit of this adventure into the unknown if one tried to impose pseudo-objective conditions to eligibility. In the final analysis, it is not important to know that Sautter did conventional figure paintings as a young man, that Bourbonnais designed one of the entrances to the Paris métro (on the

trans-city express line, be it noted!), that Scottie Wilson had several shows in London galleries, that Friedrich Schröder-Sonnenstern has made money selling his drawings, that François Monchâtre, say, reads an occasional magazine or book. Even Wölfli did small pictures on demand to earn a bit of pocket money. Of course these are concessions to social reality, but it cannot be seriously held that they appreciably diminish the authenticity of the art itself. What matters above all is the distinctive impact of the works themselves upon our senses. Outsider art acts as its own guarantee: it validates itself to the extent that it is compelling and fascinating, and obliges us to acknowledge its singular intensity, its effect of high voltage.

One of the most attractive aspects of outsider art is the way it draws the spectator in, making him almost an accomplice in the act of creation. The finished product lies before us, yet we cannot but feel something of the vital energies released in the making process. Thévoz writes that 'in none of the forms of cultural art does one feel so vividly the creator's pleasure in the shaping act'. The outsider is jubilant: he really enjoys what he does (in some cases it is the only thing he enjoys). His creativity means more than just the fashioning of plastic forms: it is an almost voluptuous engagement in a process. If this is so, how can we explain the occasional cases where an Outsider complains of feeling himself under a compulsion? Madge Gill gave to understand that the urge which led her to execute complex designs covering hundreds of square feet of fabric was a form of submission to outside demands – in her case, the demands issued by a fancied spirit-guide who stood over her, dictating what she should do. In the case of Peter Moog, art represented a duty, a penance that would redeem the immorality of his early life. A possible explanation is that in such cases the complaint is advanced as a species of alibi. Those who produce so prolifically encounter a social pressure to justify their absorption in their art. Since other people can be insistently curious or unconsciously jealous, it serves as a defence to maintain that one is actually unhappy about one's creativity, and not responsible for it. Let us not be fooled: Madge Gill and Moog were never so happy as when they could take up pen or brush and get back to the intimate world of their own imagination. Theirs was the creative euphoria which another outsider, Augustin Lesage, perfectly evokes: 'When I am working, I have the impression of being in another atmosphere than the normal one. If I am alone, as I love to be, I fall into a sort of ecstasy. It's as if everything around me were vibrating.'

The outsider thus loves to be enclosed in the radiant space of his own creativity. It is a self-sufficient domain. While the world outside may be alien and unmanageable, this world within is reliable and accommodating. As Henri Raynal observes, 'the artist's euphoria stems from the ease with which he can move around within this environment; it is by definition homogeneous since it proceeds solely from himself'. Thus Adolf Wölfli elaborated for his own pleasure an entire mythology in which he was reincarnated as the child divinity Saint Adolf II – an innocent version of himself as he had been prior to his fall from grace and confinement in an asylum. Commenting on the fantastic inventions of this cosmogony, Dr Walter Morgenthaler

writes that 'this world shaped according to his desires and his deliriums is for him more authentic than the real world'. Within the private space of the individual imagination, an alternative reality can be conjured up on which external facts cannot encroach. The outsider's creative work represents a documentation of the inner life of one for whom creativity implies, in Dubuffet's phrase, that he is 'dissatisfied with what already exists, what other people make do with', and who exercises his power to shape a new reality according to personal caprice. Joseph Yoakum's picture album of landscapes from around the Earth is almost wholly invented. Though he did make some actual journeys, the globe-trotting reflected in his pictures is essentially a voyage across the geography of his own psyche. The theatrical scenes mounted by Aloïse are the repository of her richest emotional and erotic impulses, so that her work constitutes a multiple portrait of her private sensibility. Such art is at once a reflection and an extension of the creative self, and Navratil suggests that what we call originality has to do quite simply with an exceptionally direct contact with what is most uniquely one's own: 'Perhaps the peak of originality may be understood as the intensification of what is truly individual'. In other words, it is because he is conscious only of his singular vision that the outsider is able to transcend the limits of his particular existence and tap resources which seem totally out of proportion to the actualities of his social life.

Perhaps the most remarkable thing about the Outsiders is this discrepancy between their art and the mundane facts of their external existence. They are often limited in terms of education and social know-how: several creators in the present exhibition had no schooling, and Ramirez exemplifies an extreme of withdrawal from social life in that he was at once a hospitalised schizophrenic and a mute. Yet, so it seems, deprivation can function as a mysterious prelude to enrichment. The 'have nots' can suddenly become the 'haves'. Scottie Wilson, who ran away from school before he had learned to read or write, once claimed: 'My mind is reading all the time. I don't need papers or books. My mind is full of books.' In turning away from public communications, the Outsider enters on a domain in which he alone is in charge of meanings. What Arnulf Rainer terms the 'autistic theatre' of the self-engrossed individual may be seen as the elective domain of an enriched sensibility which needs no external audience in order to act out gala performances where the individual is author, director, actor, scene-painter and audience, all in one.

It is perfectly understandable that the true outsider should be suspicious of any interest shown in his work by others. After all, it is *his* private work, and there is likely to be nothing but trouble if he lets anyone else in on it. A reluctance to communicate follows from this position, and several Outsiders, such as Klotz and Walla, took great pains to develop complicated linguistic and pictorial codes in which to enshroud their ideas. The fascination of their work for us lies in our being able to guess at the rigorous coherence of the system while being kept in the dark about its final meaning. Again, August Neter's hallucinatory images are packed tight with private symbols to which he alone held the key: we have access

to only a few of his convoluted 'explanations' of his work. Other creators, half aware perhaps of the eventuality of their work being scrutinised by others, seem to lay deliberate stress on *strangeness*. The eerie atmosphere of Oskar Voll's chiaroscuro drawings, the raucous distortions of Hauser's portraits, the derisive weirdness of Schröder-Sonnenstern's half-human, half-bestial figures, the studied improbability of Karl Brendel's hermaphrodites, the inhuman precision of Lesage's monumental canvases, the eccentric amalgams of human and mechanical parts in Joel Negri's toys, the totemic mysteriousness of Michel Nedjar's gargoyles – there seems no end of examples of works whose appeal for us lies in the veiling of their meanings and the strangeness of their forms. Of Heinrich Anton Muller's deliberately 'unbeautiful' portrayals of people and animals, Dubuffet writes that 'he strove, very lucidly, to produce exceptionally strange objects. He sought strangeness above all things. He was obsessed by it, it was his chief joy'. In this perspective, alienation represents a chosen path leading to a position of deliberate differentness and hence of creative originality.

The encounter with strangeness, with a reality so dramatically remote from what we know, poses special strains on our sensibilities. The only way for us to cope with enigma is to involve ourselves patiently in the work, moving through a process of gradual absorption and intimate involvement which can finally lead us to an appreciation of the seemingly inscrutable. In the first instance, we are 'outsiders' ourselves, and we need time to adjust to the new world we have entered.

My claim is simply that the rewards accruing to a sympathetic contemplation of outsider art are incredibly rich. The fascination of Henry Darger's *Realms of the Unreal* lies in their endless fertility of invention, their unstoppable growth. To enter them is to leave the real world behind, yet to enjoy a genuine magnification of one's own imaginative experience. A casual observer may see little in the wooden boxes of Pascal Verbena, whereas a more perseverant and less selfish eye will travel far towards a grasp of their inner mysteries. These are objects in which psychological energies and emotional values have been invested, and they evoke a sense of something sacred.

Almost all outsider art has to do with the projection of deep meaning into shapes and materials which everyday living discounts as being of negligible value. The structures erected by the three major outsider environmentalists Ferdinand Cheval, Simon Rodia and Clarence Schmidt are typical in this respect. Each embodies material of the most commonplace kind – rough stones, cement, surplus timber, scrap metal, industrial junk – and each transmutes this amorphousness into something akin to a temple or sacred site. Both Cheval and Schmidt built a series of shrines into their overall design, and Rodia's *Towers* have been compared to the spires of a church. But this is not to say that their intentions were overtly religious; and while it is true that many Outsiders remain attached to religious concepts with which they grew up, as many again seem prepared to seek in art itself a fulfilment for their mystical inclinations.

This mysticism, if I may hazard the expression, is not to be confused with an aspiration to a transcendental realm, but has to do with a reverent engagement in material realities, an engagement which, by virtue of a paradox inherent in the outsider's situation, is based on a far more meaningful contact with the outer world than one which rests on perceptions channelled and regulated by cultural prejudices. Verbena was once a sailor and his elective material is driftwood polished by the waves. August Walla inscribes his visionary ciphers on tree trunks and once transformed his allotment garden into a kind of private utopia. Many Outsiders across North America have exerted their fantasy upon the environment, celebrating the union of imagination and the natural world. Emile Ratier constructs his assemblages out of scrapwood in a barn attached to his farm, and his declaration that 'my objects come out of my brain and my hands' seems to imply an ambition to reconcile subjective vision with outer materiality.

The Outsider's typical preference for indigent materials bears out this sense of veneration for humble textures. His works are made of substances which the cultural artist would never utilise (except perhaps in a coyly provocative way)- roots, hair, burnt paper, bread, scraps of thread, trash of all kinds. Francis Marshall makes use of nylon tights and bits of plastic cast up on the riverbank. Denise Aubertin puts kitchen spices, coffee grounds and sand into her books. Outsiders who have recently come to light in Scotland make use of blood or knotted grass. There is a marked tendency amongst institutionalised Outsiders to prefer old scrap paper and blunt pencils to the shiny drawing blocks and gleaming crayons offered by their kindly guardians. Aloïse, Ramirez and Müller would jealously appropriate the thick packing paper from any parcels arriving at the clinic and sew pieces together to make larger sheets on which to draw. Gaston Duf scribbled feverishly on tiny scraps of paper that he kept stuffed in his pockets. Madge Gill did thousands of drawings on twopenny postcards, while Klotz made a point of painting on newspaper. The works of art that arise from such habits are accordingly unkempt, marvellously rough at the edges. As Dubuffet once remarked, 'the characteristic property of an inventive art is that it bears no resemblance to art as it is generally recognised and in consequence – and this all the more so as it is more inventive – that it does not seem like art at all'.

This almost perverse insistence on unsuitable materials is of course in keeping with the Outsider's resistance to assimilation to cultural standards. A kind of intuitive choice, so it seems, leads him to modes of expression which cultural connoisseurs either ignore or reject outright as unaesthetic. Yet a drawing done on the back of a stolen envelope in broken chalks and pencil stubs, with areas rubbed over with saliva, toothpaste, and anything else that comes to hand, is no less an expression of human meanings than the silk-screen print on expensive paper from which all trace of accident and the artist's 'handwriting' has been erased. Indeed, the former is arguably more humanly moving than the latter.

To entertain such thoughts is implicitly to contest some quite deeply rooted assumptions in our culture, specifically the puritanical notion that artistic

competence ought to transcend the accidents of fingerprints, smudges and dirt. But it is the virtue of such accidents firstly that they remind us the creator *is* human, and secondly that they bring us face to face with the raw processes of creation. We *see* the mistakes, the second thoughts, we feel the living texture of the tree root even after it has been carved into a figure. Facing the outsider's finished work, we can feel our way through to the intention underlying it, and glimpse something of the creative collaboration with the materials, which indeed often seem to take the initiative. Regrettably, the present exhibition takes place in a setting where textural examination by the sympathetic visitor is not possible; one cannot rely on a public whose culture conditions it to utilise and consume objects to handle these works with the reverence they deserve.

In one aspect, however, it is hoped that a sense of participation can be encouraged, that aesthetic distance can be broken down by an awareness of the living qualities of the works. I am thinking here of those creations which are not static. Bourbonnais's turbulent monsters can be wound up by clockwork and set in motion. Monchâtre's fantastic machines have handles too, and Ratier's roundabouts and circuses have levers and rough cogs with which to manifest their vitality. By extension, one can travel to France and California and walk into the buildings shaped by Cheval and Rodia. The creations of these *habitants-paysagistes*, as Bernard Lassus calls them, are precisely 'landscapes' which we can 'inhabit', as we tread inside the material concretion of a mental reality. The physical presence of such works suggests that they are not so much escapist alternatives to the world of sensation, but powerful additions to that world.

Machines which function to no evident purpose, buildings which no respectable family could possibly live in – these are neat symbols of the outsider's refusal to accommodate himself to the practicalities of normal social life. They are in a sense parodies of a technological civilisation devoted to making all things functional within its orbit. Such parody links up with the general tendency of outsider art to subvert the standards of the established order. Where most academic art caters to the sense of collectively desirable functioning, the work of these Outsiders is an anarchic attack on smoothly running systems.

This by no means implies that the work of the Outsiders has no bearing on our lives. In fact, their work can sometimes carry very direct messages about the way our world is run. Marshall's depictions of rural existence, in particular his corrosive tabulation of the stages in the life of Mauricette, carry a message of protest against the banalities and social which asphyxiate individuality. Mario Chichorro's paintings of modern crowds are caricatures of the predicament of urban man trapped in the perversions which are the negative expression of his natural desires. Schröder-Sonnenstern's ferocious vulgarities carry a menacing reminder that below the respectable surface, people's lives are governed by less seemly impulses. Hauser's blatantly sexual images speak of levels of contact which our present erotic sensibilities can do no more than glimpse. Max's poignantly shapeless and lonely figures can have significance

for us as pointers to a more desirable society in which to be an individual would not be a state of vulnerability, but one in which to share enriching contacts with other people, and with the material world at large. In his earlier pictures, Scottie Wilson shows us the way of the so-called civilised world in allegorical depictions of the struggle between the malevolent Greedies and the innocent Clowns; and in his later works beckons us to contemplate a vision of eventual peace and harmony. Such works may be distant from the preoccupations of academic art, but they can have extraordinary immediacy as existential documents.

Time spent in the presence of outsider art finally leads us from the contemplation of alien territories to the recognition of things which seem deeply familiar. The singular outsider is, in the last analysis, sending out messages to the collectivity. What at first appeared to be negative withdrawal, a refusal of reality, may turn out to be a lengthy process of re-defining human perspectives, a process which will be complete when strangeness modulates into familiarity, when individual remoteness becomes accessible to others without violence. We are probably going to feel surprised when we first encounter such art as this: we will find it difficult to let go of the cultural handholds and venture into a dialogue in a language which must be picked up without the aid of a dictionary. But once it has begun, this dialogue cannot but develop.

The encounter which takes place each time is in essence the encounter of two singular worlds: my own and that of the individual outsider. My evaluation of his work must be a unique event, as should be my evaluation of any individual I meet. My own freedom indeed rests upon my recognising each Outsider as a separate person. There is no place here for generalisations, for blanket enthusiasms or rejections. In the end, there is really no such thing as Outsider Art, no more than there is such a thing as the General Public. There is only the ferment of individuality, that is: the contrary of anonymity and generalisation. An exhibition of this kind cannot be conclusive: it asks only that we make our decisions and discoveries in our own right. And no one can teach us to rely on our own responses – except perhaps the Outsiders, those obscure heroes in the struggle against letting other people do our thinking for us.

MARK HAWORTH-BOOTH
ON DAVID HOCKNEY'S PHOTOGRAPHY

Hockney's Photographs
1983

Hockney's Photographs *featured more than 100 photographic works made by David Hockney between 1968 and 1983. Among them were casual snapshots, Polaroids and large-scale collages. The show was curated by Mark Haworth-Booth, Senior Curator of Photographs at the Victoria and Albert Museum from 1970 to 2004. In a letter to Haworth-Booth, Hockney described the most recent work in the exhibition – made between 1982 and 1983 – as 'a critique of photography made in the medium of photography'. Before this exhibition of his photographic works, Hockney had participated in a number of group exhibitions at Hayward Gallery, including* Pop Art *in 1969, and the first* Hayward Annual *in 1977.*

A photograph cannot really have layers of time in it the way a painting can, which is why drawn and painted portraits are much more interesting. It's a problem I still keep thinking about. Sometimes I think photography isn't much at all, and people have got it all wrong.
DAVID HOCKNEY, 1980

Speculation about Hockney's future is an entertaining game; but one that we are unlikely ever to win, now more than ever that he has declared his freedom to move in any direction he wishes.
MARCO LIVINGSTONE, *DAVID HOCKNEY*, 1981

I had to concede the difficulty of presenting a fixed image of a character as much as of societies and of passions. For character changes as much as they do, and if one wishes to photograph [clicher] its relatively immutable aspect, one can only watch as it presents in succession different appearances (implying it does not know how to keep still, but keeps moving) to the disconcerted lens.
MARCEL PROUST, *IN SEARCH OF LOST TIME*, 1913

A photograph is a photograph is a photograph. In recent years David Hockney has been saying what Gertrude Stein did not, quite. By now it is well known that Hockney finds the still photograph still to the point of being frozen, that a photograph excludes more than it reveals and is constructed in ways that are contrary to natural vision and traditional art. On the face of it, his solution seems simple. Over the last two years he has been adding a photograph to a photograph to a photograph – or scores of photographs to each other – as a challenge to conventional photography. The challenge is worth taking up because his camera production questions more than the traditionally celebrated photography of the decisive moment.

The 1970s and early 1980s are oddly reminiscent of the controversies and definitions provoked by photography in the 1850s and early 1860s. At that time photography

MARK HAWORTH-BOOTH ON DAVID HOCKNEY'S PHOTOGRAPHY

had only just moved into the era of the truly transparent (glass) negative and found the binding agents and techniques which allowed for rapid exposure and mass production. It was on the verge of its major industrialisation phase; 70 years later the half-tone process, high speed printing and faster lenses gave photography domination over mass illustration. It could be said that most is talked about photography when it is on the verge of change. It is also arguable that the pre-industrial phase (1850s/ early 1960s) is echoed now in a reverse order. The expansion of the domain of photography into the museums occurred during the years when television was taking over many of the roles of the (photographically) illustrated page. When the various modes and possibilities of photography were being investigated in the mid nineteenth century these were checked carefully against painting. The best critic of the day, Lady Eastlake, decided that photography was a phenomenon too various to be classed either as art or description but as a 'new form of communication between man and man – neither letter, message, nor picture – which now happily fills them'.

Another useful early critic asked that photography be distinguished into its constituent kinds. Jabez Hughes, a notable professional portrait photographer, suggested in 1861 that there were three main kinds. Mechanical Photography includes all 'kinds of picture which aim at a simple representation of the objects to which the camera is pointed, and will include not only all reproductions [e.g. of paintings] but the great majority of portraits and landscapes'. He did not depreciate this kind of photography. His next category is Art-Photography which embraces 'all pictures where the artist, not content with taking things as they may naturally occur, determines to infuse his mind into them by arranging, modifying or otherwise disposing them, so that they may appear in a more appropriate or beautiful manner than they would have been without such interference'. In light of the works of such artist photographers as O.G. Rejlander and Henry Peach Robinson, who joined up series of photographs from different negatives into large tableaux – notably *The Two Ways of Life* (1857) and *Fading Away* (1858) – Jabez Hughes thought fit to suggest another category. High-Art Photography, he admitted 'may appear presumptuous; but I feel a necessity for it to include certain pictures which aim at higher purposes than the majority of art-photographs, and whose aim is not merely to amuse, but to instruct, purify and ennoble'. Hockney has been photographing in different ways for 20 years or so and his use of the camera flows into each of these categories. When photography is discussed as all-inclusively as is customary – 'Photography is…', etc. – the formulations of the early critics remain useful and are substantially correct.

The first part of this exhibition is a selection from Hockney's albums. The albums are large – 18 by 22½ inches when open – contain six or eight photographs of standard snapshot size (usually 4⅝ by 3⅛), number nearly 100, include about 20,000 photographs and go back to 1961. They are to do with holidays, friends, preparations for paintings or drawings, completed work and exhibitions. They record visits home, weddings, Christmas and travel, like most albums. Many of the most striking photographs were selected from the albums two years ago by Alain Seyag, curator of photography at the Centre Georges Pompidou, for an exhibition in a series on

painters' photographs. Others in the series are Man Ray and Robert Rauschenberg. The book *David Hockney Photographs* gives a good idea of the contents of the albums. In the early days Hockney might have been satisfied with snaps but as time went on – by 1968 – he was photographing carefully and concentratedly. This is probably because he had designs in making the photographs. They were taken as data for paintings such as the double portrait of Christopher Isherwood and Don Bachardy (1968) or they were taken, like the solitary swimmer, because they record visually surprising phenomena which might later become part of a painting (in this case, *Portrait of an Artist, or Pool with Two Figures* [1971]). This exhibition takes a different approach from that of Alain Seyag. Instead of choosing and isolating individual snapshots, even though they are often deliberately considered and certainly beautiful, the albums are represented here by whole pages and sometimes double-page spreads. This gives a better idea of the way the albums are composed. Six, eight or a dozen pictures of a place or an afternoon are more informative than single shots and this method also shows how purposefully Hockney photographed. He has always worked with photography in series. The layouts from the albums illustrate, as was pointed out in Seyag's book, that the notion of joining up snapshots in clusters goes back some time, back to 1969 when *My Father in His Workroom* required two adjoining snaps to fit in all the odds and ends, and was used quite frequently afterwards.

As Marco Livingstone suggests in his book *David Hockney* (1981), there are times when Hockney has seemed paralysed by the photographs from which certain paintings derive. He moved closest to photo-realist painting, the genre celebrated for being neither photography nor realist, in 1971–72. Certain paintings like the *French Shop* of 1971 bring together a double-page spread of detail photographs from the albums but others – *Bench Umbrella* from the same year – are one-to-one painting to photograph with a slick or at least deadpan painted surface. Such paintings look like theatre sets. Hockney devoured the photographic effect of arrested time precisely because it provided him with an unnatural, Magritte-like, sense of suspense and theatre. That is one way of putting it. Another is to recall Henry Geldzahler's phrase about that spirit of place Hockney captured in his paintings from Los Angeles: 'blank allure'. Before Hockney came to the conclusion that the photographic effect was artificial and unreal he had himself taken this characteristic to its limit in his paintings.

The albums reach their most congested state with a series of spreads of photographs of a painting of Gregory Evans in a blue dressing gown, apparently asleep on a couch. These studio views include a painting in which Hockney sits at a table apparently looking at the real sleeping Gregory while, of course, the real Hockney photographs the whole studio including the painted Hockney and the real and painted Gregorys. This was the period (1977) of Hockney's homage to Picasso inspired by Wallace Stevens's *The Blue Guitar*. The series of photographs of the real and painted Gregory are meditations which reach a theatrical conclusion when another young man (Peter Schlesinger) slips into the dressing gown and onto the bed. These spreads labour the comparison of reality and illusion through multiple imagery and it is worth labouring

MARK HAWORTH-BOOTH ON DAVID HOCKNEY'S PHOTOGRAPHY

the point that they are 'theatrical'. The next phase of Hockney's photography is theatrical in several ways.

Hockney has said that he began the Polaroid series of collage photographs after Alain Seyag had visited him to select photographs from the albums for the Pompidou show. They argued about the validity of the single photographic image. Later Hockney started taking individual instant Polaroids of the living room of his newly decorated house in Montcalm Avenue, then of the balcony or terrace outside, then of the garden and pool beneath. He had been trying to paint the same triple view and joined the three sets of Polaroids up into a unified group edge to edge. The experiment with the Polaroid SX-70 camera was designed to overcome the frozen moment of traditional photographs, which Hockney now disparagingly calls 'one-eyes'. He broke all the rules, of course. The SX-70 has a fixed fairly wide angle lens. To build up a convincing overall picture of an interior and a figure, it was necessary to choose a position from which the subject is to be regarded as seen – and then move about the space taking a set of close-ups of details. Each detail had to be more or less coherently related to the position from which it is notionally seen and to relate also to the adjoining prints. Such large-scale pictures could be laid out on the floor, allowing for trial and error, as the individual Polaroids were added. The larger efforts took four to six hours to complete. The results are lively, unpredictable in detail but pictorially logical as a whole. Contours are noted in passing, are interrupted by the grid formed by the white margins of the Polaroid, continue their passage or spin into another descriptive direction. Instead of getting in the way the grid provides interstices across which matter jumps, invisibly for a moment, to reappear – in any one of four sectors of adjacent space. The intention was to use photography to recreate the mobile, clue-seeking, fluctuating series of glances which make up vision. When he exhibited the Polaroids for the first time last year Hockney called the show 'Drawing with the camera'. Sometimes the drawing falls down, as when the constituent fragments of a head fail to combine and a hole is punched into the surface of the illusion. The qualities available from this method are shown by comparing the (significantly) unfinished painting of George Lawson and Wayne Sleep with the complexity and characterisation achieved in the Polaroid.

The Polaroids had a drawback which was that they needed abundant time, space and trial and error to take. They were also pictures you could only make in one place, like a studio or a garden, and needed to be laid out at the notional point of vision. Hockney started another experiment, using a pocket camera, the Pentax 110 which has a selection of three lenses including a telephoto. With this he could make large-scale pictures in the street, on a plane, in a subway train in New York, or from the enclosed space of a car interior; the dining chair at an Embassy function, or from the pillow of a bed at the Mayflower Hotel.

The photo-collages which follow the Polaroid series were taken with the small Pentax or with a Nikon with a long, approximately 100 millimetre lens, processed and printed at the local photomat, pieced together and finally glued into permanent

position. They are called 'joiners' in Hockneyan parlance. Early examples followed the grid system of the Polaroids but this imposed too predictable a nature on the final picture. There was insufficient expansiveness and surprise. This is shown particularly clearly in two differently joined up versions of a river in Yosemite. The second, irregular, solution evokes the torrent more successfully, partly because the details have to be read more rapidly and less schematically. Some early joiners are in black and white but later examples are all colour. For obvious reasons the crude vigour of photomat colour prints is suited to synthetic rather than natural colour subjects. The albums show Hockney's interest in the way changes in light intensity transform colour from frame to frame and these small changes are built into the joiners.

Professional photographers have frowned at his use of colour for his snaps and more serious photographs. Of course, he has a canny knowledge of commercial photography, having sat for many of the best portraitists in the business and he is naturally well aware of the subtleties involved in the accurate copying of works of art. However, part of the impetus of the last two years has been to attempt to extend photography by using a popularly available camera, available light, drugstore processing and his own life.

That life is sometimes high-life (as well as a very hard-working one) and it is no surprise to find visits to the late Sir Cecil Beaton in the albums. As traveller with the pen and the camera Hockney is linked with Beaton from the outset. One of the plates of *The Rake's Progress*, in which Hockney etched an account of his first visit to New York in 1961, is based on a photograph of a Harlem funeral (by James Van Der Zee) which appeared in *Cecil Beaton's New York* (1938). When I compared the collage of the Mayflower Hotel bedroom, the *Sunday New York Times* loading the bed (page 25) with Beaton's photograph from the same book Hockney responded at once – 'Yes, but Cecil Beaton couldn't see what the camera was seeing.' There is a 180-degree difference in angle and purpose. The point about photographing everything likely to be scanned from a normal fixed position is that it traverses the areas between obvious interest. In this, as well as a preference for the vigour of colour against the good taste of black and white, Hockney is linked with the most sardonic photographer of the contemporary American interior, William Eggleston. It would be foolish to imagine that Hockney is unaware of the most witty photographer of American streets and highways, Lee Friedlander. For many years now Friedlander, a friend of Hockney's colleague R.B. Kitaj, has been inventing ways of making photographs which have the fractured complexity of collages. Hockney's *Steering Wheel* looks like a salute to Lee Friedlander as well as to Bryce Canyon.

Hockney's photography is, he says, an attempt to extend the range of photography so that its imagery should be less remote from the mechanics of perception. One of his methods is to indicate his own presence by including hand,

David Hockney
*George Lawson and Wayne Sleep
Pembroke Studios London W8,
2 May 1982*, 1982

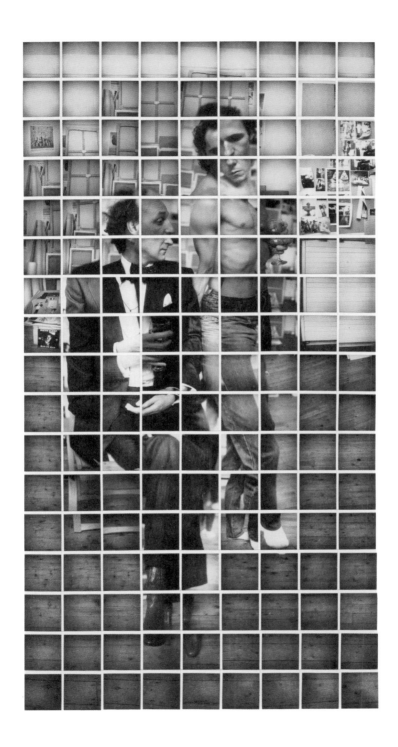

foot, some evidence of photography being done, occasionally (also a Friedlander trade mark) his own shadow. Part of his reasoning is that all photography (space shots, etc. apart) is necessarily autobiographical, in the sense that the maker has to be present at the scene pictured. This is a polemical point still well worth making even in exaggerated form, especially in the context of war photography. The observing human witness behind the camera is easily forgotten in the horror of the message. This places the camera operator but also the photograph consumer in a sometimes questionable but usually unquestioned relationship.

Hockney is not as theatrical a photographer as Beaton but the adjective is useful because Hockney's intense use of the camera has coincided with his main periods of work for the opera and ballet (1974–75, 1980–83). This experience has had several effects. Working with the scores of Poulenc, Satie, Stravinsky and Ravel provided an impetus further to immerse himself in the Paris of the early decades of the century and to bring to the music fresh interpretations inspired by Picasso, Matisse and Dufy. The problems of relating figure to ground, or dancer to back-drop, gave a new interest to the space and time relationships in cubist paintings. Then there is the question of scale. The photographs made during the recent period of work for the theatre are large and the last in the series is a triptych of hundreds of photographs (*The Wedding in Hawaii*). Photographers in many countries have recently been working at the scale of paintings and the range of activity (including Hockney's) was reviewed in the exhibition *Big Pictures by Contemporary Photographers* organised by the Houston Museum of Fine Arts and shown earlier this year at the Museum of Modern Art, New York. In Hockney's case there seems to be a structural relationship between the stage and the photographic work, and not only in scale. This is not merely a case of finding that his most 'Dufy'-like photographs from the mid 1970s have become elements in the mise-en-scène of *Les Mamelles de Tirésias* (1981). There is a strong additive or collage principle at work in the backdrop of the Porcelain Palace of the Chinese Emperor in Stravinsky's *The Nightingale* (1981). The cut-out hieratic shape of the palace is similar to the shapes of the photo-collages. In *The Wedding in Hawaii* the chief scene is collaged into the form of an ancient arch. The sign-shapes invented for the theatre reappear in the outlines of the joiners.

Work for the theatre is unlike other kinds of work, Hockney has said, because it is never really finished, not even when the curtains part on opening night. There are always adjustments, re-scalings, modifications which the designer is called in to make. The photography experiments of the last two years have resulted in hundreds of new works at a period when time for concentration on new paintings was hard to come by. However, the cross-breeding of a kind of drawing, a kind of photography and ideas from theatre has resulted in unprecedented new forms.

Immersion in the Paris of the early century, together with his camera experiments, gave Hockney a new sense of excitement about some key passages in Roger Shattuck's book *Proust's Binoculars*. Perhaps the book provides the programme

for the collages. Shattuck traces the optical figures which recur in Proust's novel, notably the magic lantern, the kaleidoscope, the *instantanée* (snapshot) and the cinematograph. While Proust was writing the novel, Jacques Henri Lartigue began, at the age of seven, to take his famous *instantanées* in the Bois de Boulogne. The snapshot assumed special importance in Proust's thinking. Shattuck distinguished three primary ways of seeing or recreating the world. The cinematographic principle is a sequence of separately insignificant aspects which produce the effect of motion. The montage principle employs a succession of large contrasts to reproduce the disparity and contradiction that interrupt the continuity of experience (and the movies employ both of these principles). The third principle held Hockney's particular attention:

> The stereoscopic principle abandons the portrayal of motion in order to establish a form of arrest which resists time. It selects a few images or impressions sufficiently different from one another to give the effect of continuous motion, and sufficiently related to be linked in a discernible pattern. This stereoscopic principle allows our binocular (or multiocular) vision of mind to hold contradictory aspects of things in the steady perspective of recognition, of relief in time.

Proust moved between the three principles in the novel in the quest for truth, which Shattuck's eloquent book affirms as 'a miracle of vision'.

This exhibition shows Hockney's romantic quest for a photographic form equivalent to the natural dynamics of looking. After the final work in the series, *The Wedding in Hawaii*, he made the central moment into an etching of a few lines. The experience of making the collages is likely to appear in later works, in one medium or another, or a unification of several.

To some extent Hockney's experiment in photography during the last two years is a provocation, a tease. It has to be admitted that the West Coast has its share, or perhaps more than its share, of humourless art photographers, as well as possessing some of the most thoughtful practitioners working today. One of the funniest spreads in the albums is a series of pictures, eight or a dozen, of Hockney's father kindly helping his brother Paul with a jammed camera. The struggle with the infernal machine is sustained from frame to frame like a Laurel and Hardy sequence – and ends in time to take the wedding pictures. One of the new collages shows Gregory Evans fumbling film into a Nikon and there is an affectionate spoof on commercial portrait photography involving Annie Leibowitz of *Rolling Stone*. She is well-known and respected for her portraits of rock singers and music business celebrities and when she arrived to photograph Hockney late last year he was impressed by the seriousness of the whole operation. An estate wagon, an assistant, cables, floods, decisions about what Hockney should wear – and a drive to the desert. It was a greyish day and

Hockney amused himself by photographing the set-up, the carting of paraphernalia into the desert, red cables, checks and tests, and then rays of light emitted from a huge umbrella – he drew in four yellow lines afterwards – and, lo! – there in splendid colour is a smiling and sunlit Hockney, hand-crafted by Annie Leibowitz.

ADRIAN FORTY
ON LE CORBUSIER

Le Corbusier:
Architect of the Century
1987

Le Corbusier: Architect of the Century explored the life and work of the pioneering modernist. Taking place at the beginning of Le Corbusier's centenary year, the exhibition featured furniture, original drawings and paintings, as well as photographs and models of the architect's major public and private buildings. It was organised with the collaboration of the Fondation Le Corbusier, Paris, and selected by a committee that included architectural historian Tim Benton, Christopher Green of the Courtauld Institute of Art and Richard Francis of the Tate Gallery. Architect Neave Brown also contributed to both the selection and the design. At the time of the exhibition, Le Corbusier's claims for modernism were coming under fire, particularly in the UK. The architect's shifting reputation is the subject of this essay by architectural historian Adrian Forty.

LE CORBUSIER'S BRITISH REPUTATION

> When you open a new volume of the *Oeuvre Complète* you find that he has had all your best ideas already, has done what you were about to do next.
> ALISON SMITHSON[1]

This remark by the architect Alison Smithson, reported in 1966 and probably uttered ten years earlier, gives an idea of just how great a regard some British architects had for Le Corbusier. By contrast 30 years later, in 1986, during the planning of this exhibition, the organisers were all too conscious of the effect the 'Broadwater Farm factor' might have on the show's success, such was the likelihood some people would link Le Corbusier's name with the ugly confrontation between police and residents on that North London estate in the autumn of 1985.

Naïve as Alison Smithson's enthusiasm may now seem, and over-simple the notion of the 'Broadwater Farm factor', the reversal of the underlying sentiments is as good an illustration as any of the change that has taken place in Le Corbusier's reputation in Britain over the last 30 years, and the gulf that has opened between the respect some architects have had for him, and what he represents to the public. To a large extent, the history of Le Corbusier in Britain is the history of modern architecture in this country. In a way that has happened to no other architect, he has been used to personify the ideas, ideals and the architecture of modernism; as a result his name has been used, sometimes as a talisman, sometimes in the place of Lucifer himself, in arguments that may be related only distantly to the man. That he has attracted so much controversy is not only on account of his own talents, or failings, but because of what he has been taken to represent in the debate about modern architecture.

LE CORBUSIER AND THE ARCHITECTURAL PROFESSION

Modernism in Britain, as an active building tradition rather than a poorly-understood set of foreign ideas, dates from 1945, and it is here that discussion of Le Corbusier's relationship to British architecture should begin. Although Le Corbusier was known, and indeed notorious, to British architects and the public in the 1930s, this was mainly through his books, and his contribution to the development of British architecture had been insignificant. After 1945, when modernism was adopted generally as the architecture of the welfare state, the new generation of architects responsible for reconstruction and the new building programmes was faced with interpreting and applying the precepts of Modernism for the first time. In these circumstances, making sense of Le Corbusier acquired a more real importance than it had had before.

That it was Le Corbusier to whom British architects turned rather than any of the other first-generation modernists was partly because his writings and architecture were better known than those of any of the Germans, but especially because he alone of the 'masters' had remained in Europe and accommodated his thinking to postwar European problems. The pre-war ideas of Mies van der Rohe and Walter Gropius, both of whom had emigrated to the United States in the late 1930s, seemed out of date, and they showed no interest in the reconstruction of war-damaged cities. Le Corbusier, on the other hand, had remained in France and after an unsuccessful attempt to attach himself to the Vichy government, had applied himself to adapting his pre-war radiant city plans to the specific requirements of particular towns. These demonstrations of the practical application of ideas from pre-war modernist thinking to new circumstances, and the fact that Le Corbusier was available to discuss them (he attended, for example, the Bridgwater meeting of CIAM) gave him a stature above all others.

Of his various reconstruction projects, one in particular, the Saint-Dié scheme, was of enormous interest to British architects when it was published in the *Oeuvre Complète* in 1946, because it showed how the radiant city idea, hitherto presented only in terms of either imaginary ideal sites or involving the total erasure of large parts of existing cities, might be applied in practice. Saint-Dié was a town in the Vosges which had been blown up by the Germans in 1944. Le Corbusier's proposal retained the principal historic building, the cathedral, to the south of which was to be a new municipal centre with town hall, museum, shops and offices in and around a large plaza. South of the river was to be the industrial zone; three-quarters of the housing was provided in Unités to the east and west of the centre and the remaining quarter in houses in the roads beyond. Of the features that interested British architects in this scheme, two in particular are worthy of attention: the idea of retaining and giving prominence to important cultural monuments within otherwise totally new schemes, and secondly the provision of accommodation in a combination of flats and houses, an arrangement that was to become known in England as 'mixed development'.

Even amongst those British architects who were committed to modernism, there were critics of Saint-Dié. For example, Lionel Brett, in an article that was distinctly lukewarm about Le Corbusier, having acknowledged the ingenuity of the Saint-Dié circulation system and commended what he called the 'Attic grandeur' of the plan, concluded by saying: 'one wonders whether human beings as one knows them – fond of slums, fish and chips, overcrowded cafes, romantic ill-lit alleys – could quite live up to these splendid but austere spaces, or get much out of them in the hot sun or the rain'.[2]

Unlike the Saint-Dié scheme, which was never executed, the Marseilles Unité presented British architects with the opportunity to study not only the master's thought processes, but also their physical result. Although this building was in a sense only a fragment of the radiant city scheme, the interest it aroused was unequalled by any other building in Europe in the decade after 1945. The variety of responses it evoked distinguish fairly clearly the various camps of opinion about Le Corbusier within British architecture.

For the group that came later to be associated with the Cambridge University School of Architecture, Le Corbusier's significance was primarily as a man of ideas, a speculative thinker, with an unusual ability to express his speculations in terms of architectural form. Sir Leslie Martin represented the clearest version of this view. Paraphrasing his attitude to European modernism, Martin has stated that he considered that the real significance of the new architecture of the 1920s was in the ideas that it developed, rather than the form that it used, and that the failing of modernism in the 1950s was to have become obsessed with style and to have neglected to continue research into theoretical principles. Le Corbusier represented an almost unique exception to this, as Martin explained referring to the Ville Contemporaine:

> the comparison between the parallel rows of the German Siedlungen and the environmental areas formed by Le Corbusier's housing with setbacks (in all its modulations) is a telling illustration of his theoretical advance and the quality of his speculative thought [...] These plans are not just 'images'. They are packed with ideas about housing, about environment, about traffic. They demonstrate that these things can be set down in measurable terms and can also be given a clear physical form. They also make clear that it is only through this physical form that ideas about individual component parts can be brought into relationship and ultimately assessed.[3]

Martin regarded the actual forms of Le Corbusier's architecture as of minor interest – their significance was that they clothed a set of ideas, but they were not therefore to be considered as providing relevant or useful precedents.

Rather similar views were expressed by Sir Leslie Martin's one-time associate, Colin St John Wilson, though Wilson's architecture of the 1950s bore more direct visual

resemblance to Le Corbusier's than did Martin's. Like Martin, Wilson insisted that the value of Le Corbusier's work lay not in its style, but in the architect's ability to synthesise ideas in architectural form. Speaking at a conference in 1965, Wilson explained: '…growing up and around the ideas formulated at CIAM, there is very strongly the notion of architecture as carrying a body of ideas and turning them into the body of a building in some way. These two things had to go together; merely to tell the story of a plastic system, or merely to talk of *existenz minima* were not enough. And this clearly is why Le Corbusier is important for us because he has always achieved this embodiment.'[4] Wilson felt that this architecture of ideas had been betrayed by the entire older generation, apart from Le Corbusier. The Unité, he explained, 'has a stature quite beyond any of our post-war buildings precisely because it carries a load of ideas'.[5]

A significantly different attitude towards Le Corbusier's thinking was to be found amongst the group of young architects who attended the last CIAM meetings in the 1950s, and formed the splinter group known as Team X. The British members of this group – Peter and Alison Smithson, William Howell and John Voelcker – while expressing great, sometimes unbounded admiration for Le Corbusier's architecture, considered his thinking, particularly on city planning, to be the greatest failing of modern architecture. Le Corbusier's concept of the city in terms of the four functions of work, residence, recreation and circulation, as expressed in the Athens Charter, was taken by Team X to embody the orthodox pre-war CIAM position. The Smithsons expressed their criticisms variously; in 1953 they wrote: 'The time has come for a reorientation of urban thinking, a turning away from the hitherto functional Theory of CIAM, towards a human theory based on the associations of people with each other and their work.'[6] Their contempt for the four-function model is evident elsewhere: '…where the extent of development is sufficient we can see the working out of the theoretical isolates, dwelling, working, recreation (of body and spirit), circulation, and we wonder how anyone could possibly believe that in this lay the secret of town building'.[7] Le Corbusier was seen as largely responsible for the identification of the four-function model with CIAM, and the Smithsons had no hesitation in criticising him for it: 'Le Corbusier's dream of a ville radieuse was supported by a geometry of crushing banality […] the plans move us as little as the pattern on the tablecloth at the "Vieux Paris" which is, indeed, where it may have originated.'[8]

Against what they saw as the sterility of this model, Team X proposed a different approach. As the Smithsons put it, 'we must evolve an architecture from the fabric of life itself'.[9] The question of what constituted 'life itself' was resolved by the British branch of Team X as being the pattern of human association. The earliest Team X documents proposed a new view of the city based on the levels at which association occurred, the four categories behind house, street, district and city.[10]

Accompanying this new formulation of the city was a marked distaste for the abstracted and utopian nature of Le Corbusier's thinking, which was replaced by

new values, in particular the concept of 'community', as the source of architectural ideas. As the Smithsons put it: 'It is traditionally the architect's job to create the signs or images which represent the functions, aspirations and beliefs of the community, and create them in such a way that they add up to a comprehensible whole.'[11] Without going into the question of how the architect was to do all this, the statement bore the signs of the Smithsons's contact with the origins of pop art, with its stress on ordinary, everyday experience and imagery, and on Joycean 'epiphanies', the revelation of profundities in commonplace events.[12]

While the Smithsons had no difficulty in distancing themselves from Le Corbusier's ideas about the city, they found his architecture more difficult to assess. Especially problematic was the Unité, which, while being to them a remarkable and exciting piece of architecture, was also contaminated by the undeniable fact, corroborated by Le Corbusier himself, that it was the culmination of his pre-war radiant city ideas.[13] The Smithsons revealed their uneasiness about the Unité, and during the course of the 1950s offered various interpretations of it. On the one hand, while acknowledging its origins within the four-function model of the radiant city, they regarded it as a prototype of the new urban theory of association because of the way it dealt with the relation between the individual dwelling and the community.[14] Elsewhere, they frankly accepted that it was derived from the four-function model, and saw its significance in the way it gave plastic form to the old concepts.[15] Not until the 1960s were the Smithsons able to turn their backs on the Unité and declare unequivocally 'the Unité is no longer a valid formal crib'.[16]

Rebellion against Le Corbusier should be seen as a necessary part of Team X's own development. This was carried out in a somewhat self-conscious way, the members of Team X making public avowals that this was what they were doing, while Le Corbusier, for his part, actively encouraged them to do so, giving, in a sense, permission to rebel, as is confirmed by the text and drawing in his letter to Karl Krämer, showing the new generation standing on the shoulders of the old.

To other architects within the modernist camp, the tortuous intellectual problems which the Smithsons created for themselves were irrelevant: what was to be valued and respected in Le Corbusier was his ability to invent marvellous architectural forms.

The work of Le Corbusier familiar to those trained in the immediate post-war period was that of the 1920s and early 1930s. James Stirling and James Gowan, partners between 1955 and 1964, both admired Le Corbusier's work of the 1920s because of the architectural language, symbolising modernity, that he had created. Gowan recollected: '…the manifesto that accorded most closely with how we felt, social-reforming artist-scientists, was *Vers une Architecture* […] Le Corbusier convinced us that style should correspond to its own particular period and emanate directly from its technology, and, as a consequence bear some resemblance to the other products of industry, motor cars, aeroplanes and the like.'[17]

Installation view, *Le Corbusier: Architect of the Century*, 1987

Stirling likewise valued the work of the 1920s for its success in creating a formal architectural language for technical progress and social emancipation. As he wrote of the Villa Stein-de Monzie at Garches: 'Utopian, it anticipates and participates in the progress of twentieth-century emancipation. A monument, not to an age which is dead, but to a way of life which has not generally arrived, and a continuous reminder of the quality to which all architects must aspire if modern architecture is to retain its vitality.'[18]

The problem for those architects so taken with the machine-age imagery of Le Corbusier's architecture of the 1920s was what to make of his work of the 1950s, which constituted something of a personal rebellion against his earlier work. Confronted by the Maisons Jaoul, Stirling was bewildered, and unable to explain the apparent rejection of what he had revered in Le Corbusier. Comparing Jaoul to Garches, he wrote: '…it is disturbing to find little reference to the rational principles which are the basis of the modern movement, and it is difficult to avoid assessing these buildings except in terms of "art for art's sake".'[19] If Stirling's response to Jaoul was muted, his criticisms of Ronchamp left no doubt of what he thought: '…when the emotions subside, there is little to appeal to the intellect, and nothing to analyse or stimulate curiosity'.[20]

At exactly the time these two articles were published, Stirling and Gowan were working on the design of a group of flats, the Langham House development, Ham Common, which, while they bore superficially a close resemblance to the Maisons Jaoul, would appear also to have been an attempt to correct the 'errors' Stirling had perceived. The messy brickwork of Jaoul was cleaned up, the concrete detailing was sharper, neater and more 'machine age', there was a clear geometry to the scheme, whereas none was evident at Jaoul, and a deliberate spatial effect was created in the entrance halls and staircases – Stirling had noted the absence of a modernist use of space at Jaoul, commenting: 'there is certainly no question of being able to stand inside and comprehend the limits of the house'.[21]

A similar impulse to correct the 'faults' of Le Corbusier's recent work can be seen in the slab blocks at the London County Council's (LCC) Alton West estate, designed in 1954 and completed in 1959. These blocks, designed by a group of LCC architects which included William Howell, have often been regarded as close imitations of the Unité.[22] Although this was certainly intentional, there are some important differences which make it clear that the architects did not regard Le Corbusier's recent work as an altogether satisfactory model. For example, the buildings stand on slender *pilotis*, unlike the squat legs of the Unité, so restoring some of the machine aesthetic purity of the 1920s. Also, the dark interior street, perceived as the greatest fault of the Unité, was eliminated and access to the maisonettes provided from balconies.

If Le Corbusier's work of the 1950s presented a problem to some British architects, others were prepared to borrow directly from it without question. Sir Basil Spence's buildings of the late 1950s and early 1960s use various Corbusian motifs, for example,

the concrete vaults of Jaoul, which appear on the exterior of the Kensington barracks and Falmer House at Sussex University, or the leggy sculptural concrete shapes of the flats in the Gorbals. In these buildings, Corbusian motifs are used in a straightforwardly picturesque way, and have nothing to do with Le Corbusier's ideas or theory; they represent a diametrically opposite response to Le Corbusier than that offered by Sir Leslie Martin.

It would be a mistake to assume that all modernist British architects were in one way or another enthusiastic about Le Corbusier in the 1950s and early 1960s. There were certainly some who felt that there was little for them to learn from either his architecture or his theory, and were critical of his arrogance in claiming that the new architecture was the way to a new social order. The view of Le Corbusier expressed by a group of LCC architects that included Oliver Cox and Cleeve Barr at a discussion of the Unité in 1951 was that 'He is at fault when he suggests that it is the task of architecture to create a new way of life', and they criticised his tendency to impose conditions on people.[23] Further occasional criticisms of the authoritarianism implicit in Le Corbusier's architecture appeared during the 1950s, but it was above all over the issue of technology in architecture that the first major revision of Le Corbusier's reputation occurred.

Two developments gave rise to this. The first was the appearance of an architecture based upon industrialised building systems – the Hertfordshire schools programme, the CLASP and other systems – which together with the government's support of systems for housing and other welfare state buildings made for the first time the old modernist dream of a factory-made building (with all that that implied) a reality. Despite his rhetoric about the need to make a house like a Ford car, it was only too obvious to the architects involved in these developments that Le Corbusier's work contained nothing, theoretical or practical, of any use to them; furthermore, the technology of his recent buildings, far from being progressive, seemed to be moving rapidly backwards towards the middle ages. Secondly, a new critique of the architecture of the 1920s was presented by the historian and critic Reyner Banham in his *Theory and Design in the First Machine Age*, published in 1960. Banham argued that the failure of the first generation of modernist architects to develop any further arose from their failure to utilise the lessons of technology, rather than merely symbolising technology in their architecture. The future of modern architecture, according to Banham, depended upon the ability to learn from and assimilate the latest technology: 'The architect who proposes to run with technology knows now that he will be in fast company, and that, in order to keep up, he may have to emulate the Futurists and discard his whole cultural load, including the professional garments by which he is recognized as an architect. If, on the other hand, he decides not to do this, he may find that a technological culture has decided to go on without him.'[24] Le Corbusier, as was amply clear from his recent work, fell into the latter category, and was seen by Banham as having contributed little to the 'true' course of modern architecture, represented in the former category. In the early 1960s, with the benefits of recent technical progress widely obvious, this was a

view with which it was easy to sympathise, and Le Corbusier's neglect of technology made his work seem much less interesting than it had appeared 15 or 20 years before. As one correspondent to *The Architect's Journal* in 1965 remarked: 'it has always seemed to me that Corb had the opportunity of putting technology in its place and that the place he chose to put it was a romantic penumbra where other architects who are unable to work scientifically have been very happy to leave it'.[25]

At the time of his death, therefore, Le Corbusier's reputation amongst British architects was no longer quite as brilliant as it had been 20 years earlier; although there were many who were still loyal to him, in one way or another, there was also much more open criticism of him (and particularly of him in his *uomo universale* persona), provoked partly by the changes in his own architecture in the late 1940s and 1950s, but above all by the changes that had been taking place within British architecture. Within a very short time after his death, though, a resuscitation was attempted, with the ironical intention of setting up Le Corbusier, the pioneer of modernism, as the 'father' of postmodernism. Referring to Le Corbusier's work of the 1950s, Charles Jencks argued that the plurality of meanings it created, and his masterful ability to synthesise classical and modern systems of architecture, made him the prophet of the kind of architecture to succeed modernism.[26] Since this new argument was based largely on the analysis of form in Le Corbusier's architecture, it added new heat to the debate about Le Corbusier within British architecture, outraging those who had insisted that the significance of his work lay in his intentions and ideas, and that conclusions should not be drawn merely from the actual results of his architecture. By the early 1970s, however, architectural controversy was beginning to be overshadowed by the general reaction against modern architecture taking place in the press and in popular opinion. Although this cooled the interest of some architects in Le Corbusier, there were many who retained their interest, though they became more circumspect in their enthusiasm, and careful to be more specific about which aspects of his work they considered important.[27]

LE CORBUSIER AND THE BRITISH PUBLIC

At his death in 1965, Le Corbusier was fairly generally regarded in Britain as the greatest modern architect. He had received public honours (RIBA Gold Medal 1953, Honorary Doctor of Law at Cambridge 1959) which confirmed his 'great man' status, but the most popular view of him seems to have been as the architectural equivalent of Picasso. The persona of the romantic artist-architect is one that Le Corbusier was fond of himself, and it received a good deal of support from intellectuals like Sir John Summerson and John Berger writing for the non-architectural highbrow public.[28] Nowhere in 1965 was there a murmur of the tirade that was to come.

The vilification of Le Corbusier that has taken place in Britain since the late 1960s has had no parallel in other countries, where, whatever criticism has been made of modern architecture, Le Corbusier has not been blamed exclusively for it. The

British attack on Le Corbusier has had certain characteristics: it has been conducted almost entirely in terms of housing, and in so far as Le Corbusier's own work has been referred to, it has almost entirely been that of the 1920s and 1930s, which he himself largely rejected during the 1950s. In addition, the terms of the attack have not remained the same, but have changed considerably as the critique of modernism has shifted.

Social, as distinct from aesthetic criticism, began in 1967 with a special issue of *Architectural Review* in November of that year entitled 'The Future of Housing', prepared and partly written by Nicholas Taylor. Taylor, a journalist hitherto fairly loyal to Corbusian modernism, on this occasion opened a line of criticism which he was later to develop much further. The gist of his argument was that modern architecture's solutions to housing suppressed individuality and imposed an autocratic uniformity upon the inhabitants of state housing schemes. This populist line proposed that a better kind of architecture would be one where tenants could adapt their dwellings and express their individuality through variations in the external colour schemes or planting. Taylor advanced this argument further in *The Village in the City*, published in 1972, where he commended the Victorian terrace house as the best type of dwelling, and attacked all utopian housing schemes for their suppression of the individual. Both in this book and in the earlier article, Taylor reserved his scorn for British interpretations of Le Corbusier and made no direct criticism of the master himself, though this was not long in coming from elsewhere.

In 1969 a study of Le Corbusier's 1920s housing scheme at Pessac, near Bordeaux, was published in France by a French historian, Philippe Boudon. Boudon recorded the changes that the occupants of the houses at Pessac, and Lège (another of Le Corbusier's 1920s housing schemes) had made to their houses in the intervening 40 years, interviewed the occupants about their feelings towards the houses and the architect, and compared these with Le Corbusier's intentions. Boudon's findings were ambivalent: on the one hand, the architect was at fault for designing dwellings so unsatisfactory that people had had to alter them; but on the other hand, the designs lent themselves particularly successfully to being altered and individually customised, a point that the occupants themselves stressed. The book produced only a modest amount of interest in France, but when it was published in English under the title *Lived-in Architecture* in 1972, it attracted immediate attention, because it provided actual data for Taylor's somewhat speculative argument. Moreover, certain reviewers, rather than accepting Boudon's clearly stated dual conclusions, responded to the book as an indictment of what they saw as the autocratic and aesthetic preoccupations of Le Corbusier in particular, and of modern architecture in general.[29]

By the early 1970s, the notion that what was wrong with modern architecture was that it did not allow housing tenants to express their individuality was becoming a journalistic cliché: the student essay prize in *Building* magazine in 1972 went to a piece that reiterated what was rapidly becoming a commonplace.[30] Although as an

idea it was to inspire a number of housing schemes in which there was artful variety, and opportunity for tenants to cultivate their individuality, this critique of Corbusian architecture rather disappeared after the early 1970s, largely, one suspects, because it made such a poor conversational topic and such unexciting newspaper copy. In its place was to appear a very different, and much more sensational critique of modern architecture: namely that it was making people ill, turning them to crime, and driving them mad. Not only did this make a much more promising subject for conversation, since here was a forceful proposition which could be argued interminably, yet neither proved nor disproved, but it also made more melodramatic newspaper headlines. 'Lonely High Rise Flats are Marriage Wreckers',[31] and countless other stories bore an identical message, that modern architecture was responsible for social ills of all kinds.

Le Corbusier was often brought into this debate, partly because he was widely thought to have advocated housing in tower blocks (though this was not in fact so), but also because of his frequently expressed belief in the power of architecture to affect human behaviour.[32] The irony that whereas Le Corbusier's sketches and writings had suggested the new architecture would bring social harmony and happiness, schemes resembling his appeared to be populated by vandals and depressives was not lost on his critics.

A particularly good example of the level of hysteria about modern architecture in general and Le Corbusier in particular that had been reached by 1977 was a *Sunday Times* colour supplement article on post-war British architecture by Conrad Jameson, a social researcher who had been one of the reviewers of the English edition of Boudon's book in 1972. The article contained a series of photographs of some of the uglier examples of recent British architecture. A two-page spread on the very large Aylesbury estate in south London showed graffiti, broken windows, and dingy walkways. The caption blamed the aesthetic preoccupations of modern architects and is worth quoting because it is characteristic of the whole piece, as well as of Jameson's tendency to conclude every observation with an indictment of Le Corbusier: '…during the manhood of modern architecture, beautiful was big: big because of the aesthetic feats that only size would allow, and big because only size would realize Le Corbusier's ideal of a Unité, a single building, embracing the leisure, shopping and housing for a whole community. Secondly consider comprehensive development (Le Corbusier was willing to tear down all Paris for his high rise flats).'[33] The factual inaccuracies – Le Corbusier did not propose tearing down the whole of Paris, nor did he propose high-rise flats there – are also typical. The message of the accompanying article was that it was British architects' aesthetic obsessions, learnt from 'their Swiss-born master'[34] and promoted on a spurious dream of a new social utopia, that had been responsible for the production of such poor buildings. Le Corbusier, the only non-British architect to be named in the article, acquired the role of Mephistopheles in the tragic story of British architecture.

Le Corbusier's implication in the rebuilding of post-war Britain was reinforced two years later in a long BBC TV documentary called *The City of Towers*, made by

Christopher Booker and Christopher Martin. The film, which was incomparably more intelligent and better informed than Jameson's article, was primarily concerned with what had been lost through the process of post-war reconstruction, and set out to show why the idea of new architecture and new cities had seemed once so persuasive, and in whose interests the process of redevelopment had been carried out. Despite its more extensive coverage of the subject, the film was again unequivocal in pointing blame at architects, and ultimately at Le Corbusier, for the arrogance of conceiving a new image of the city to replace the existing one.

Whether or not Le Corbusier was personally responsible for the defects of post-war British architecture no longer seems a promising subject for enquiry. There is no doubt that his urban ideas were used by British architects and planners, but they were far from being the only sources, nor were they necessarily the most important. Even if one can identify a direct relationship between a Corbusian project and a completed English scheme, as is possible with Park Hill, Sheffield, where the circulation system of covered 'streets' was derived from Le Corbusier's Ilot Insalubre project of 1936,[35] ultimately the important question is not why the idea came from Le Corbusier rather than someone else, but what process gave these ideas credence and turned them into a building. In history, ideas themselves are impotent: it is the use made of them that matters. The whole issue of Le Corbusier's personal responsibility for the state of post-war British architecture was succinctly expressed by the architect Sam Webb on the occasion of the ceremonial start of the demolition of Ronan Point, the block of highrise flats notorious for its partial collapse after a gas explosion in 1968: 'Blaming Le Corbusier for this', he said, 'is like blaming Mozart for Muzak.'[36]

A more important question is whether the unsocial behaviour found in parts of many British cities today has indeed been caused by Corbusian environments. The pervasiveness of modernism as a set of ideas was partly the result of the social utopia it claimed to offer, an offer that was presented, as Booker's 'City of Towers' showed, in such a way that no reasonable person could possibly refuse it. If it could now be proved that modernist housing estates are not only the settings of muggings and vandalism, but actually induce them, then this would surely be an indictment of modern architecture. Much research time and money has been invested in trying to establish the nature of the relationship between architectural form and social behaviour. Two studies in particular, Oscar Newman's *Defensible Space* (1972) and Alice Coleman's *Utopia on Trial* (1985) have attracted a good deal of attention: both claim to prove a relationship between street crime and modern architecture, and recommend certain modifications to existing housing schemes to reduce the incidence of crime. The irony of their research is that despite their criticisms of modernist environments, both share with Le Corbusier the same fundamental assumption, that architecture does determine behaviour. When Alice Coleman writes, 'most of the design features that have failed our tests prove, in retrospect, to stem from his [Le Corbusier's] Utopian vision', and goes on to say, 'he was fundamentally right in one respect – that design can affect the character of a

community',[37] she exposes the premise on which her research rests. This premise cannot be proven, for the nature of social research, unlike laboratory experiments, makes it impossible to exclude the influence of other potential factors determining social behaviour. The value of Newman's and Coleman's findings is therefore in question, as the political and methodological dispute surrounding their work has made clear.[38]

The architectural determinism controversy is a good example of how Le Corbusier has been used to personify a position in a debate in which he is only partially implicated. Although Le Corbusier had strong views about architectural determinism, which were appreciated, and sometimes disputed, by British architects, there is no sense in holding him, as Coleman does, solely responsible for its design applications. Modernism is too complex and far-ranging a set of ideas for attributions to be made to single individuals. That this has happened with Le Corbusier, to the exclusion of all other early modernists, must be partly to do with his own abilities as a self-publicist, and partly with the accessibility and attractiveness of his ideas to a British audience at a particular point in history. It is instructive to compare Le Corbusier's reputation as the personal representative of modernism in all its aspects with Mies van der Rohe's reception in Britain. The preparation of a case against Mies van der Rohe's Mansion House Square scheme at the public enquiry in 1984, given the absence of intelligible statements by the architect, called for a much more circumspect and sophisticated argument than anything to be found in the popular debates in which Le Corbusier so regularly features. Mies van der Rohe, not being a household name, could be treated as a historical figure exemplifying a particular period of American commercial development; this would not have been possible with Le Corbusier, who, whatever he might have wished to the contrary, is modernism itself as far as the British are concerned.

LYNNE COOKE
ON TONY CRAGG

Tony Cragg:
Thinking Models
1987

Tony Cragg: Thinking Models was the first large-scale exhibition of Cragg's work to be staged in the UK following his solo exhibition at the Whitechapel Gallery, London in 1981. Taking place in the upper levels of the Hayward Gallery – and extending onto the outdoor sculpture terraces – the exhibition featured 31 works made between 1984 and 1987. The accompanying catalogue included an essay by the curator and critic Lynne Cooke, as well as an interview with the artist in which Cragg defined himself as an 'extreme materialist' and his sculptures as 'thinking models'.

TONY CRAGG: THINKING MODELS

Tony Cragg's emphatic assertion that he is a materialist provides a revealing insight into the very heart of his work without, however, fully defining it.[1] Cragg's materialism invites various interpretations. At its most encompassing it implies a philosophical outlook, a conception of the world that focuses on physical phenomena, and those relationships which can be directly derived from it.[2] His activity as an artist is predicated on a notion of man defined and known to himself through his relation with his environment, which encompasses everything from geological formations to urban constructions, from the tools and implements with which man shapes the world to the furniture and other objects which he makes to accommodate his needs. Cragg's sculpture alludes to both the organic and the inorganic world at their most commonplace and humble as well as their grandest.

For him, man's relationship to the world at large is best explicated through the sciences which, he feels, provide both an unrivalled world-view and invaluable thinking models for discerning truths, even should these prove to be provisional and hypothetical.[3] His materialist outlook ensures that it is the physical sciences rather than the human sciences which most engage him: references to geology, crystallography, biology, physics, and biochemistry abound in his art, in various guises,[4] from a direct incorporation of molecular models of sugar and alcohol atoms in *The Worm Returns*, to the more oblique 'biological structuring' of the surface of *Aqueduct*, to references to rock strata and geological layering in *Echo*.[5] When the behavioural sciences are relevant, it is anthropology with its focus on material culture, rather than politics, sociology or psychology that provides the most direct and apposite point of reference. Where the human form appears it is always as an emblem or image, and thus it has to date been confined to wall pieces like *Riot*. In Cragg's three-dimensional work man's existence is intimated through the tools, furniture and other objects with which he shapes his existence.

Confronting matter itself is for him a basic requirement for existing in the world. How, he asks, can one live without the kind of understanding that these sciences even at their most elementary provide? The consequences of this deep-rooted premise are manifest in his approach to form and material as well as to imagery. In one group of works, of

which *Axehead* is characteristic, a multiplicity of diverse components has been ordered according to certain simple criteria; in this case the elements which are all composed of real or simulated wood, are disposed into the required configuration according to their height. Assimilating this panoply of heterogeneous objects involves postulating certain connections, or establishing certain relationships amongst them. An ordering schema which gives coherence is necessary to any attempt to make sense of the world; that employed here is rudimentary and directly stated but, as in much of Cragg's work, it provides a basic starting point for further enquiry because it neither transforms the raw matter nor does it become the vehicle for projecting the artist's persona.

Materialism in Cragg's work has a further meaning; it indicates a concern with materials as such. Although his work is built around a three-way dialogue between images, objects and materials, any one of which may be given primacy in a particular sculpture, a fascination with materials nonetheless constituted his initial point of departure, and remains a guiding tenet. As a student in the mid 1970s Cragg amassed and manipulated a wide array of substances, from string through to paper, stone, rubble and wood: the remainder of the time he drew, generally in unorthodox material on unconventional supports. His diverse activity included cutting, slicing, stacking, smashing and pulverising the material. But whereas as a student he concentrated on getting acquainted with matter, by rehearsing his understanding of it through the devising of what he called gestures rather than fully-fledged sculptures (works which were somehow provisional or transitory and did not reach definitive form) by the end of his course he felt the need to extend beyond this to something more complex and multilayered.

The inclusiveness of Cragg's attitude to materials (and thus objects) has no exact counterpart in his approach to imagery which, by contrast, tends to be carefully marshalled into an identifiable vocabulary: 'I would like to use every material possible […] anything that is man-made or is being moved by man, or changed by him', he stated in 1982, and then went on to admit just how inclusive such an ambition might prove to be: '…finally, we have touched everything. [There is] nothing on this planet that we have not managed to sort of put our finger in.'[6] Material for him is a resource. Consequently, fragments and remnants which he finds in a state of 'returning to nature' are as legitimate 'raw' material as items in a pristine condition. Since it is with raw material and not with any notion of recycling or bricolage that Cragg is primarily concerned, objects are not simply recuperated or reclaimed for the realm of art but instead are used in ways which he deems more consequential, to make propositions and statements.

The shift to a more complex art evolved through a series of sculptures in which he first established a visual lexicon. Initially, as seen in *Redskin*, and the numerous bottle sculptures of 1981–82, which pair a small object with its image constructed from plastic shards, this involved a kind of denominative procedure, a form of visual naming which established identity. As with many of the techniques he later employed it had been foreshadowed in certain of his student works, for example *Untitled* where he defined an object by dissecting the mass and form through a series of juxtaposed cross-section-drawings. This work comprises both the actual object (the given piece

of wood), and the sheet of paper on which its silhouettes are portrayed through an elaborate procedure which dispensed with drawing, for Cragg first coated the sheet evenly with graphite and then revealed the forms by rubbing away the areas between the templates. Eventually he eliminated both the prototype and the independent support, so that 'picturing' was carried out simply with plastic shards attached directly to the wall, a method he has described as 'my own language'. A personal genre somewhere between drawing and painting it is most eloquently epitomised in the signature palette which he has incorporated into a number of exhibitions. In the early 1980s plastic became his preferred material for works in this mode, but wood was also used on occasions, as seen in his first solo show, held at the Whitechapel Gallery in London in 1981, in which a wooden submarine floated alongside a plastic soldier, crown, Union Jack, and vacuum cleaner. The striking novelty of the material even more than the method and imagery meant that these plastic works attracted greater critical attention than those others in different idioms which were made concurrently.[7] Consequently, Cragg's work was interpreted for a time largely in terms of social critique, of appropriation and bricolage despite the fact that he was simultaneously employing several other techniques and types of imagery which could not easily be reconciled with such a reading.[8] Perhaps the most significant of these alternative modes involved blocking out forms in negative, as seen in the wooden palette where the image has been made by painting over those sections of the raw material lying outside the desired shape with white housepaint; the subject is revealed as an amalgam of various substances. In the former, palette pigment (the painter's primal substance) has been redefined as atomised coloured particles of plastic; in the latter it has become the multifarious raw material of the world at large. As if to reinforce this interpretation, Cragg also executed a number of sculptures of windows by the same method. In these works that paradigmatic conception of a painting as a window onto the world was no longer defined in terms of illusory representation but as a projection of matter in its most literal terms. Increasingly, the vertical zone of the wall has tended to be identified as the site for projections, and as the arena for a mediated reality of signs and emblems, as found in *European Culture Myth*, *E. R.*, and *Crown*. In works of this type the elements are generally flat, relatively small, and similar in size and character, whereas those which are incorporated into sculptures on the floor like *Canoe* and *Axehead* are less homogeneous: asserting an obdurate identity, quiddity and tangibility they are also far from neutral.

This personalised genre has lately assumed a more subsidiary role in Cragg's oeuvre, as he concentrates on devising new kinds of three-dimensional structures, and as other typologies gain precedence. In the 1986 Hannover exhibition, for example, the theme of landscape, widely interpreted to encompass both rural and industrial terrain, both surface and substructure, dominated; in the forthcoming Hayward show the theme of the city will play a large role. As is the case with the recurrent images and materials, so the preferred themes are constantly revised and mutated, and assume different degrees of prominence at different times in his career.[9] However, with the panoply of new materials that he has recently introduced, which now include the more orthodox sculptors' materials, stone of various types, bronze and iron, Cragg's omnivorous approach to matter has reached its widest expression. Linkages between the various

components in a sculpture may be established in a variety of ways: exclusively through physical congruence, as in *The Worm Returns*, through uniformity in materials as in *Inverted-sugar Crop*, through an applied surface, of PVC cuttings in *Aquaduct* and of graphic gestures in *Echo*, or by means of repetition, as in *Citta*. Yet in *Citta*, as elsewhere, the method of composing is more than a formal device; it carries specific meaning. This unfolding structure of repeated units resembles the growth patterns of certain crystals, and other organic forms, as if the ordering and structuring patterns instinctive to man mirror those of nature and thus indicate his fundamental rapport with nature. As Rudolph Arnheim has argued: 'Order is a prerequisite of survival; therefore the impulse to produce orderly arrangements is inbred by evolution. The social organization of animals, the spatial formations of travelling birds or fishes, the webs of spiders and bee hives are examples. Order is a necessary condition for anything the human mind is to understand.'

Arrangements such as the layout of a city or building, a set of tools, a display of merchandise, the verbal exposition of facts or ideas, or a painting or a piece of music are called orderly when an observer and listener can grasp their overall structure and the ramifications of that structure in some detail and he continues in a passage which is particularly apposite for Cragg: 'In many instances, order is apprehended first of all by the senses […] But it is hard, perhaps impossible, to find examples in which the order of a given object or event is limited to what is directly apparent in perception. Rather, the perceivable order tends to be manifested and understood as a reflection of an underlying order, whether physical, social or cognitive.'[10]

Typically, Cragg's works invite a strong visceral response. Not only is the concrete, tangible nature of the object/material inescapable but there is an overtly sensual appreciation of texture, surface, and colour. The initial impact is made in terms of the senses, or what Cragg calls 'first order experience'. From sensory response to sensual thought to abstract speculation seems almost an inevitable sequence of steps. In this series of responses sight plays the key role.[11] As Cragg wrote in 1986:

> The phenomenon of sight – assisted by other senses – combined with a learnt register of information and responses has an important function in physical survival: telling me where I am and where something else is, telling me what it is and what I am. This information is a direct input to my emotional and intellectual existence, the substance of my thoughts, fantasies and dreams. Yet, this vision of the world is supplemented by other information, which in the course of the last two hundred years has played an increasingly important role. This information is not just gleaned from the surface of the world around me, but tells me of laws, physical structures and conditions, chemical and atomic constellations and energies which are imperceivable. There exists an enormous and exciting world, worlds, beyond the limits of my senses with views and landscape as spectacular and fantasy-awakening as the surface I can see. It is no longer possible to deal with one, without dealing with the other, every surface is the portal to a hidden world.[12]

By identifying an underlying order, and by revealing something of the connections between the laws governing the man-made world and those attributed to the organic world Cragg attempts to indicate to contemporary man routes to a more meaningful relationship with his environment, routes that start from a very elementary, almost primal level of direct and immediate response to simply presented matter. Since for him this rudimentary knowledge and appreciation is too often lacking in modern man, it is necessary to begin on, as it were, 'a molecular level which relates directly to the physical properties and appearance of a material' in contrast to that more heroic affirmative approach wherein man is 'defined by his powers to change the physical world, building systems of change through language and technology, and exploiting all that is given by nature to the survival of himself and other groups to which he feels related and [which] will give him mutual support'.[13] For Cragg, such grandiose anthropocentric sentiments have become increasingly suspect. Yet, as seen in the correspondence, posited in *Citta* and elsewhere, between man's systems of ordering and those of nature he refuses to make a facile distinction between the natural and man-made, between the organic and artificial, between nature and culture. As he stated in 1984, in what almost amounts to a credo:

> At one time the number of objects produced was quite limited. They were functional and there was a very deep relationship with these things. Because of industrial manufacturing techniques and commercial producing systems we are just making more and more objects and we don't gain. We don't have any deep founded relationship with these objects, even those made of traditional materials like wood, as in the case of *Axehead*.
>
> Tony Cragg, *Tools*, 1986. Installation view, *Tony Cragg: Thinking Models*, 1987
>
> There are lots of familiar materials which are now produced in new ways through industrial techniques and we don't even have time to really reflect on these changes. If we work on the premise that the quality and nature of our environment and what we are surrounded with is actually having a very direct effect on us, on our sensibilities, perhaps even our emotions and intellects, then we have to be more careful with these objects and spend more time learning something about them.[14]

Whilst affirming the parlous nature of our present plight he nonetheless refrains from nostalgia for past eras: 'I am not interested in romanticizing an epoch in the distant past when technology permitted man to make only a few objects, tools, etc. But in contrast to today I assume a materialistically simpler situation [then] and a deeper understanding for the making processes/functions and even metaphysical qualities of the objects they produced.'[15]

Thus rudimentary tools like the axehead and the mortar and pestle, simple yet ubiquitous means of locomotion such as the canoe, and universal archetypes of man's imaginative life like the moon, together with generic furniture forms of the ilk of the straight-backed chair, recur over and over in his oeuvre.[16] That such objects signify man's attempts throughout history to come to terms with the given world

was first fully indicated in Cragg's contribution to Documenta 7 in 1982 where he juxtaposed three large floor sculptures: an axehead composed from wooden objects, a canoe from metal objects and a horn from blue objects. Their generic standardised forms serve both to raise the content from the level of the specific and historically particular to the general and the philosophical, and to provide a tension between 'the sophisticated' or technologically advanced and 'the primitive', elementary modes of production: in each the shape of the image is mapped out with items produced by a far more developed technology. Whilst this approach continues in his recent work – *Tools*, for example, comprises elementary implements cut in stone with a diamond blade machine, one monumental mortar and pestle is made from skewered fragments, while another has been cast in iron – the converse also occurs, when test-tubes and other standard laboratory equipment are transformed into giant iron vessels. In these contradictory metamorphoses Cragg provides thinking models for investigating man's relationship with the familiar, serviceable artefacts which he has routinely produced to negotiate his environment. In certain other sculptures, however, like *Three Modern Buildings* there is a more straightforward interrelationship between image and object, form and substance. (Only seldom as in *Crackerboxes* do his works risk becoming too circumscribed by their literalism, and too limited by his fascination with matter per se.)

Notwithstanding the urgency of the underlying thesis, Cragg's work always maintains a distanced, dispassionate tone: it never become didactic. That it adumbrates an instrumentalist vision without succumbing to ethical prescription can be gauged from his statement *'Au moins un animal est responsable de sa fiente'* – even an animal is responsible for its excrement.[17] To the degree that 'responsible' here implies more than a causal connection, Cragg departs from an impartial and 'objective' position; for him the quality of the relationship which man forges with the physical world around him can and must be judged; it may be better or worse. Improvement, however, does not depend on a form of technological utopianism but on a deeper more resonant relationship with the world, one that ultimately can only be described in metaphysical terms.

In his Reith Lectures of 1961 Sir Peter Medawar argued that man learns about his environment not through being instructed by it but by being challenged by it. Thus the process of discovery or learning about the world could be said to be *evocative* rather than instructive. Responses are provoked, and knowledge arises as a speculative process of positing and eliminating conclusions.[18] If western man's understanding of the world since the seventeenth century has been governed by science, in place of religion, it is arguably only in the twentieth century that it is widely recognised that science provides neither the truth nor objectivity. On the contrary: science is corrigible and speculative, a nexus of theories and hypotheses which are constantly being replaced by better ones, that is, by ones which are deemed more accurate, clearer, explanatory of more... Truth cannot be a copy of the external facts; a human, conceptual contribution is always required to determine the categories in which the world is conceived, or experienced and organised. What results is a process of interaction between what man contributes and what he discovers.

For Tony Cragg science not only structures and conditions modern man's world-view but it provides the best means for understanding and coming to terms with the situation that currently faces him. Given that the physical sciences must, for Cragg, take priority in this effort to comprehend so those methods by which they examine the world – observation, experimentation and theorising – are central to his approach. Observation in his art entails both an initial attentive response to the phenomenal world, and the subsequent ordering and presentation of objects and material for scrutiny. Experimentation involves the manipulation of materials and objects as thinking models. Both approaches permit a direct sensory apprehension, one which is never in thrall to abstract theorising. They ensure that Cragg's notion of sculpture is rooted in physical being – however unconventional its form, techniques or substance may at times become. If this is a materialist vision it is neither a narrow nor a shallow one: as he argues, 'The need to know both objectively and subjectively more about the subtile [sic] fragile relationships between us, objects, images and essential natural processes and conditions is becoming critical. It is very important to have first order experiences – seeing, touching, smelling, hearing – with objects/images *and to let that experience register.*'[19]

GUY BRETT
ON LATIN
AMERICAN ART

Art in Latin America:
The Modern Era, 1820–1980
1989

Art in Latin America: The Modern Era, 1820–1980 was curated by the art historian Dawn Ades, with assistance from critic and curator Guy Brett and an international committee of artists and historians. The exhibition included more than 400 works by over 170 artists from Argentina, Brazil, Chile, Colombia, Cuba, Ecuador, Guatemala, Haiti, Mexico, Peru, Uruguay and Venezuela, and was the first exhibition in Europe to examine the history and development of Latin American art from the early years of the nineteenth century. The section of the exhibition focussing on Latin American modernism – which featured artists including Lygia Clark, Lucio Fontana and Hélio Oiticica – was curated by Brett. The work of these artists is the subject of Brett's essay written for the accompanying catalogue, which also featured contributions from art historians Dawn Ades, Loomis Catlin and Rosemary O'Neill.

A RADICAL LEAP

When describing the concrete-optical-kinetic art movements of the 1950s and 1960s it is tempting to use an analogy with science, not only because most of the artists were interested in and knowledgeable about science, the relation of science to philosophy, and often expressed themselves (verbally) in scientific phraseology, but also these did seem to be genuinely international movements. Radical innovations were made in different parts of the globe; travel, exchange, seemed to take place relatively independently of the commercial/bureaucratic/institutional culture-machine of the Western powers; there was a common feeling of working at the forefront of modernity.

Without completely abandoning the scientific analogy (as a corrective to localisation, folklorisation, and therefore subordination of Latin American art),[1] I would like to delve deeper into the works considered in this chapter, both as 'international' (a radical leap in the practice and theory of art) and as 'Latin American' (i.e. not the same as European or North American art). To do this soon reveals tensions and complex relationships which upset many of the categories and labels which have been handed down to us.

To begin with – the comings and goings of the artists themselves. Mira Schendel was born in Zurich, grew up in Italy and went to São Paulo as an adult. Lucio Fontana was born in Rosario de Santa Fe, Argentina, spent significant periods there or in Buenos Aires but most of his life in Italy. Alejandro Otero, Jesus Rafael Soto, Carlos Cruz-Diez, Sergio Camargo and Lygia Clark have all spent important periods of their life in Paris, and Hélio Oiticica in London and New York. Lygia Pape, however, has rarely left Brazil. Mathias Goeritz arrived in Mexico in 1949 from Germany and Spain, and has at times faced a certain Mexican xenophobia.

Secondly, any grouping of artists which merely follows the labels and -isms provided by art history misses what was really innovatory in this period. Abstract art, constructivism, concrete, neo-concrete, informal art, kinetic, optical, process art: the artists grouped here touch all of these movements at certain points without entirely belonging to any of them, because in a sense all these labels describe the search for something which was 'in the air' but could not at the time be named – a *new space*. The feeling that this new space represented something volatile and dynamic, a turning-point and not a system or doctrine, is confirmed by the fact that these artists, whose work was quite closely related in the 1950s and 1960s, later moved in directions so different that these divergencies themselves raise profound questions about the development of art. This discussion concentrates on that historical moment of relationship and only hints at the artists' later development.

A third complexity is these Latin American artists' relationship to the metropolitan art centres, especially to Paris. This can't be described as one of provincial imitation of the latest fashion, since the artists they sought out were not fashionable in the Europe of the 1950s. Otero and Soto made special trips to Holland to see Mondrian's work. 'At that time [1950] no one in France was talking about Mondrian, still less might one see any of his work', Otero said.[2] Camargo visited Brancusi. Many Latin Americans called on Vantongerloo – then working on his prism-objects, wire 'nucleuses' and 'atomic' drawings – at a time when Vantongerloo was completely ignored in France and was living in Paris in poverty. (Fontana, being somewhat older, had conducted his own highly individual dialogue with Futurism and abstract art in the Italy of the 1930s, before making his first theoretical approaches to Spazialismo in Buenos Aires in the mid 1940s.) In other words, these young artists took from Europe what corresponded to their own needs.

And not only by going to Europe themselves. Le Corbusier made lecture tours in Argentina, Uruguay and Brazil in 1929 and 1936. He arrived the second time by zeppelin! Joseph Albers, Max Bill and Alexander Calder were invited to Brazil in the 1950s. The second São Paulo Bienal (1953) was one of the most comprehensive exhibitions of modern Western art ever mounted (a room of 51 Picassos, including *Guernica*, a room of Klee, of De Stijl and Mondrian, a room of Italian Futurists, constructivism, Americans such as Calder and De Kooning, and so on). During the late 1950s the Rio newspaper *Jornal do Brasil* published a Sunday supplement which surveyed the whole modern movement from Cézanne to Pollock and from Mallarmé to the Beats. Its pages were often designed by artists. In Venezuela, the architect Carlos Raúl Villanueva invited artists like Léger, Arp, Laurens, Calder and Vasarely to design work for the new University City of Caracas (1948–57), alongside young and then unknown Venezuelans like Otero and Soto. By dint of his friendship with artists, Villanueva built up one of the finest collections of experimental art in the world, a collection which subtly combined the geometric with the surreal strands in abstraction (for example, Wifredo Lam and Calder with Moholy-Nagy and Vantongerloo).

These interchanges bear on a fourth complexity: that of locating this work within a Latin American history and a Latin American space. The term 'Latin American' is itself obviously a gigantic simplification in the face of such obvious differences of nation, class, cultural tradition, and of levels of wealth and poverty. Nevertheless, many writers and speakers have proposed in one form or another a Latin American 'subject' faced by overwhelming contradictions: between experiences on the one hand of the immensity and richness of nature (itself a source of wonder and of fear), and on the other hand of its waste and destruction by corrupt administrations (in league with foreign interests which have been continuously engaged in robbing the continent for more than 400 years), a 'subject' caught in a cycle between economic booms and busts, between civilian and military rule, between socialist experiments and right-wing tyrannies. ('Devastating experiences', as a Chilean writer has put it, 'where the greatest hope is mixed with the greatest terror.')[3]

It was in a moment of such high optimism, and of desire for the modern, that the concrete and kinetic movements were born. While Europe was immersed in the war and its aftermath some Latin American economies were booming (partly from supplying war materials). In Argentina, Perón had shaken the rule of the landowning aristocracy (though without seriously weakening their power) and released the energy of the growing numbers of industrial workers. Brazil and Venezuela were urbanising intensively, and the modern architecture movement flourished with the demand for many public works. Soto has described the immense aspiration of the Latin Americans to take on and surpass modern art.[4] They had an almost explosive eagerness both to enjoy the new freedoms of form and to ask the fundamental questions which arose from the discoveries of the pre-war avant-garde. It seemed natural to couch their work in universal, almost cosmological, terms. Geometry provided a synthesising key rather in the manner of Mondrian's 'plus-minus'. (Lygia Pape's recasting of the creation myth as a concrete/kinetic book (*Book of Creation* [1959]) is a characteristic expression of this.) But lying behind such universalising abstractions there are two legacies in some way irreducibly connected with Latin American history; a sense of the vastness of nature and the precariousness of human existence, which are here welcomed as the springboard to new perceptions, and a social and political consciousness, related at this period, in the tradition of constructivism, to the environment, to architecture and to the participation of the spectator, but interpreted in profoundly different ways.

To go back again to the scientific analogy, we can see a number of Latin American artists in the 1950s and 1960s working with the most advanced research questions of the time (often, defining what those questions were). They inherited the language of geometric abstraction exemplified by Mondrian, which marked the most complete break with traditional representation, and they inherited Dada exemplified by Duchamp and his ready-mades, which gave the freedom to posit any object as a 'sign', and which engaged the institutions of the art world in continual critical questioning.[5] In a sense a common starting-point for all their work was the adoption

Installation view, *Art in Latin America: The Modern Era, 1820–1980*, 1989

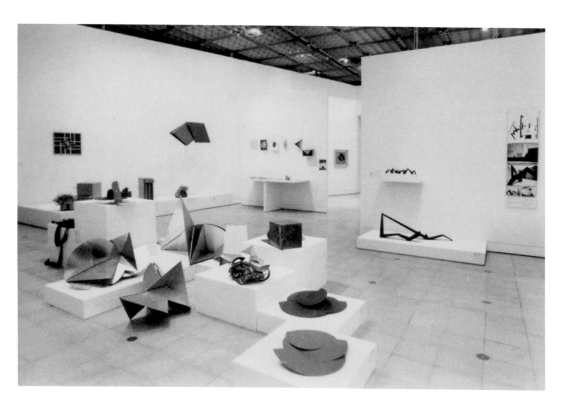

and then the interrogation of geometry and its rationale of order. Geometry here means not simply 'lines and squares' on the picture's surface, but the surface itself as a two-dimensional plane creating a fictive space isolated from the surrounding 'real' space.) So a fertile tension arises between a geometric order, with its values of lucidity and modernity, and an invitation to chaos, disorder, flux, organicity, the random, the void – which begins to create a new kind of space. Artists of Latin American origin were not of course the only ones involved in this search, but they played a very significant part in it. It was an international dialogue of different origins, experiences and aspirations.[6]

LUCIO FONTANA

Much of Lucio Fontana's work playfully 'makes light' of the categories of painting and sculpture, showing up the protocols which separate, and therefore limit them. For example, *Spatial Concept*, the metal sheet erupting with two holes: is it simultaneously a painting and a sculpture? between painting and sculpture? or neither painting nor sculpture? The ceramic objects made at the same time as the early *Spatial Concepts* are substantial volumes made up of what might be

tumultuous brushwork. Fontana's works have an unmistakable feeling of a cosmic energy brought about by his poetic collision between 'matter' and the traditional formats and supports of art; the surface as matter, space as matter, colour as matter – and matter as energy. Already in the 1930s, Fontana had made a witty series of sculptures in which the geometric lines and plane take on a plant-like look. Throughout the 'White Manifesto', written in Argentina in 1946, which was Fontana's first announcement of Spazialismo, there are references to the need for 'an art springing from materialism (not from ideas) which in a sense generates itself in accordance with natural forces'. Premonitions of 'action painting', of the Yves Klein void, and of the coming diversity of 'kinetic' proposals can all be felt in Fontana's formulations: 'The "representation of known forms" is out of date [...] The aesthetics of organic motion substitute for the aesthetic weakness of congealed forms [...] We are taking the very energy of matter and its need to exist and develop' ('White Manifesto', 1946).[7]

ALEJANDRO OTERO

The outstanding Venezuelan art of this period is certainly closer to painting than sculpture (however defined), and makes its leap towards a new space out of a tradition of great optical refinement (traceable in Venezuelan art from colonial painting, through Reverón, to the present). In the late 1940s, Alejandro Otero had already aroused violent controversy in Venezuela with his *Coffeepots* (painted in Paris), in which he worked through the influence of Picasso. But at the moment he broke with Picasso and became aware of Mondrian's work, he produced a series of canvases which Soto and others still acknowledge as of great importance: the *Coloured Lines*. 'A few gently slanting lines of colour floating on a white surface'; the description belies the drama involved a drama of orientation: 'Putting that red line there was like walking to Patagonia [...] it's a space where there is practically no top, no bottom, no right, no left, certainly no horizon line...'[8] These 'slightly inclined lines' are also the armature of Otero's *Colourhythms* (1955–60), one of the most remarkable serial works (75 panels in all) in abstract art. Painted with the industrial technique of airbrush and duco, their dynamism is due to their emphasis on 'rhythm' rather than 'form', produced by a sustained ambiguity between figure and ground. Our perceptual habits themselves are disturbed, or set in motion, but without the behavioural rigidity of much later 'optical' art. As the series develops (unplanned and improvisationally, according to Otero) it is not hard to see a transposition of tropical light and shadow, of colour and vegetation in the geometric elements.

JESÚS SOTO

The audacity and freshness of Jesús Soto's early works is undoubtedly partly due to an application of the conceptual freedom of the Duchampian ready-made to purely pictorial problems. (Soto produced his first *Superimpositions* after seeing Duchamp's

motorised spiral [*Rotary Demi-Sphere* 1925] at the *Mouvement* show at the Denise René Gallery, Paris, in 1955.) Soto had already reduced his means to elements of no compositional interest (dots, rectangles, etc.), and the device of superimposition enabled him to create a space *between* the elements, fluid, unstable, both 'pictorial' and 'physical' at the same time. When he hung a metal rod in front of a lined screen, the optical interference of these two elements released a third – the vibration – which is real though it has no material existence. The rod is not exactly *dissolved* into vibrations, for then it would be absorbed into another medium and would disappear altogether. The vibrations take the shape of the solid rod, tracing its movement in pulses. But the situation is so finely balanced it could equally be that the solid rod is the trace of the energy pulses, which 'really' constitute the rod, and everything else we see as solid, stable objects in the world. Early Sotos are ironic objects: 'constructions' which are impossibly impractical and fragile as part of the everyday world but which, hung on a wall as paintings, become an expression of freedom and play. They are metaphors of age-old problems – the relation of real and illusory, of chaos and order – but at the same time they suggest a new equilibrium beyond a static geometric order.

CARLOS CRUZ-DIEZ

Somewhat later, a third Venezuelan, Carlos Cruz-Diez, embarked on series of perceptual experiments. His *Physichromies* were specifically concerned with colour. The strips, vanes and louvres of colour, some opaque, some transparent, at right-angles to the surface, constitute a device whereby colours mix and interfere with one another, not by juxtaposition or layering, but in the spectator's vision. This mixing depends on variable factors such as the angle of the light or of the spectator's eye. Again the effect is to create an ambiguous space, a 'climate' of colour.

LYGIA CLARK

If Venezuelan art of this period makes its innovations by 'specialising' in the visual sense, the work of some Brazilians (especially the artists of Rio de Janeiro) does almost the opposite: de-emphasises the visual sense in favour of the ensemble of senses, in fact of the whole body, conceived in terms of its 'plenitude'. It would be interesting to trace in more detail than is possible here the tensions and perturbations introduced into the geometric order as the work of these artists develops. Lygia Clark, Hélio Oiticica and Lygia Pape were all members of the Neo-Concrete group (1959) which broke away from the more strictly Bauhausian Brazilian constructivism, which followed the principles of the Swiss-German Max Bill, to reintroduce the 'subjective' and 'organic' dimensions (though still within strict non-representationality, as a guarantee of absolute modernity). But one has the feeling that this was where they had of necessity to begin. Lygia Clark's early painting (for example, *Unities* and *Linear Egg*) are simultaneously the most rigorous statements of the exclusion of representational devices from the picture

surface, and of *opening up* this space to the world 'outside the frame'. The next phase of her geometric work – the *Cocoons* – explicitly suggests by its interior space (as well as by its title) some organicity, dormant life, discoverable within rational geometry. 'I began with geometry, but I was always looking for an organic space where one could enter the painting',[9] a desire which now she realised by opening up this abstract language to the direct participation of the spectator in her *Bichos* (*Animals*) of 1960:

> The *Bicho* has his own and well-defined cluster of movements which react to the promptings of the spectator. He is not made of isolated static forms which can be manipulated at random, as in a game: no, his parts are functionally related to each other, as if he were a living organism; and the movements of these parts are interlinked.[10]

Lygia Clark produced *Bichos* of many different shapes and sizes, as well as the slightly later *Trepantes* (*Climbing Grubs*) and *Borrachas* (*Rubber Grubs*) (1964) which are nonrigid, non-precious, and for which any part of the environment, any support, is as good as any other. But while appreciating the marvellous range of sensibility within the geometric schema, we can see that this is only a transitional, provisional phase. From Lygia Clark's extraordinary later development and body experiments, culminating in her *Therapy*, whose implications are only gradually becoming known and understood (and which cannot be properly experienced in a conventional exhibition setting), we know that the important thing is the dialogue, the object as 'relational'. The early geometry, like the later airbags, elastic bands and stones, are only vehicles by means of which the 'spectators' can let their own poetics flower.

HÉLIO OITICICA

Hélio Oiticica began like Lygia Clark with the surface and geometry. In his *Metaschemas* (1959) the forms animate the surface and edges of the canvas. But his planes soon became the agents of an environmental art: at first reliefs suspended in space (1959–60) and then a series of *Nucleic Penetrables* (1960), which one could enter and be surrounded in an ambience of colour of an intense hedonistic beauty. Colour began to change here from a purely optical to a bodily sensation by means of the demarcation of the space surrounding one by painted geometric planes. Next, Oiticica presented colour in quite a different form. His *Bólides* (*Fireballs*, *Nuclei* or *Flaming Meteors*) are objects which contain colour as a mass (of pigment, earth, dust, liquid, cloth) and isolate it from the global field as a kind of energy centre to which the psyche and body of the spectator immediately feels attracted, 'like a fire', as Oiticica once described it. *Bólides* later became for Oiticica a generic class of containers: a box, bag, bottle, basin, can, cabin, sack, nest, bed and so on – full of a substance or waiting to be entered by the spectator. They are a way of focusing perceptions and desires across a whole range of phenomena, both natural and cultural, both communal and personal for example in his participatory *Parangolé*

(*Capes*), his Eden, a 'mind-settlement', set up for the first and only time in London's Whitechapel Gallery in 1969, and in his later installations.

LYGIA PAPE

Pape's *Book of Creation* is one of the expressions most characteristic of Brazil's Neo-Concrete movement. A recasting of the creation story and early human discoveries in lucid geometric metaphors, it is also a set of manipulable models for the viewer to exercise his/her own creativity. A kind of sub-text linking abstraction with the body, and *vivências* (or 'lived through') – what the poet Haroldo de Campos has called 'this special character, this Brazilian communication, so characteristic, this *marca tropicalista*'[11] – is beautifully brought out in Mauricio Cirné's and Lygia Pape's photos of pages of the *Book* deposited around Rio: on the beach, on car-bonnets, on a rounded rock as bodies dive into the sea… Like Lygia Clark and Hélio Oiticica, Pape took participation further. In 1968, for example, she invited people to put their heads through holes cut in an enormous (98 by 98 inch) white sheet (*O Divisor*), which separated heads from bodies and whose mathematical order was once again displaced by people's movements and speech within this ocean of cotton.

SERGIO CAMARGO

The process suggested here, of a sort of derangement of European constructivism by Latin American artists (though not as an end in itself: constructivism was adopted as a starting-point for their own concerns) – this process could hardly be more lucidly and succinctly expressed than in Sergio Camargo's work. On the one hand so linked to the constructivist tradition – in its use of system, of simple, uniform volumetric elements, of the white monochrome, and so on – on the other hand taking precisely that logic of the system to a point of imponderability, of the unknown and the perturbing, of what the critic Ronaldo Brito calls 'the madness of order'.[12] Camargo's work is in perpetual tension between these two experiences. In his long series of reliefs and sculptures he goes back again and again to the same constructive paradigm – a cylinder or cube and the ways it may be cut and combined – and the more he explores it, the more he articulates all its possibilities, the more he undermines its status as a paradigm, as 'law', making us question the sort of stability and finality we invest in paradigms. The most subtle thing, perhaps, is that Camargo does not investigate this paradox in an ideal conceptual realm but in *light*, in the changing light of the everyday world with its incalculable complexity of nuance.

MIRA SCHENDEL

Mira Schendel produced a remarkable series of graphic works during the 1960s whose existence is practically unknown outside Brazil. Done by a method of

transferring marks and scratches made on an inked glass to extremely thin and fragile Japanese paper, they astonished, then, by their bareness: 'I would say the line, often, just stimulates the void. I doubt whether stimulate is right. Something like that. At any rate what matters is the void, actively the void [...] The void is not the vicarious symbol of non-being.'[13]

In some ways analogous to Fontana's 'hole', the blank paper in Mira Schendel's work is the scene of disorientation, of indeterminacy – and of freedom: of possibility rather than necessity. The line acts upon this void in different ways: as a boundary, as an energising coil, or by littering or herding across it a 'cosmic dust of words.'[14] The acceptance of the blank/void sheet of paper brings to mind the Zen-inspired principles of Chinese painting, which imply, as Bertolt Brecht noted, that the artist 'has gladly renounced the idea of completely dominating the spectator, whose illusion can never be total'.[15] In 1964 Schendel extended this idea with wonderful irony into the domain of 'sculpture'. Her *Droguinhas* (*Nothings*) are actually made from rolled up and knotted sheets of the same Japanese paper. With their nucleic structure they have an aura of intense energy while remaining soft, fragile, ephemeral 'little nothings' in comparison to heroic monumental sculpture. These 'sculptures', which can be displayed in any way one chooses, are a proposition from the 1960s which remains extremely fresh, interweaving notions of energy, matter and language by hinting at the etymology common to tissue, textile and text.

MATHIAS GOERITZ

In Mexico the situation was rather different from Brazil, Venezuela and Argentina, since Mexico had experienced a revolution whose forces had become institutionalised. This revolution had been given its image by the unique enterprise of the mural movement, and therefore the national and official status of this art made the introduction of abstraction, for example, very difficult in Mexico. Mathias Goeritz came from Germany with new ideas, organisational energy and a polemical personality. He found himself resented – by Diego Rivera and David Alfaro Siqueiros, among others: '...A faker without the slightest talent or preparation for being an artist, which he professes to be', they wrote (in a joint open letter to the president of Mexico's National University).[16] Goeritz's is certainly a strange and unruly body of work: ranging from expressionism to geometric abstraction, from religious art to a proto-minimalism, from architecture to concrete poetry. He pioneered the introduction of visual education in Mexico and is highly regarded as a teacher, as well as founding galleries, museums and artists' groups. Goeritz created in Mexico in the 1950s and 1960s architecture-sculptures of an awesome gigantism which anticipated some of the work of the later North American minimalists, as well as presaging artists' 'installations'. The Museum of the Echo (Mexico City, inaugurated 1953) was a synthesis of his work as artist, architect, teacher, catalyst and writer. Passing the non-figurative *Plastic Poem* at the entrance, you entered 'neo-concrete' spaces (asymmetrical and with virtually no right-angles) to arrive

at a walled courtyard filled with a single sculpture. The huge *Serpent* was itself a conjunction of modernist 'drawing in space' with pre-Colombian pyramid and serpent forms. It was intended too as a set for the performance of the Walter Nicks dance group, with choreography by Luis Buñuel which Goeritz organised, among other experimental events, during the Museum's short life. In this early challenge to the institutional museum, one art form was echoed in another, and the past echoed in the present.

<p style="text-align:center">*</p>

We have been describing here a phenomenon of the avant-garde, with its complex relationships between 'universal' research questions and regional histories and cultures, between 'international' communications/rapports and 'local' circles – both of which, as at all the most creative periods of experiment, have brought painters, sculptors, musicians, poets, scientists, philosophers, architects, film-makers together. The work of these Latin American artists has much in common with that of certain artists living in Europe (which is only a way of putting it, since with their travels and changes of domicile they often had direct contact); with, for example, Yves Klein's and Piero Manzoni's concepts of the void and of a 'living art', with the meta-machines of Jean Tinguely, provocative and liberating, or with David Medalla, whose *Bubble Machines* (1964–), inspired by the movement of clouds, are a daring statement of the same 'new space' and order/disorder paradox. Medalla also, with Paul Keeler at Signals London (1964–66), gave the first major European retrospective exhibitions to Camargo, Clark, Otero, Soto and Cruz-Diez.

Within Brazil, for example, the radical leap in the visual arts was closely paralleled in literature by the Concrete Poetry movement (in fact, a dividing line can hardly be drawn between them). 'The Neo-Concrete Manifesto' was written by a poet, Ferreira Gullar, while in São Paulo the Noigandres Group (Haroldo de Campos, Augusto de Campos and Décio Pignatari) have formed what amounts to a multi-disciplinary movement in itself. Their poetic production, which broke with traditional syntax and structure by applying to alphabetic language the technique of the ideogram ('poetic crystallography' as Haroldo de Campos called it at the time) was interwoven with a prodigious work of literary theory, of translation (especially by Haroldo de Campos), and of cross-fertilisation with the other arts – with music and visual arts in Augusto de Campos's case, and with architecture/design in Décio Pignatari's work. The Brazilian concrete poets often secrete in their spare ideograms a harsh social comment.

The relationship with architecture among these artists is much more striking than it is among artists in Europe and North America in the same period. The permutations and inflections of this relationship are suggestive and fascinating. For example, Fontana, whose spatial language is so clearly related to the gestural (in his case, to the dynamism of the baroque gesture) has been continually interested in environmental space. In the early 1950s he collaborated several times with

architects on designs which, revealingly, gravitated towards the ceiling: punctured ceilings, ceilings with indirect lighting, neon arabesques hanging in space, and so on. Mathias Goeritz has collaborated with several of Mexico's leading architects; in fact it was they who defended him against the attacks of the muralists and the press. The uniquely close collaboration between Villanueva and his artist friends in University City, Caracas, is well known (Otero's colour-grading of the outside surfaces of the Architecture Faculty vies with Calder's ceiling in the Aula Magna as the most imaginative artist/architect collaboration in the University). For his part, Sergio Camargo has designed several beautiful sculpture walls for buildings in Brazil.

'Architecture' enters in quite another sense into the work of Lygia Clark and Hélio Oiticica. Into their early geometric work quite overtly – Oiticica designed an imaginary domestic-poetic architecture with close connections to Gaston Bachelard's ideas of the 'poetics of space', and Clark's *Bichos*, matchbox constructions, and *Abrigos Poéticos* (*Poetic Shelters*), can be read in terms of architectural ideas. Later, the *Beds, Tents, Cabins* and *Nests* of Oiticica's environmental experiments, his 'mind-settlements' (partly influenced by Amazonian Indian *tabas* – communal houses, campuses and village settlements), invoke architecture as part of a proposal for new ways of living, new ways of behaviour: 'To inhabit is to communicate' was one of his slogans. Later too, Lygia Clark experimented with the notion that people would make architectural spaces out of their own bodies – using elastic bands, plastic and gestures of arms and legs. This was part of her 'return' of certain basic human cultural forms to the living body, to its most intimate sensations and memories. She called this series of works *L'Homme, Support vivant d'une architecture biologique et cellulaire*.

In fact the relationship of art with the 'social', which the link with architecture implies among other things, could hardly have taken more different courses as these artists moved away from the common area they had shared in the 1950s and 1960s. In Venezuela, after the collaboration with Villanueva which was carried out, according to his socialist-humanist principles, very much in the public sector, the commissions for Soto, Otero and Cruz-Diez increased dramatically in both the public and the private sectors: art works for plazas, bridges, theatres, corporate headquarters, hydro-electric projects, hotel lobbies. This can be explained by several factors: the revenue from Venezuela's oil, the presence of active patrons like Alfredo Boulton and Hans Neumann in the upper reaches of Venezuelan economic and political power, an identification of these artists' 'abstract' work with national pride. It is hard to think of any European country which has given commissions to artists on the scale of Venezuela. Otero's *Solar Tower* and Cruz-Diez's turbine paintings at the new Guri Dam must be among the most ambitious applications of art to an industrial installation seen anywhere in recent times. But was something sacrificed in the process? Did the artists accept a social role which compromised their original discoveries, making the insubstantial substantial, the disturbing sign of a possible freedom into the decorative harmonisation of a disjointed environment?[17]

130

In Brazil, two different kinds of trajectory can be seen, which may be described in terms of a distinction between 'closed' and 'open' work. The 'closed' work is represented by Camargo and Schendel: artists, in other words, who accept the prevailing view of the artist as the creator of autonomous objects for the spectator to contemplate, within the given institutional venues – the gallery and Museum – but who, within those limits, continue to make discoveries and to challenge and disturb with their artistic languages. With the practitioners of 'open' work, like Clark, Oiticica and Pape, it is exactly those limits which are questioned. 'Participation' had clearly been intended to change the received myth of the artist as the sole creator, by bringing forward ideas which have no life or meaning without the spectators' active intervention. These artists felt sympathetic and close to the youth revolt and counter-cultural movement of the later 1960s and early 1970s, a very widespread expression of desire, which Oiticica at the time perceptively summed up as 'the re-taking of confidence by the individual in his/her intuitions and most precious ambitions'.[18] In this search for a new definition of the 'public' (both in terms of 'people' and of 'site') Clark moved inward, towards the most intimate interior world, and Oiticica outward, towards the external world. Does such work need to turn everyone into artists to escape the eventual absorption into the commercial, museum, and academic context which it violently rejects? Between these different courses the viewer/reader will draw his or her own conclusions. These questions of the relationship of art to society cannot be answered by artists alone.

RASHEED ARAEEN
ON THE OTHER STORY

*The Other Story: Afro-Asian
Artists in Post-war Britain*
1989

This seminal exhibition – devised and selected by artist, writer, editor and curator Rasheed Araeen – celebrated the contribution of artists from Africa, Asia and the Caribbean in post-war Britain. The Other Story: Afro-Asian Artists in Post-war Britain *was deliberately not an academic or objective history. Instead, it was curated by an artist who declared himself to be 'wholly involved in the story'. According to Hayward Gallery's then Director of Exhibitions, Joanna Drew, this gave the exhibition 'more fire, more tension, even more awkwardness than a conventional survey or anthology'.* The Other Story *was divided into four thematic sections:* In the Citadel of Modernism; Taking the Bull by the Horns; Confronting the System; *and* Recovering Cultural Metaphors. *Twenty-four artists took part in the exhibition, among them Araeen, Sonia Boyce, Eddie Chambers, Mona Hatoum, Lubaina Himid, Keith Piper and F.N. Souza. The exhibition catalogue featured contributions from a number of artists in the exhibition, including Himid and David Medalla, as well as essays by Araeen on each of the thematic sections. His introduction is reproduced here.*

WHEN CHICKENS COME HOME TO ROOST

T his is a unique story. It is a story that has never been told. Not because there was nobody to tell the story, but because it only existed in fragments, each fragment asserting its own autonomous existence removed from the context of collective history. It is therefore a story of those men and women who defied their 'otherness' and entered the modern space that was forbidden to them, not only to declare their historic claim on it but also to challenge the framework which defined and protected its boundaries. My attempt to tell this story, given my lack of proper expertise and insufficient discipline, aims to pay homage to this defiance. My own struggle as an avant-garde artist (in the West) has been fundamental in my realisation of the issues, and without this struggle it would not have been possible for me to recognise the importance of this story. However, it is not the only story. There are many more, and I believe it is crucial, in our attempt to recover our place in history, 'to tell other stories than the official sequential or ideological ones produced by institutions of power'.[1]

My aims here are exploratory rather than critical, insofar as they are separable. However, this exploration must take into consideration the change that has taken place in the world since the last war, in particular the mass emigration of peoples from Africa, Asia and the Caribbean to the West, which not only changed the demographic map of Europe but also challenged the old social structures that had been maintained by the geographical separation of the coloniser and the colonised. This challenge was part of the process of decolonisation across the world, with its specific articulation in the metropolis.

It would be a mistake to emphasise only the socio-political determinants of mass emigration and not to fully understand the actual aims of individual artists who left their countries of origin simply to fulfil their artistic ambitions abroad. We should also recognise the peculiarity of these ambitions, which are not fulfilled merely by a success in the market-place but by the artist's entry into the history of art. It is this entry that allows his or her work to be discussed seriously and to be recognized for its historical significance. What we face here is the dominant ideology of an imperial civilisation for which the racial or cultural difference of the colonised constitutes Otherness. And of course the Other is part of its history as long as it stays outside the master narrative.

Would it be possible to inscribe this story within the master narrative of modern art history? Would not this have produced an unresolvable contradiction? A slap in the face of Hegelian metaphysics? Is not the history of art still being written according to the Hegelian historical framework in which only the Western subject is privileged? And is not this privilege achieved by arbitrary removal of other cultures/peoples from the dynamics of historical continuity? I should not perhaps have used the word 'arbitrary' and should be more profound in this respect, but I wish to avoid a situation in which I might be dragged into accusing Hegel of racism.

A good example is the way Hegel looks at Indian art and interiorises it by comparing it with Greek art. What is the point or comparison here? Is there a rational discourse which can establish any point of comparison objectively, beyond and outside the mythical historicisation of the evolution of different cultures? Hegel's world-view removes India from any dynamic of history because it helps establish the supremacy of Western culture. India is therefore 'condemned to remain always outside history, static, immobile, and fixed for all eternity', because for Hegel 'The Hindo race has [...] proved itself unable to comprehend either persons or events as part of continuous history, because to any historical treatment a certain objectivity is essential.'[2]

The art historian John Ruskin, whose socialist credentials are often thrown in to support his humanism, did not hesitate to use strong words to belittle other cultures:

> The reader who has not before turned his attention to this subject may, however, have some difficulty in distinguishing between the noble grotesque of these great nations, and the barbarous grotesque of mere savageness, as seen in the work of the Hindoo and other Indian nations; or, more grossly still, in that [...] of the Pacific Islands [...] I can put the relation of Greek to all other art, in this function, before you, in easily compared and remembered examples [...] Here, on the right [...] is an Indian bull, colossal, elaborately carved, which you may take as a sufficient type of the bad art of all the Earth. Faulty in form, dead in heart, and loaded with wealth externally. We will not ask the date of this; it may rest in the eternal obscurity of evil art, everywhere and forever. Now, beside this colossal bull, here is a hit of Daedalus-work, enlarged from a coin not bigger that a shilling: look at the two together, and you ought to know, henceforthward, what Greek art means to the end of your day.[3]

What do we make of it? Diatribe? 'Diatribe' may be a strong word, but can we consider this an objective view? What is the basis of this 'objectivity' other than the power of his speech, which derives not so much from an intellectual argument but from his consciousness of belonging to the privileged class of the British Empire? Can a view founded on military conquests, and its justification on the racial and cultural superiority of the conqueror, have an objectivity? Is this objectivity not a camouflage to hide something which will reveal its imperial fantasies?

John Ruskin is not alone in his views, nor are they now out of fashion. Such views may not today be expressed so openly, or they may not be influential in the way they were a hundred years ago. But there still exist assumptions and attitudes which consider other cultures/peoples outside modern history. These attitudes and assumptions are so pervasive, so intransigent, that the very presence of the others in the modern world is seen with suspicion. When it comes to the question of the modernity of other people, the whole citadel of modernism begins to fall and the question is buried under its debris in the name of the new Father, postmodernism.

A World History of Art,[4] winner of the 1982 Mitchell Prize – 'the most prestigious award in the field of art history', according to its publishers – which is claimed to have represented for the first time all the cultures in the world equally, does include in it all the cultures and treats them almost equally. But this pluralism ends by the end of the nineteenth century. As we enter the twentieth century, African/Oceanic sculpture is taken up again, but only in connection with modernism, the development of various movements and styles – in particular cubism. After that everything non-European, both peoples and cultures, disappears. The West then shines alone this century, the whole world reflected in its image.

Installation view, The Other Story: Afro-Asian Artists in Post-war Britain, 1989

When this book came out in 1982, almost everyone praised it, including Kenneth Clark: 'Much the best complete history of art that has ever been put together'. Indeed 'it explores', unlike Gombrich's *The Story of Art*[5] which cursorily mentions other cultures, 'every branch of the visual arts from every corner of the world throughout man's history […] the arts of Asia, Africa, the Americas and the Pacific Islands as well as Europe are discussed chronologically...'[6] In spite of all its claims to represent 'arts […] throughout man's history', it falls into an established pattern that obscures the achievement of other cultures in the twentieth century on the assumption that other peoples belong to historically receding cultures. We can fully understand the implication of this assumption if we return to Hegel, amongst others, who assumes that history is a narrative of the progress of ideas in the process of change, where the ultimate narrative is the narrative of Western civilisation from which others must be excluded.

Art history is peculiar in its function as a master narrative, not only in that it is fundamental in the recognition and legitimation of Art with a capital A, but that

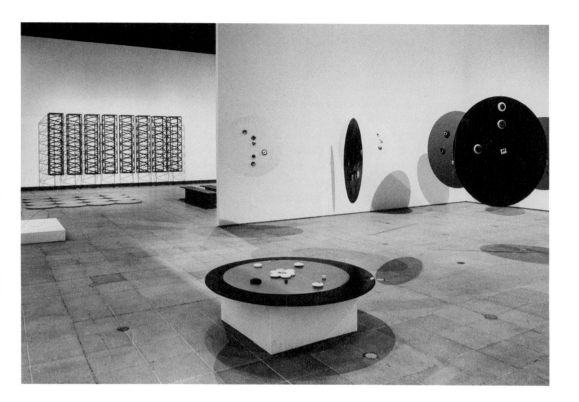

it seems to be the only discourse (unlike the discourse of literature or science) which protects its Western territory so rigidly that we find hardly any exception to its Eurocentric rules.

We are confronted here by a discourse which is complex and ambivalent, for when the mask of its objectivity is lifted, what is revealed is not only a phoney rationalisation but a structure which is mythical. It is this mythic structure that hides the contradictions of the bourgeois/imperial society by the invocation of the magical power of the modern artist (white, male, individual, heroic). Its ambivalence, expressed particularly in its fascination for the Other's traditions, does not hide its reaffirmation of the centrality of the Western/white artist in the paradigm of modernism.[7]

There is perhaps no internal contradiction here. If art history is an ideological presentation of Western civilisation, it would be logical for it to produce a narrative which conforms to its assumptions, functions and ambitions. My concern here is not to denounce its imperial (and/or patriarchal) ideology. It would be more fruitful to interrogate the nature of its narrative; to reveal the underlying myth which disguises those contradictions inherent in its claim of objective superiority, both historical and epistemological.

In order to explain what I mean by myth I quote from a recent article by Abigail Solomon-Godeau:

> Myth, as Roland Barthes famously defined it, is nothing more than depoliticised speech – consistent with the classical definition of ideology (a falsification or mystification of actual social and economic relations). But mythic speech is not only about mystification, it is also, and more crucially, a productive discourse – a set of beliefs, attitudes, utterances, texts and artefacts that are themselves constitutive of social reality. Therefore, in examining mythic speech, it is necessary not only to describe its concrete manifestations, but also to attend to its silences, its absences, its omissions. For what is not spoken – what is unspeakable, mystified or occulted – turns always on historical as well as psychic repressions.[8]

The smooth working of the myth had entailed the smooth working of the colonial system by which the imperial metropolis was successfully separated and insulated from the people of the colonies. But when the chickens began to come home to roost the outer shell of the myth began to crack. Francis Newton Souza, one of the pioneers of modern art in India, had this to say about his arrival in London in 1947:

> I was astonished by the grimness of Britain. Here was the country that was running, only a few years before, an empire encircling nearly three-quarters of the globe. Yet there was no joy in it. The people were grim-faced after the prolonged war. So this was the environment when I arrived in England. The empire had been lost; the Labour government was in power; half-baked ideas of socialism floated around; the Marshall Plan with its heavy dose of US aid to Europe was in operation.[9]

Europe after the War was in ruins, facing the anguish of unprecedented human death and suffering. There were no fruits of the Empire to be reaped. There were no roads paved with gold. Instead the cities of Europe had to be rebuilt; and this was the first stage in the process of the demystification of imperial greatness and its humanism, on which the whole colonial apparatus had been built.

The colonial administration used both the stick and the carrot. Schools were set up on Western educational patterns, out of which emerged a middle class which served the Empire. Nevertheless there also appeared a modern consciousness which aspired to change, progress and individual freedom; and this consciousness was fundamental to anticolonial struggles. It was therefore no surprise that many artists in Africa, Asia and the Caribbean who adopted the framework of modernism for their artistic practice were also engaged in the anticolonial struggles of their countries. It was perhaps the anticolonial position held by many artists that helped them 'appropriate' the ideas of rebellion and revolt inherent in the avant-garde. If the attack of the avant-garde in the West was directed at the affluent and dehumanised bourgeois society, the artists in the colonies were concerned with the lack of basic modern progress.

Of course, the situation was not the same everywhere. There were places where there were no schools, and even traditional activities were not allowed. However, when things changed there emerged self-taught artists whose aspirations were no different from those who came from established art schools.

The artists also had the double task of dealing with the prevailing situation: on the one hand with traditional structures (tribal/feudal) that were re-enforced by colonialism, and on the other, with art institutions that were supposedly modern but were in fact extremely conservative. There were widespread revolts against the status quo, made manifest by the formation of various radical and progressive groups. 43 Group was formed in Ceylon (now Sri Lanka) in 1943 'to bring together a group of talented painters whose common meeting ground was that their work stood in sharp contradiction to the existing colonial convention, exemplified in the imported and orientalized academicism of the Ceylon Society of Art'.[10]

In India the debate about what is progress and what is progressive, which began over a century ago, is still not resolved. It was never a question of a rejection of traditions, but of how to revitalise them in terms of 'modern progress'. This is what Rabindranath Tagore said: 'Fearfully trying to conform to a conventional type is a sign of immaturity [...] I strongly urge our artists vehemently to deny their obligation to produce something that can be labelled as Indian art, according to some old world mannerism.'[11]

Throughout history artists have travelled from one country to another in search of patronage, quite often ending up in a dominant centre. The arrival of Picasso, Brancusi, Mondrian, for example, in Paris in the early years of this century, was very much part of this tradition. So when artists from the ex-colonies began to arrive in the metropolis after the War it was not an unusual phenomenon. The independences of their countries removed the constraints, both physical and psychological, from travelling to those places where they could find institutions to support their work. The paradox here is not that of chasing the old colonial masters, but that the lack of modern institutions in their own countries made it impossible for these modern artists to receive all the support they needed. Of course, it would be foolish to ignore other reasons that were to do with the artists' own individual ambitions. It would also be difficult to separate these ambitions from the repressed aspirations, desires and fantasies of the colonial times.

However, it would be incorrect to conceive the British society as a monolithic power concerned only with its oppressive imperial functions. There also existed a liberal intelligentsia, in the metropolis and in the colonies, whose ambivalence towards the 'natives' was characterised by a good measure of sympathy for their welfare; and in some cases it constituted that progressive section of British people which openly showed sympathy for independence movements.

It should be understood that England has been marginal in terms of twentieth century modern movements, since all the important movements before the War

took place on the Continent. London had never been an international art centre like Paris. It was this consciousness of marginality and the hope that London would develop into an international cultural centre within the independent Commonwealth that created a euphoric spirit among a section of British society that welcomed the arrival in England of artists from abroad.

These artists faced many difficulties in the beginning, no different from those faced by any artist in a new place or country. These problems may have been compounded by the fact that we are here dealing with a society with an imperial past and within which racism has been rampant and overt. One could see in those days notices openly displayed which said 'No Blacks or Coloureds', and there was nothing one could do except to protest individually and collectively. Of course this was the unacceptable face of British society, which was eventually changed. However, it would be a mistake simply to evoke this kind of racist bigotry in order to understand the position of Afro-Asian artists in Britain. This is determined more by the kind of ambivalence about which Homi K. Bhabha has written.[12] The point here is that this position depends not only on individuals' responses to these artists but also on the attitude of the institutional structures of this society.

However, one is amazed by the kind of support and response which Afro-Asian artists received during their successful period. They began to exhibit their work in the mid 1950s, and success followed in many cases. The success of F.N. Souza and Avinash Chandra had become so phenomenal by the early 1960s that there must have been many English artists envious of their success. There was hardly a critic who did not write about them. Souza became so self-conscious of his position that he had to say: 'I make more money by my painting than the Prime Minister by his politics.'[13]

However, despite all their success they remained the Other, in the sense that their Otherness was constantly evoked as part of the discussion of their work. Headlines such as 'Oriental Week', 'Indian Vision' or 'An Indian Painter' were not uncommon, but there were also critics who tried to deal with the problematics of the Otherness, critically and sympathetically, not in order to exclude those artists from the discourse of modern art but to raise the issue of other cultural traditions in relation to modernism. It seems that the most important statement in this respect was made by W.G. Archer:

> Is modern art a closed ring, a private club, a preserve for Europe and the United States? Can artists from other countries break in? […] Such questions are posed by the Cuban Wifredo Lam, and the Mexican Rufino Tamayo […] And they are raised with even greater acuteness by the paintings and drawings of Indian Avinash Chandra… [which] with their life-enhancing symbols, brilliant burning colour and gay vitality are nothing if not Indian – Indian to the same degree and [in] the same way as the art of Picasso and Miró is vividly Spanish. Yet just [as] these pioneers of modern painting are part of one world, a world

which far transcends national frontiers, Chandra, it could be claimed, is more than Indian […] In his painting, modern art has received an Indian injection and just as Nehru has made an Indian impact on world ideas, we must expect more and more artists from India, South America and the East to [join] the 'private club'.[14]

W.G. Archer was not the only person who was aware of the problem, and in spite of the success of some of these artists, many people knew that there was something not quite right. Norbert Lynton had his to say:

A few years ago there appeared a handsome, internationally published book entitled *Art Since 1945*. It is significant that this book, purporting to present the international art scene of our time, ranged geographically from Poland and Yugoslavia westwards to the United States and simply omitted everything east of Belgrade and West of Seattle. To ignore the oriental contribution to modern art is such an act of ingratitude to a group of civilizations from which many of the concerns and attitudes of modern art derive, that one is justified in interpreting it also as a defensive act against developments that, if seen, would tend to diminish the glory of sections of western artistic achievement.[15]

Norbert Lynton was not concerned specifically with 'Oriental art', but this quote is the first paragraph of an article he wrote about Iqbal Geoffrey, who was from Pakistan and was a successful artist in Britain at the time.

This concern of Archer and Lynton, amongst many others, was not unfounded. The success of these artists was short-lived – so much so that by the end of the 60s nobody knew or even wanted to talk about them. On the other hand, many of the younger artists of the early 1960s, English and White, took over the art scene and became part of the history of the period. What happened to Afro-Asian artists? Why did none of them manage to enter history?[16]

The rise and fall of an artist is not an uncommon phenomenon. Few artists can sustain their position for long. Success is an extremely complex issue, but it can be observed that success in the art market alone is not enough to sustain an artist's career for any length of time, and institutional support is necessary in the consolidation of the artist's position and his/her place in history. Can we conclude from this that Afro-Asian artists did not receive support from the institutions? If so, why not?

Of course, Souza, Chandra, Geoffrey, Bowling and Parvez did leave London in the second half of the 1960s to live in New York, but they left only because they were no longer doing well in England. And they were also lured by the success and glamour of New York. In any case, living abroad should not make any difference to the status of an artist. David Hockney has lived most of his life in California, but is still a favourite of the British establishment. An ex-patriot, Malcolm Morley, who spent

little time in Britain during his career as an artist, was given the first Turner Prize a few years ago. The explanation must be that they are *English*.

Why were things so different for Afro-Asian artists? The situation can be better understood in the context of the changes that took place after the War, not only in Britain but worldwide. Since the details are so complicated I have to generalise and simplify the whole thing in order just to explain its relationship with the emergence of a new situation in Britain. If the Commonwealth euphoria of the 1950s welcomed Afro-Asian artists as what Denis Bowen called 'a breath of fresh air', the shift of Britain towards America in the 1960s became detrimental to the status of these artists.

Given the fact that Britain had lost the Empire and its economic power, its new alliance with an emerging imperial power is understandable. London was not just the focal point of the Commonwealth in the post-war period, it also became an important art centre, which by the early 1960s had direct and close connections with New York, the new Mecca of the art world. The opening-up of the New York art market to British artists was a crucial boost to the confidence of the new generation leaving art schools in the early 1960s, who soon became part of the international art scene. In fact, without this alliance the emergence of new art in Britain in the 1960s is unthinkable. The art schools themselves had an important part to play in preparing those artists who later became successful. From the early 1960s it appeared to be common practice for dealers to choose artists from diploma shows. The 'New Generation' exhibitions of the first half of the 1960s set the tone and direction of new developments, and were followed by the participation of English artists in exhibitions in New York and elsewhere. At the same time there emerged a new class of art critics, historians and art administrators, whose confidence was formed and enhanced by this change. The Tate Gallery in particular played an important role in the promotion of American interest, in some cases at the expense of British developments.[17]

It is difficult to suggest any direct connection between the situation in Britain and America's use of art (particularly Greenbergian formalism) in Cold War politics, or any collusion between the two in relation to what happened to Afro-Asian artists. But it must be remembered that the objective of post-war American cultural imperialism was not just anti communism but also the assertion of its own cultural hegemony over the world. Freedom of expression in newly independent countries was inevitably affected. It seems that the eventual disappearance of Afro-Asian art from the British art scene was not fortuitous, nor can it be explained simply as a result of the emergence of new racism, epitomised by the famous speech of Enoch Powell in 1968 in which he demanded the return of the new Commonwealth peoples to the countries of their origin. It is no coincidence that the British art world became completely white by the end of the 1960s – so much so that no major art gallery showed work other than English, American and, to a lesser extent, European. Subsequently no national or international survey of post-war art in Britain has mentioned or included any non-European artist.

But things are changing again, mainly as a result of the anti-racist struggle and it is now officially recognised that Britain is a multiracial and multicultural society. Can true pluralism be achieved without recovering what we have lost in the past, for whatever reasons? Can we afford to be complacent any more?

JON THOMPSON
ON POST-MINIMALIST SCULPTURE

Gravity and Grace:
The Changing Condition
of Sculpture 1965–1975
1993

Gravity and Grace: The Changing Condition of Sculpture 1965–1975, curated by artist, curator and critic Jon Thompson, was the first major international sculpture show to explore the period spanning from the mid 1960s to the mid 1970s. The exhibition presented around 60 works by 20 artists, including Giovanni Anselmo, Joseph Beuys, Barry Flanagan and Eva Hesse. Its title, taken from a book by the philosopher Simone Weil, captured the spirit that informed many of the works in the exhibition, which was characterised by Thompson as a 'combination of material strength, of earth-boundness, with high seriousness and conceptual elegance'. Reviewing the exhibition in the Times, *the writer Richard Cork described* Gravity and Grace *as a 'lucidly installed exploration... of how post-war sculptural potential was transformed'.*

NEW TIMES, NEW THOUGHTS, NEW SCULPTURE

American artist Ad Reinhardt is supposed to have defined sculpture as 'something that you fell over when you stepped back to look at a painting'. Whether the story is true or not matters little: the sentiment is precise enough. Painting took precedence over sculpture – was considered to be a superior fine art practice – from the late mannerist period of the Renaissance until the end of the Second World War. The reasons are obvious enough. Painting was capable of carrying all the transcendental qualities that sculpture was not. It was painting that had the monopoly of the supra-physical world of angels and gods. It was painting that could speak most easily of the enchantments of Arcadia: its honeyed light; its rolling vistas and mysterious recesses. Only painting could contain the sublime exaggerations of the picturesque landscape, or the crusted detail and material transformations of realism. Only painting could yield up the luminous evocations of impressionism. Even in the immediate post-war period it was painting that offered the freedom necessary for the gestural excesses of abstract expressionism. By comparison, sculpture seemed confined by its materiality, earthbound, resistant to flights of fancy, always stubbornly what it was; a shaped piece of wood or stone, a lump of plaster or wax or clay, a moulded piece of bronze. Yet, more recently, sculpture has increasingly occupied the centre stage.

My purpose here is to trace this change of focus and to seek explanations for it from within the practice of sculpture itself as well as from the complex critical and theoretical discourse which has grown up around it. Nor do I want to make of it a simple polarity of interests. Sculpture too has been transformed in the same period, losing the centrality of its different generic practices (modelling, carving and constructing) and taking under its mantle a wide diversity of hybrid forms and strategies of making. In the first instance this was powered by the mixture of 'high' art with popular forms of communication that came together in American pop art. Afterwards, minimalism and conceptual art took sculptural practice into an area of theory which connected with the speculative thinking of other more scholarly

disciplines: philosophy, linguistics, phenomenology, psychology and social and political theory.

My chief intention is to shed light upon the transition which took place in the 1960s, when minimalism gave way to the post-minimalist tendency in America and Europe. Previously, American influence had tended to dominate the development of the visual arts in Britain, France, Germany and Italy, as well as further afield. With the rise of arte povera in Italy and the activities of Joseph Beuys and those around him in Germany, the transatlantic exchange was suddenly transformed into one between equals. Even so, the political climate of the time meant that relations between American and European art in the 1960s and early 1970s was marked by very considerable tension, as can clearly be shown in the critical writings of the time. By the middle of the decade resentment had begun to surface in Europe and a corresponding defensiveness arose in America, as exampled in the early writings of the American critic, Rosalind Krauss.

In her seminal essay on post-war American sculpture, 'The Double Negative: a new Syntax for Sculpture',[1] Krauss argues that there is a clear difference of approach between the emergent generation of New York artists working with sculptural ideas – later called the post-minimalists – and their counterparts working in Europe. And she gives authority to this notion of difference by quoting from Donald Judd's essay in the *Arts Yearbook* of 1965, and by reference to the joint interview that Judd and Frank Stella had with the art historian Bruce Glasser, 'New Nihilism or New Art',[2] which appeared in *Art News* in 1966. These quotations are well worth repeating since they shed light upon the attitude of the artists of Judd's generation towards European art in the first half of the 1960s, an attitude which was to change dramatically in the course of the next decade. Donald Judd writes about the new sculptural order: 'It is not rationalistic and under-lying, but is simply order: like that of continuity, one thing after another;' later, in tandem with Stella, when questioned by Glasser about this 'one thing after another' way of making works of art, he argues it as standing in sharp opposition to what he calls 'European Formalism', an approach which Stella says is primarily concerned with balance: 'You do something in one corner and you balance it with something in the other.' In Donald Judd's more philosophical manner of speaking: 'It is that they [the Europeans] are linked with a philosophy – rationalism, rationalist philosophy […] All that art is based on systems built beforehand, a priori systems; they express a certain type of thinking and logic that is pretty much discredited now as a way of finding out what the world is like.'

This statement is revealing, not simply because, as Krauss points out, it shows minimalism to be an attempt to make a form of art which, to all intents and purposes, was analogous with 'inert matter – things untouched by thought or unmediated by personality' – but also because it contained within it a programmatic, one might even say a political, intention too – that of continuing the search for uniquely American ways of thinking about things; establishing clear criteria of difference between themselves and their European counterparts. It also demonstrates, with startling clarity, just how inward-looking the New York art world had become by the early 1960s.

Even the most cursory examination of that particular period of art activity in western Europe will serve to show that Stella and Judd could not have been wider of the mark. Indeed, far from being a time of formalist retrenchment as they would seem to suggest, the early 1960s in Europe was a period during which the ground was cleared and the foundations laid for an extraordinary resurgence in the visual arts. Two quite remarkable facts will suffice to demonstrate this beyond peradventure. In 1966, at the time of the Judd/Stella interview in *Art News*, Joseph Beuys was already well established as a teacher at the Academy in Dusseldorf and engaged with his 'revolutionary', 'free' seminars linking art, politics and economics.[3] In his own work too, Beuys was passing through his most radical and iconoclastic phase, halfway through a long series of performance works of which *The Infiltrationhomogen for Grand Piano: the greatest contemporary artist is the Thalidomide Child* was dated 1966, exactly coincident with the interview under discussion. Similarly, the work of the Italian artist Michelangelo Pistoletto bridged some of the most important tendencies current at the time,[4] most especially between American and European Pop and the early formative stage of Arte Povera.[5] Pistoletto had made his first 'mirror piece', synthesising past, present and future in the form of an image at the surface, in 1962. In 1966, the year in question, he made his most ambitious 'mirror' installation to date in the Italian pavilion at the Venice Biennale. More significantly, he had already completed his innovatory series of constructed objects, the *Oggetti in Meno* (*The Minus Objects*).

Installation view, *Gravity and Grace: The Changing Condition of Sculpture 1965–1975*, 1993

It is of no relevance to our purpose here to decide whether the attitudes underlying the Stella/Judd interview were the product of ignorance, prejudice or a combination of both. What is important is to reach an understanding of just how much the ethos governing attitudes in the New York art world had changed by the 1960s. The open handed and optimistic internationalism which had characterised the immediate post-war period, during which New York had become a safe haven and creative forcing ground for a whole generation of artists, one or two of whom were indigenous Americans but most of whom were political refugees from western Europe, had given way by the end of the 1950s to a more American-centred view of things. For the first generation of New York artists – the generation of Pollock, Rothko and De Kooning – the issue had been one of personal freedom. They were not interested in identifying themselves with narrow nationalistic interests or prescriptive ideologies. As far as they were concerned, freedom could never be the gift of a type of state or a particular shade of political philosophy. As Robert Motherwell wrote in his essay of 1944, 'The Modern Painter's World',[6] modern artists 'value personal liberty because they do not find positive liberties in the concrete character of the modern state', and he continues, 'Modern art is closely related to the modern individual's freedom [...] for this reason the history of modern art tends at certain moments to become the history of modern freedom.' The painter William Baziotes, writing at about the same time, strikes an even more uncompromising note: 'When the demagogues of art call on you to make the social art, the intelligible art, the good art – spit upon them and go back to your dreams...'[7]

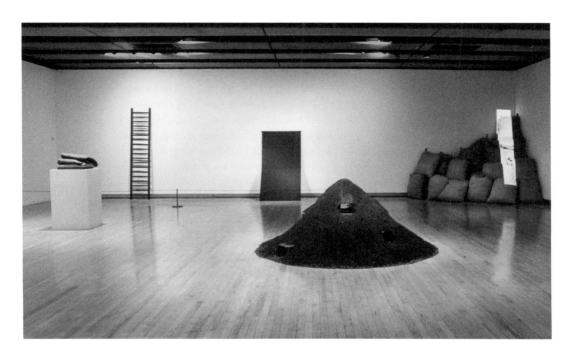

By the end of the 1950s this untrammelled idealism, which allowed the first post-war generation of New York artists to stand aside from any form of overt political commitment, was quite dispersed. America was locked into a bitter ideological struggle with the Soviet Union, seeking to win and to hold the hearts and minds of the peoples of what was then euphemistically referred to as the free world. And as the shadow of the Cold War widened and deepened, as the dissemination of propaganda intensified, American avant-garde art was increasingly drawn into the fray. The model of individual freedom, so beloved of Motherwell and his contemporaries, effectively placed the creative necessity of the individual artists and by implication of all individuals, above the power of the state to command it. Here was a society which not only tolerated individual dissent, but also saw it as intrinsic to its social strength and cultural purpose.

Not surprisingly, there was a negative side to this belated and somewhat cynical process of official endorsement. It showed itself, first of all, as a gathering sense of disillusionment amongst the older generation of New York artists, who felt that they were being used, manipulated – their work re-interpreted, even misrepresented – and for nakedly political ends. The belief which had sustained them, namely that the practice of art could best exist in an apolitical Arcadia, a utopic space in which there occurred a pure combination of originating gesture, material process and sublime insight – a product of what Harold Rosenberg has called the 'authenticity of the real act'[8] – looked less and less tenable and, as a consequence, unsustainable

as a modus operandi. As Max Kozloff put it, by the late 1950s 'false consciousness' had become 'a not so secret enemy within the artist's organism'.[9]

By contrast, the effect of this process of cultural politicisation on the younger generation of American artists was altogether more constructive. They were much more prepared to recognise and respond to the invasive power of political realities. For them, the activity of making works of art took its *raison d'être* unavoidably from within the public domain, and was therefore subject to the same social, political and economic factors as all other forms of human endeavour. The issue was no longer one of how to sustain a private and more-or-less autonomous world in which to perform uniquely insightful creative acts, but of how to position oneself as an artist in relation to the pressing political realities governing society at large.

This progress away from a creative site which was interior to the individual artist concerned, towards one which cast the social world as both cause and proper location for creative work, started, in the case of sculpture, with the 'totemic' works of David Smith. Smith was the first to empty out the internal volume and material density of the sculpted object conceived in the round, in favour of a form of construction which allowed, even celebrated, formal discontinuity. The fullest comprehension of the work required the reconciliation of opposing energies and forcefully different imaginal configurations. The effect of this change, in short, was to make the viewer an active participant in the construction of the work through a self-conscious act of reading. For the first time, the viewer was made present within the space of the work, not as a passive receiver of the traditional sculptural verities (as sense of wholeness emanating from within the form; material coherence being the play of symmetry and asymmetry; the gradually transforming and always surprising profile), but as a respondent, aware of the self, positioning in relation to the work, and the constructive play of his or her own thoughts. Smith had opened the door on a world in which the viewer was incorporated physically and implicated psychologically in the life of the work.

Nevertheless, as Rosalind Krauss argues in her essay 'Tanktotem; welded images', even though Smith had cleared the way for a new attitude to sculpture, he himself remained at root a classical 'modernist'.[10] His adherence to 'totemic' form – with all its hermeneutic referencing of the human figure – meant that the offer that he made, of an equalising play between the sculptural object and the viewer, was never to be fully consummated. Always, at a certain point of engagement, it was curtailed in favour of a powerful, even overpowering sense of 'otherness'. The physical space was transformed into a mythical one – an arena for subjective identification – in which the sculpture was translated into a surrogate human or superhuman presence.

However, Smith had once more raised the question – touched upon first of all in the analytical phase of Cubist painting – of the relationship that obtained between the work of art as image and the work of art as material transaction and material form. He allowed himself to entertain the possibility, in other words, that the one aspect could exist independently of the other, or at least, that a separation might

be effected between the two, which would allow much greater scope for formal invention and imaginative play. And while his predilection for the 'primitive' power of the solitary vertical, figural image was such as to prevent him from fully exploring this more 'open' territory for himself, his work served as a crucial speculative pointer for those who came later, amongst whom the most notable and influential was the British sculptor Anthony Caro.

Caro was quick to recognise that the separation David Smith had essayed, between the image and its material form, had cleared the way for a radical and far-reaching re-appraisal of the language of sculpture. On the one hand it offered the possibility of a more concrete – that is to say less referential – notationally abstract and syntactically precise, material form; and on the other, a less concrete, more ethereal image-quality, closer to the sublimity of painting. The issue was one of how to hold in play at one and the same time two quite different intersecting modes of existence: the 'real' and the 'pictorial'; the extended spatial world of sculpture, with the flattened, illusionistic space of painting. Caro solved this by imposing a strong feeling of frontality that worked counter to the sculpture's disposition in real time and space. This duality demanded that the viewer's apprehension of the work shifted between its identity and its 'presence': it involved nothing less than a complete change of state of the kind referred to in Rosalind Krauss's description of the Caro work (now in the collection of the Tate Gallery), *Early One Morning* (1962): 'The axis along which one relates to the work as physical object is turned ninety degrees to the axis which establishes its meaning as image. The change from horizontal to vertical is expressed as a change of condition or being.'[11] Furthermore, this change of state within the object demanded a corresponding transformation in the mental disposition of the viewer: a knowing appreciation of two distinct and radically different principles of formal unity.

On one level, Caro's work of the 1960s answers the programmatic analysis of an aesthetic style compatible with the condition of modernity, sketched out by the American critic Clement Greenberg in his essay of 1949, 'Our Period Style'.[12] While recognising that the modern period 'presents a picture of discord, atomization, disintegration and unprincipled eclecticism', Greenberg makes a plea for an art which is 'characterized by directness and consistency in the fitting of means to ends'; what he chooses to call 'rationalization in the industrial sense', and an art which is free from 'illegitimate content – no religion or mysticism or political certainties'. It would seem that works such as *Early One Morning, Red Splash* (1965), and *Shore* (1968) are exemplary in both respects. But on another level, Caro's flight into 'pictorialism' represented a considered act of aesthetic entrenchment: an insistence upon 'art for art's sake'. It is by now a curious fact of post-war art history, that Caro and his immediate followers – Philip King and Tim Scott amongst others – having fully opened up the space of sculpture to the human presence by ridding it of its own very particular brand of illusionism, then strove to impose upon it the spatial artifice of its sister art, painting. Having at last allowed the sculptural object to enter into the world of real things – to stand four-square as object amongst other objects, stripped of the magical, ritual and referential trappings which had been

its burden since pre-historic times – the artists themselves, fearful of an absolute convergence between art and the real, of a kind that might render the art object indistinguishable from any other class of object, sought refuge and solace in the illusionistic language of pictorial space.

The answer to this riddle is to be found, in part at least, in the critical debate which came to surround the practice of sculpture as the 1960s progressed. The central question was one of boundaries. Does art define itself through the gradual evolution of its own peculiar rules of practice. Or is it, necessarily, permeated by and therefore subject to factors derived from the social world?

The argument is best approached through the writings of Clement Greenberg, with particular reference to his notion of 'purity'; through the historical perspective provided by the British critic Adrian Stokes's discourse on 'handling'; through the New York-based critic Michael Fried's critique of minimalism – his negative use of the term 'theatricality'; and by contrast, through the influential writings of the Italian philosopher and critic Umberto Eco – his important concept of the 'open' work.

THE FEAR OF DECORATION

In his book *Modernist Painting*, Greenberg argues that for any 'formal social activity' to survive, it must be capable of generating firm and stable grounds and irrefutable criteria, sufficient to sustain an ongoing and aggressive process of self-criticism; and the purpose of this self-criticism is one of purification: 'The task of self-criticism became to eliminate from the effects of each art any and every effect that might conceivably be borrowed from or by the medium of any other art. Thereby each art would be rendered "pure" and in its "purity" find the guarantee of its standards of quality as well as its independence.' And elsewhere: 'Having been denied by the Enlightenment all the tasks they could take seriously, they [the Arts] looked as though they were going to be assimilated to entertainment pure and simple, and entertainment itself looked as though it were going to be assimilated like religion, to therapy. The arts could save themselves from this levelling down only by demonstrating that the kind of experience they provided was valuable in its own right and not to be obtained from any other kind of activity.'[13]

Purity for Greenberg, then, is closely bound up with the question of value, and not, as the critic Stephen Melville has pointed out, merely with the question of whether works of art have value, but with the much more rounded question of whether art itself can retain its value in the face of a culture which threatens, always, to engulf and eventually submerge it.[14] In this context, the repeated marking out and patrolling of the boundaries which define a particular generic, aesthetic practice are as important to its continued existence as the reiteration of its central founding principles. What appears at first sight, then, to be a thoroughly defensive posture on Greenberg's part, is not entirely devoid of purpose. Even though it works with a

JON THOMPSON ON POST-MINIMALIST SCULPTURE

fear of loss which is to a large extent illusory – it fails to recognise the importance of assimilation to the dynamic of cultural history – it is nevertheless an argument made on behalf of the well-being of art, and voices an anxiety which, in historical terms, seems to have been endemic to its several practices from the outset – the fear of 'decoration'.

THE DECLINE OF HANDICRAFT

The British critic Adrian Stokes, writing in *Stones of Rimini* (first published in 1935), makes what was then a fairly unexceptional claim, namely that 'the visual arts are rooted in handicrafts.'[15] At this point in his text, Stokes was engaged in making clear the distinction between two different forming processes, 'carving' and 'modelling'. Furthermore, he was attempting to show that the former was in certain important respects superior to the latter, in as far as it offered a more complete and challenging aesthetic experience. The sense of this assertion depends upon the qualitative judgement that he makes between what he calls 'plastic shape' on the one hand and 'carving shape' on the other. Plastic shape, Stokes argues, is by its very nature abstract, whereas carving shape is always perceived 'as belonging to a particular substance [...] one recognizes "fine carving" when one feels that not the figure, but the stone through the medium of the figure, has come to life.' By comparison, modelling allows for no such separation: the image is through and through the artist's conception. Clay has 'no "rights" of its own': it offers no resistance to the process of conceptualisation. For this reason, modelling, like handwriting, is essentially calligraphic. And he carries this argument further in a brief discussion of painting, finally concluding that only paintings 'in which the pigment is directed by some architectural conception of planes, is preferably classed with carving'.

Despite the fact that the subject of Stokes's address is quattrocento sculpture and architecture, and the relief carvings of Agostino di Duccio in particular, it is important to recognise that his critical insights and sensibility are quintessentially 'modern'; indeed we might even use the term 'modernist'. As a painter, Stokes had chosen Cézanne as his major influence. In his criticism too, he used Cézanne as a touchstone: he was the artist who, more than any other, had succeeded in carrying the achievements of Renaissance painters through into the modern movement. In Stokes's own words, taken from an essay on Cézanne written in 1947, it was Cézanne who managed 'to coalesce this revolutionary art [postimpressionism] with the more important lessons that may be learned from the masters'.[16] Nonetheless Stokes's commentary remains essentially a post-cubist commentary, bringing together his own insights from the earlier *Stones of Rimini* and an analysis of pictorial construction which properly belongs to cubist painting. Elsewhere in the same essay, in trying to articulate the 'strangeness and shock' we experience in front of a late Cézanne landscape, Stokes writes: 'The painting will not be regarded as a conceptual painting' – in other words it is neither 'modelled' nor drawn in a

conventional sense – 'neither is it concerned with mimesis, or with imitating the play of light, such as one finds in Monet'. Instead, Cézanne 'needed to treat every part of every plane as minutely divided and differentiated and yet merging and coagulating like the advancing and receding planes of a sphere [...] he wanted the volumes to take their place without belying the homogeneity of the picture surface, without hindrance to a mosaic of distance'.

I have spent some little time detailing some of Stokes's more important critical constructs, because in many respects they provide a description of 'the modern' in painting and sculpture which is altogether more profound – because it is less reductive – than that provided by Clement Greenberg. Like Greenberg, Stokes starts from an antipathy towards the 'decorative', but where Greenberg found a solution in the closely related notions of 'formal purity' and 'emphatic flatness', Stokes searches for an antidote in the more immediate and intimate realm of material practice. Since the visual arts are for him 'rooted in handicrafts', they are at their most revealing when studied from the point of view of 'handling'. And it is through a close analysis of this topic that he is able to make some extremely telling modal distinctions; distinctions which, in their turn, serve to illuminate some of the more puzzling aspects of the development of modernism.

The underlying question for Stokes revolves around the role and functioning of drawing – an activity which he divides into two main categories: calligraphy and geometry. Calligraphy is seen as an attribute of plasticity, and while the plastic, in its abstract sense, is a part of both the carving and the modelling processes, in Stokes's scheme of things, it is most closely connected with the latter. Geometry, on the other hand, is seen as a property – maybe even a prerequisite – of carving: it is the architectonic aspect of carving shape. Calligraphy involves a contradiction which is without resolution. Like handwriting it is at one and the same time highly conventionalised, and thus demands a considerable degree of conceptualisation (for Stokes, this, by definition, always occurs before the act) and yet it must be evidenced through an immediate expressive involvement with the material. By comparison, 'geometry', because it permits a clear separation between construction and the surface treatment of forms, is free of this kind of contradiction. The two aspects of carved shape, the locating of edges, the fixing of boundaries – its geometry in other words – and the working of the surface in relation to these limits, are brought together and reconciled, in painting by achieving an equal play of light across the picture plane, and in sculpture, when the substance carved becomes 'animated by the equal diffusion of light'. He examples this by reference to the separation he observes between the obsessive re-stating of drawn forms and the 'tegament' and treatment of surface texture in the paintings of Cézanne, and by reference to the distortions which occur in the sculptures of Agostino di Duccio, out of the need to flatten the forms against the light.

Stokes's modal distinctions offer some important lessons in relationship to the development of modernism. On the level of material practice, for instance, they go a long way towards explaining the conspicuous decline of modelling as a primary

sculpture discipline. If the artist's task is seen as essentially a 'dialectical' one; that is, as the day-by-day working-out of certain contractions which are inherent to the practice itself – between surface and spatial construction; between volume and flatness; between abstract schema and material evolution; between conception or preconception and realisation – then clay is at once too submissive a substance and too 'earthbound' to hold all of these several contradictions in play at one and the same time. This problematic is perhaps most vividly demonstrated in the serial bronze sculptures of Henri Matisse: in the five portrait heads of 'Jeanette', modelled between 1910 and 1913, and more especially in the series of *Nu de Dos* (*The Back*), executed at widely spaced intervals between 1904 and 1929.[17] Both series of works bear testimony to a gradual translation of sculptural form which moves away from that which is characteristic of modelling – in Rosalind Krauss's words, 'the gouging and pinching, the minor editions and subtractions of material, the traces of thumb and hand as they worked the clay'[18] – and arrives at forms that are more typical of carving. The hand is less and less in evidence, and the fine, manual modulation of surface gives way to the slicing, cutting and incising of curved and flattened planes. The forms themselves are made more geometrically simple and therefore more concrete, belying the yielding friability of the stuff out of which they are made. In this respect, it is informative to compare the last of the *Nu de Dos* series of 1929 with the stone sculptures of Constantin Brancusi, made between 1910 and 1916, in which the formalisation, although more extreme, is of a similar order. In the Brancusi sculptures no such conflict is apparent. Form and material act together; indeed, the one appears to be absolutely integral to the other.

But more importantly, Stokes's criticism provides a historical rationale for sculpture after cubism to veer progressively towards the use of open structure and constructed form. There are major exceptions to this general tendency, of course (Alberto Giacometti and Henry Moore might both be cited, but even they are not entirely free of the apparent need to deconstruct the solid, modelled form); nevertheless, overall the general drift is clear. It could well be described as a movement away from 'handling' in its most literal sense, towards methodologies which are at once more technical and more mechanical. There is, then, a curious paradox at the very heart of Stokes's writings on sculpture. Despite his insistence on the founding role of handicraft in the visual arts, the separation of geometry from the surface working of forms which he observes and admires so much in the late paintings of Cézanne would appear to be nothing less than the acknowledgement of the start of a gradual process of manual disassociation which reaches its apotheosis with minimalism.

Both Stokes and Greenberg feared that the pursuit of decorative effects would disempower art in some way and it would no longer be capable of carrying the level of serious content observable in the work of the old masters. For Stokes, the resolution of this problem lay in the intimate engagement of hand and eye towards the piece-by-piece construction of the image, or reconstruction of the motif. Greenberg, on the other hand, adopted a more essentialist approach, arguing that each generic practice should be pared down to its most fundamental and unique characteristics.

Greenberg's argument is fleshed-out historically and given greater weight and precision in a series of essays by the art historian and critic Michael Fried, published collectively under the title *Absorption and Theatricality: Painting and Beholder in the Age of Diderot*.[19] And one of Fried's main objectives here is to sound a cautionary note to the artists and critics of his own time.

THEATRE: THE ENEMY OF ART

By the mid 1960s, the critical focus in New York had shifted away from the generation of artists so strongly supported by Clement Greenberg, and towards a group of mostly younger artists, the minimalists – Tony Smith, Robert Morris, Donald Judd, Sol LeWitt and Carl Andre.[20] These artists had continued with the task, begun by David Smith in the *Cubi* sculptures made in the early 1960s, of evacuating extraneous content from the language of sculpture, but in their case this included the 'gestural' and 'pictorial' effects characteristic of the work of Caro and his followers. Their attack was directed, then, at the residual traces of 'handling' in the work: their project was nothing less than the elimination of all evidence of aesthetic process from the sculpture itself. In Fried's view, the anonymity that this more distanced way of working brought to the sculptural object laid these artists open to the charge of 'theatricality'. They had surrendered some of sculpture's essential qualities, bringing it into close proximity with decor. I quote from his important essay 'Art and Objecthood': 'The concepts of quality and value – and to the extent that these are central to art, the concept of art itself – are meaningful, or wholly meaningful, only *within* the individual arts. What lies *between* the arts is theatre.'[21]

Once again we are faced with a conceptual framework which links purity with value; but this time with the significant corollary that the enemy of both is theatre – a term which Fried allows from time to time to slip into the more general and contentious category of entertainment.

Now it is no simple matter to arrive at a clear idea of precisely what Fried means by 'theatre'. Clearly he sees it as a hybrid form, and one which uses key aspects of the other arts – dance, literature, music and the visual arts – for the purpose of its own adornment, whilst at the same time preserving its own dramatic and oral traditions intact. In other words, theatre has the ability to elide or even to colonise the other arts without in any way putting itself at risk. But this is altogether too general an account of Fried's position to be of much use to us here. It is important to bear in mind that his critical attack, in the first instance, was directed at the Minimalist sculptors Morris and Judd, accusing them of surrendering 'presentness and instantaneousness' in favour of a sculptural experience which unfolded in time. This he connected with the overbearing scale of the works and the rhetoric of repetition they employed, thereby 'theatricalising' the space and rendering the work's relation to the viewer unclear. Fried casts this change in the nature of sculpture's address to the viewer in moral terms: minimalist sculpture had given

over its essential self and could no longer function as an exemplar of ineluctable values; it had 'lost' itself and in doing so could no longer lay claim to being a model of rightness and so continue to speak on behalf of the good of art.

To grasp fully Fried's position, we must understand more completely the distinction that he seems to make between what, for the sake of argument, we will call 'normal time', meaning the unreflected-upon passage of time in which we exist and experience everyday events – the illusory version of which is the proper condition of theatre – and 'present time', experienced as a compression rather than a continuum. This latter, for Fried, is the condition to which 'real' sculpture aspires, and the nature of the experience which 'real' sculpture seeks to invoke: 'It is this continuous and entire presentness, amounting, as it were, to the perpetual creation of itself, that one experiences as a kind of instantaneousness; as though if only one were infinitely more acute, a single infinitely brief instant would be long enough to see everything, to experience the work in all its depth and fullness, to be forever convinced by it.'[22]

It is on this basis, because they compress the experience of the work into a transcendental moment, that Fried places the works of Caro and Smith above those of Morris and Judd in the rankings of sculptural excellence.

Fried, like his teacher and philosophical mentor Clement Greenberg, developed his critical position along distinctly Kantian lines. It follows, then, that to understand his resistance to the inclusion of art in general and of sculpture in particular, within a wholly contingent reality – the world of our everyday experience or what Kant calls the 'phenomenal' world – such resistance must be viewed in the light of the general distinction Kant makes between the 'phenomenal' and the 'noumenal'.[23]

The phenomenal world, Kant argues, is nothing more nor less than the world 'as it appears to us', and is constituted out of the forms that our intuition takes and the categories we devise for the understanding of it. The noumenal world, on the other hand, is the world and its objects as they exist 'independently of our mind's grasp', and the structuring of our intuitions in knowledge. Consequent upon this splitting of the world is a corresponding division of the self. As selves, like all other things in the world, we are both phenomenal and noumenal, so that the self participates in both worlds. The phenomenal world, including the phenomenal side of the self, is subject to the iron rule of physical causality, leaving the possibility of human freedom as an open question only in the noumenal realm. It is this openness which permits the bringing together of notions of aesthetic freedom and morality such as we have remarked upon in Fried's commentary on Minimalism. For Kant, art, like morality, demands freedom of action as a basis for moral responsibility. The aesthetic, then, is part and parcel of the several complexions of freedom, characteristic of noumenal selves. Given this particular critical background, Fried's construction of 'presentness' and 'instantaneousness', in as far as it represents some kind of rupture in the temporal continuum of the everyday, phenomenal world, suddenly takes on the appearance of a slippage which allows us a glimpse through the endless curtain of

the phenomenal into the more open noumenal realm beyond. Thus, to experience a work of art 'in all its depth and fullness' means nothing less than to experience the possibility of a 'real' freedom of action outside the restrictive bonds and seamless web of the causality that defines 'normal' existence.

As T.J. Clark has pointed out, there is something fundamentally regressive in Fried's espousal of Kant's dualism, which shows itself in a concern to preserve 'a certain myth of the aesthetic consciousness, one where a transcendental ego is given something appropriate to contemplate in a situation essentially detached from the pressures and deformities of history'.[24] In this respect, Clark argues, in as far as Fried situates the aesthetic experience in a place which is either removed from or elevated above contingent reality, his account of it is indelibly marked by bourgeois notions of consciousness and freedom: 'The interest [in art] is considerable because the class in question [the bourgeoisie] has few other areas (since the decline of the sacred) in which its account of consciousness and freedom can be at all compellingly phrased.'[25]

On a less political note, it would be reasonable to argue that the locus of Fried's version of aesthetic contemplation – this inwardly inflected, more-or-less private revelation of the noumenal – is at odds with the broad drift of modernist culture as it unfolded in the post-war period. Perhaps it was deliberately so. Certainly it is tainted by a desire to escape from, or to resist, those aspects of modernity which embrace dislocation, disjunction, doubt and uncertainty as their meat and drink. Ultimately, as Fried concedes, the question is how works of art gather to themselves their audience, how they come to build their constituency of interest. This would suggest that the work of art cannot stand altogether apart from the temper and character of the culture of which it is a part. As Stephen Melville says, there can be no true account of modern painting which does not take full cognisance of 'its violations and excesses – performance work in particular'.[26] By the same token, there can be no account of modern sculpture that does not recognise the collapse of its generic disciplines – carving, modelling and construction – and the movement away from the 'prioritizing of perception';[27] sculpture's romance with the machine aesthetic, technology and the media; the challenge to its very life posed first of all by the ready-made, and afterwards by the happening and the preformed cultural artefact.

In this respect, Fried's historical view emerges as a highly selective one. It takes no account, for instance, of the tradition of the counterculture inaugurated by Dada and surrealism. It chooses to ignore the influence of important post-war movements, groups and tendencies, in America and Europe, which had already opened up the visual arts to forms of practice intended to subvert the objective of the singular masterpiece and the kind of monumentality of which Fried speaks. Often these new formulations were time-based, ephemeral, hybridised or transient. Reading Fried today, one might be forgiven for concluding, for instance, that movements such as pop art, new realism, the Zero Group, Fluxus and destructive and auto-destructive art had never actually occurred.

Indeed, with the benefit of hindsight, Fried's highly prescriptive writings look more and more like a futile attempt to stem a flood of change which, in reality, had already engulfed him. By 1967, when 'Art and Objecthood' appeared in bookshops and news-stands on both sides of the Atlantic, the 'pure-bred' aesthetic horse had long since fled the cultural stable. Even on his own doorstep, the formalist aesthetic he espoused had been overtaken by a new and much more inclusive attitude to the sculptural object and the range of possible experiences it might offer to artist and viewer alike. Pop artists Jim Dine and Claes Oldenburg had shown the way. Their pioneering work in the area of 'environments', and in Oldenburg's case, performance, film and video, had cleared the ground for artists such as Robert Morris, Dan Flavin, Richard Serra and Bruce Nauman to initiate an in-depth exploration of 'placement' as a form of mediation between the factured object and architectural space; for Allan Kaprow's and Vito Acconci's happenings and 'event structures'; for Jasper Johns's and Andy Warhol's simulated objects. By 1967, the definition of the sculptural object had already been expanded to include photographs and film, video and performance work, propositions and declarations, informal scatterings, imaginary sites and specified geographical locations, maps, books and audio-discs.

Both Greenberg and Fried start from the proposition that the modern experience of the world is characterised by uncertainty, disorder and chaotic change, and that faced with this confusion, the purpose of art is to manifest orderliness. In his later writings, especially in his public correspondence with T.J. Clark carried on through the pages of the magazine *Critical Inquiry*, Fried repeatedly denies that this separation amounts to the arid formalism of which he often stands accused. Nevertheless, the undertow of reaction is unmistakable. If the purpose of art is to stand aloof from the conditions which prevail in the world at large, it must also, to a degree at least, deny social, political and historical context. If it is to put its capacity to endure before all else, it is hard for it to escape the accusation of disconnectedness. Furthermore, a close reading of his replies to Clark shows that despite all Fried's protestations, the distinction that he draws between serious art and trivial art privileges the past over the present; disengagement from rather than involvement with the temper of the time. Here is his riposte to T.J. Clark's accusation that the codes of modernist, abstract painting 'lack the constraints of social connectedness':[28] 'Does he [Clark] simply dismiss the insistence by Greenberg and others on the need to distinguish between the large mass of ostensibly difficult and advanced but in fact routine and meretricious work – the product, according to those critics, of an ingratiating and empty avantgardism – and the far smaller and less obviously extreme body of work that really matters, that can survive comparison with what at that juncture they take to be the significant art of the past?'[29]

Thus we can see clearly that underlying Fried's critical assault on the minimalists is an idea of continuity with the past, at least on the level of values. As well as introducing 'theatricality' into sculpture, minimalism is an art built upon negation; an extreme point in the relentless progress of vanguardism's rhetoric of nihilism. It cuts across what Fried construes as the deepest impulse of mainstream modernism

(in sculpture this means Smith and Caro) not to 'break with the pre-modernist past but rather to attempt to equal its highest achievements, under new and difficult conditions…', with the deck stacked, as he puts it 'against the likelihood of success'. Given this scenario the artist is cast in the archetypal role of tragic hero, driven to fight a more-or-less doomed rear-guard action against the forces of scepticism and disbelief. It is interesting to compare this bleak view of the condition of art in the second half of the 1960s with that of the influential Italian philosopher and critic Umberto Eco.

THE OPEN FIELD

Eco too, sees the modern world as 'unstable, crisis ridden, senseless and disorderly', but as a social philosopher and. cultural critic, he is concerned to place the emphasis on positive human qualities: on awareness, involvement and the recognition of the redemptive power of change. For this reason his conclusions about the condition of modern culture are entirely opposite to those of Greenberg and Fried. Where they are largely pessimistic and defensive, Eco is unfailingly optimistic and progressive. It comes as something of a shock, therefore, to discover that his revolutionary work, *Opera Aperta* (*The Open Work*), in which he attempts the first interdisciplinary, critical and theoretical analysis of modern culture and its impact upon aesthetic practice, was first published in Italy in 1962, thus pre-dating Fried's 'Art and Objecthood' by some five years.

Opera Aperta starts by accepting 'complexity' as a precondition of any 'contemporary' cultural endeavour. According to Eco, information – in its broadest sense – is the lifeblood of the modern society: it powers the engine of change; combats 'conformism, unidirectionism and mass thinking', it prevents 'the passive acquisition of standards', it serves to question 'right form' in ethics, politics and matters of taste. Art is a part of the same machinery of transgression. By constantly frustrating its own rules and conventions; by courting diversity; by dwelling in ambiguity; by refusing to exercise closure; by continually frustrating normative expectations, it serves to expand and accelerate the flow of information in favour of new codes and new patterns of behaviour. 'How often', Eco asks, 'have new creative modes changed the meaning of form, people's aesthetic expectations, and the very way in which humans perceive reality?' and he continues: '…here is a culture [the culture of fine art] that, confronting the universe of perceivable forms and interpretive operations, allows for the complementarity of different studies and different solutions; here is a culture that upholds the value of discontinuity against that of a more conventional continuity; here is a culture that allows for different methods of research not because they might come up with identical results but because they contradict and complement each other in a dialectic opposition that will generate new perspectives and a greater quantity of information.'[30]

To grasp fully Eco's theory of 'openness' it is necessary to reach some understanding of the linkage that he makes between 'formal innovation', 'ambiguity' and 'information'.

JON THOMPSON ON POST-MINIMALIST SCULPTURE

We shall start with 'ambiguity' since it is this which, for Eco, distinguishes the 'modern' work of art from all that went before.

Traditional or classical works of art, Eco argues, are in an essential sense unambiguous. They worked always with a preferred reading, and while they were open to misreading or misunderstanding, there was generally only one correct way in which they were meant to be read or understood. By contrast, the work of modern art, he argues, 'is deliberately and systematically ambiguous'; a great variety of potential readings coexist within it, and none can truly be said to be dominant. Ambiguity is generated out of formal innovation and increases proportionately with the breaking of established conventions. As David Robey puts it in his excellent introduction to the 1989 revised edition: for Eco, 'conventional forms of expression convey conventional meanings, are part of a conventional view of the world […] the less conventional forms of expression are, the more scope they allow for interpretation and the more ambiguous they can be said to be; since ordinary rules of expression no longer apply, the scope for interpretation becomes enormous'. Traditional works of art confirm existing attitudes, stabilise cultural prejudices, institutionalise existing patterns of knowledge, and ground existing opinions. The modern work of art, the 'open' work of art, on the other hand, puts all of these things in question by means of ambiguity. This represents a radical change in the relationship between art and the public at large; between the work of art and the viewer. More than this, it places art at the very centre of what Eco calls the 'modern questioning culture'. In its new-found openness, Eco argues, art has become invested with the power to 'go well beyond questions of taste and aesthetic structures, to inscribe itself into a much larger context'; in his view it might even come to 'represent man's path to salvation, towards the reconquest of his lost autonomy at the level of both perception and intelligence'.[31]

We must now turn our attention to the link that Eco makes between formal innovation, ambiguity and his theory of information. Already, by the time Eco was engaged in writing *Opera Aperta*, he was beginning to lay the ground for his later work in linguistics and semiotics.[32] At this early stage this took the form of a fascination with the then fashionable subject of 'information theory', most particularly the mathematics-based theories of Max Planck and the linguistic theories of Roman Jakobson. This interest came to focus around the formula, traceable to Jakobson, that 'the information of a message is in inverse proportion to its probability or predictability' – the more unpredictable a source of information is, the more information it generates.[33] It is important to recognise here that Eco makes an absolute distinction between 'meaning' and 'information'. For him, meaning is something moreor-less fixed, and where it exists in a strong sense, tends to work against the efficacious functioning of information. By contrast, information is characterised as an expanding field: '…it is an additive quantity, it is something added to what one already knows as if it were an original acquisition'.[34]

Information, then, is the natural and necessary offspring of the unfamiliar. Furthermore, because it is liberated from, rather than embedded in, its source, it is

non-confirming – it works against finishedness, completeness or textual closure – and in this respect acts, in the strictest sense, as an opening up.

Even from this very brief description of Eco's interest in 'information theory', it is easy to see how his notion of information ties in with a theory of art based in formal innovations and ambiguity. Formal innovation means the continuous generation of new and unfamiliar patterns, configurations and codes, and these in their turn serve to expand the quantity of available information like ectoplasm around a nucleus. Given this model, the work of art operates at the centre of what Eco calls a 'field of possibilities' and offers up 'a plurality of possible readings', and he examples this by reference to developments in modern physics: 'The notion of "field" is provided by physics and implies a revised vision of the "classic" relationship posited between cause and effect as a rigid, one-directional system: now a complex interplay of motive forces is envisaged, a configuration of possible events, a complete dynamism of structure.'[35]

And this dynamic 'field' of forces interlocks and reacts with 'a continuously altering and sensible subject' – the viewer – displacing the traditional dualism between subject and object.

As befits a synthesiser and a polymath of Eco's intellectual standing, his theory of openness draws upon a wide range of disciplines, philosophical concepts and theoretical topics current at the time. His notion of a 'reactive subject', dependent upon external stimulus as a confirmation of existence, is clearly drawn from the 'existentialism' of Jean-Paul Sartre. We can recognise (as Eco does himself) a profound debt to the phenomenologists Edmund Husserl and Maurice Merleau-Ponty, in his insistence upon 'open reading' and his theory of 'incompleteness': his refusal, in other words, to accept 'closure'. The link that he makes between 'information theory' and perception was essayed first of all by Roman Jakobson and afterwards, more cogently, by Jean Piaget and his circle, and his forays into psychoanalytical theory owe much to the early writings of Lacan. Nevertheless, *Opera Aperta*, at the time of its publication, represented a significant step forward in the developing discourse of art criticism and cultural theory. Certainly it sprang from a close engagement with the most advanced manifestations in art, music and literature available for critical scrutiny at that time. More than this, as a political activist (political in its broadest sense) he was also concerned with the promulgation of his critical ideas at the level of practice.

As a founder member – with Nani Balestrini, Edoardo Sanguineto, Antonio Porta and others – of the Gruppo 63,[36] he set about trying to establish grounds for a renewal of the spirit of Italian vanguardism. The declared purpose of the Group was 'to blow up the invisible structures of the "tiny clique" which governed cultural affairs' and to reveal 'culture as political act'. As Eco himself puts it in his essay of 1970, 'The death of the Gruppo 63': 'We had to call into question the grand system by means of a critique of the superstructural dimension […] Hence we decided to set up a debate

about language. We became convinced that to renew forms of communication and destroy established methods would be an effective and far-reaching platform for criticizing – that is overturning – everything that those cultural forms expressed.'[37]

Despite the revolutionary rhetoric, which has a more than familiar stridency to it, the avant-gardism of the Gruppo 63 is curious in two very important respects. Firstly, it was an avant-gardism of the already established, rather than of the disestablished. Eco, Sanguineto and the rest of the Group were already successful poets, writers and academics, and they started from the proposition that the precondition for subversion in a highly complex modern culture was that you were already a part of the value-forming machinery of that culture. Subversion could only be achieved from within, not from outside. Secondly, in the aesthetic domain, avant-gardism necessitated an acceptance of the existing organs of cultural promotion and distributions: the theatres and opera houses; literary magazines and music publishing houses; the gallery system and museums; publishers, newspapers and the media. The poet and polemicist Sanguineto expressed this in terms of a revolutionary 'rite of passage', arguing that the purpose was 'to turn the avant-garde into an art of museums', and that the new avant-garde would plunge themselves 'into the labyrinth of formalism and irrationality, into the "palus putredinis" of anarchy and alienation with the hope of really escaping from it, perhaps with dirty hands, but certainly with the mud left safely behind us'. The vision of the vanguardist revolution espoused by Gruppo 63, then, was of a revolution which took place from within the confines of specialist discourses. Its purpose was to put those discourses into a more-or-less permanent state of internal transformation. In the case of the visual arts, this posited a new and more interventionist role for the museum: making it the proper site for the most extreme manifestations of the avant-garde impulse.

With all of Eco's early writings it is difficult to make a clear distinction between original, speculative thought and closely observed cultural commentary. Certainly by the time Gruppo 63 was formed, some of the changes pointed up by their new avant-gardism had already begun to take place. The growth of the new critical disciplines in the social and political sciences, in the universities of North America, Britain, France, Germany and Italy, had produced a new generation of politically educated young people from the ranks of the affluent middle classes. Thus it was that when the student revolutions of 1968 started, it was the university departments of sociology, social anthropology, political economics and political science which led the way, reversing the classic Marxian narrative of the proletarian uprising. This was a revolution engineered by the bourgeoisie and staffed by the bourgeoisie. Its revolutionary discourse was powered by the new academia. It was a revolution bent on exorcising the newly awakened conscience of a class which had come to see war and social disadvantage as a devastating indictment of its own political philosophy and political institutions. In this respect, the project of Gruppo 63 had been overwhelmed by events. As Eco himself relates in 'The Death of the Gruppo 63', the clarity of a revolutionary scenario based upon the idea of giving a voice to the oppressed summed up in Lacan's famous question, 'Who is to speak?' – had been

transformed into questioning of a more distanced kind: 'Who is one speaking to?'; 'How is one to do it?'; 'Why?'; 'Should one go on speaking at all?'

The transformation in the culture of the visual arts, although less obviously dramatic, more-or-less paralleled developments in the political domain. The middle and late 1960s constituted a period of great turbulence and change. Already by 1965, the museums had begun to open their doors to young, living, avant-garde artists. New kinds of exhibition space had opened up – converted warehouses, old garages and disused factories – operating outside the confines and financial constraints of the art market. First the minimalist and then the conceptual artists had set about testing the capacity of the traditional commercial gallery to deal with the 'unsellable' work of art. The sculptural object had been massively increased in size, dissolved altogether, reconstituted as process, as event, as direct intervention in landscape. Installation and site specific work had brought the sculptural project into more complex relationship with architecture and landscape, as well as with the existing institutions of promotion and patronage.

On the theoretical front, the critical arguments surrounding the practices of painting and sculpture had been subsumed, incorporated into the wider cultural debate inaugurated by structuralism and the New Linguistics. The question of value – of art's enduring value – in the terms in which it had been couched first by Clement Greenberg and afterwards by Michael Fried (namely that painting and sculpture possessed unqualified, intrinsic merit as distinctive aesthetic practices, precisely because they were 'univocal' and spoke only in the dumb language of their own immutable 'presentness'), seems unsustainable when subjected to the searching general critique of structuralism. If we take the generic practices of art to be languages of some kind, subject to the same rules of interpretation that govern language in general – the complex interplay of codes, schemata and mechanisms of selection – then it follows that topics such as 'purity', 'instantaneousness' and 'presentness' in the Friedian sense are reduced to something approaching wish fantasy.

But this complex question should not be left here. As the structuralist Claude Levi-Strauss argues in his 'Ouverture' to his classic work *The Raw and the Cooked*,[38] to define the various practices of art as language presents important theoretical difficulties. Works of visual art, Levi-Strauss argues, are 'grasped in the first place through aesthetic perception and secondly through intellectual perception, whereas with speech the opposite is the case'. This reversal in the normal perceptual order by which language is understood – giving primacy of the perceptual over the intellectual – would seem to offer some scope for the kind of experience Fried, at least, is arguing for, although not, perhaps, in the transcendent terms in which he argues it. Be that as it may; more germane to the discussion here is the debate that Structuralism inaugurated around the question of 'seriality', which brought Umberto Eco into direct dispute with Claude Levi-Strauss. A rehearsal of the argument brings us full circle to the 'one thing after another' theory of forming, espoused by Donald Judd and Frank Stella in their interview with Bruce Glasser

'Structural thought', Eco argues, is an attempt to adduce 'eternal structural principles' out of the complex interaction of the whole diversity of existing language forms, 'the deepest generative structures underlying all grammar, and all negation of grammar, as well as every selective system'. In this respect its ambition is to provide 'deep' explanations for existing states of affairs. 'Serial thought', on the other hand, 'is an activity that involves the production of forms'. He continues: 'Permanent structures may well underlie all modes of communication, but the aim of a serial technique (technique rather than thought – a technique that may imply a vision of the world, without being itself a philosophy) is the construction of new structural realities and not the discovery of eternal structural principles.'[39]

The weakness of structuralism in relationship to aesthetic operations, then, for Eco lies in the fact that it is a theoretical model which pretends to deal not only with forms as they are, but also with formations which have yet to occur. His criticism is that such a model may, in the end, lack sufficiency.

The importance of Eco's observations regarding structuralism to our understanding of the developments which occurred in the visual arts in the late 1960s and early 1970s cannot be overstated. Indeed, the change of outlook which took place as minimalism shaded almost imperceptibly into post-minimalism and arte povera could perhaps best be characterised as a change of the kind Eco is pointing to: a movement away from 'thought' – the deployment of some kind of structured, holistic principle of forming – towards 'technique' – ways of dealing with things which were non-predictive. Such a rationale would also serve to explain why, in the wake of abstract expressionism, the focus of aesthetic practice moved so dramatically in favour of sculpture as the predominant fine art practice. It was sculpture that appeared to give the greatest scope for innovatory 'techniques' – I use the term as Eco intends it, to mean strategies rather than methods. It was sculpture that permitted new kinds of operations and new ways of structuring the relationship between the work of art and the viewer. Where the capacity of painting to invent new strategies of forming seemed to have exhausted itself, sculpture presented the practitioner with a seemingly endless horizon of new possibilities.

The degree to which Eco's writings influenced the work of the post-minimalists and arte povera directly is hard to say. We have no means of knowing which artists had read or were aware of *Opera Aperta*, for instance, or his classic riposte to Claude Levi-Strauss, *La Struttura Assente (The Rise of Structure)*,[40] published in 1968, the year the students occupied the University of Turin. Certainly Eco's writings provide the most vivid, informed and precisely weighted account of a critical moment of transition in terms of the history of modern culture.

The affluence of the post-war period in the countries of the West had allowed the rapid expansion of the education system to encompass a wide cross-section of class interests. Even so, this egalitarianism had only reached so far, exposing at the same time the deep-rooted societal rigidities which sustained urban poverty,

social disadvantage and racial prejudice. The Vietnam War had brought to the surface questions pertaining to western imperialism and democratic freedom, which in America led to a prolonged confrontation between the people and the hierarchical structures and institutions of government; and in the countries of western Europe, to a ground swell of anti-American feeling amongst the students and the new intelligentsia. All of these issues were brought into sharp focus by the student uprisings of 1968. But beneath the frenetic surface of events a far more fundamental confrontation was taking place. The issue, in the political sense, was one of power. Where, in the emergent technological society, did power reside? How was it to be deployed and on whose behalf? And in the ethical domain, whose values were to prevail, those of the political and professional 'elites' who dominated the formations and instruments of the state, or those of the broad mass of ordinary people? In short, the events of 1968 represented a new kind of class struggle along 'Gramscian' lines,[41] a struggle between a newly politicised, critical intelligentsia and the established interests of the several 'hegemonies' – to use Gramsci's term – that constituted modern government: politics, economics, law, education and religion. This was a revolution which despised Soviet-style state socialism as much as it distrusted rampant capitalism. Rather than Karl Marx and Vladimir Ilyich Lenin, it took G.W.F. Hegel and Antonio Gramsci as its theoretical progenitors, placing the revolutionary emphasis on action rather than a thoroughly worked out ideology expressed in words. For this reason it lionised Mao Tse-Tung, Che Guevara and Fidel Castro. It sought an ideal, participatory, socialist democracy, possessed of 'moral direction' and built upon the Gramscian principle of polycentralism – diversifying the instruments of decision-making to encompass people from all walks of life. It also represented an important theoretical change of direction for the culture of the left: shifting the attention from base to superstructure; from the economic foundations of the society to its cultural configurations; from an obsessive concern with structural questions to an interest in 'organic' evolution; and from the modes of production to the means of communication. Most importantly, it envisaged a truly liberal socialism, which could embrace the aesthetic of 'modernity' as a valid cultural project as well as the politics of the factory and the field.

The historical development that preceded this important revolutionary moment coincided almost exactly with the rise to prominence of the neo-minimalist artists in America: the generation of Eva Hesse, Robert Morris, Bruce Nauman, Richard Serra, Robert Smithson and Keith Sonnier; with the emergence of arte povera in Italy: Giovanni Anselmo, Luciano Fabro, Jannis Kounellis, Mario Merz, Giulio Paolini, Giuseppe Penone, Michelangelo Pistoletto and Gilberta Zorio; and with a new generation of artists in northern Europe: amongst them Barry Flanagan and Richard Long in Britain; Marcel Broodthaers and Panamarenko in Belgium; and Joseph Beuys and Reiner Ruthenbeck in Germany. In stark contrast to the Minimalists, these artists saw themselves, in the first instance, as part of a distinctive international tendency, showing together in exhibitions on both sides of the Atlantic. By the middle of the 1960s, however, this initial spirit of unity had begun to break down. In

part this was connected with the increasing power of the New York gallery system, which, supported by the immense purchasing capacity of America's museums and private collectors, had come to dominate not just the American art market but the European art market too. As the American critic Dan Cameron has documented, when Robert Rauschenberg carried off the first prize at the Venice Biennale of 1964, 'it was as if someone had challenged Europe's honour directly'; more importantly, it provided the Italian critic Germano Celant, with the opening he needed to launch arte povera as a specifically Italian phenomenon. Significantly, Cameron argues, Celant's text of 1968, in which he uses the term 'arte povera' for the first time, is subtitled 'Notes for a Guerrilla War', and while Celant does not refer to America by name, the idea of poverty is intended as a rebuff to the money-led, propagandistic and competitive aspects of the American art market.

But to dwell too much on the internal politics of the art world is to concentrate on the symptom rather than the disease itself. Anti-American feeling had been increasing in the countries of western Europe from 1962 onwards, and when in 1964 the American Congress passed 'The Gulf of Tonkin Resolutions', committing America to direct military involvement in the Vietnam War, thus ensuring a substantial escalation of the conflict, what had existed as an undercurrent of protest surfaced as a widespread and highly vocal opposition led by students and intellectuals. America's image as the protector of liberal, democratic ideals was suddenly eclipsed by a vision of her as a rampaging imperialistic power, bent upon the military subjection of a small and economically backward Asian country. In this respect the fragmentation which occurred in what, for the sake of argument, we will call the international post-minimal tendency, was only a reflection of a much deeper malaise: a breaking up of the political and cultural consensus binding together the western democracies. Viewed in this light, Germano Celant's 'declaration of Italian independence' was clearly grounded in a politics of protest which reached far beyond the confines of the art world. Nevertheless, there remains something chimerical about Celant's protestations of independence. In as far as he was seeking to align the aesthetic avant-garde with the political avant-garde occupying the universities of Milan, Turin and Rome, he was also, by implication, aligning it with the anti-war demonstrations that were sweeping the campuses of America's universities: Berkeley, Ann Arbor, Wisconsin and Kent State.

Today it is against art-historical fashion to view post-minimalism as a tendency, and arte povera in particular as representative of a crucial revolutionary moment – even of the last possible revolutionary moment. And yet, if we address the literature that attended these movements, the feeling that emerges most strongly is that of a vanguardism of the kind that was advocated by Eco and the rest in the Gruppo 63: a vanguard of 'insiders', bent upon revolutionising the very institutions of which they were already an accepted part. The idea of 'poverty' as described by Celant is clear in this respect. In his 'Arte Povera: Notes for a Guerrilla War' he says this is 'a "poor" inquiry that aims at achieving an identity between man and action, between man and behaviour'[42] (a formulation which finds a neat equivalent in Rosalind Krauss's

description of the work of Eva Hesse and Richard Serra as a sculpture 'of activity and effect'),[43] and this makes no sense except when viewed from within the confines of an already elaborated, specialist discourse. In fact, Celant himself is quite explicit on this point, declaring that this 'poor inquiry' does not seek 'dialogue with the system of society or that of culture'. It would seem then, that 'poverty' is defined in opposition to an 'affluence' which Celant perceives as already characteristic of the formations and procedures of art itself.

On a superficial level it would be easy to construe the change from 'affluence' to 'poverty' in strictly technical and material terms: as the rejection of sophisticated ways of forming things in favour of simple processes and structural directness. But it is perfectly clear that Celant means more than this and the clue to this surplus is to be found in his use of the term 'essential information'. 'Poor' art, Celant argues, 'prefers essential information'; it is an art, in other words, which is stripped of superfluous meanings. It addresses the viewer on its own terms, without the obfuscations and mediations of existing interpretive structures. Thus the 'poor' work of art is a 'transparent' work of art; it hides nothing, it carries nothing within its interior space least of all the psychological trappings or biography of its maker. 'Poverty' is revolutionary, then, because it represents a clear shifting of the locus of authority, away from the artist to an authority of interpretation invested in and by the viewer, through their direct engagement with the work of art.

Thus it is that the process of 'empowerment' which began with David Smith emptying out the solid sculptural form and using formal dislocation as a way of encouraging the act of reading, reaches its conclusion with post-minimalism and arte povera. 'Poverty' had finally turned the viewer into the one who 'acts'.

JAMES TURRELL
ON JAMES TURRELL

James Turrell: Air Mass
1993

Since the late 1960s, the American artist James Turrell has made installations, or 'perceptual environments', using natural or artificial light as his raw material. This exhibition of Turrell's work, held at Hayward Gallery in 1993, was the first solo show by the artist to be held in a public institution in Britain. James Turrell: Air Mass *featured three of Turrell's installations –* Wedgework IV *(1974),* Trace Elements *(1990) and* Air Mass *(1993) – as well as documentation about his immense environmental artwork* Roden Crater. *For this exhibition, one of Turrell's* Skyspaces *– which enable heightened perception of the sky and act as sites of contemplation and revelation – was constructed on the Gallery's outdoor sculpture terrace.* James Turrell: Air Mass *was accompanied by a book developed by the artist in collaboration with editor and publisher Mark Holborn, which featured two autobiographical texts by the artist alongside his drawings and photographs.*

NIGHT CURTAIN

My father was very fond of birds. As the director of a technical school in Pasadena and an aeronautical engineer, this interest in birds was a Romantic parallel to his involvement with flight. He loved to call in the birds, whistling in their unique way. Using more than one tone, by adding an overtone of a third, a fourth or a fifth to his whistle, he made the complex calls of various birds. These overtones were achieved by whistling the primary note, then changing the shape of the mouth by puffing out part of the cheek to get the overtone. He called in the birds to feed them. He particularly liked the mockingbird, because this bird imitated the songs of the other birds. He was able to introduce a song of his own to that of the mockingbirds.

My father would sit on the roof of the laundry closet, which was accessible from the second floor of our house, and call the birds to feed. Eventually he made a better place by roofing over the area and putting windows on three sides, so creating a special spot from which to call the birds.

This was a very odd time in America. It was 1942, and war had only recently been declared. There was great paranoia about the possibility of Japanese attacks on the West Coast. On one extraordinary night there was an incident which was a response to a real or imagined attack on the city. The anti-aircraft positions opened fire at what were thought to be attacking aircraft. Los Angeles was such a large city that shells fired from one part of the city would come down in another part of the city. This gave the impression there was an attack. Other positions returned fire, resulting in a large gun battle. No one knew for sure if there was an enemy attack. It seems Los Angeles has a long tradition of making no distinction between the imagined and the real. However, there was considerable damage to scattered parts of the city.

On the night of this attack, my father and mother celebrated the completion of the bird feeding room. In the midst of this real or imagined attack I was conceived. The bird room became my room. The events of that night showed that imaginary events could have as much effect on reality as events which were physically real.

At Pasadena Junior College my father developed programs where the students actually built what they had designed. The architectural students built the houses they had designed, and the aeronautical engineering students built aeroplanes with an advanced design by Max Harlow. The Harlow PJC-2 was designed in 1934, built in 1935 and 1936, and licensed in 1937. It was a monocoque plane, which meant that there was no framework other than the skin itself. It had low wings, retractable gear, a fully faired engine and an enclosed cabin. One of the constructed examples was purchased by Howard Hughes, who later hired Harlow to build the H-1, the Hughes Racer. This famous plane had the same elliptical, low-wing, almost laminar-flow look to the design. One of my father's students, now an airline pilot, owns a PJC-2, which he had worked on as a student. I have flown this plane.

A connection existed between my father's involvement with the aircraft as an instrument of flight and the natural flight of birds, as well as with the birds as instruments of song. As a child, I had to surrender my room to my father when he needed to call in the birds. The room was inhabited by my father's presence and the birds' song. The room, with its windows on three sides, provided a panoramic view of 270 degrees. The wainscot rose 42 inches up to the window frames. The windows opened up completely so the birds could come in, while my father was protected from the rain and, in particular, the sun. This was important since he was fair-skinned and burned easily. He would sit endlessly and call in the birds. The room was occupied by song.

In my youth there was the considerable presence of astronomy in Pasadena. On Mount Wilson was the Hale Observatory. The huge 200-inch telescope of the Palomar Observatory was being created at Cal Tech in Pasadena at that very time. I went to school with the daughter of Horace Aubrey, the head of Mount Wilson-Palomar. Even my elementary school was named after the astronomer George Ellery Hale. There was considerable public interest in deep space.

Probably as a result of the air attack back in 1942, an edict had been issued for all houses to place blackout shades over the windows at night. My room had these dark green curtains with tar in the middle that were completely opaque. You could pull them down and make the room quite dark in the day, although some light would come in around the edges. When I was six years old, in order to assert my own presence in the room, I took a pin or needle to these curtains and pierced them to make star patterns and the constellations. I would simply make bigger holes for stars of greater magnitude. Pulling down the curtains and darkening the room, you could see the stars in the middle of the day.

These weren't just holes in the curtains, they were holes in reality. By changing the reality of the conscious-awake state of day, one could see further into imagined space to the stars, which were actually there but obscured by the light of the sun. In the same room my father could still raise the curtains and open the windows to allow in the birdsong. The curtains did not last long and began to tear because they were riddled with so many holes. Several curtains were greatly weakened by the Milky Way.

Years later, after my father had died, I returned to the room. When consciousness leaves a space or an object there begins a death, a leaving. The room was no longer vital. But I heard a mockingbird. It sang my father's song.

EARLY FLIGHT

I had flying experiences when I was young but my early memories of flight are influenced by stories, particularly the writing of Antoine de Saint-Exupéry. He described spaces within space, not defined physically by the architecture of form, but by pressures within the atmosphere that advance in the sky. He wrote about the experience of night flight with the advance of light or darkness. In *Wind, Sand and Stars* you gain a sense of atmosphere advancing to form amazing spaces that can be entered by flight.

I was also very interested in the idea of the journey into these spaces, so that consciousness moves into and inhabits the sky. The aeroplane is then seen as an instrument that comes from our own sensibility and takes us into space. There are people who have inhabited the space of the sky for some time – the Tibetans in the Himalayas, the Hopi on top of the *mesas*. The Hopi live near the cloud base of the summer cumulus which pass closely overhead. In a true sense they are actually inhabiting the sky.

As my father was particularly interested in aeronautics, I decided to be interested in sailing, an irony not lost on my mother. I built small sail boats. My father gave me a copy of the journal of Joshua Slocum, the first man to circumnavigate the Earth by sea, singlehanded, in the late 1890s. Sir Francis Chichester was the next to do it almost a century later. I was very interested to read about the voyages, which were journeys of self into another realm. It is in such accounts as those of Saint-Exupéry, or Slocum, or Chichester that you find the imagined merging with the real in the same way that truth can become stranger than fiction.

All this is connected with the expansion of territories of the self. At night in the city, light pollution closes off access to the stars. It actually physically limits the extension of our territory into the universe. It psychologically encloses our world and limits territory. My interest in flight, the journey and the sky is not much different from the Peter Pan syndrome of many artists. We do not wish to grow up because we want

to have a life where the imagined can be as 'real' as that which is commonly agreed upon as reality. The expansion of this 'shared reality' then seemed to create a clear purpose to the somewhat solitary acts of these journeys of self.

My greatest interest in flying is soaring. Soaring gives a very good understanding of the conservation of momentum. There are no worries about 'engine out' experiences because your entire flight experience is 'engine out'. Landings are carefully planned. Soaring is flight which uses air that is moving upward, either from mechanical convection blowing against the moving upward, either from mechanical convection blowing against the mountain, or from the lift provided by thermals, which in summer is usually marked by the build-up of cumulus cloud, or by mountain lee wave. This lee wave is created by an obstruction which causes waves in the atmosphere downwind of the obstruction similar to standing waves in water downstream from a large stone. You find the waveforms, for example, behind the Himalayas, the Sierra Nevadas and the Rockies. There are even waves that come off certain landforms in England. New Zealand has very good wave soaring. Soaring is more than gliding, which is merely a downhill ride. Soaring is about getting up, staying up and going somewhere. There are also the jet streams, narrow streams of high speed air usually between the troposphere and the stratosphere, which some people are thinking of soaring, though no one has done it. The jet stream twists like a braid. If you are looking to the east, it rotates in a counterclockwise mode. In the southern quadrants you could find lift and follow it, thus sustaining flight.

On a soaring journey you can plan a flight path advancing through interconnecting cones of possibility for landing sites, as when crossing a stream you don't leave one stone until there is another stone within stepping distance. With engineless flight the imagined cone is inverted, with the point over a possible landing field. The higher the altitude, the further away you can be from your landing site. The cone of possibility increases in size as you go up in altitude and is tilted towards the wind; the more you are upwind of the site, the further back you can glide downwind to land. When you have another landing site where cones of possibility coincide, you can advance into the next cone and proceed on your journey. Today's gliders have glide ratios of more than 50:1. If you are one mile up, you can glide 50 miles before you contact the Earth without either updraft or downdraft, so you have very large cones of possibility and soaring becomes easier. In streeting clouds – clouds which arrange themselves in lines – you do not even need to spiral. Flying under the cloud streets, you merely pull up when you meet updrafts to stay in them longer, and you push over to speed up as you pass through downdraft areas. This is sometimes called 'dolphin flight'. There are many new strategies to flight now which make it possible to stay up most of the day without power. Soaring flight is like that of hawks, buzzards and eagles.

Flying out of south-east Asia, over Tibet and amongst the Himalayas, I saw great mountains, jungle and beautiful terrain on journeys that expanded the territories of self. As the instrument of flight becomes more refined, we begin to intellectualise

the process and subvert the experience, so that pilots judge each other by their abilities in instrument flight (flight without seeing outside the plane) and in the quality of the landing, which is no more than the termination of the experience. It is like judging the dream by the manner in which you awakened. The more you have extraordinary experience in flight, the more you realise the difficulty in passing on the experience to others. Your experience becomes such that it is almost too difficult to talk about it. It seems useless to try to transmit the experience. It would be easier to send others on the flight itself. The idea of the Boddhisattva, one who comes back and entices others on the journey, is to some degree the task of the artist. It is a different role from that of one who is there when you get there. The Boddhisattva entices you to enter that passage, to take the journey. This is where I began to appreciate an art that could be a non-vicarious act, a seeing whose subject was your seeing.

With the experience of extremely high altitude flight, new vantage is gained. The veneer of atmosphere and surface of Earth exists as an emulsion, as holder of image, holder of life. We develop, emerge out of Earth and fade back into it. Our convention of burial mocks civilisations' disintegration into Earth. Civilisations are buried in the sands of time, then they can become exposed again. I began to see aerial photography as a form that looked upon the surface of the Earth almost as the emulsion to be developed. Ancient cultures are revealed through differences in crop water retention, as with the discovery from the air of Woodhenge in England. Other cultures are dissolving back into the surface. Flying over the jungle and seeing the extreme beauty, you are aware that the jungle has swallowed many planes. Craft go down and jungle folds right over. Out of the jungle other remnants of culture emerge such as the forms of stupas and temples – amazing visages.

Installation view, *James Turrell: Air Mass*, 1993

Throughout Asia there are temples in large stupa form. The stupa which exists in Tibet is generally a solid form which is not entered. The symbolic language of the architecture reflects the relationship of Earth to heaven and of conscious-awake daytime state to dream states and planes beyond. These relationships are expressed in the shapes of the stupa, from the base to the dome to the antenna.

When these forms emerged later out of memory, I wanted to make similar forms that were physically entered. Instead of symbolising the relationship between the physical plane and those beyond, I wanted a visual confrontation between physical seeing and spaces that created an experience of seeing, familiar to us beyond our conscious-awake state, only we had never experienced it that way. This would be a seeing where the space of the sky would be brought into contact with the space we were in, as in *Air Mass*. The sky would no longer be out there, away from us, but in close contact. This plumbing of visual space through the conscious act of moving feeling out through the eyes, became analogous to a physical journey of self as a flight of soul through the planes.

174 JAMES TURRELL ON JAMES TURRELL

The most interesting places for physical flight generally have large topographical differentiation – mountains, valleys, eroded stone formations – places that give a sense of the surface of the planet. The American Southwest has this in the topography of Monument Valley, Grand Canyon, Lake Powell, Canyon de Chelly, the Painted Desert and the Rockies. This topography invites flight close to the Earth. This 'nap of Earth' flight provides a constantly changing perspective.

The space up from this terrain is inhabited by weather phenomena. Heat structures are created in the thunderstorms and incredible visual worlds exist above the Earth. Most action is at the weather front, the pressure dip. Frontal passage signifies entry into another air mass. This weather 'picture plane' also brings a visual change in the weather, squall lines, dense curtains of rain and stacking cloud layers. Flight in the area of the front is not always recommended, but it is usually exhilarating. I remember Saint-Exupéry's description of a flight over the sea between water spouts that existed like Greek columns from sea to cloud. Everything was very still except for the water spouts.

In the same way we co-inhabit the spaces within the sky through the instrument of flight, we can consciously inhabit this space by moving the feeling of vision out

through the eyes and so move consciousness out into the space. This is not to say that flight is not useful for the expansion of one's territory, only that the instrument of flight can sometimes subvert the purpose of the journey. At the time of the space race I was interested in our need to go to the moon, to substantiate our arrival in space. Although the Earth *is* a far bigger orb than the moon, we do not feel ourselves to be 'in space'. We had to go to the moon and step on to it in order to have entered space. In 1969 we went to the moon and came back with the moon rocks. Three of these were displayed at the gallery at UCLA in triangular, prismatic, sealed and evacuated glass cases set upon sculpture stands. They were most ordinary looking rocks, appearing as if they had been found in someone's backyard. There was nothing distinctive about them. I was there for half an hour. Another couple was also examining them. We passed around the three stands, looking at each other and looking at the stones. Later in Japan, I was visiting the Osaka Expo, where the rocks were exhibited in the American Pavilion. Crowds of Japanese rushed to see these same three rocks. For us, our stone is the moon itself. We behold the cosmos through the macrocosm. The Japanese on the other hand, attuned, or perhaps conditioned, through the art of *bonseki*, the art of garden stones, and through other forms of visual poetry, are able to see the cosmos in a single stone.

I had gone to Osaka in connection with an art and technology project on which I had been working in Los Angeles. Sam Francis had lent me his studio in Tokyo. I also made a trip south to Suwanose and the Amami islands, along the volcanic chain between Kyushu and Okinawa. I was very impressed by some of the traditional Japanese forms of art, which seemed so modern. I also realised that the young Japanese artists had to react in some way against their own traditions in order to be artists. When I originally visited Europe I realised that it would be difficult to be an artist in Europe because so much art had already been made and the culture constructed. In northern Arizona there is little culture, but Frank Lloyd Wright, Max Ernst, Frederick Sommer and Zane Grey each existed here in isolation.

Having been raised as a Quaker, I was responsive to the straightforward, strict presentation of the sublime, which Japan seemed to offer. Through Sam Francis's father-in-law, a distinguished Japanese, I was introduced to the Japanese garden. I originally visited a garden near Izumu. After sitting for some time I went to the toilet. It was a low toilet over which you squatted. Then I noticed at eye level a small triangular window, which provided another view of the garden. The view opened onto the same part of the garden as a larger window above, except the view was scaled down. The small rocks appeared as mountains, blades of grass became wooded hillsides and the *bonsai* looked like large trees. The microcosm had become a macrocosm, which perfectly echoed the motifs and forms of the larger view. I then realised that the garden should be viewed from numerous vantage points. The garden assembled a universe of seeing, enabling you to pass from microcosm to macrocosm and back. Unlike many Western gardens where you have limited dimensionality, here the pattern of the design was submerged into different levels. On the surface it seemed as if there was no overall organisation

and the garden quite naturally dissolved into the far hillside. You had no sense of where the garden began or ended. I was discovering the depth of thought behind the design. Flying had also changed my perspective and sense of territory, allowing me different vantages. Saint-Exupéry remembered driving to the aerodrome in a taxi and realised that the lives of the people on the ground were defined differently because they never saw from the other vantage point of flight. But with this vantage came responsibility.

I was engaged in both cartography and photography. I was also an artist developing an art that was concerned with light. I came to the installation works wanting to bring the light of day into a landscape. I did not want to make a mark on the surface of the Earth. I wanted to employ sunlight, moonlight and starlight to empower a work of art. Instead of competing with the sunset, I wanted to use it, to take it in. I created spaces with a similarity to the *camera obscura*. I wanted the spaces entered to be an expression in light of what was outside. I formed an interior space to be sensitive to that which occurred in the space outside – a sensing space. The stupas that I saw in the jungle represented this relationship of inside to outside, of Earth to cosmos symbolically. The experience of inside is formed by that which occurs outside. Looking into the interior space, we are observing a space which is itself looking. This inside space becomes an expression of the outside. Similarly, my work is not so much about my seeing, as it is about your seeing. There is no one between you and your experience. It is a non-vicarious art.

I work with the convention of the picture plane and framing. The first way of doing this is when the work is out, away from you, existing simply as a picture. Then you come to enter it through seeing. The second way involves the 'window' of the picture plane, which is brought forward so that one enters the whole piece. The third way is when the picture plane is almost pulled over your head like a shirt. The light from inside then meets the light from outside in such a way that it becomes insignificant to determine from where exactly the light comes. You may ask yourself in the dream from where the light of the dream comes. The dream light has more clarity and lucidity of colour than light through open eyes. At times this seeing that we are able to generate from inside, as in the dream, merges with the seeing from without. This situation is manipulated in the dark spaces.

The picture plane is analogous to weather phenomena. The pressure front is the place of action between cold air and warm air. If you are on stage, the stage lighting can make it impossible for you to see the audience. You are in the same space, architecturally and physically, as the audience. They see you and the people in front of them. You see only the stage and into this mist. The penetration of vision is stopped without physical form. In the same way the sun lights the atmosphere during the day and you cannot see the stars. Take the lighting of the atmosphere away and the stars emerge out of the twilight. Similarities exist with a weather front. Action is at the trough or the pressure dip. Visual penetration can end at the front or extend through it. Again, without solid form, penetration of vision can be halted.

First, I am dealing with no object. Perception is the object. Secondly, I am dealing with no image, because I want to avoid associative, symbolic thought. Thirdly, I am dealing with no focus or particular place to look. With no object, no image and no focus, what are you looking at? You are looking at you looking. This is in response to your seeing and the self-reflexive act of seeing yourself see. You can extend feeling out through the eyes to touch with seeing.

When I went to Japan, especially to Suwanose, an active volcanic island, I felt to be on a living surface. The Earth was a living skin. The aerial view reveals the vitality of the Earth and the passing and re-emerging of cultures. Geology reinforces that view with the movement of continental plates, with subduction and volcanic re-emergence. I remember earthquakes in California, but on Suwanose the ground shook daily. Volcanoes, of course, connect to the centre of the Earth with molten magma. The moment I saw the chain of volcanic islands south of Japan, I knew I wanted to find a volcano myself. Volcanoes and islands have a terrestrial *thingness* to them. Likewise, my interest in the perception of light is in giving it *thingness*. It exists just as a physical object has presence. I make *thingness* of perception by putting limits on it in a formal manner. There is no object there, only objectified perception. By putting into question physicality and *objectness*, the work may reveal more about physicality than any physical object.

The spaces I encountered in flight encouraged me to work with larger amounts of space and with a more curvilinear sense of the space of the sky and its limits. The *Skyspaces* worked with limited amounts of the sky space brought down to and against the rectilinear limits of the interior space. There is little shaping of the limits within these spaces.

If you stand on an open plain you will notice that the sky is not limitless and it has a definable shape and a sense of enclosure, which is referred to as celestial vaulting. If you lie down the shape changes. Clearly, these limits are malleable. I looked for a hemispherically-shaped, dished space, between 400 and 1,000 feet above a plain, in order to work with the limits of the space of the sky. The plain would provide the opportunity for celestial vaulting. The dish shape would effect changes in the perception of the size and shape of the sky. The height above the plain was important so that the slight quality of concave curvature to the Earth experienced by pilots at low altitudes would increase the sense of celestial vaulting after you emerged from the crater space. I also wanted a high-altitude site so that the sky would be a deeper blue, which would increase a sense of close-in celestial vaulting from the bottom of the crater.

I flew all the Western states looking for a site and found Roden Crater, a volcano on the edge of the Painted Desert. Rather than impose a plan upon the landscape, I decided to work in phase with the surroundings of the volcano. The site is approached from the west, driving across the desert. The road makes a half circle on the north side of the crater and comes up a ravine on its northeast side. At the

top of the ravine you reach a walkway that follows the circular malapai rim of the fumarole on the northeast side of the crater. The walkway is approximately 250 feet above the plain and gives the first sense of the expansion of space. From here, a trail proceeds up the side of the fumarole. At the top of the fumarole there will be several different spaces, which are themselves pieces which work with the space of the sky. Some of the events in the spaces might occur daily, some semi-annually, equidistant from the solstices, and others will be very infrequent. From these spaces on top of the fumarole, a tunnel extends 1,035 feet and is aligned to capture the southernmost moonset. The tunnel is a semicircular arch 8½ feet in diameter and 9 feet tall. It will allow full vision of the lunar disc when the alignment occurs. As you proceed up the tunnel you will be able to see only sky. The entrance from the tunnel into the crater is made through an intermediate space and as you emerge the sense of enclosure will recede as you enter the large space of the open sky.

At Roden Crater I was interested in taking the cultural artifice of art out into the natural surround. I did not want the work to be a mark upon nature, but I wanted the work to be enfolded in nature in such a way that light from the sun, moon and stars empowered the spaces. Usually art is taken from nature by painting or photography and then brought back to culture through the museum. I wanted to bring culture to the natural surround as if one was designing a garden or tending a landscape. I wanted an area where you had a sense of standing *on* the planet. I wanted an area of exposed geology like the Grand Canyon or the Painted Desert, where you could feel geologic time. Then in this stage set of geologic time, I wanted to make spaces that engaged celestial events in light so that the spaces performed a 'music of the spheres' in light. The sequence of spaces, leading up to the final large space at the top of the crater, magnifies events. The work I do intensifies the experience of light by isolating it and occluding light from events not looked at. I have selected different portions of sky and a limited number of events for each of the spaces. This is the reason for the large number of spaces. Each space essentially looks to a different portion of sky and accepts a limited number of events.

I wanted to advance from the floor of the desert up into the sky. I did not want to go up a mountain and down into a hole. This is the reason for the tunnels leading to the top. Advancing from the east or the west, the path up into the bowl describes a stepped or truncated pyramid that arrives at a bowl at least 600 feet above the surrounding terrain. In this top space, the sky literally changes shape as you move about the crater. Lying down in the top crater space you can notice the shape of the sky change. Clearly this shaping of the sky is malleable and formed by our perception. After you walk out of this space and up to the top lip of the crater and then look out over the horizon, you will notice the Earth slant beneath and towards you. People flying between 600 and 3,000 feet notice the Earth curving beneath them the wrong way. This sense of concave curving below balances the sense of the convex curving of the sky above. The volcano, the bowl-shaped space above the plain, provides the possibility for this conjunction.

ADRIAN SEARLE
ON PAINTING

Unbound:
Possibilities in Painting
1994

Unbound: Possibilities in Painting was co-curated by Adrian Searle, art critic and painter, and Greg Hilty, curator at Hayward Gallery. The exhibition, which was intended as a 'strong and provocative account of... painting today', featured 14 international artists who were taking painting in new directions. These artists were: Juan Davila, Peter Doig, Gary Hume, Zebedee Jones, Raoul De Keyser, Imi Knoebel, Michael Krebber, Jonathan Lasker, Olivier Mosset, Fiona Rae, Paula Rego, Julião Sarmento, Jessica Stockholder and Luc Tuymans. Henry Meyric Hughes, then Director of Hayward Gallery, summarised the press response to the exhibition as 'genuinely mixed... with opinions varying from rapture to studied neglect to outright condemnation'. To Tim Hilton, writing in the Guardian, *the exhibition was just like its curator: 'genuinely art-loving, curious about anything that comes its way, debonair and elusive'.*

I t took me years to recognise the importance of Cézanne's querulousness – visible in the breaths or pauses between each discrete dab of the brush, in the breaks in the fabric of the painted image where the white canvas shows through, and which often bears traces of pencil lines from his first sketch. All in recognition that concretion was impossible, and that this was, after all, only a painting.

To begin with: an empty canvas. A bounded, flat plane. A possibility, but not yet a painting, although it might almost be one, if not a successful one. Perhaps not conceivably one.[1] How little, or how much would need to be done to make this a painting, and how little difference would there be, between its success and failure? It is nearly nothing, just a little more than nothing. If painting didn't already exist, no one could invent it. There it sits, dangling from a nail, or leant against a wall, propped on paint-cans, surrounded by the stray flecks and spume of *painting.*

The application and rubbing out of pigments, dyes, oils, tinted emulsions and solvents. Forms brought into being, then lost again; divisions, lines and imaginary planes. Recessions, cavities and skins of paint… layerings. A flat plane covered in little lumps and stains.

You walk around in front of it, stand slightly to one side and look at it, pay it some attention. Measure it against yourself, calculate its size and, more than that, make some attempt to measure the dimensions of a space that does not exist, a space that appears, then disappears, then announces itself once more, as you look. The painter, too, has spent a long time in front of this object, more time looking at it than anyone else ever will.

An interruption in the plane of vision, a blind spot. It is not a window – a painting is opaque. Yet there's talk of transparency, and of the air in a painting, even when

what is referred to is a perfectly opaque arrangement of coloured patches and zones, spread over a surface which itself is opaque. They talk too of warmth and coolness, of hot colour and cool painting, even though a thermometer would measure only the ambient temperature of the room. Body heat.

How is it that people can say that a painting breathes, or that a painting looks back at you? It is a thing, it is not alive, not like flesh and blood. Yet one hears of its death, as though it were once alive, and there's talk of its crisis, as though it should go and see a therapist.

It has become customary – even mandatory – to frame almost every discussion of painting today in terms of crisis; a crisis, moreover, which inexorably leads to the inevitable end of painting as an art form. Beginning at the end – this is where writing about painting begins, and, more importantly, where painting begins. But if it is a crippling place to start, it may also be an inducement, a charm: what, after all, could be more stimulating or more energising than this crisis, this exhilarating rush towards finality? What could be more certain a route to immortality, than to be the one who paints the last painting?

> Yet has the end come? To say no (painting is still alive, just look at the galleries) is undoubtedly an act of denial, for it has never been more evident that most paintings one sees have abandoned the task that historically belonged to modern painting (that, precisely, of working through the end of painting) and are simply artefacts created for the market and by the market (absolutely interchangeable artefacts created by interchangeable producers). To say yes, however, that the end has come, is to give in to a historicist conception of history as both linear and total (i.e. one cannot paint after Duchamp, Rodchenko, Mondrian; their work has rendered paintings unnecessary; or: one cannot paint any more in the era of the mass media, computer games, and the simulacrum).[2]

That this end has not arrived is attested to by this exhibition, which concerns itself with paintings made very recently, and being made as I wrote this. It is also an exhibition about possibility, of openings as much as closures, of leaps outside or beyond painting as much as the articulation of its limits and boundaries. What painting is, isn't and won't be are matters that will be decided by those who make them.

A painting by Imi Knoebel, from a recent group, at first sight seems nothing more than a blank sheet of plywood, pinned to the wall. We are not asked to believe that this surface, with its whorled grain, is the painting itself, a Duchampian ready-made, standing in for a painting. Instead it is a painting which has turned its back to us: it is the reverse side of a painted panel. More than that, it comprises several painted panels sandwiched together, paintings we shall never see. Along the edge between them a little colour is visible, a tantalising glimpse of painting withheld, painting compressed rather than suppressed – but not the last painting. Instead it

is a painting with a secret history, and there are many of those, just as there is a secret history of painting.

There are many kinds of paintings, some of which depict rooms, objects and people, things. And others from which every trace of the world we are familiar with has been expunged – although that it not quite possible. We can always say 'this is a pattern', or 'these are droplets of rain', 'this is blue paint', 'this has been poured' or 'it looks like a painting'. Paintings of paintings, and paintings as objects.

Perhaps the painting covers a hole in the wall or a patch of damp. Or conceals the door to a locked safe, buried in the wall behind. Certainly I've heard of keyhole paintings, and I've seen a painting, by Raoul De Keyser, titled *A Door Ajar*. And paintings of his where a representation of sky or atmosphere (the atmosphere of lowland fields and rivers) is blocked by an obstacle which all but fills the field of vision, a rectilinear block, a figure that could itself be a blank canvas. I have seen paintings of his in which the branches of a monkey-puzzle tree (the one outside his studio window) cancel the sky, cross it out. Without visiting him, and seeing this tree whose branches almost scrape the window, one might take the painting for a pure abstraction.

Is it the depictions we are supposed to attend to, or the surfaces they are painted on, the way that they have been covered or not covered in paint? We might ask why these things have been painted at all, and why we are looking. What keeps us looking? And were these works done for our eyes or, solipsistically, for the pleasure or displeasure, first and foremost, of their maker?[3]

No one, after all, has asked us to suspend our disbelief, to pretend that these painted scenes are actual, however engaging their apparent verity. No one is asking us to take these things at face value.

There is a recent painting by Peter Doig of a young man peering down at his own reflection on a frozen pond. In a subsequent version of the painting the figure has disappeared. He may not have arrived yet, as there's no way of telling whether this second painting represents an earlier moment. The painter is not bound to adhere to the conventions of time and place, any more than the film-maker or novelist is. The natural scene – the pond, the snow-clad trees – is nearly the same, except that the horizon has risen, and the imaginary viewpoint has shifted, moving us closer to the frozen bank, almost to where the boy had once stood, or will stand later. Globs of white, representing snow, remain suspended forever while we imagine time passing.

What could be more simple, more everyday as the subject for a painting than a dead chicken? A dead chicken, gutted though not beheaded or trussed, and some vegetables. A pear. What could be more normal than this kitchen scene, what could be more homely and comforting than this culinary still life, with its promise of satisfaction, a full belly? But within the composition's central triangulation – the

dead eye of the chicken, the liverous mould on the pear, the gaping opening where the splayed body of the chicken has been cut, so as to remove its organs – there is something disturbing, terrifying even. The dispassionate, matter-of-fact execution of the painting, the paint doing its job to articulate the table-top, the limbs and breast of the bird, the leek, the scaly leg, the torn cavity. That opening, and the almost humorous attitude of the wings, raised and splayed… Paula Rego has painted a body ravished, a body ravaged.

As an art student over 20 years ago, I was asked why I was painting a still life when I could more easily take a photograph of it (unlike the painting, which was laborious and laboured, it would be the work of a moment). At the time I thought it was a trick question. Painting does not have to compete with the camera, with cinema, with television, with sculpture, performance or installation work, with computer games or virtual reality. It is not a competition, or a matter of contesting genres.

This is an exhibition about painting, and comes at a time when there is talk of a revival. Cynics will wonder whether this renewed interest, if it exists at all, is nothing more than a sign of temporary boredom with works in other media, a reaction by what Dan Cameron has called the 'ABI' (Anything But Installation) generation.[4]

A room hung with paintings. The floor is bare, allowing us to move freely about. We come and go, obeying the usual rituals. 'A picture in the wall, on the wall, and off the wall – not a picture at all', wrote Jessica Stockholder, in one of the notes she writes about her works.[5] And of another piece:

> Entering the gallery is at all times a little awkward, first one door, a few feet and another. The door handle sticks, it must be turned the other way and you are in – smack up against the work. A ramp hits you just above the knee and a lot of red spills on and off the ramp on to the gallery wall.[6]

For her, painting is not bounded by the rectangle, by the wall, or by its materials. Not everything comes courtesy of Winsor and Newton, Liquitex and the artists' supply store. Nor is the gallery taken as a given or a neutral space. She describes an experience of her work as 'walking through this fiction'. The work flows, takes sudden leaps, makes visual rhymes with materials, surfaces, colours – the viewer, wandering out of curiosity, but led by the eye, is brought up short. She uses real highlights, electric lights, and shadows. Can one call it painting? It constantly plays with the real and the imaginary, using objects and materials to create an experience like that of painting. Like painting but not always painted. It might as well be described as an installation.

Stockholder's work, with its surprising emphasis on pleasure – surprising if only because pleasure nowadays is often (mistakenly) taken for lack of seriousness, for an absence of gravitas – its exhilarating juxtapositions and sudden interruptions, has a lot in common with the paintings of Fiona Rae, which are, on the other hand,

determinedly painted, a game played out within the bounds of the flat, rectilinear canvas. Yet both artists work with what they perceive as an impure situation; both, in their way, play on painting's charade of purity, self-containment and seamlessness. There is always what Stockholder calls 'leakage'.

That the gallery or museum frames the artwork, and mediates our response to it, is a fact that every so often we need to remind ourselves of. It is an impure situation – as if we could forget. As if we could forget the raging, disordering subjectivity of our own gaze, our own responsiveness. The artist's studio is hardly neutral either, and is invariably recognised as an expression, no less than the work, of the individual's mental life (think of Francis Bacon's splendid mess, and the order of Mondrian's atelier). The condition, and even the neighbourhood, of the studio, put a spin on the artist's work. When I remarked on the blips, accidental bleeds of paint and the contours of cancelled, buried images which disturb the slick surface of Gary Hume's paintings, he said, 'Don't worry about them. Once they get to the gallery they'll look like nuances.' And so they did. The panorama of the city, framed in the window of an East Village loft, lends a New Yorker's work even more urbanity than it can possess on its own. Sometimes, we get the feeling that the studio is a set, contrived to lend verisimilitude to an entirely fictitious role. The cats, patrolling the storage racks and making their strange cries before settling down on a bolt of unused canvas, would have to be Burmese.

Jessica Stockholder, *Fat Form and Hairy: Sardine Can Peeling*, 1994. Installation view, *Unbound Possibilities in Paiting*, 1994

And we two, the curators, Greg Hilty and I, going from gallery to gallery, from studio to airport with our briefcases, like a couple of insurance salesmen. 'I knew you were European', said the artist who'd spotted us at his downtown show, 'you were *looking* at the paintings.'

In an essay published in 1991, the critic Thomas McEvilley wrote that, 'A postmodern exhibition might avoid both the absolutism of presence (essence) and that of absence (emptiness). It might remain in the corrupt zone of intersection, mediation and cross-pollution, with a jaunty air either of scepticism or of irony, scepticism's fun-loving doppelgänger'.[7]

McEvilley's postmodern exhibition sounds like a postmodern artwork, only livelier than most. We are all postmodernists now. It is difficult to avoid the paralysis of knowing too much, of seeing too many points of view; the doubts come tumbling in. Too much leakage. The multiplicity of discourses, formal approaches, language games, all the 'postmodern' instances of quotation, re-quotation and decontextualisation; the deconstructionist vortex, with its centrifugal locutions, reversals and 'misreadings'; all the socio-political arguments concerning context and commodification, all the literature, the applications of Freud and those who come after him, all the appropriations (in the case of the analysts, frequently by those who have never in their lives lain on a couch)… one has to believe that something is still possible, that the situation is not completely framed and bounded.

What could be more bounded, more emphatic than the surface, gone over again and again, the colour degraded to an almost zero-degree of grey nullity, in Zebedee Jones's paintings? If something is still possible here it is the articulation of silence, in an object muffled in paint. One should not make too much of the artist's deafness (which, in Jones's case, is acute), but it seems here that irony – the going over, time and again, of an unpaintable picture – becomes a kind of melancholy. The grey is no longer grey, the surface no longer a surface.

Irony and scepticism might be signified in the placing of one kind of form on top of another, or in something so small as a visible pause, the turn of the wrist as the loaded brush is brought to the surface, then lifted again: a moment which signals a turning away, a recognition of intractability and doubt as much as an affirmation of possibility, a record of the certainty and uncertainties of the artist's fiction. Jonathan Lasker has said, 'Paint bears physical record to the expressions of the human hand. It conforms to the trail of the brush being driven by the impulses of the psyche. In no other art medium is creation more permanently and intimately bound to the movement of the human body…'[8] This 'impulse of the psyche' embraces doubt, and knows that absolutes are not possible.

The fiction of painting, these grand aspirations bound to this poor object, this thing that does not shrink from impossible tasks: the depiction of mountains, cafes at night, human dramas, religious ecstasies, visions of hell, bowls of apples, the façades and interiors of the cities we live in, rain against a window, flowers, ourselves – the fiction of painting knows that it is a fiction so well that its acknowledgement of itself becomes a reflex, about which each work turns. The American poet John Ashbery, in his *Self-Portrait in a Convex Mirror*, calls the drive towards this acknowledgement 'the painter's deep mistrust'. It was always there, and always returns. It is in the emblematic clover-leaf which anamorphically doubles as a portrait of superannuated disc-jockey Tony Blackburn, by Gary Hume. It saturates the work of Michael Krebber. It is in the blank spaces of Julião Sarmento's paintings. In Raoul De Keyser's dry recklessness and in the premeditated turd-like rope of paint which both completes and despoils what underlies it in a painting by Jonathan Lasker. And in Olivier Mosset's effulgent negativity, in Juan Davila's excessiveness, and in the delicacy of Luc Tuymans's paintings, a shocking look masquerading as tenderness.

Dirty pictures. White surfaces, spoiled surfaces. Injunctions to look but not to touch. Yet someone has already touched Julião Sarmento's paintings. Images have been drawn on them. There's been some attempt to rub some of these pictures and symbols out. These forbidden images, half-exposed and half-buried. We look, and turn away, just as the figures in his fragmented scenes do. What happens here, when no one's looking? What is withheld can be made up, imagined, invented; the will to imagine and to fantasise is always ready to do its work. Here, in Sarmento's paintings, the figures quietly slip in and out of focus, go about their business, stand for a moment and allow us to look. But not to see too much.

A painting is nearly nothing, just a little more than nothing.

A lapse in even the short-term memory of the art world (and that is the only kind of memory it appears to have) allows painting back in again, even if, moments ago, its supposed moribundity was used to underwrite the claims for radically oppositional art forms. But, it must be said, any art form is prey to mannerism, academicism, stultification. It was as if painting had been mislaid for a while, and someone accidentally came across it again and thought that it might come in handy: suddenly, it looked fresh again. The much touted revival of painting, like all marketing promotions, ignores, when it doesn't simply distort, the real issues. But the fact is that painters continue to paint, and an audience for painting remains.

This is not a return to painting. And, I might add, painting is not a patient, it is not ill or dying, or in need of resuscitation. It is not convalescing or in remission, reborn, or revived. It needs no revivals: painting is not an old-time religion.

Those who treat painting precisely as an 'old-time religion', and they are endemic, especially in Britain, will find little comfort here. This is not a return to order but a breaking of bounds. Implicit in many of these works is what might be termed 'the

breaking of form'. This is not the moment to signal any new movement or style, or to make premature claims to greatness. Maybe we are in the wrong place, and come at the wrong time to identify such things. Perhaps we have seen too much.

The 1980s were ushered in on a wave of painting – there was a 'New Spirit' abroad; Italian 'Transavanguardia', 'New Image' painting, a 'new' romanticism (in popular music and fashion as well as in painting), and ironic abstraction – the jesting pallbearers of painting, liveried in Bridget Riley stripes, Day-Glo and gingham. The epithet 'Neo-Geo' later became the name of an arcade computer game. That significant works were produced at this time there is little doubt, though the tendentious claims and triumphalism, all the curatorial and critical packaging, can now be happily discarded. History will be more just, one hopes, to the art itself than fashion was.

> All the decadence of painting, which has now become a real collapse, was caused principally by the great industrial development which took place in Europe about the middle of last century and led to the commercial production of artists' materials… [this commercialisation] brought about the loss of all those principles and methods which, during the course of the centuries, had allowed the development of the skill of painting and the consequent possibility of good work which bought about the emergence of the master painters and allowed the creation of so many masterpieces […]

> All art, or rather modern pseudo-art, is due to this fact, and all these tendencies, these so-called isms, from impressionism down to the more recent manifestations of abstractionism […] are the consequences of this loss of skill, this incapacity to work well, to create a true work of art, this loss of grammar and language which have forced painters to seek new ways of deceiving other people, and sometimes themselves, in order to make both ends meet.

> This is the pure and simple truth about the origin of contemporary painting. Anything else that has been said in reply to this proposition is absolutely false and its sole purpose is to conceal the desperate state of painting today.[9]

In this text Giorgio de Chirico, casting himself as a latter-day Benvenuto Cellini (though he seems, in his endearing way, more like a character from Federico Fellini), rails against the loss of artistic order, and sets himself to the task of halting this decline. At about the same time as his book was published, Yves Klein was setting paintings on fire, effecting a quite different kind of metaphysical transmutation from the one envisaged by the Italian painter in his work.

The decline of technique, although cast in more complicated terms, still figures today. By and large, though, the physical exigencies of painting have been subsumed by a purely theoretical closure. But such arguments share with De Chirico the idea that the growth of mechanisation since the industrial revolution of the nineteenth

century prefigures an end of painting. It is certainly true that the proliferation of ever more sophisticated technical resources allows for new kinds of expressions, though not necessarily better ones, and creates new kinds of audiences, though not necessarily more enlightened or more engaged ones.

To work in painting now does not mean that one has to take Rembrandt on one's shoulders, seek to emulate him, or push him aside. Nor does it mean that one must go back and re-learn Renaissance perspective, or resuscitate the concoctions and recipes of the old masters, even if one could. (De Chirico advised that the canvas be coated with isinglass before beginning to paint. Pity the sperm whale that provided it.)

The art of the present shall become the art of the past – some of it remembered, some of it vilified, and some forgotten (and then remembered again, as happened with El Greco). In retrospect, the perceived intentions of whatever has been done will be modified – to create new readings. Belatedness, the sense of coming after everything has already been done, can lead to a melancholic sense of exhaustion – but is painting exhausted? There is melancholy in it (how could it be otherwise, than that the flavour of the work is sometimes bitter or mordant), but it isn't over. The art of the present remembers (and perhaps this accounts for its melancholy), or tries to suppress the past (which might account for its intermittent bouts of hysteria).

And instead of technique, we have techniques, and instead of absolutes and essences, discontinuities, multiformity, differences. In the face of doomy presentiments concerning the loss of language and power – the loss of affect – a sense of language used with more self-consciousness and even awkwardness. Instead of new movements or revivals, a more heterodox way of thinking, a greater diversity. But more than simply demonstrate the diversity within painting, we wanted to show that there is no fixed viewpoint from which to look, no one way of reading the exhibition. Ironies, scepticism, and a certain doubt are highlighted here, but also a sense of the continuing desire to paint, and what such expressions may entail.

JAMES LINGWOOD
ON CONTEMPORARY PHOTOGRAPHY

The Epic and the Everyday:
Contemporary Photographic Art
1994

The Epic and the Everyday was an exhibition of contemporary photography curated by James Lingwood – Co-Director of the arts commissioning body Artangel – and Martin Caiger-Smith, then curator at Hayward Gallery. It featured 13 artists from Europe and North America, each of whom were concerned with 'the real world, with ordinary life: with the everyday, the vernacular' and 'the familiar'. These 13 artists were: Bernd and Hilla Becher, Jean-Marc Bustamante, John Coplans, Patrick Faigenbaum, Andreas Gursky, Craigie Horsfield, Reinhard Mucha, Gabriel Orozco, Robert Smithson, Annelies Štrba, Thomas Struth and Jeff Wall. Among the works exhibited were Struth's deserted cityscapes and Coplans's images of his own naked body. As Marina Benjamin in the Evening Standard *declared, each of the works in the exhibition featured '...the minutiae of daily life writ large'.*

DIFFERENT TIMES

A sudden gust of wind. Sheets of paper are swept across the landscape, autumn leaves are blown from spindly trees. A hat spirals high into the air and a man in a smart overcoat swivels to see where it has gone. Another figure, also smartly dressed, and two more, in boots, padded jackets and baseball caps, cover up from the force of the wind. Further off, a labourer continues to work the land. Telegraph poles traverse the scene, a city appears to loom over the horizon. The land is flat and unremarkable; it is an intermediary place between the city and the country.

Jeff Wall's *A Sudden Gust of Wind (after Hokusai)* is a picture of a moment elevated to the scale of a history painting. Yet although the work is brilliantly luminous – it is a back-lit transparency – its meaning is opaque. Dress codes suggest different steps on the rungs of capital. But we don't know what the papers represent; land rights, contracts, a business plan? We don't know whether the figures are associates or strangers, nor whether a deal has just been struck. How the narrative will unfold is not clear. And because narrative development is refused, we are compelled to dig below the visible surface of the picture, to consider the layers of time and experience embedded within it, and to reflect upon the structures and forces which shape everyday life.

A Sudden Gust of Wind contains a number of different times; the time of the incident, the time of the season, the time of the country and the city. And these times implicate different histories: the personal histories of the figures in the landscape, the social and economic histories suggested by the proximity of the city, the history of the land itself. Such layering of times, and the complex relations of history to the present which they imply, resonate through *The Epic and the Everyday*. How can these different times and experiences be made visible, how are they given material form in the work of art?

The relationship of history to the present is currently being contested with some urgency. One school of thought holds that history itself has ended, that contemporary existence is disconnected from the experience of history, that the individual floats free of the past in a weightless world of signs and images. Under the insistent evidence of recent years (the disintegration of the post-war settlement in Europe, the resurgence of fundamentalism and nationalism), the idea of the end of history has been countered by an assertion of a return of history. Both have a seductive symmetry, but neither fully accounts for the complexities of our contemporary condition. Another way of understanding the relation of history to the present is needed, one which can chart the different 'speeds' of time which coexist in the present, and which can mine the hidden depths of our everyday experience.

The great French historian Fernand Braudel suggested that events are to history what moths are to the night – flickering moments, briefly illuminated and then absorbed back into the semi-stillness of the dark. Rather than viewing the past as a succession of events, Braudel proposed a 'dialectic of duration' as 'the only language binding history to the present, creating one indivisible whole'.[1] Within the time of history, Braudel detects three different speeds. First, a history of humanity in relation to environment, climate and demography which he calls 'the ground floor of history'. This 'geographical time' moves at a near-glacial speed. It is a time of stasis rather than discernible change. Over this ground floor lies a second history, a history of habits, customs, beliefs, ways of living and thinking, a 'social time'. Its rhythm is gentle, its changes gradual. And over these two tempos, one barely perceptible, the other very slow, is a third time which Braudel calls 'biological'. Based on the time-scale of the individual life, this is a history of everyday incidents and chance occurrences, a time of 'surface disturbances'. A true history, he argues, is composed of this multiplicity of times: geographical, social and biological. And it needs to embrace their synchrony; they do not happen at different times, they are all part of the same time.

Such an approach to history embraces the panoramic and the microscopic. It focuses on processes which a linear chronology of significant events habitually ignores: the imperceptible changes in climate or population on the one hand, and the minutiae of everyday life on the other. Braudel's dialectic of duration doesn't simply restore to view the exchanges and incidents of the everyday. It gives them form, as beliefs, habits, customs and stories; it creates from them a pattern and a texture. The ways in which the individual negotiates daily life and works through the systems and classifications which society imposes are no longer merely incidental. They carry with them the memories, and the accumulated experiences, of generations before them. They embody an unconscious of historical experience which exists below the signs and surfaces of the present.

Massive and incontrovertible as they are, the vast sweeps of history need the qualification of these other histories embedded in everyday life. The different times of history are mutually dependent; they need each other, they illuminate and give meaning to one another. 'Nothing is more important', Braudel affirms, 'nothing comes

closer to the crux of social reality than this living, intimate, infinitely repeated opposition between the instant of time and that which flows only slowly.'[2]

In a conventional history of events, Braudel found, the ordinary individual was 'all too often a mere abstraction. In the living world there are no individuals entirely sealed off by themselves; all individual enterprise is rooted in a more complex reality [...] The question is not to deny the individual on the grounds that he is the prey of contingency, but somehow to transcend him [...] to react against a history arbitrarily reduced to the role of quintessential heroes'.[3] The philosopher Michel de Certeau takes up this theme in his book *The Practice of Everyday Life*. The common man and woman, 'the murmuring voice of societies',[4] is rescued from anonymity. This ordinary person who 'in all ages [...] comes before texts' and who 'does not expect representations' is restored to view, and given a place in time – the time of the present and the time of history. Through the endless dialectic of historical structure and everyday life, of causality and contingency, of collectivity and singularity, he or she acquires a substance and a presence. History exists within the individual, and the individual exists within history. The everyday is infused with an epic dimension.

What might be understood by the term 'epic' needs some qualification. Broadly speaking it might imply a historical sweep and a cinematic scope. It recounts the experiences of nations and individuals unfolding over time, tells the stories of people living within a dramatised historical landscape, a panorama of hopes and memories. But, as Mikhail Bakhtin argued in his essay 'Epic and Novel', the epic has a closed relation to the present. In its classical form, the time of the epic is separated from the moment of contemporary reality; the time of the tale is distant from the time of the reader or the story-teller. The traditional epic is always of another time, often of another place. Its patterns are relatively fixed, its beginnings and conclusions are pre-ordained, its capacity to convey the full complexity of contemporary experience is limited. To transcend these limits, it needs to incorporate another time, the time of the present. When this happened, at the beginning of the nineteenth century, a new literary form began to emerge. Compared to the more formalised recounting of the past in the epic form, the novel created a fluid 'zone of contact' with the present. It was able to embody some of the fundamental characteristics of contemporary life, its 'indeterminacy, a certain semantic open-endedness, a living contact with unfinished, still evolving contemporary reality'[5] – what Bakhtin called 'the open-ended present'. The stories it might tell, and the ways that it might tell them, became infinitely greater.

Rather than emphasising a deep divide between the time of the story and the time of the story-teller, the novel produced a continuum between the past and the present. The construction of this continuum had profound consequences. In distinction to earlier literary forms, the novel could integrate the different speeds of time within an experience of the present; it could create a different relationship between history and contemporaneity. As Bakhtin states, 'The revolution in the hierarchy of times makes possible a radical revolution in the structuring of the artistic image as well.

The present, in its so-called "wholeness" (although it is, of course, never whole) is in essence and in principle inconclusive [...] The temporal model of the world changes radically; it becomes a world where there is no first word (no ideal world) and the final word has not yet been spoken [...] time and the world become historical.'[6] The novel, then, emerged with, and gave form to, a new historical consciousness. And a new medium emerged with it which had an even more immediate relation to the present – the medium of photography.

<p style="text-align:center">*</p>

Photography is made in an instant; that is the basis of its potential and the root of its limitations. Doesn't the medium's dependence on the fix of the moment prevent it from giving form to the multiple textures of time? Can it do more than simply and passively register appearances and impressions? The essential condition of photography, it is often argued, disallows it from engaging with different layers of experience in the way that a novel or a film might do; a medium of surface cannot deal, it is said, with an experience of depth or duration. It cannot produce an experience *in* time. Made in an instant, it is absorbed in one; it is a transmitter of sensation or information, but not much more. And as Walter Benjamin observed in his essay 'The Storyteller', 'The value of information does not survive the moment in which it was new. It lives only at that moment; it has to surrender to it completely, and explain itself to it without losing any time; a story is different. It does not expend itself. It preserves a concentration of strength and is capable of releasing it even after a long time'.[7] How can the photograph resist this surrender comparable to the story?

A second troublesome line of enquiry: no sooner has the exposure been made than the moment of its making has passed. We look at a photograph of a friend, a relative, of people or places we know or knew. We recognise them, we remember them. Is the photograph not always, first and foremost, a record of what has been and is no more? How can this tyranny of distance, this pastness of the past, be overcome, without recourse to mythology or fantasy, and without denying photography's descriptive capacities? The reader of the novel can inhabit the story that he or she is reading; the cinemagoer participates in the unfolding narrative of the film. The photographic artist must find a different way to involve the viewer, to resolve this dialectic of absence and presence and to ensure that the past moment is brought into the present of the work; to ensure then that the present of the work is not simply a picture of the past. A failure to resolve this leads the photograph inexorably towards a melancholy aesthetic of loss.

And again, if we recognise that an essential characteristic of contemporary life is its contingency and indeterminacy, that the present is inherently open-ended, wouldn't the most truthful representation of the present be a relatively formless one, a series of snapshots issuing from an aimless photographic automatism? Garry Winogrand is supposed to have said, 'I photograph to see what things that interest me look like as photographs'.[8] Why should the photographer mediate the photograph's

immediacy? Why intercede when the photograph makes its own form, creates its own choreography?

By the 1950s such views had coalesced in the 'snapshot aesthetic' which saw a meeting-point of information and authorship within 'The Decisive Moment' of the photograph. The photographer became a kind of sophisticated medium of the street; the camera froze the fluidity of everyday life, captured the snatched kiss, the impromptu performance, through an instinctive composition, a dextrous marshalling of available elements. It was a way of working which did not trespass too far onto the terrain of art, which could exist equally within the crowded columns of the illustrated magazine and the quieter spaces of the museum, where it was beginning cautiously to be welcomed (at least in the United States). Through the achievements of the most lyrical of these photographers, such as Henri Cartier-Bresson, or the most brutal, such as Weegee or Gary Winogrand, the 'snapshot aesthetic' emphasised the photographic instant rather than the slower processes of time and history. It represented an apotheosis of the informal, a celebration of the spontaneous. It seemed to suggest that other ways of describing the world through the camera were somehow less authentic, less 'photographic'. Yet these other more traditional or more prosaic forms persist and retain a validity and importance for contemporary art – on the one hand the 'imposed' form of the catalogue, record, archive or album, and on the other the 'composed' form, grounded in the traditional practice of picture-making.

The methodology of the archive involves the standard imposition of a preconceived format onto a predetermined object. Archival photography is typically marked by directness, frontality, regularity, an apparent lack of artifice or artistry. A tool to create visual evidence for the encyclopaedic ambitions of the emerging social and natural sciences of the nineteenth century, this mode of photography enabled comparative readings of types, physiognomies, cities. It created visual systems of classification, of likeness and difference. Such seemingly dispassionate and systematic applications of photography recur in contemporary art in addition to (and often in critique of) the archive's continuing role as an instrument of ordering and control – or, as the critic Benjamin Buchloh has characterised it, 'its dialectic principle of melancholic commemoration and enterprising surveillance'.[9]

At the other extreme to the standard or 'uniform' application of photography stands the practice of picture-making: the application of a set of codes, conventions and forms from the tradition of easel painting which photography was quick to assimilate. Just as it ranged across the genres of painting, aspired to its loftier subjects, borrowed its poses and gestures, copied its formats (for example the panoramic), even imitated its surface effects, photography also adopted ways of organising vision drawn from the history of composition in pictorial form.

A photograph could be composed just as a painting could. In no small measure, this effort to create an 'artistic' photography was motivated by the desire to distance

itself from the functional applications of the medium. By the end of the nineteenth century, it had created a kind of photography against itself – a pictorialism from which photographic picture-making has had periodically to rescue itself. But the recurrent excesses of pictorialism in no way invalidate the importance of pictorial composition – the thinking of form to create a photographic picture of a world. The conventions of ordering and picturing the world are no less important to the photographic work than to the painted image.

Imposition and composition, the serial and the singular, the 'uniform' of the archive, the 'thought form' of the picture and, between them, the *'informe'* of the snapshot: these modes co-exist in photography to the present day. The tension between them animates *The Epic and the Everyday*, from the typologies of industrial structures built up by Bernd and Hilla Becher over more than 30 years, and the family archive made by Annelies Štrba, to the snapshots of Robert Smithson or Reinhard Mucha and the crafted compositions of Patrick Faigenbaum or Craigie Horsfield. But in themselves, these modes remain only generalities, conventions to be worked *through*, to be transcended by the contemporary artist intent on achieving a specific and exceptional form.

Whilst stressing the singularity of each of the artists presented in *The Epic and the Everyday*, it is worth recognising one vital point of convergence. Like the novel, the photograph derives from the prose of the world. The photograph needs its prosaic details, it needs its 'zone of contact' with the vernacular which is the surface and substance of the present. The zones of contact in this exhibition range far and wide; they embrace people working in modern factories, foraging in a rubbish tip near Kraków, involved in an encounter in some nondescript field near Vancouver, looking at masterpieces in museums; the domestic interiors of Neapolitan palazzi or a Swiss family apartment, a ramshackle hotel in Mexico, mineheads in South Wales or the Ruhr, station signs in Rome, city streets in Chicago or Milan, a sleeping dog or a standing horse. These artists look outwards, they work in the studio of the world – but a world which is also always a particular place. There is one exception here (there should always be one!): John Coplans's monumental photographs of his own body do not require his departure from the studio. But even here, Coplans's body is a particular place, a world to be described and transformed.

Whilst advertising images often celebrate a seamless surface, an immaculate conception available for immediate consumption, the works in *The Epic and the Everyday*, by contrast, draw from the reservoir of processes and marks, the signs of the contingent and the particular which constitute the lived world. The well-trodden tracks in Jeff Wall's *The Crooked Path*, the clothes-lines strung out on rooftops in Andreas Gursky's *Cairo, Overview*, the cracked and worn surfaces of the buildings in Thomas Struth's street photographs, even the creased surfaces of John Coplans's body, are the material evidence of constant usage. Whether in a carefully considered composition or a sequence of snapshots, these artists

inscribe the vernacular of everyday experience within the body of the work. This integration of a descriptive dimension from the lived world is critical. It insures against the dissolution of the photograph into a world of pure artifice, fantasy or kitsch; it creates a closeness to the nuances of reality, resists homogeneity, idealisation, abstraction. And, most importantly, it ensures the vital continuum of the work with the world. For the work and the world are 'indissolubly tied up with each other, and find themselves in continual mutual interaction; uninterrupted exchange goes on between them. The work and the world represented in it enter the real world and enrich it, and the real world enters the work'.[10]

Each photograph, then, is of a time and a place. But it is extracted from that time and place, cut off, given an edge, a definition, recreated as a form in a single picture or an extended series. In short, it is given another reality, different from its first. Braudel's observation about the historian is no less pertinent here: 'the researcher occupied with the present can make out the fine lines of a structure only by himself engaging in reconstruction [...] not getting embroiled in reality as it appears, but truncating it, transcending it...'[11] Bakhtin emphasised a similar need for the building of form: '...the absence of internal conclusiveness [...] creates a sharp increase in demands for an external and formal completedness'.[12] Practices of reconstruction and reconstitution are central, from Horsfield's building of pictorial form to the process of computerised montage which Wall has used in his recent work; from the transformations of scale in Coplans's body or Struth's city stills to the narrative reordering of Mucha or Smithson's snapshots. This reconstruction of the vernacular creates a double status for the completed

Andreas Gursky
Cairo, Overview, 1993

work; it is at one and the same time a part of the world, and apart from it. Made from a particular time and place, it is reconstituted in a different place and time: the place of the exhibition and the time of the viewer.

In every case, the recognition of the complexity and open ended character of the present requires of the artist a profound response rather than an automatic reflex. It calls into play a dialectic of duration which can transform a trace of what has passed into an enduring picture of an experience in the present. The resolution which Joseph Conrad demanded of writing in his preface to *The Nigger of the 'Narcissus'* is equally appropriate to the transformation of the vernacular effected by the artists in *The Epic and the Everyday*: 'It is only through complete, unswerving devotion to the perfect blending of form and substance... (that) the light of magic suggestiveness may be brought to play for an evanescent instant over the commonplace surface of words: of the old, old words, worn thin, defaced by ages of careless usage.'[13]

The question of how the times of history and the contingencies of the present are materialised in the work of art is of singular importance. It is a general question to which

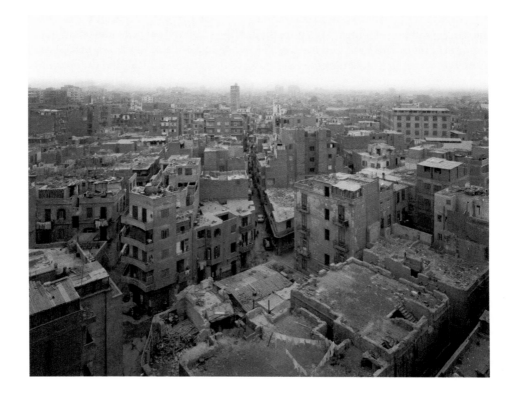

there is, each time, a different resolution, in the specific form of the individual work of art. In Robert Smithson's photographs, time is slipping back. In his seminal photo-essay, *A Tour of the Monuments of Passaic*, published in *Artforum* magazine in 1967 with six black and white photographs (he subsequently mounted 24 in a private album), Smithson surveys the signs of industrial disintegration in his native New Jersey. Photographing with his Instamatic, Smithson snapped the 'memory traces of an abandoned set of futures',[14] a graveyard of the high hopes of the industrialised era and of the ideologies of advancement and progress which underpinned it. Smithson charts a travelogue through a distressed landscape in which the post-industrial vedute of gas-holders, waste pipes and pumping derricks are evidence of the irreversible process of entropy. Three years later, when Smithson visited Mexico, he stayed in the town of Palenque, famed for its nearby Mayan temples. Undermining expectations that he would head for the Mayan ruins, he conducted an archaeological exploration of the ramshackle Hotel Palenque. The hotel was a 'contemporary ruin', a perfect locus for Smithson's recurrent fascination with entropy. Smithson leads his audience – the photographs were originally presented as a slide lecture to students at the University of Utah in 1972 – on a meandering journey through the chaotic building. The hotel was in a simultaneous process of construction and disintegration, sliding into the past before it could build its future. For Smithson, it was a perfect embodiment of a time run out of steam.

A great lover of paradox, Smithson ordered his portrait of a listless present into a moving sequence of slides. This unrolling of the work in real time has one notable counterpoint in *The Epic and the Everyday* – Jean-Marc Bustamante's installation *Stationnaire I*. In *Hotel Palenque*, the viewer's body is motionless and the slides are in motion. By contrast, in *Stationnaire I*, the objects and photographs are static, rooted to the floor or fixed to the wall; it is the viewer who makes both a mental and physical journey in the place of the exhibition. Bustamante's installation is a work of passage between a configuration of identical cement and brass objects distributed over the floor, and a series of slightly different colour photographs, close-ups of cypresses, fixed to the wall. The cones on each tree suggest the constant renewal of nature, but the room is still. We move around the earthbound forms and the silent walls of trees like visitors in a cemetery. In its totality, the installation establishes a dialogue between sameness and difference (the variety of natural form within the uniformity of each species, the individuality of the figure compared to the ultimate conformity of death), between the stability of the object or picture and the mobility of the viewer. In a similar vein, Bustamante has referred to his large colour photographs of unremarkable landscapes, building sites and factories, as 'slow snapshots'. There are no incidents here, no movement in the picture. The time of these works is the time created by the viewer.

In considering the condition of spontaneous photography, Jeff Wall cautioned that it 'thins out' the subject, 'reduces the level at which the permanent dialectic between essence and appearance operates in it'.[15] Wall's lightbox, *The Well*, is a still picture of frenetic activity. Why is the woman digging for water? It could be the result of conscious planning, an act of desperation, a sign of dementia. We have no idea of the causes of the action, nor its consequences. The moment is suspended, the opacity of the present is opened up to view. Rather than a 'thinning out' of the spontaneous, Wall's pictures condense time. They correspond to Bakhtin's observation that, in the great novels, 'spatial and temporary indicators are fused into one carefully thought out, concrete whole. Time as it were thickens, takes on flesh, becomes artistically visible'.[16] The reluctance of the narratives to explain themselves leads to a deepening of time in the picture, and a lengthening of time in the response of the viewer. Like the woman in *The Well*, the viewer must excavate the dense matter of experience which exists beneath the surface of the present.

'The everyday has a certain strangeness that does not surface, or whose surface is only its upper limit, outlining itself against the visible', wrote Michel de Certeau.[17] Craigie Horsfield's pictures disclose this strangeness of the everyday through an endless movement (comparable to the movement in Jeff Wall's works) between visible surface and historical depth. In Horsfield's large picture of his wife, *E. Horsfield. Well Street, East London, March 1988*, the artist's hand breaks into the picture plane, as if to bridge the distance which separates even the closest of people. The intangible is made visible, the moment of the gesture is transcended, given another time.

JAMES LINGWOOD ON CONTEMPORARY PHOTOGRAPHY

Horsfield's photographs are taken in the places he has lived in, either Kraków or East London. Rebuilt in the artist's studio to create a 'chiaroscuro of the everyday' (Lukács), these places acquire a palpable weight and density. They are heavy with the experience of history; time has taken on flesh. The figures and the places in Horsfield's work give substance to Bakhtin's observation of 'the special increase in density and concreteness of time markers – the time of human life, of historical time that occurs within well-delineated spatial areas'.[18] In the two dimensionality of the picture, the figures are present, as physical and corporeal beings, and historical, as much a part of the unfolding drama of the present as the people in Tolstoy's novels. The people in his portraits are at the same time closed off and indeterminate (like the open-ended present), animated by that 'permanent dialectic of essence and appearance' which is also the endless drama of interiority and exteriority.

The potential of the panorama to make time visible has been explored in turn by Wall, Horsfield, Gursky and Struth. A sweep of vision which can also be an expanse of time, the panorama encourages a traversal of the moment. It contains both the concentration of time in painting and the unfolding development of film, and encourages a reading in time across the picture as well as into it. The solitary individual standing by the river in Wall's *The Old Prison* surveys the perpetual slow motion of the water and the expanse of industrial and commercial activity which the river has made possible. The silent reflection of this contemplating person, his interiority, seems to animate the history of the rivet and the city. The panorama contains the 'biological' time of the individual, dwarfed (though not diminished) before the immensity of the landscape, and the historical experience of the place. Horsfield's panorama of a rubbish tip on the outskirts of the city, *Barycz. Kraków. May 20 1994*, constructs a similar relation between individuals and the ever-presence of history in their environment. Across the length of the panorama, figures search and scavenge. They swarm around newly-arrived lorries, stuff their abject booty into sacks, then rest, waiting for the next delivery. Dependent on what has been discarded, the figures are absorbed in this landscape of exhaustion – a graveyard, like Smithson's *Passaic*, in which only the most prosaic of resurrections takes place. They are animated by the daily struggle for survival, the desperate hope of escape from the place which history has made for them.

Andreas Gursky's photograph over the rooftops of a modern ancient city, *Cairo, Overview*, presents a comparable interchange between the immeasurable vastness of the metropolis and the everyday realities of the people who live there. Lines of clothing hang on the rooftops of the city in casual or random configurations, each one a mark of mundane human activity. The city is not only its architecture, its grid of streets, its blueprints for organisation. It is also the accumulated experience and habits of the people who live there, the way they organise their lives. The patterns of living evolve slowly; similar lines of clothing have doubtless hung for hundreds of years.

This dynamic between the deep time of history and the detail of the everyday also activates Gursky's photograph of workers staking out the bank by a new motorway

in *Breitscheider Kreuz*. The individuality of the labourers (like the workers Gursky depicts in textile factories or car assembly plants) is absorbed into the anonymity of social and economic structures. They represent and embody a historical process, the abstraction of the individual which lies at the heart of mass production. The wide-angled view or the panoramic form integrates the dimension of historical experience (the unconscious of the city) and the evidence of the everyday: invisible processes and anonymous people, the surface of haphazard incident and the depth of an historical story. Gursky's photographs, singly and collectively, seem perfectly to embody Braudel's three times: the 'geographical' time of the land (most obviously in his photograph of a glacier), the 'social' time of the city, and the 'biological' time of the individual, whether a factory worker or a tourist.

Reinhard Mucha's work also contains different times. Like the panorama, his *24 Photographs* reads in time from one side to the other. Arranged from small black and white prints, the work constitutes a journey through signs which begins and ends at Rome's central station and takes in the 12 stations within the boundaries of the city, each of which carries the word Roma in its name. Individual signs suggest something of Rome's history but say little more than that – they are just place names marking a point of arrival or departure on a railway network. The photographs are similarly prosaic, they display no particular artifice. Some appear to have been taken on the move, others from the platform or the street outside. All of them look like snapshots intended as souvenirs in a private album. But the private collection of public signs acquires a different weight when assembled and condensed on the wall in the exhibition. Like the metronomic rhythm of the railway journey, the word Roma repeats and repeats. What is Roma? On one level, a place made up by all these different districts and more. But the name is also the beginning of a mental journey, and the city (which is always experienced through its detail) is the totality of these journeys – the countless stories and speculations, experiences and memories which make up the collective biography of Rome.

The typologies of industrial objects and structures methodically built up by Bernd and Hilla Becher, over more than 30 years, also create a collective portrait. Although many of the structures are monumental in scale, the photographs of mineheads, blast furnaces or gas-holders attest to a fragility within historical time. Many of the mineheads photographed in South Wales, northern England, the Ruhrgebiet or the Appalachians no longer exist. Many of them, already in disrepair at the time of the photograph, have been left to decay in their own time. Many have since been deliberately levelled. But, assembled as typologies, they persist as a kind of collective memory of a historical moment. Each of these structures has the same function – to bring coal to the surface (once more we find ourselves between the metaphorical poles of surface and depth). Each resembles the next, but each is different, a vernacular expression of a functional form. Scrutinising the details of each object, scanning across the series, the archives of the Bechers appear to be much more than an index of

industrial information; they become a meditation on a particular historical time, recounted with precisely that 'chaste compactness' which Benjamin identified as an essential characteristic of the story.

The distillation of time into photographic form finds another expression in the work of Thomas Struth. The streets of the cities Struth photographs are silent. They are imbued with a stillness which is in sharp contrast to the constant movement and noise of the metropolis. The first abstraction of photography is its elimination of noise, the second, its arresting of movement. But if the places are silenced, it is to ensure that their essence is not submerged by the distractions of incident, that the substance of their unconscious life (Struth called his first book, of street photographs *Unconscious Places*) is immanent in the facades of the buildings or the surfaces of the street. And if movement is arrested (as it is quite visibly in Struth's photograph of visitors in front of a Jackson Pollock painting in the Museum of Modern Art in New York), it is precisely to create a deepening of the experience of the place or the picture. The silence of Struth's photographs does not lead to some withdrawal into a timeless zone; the signs of contemporary life are too visible for that. It enables a reading in slow motion, a distillation of the accumulated history of the city. Struth's photographs give the city back its experience in time.

The stillness of Struth's photographs is echoed in the photographs Gabriel Orozco makes in Mexico or Manhattan. Sometimes the photographs result from a momentary intervention by the artist; on other occasions, they are observations of a particular detail on the street. Nothing could be more ephemeral than the condensation of breath formed on the top of a piano, or the concentric rings caused by stones thrown into rooftop pools of rainwater, nothing more apparently ordinary than a sleeping dog or broken curb. But the artist honours these fragile moments with a long and patient look, not a passing glance. Our looking is concentrated, the world beyond each picture fades away, the ephemeral is given a longer duration made from the reflection of the artist and the contemplation of the viewer. Like the dog whose ears are pricked in the alertness of sleep, Orozco's photographs suggest a psychological depth of experience, the time of the unconscious.

Amidst all these other times, there is, finally, the time of the body. Like Smithson's *Hotel Palenque*, like Gursky's *Cairo, Overview*, the body is always in the process of construction and disintegration, development and deterioration. Patrick Faigenbaum's portraits of aristocratic Neapolitan families in shadowy interiors embody the idea of genealogy. Gathered in groups or generations, his subjects are surrounded by their inheritance – an accumulation of books, paintings, artefacts – and their inheritors, the children Faigenbaum often includes in his compositions. Both attest to the continuity of the family and the intactness of their lineage. What else do they inherit? Attitudes, traditions, physiognomies: Faigenbaum's social tableaux portray an endless dynamic between the living generations and their forebears. The time-span of the geneaology is commensurate with Braudel's 'geographical time', but it finds expression in the body of the living person, in 'biological time'. The

families appear immersed, sometimes even entombed in their collective histories. But their individuality is not erased, they have sufficient independence to emerge from within the genealogy. Through the extended series, Faigenbaum collides the artificial half-light of the interior with the glaring Neapolitan sunlight, invades the recesses of history with the light of the present.

Annelies Štrba's family photographs similarly pull the viewer back and forth between the past and the present. Old archival photographs of Štrba's mother and sisters, photographs made by her of her own son and daughters when they were children, then adolescents, and now as young adults: the album is constantly being brought up-to date. The centre of this history, Annelies Štrba herself, is only rarely pictured. She is the recorder of these informal stills which make up the fragmented film of family life, the invisible link between the past of her ancestors and the futures of her children. Like all family albums, Štrba's photographs are animated by fugitive details – the piles of domestic clutter, the cats, the jewellery, or the bandaged head – which make memory possible. As well as being enlarged and printed on canvas, the photographs are fundamentally re-formed in their transposition from the family album to the place of exhibition. They become a private theatre of memory made public.

The body in John Coplans's photographs is as removed from context as Štrba's family archive or Faigenbaum's Neapolitan family portraits are contained within theirs. Coplans never shows his face, the body is always truncated, the background in the photographs is always neutral. Freed from facial physiognomy and personal identity, the body becomes an independent form. Coplans's has spoken of his intention to create a kind of archaeology of the body 'which could transcend time and integrate the totality of times from pre-history to the present day. Coplans's skin, that thin veneer over the substance of his body, is an expression both of the accumulated experience of a single body, and of the genetic information which has been carried from body to body over thousands of years. Once more the viewer is engaged by the movement between essence and appearance, between what is visible and what lies beneath the surface. Time itself is made palpable in these monumental forms which, like the Bechers's archive, confront the viewer with a massive embodiment of experience and a more fragile sense of mortality.

The photographic works in *The Epic and the Everyday* materialise different times, different experiences, within the presentness of the picture. Moving from fragment to totality, from figure to environment, they enclose and disclose the contingencies of contemporary life and the details of the world in the completed work. Condensed or distilled, given depth and weight in series or in single pictures, they constitute a dialectic of duration – between the times of history and the time of the present, between the time of the work and the time of the viewer. The instantaneity of the image is superseded by the enduring experience of the work of art. These works give to the viewer, and ask back, a longer time.

DAWN ADES
ON ART AND POWER

Art and Power:
Europe under the
Dictators 1930–1945
1995

Art and Power: Europe under the Dictators 1930–1945 explored the relationship between art and politics in Europe during the 1930s and 1940s. Taking place in the 50th anniversary year of the end of the Second World War, the exhibition featured over 500 objects, among them posters, painting, sculpture, murals, photographs and representations of public architecture. Art and Power *was selected by a committee consisting of Dawn Ades from the University of Essex, Tim Benton from the Open University, David Elliott from the Museum of Modern Art Oxford and Iain Boyd Whyte from the University of Edinburgh. It was the 23rd Council of Europe exhibition – a series of exhibitions begun in 1954 with the aim of increasing the understanding and appreciation of European art. In addition to Ades's text, the exhibition catalogue featured contributions from the committee members, as well as British historian Eric Hobsbawm and the journalist Neal Ascherson. Ades, an art historian and curator who has been involved in many landmark exhibitions at Hayward Gallery over the past 30 years, continues to publish widely on Dada and surrealism, modernism and art from Latin America.*

ART AS MONUMENT

In 1940, Diego Rivera painted a mural over 22 metres long and six metres high at the Golden Gate Fair in San Francisco. It was part of the 'Art in Action' section of the exhibition, and the public paid 50 cents to watch the famous Mexican artist at work. The mural's theme, immediate context and subsequent history open up some of the problems and debates that surround monumental art in the twentieth century.

Its theme was the politically hot topic of 'Pan-American Unity', which was being actively canvassed at the time, most strongly by those anxious to keep the United States out of the Second World War. Most of the giant mural compares the creative and scientific achievements through history of 'the North and South of this continent': i.e. Canada, the United States and Mexico, but one panel is dedicated to the European dictators. A twisted scene of carnage, barbed wire and bodies, with the busts of the dictators – Stalin clasping the bloody ice pick that had killed Trotsky earlier that year, Hitler saluting and Mussolini clasping the fasces – emerging from a cloud of poison gas. At the centre, however, is the figure of Charlie Chaplin, whose satire *The Great Dictator* had just been released, gesticulating towards a scene from the film, with 'Hitler' holding the world-balloon.

The difficulty of judging the tone of this scene, which seems compounded of both outrage and mockery, is partly explained by attitudes in the United States to the European War, which seemed to mark the end of the Old World and the collapse of its civilisation. The Golden Gate Fair itself was a frank celebration of the New World, a little regretful at the absence of some of the countries that had been swallowed up

by Hitler since the Fair the previous year, but on the whole optimistic. Another factor may be Rivera's own sense of the contradictions of making monumental art in a site of ephemeral entertainment, and even perhaps of rivalry with the medium of film.[1]

This mural and its setting have been construed as the final straw for artists long suspicious of politically committed art, fearful of its descent into frank propaganda and confused by the numerous changes in the official cultural policy of the Communist party and the left since 1935. Meyer Schapiro's group, the Federation of Modern Painters and Sculptors, whose position was loosely based on the André Breton-Leon Trotsky manifesto of 1938, 'Towards a Revolutionary Independent Art', 'rejected the politicization of art which led to such absurdities as posters advertising the Golden Gate Park exhibition in 1940, which combined Diego Rivera with strippers from the Folies-Bergère'.[2] Political art seemed to be reduced to the fairground, to pure entertainment rather than serious criticism; and, 'if this was the price of democratization in art, then democratization was unthinkable'.[3]

The ground was thus laid for Clement Greenberg's idea of an avant-garde art, essentially opposed to kitsch, to develop into the highly influential theory of an art whose critical function was to investigate its own medium and form.[4] The history of modern art has largely been written according to Greenberg; and monumental art, Rivera's along with that of the totalitarian regimes, has become an embarrassing footnote. It is not a question here of re-evaluating this position, but rather of attempting to shake loose the tight knot of rejection that has bound all monumental art together, whether of the Fascist or Communist regimes, of the Spanish Republic, of revolutionary Mexico or of the bourgeois democracies.

A monument in the classic sense of the term commemorates a person, event or action; it can refer to a written record, a sepulchre, a boundary, or the remains or remnant of something. 'Monumental art', on the other hand, can be taken simply to mean sculpture or painting that is huge or stupendous; in other words, the term's significance as *reminder* – celebration or memorial – may be emptied out. This essay considers works of art, made in the period roughly covered by the *Art and Power* exhibition, which laid claim to be *monumental* in more than sheer size. An examination of these claims, how they interlocked with questions of style, function or ideology and what shifts occurred in the deployment of the word monumental may help to outline changes in the relations between art and its publics, public art and its patrons.

Built monuments – sculpture or combinations of architecture and sculpture – are for public spaces. Visible signs of authority, they have constituted complex and various messages to the present. They assert power in various ways: through a particular idea of history, or of nationhood, or the celebration of superior individual achievements. The shift to the frankly didactic or agitational that has occurred this century was a natural extension of the power of exhortation that was already implicit or explicit; but this has raised an important question for twentieth-century monumental art: who is being addressed and by whom?

Can there be such a thing as a genuinely demotic monumental art – that is, a monumental art not addressed to, but rather of, the people?[5] Certainly, such claims were made in some quarters. Was it possible for monumental art to reinvent itself? Monumental art tried to come to terms with a newly defined 'popular', and this process had inbuilt contradictions.

Following the revolutions in both Mexico (1910–20) and the USSR (1917), plans were swiftly elaborated for programmes of public art. One of Lenin's first legislative acts in April 1918 was to decree the removal of the monuments erected in honour of the Tsars ('monstrous idols'), and 'organize a broad competition in designing monuments to commemorate the great days of the Russian Socialist Revolution'.[6] In August 1918 he drew up a list of persons to whom monuments were to be erected, which included 66 names of revolutionaries, writers, philosophers, scientists, artists and composers.[7] Sergei Eisenstein opens his filmic celebration of the October Revolution of 1917 with the dismembering of the enormous statue of Tsar Alexander III, which finally, roped and mutilated, topples ignominiously, together with its chair, from the high pedestal. It is notable, however, that he intercuts this scene with revolutionary groups and masses, including some 'spotlit' anonymous heroic figures, ancestors of Vera Mukhina's peacetime peasant and industrial worker, rather than with individual heroes of the Revolution.

In the early years of the Soviet Union, notwithstanding Lenin's decree, the right to determine what the new monuments and monumental art should be was strongly contested, and the irrelevance of monumental figurative sculpture was argued from the constructivist side. Nikolai Punin, writing about Tatlin's *Monument to the Third International* in 1920, favourably compared its dynamic creative design and use of materials with the limitations and static quality of figurative monuments: 'The agitational action of such monuments is extraordinarily weak amidst the noise, movements and dimensions of the streets.'[8] For Punin, moreover, a monument without a practical function – which Tatlin's (ideally) had – was pointless.

Punin objected to figurative monuments on the grounds that, beside their static and feeble effect, they cultivated individual heroism and conflicted with history: 'At best they express the character, feelings and thought of the hero, but who expresses the tension of the emotions and thoughts of the collective thousand?'[9] They conflict with history, because – as Einstein demonstrates so vividly in *October* – it is the people and not the individual hero whose acts are history.

Attacks on figurative monuments also came from very different quarters: at the end of the 1920s, Robert Desnos, the Surrealist poet, distinguishing between stone allegories and portraits, wrote: 'To erect the effigy of a being, who once lived, on a pedestal, is equivalent to raising him to the rank of a god, and in our times such an enterprise is less legitimate than ever.'[10] Statues, he suggests, should be only the

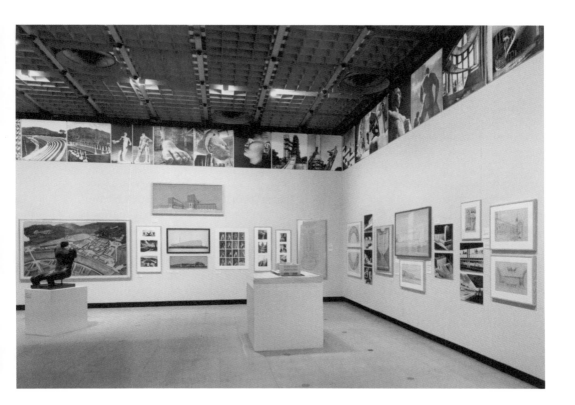

accessories to life, 'with its procession of strange manifestations, miracles, deep looks, insults and warm embraces'. Desnos's proposal was to take the statue off its pedestal, and have a bronze Baudelaire strolling among the crowds or leaning on the parapet of a bridge. What both these arguments have in common is the underlying idea that the genre of the monumental figure portrait cannot hold its own in the modern age: that it is either ineffectual, illegitimate, unnatural or offensive.[11]

Although the constructivist monument (arguably a completely new form, rather than a hybrid of sculpture and architecture) championed by Punin, Tatlin and others soon lost official support in favour of precisely the kind of figurative monument it sought to replace, the questions that Punin raised were among those that continued to be debated in relation to twentieth-century monumental art in general: the leader vs. the masses, modernity vs. tradition, national vs. universal. In the decades that followed the Revolution, the Soviet leadership went on to plan fantastic edifices topped with the giant figure of Lenin or Stalin. (The competition for the Palace of the Soviets produced perhaps the supreme examples.) In these the monument ceases to represent the ideal fusion of architecture and sculpture: the building, vast as it is, becomes the pedestal for the figure. There is a strange disjunction of scale that fails to resolve itself, except in the idea ridiculed by Desnos of a superhuman

mortal. To an extent, subjects such as Stalin or Lenin as 'Leader, Teacher, Friend' can be seen as attempts to defuse and conciliate the tension between the cult of the hero and the rights of the collective.

The populist rhetoric of the totalitarian regimes thus sometimes offers revealing contradictions in the context of monumental art. Perhaps surprisingly, there were no monumental figures in bronze or stone of Hitler, although his image was ubiquitous in paintings and smaller portrait busts. (Mussolini, however, did not stint in presenting himself and the King Emperor on all scales.)

If portrait monuments were the natural expression of the cult of the Leader, another major genre of monumental sculpture and painting, allegory, was intended to form the symbolic order that constructed a sense of nationhood, especially for those regimes seeking to authenticate and legitimise themselves through history and tradition.

At least since Hegel, allegory – the appropriation of an existing image to make a present point – has been regarded as a debased device, icy, remote and inauthentic, an 'aesthetic aberration, the antithesis of art'.[12] Walter Benjamin restored interest to the term, if not to the type of official art that continued to be produced under its name. Normally banished from the modernist canon, allegory posited a relationship between modernity and history, which Benjamin as a Marxist recognised as an urgent issue. For him, though, it was not monuments but their ruins that constituted 'allegory'. This had a disjunctive, atomising character – not being whole, essential or organic – and could thus be extended to refer to collage and photomontage as well, which recycle and juxtapose materials in unexpected but significant combinations. In this light, George Grosz's montage of a bourgeois constructed of newspaper clippings, coloured lithograph and hair could be read as an allegory of capitalism.

The type of art that interested Benjamin, usually in a Dada or surrealist context – montage, photography, film, the city street that was also the surrealists' natural hunting ground – was as remote from Greenberg's modernism as was kitsch or propaganda. At the first International Dada Fair in Berlin in 1920, Johannes Baader erected a large conglomeration of material, objects, photographs, slogans, newspapers, in a heap that was described as 'Dadaist monumental architecture in five floors, three parks, a tunnel, two lifts and a cylinder end'. It has been suggested that this was an ironic comment on Oswald Spengler's *The Decline of the West*;[13] certainly it revels in the appropriation of imagery that is part of the 'allegorical impulse', as later defined in postmodernist theory. From this perspective, Dada's disruptive iconoclasm is seen as a 'truer' face of the twentieth century than its faded monuments. Dada's techniques of disjunction and appropriation seem the opposite of the binding and controlling impulses of monumental art, but 'allegory' presides at the heart of each.

Both Germany and Italy laid claim to the classical tradition. Sironi represented Italy as a female version of Emperor Augustus, while Giorgio Gori's equestrian statue

The Spirit of Fascist Italy, which fronted the Italian Pavilion at the Paris 1937 exhibition, drew upon many layers of equestrian imagery from Rome onwards. For Germany and Italy, the monument had a classical aura that reinforced its message of longevity and a continuity that was intended to legitimise the illegitimate dictatorship. By contrast with Italy, though, there was little in Germany that mediated between the classical and the modern: between the pastiche antique and the great machines and autobahns. It is significant that *Cahiers d'Art*, while attacking the aesthetic of the Third Reich, reproduced photographs of German machinery – the diesel motor and the Mannesmann tube– among its photographs of modern buildings and their interiors at the Paris Exhibition. Its editor, Christian Zervos, commented on the sculpture of the Third Reich as consisting of 'beings carved out for sport, struggle, violence; depth is missing'.[14] Virtually interchangeable male nudes represent things such as Comradeship, Youth, Sport, Victory, even the Ostmark ('Eastern Frontier'). These lack depth in the sense in which Zervos understood it: that is, signs of human sensibility or specific individual being, but also signs of the elaborate culture required by allegory. The only attributes tend to be helmets and cloaks, unlike the giant nudish figures in the Foro Mussolini in Rome, who are carefully identified via the signs of the modern sports they represent. Would both these cases be condemned under the one label of 'Alexandrianism', as Greenberg dubbed it, a late version of the academicism 'in which the really important issues are left untouched because they involve controversy, and in which creative activity dwindles to virtuosity in the small details of form'?[15]

These instances of monumental sculpture attempting to authenticate themselves and the idea of history they represent are in fact quite different, and both, though probably unintentionally, offend against virtuoso academicism. In the case of the Nazi sculptures, there is a clue in the Ostmark sculpture. This archaic term is resonant not of classical Rome but of medieval Germany, and it reminds us that the past had to incorporate Wagnerian Nordic mythology and the Teutonic Knights as much as classical antiquity. Thus these native/classical bodies had to compromise and lose specificity in order to retain both their aesthetic and their ideological character. In the Roman sculptures, by contrast, the modernised versions of allegorical attributes, which deliberately display familiarity with and capacity to ring changes on their ancient sources, become dissonant and ludicrous because what is being sought is a non-allegorical identity with the ludic nudes of the past. (Tennis is not played in the nude.)

A much more elegant response to allegory's 'conviction of the remoteness of the past, and desire to redeem it for the present'[16] is Arturo Martini's great bronze *Winged Victory* or *Victory in the Air*. This celebrated the crossing of the Atlantic by an Italian air squadron led by Marshal Italo Balbo, and dominated the Cour d'Honneur of the Italian Pavilion at the Paris International Exhibition of 1937. Fully three-dimensional, the huge female figure is suspended from the wall so that she appears to be in flight, attended by eagles flying in formation like the pilots. She honours as much the national exploit as the conquest of the Atlantic, and

therefore combines the idea of the Italian nation – so often, as in Sironi's murals, represented by a draped female figure – with a modernised version of the antique figure of *Winged Victory*.

Italy was not alone, of course, in rooting much of its monumental art in nationalist allegories, centred on the classicised female figure, which were then elaborated to suit the particular context (Industry, Transport, Justice or whatever). Versions of this had long been part of the official rhetoric of many nations, including France and Britain. Marianne, the Revolutionary symbol of the French Republic, reappears at the heart of the Popular Front's 'Peoples' Fair', the Paris 1937 exhibition. Antoine Bourdelle's bronze *La France*, complete with spear, stood on the top terrace at the centre of the colonnades of the Palais de Tokyo, the new Musées d'Art Moderne, above bas-relief allegories elaborating on the idea of France's geographical extensions by sea and air (Imperial France).

Germany chose as its national sign the eagle, usually publicly displayed in conjunction with the swastika. Architectural decoration in the Third Reich was almost exclusively limited to these two forms. The USSR obviously needed a universal symbol of revolution; it is a matter of debate whether figures carrying the hammer and sickle could be described as allegorical. The sculptures topping the German and the Soviet Pavilions at the Paris International Exhibition make an interesting comparison. The inevitable eagle faced Vera Mukhina's colossal steel-clad statue, *Industrial Worker and Collective Farm Girl*. These figures are anonymous but not abstract; they are not 'allegories' of an abstract concept or virtue, but the young heroes of a new world order. Unlike images of specific heroes, martyrs or leaders, though, they do not stand out from the crowd as individuals, for they are simultaneously of it. It is important to note that the two figures, striding and dynamic man and woman, are treated equally in terms of gender, for this is one of the many features that distinguishes Soviet imagery from that of Nazi Germany. The tendency of the latter in monumental statues, and indeed in all plastic arts, was to a ludicrous exaggeration of male and female difference, as in the towering Thorak triads that flanked the entrance to the German pavilion.

What modernity should constitute in the context of monumental art was also of course inflected by the political context. For Léger,, the ideal modern monument was Radio City in New York. For Punin: 'A monument must live the social and political life of the city and the city must live in it. It must be necessary and dynamic; then it will be modern. The forms of contemporary, agitational plastic arts lie beyond the depiction of man as an individual. They are found by the artist who is not crippled by the feudal and bourgeois traditions of the Renaissance, but who has laboured like a worker on the three unities of contemporary plastic consciousness: material, construction, volume.'[17] Mural painting in this century, secular offspring of religious frescoes, has taken on a more elaborate didactic function than statuary was capable of, especially in the hands of its greatest exponents, the Mexican muralists.

In Mexico, a programme of monumental art to decorate public buildings was inaugurated shortly after the Revolution of 1910–20, by José María Vasconcelos, the new Minister of Education. However, his plan for harmoniously vague and elevating humanist allegories was rudely overtaken by the artists he had gathered together. In 1923 the newly formed Union of Mexican Workers, Technicians, Painters and Sculptors issued their Manifesto repudiating easel painting and asserting their commitment to a didactic and national mural art. Although this is not directly part of our story, it is important both as precursor and comparison in relation to the claims and practice of mural painting as a monumental art. Signed by, among others, José Clemente Orozco and Diego Rivera, but largely composed by David Alfaro Siqueiros, the Manifesto claimed that the art of the Mexican people was directly linked to their Indian traditions, was 'of the people and therefore collective [...] We reject so-called salon painting and all the ultra-intellectual salon art of the aristocracy and exalt the manifestations of monumental art because they are useful. We believe that any work of art which is alien or contrary to popular taste is bourgeois and should disappear because it perverts the aesthetic of our race'.[18]

What would have seemed a natural alliance, though, between the Soviet Union and the Mexican muralists came to little; plans for Rivera to paint a mural in Moscow during his visit there in 1927–28 never materialised, and official art there remained largely concentrated in the production of posters, statues and easel painting – admittedly often on a large scale – rather than murals.[19]

Appreciation of Rivera in Europe came from an unlikely quarter: the surrealist leader André Breton, who visited Mexico in 1938, and wrote enthusiastically of Rivera's work, not only in his essay 'Souvenir du Mexique' but in letters to surrealist friends and colleagues. André Masson wrote in response: 'I have often thought of his [Rivera's] lot (to be a great monumental painter), which has always seemed to me the best career there is for someone who wants to reveal the conception he has of the world, of life, his *raison d'être* – "by means of painting".'[20] For Masson himself, a painter who, through surrealism, was committed to the idea of revolution but lived in a bourgeois democracy, this was impossible: 'Long live Mexico which is in harmony with Diego Rivera, and long live Diego Rivera who puts his genius at the service of an entire people.'[21]

How did Breton, whose resistance to propaganda in art, and to the very idea of a 'proletarian' art or literature, had been thoroughly honed and articulated in a series of confrontations with the French Communist party earlier in the 1930s, justify his response to Rivera?[22] In 'Souvenir du Mexique' he talks not of the grand political vision of Rivera's murals but of their direct, story-telling character, like a popular picturebook, and their link to the Pre-Columbian past.[23]

Breton refuses to relate Rivera to the issues of Socialist realism, but his companion in Mexico, Leon Trotsky, does precisely that in a letter to the editors of *Partisan Review* in 1938. Trotsky contrasts Rivera's work with Stalinist socialist realism,

whose anachronistic photographic naturalism and historical falsifications express the 'profound decline of the proletarian revolution': 'Incredible as it seemed at first sight, there was no place for the art of Diego Rivera, either in Moscow, or in Leningrad, or in any other section of the USSR where the bureaucracy born of the revolution was erecting grandiose palaces and monuments to itself. And how could the Kremlin clique tolerate in its kingdom an artist who paints neither icons representing the "leader" nor life-size portraits of Voroshilov's horse?'[24]

The 'Manifesto for an Independent Revolutionary Art', signed by Breton and Rivera, though drawn up by Breton in collaboration with Trotsky, was published in 1938. While drawing a clear distinction between fascism and communism, this robust assertion of the artist's need and right to complete creative independence outlines the degradation of conditions in Germany and the USSR. The Soviet Union represents 'not Communism but its most dangerous and treacherous enemy'.[25] The Manifesto is an appeal to find a common ground for all the scattered and isolated revolutionary artists. Although the movement it represented, FIARI, was short-lived and utopian, the Manifesto sought to address in simple terms the conflict between the individual artist and hostile social forms, without reviving 'a so-called pure art which generally serves the extremely impure ends of reaction',[26] or losing a belief in the capacity of art to influence the fate of society.

The International Exhibition of 1937 in Paris was the last showcase in Europe before the Second World War for the display of art that was 'monumental' in a variety of different senses: that is, monuments in the classic sense of commemorative sculpture, allegorical and symbolic figures, and work in two or three dimensions that was simply on a massive scale. The works of mural painting, mosaic, stained glass and tapestry fell into both didactic and decorative categories.

The most prominent two-dimensional monumental works were those of Sironi, Picasso, Dufy, Léger and the Delaunays. Those who had publicly entered the debate – Sironi and Léger – claimed their *raison d'être* to lie in the popular, collective character of the mural. Le Corbusier, however, *raised* some awkward questions about the character of the spectator-public. He noted that few paused to look at Picasso's *Guernica*, while Dufy's vast mural on the history of electricity, which was simply a panoramic view of individual inventors with a few illustrative anecdotes but with very little concern for structure, drew crowds who amused themselves identifying the various characters.

Both Sironi and Léger wrote about monumental mural painting, but from very different perspectives. Sironi's 'Manifesto of Mural Painting', which was also signed by Achille Funi, Massimo Campigli and Carlo Carrà, argued that art had a social function, and that mural painting was 'social painting *par excellence*', because it 'acts on the popular imagination more directly than any other form of painting'.[27] The Manifesto is haughtily vague, however, about what exactly the social, civic, didactic function of fascist mural painting constituted. The impression that mural

painting should leave on the public would not be by virtue of the subject matter –
which was, Sironi argues, the error of the Communists. It should rather be by the
'style'. The mural 'must give a unity of style and grandeur of contour to common
life. Thus art will once again become what it was in the greatest of times and at
the heart of the greatest civilizations: a perfect instrument of spiritual direction'.
Through mural painting, order, control and the authority of antiquity would become
the 'Fascist style'.

Far from Rivera's rousing and polemical populism, Sironi dreamed of the unforced
superiority of muralism, which would synthesise tradition and contemporary life.
His own compositions, such as the mosaic for the Italian Pavilion of 1937 or the great
stained-glass window for the Palazzo dell'Industria in Rome, avoid specific subject
matter in favour of an 'ideal tension', to apply Mussolini's phrase, between grand
abstractions embodied in allegorical figures and 'typical' scenes from contemporary
Italian society exemplifying work and sport, home and the battlefield, etc. His images
are thus intended structurally to represent Italy: 'the juridical and ideal structure of
Italy today. This structure draws its strength from age-old tradition […] and from the
perpetual capacity of the Latin race for work and renewal. "Believe, Obey, Fight":
that is the inscription placed between the large silhouettes of the mosaic in which
Mario Sironi represents Italy today. The manly figure of the Duce beside that of the
King-Emperor opposite the stained glass where one sees the mystical faces of St
Ambrose, St Martin and the Archangel Michael, seems to warn us that in the life of
the people, what is of value is not just material riches, but above all the ideal forces
of faith, discipline and sacrifice.'[28]

Fernand Léger, whose huge mural *Transport of Forces* was housed in the Palace of
Discovery in Paris in 1937, believed no less in the triumph of the mural as 'modern
monument', but from a diametrically opposite position to that of Sironi. He regarded
mural painting as a necessary response to the exigencies of modern architecture (the
'new pitiless reality' of the architect's white wall) and to public needs of a practical
and psychological kind. The monument is or should be a 'popular work', which
needs the collaboration of architect, painter and sculptor; but this is not a matter
of 'demagogical concessions' or lowering standards to meet popular desires: 'It is a
human necessity which demands that, in works or realizations that touch people,
crowds, the men who direct or command them must listen to hearts beating.'[29]

Mural painting is artisanal and collective. The problem, as Léger saw it, was to
forge a work that was monumental – in the sense that it was public, collective, and
a hybrid of painting, sculpture and architecture – and would act as directly on the
crowd through 'pure plastic values' as did the advertisements, shop windows and
modern form of spectacle to which people were already accustomed. Both Léger
and Rivera keep to the ideal of an art that will be comprehensible to the people. But
while Rivera structured his giant, multi-figure canvases to present strong arguments
about the evils of capitalism, the importance of its specific historical past to present-
day Mexico, contrasting the oppression of the colonial period with the harmony of

Pre-Columbian Mexico, and revelling somewhat contradictorily in the power and magic of the machine, Léger avoided the didactic and the distracting character of figurative narrative in favour of the free use of colour on large surfaces. Wary of coercive claims, Léger saw the 'social function' of his murals in terms of a loosening of habits of thought chaining 'the ordinary man' to a subservient past. His revolution was 'not only of a plastic order, but also of a psychological order':[30] a statement which raises intriguing connections with surrealism.

The fact that, outside the totalitarian regimes, the ephemeral International Exhibitions or World Fairs proved the most viable venue for monumental art is paradoxical. That which was conceived as embodying an idea of permanency and the constant and vital interpenetration of past and present proved even more vulnerable than portable works of art. Little of the monumental art from the Paris 1937 exhibition found a permanent home, and much, like Léger's *Transport of Forces* and Joan Miró's *Catalan Peasant in Revolt (The Harvester)*, disappeared. Robert and Sonia Delaunay's large paintings from the Railway and Aeronautical Pavilions were rolled up and forgotten for decades – as indeed was Rivera's huge mural for the 1940 Golden Gate Fair.

Commemorative figurative monuments in their imperishable materials of stone, bronze or steel appear to guarantee eternal fame, while reminding the spectator of mortality. 'Civic sculpture', Carlos Monsivais wrote, 'is the homage of the lasting to that which will never return.' Statues both *'are*, and *represent'*.[31] Perhaps this is one of the reasons for the violence of the reaction against them when power changes hands. As fetishes of the symbolic order that constructed them, they arouse a kind of primitive animistic awe. At least since the destruction of the idol of Baal, or the disfigurement of the stone heads of the Olmec in America over two thousand years ago, one of the first acts of a liberated people has been the overthrow of the monuments of the previous rulership, which overnight has become illegitimate. When the Soviet Union and other Eastern Bloc regimes crumbled at the end of the 1980s some of the most memorable images were of the dismantling of the stone effigies of the leaders and heroes; the violent destruction of the statue of the police chief – and the careful dimantling with saws, ropes, and cranes of Dolezal's double statue of Lenin and Stalin;[32] photographs show Stalin almost covered with autumn leaves, and graveyards of disgraced monuments in forgotten corners of the cities.

RICHARD J. POWELL
ON THE HARLEM RENAISSANCE

Rhapsodies in Black:
Art of the Harlem Renaissance
1997

Rhapsodies in Black: Art of the Harlem Renaissance *was a transatlantic collaboration between Hayward Gallery, the Institute of International Visual Arts (INIVA) London, and the Corcoran Gallery, Washington, D.C. Co-curated by the American academic Richard J. Powell and the British curator David Bailey, it brought together painting, sculpture and photography, as well as rare archival film and sound recordings, to explore the global significance and impact of the Harlem Renaissance. Alongside the exhibition, the artistic achievements of the Harlem Renaissance were celebrated in a series of readings, performances, talks and a conference, while the Hayward Gallery café was transformed into a jazz café with music selected by broadcaster Paul Oliver. The exhibition catalogue included contributions from the curators, the actor Simon Callow, the academic Paul Gilroy and film director Martina Attille.*

JAZZ AGE HARLEM AND BEYOND

In 1923 the African-American writer Jean Toomer wrote 'Song of the Son', a poem that attempts through imagistic writing and metaphor to describe the peoples and landscape of the southern United States. The setting that Toomer created was one bountiful in nature and gushing with a strange anthropomorphic life force. The last two stanzas are particularly evocative, conjuring images of an African-American past that, like fruit ripened on the vine, exude an accumulative aura of life, death, violence artistry and remembrance.

> O Negro slaves, dark purple ripened plums,
> Squeezed, and bursting in the pine-wood air,
> Passing, before they stripped the old tree bare
> One plum was saved for me, one seed becomes
> An everlasting song, a singing tree,
> Caroling softly souls of slavery,
> What they were, and what they are to me,
> Caroling softly souls of slavery.[1]

Prior to writing 'Song of the Son' Toomer made a symbolic sojourn from a bustling, artistically rich literary scene in New York City to the insular, backwater town of Sparta, Georgia. He stayed in this bleak, southern outpost long enough to conduct an inventory of its sights and sensations, to grasp a deeper understanding of its black folk life and to obtain artistic inspiration for 'Song of the Son', which he included (along with other poems, short stories and a play) in his book *Cane* (1923), now considered one of the most important literary works produced during the period of the 'Harlem Renaissance'.

The Harlem Renaissance – proclaimed in a collection of prophetic black tracts and manifestos, and distinguished by the iconic bodies and voices of Paul Robeson, Marcus Garvey, Josephine Baker and others – was a cultural and psychological watershed, an

era in which black people were perceived as having finally liberated themselves from a past fraught with self-doubt and surrendered instead to an unprecedented optimism, a novel pride in all things black and a cultural confidence that stretched beyond the border of Harlem to other black communities in the Western world. The 'Renaissance' artists who immediately come to mind – painter Aaron Douglas, author Langston Hughes, jazz musician Duke Ellington, blues singer Bessie Smith, dancer Josephine Baker and the consummate all-round performer Paul Robeson – had certain attitudes about the black-experience-as-art that, through paintings, writings, musical compositions and performances, explored an assortment of black representational possibilities, from Langston Hughes's and Bessie Smith's images of the rural and folkloric to Aaron Douglas's and Duke Ellington's invocations of the progressive and ultra-modern.

The term 'Harlem Renaissance' (as employed by many historians and critics, especially after the 1950s) usually describes an African-American, New York City based cultural experience. It not only locates this black creativity in Harlem but situates it between the end of the First World War and the 1929 stock-market crash and ensuing worldwide economic depression. It also refers to a particular type of art (overwhelmingly literary and musical, and occasionally visual) and frequently excludes certain art forms (like film and, curiously, graphic design) and certain artists (particularly African-Americans from places other than New York City, and European-American, European and Caribbean artists). Similarly, the term's association with the 1920s presupposes that the Great Depression (and the related, ideological shift to economic and populist concerns) interrupted this race renewal impulse. Scholarly debate about the Harlem Renaissance has too often concluded that it was no more than a decade-long window of opportunity for black culture: a lone, shooting star in what was otherwise a vast, black void of artistic gloom and inertia.[2]

However, the arts, artists and ideals of the Harlem Renaissance did not evaporate once they entered less exalted eras. Most of the major Harlem Renaissance figures continued to create important work in the 1930s and later; their legacies were handed down to the next generation of artists; and their historical importance increased in the years to follow. The celebration of this distinctly African-American time and place – recognised in the 1920s but apparently first named 'a Harlem Renaissance' in 1947 by the eminent historian John Hope Franklin – expanded with each passing decade, so much so that by the late twentieth century the idea of a burgeoning, early-twentieth-century African-American and Harlem-based cultural groundswell was endemic to modern American arts and letters.[3]

The plethora of past exhibitions and publications addressing 'the art of the Harlem Renaissance' has, however, provided little more than a series of introductory art surveys: pictorial 'roll calls' that, in their endeavour to present names and figures accurately, too often omit the artistic motives and implications of the work itself. What are we to make of Aaron Douglas's slit-eyed, streamlined silhouettes, for example, or of Richmond Barthé's sensuous African nudes in bronze? How can we reconcile the caricatured, grinning, 'darky' types in the 1930s paintings of Palmer C. Hayden?

And what are we to glean from Harlem Renaissance works if the artists are *not* from Harlem but, say, from Chicago, San Francisco, the southern United States, London, Paris, or even Kingston, Jamaica? Are these works still the products of the Harlem Renaissance, or are they the fruits of some other, thus far unnamed, concurrent cultural phenomena? And what are we to garner from artists such as Carl Van Vechten, Winold Reiss and Doris Ulmann, who were passionately engaged in black representational discourses and yet not black themselves? Do we dismiss these artists entirely, or do we include them in the larger investigation surrounding the artistic pursuit of an earthy, unapologetically hybrid, subversive modernity?

In addition to focusing on the 'visual' within this black aesthetic frame, what is needed is a reformulation of the Harlem Renaissance concept: a reconceptualisation that, while retrospective, is also revisionist and resourceful, given the creative, mutable presence of the Harlem Renaissance ideal in assorted post-Harlem Renaissance cultural forms (literary and art criticism, exhibitions and contemporary cinema). For the purposes of this exercise the insertion of a virgule (/) into the word *Re/Birth* (or *Re/Naissance*) underscores this act of reconceptualisation. By diacritically separating the prefix *Re* (which in Latin means 'back', 'again', 'anew' and 'over again') from the suffix *Naissance* (whose Latin root natus refers to 'birth', 'descent', 'beginning', 'dawn' and 'rise') we emphasise the concept's original sense of cultural and intellectual renewal and its visual agenda to rediscover and recreate a modern body (in this case a black one). Furthermore, by isolating *Naissance* and encouraging aspects of the Latin suffix *natio* to re-emerge (and, consequently, allude to 'tribe', 'race', 'people' and 'class'), we invite interpretations of the *Harlem Re/Naissance* that take into consideration the movement's often overlooked objective of establishing a new, spiritual, political, and self-conscious *nation*.

With these modifications in mind, *Harlem Re/Naissance* no longer functions as an essentially literary, racialised phenomenon, isolated from assorted art forms and creative forces in the years between the two great World Wars. Rather, *Harlem Re/Naissance* is a provocative response to a new art era: an aesthetic retort that, like Jean Toomer's anthropomorphic, plum-bearing perennial, transcends time to celebrate identity, creativity, the past, the present and the body politic. With the visual arts of the 1920s and 1930s anchored by black peoples, we can recollect and reimagine this twentieth-century moment when Harlem was not only 'in vogue', or 'on the minds' of a complacent few, but also a geo-political metaphor for modernity and an icon for an increasingly complex black diasporal presence in the world.

BLACK LIKE ME

Rest at pale evening,
A tall, slim tree,
Night coming tenderly
Black like me.
LANGSTON HUGHES[4]

RICHARD J. POWELL ON THE HARLEM RENAISSANCE

Although first conceived circa 1920, *Ethiopia Awakening* by the New England based, Rodin-trained sculptor Meta Vaux Warrick Fuller was art for the future. In spite of the sculpture's roots in early-twentieth-century Pan-Africanist thought, and in the part classical, part allegorical form of Antoine-Louis Bayre and Augustus Saint-Gaudens, Fuller's vision of an ancient Egyptian noblewoman, aroused and emerging from the cloth and papyrus wrappings of the dead, was a spirited message of rebirth and self-realisation: an artistic statement articulated by many African-Americans in the aftermath of slavery and the post-Reconstruction period, and one that clearly resounded with black modernists in the 1920s and 1930s.

This figure, looming from a cocoon-like sculptural base, gave concrete form and signification to the uprooting and resettlement process experienced by blacks in the early twentieth century, whether African-Americans migrating in droves from the rural South to the urban North or blacks from the Caribbean and Africa moving in ever increasing numbers to Paris, London and other European cities. This diasporawide arousal, akin to a reawakening, was the rediscovery of an African identity that had been submerged under decades of peonage, servitude and stultifying tradition, but was now freed from a chrysalis-like state in order to explore and interact with an industrialised world and to see the self and other people of African ancestry in a new light.

In a 1925 essay entitled 'The New Negro', Howard University Professor of Philosophy Alain Locke described this transformation as not relying on older, time-worn models but, rather, embracing a 'new psychology' and 'new spirit'. Central to Locke's prescription was the mandate that the 'New Negro' had to 'smash' all of the racial, social and psychological impediments that had long obstructed black achievement. Six years prior to Locke's essay, the pioneering black film-maker Oscar Micheaux called for similar changes. In his 1919 film *Within Our Gates*, Micheaux presented a virtual cornucopia of 'New Negro' types: from the educated and entrepreneurial 'race' man and woman to the incorrigible Negro hustler, from the liberal white philanthropist to the hard-core white racist. Micheaux created a complex, melodramatic narrative around these types in order to develop a morality tale of pride, prejudice, misanthropy and progressivism that would be revisited by Locke and others.[5]

Photography was another medium through which artists sought to visualise this new racial entity in modern society. A cursory look through the pages of *The Crisis* (the monthly magazine published by the National Association for the Advancement of Colored People) shows an editorial interest in depicting the 'New Negro'. From the painterly soft-focus studio portrait to the crisp identification picture (or 'mug shot') culled from assorted educational institutions nationwide, *The Crisis* visually linked the enterprising black man, woman and child to the larger, contemporaneous, race-based movement then in progress. Sociologist Charles S. Johnson's 1925 observation that a 'new type of Negro is evolving – a city Negro' was subliminally affirmed in countless photographs of black folk, dressed up and placed in front of studio backdrops or standing before elevated train stations and urban brownstone stoops. Even in the photographs of Richard S. Roberts (taken in Columbia, South Carolina, among the black businesses and

homes revealingly referred to as 'Little Harlem'), a citified image of African-Americans reflected the phenomenon of a growing black urbanism and the marketing of a black urban identity to public policy advocates and the common people alike.[6]

Richard Roberts's unidentified portrait of an anonymous young man brandishing a pistol – a precursor to today's 'gangsta' rap videos showing black male bravado – certainly spoke to this new, emerging black identity, but without the aesthetic allegorical airs of Fuller's chrysalis-like figure. One is reminded here of the 'con-artists' of Rudolph Fisher's assorted Harlem stories or of the mean and tough men sung about in certain blues recordings of the period. That this young man's aggressive display would have dissipated in the face of southern United States white male dominance and racial violence is worth noting, yet Roberts's intentions are clear: an embodiment of power and, simultaneously, an imagined black male as social outlaw and predator. [7]

In contrast, Charles Alston's *Girl in a Red Dress* depicted his 'New Negro' subject as neither allegory nor social agent but, rather, as an expressive contemporary persona. Physically elongated and resembling an African figurine, Alston's sitter had as much in common with the women in Amedeo Modigliani's Parisian paintings as with images of women from New York, South Carolina or other 'New Negro' areas. And as with the female protagonist in *The Blacker the Berry* (Wallace Thurman's 1929 novel about race, gender and self-image), Alston's woman is defiantly black, beautiful and feminine, yet also unsettled, mysterious and utterly modern.[8]

These representations of the 'New Negro' went far beyond Alain Locke's 1925 admonition that 'Art must discover and reveal the beauty which prejudice and caricature have overlaid.' By photographing this young man as a pistol-wielding transgressor, and by painting this woman as a lovely yet impenetrable enigma, Roberts and Alston challenged the stock characterizations of the modern black man and woman, investing them not only with beauty, light-heartedness and urban sophistication but with psychological depth, a Toomer-like allegiance to 'the soil of one's ancestors' and a growing social presence. These 'New Negroes' – not only *reborn* but *self-made* – sprang from the imaginations and real-life narratives of an at times exhilarated, at other times disillusioned post-First World War generation that, despite characterisations to the contrary, took on as many forms, shapes, colours and perspectives as these modern times required.[9]

THE ETERNAL RADIO

(Harlem) is romantic in its own right. And it is hard and strong; its noise, heat, cold, cries and colours are so. And the nostalgia is violent too; the eternal radio seeping through everything day and night, indoors and out, becomes somehow the personification of restlessness, desire, brooding.
NANCY CUNARD[10]

RICHARD J. POWELL ON THE HARLEM RENAISSANCE

In a 1931 issue of the Parisian journal *La Revue du Monde Noir*, Paul Guillaume, the famous collector and promoter of 'modern' and 'primitive' arts, is quoted as having said that 'the mind of the modern man and woman must be Negro.' While such a claim could be dismissed as an outrageous pronouncement, the idea that modernity was at least *partially* informed by an unrecognised black diaspora factor was certainly in the air. Modern poets, novelists and playwrights of the 1920s and 1930s who incorporated black characters into their writing (William Faulkner, Fannie Hurst, Julia Peterkin, Claude McKay and Eugene O'Neill, for example) suggest that this interest in blackness was not inconsequential. Similarly, modern musicians and composers of the same era who appropriated key elements from assorted traditional, popular and religious black musical forms (George Antheil, Duke Ellington, George Gershwin, Darius Milhaud and William Grant Still, among many other) were often forthright in their praise of (and acknowledged borrowings from) African, Caribbean and black American aural arts.[11]

In terms of visual art, the role that black people, their art and their ideas has played in the construction of modernity remains resolutely unrecognised by some. Despite the amount of documented European indebtedness to African art and peoples, recognition of the centrality of *l'art nègre* to modernist thinking and the restating of Alain Locke's theses or Robert Goldwater's writing on this subject, there are those who argue that blackness was immaterial (or even antithetical) to modernity in the visual arts. For these naysayers, blackness is equated with a fleeting, superficial fascination, more about nostalgia and timelessness than about speed, technology and the future.[12]

Yet several artists during the 1920s and 1930s succeeded in visualising a modern black culture. In the work of New Yorker James VanDerZee, Washingtonian James Lesesne Wells and the San Francisco Bay area sculptor and graphic artist Sargent Johnson, black people and communities were often portrayed in a streamlined, modern 'style'. The visible markers employed in these and other artists' works read like an inventory from a Sears Roebuck catalogue or, better yet, from advertisements in *Vanity Fair*: images of paved streets, factory smokestacks, Pierce-Arrow Runabouts, and 'flappers' and 'sheiks' wearing racoon coats, pomade-laden hair, and striking elegant sculptural-like poses.

In Sargent Johnson's *Lenox Avenue*, the legendary Harlem locale was visualised not as an urban landscape but rather as an abstract compilation of carefully drawn elements: a pencil, piano keys, palette-like forms and, of course, Johnson's ubiquitous referencing of African facial physiognomy (as seen in his linear treatment of full everted lips). Johnson's modern black city took its form from a perceived racial distinctiveness, from the tools and implements of creativity and, most importantly, from those parts of the black body that provide speech *and* song: vocalisations that, from the black nationalist Marcus Garvey to the blues singer Bessie Smith, bore poetic witness to the modern black condition.

In the paintings of Chicago artist Archibald J. Motley Jr, signs of modernity fused with compositional fracturing and chromatic freedom, resulting in works that, while ever conscious of the figurative tradition, forged ahead with a pictorial dynamism

and thematic complexity that complemented works by many European and white American modernists. Motley's *The Plotters*, for example – with its cubist/realist repartee and implied conspiratorial scenario – echoed similar representations of a gendered and territorial urbanism present in many 1930s paintings and films. And in Motley's *Saturday Night Street Scene* the artist's recurring fascination with Chicago's 'Bronzeville' community invoked comparison with Stanley Spencer's provincial community and Phillip Evergood's 'taxi-dancing' Manhattanites. The parade of 'black, tan and beige' humanity in a street patrolled by a white cop and scrutinised by an unruly haired, impervious black girl, underscored the absurdities, dangers and possibilities of life in this new urban milieu.

With the move from small towns to cities, and with the branching out into previously off-limit professional terrains, blacks embraced a new set of rules. The proverbial, old-time 'Bandanna Days' (mockingly sung about by the popular musical duo Sissle and Blake) were superseded by a time when clothes were pressed and store-bought, and when the new invocation was 'race progress'. 'In the very process of being transplanted', wrote Alain Locke in 1925, 'the Negro is becoming transformed.'[13]

For the African-American painter Aaron Douglas, this 'transformed' Negro was an art-deco silhouette, enveloped in tonally graded arcs, concentric circles and waves, and hieratically placed in a neo-Egyptian *jazz moderne* setting. For the British-born Jamaican sculptor Edna Manley, this same silhouetted, upward-looking entity made a cult out of progressivism, turning popular religion and mysticism into a statement on race pride. Like Sargent Johnson, Manley layered her cultural nationalist sympathies on to modern art and, in the process, made contemporary icons out of the politically awakened (and duly transformed) 'folk'. This new, diaspora-informed, black visual modernism developed out of an inherent contradiction: a celebration of skyscrapers, Cadillacs and progressivism that existed alongside indelible memories of rural shacks and mule-drawn wagons – what Aaron Douglas articulated in 1925 as his desire to create an art that was 'transcendentally material, mystically objective. Earthy. Spiritually earthy. Dynamic'.[14]

VAMPED BY A BROWN-SKIN

I hate to see de evenin' sun go down,
Hate to see de evenin' sun go down,
'Cause my baby, he done lef' dis town...
W.C. HANDY[15]

Rhapsody in Blue by the Mexican artist Miguel Covarrubias represents more than an illustration of what one might have seen upon entering a Harlem cabaret in 1927. Although all of the likely characters (the blues singer, the musicians, the enthralled and slightly inebriated audience members) are there, what is also present is a synaesthetic

Sargent Johnson
Lenox Avenue, c.1938

Lenox Avenue Sargent Johnson.

exploration of pictorial space and colour: a response to an observed, heard and sensed performance that spoke to the essentialness of a multi-experiential reception of black culture.

By way of juxtapositions, colour contrasts and cylindrical, Fernand Léger-like formations, Covarrubias turned a seen Harlem cabaret into an intuited one: a composition that, like Gershwin's of the same name, moved effortlessly between the documentary, the artistic and the delirious. The earth-coloured background of this cabaret scene – punctuated by deep shadows and atmospheric highlights – functioned as a machine-like counterpart to the sensuous, undulating blues singer. In her electric teal-coloured dress, and with her golden, upper body pictorially frozen in an ecstatic, swaying gesture, the blues singer appears as if sprung from the big golden tuba and the quartet of black musicians behind her. And, like her 'sisters' in the audience, the blues singer's gestures communicate a gendered response to music, love and life that would have been understood automatically by many during 'the Jazz Age'. Although Covarrubias had only been a participant in New York City's burgeoning black cultural scene for about four years, *Rhapsody in Blue* provides evidence that he did more than simply illustrate the 'New Negro' arts movement: he visually excavated the rhythmic and emotional dimensions of black performance by placing it on the level of an aesthetic prototype.[16]

This jazz paradigm (or 'blues aesthetic') explains to some extent why the moniker 'the Jazz Age' is attached to this period. Yet critics are often at a loss as to how to articulate exactly what it was (beyond the popularity of Louis Armstrong, Duke Ellington, Bessie Smith and others) that made black music so central to a description of these times. While whites like Al Jolson, Eddie Cantor, Sophie Tucker, Bix Beiderbecke and Paul Whiteman were involved in performing and popularising jazz and blues, most consumers of popular music acknowledged that 'Negroes' were the primary source for it, and that this racial group made jazz and blues not only sound different, but appear and feel different.

Even Jessie Fauset, a conservative writer, acknowledged black performing artists in the construction of a 'blues aesthetic' when (while writing for Locke's *The New Negro*) she quoted the popular saying: 'If you've never been vamped by a brownskin, you've never been vamped at all.' In his painting *Blues*, Archibald J. Motley Jr placed this notion of an enticing, performance-based black agency into immediate visual action. Set in a Parisian 'Black and Tan' club (where a clientele, comprised mostly of blacks from Africa, the Caribbean and the US, would fraternise, dance and listen to the latest black American music), *Blues* gives form, colour and meaning to the Harlem Renaissance idea of a part aural, part performative act of black enchantment. Motley's dense composition of cabaret patrons, wine bottles, musicians, instruments and seemingly disembodied arms and legs all add up to a pictorial *gumbo* of black creativity: a painted space where musical layering and sexual partnering parallel a fractured, cubistic approach to art and representation. But, unlike the emotional and cultural distance from artistic subject matter found in the 1920s cubist paintings of

RICHARD J. POWELL ON THE HARLEM RENAISSANCE

Picasso and Braque, Motley's *Blues* is bold in its racial and cultural locus, and assertive in its aesthetic privileging of black performers.[17]

In *Song of the Towers* Aaron Douglas perhaps paid the ultimate tribute to the black performing artist, with his commanding image of a black man with a saxophone held high above his head. This figure, rendered in Douglas's tonally gradated and silhouetted painting style, functioned within the narrative as the embodiment of the 'New Negro Arts Movement' and the personification of the African-American experience up to 1934. As an avatar of black creativity and self-expression, the man with the saxophone is flanked by two other symbolic personae: the great African-American migration (in the guise of a running and valise-carrying figure in the lower right corner) and Depression-era apprehension (in the form of a fallen and dazed figure in the lower left corner). All three representations of a twentieth-century African-American experience are depicted by Douglas as standing upon, running on top of, or having fallen off a huge cogwheel, the same symbol of an industrial rat race that Hollywood legend Charles Chaplin would employ in his 1936 film, *Modern Times*.

Song of the Towers – along with three other paintings by Douglas collectively titled *Aspects of Negro Life* – hung over the heads of readers in the 135th Street branch of the New York Public Library with a specific mission: to celebrate past and present African-American achievements and to help viewers link art with struggle. Like Francis Ford Coppola's homage to the Jazz Age and human endurance in his 1984 film *The Cotton Club*, Douglas's *Song of the Towers* addressed an American tragedy that African-Americans were intimately familiar with during this period: disillusionment with the American dream and, concurrently, the desire and longing for a home among the city's tall buildings and within a transcendent, spiritual realm. Like Ellington's metaphoric 'Harlem Airshaft', Aaron Douglas, Archibald J. Motley Jr and Miguel Covarrubias channelled African-American realities through an urban machine whose conduits and vents profoundly altered all that flowed through them.[18]

What these and other artists had discovered was that the rumbling of a stride piano, or the dipping and sliding of a black dancer, contained a host of interpretive possibilities: rhapsodies in black set against race and class politics, and capitalism's call for mechanisation and depersonalisation. 'Sooner or later', wrote the French surrealist Paul Morand concerning the centrality of black performers to contemporary life, 'we shall have to respond to this summons from the darkness, and go out to see what lies behind this overwhelming melancholy that calls from the saxophones'.[19]

HOW MUCH OF YOU IS STILL SAVAGE?

My aim is to express in a natural way what I feel, what is in me, both rhythmically and spiritually, all that which in time has been saved up in my family of primitiveness and tradition, and which is now concentrated in me.
WILLIAM H. JOHNSON

The above section title and epigraph were written in the early 1930s, the former by the Martiniquan scholar Louis Achille and the latter by the African-American painter William H. Johnson. From their respective bases (in France and Denmark) they shared an interest in the then popular notion of 'the primitive'. In his essay 'The Negroes and Art' Achille attempted to describe the 'Negro's aesthetic constitution', a sensibility informed by an innate sense of rhythm and spirituality. For Johnson, creating paintings that ultimately reflected a primal and interior self resonated with Achille's views and with those of the European modernists who were also proponents of primitivism. Despite the unscientific (and often racist) presuppositions of these two points of view, what they both argued for was an acknowledgement of the cultural importance and artistic genius of the 'folk'.[20]

The inspirational capacity of the 'folk' (and 'black folk' in particular) was perhaps most evident in the writings of the period. Jean Toomer, Langston Hughes, Zora Neale Hurston and Claude McKay all made strong cases for a focus on the lives of everyday black people, despite opinions to the contrary (W.E.B. DuBois's 1926 art and propaganda essay, 'Criteria of Negro Art', for example). For visual artists like Malvin Gray Johnson, Albert Alexander Smith and Doris Ulmann, this same interest in the common black man and woman was part of a larger international art movement: images of the working class, examinations of labour and leisure among this socio-economic strata and figural studies on the theme of community.

To the undiscerning this modern cult of the primitive was a throwback to an earlier tradition of 'plantation' art and 'colonialist' literature. Yet Ulmann's photographs were a radical way of looking at something old and familiar: a view infused with respect, awe and (as Toomer and others implied) a modern 'ancestorism'. More difficult to distinguish from the plantation art tradition was the work of the African-American painter Palmer C. Hayden. *10th Cavalry Trooper*, painted by Hayden in the early 1930s, had a discomforting resemblance to nineteenth-century racist black imagery. But so did many of the writings of Zora Neale Hurston, the 'Hokum blues' recordings of various musical groups and the 'downhome' antics of Louis Armstrong, Bill 'Bojangles' Robinson and other black performers. This tendency towards a humorous and expressionistic image of black culture was a terrain that many of the more radical artists were willing to enter in order to infuse their art with the totemic allure of 'the folk'. At this moment of economic deprivation, proletarianism and spiritual soul-searching, a painting like *Cavalry Man* – with its broad humour and fantastic imagery – served as a cultural pressure valve and a statement (quoting Nancy Cunard) of 'violent nostalgia' for the citizens of Harlem and other black communities in transition.[21]

Art historian Robert Goldwater argued in his 1938 book *Primitivism in Modern Painting* that this fascination with the arts and cultures of subaltern people was only one component of primitivism. Another major current was the celebration of the primordial in art: truth, beauty and power residing in basic elemental forms, rather than in overwrought ones. Thus the paintings of Georgia O'Keeffe, the photography

RICHARD J. POWELL ON THE HARLEM RENAISSANCE

of Edward Weston, the writings of Jean Toomer and the sculptures of the Jamaican artist Ronald C. Moody all subscribed to an aesthetic that, while subsumed under the tenets of a nature-inspired early-twentieth century modernism, also embraced a decidedly non-European artistic animism. As signified in the widely published photograph of two African children looking up at Ronald C. Moody's *Midonz (Goddess of Transmutation)*, the art of the 'New Negro' was capable of making a shrine out of creativity itself and a fetish out of racial and cultural difference.[22]

Louis Achille's sarcastic question – How much of you is still savage? – was answered by many of these artists in images of the masses, in disclosures of an absurdist and at times ribald world, and in a coded art of sexuality and vitalism. Cloaked in the propriety of an art ostensibly about 'Africa' and 'the performing arts', Richmond Barthé's *Feral Benga* was publicly lauded by legions of Harlem Renaissance patrons, from Carl Van Vechten and Alain Locke to the administrators of the philanthropic Harmon Foundation. Rather than asking themselves how much of one's nature was 'still savage', Barthé's admirers could avoid the question, although their fondness for these veiled works of black eroticism ultimately implicated them. Barthé, Moody, Hayden and the other neo-primitives, labouring in the asphalt and concrete jungles of the West, willingly placed their reputation on the altar of the 'New Negro' in the hope of obtaining recognition, recompense, or at least a modicum of personal and professional fulfilment for this unprecedented baring of the black soul and self.

AFRICA? A BOOK ONE THUMBS

In 1913 the white American poet Vachel Lindsay conjured an image of Africa that, despite almost a century of re-education and enlightened revisionism about the continent, still remains embedded in the Western cultural conscience. In countless literature classes students have read aloud and remembered the following lines from Lindsay's popular poem 'The Congo: A Study of the Negro Race' with an obvious, recitative flair:

THEN I SAW THE CONGO, CREEPING THROUGH THE BLACK,
CUTTING THROUGH THE FOREST WITH A GOLDEN TRACK.

'The Congo' perpetuated an image of Africa that drew upon centuries of negative portrayals of Africa's peoples, cultures and geography. At the height of the New Negro Arts movement, these same stereotypes – Africa as dark, savage, deadly and sensual – were employed by a range of artists, from Richard Bruce Nugent and Countee Cullen writing about an imagined 'dark continent' to Archibald J. Motley Jr and Richmond Barthé making art works about ethnic types and racial temperaments. African-American singer and actor Paul Robeson also contributed to this mythology with several films created in the 1930s, each with imaginary African settings and Edgar Rice Burroughs-like encounters between noble whites and savage blacks.[23]

Africa's visual arts fared better, though still tainted by the broad perceptual spectre of primitivism. Mixing commendation with discredit, many early twentieth-century critics (like the avant-garde Mexican intellectual Marius De Zayas) could say that African art was 'without history, without tradition and without precedent' and yet proclaim that it served as 'the stepping stone for a fecund evolution in our art'. Writings that extolled the virtues of the art of Africa, and exhibitions that gathered some of the most striking examples of African artistry, encouraged many visual artists of African descent to look at their 'legacy of ancestral arts' and to base their work upon this inheritance. For some this amounted to little more than the insertion of an African mask or figurine into an academic still life, as if its very presence among the flowers and furnishings racialised these paintings. For others the integration of mask-like forms and sculptural elements into semi-representational formats was a visual retort to Jean Toomer's prophetic African-American cultural equation: 'The Dixie Pike has grown from a goat path in Africa.'[24]

In contrast to American notions about Africa (conditioned by long-standing negative perceptions and an uneasy relationship with Africa's New World descendants), the French view of Africa and its peoples (informed by at least half a century of military intervention, colonialism and economic exploitation) was more complex. France's socio-political heterogeneity after the First World War, along with Paris's status as the world's cultural capital, made those parts of Africa then under French colonial dominion fodder for France's appetite for validating, appropriating and reinterpreting world culture. According to Herman Lebovics, in his 1992 book *True France*, to be 'modern in France was to seek a colonial [i.e. an African and Asian] vision of the world'. What Lebovics meant was that as a result of several large-scale Franco-African colonial projects (the Citroën-sponsored Croisière Noire expedition across Central Africa in 1925, for example, and in 1931 the Exposition Coloniale that re-created African and Asian architecture in Paris's suburbs), the modern French cultural agenda frequently placed the arts and peoples of the continent within exotic, subservient and/or hierarchical frames of reference. For example, *Noire et Blanche* by Man Ray derived its meaning not only from the juxtaposition of the head of a white Frenchwoman with a black African mask (specifically a Baule mask from the French West-African colony of Cote d'Ivoire) but from the photograph's subtext of a French regard for *l'art nègre* that often verged on the obsessive.[25]

Yet many artists (especially those who were ideologically attuned to the aspirational aspects of the 'New Negro') raised the level of discourse surrounding Africa and its peoples. During this period the African-American artist Aaron Douglas and the white American sculptor Malvina Hoffman both encountered George Specht's evocative photograph of the Mangbetu woman Nobosodru (taken in 1925 during the Croisière Noire expedition) and countered with art works of their own that spoke directly to a new racial and cultural consciousness. Douglas's drawing of Nobosodru, appearing on the May 1927 cover of *Opportunity*, signalled a shift in his art, from a generic Africa to one where pride was signified in an uplifted head and anatomical elongation. Malvina Hoffman's life-size bronze portrait-bust softened

RICHARD J. POWELL ON THE HARLEM RENAISSANCE

Nobosodru's exaggerated pose and transformed Specht's photograph of her into a positive black image, something rarely envisioned by white artists. Ironically, the settings for the display of Hoffman's *Mangbetu Woman* – first the 1931 Exposition Coloniale and, several years later, the Field Museum of Natural History's Hall of Mankind in Chicago – added to the sculpture an ethnographic and pseudo-scientific view of Africa and Africans that would take decades to rectify.[26]

Loïs Mailou Jones's 1938 *Les Fétiches* departed dramatically from these earlier depictions of Africa and Africans. The Paris-based African-American painter has merged an African art 'legacy' with the surrealistic tendencies of *l'art nègre*, from objects of a French colonial fixation to expressive yet problematic components of a modern black identity. Like the poetry produced under the African and Caribbean literary movement known as Negritude, *Les Fétiches* emphasised Africa's rhythmic and mythic dimensions (as pioneered in Lindsay's 'The Congo') but also attributed a deeper meaning to the continent, a process of reclamation where artifacts, atmosphere and a heightened consciousness created a new sense of what it meant to be 'African' (or 'black') in the twentieth century.[27]

ENVOI: WHO WILL GIVE ME BACK MY HAITI?

The Harlem Renaissance gradually evolved into a 'Reformation', where earlier revivalisms and innovations were pushed to unprecedented extremes (a seen in the provocative paintings of Palmer C. Hayden and Archibald J. Motley Jr), or abandoned for more socially 'relevant' positions within the arts (the community-based works of artists Aaron Douglas and Angela Savage, for example). The cultural consequences of the Great Depression and of the Works Progress Administration's Federal Arts Projects did not make significant impact on Harlem Renaissance artists and their audiences until the middle-to-late 1930s; the ideological deviation from the 'New Negro' to the 'New Deal' was almost imperceptible.[28]

Of special note within these changing tides was the growing significance of Harlem itself. With its ever expanding boundaries and ever increasing black population, the Harlem of the 1930s was the quintessential 'city-state': a territory where Duke Ellington, Father Divine, Joe Louis and the Reverend Adam Clayton Powell Jr had hero status , and where such institutions as the Savoy Ballroom, the Apollo Theatre and the Harlem Art Workshop were shrines. Indeed Harlem's status as a 'city-within-a-city' was firmly established during these years. Ironically, a riot during the Spring of 1935 reinforced this sense of a socially isolated and culturally independent Harlem and it increasingly began to compare itself to other legendary (and embattled) 'black republics' like Ethiopia, Liberia and Haiti.[29]

Thematic forays into a black community (or a racially demarcated 'nation within-a-nation') had actually begun long before the Harlem Renaissance (in the proto-black nationalist writing of the turn-of-the-century African-American author Sutton E.

Griggs and of the pre First World War West African novelist J.E. Casely-Hayford). But the work of art that perhaps galvanised the Harlem Renaissance's fascination with black nationhood (and black leadership) was Eugene O'Neill's 1920 play, *The Emperor Jones*. A thinly veiled drama about the failures of Henri Christophe's despotic reign over the island of Haiti, *The Emperor Jones* was an important vehicle not only for actors like Charles Gilpin and Paul Robeson, but for visual artist as well (Aaron Douglas's blockprint illustrations for the play in 1926 and Dudley Murphy's film treatment of the play in 1935). Although *The Emperor Jones* presented the idea of black nationhood and leadership in a negative, racially atavistic light (no doubt with Marcus Garvey's 'Africa for Africans' rhetoric and his failed attempts at nation-building in mind), its focus on black agency and independence was not lost on Harlem Renaissance audiences.[30]

The history, propaganda and mystique that surrounded Haiti – beginning with the military invasion and occupation of the island in 1915 – took on a life of its own during the Harlem Renaissance. In addition to *The Emperor Jones*, scores of novels, plays, ethnographic studies and journalistic exposés used Haiti and its people for a range of purposes. While Haiti's tortured political history and its cultural links to certain African traditions were viewed by many commentators as evidence of its geo-political weakness and savagery, these same attributes were viewed by others as reasons for recognising the potential for black political power among *all* peoples of African descent and celebrating Africa's gifts (via Haiti) to world culture. With the removal of the US Marines from Haiti in 1934, mythologies manifested itself in interesting ways, from Josephine Baker's staged musical portrayal of a caged Haitian songbird in the 1934 film *Zou Zou*, to two major off-Broadway plays dealing with black political intrigue, Haitian-style: John Houseman's and Orson Welles's *Macbeth* (1936) and William DuBois's *Haiti* (1938).[31]

Haiti, the second of the two Harlem theatrical productions, was especially memorable for Jacob Lawrence, a 21-year-old African-American artist. Sensing that the play had parallels with contemporary life, Lawrence felt vindication for his decision in 1937 to begin a multi-panelled series of paintings on the life and deeds of Toussaint L'Ouverture, the former slave turned military leader of the Haitian Revolution. Based on historical and fictional descriptions, the DuBois play and Lawrence's imagination, the 41 paintings stunned viewers at their 1939 Baltimore unveiling. Works such as number 25 – *General Toussaint L'Ouverture defeats the English at Saline* – were remarked upon not only for their high-key colours and narrative strengths but for their clear and unapologetic allusions to black agency. Looking back on the Toussaint L'Ouverture series and its thematic volleying between Haiti and Harlem, Lawrence noted in 1941 that 'if these people (who were so much worse off than the people today) could conquer their slavery, we certainly can do the same thing'.[32]

Lawrence's observations on the sorry state of affairs that the people of Harlem found themselves in during and after the Depression, and the necessity for recognising one's historical, cultural and political allies in the struggle for full citizenship resonated

RICHARD J. POWELL ON THE HARLEM RENAISSANCE

with a statement made by W.E.B. DuBois in 1925: 'We face, then, in the modern black American, the black West Indian, the black Frenchman, the black Portuguese, the black Spaniard and the black African a man gaining in knowledge and power and in the definite aim to end colour slavery and give black folk a knowledge of modern culture.' One sees in Lawrence's *Toussaint L'Ouverture* series a response to DuBois's 1925 call for political and economic self-awareness among peoples of African descent. Taking this challenge from one of the architects of the Harlem Renaissance, Lawrence turned first to history and then to what literary critic Houston Baker describes as a 'cognitive exploration' of culture in his reformulation of the 'New Negro' ideal.

Linking these discursive strategies to a Depression-era plea for black nation building (Garveyesque in its origins yet street orator-like in its colourful, rhythmic style), Jacob Lawrence functioned as both the *concluder* of a Harlem Renaissance and the *convener* of another, yet-to-be-recognised, black cultural 're/birth': a 'Negro Caravan' of social realism and abstract expressionism during and after the Second World War. This reformation's invitation to impose a new social, economic and political order on to the 'New Negro' essentially rendered it obsolete. However, it was in the 1940s that the Renaissance, barely cold in its grave, was resurrected by historians and critics and, like a jazz-age 'School of Athens', found its way into the history books and annals of a modern imagination. Indeed, these Harlem Renaissance 'seeds' – once considered dry and lifeless in comparison to such 1940s 'sequoias' as Richard Wright, Charlie Parker, Lena Horne and Jacob Lawrence – became 'everlasting songs' and 'singing trees', growing strong, providing cultural sustenance and multiplying with each succeeding generation. As a late-twentieth-century postmodern emblem of black artistic genius and community, the visual, literary, performative and ultimately conceptual dimensions of the Harlem Renaissance both illuminate a shadowy past and prescribe a brilliant future.[33]

DAVID SYLVESTER
ON FRANCIS BACON

Francis Bacon:
The Human Body
1998

Francis Bacon: The Human Body was developed and curated by the critic, curator and writer David Sylvester, an influential figure in the development of modern British art. This selective exhibition, which took place in Hayward's lower galleries, featured five triptychs and 18 single canvases, dating from 1943 to 1986. The exhibition was not a retrospective. Instead, it focused on Bacon's depiction of the human body, the artist's central subject for over 50 years. Sylvester, who had been writing about Bacon for more than five decades, provided the text for the exhibition catalogue. Rather than a long-form essay, Sylvester's text is divided into short standalone sections that were originally accompanied by reproductions of the work in the exhibition.

IMAGES OF THE HUMAN BODY

'I think I have seen figures by him, of which it was very difficult to determine whether they were in the highest degree sublime or extremely ridiculous.' Thus Reynolds of Michelangelo.
THE IDLER, LXXIX, 20 OCTOBER 1759

Bacon has lately survived exposure to two vast museum spaces that could have been killers – the Centre Pompidou in Paris and the Haus der Kunst in Munich. They brought out a grandeur in the work that had tended to be less manifest than its expressiveness and its vitality. Some paintings seemed to possess a Matissean severity and serenity that had not previously been suspected. Canvases hung in the two daylit areas of the Paris showing had a vibrancy that made Bacon look as much a colourist as a dramatist: the grisaille paintings of the late 1940s and early 1950s had a hushed lyricism; the monumental triptychs of the 1970s seemed to derive their power from their abstract qualities: in the great black triptych recording George Dyer's death alone in his hotel room, this document about pain – the protagonist's pain, the artist's pain – what mattered most was the density and incisiveness of the black and maroon quadrilateral shapes.

Where the constructed setting in Paris provided a relatively neutral modernist framework for the paintings, the grandiose neo-classical spaces at Munich were as much a theatre as a set of galleries. You saw a picture in another room through a portal on which it was centred and it looked like a Velázquez hanging in the Prado.

*

Bacon's choice of pictures from the National Gallery's collection for his exhibition in 1985 in the series called *The Artist's Eye* showed a strong bias towards serene and monumental works such as Masaccio's *Virgin and Child* and Seurat's *Baignade*. He did have a still life and a landscape by Van Gogh, but there was no figure-painting

that was at all expressionistic or even vigorously dramatic: Rubens's *Brazen Serpent* had been on the list of possibles but was eliminated. Another artist left out in the end in this case one who would have fitted in – was Raphael. He was left out because there was no particular example that Bacon loved enough, but, had the National Gallery's collection included the tapestry cartoons, which he often went to see at the Victoria and Albert Museum, I feel sure that *The Miraculous Draught of Fishes* would been in the exhibition.

Something in the hang came as a revelation to me. In the middle of the best wall Bacon placed three great nudes: Degas's pastel, *Woman Drying Herself,* in the centre, flanked by Velázquez's *Rokeby Venus* and the Michelangelo *Entombment.* Degas was the marriage of Velázquez and Michelangelo and thus Bacon's key painter.

It was a revelation because of the way it made an unwitting arthistorical point, not because there had ever been any doubt about how crucially those three artists had influenced Bacon. For example, in his earliest surviving image of a nude, *Study from the Human Body* (1949), the treatment of the spine clearly reflects his fascination with how the top of the spine in *Woman Drying Herself* 'almost comes out of the skin altogether', as he put it, making us 'more conscious of the vulnerability of the rest of the body'. In other respects this particular Bacon nude is less like a Degas than many others in that the realisation is more smudgy and atmospheric and evanescent, less incisive, than in later works. It is wonderfully tender and mysterious in its rendering of the space between the legs and its modelling of the underside of the right thigh. Its use of grisaille is breathtaking. None of Bacon's paintings puts the question more teasingly as to whether he is primarily a painterly painter or an image-maker. Does this work take us by the throat chiefly because of its lyrical beauty or because of the elegiac poignancy of its sense of farewell?

<p style="text-align:center">*</p>

There were two images of the human cry that haunted Bacon, one from Eisenstein's Odessa Steps sequence in *Battleship Potemkin,* the other from Poussin's *Massacre of the Innocents at Chantilly.* The first is the cry of a nanny, her glasses broken and her face streaming with blood, trying to protect a baby in its pram from the advancing infantry, the second is the cry of a mother interposing herself between a baby on the ground and a swordsman about to strike. Both cries are induced by the same situation – the threat of infanticide by soldiery.

Bacon was the son of an army captain who was himself the son of a captain and grandson of a general. He grew up in fear of his father, who despised him as a weakling. He had a lifelong devotion to his nanny. In fact, she lived with him in her old age, including the time when he was painting those cries.

<p style="text-align:center">*</p>

I have been looking at a coffee-table book about Bacon portraits in which the plates are all heads in close-up reproduced in colour about the size they are in the actual paintings. They fill me with nausea. They appear to be the outcome of an infliction of damage, of gratuitous and merciless deformation, which they don't when seen in the original. It might be because, when looked at in a book open on a table, they are very much closer than when looked at on a wall, but I do not think it is that, because I doubt whether they would have that sickening effect were they in black and white. The nausea arises from the fact that these coloured same-size reproductions under our noses have a spurious resemblance to the originals but, lacking as they do the low relief and the inner luminosity of paint, are dead. Something grand is thereby turned into something gruesome.

<p style="text-align:center">*</p>

Picasso; Brancusi; Léger; Duchamp and Picabia; Klee, Ernst and Schwitters; Arp, Miró, Calder and Giacometti; Magritte and Dalí; Dubuffet, De Kooning and Guston; Rauschenberg, Lichtenstein, Oldenburg, Warhol, Johns and Koons: all have produced witty or humorous works of art. The twentieth century likes its art to be jokey.

Bacon, who was famous for enjoying and engendering. Huge hilarity in his social life, created an art that was always resoundingly solemn.

But he was not quite alone in his solemnity; he was in the company of Newman and Rothko and Still and Pollock. Those four contemporaries of his are grouped by Robert Rosenblum as the exponents of 'The Abstract Sublime'. And Bacon's role in painting has been that of the one great exponent in our time of the Figurative Sublime.

<p style="text-align:center">*</p>

While Bonnard is not one of the artists eulogised in Bacon's published interviews, my notes on conversations in the 1950s show that at that time he was the twentieth-century painter Bacon preferred – because of the handling of the paint. He also greatly admired Soutine for his paint, but only in the work of the Céret period.

<p style="text-align:center">*</p>

Bacon's work is not companionable. It is quite often shown alongside paintings and/or sculptures by Giacometti, which is reasonable without being especially helpful to either artist, and sometimes with Balthus as well, which makes no sense whatever. It is occasionally shown with De Kooning and/or late Guston, comparisons that are by no means irrelevant but are not very illuminating, though they are more so than juxtapositions with either Freud or Andrews or Auerbach. The artist I want to see alongside Bacon – despite the generation gap – is Warhol. Which Warhols? Car crashes; a large canvas with a head of Marilyn isolated in the middle; certain Jackies; some of the *Most Wanted Men* and *Ladies and Gentlemen*

series; a head of Nelson Rockefeller with a battery of microphones: things that show the transfiguration of photographic images by accidental or seemingly accidental defacements that denote nothing but suggest a great deal.

A triptych of heads forming a sort of tragic strip culminates in an image of a 'broken' man. But what conveys his absolute defeat? Something more than the bowed head on the pillow, the hunching of the shoulders, the wailing mouth, the hand lifted in grief, something more than the conventional miming of despair. It is how the paint is smeared across the features of the face.

The smearing means disintegration: the face is already 'food for worms', the skull seen now 'beneath the skin'. The smearing means destruction: the face is wounded, shattered.

The smearing means obliteration: the face is obscured by the lifted hand, and the hand may be lifted in pain, or to ward off an attack, or to claw at nose and mouth and eyes as if in an effort to wipe them away, to rub out an identity.

The smearing means all this, but what these meanings involve conveys itself before there has been time to become aware of meanings. The meanings, all of them, lie in the paint, and they are in the paint not latently but in the impact of the paint upon our senses, on our nerves.

Nothing in these paintings is more eloquent than the paint itself.

*

The foregoing discussion of *Three Studies of the Human Head* (1953), Bacon's first triptych of heads, was written in 1957 and seems to me to say something about how Bacon's paint works. But the piece in which it was first published is largely shaming. It is a sort of prose poem (rather like those in the present text but more gnomic and incantatory). A first version was published in a French exhibition catalogue and a second shortly after in a British literary and political monthly where it was entitled 'In Camera', as a salute to Sartre's *Huis Clos*. It said things like 'Somebody seen in a fleeting moment in a world without clocks'.

For such excesses I was mercilessly taken apart in a letter from my friend Helen Lessore. Helen's manner was usually rather pi, but it concealed a waspish sense of humour which on this occasion she unleashed. Her letter took the form of a devastating parody of my piece. One of her conceits gave a new meaning to the popes, those fraught images of a father-figure who could be seen as a stand-in for the parent Bacon both feared and desired. I had said: 'One of the popes is alone with a tasselled golden cord hanging from the ceiling. His right arm is raised, and bared to the elbow. He seems to have been amusing himself by making the cord

swing to and fro like a pendulum.' The parody proposed that the pendant cord was a lavatory chain.

<p style="text-align:center">*</p>

Why did Bacon persist, whether doing figures or heads, in painting on the same scale – around three-quarters life size? He proved in the 1944 *Crucifixion* triptych and in *Study of a Nude* of 1952–53 – the back view of a man with arms raised – that he was capable of working very successfully on other scales, in the latter case about one-eighth life size. And there is no doubt that commercially it would have been advantageous to vary the scale.

Was it that he felt that painting was so difficult in our time that he didn't want to complicate things further? Was it that he didn't want to lower himself by being accommodating?

<p style="text-align:center">*</p>

Bacon always claimed that he greatly envied the sort of collaboration that Eliot enjoyed with Pound in writing 'The Waste Land'. 'I think it would be marvellous to have somebody who would say to you, "Do this, do that, don't do this, don't do that!" and give you the reasons. I think it would be very helpful… I long for people to tell me what to do, to tell me where I go wrong.'

Bacon did paint two pictures in collaboration with his best friend, Denis Wirth-Miller, in the early 1950s. But he also dreamed of working in collaboration with an artist he did not know well, Karel Appel, to whom he took a great liking. It never went beyond talk. Many years later I asked Appel whether they had ever even started a collaborative painting. He said it had never happened because they could never make up their minds who was to go first; by the time they did decide, they were always too drunk to make a start.

<p style="text-align:center">*</p>

There are times in the history of art when a lot of people are working well, breaking new ground. The years following the Second World War saw the emergence as major figures of Gorky, De Kooning, Rothko, Newman, Pollock, Dubuffet, Giacometti Mark II and Bacon. And it seems to me that 1945–53 was one of the two peak periods of Bacon's career.

The other, I think, covered the sequence of a dozen big triptychs which he painted between 1970 and 1976, virtually all of them studies of the male nude, most of them portraying George Dyer, some of them avowedly realised in a conscious wish to exorcise the pain of Dyer's death.

<p style="text-align:center">*</p>

In the great triptych of 1973 commemorating on a black ground George Dyer's death in his hotel bedroom, the left-hand panel records the fact that he expired seated on the lavatory. And in the earliest triptych in which Dyer appeared, three views of the same nude figure painted in 1964, the left-hand panel shows him seated on the lavatory.

This is not the only instance of a kind of prophecy in Bacon's work.

In Martha Parsey's documentary film, *Model and Artist: Henrietta Moraes and Francis Bacon*, the model speaks of *Lying Figure with Hypodermic Syringe* (1963): 'When Francis painted a hypodermic syringe in my arm I'd never really heard of drugs… later… I certainly did get to know what a hypodermic was. But he put it there a good ten years before I'd even thought of it.' Bacon in fact didn't think about the heroin. 'I've used the figures lying in beds with a hypodermic syringe as a form of nailing the image more strongly into reality or appearance. I don't put the syringe because of the drug that's being injected but because it's less stupid than putting a nail through the arm, which would be even more melodramatic. I put the syringe because I want a nailing of the flesh onto the bed.'

He made the same show of indifference to the practical implications of props in his pictures in his explanation of the presence of a swastika on the arm of a figure in the 1965 *Crucifixion* triptych, a detail which was widely interpreted as being ideologically significant. 'I wanted to put an armband to break the continuity of the arm and to add the colour of this red round the arm. You may say it was a stupid thing to do, but it was done entirely as part of trying to make the figure work – not work on the level of interpretation of its being a Nazi, but on the level of its working formally.'

It is hard to think of anyone who painted more self-portraits. Bacon painted dozens, mostly small canvases of his head. Usually three are put together to form a triptych; sometimes one appears as a solo canvas or as a unit in a triptych along with other people's heads.

Self-portraits as a genre have traditionally been heads or busts or half-lengths, occasionally three-quarter-lengths, very rarely full lengths. That is largely because they are generally painted from mirrors. Bacon painted from photographs and realised a substantial number of full-length self-portraits. Beginning in 1956 – with an image Quasimodo-like in face and figure – he produced 17. That count includes the *Sleeping Figure* of 1974 painted from a photograph of him stretched' out on a hospital bed. It also includes three items which in fact constitute *Study for Self-Portrait – Triptych* (1985–86). This has a look of having been undertaken as a kind of *summa* of all the artist's activity as a self-portraitist. Such enterprises usually fail. This work seems to me not only Bacon's supreme achievement in self-portraiture but the finest thing he did during the last 15 years of his life. It is in the line of those

self-portraits by old artists which are merciless acts of self-recognition, and it has a kind of grandeur which recalls the unaffected, easygoing grandeur that Bacon had as a man.

<center>*</center>

A list Bacon drew up in the early 1950s of pictures he was planning to paint was headed 'Images of the Human Body'. At that time the bodies were always male. Later they were sometimes female.

The male bodies tend to be paradigmatically male: heavily muscled, with broad shoulders and narrow hips. Even when their poses are manifestly based on photographs by Muybridge, their build is less slim and wiry than Muybridge's models tend to be, more massive: Muybridge's men could be welterweight boxers, Bacon's are like middleweights or cruiserweights. In works of the 1940s and 1950s their musculature usually seems derived from Michelangelo; in works from the mid 1960s on, from George Dyer's body as recorded in the photographs that Bacon commissioned from John Deakin. At the same time, the female bodies tend to be paradigmatically female: curvaceous and well-fleshed. They are generally based on the photographs of Henrietta Moraes also commissioned from Deakin. Bacon's lack of personal erotic interest in naked females did nothing to prevent these paintings from being as passionate as those of the male bodies that obsessed him.

A more dispassionate vision of the female body appears in the bare breasts of *Sphinx – Portrait of Muriel Belcher* (1979); none of Deakin's known photographs of her could have provided a model. This image of the Sphinx is echoed in a more stylised form in *Oedipus and the Sphinx after Ingres* (1983).

Besides these clearly male or female bodies, Bacon also painted a number of nudes whose gender seems uncertain. There are six very similar extant images dating from around 1960 – four in oils, two in gouache – of a figure lying upside down on a sofa: in every case the body is androgynous, whether it has a penis or not; indeed, while the three oils dated 1959 are entitled *Lying Figure* or *Reclining Figure*, the one dated 1961 is called *Reclining Woman*. All of them have a build which suggests that they could have been based on the artist's body. It was, in fact, with these images in mind that in my 1966 television interview with Bacon I asked him whether his figures were ever based on his own body; this he firmly denied. The exchange is not preserved in the published version of the interview, only in the film, which shows that while making his denial Bacon was repeatedly running his right thumb up and down the inside of his bare left forearm. However, *Sleeping Figure* (1974) is a sort of self-portrait and is not at all androgynous.

In the *Sweeney Agonistes* triptych of 1967 all four reclining figures are androgynous and two of them are almost certainly women. In *Triptych – Studies of the Human Body* (1970),

Francis Bacon
Lying Figure with Hypodermic Syringe, 1963

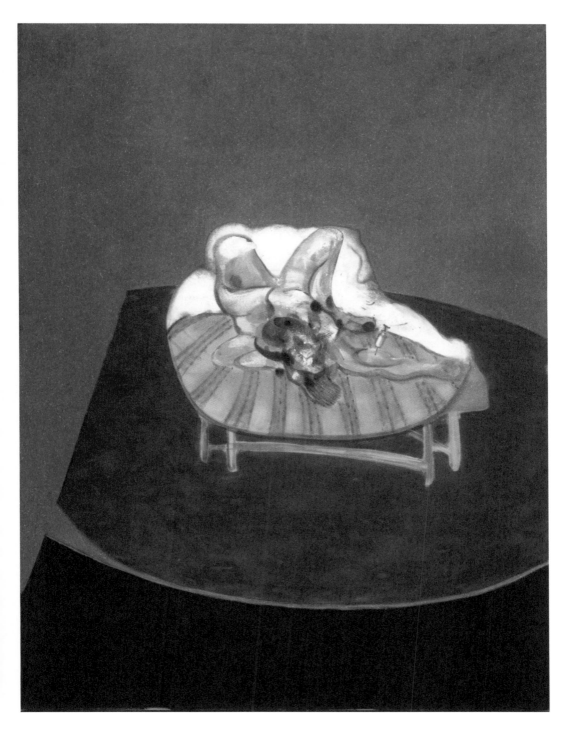

the figure in the left-hand panel is androgynous, while the other two are undoubtedly-women, and women who do not resemble the images of Henrietta. The face of the one on the right looks remarkably like Bacon's face. Furthermore, the eyes seem to be blind. An image comes to mind – that of Tiresias. (I have no idea whether Bacon consciously saw this figure either as an image of Tiresias or as an image of himself.)

In 'The Waste Land', that poem which Bacon always said was 'full of echoes', none of the voices that emerge from the murmur, the prattle, the lamentations of the rapidly changing scenes is more resonant than that of Tiresias – 'I Tiresias, though blind, throbbing between two lives, / Old man with wrinkled female breasts…' – who plays the role of detached observer of a sexual encounter which leaves the woman 'glad it's over': 'I Tiresias, old man with wrinkled dugs / Perceived the scene, and foretold the rest'. And Eliot, in his notes to the poem, says: 'Tiresias, although a mere spectator and not indeed a "character", is yet the most important personage in the poem, uniting all the rest… the two sexes meet in Tiresias. What Tiresias sees, in fact, is the substance of the poem.'

The two sexes met in Francis Bacon, more than in any other human being I have encountered. At moments he was one of the most feminine of men, at others one of the most masculine. He would switch between these roles as suddenly and as unpredictably as the switching of a light. That duality did more than anything perhaps to make his presence so famously seductive and compelling and to make him so peculiarly wise and realistic in his observation of life.

> And I Tiresias have foresuffered all
> Enacted on this same divan or bed;
> I who have sat by Thebes below the wall
> And walked among the lowest of the dead.

HOMI K. BHABHA
ON ANISH KAPOOR

Anish Kapoor
1998

This exhibition, the first major showing of Anish Kapoor's work in a public gallery in the UK, featured over 20 large-scale sculptural works made since 1990, among them a number of site-specific works that responded to the dramatic architecture of Hayward Gallery. Kapoor described the exhibition – which took over the entirety of Hayward Gallery, including the sculpture terraces – as being 'like theatre, but not theatrical'. The essay in the accompanying catalogue, reproduced here in full, was provided by the American post-colonial theorist Homi K. Bhabha, whose influential works include Nation and Narration *(1990) and* Our Neighbours, Ourselves *(2011).*

ANISH KAPOOR: MAKING EMPTINESS

Inability to tolerate empty space limits the amount of space available.
W.R. BION, *COGITATIONS*[1]

The important thing is that at a given moment one arrives at illusion. Around it one finds a sensitive spot, a lesion, a locus of pain, a point of reversal of the whole of history, insofar as it is the history of art and insofar as we are implicated in it; that point concerns the notion that the illusion of space is different from the creation of emptiness.
JACQUES LACAN, *ETHICS*[2]

Is it my role as an artist to say something, to express, to be expressive? I think it's my role as an artist to bring to expression, it's not my role to be expressive. I've got nothing particular to say, I don't have any message to give anyone. But it is my role to bring to expression, let's say, to define means that allow phenomenological and other perceptions which one might use, one might work with, and then move towards a poetic existence.
ANISH KAPOOR[3]

THE TRUE SIGN OF EMPTINESS

I t may be the most valuable insight into Anish Kapoor's work to suggest that the presence of an object can render a space more empty than mere vacancy could ever envisage. This quality of an excessive, engendering emptiness is everywhere visible in his work. It is a process that he associates with the contrary, yet correlated, forces of withdrawal and disclosure, 'drawing in towards a depth that marks and makes a new surface, that keeps open the whole issue of the surface, the surface tension'.[4] Consider, for instance, the figure of *Adam*. A cavity set so deeply in a stone that its pigmented pitch defies the depth of the rock, and floats weightless

to the surface. Suddenly the stone has shifted its mass leaving only its shadow, making more ground than it stands on. Or, walk around the silent swelling of *When I am Pregnant*. Trace the shape as it grows obliquely out of the wall and then suddenly when you stand in front of it, face to face, it is there no longer; only a luminous aureole remains to return you to the memory of fullness, as the wall turns transparent, from white to light. The monumental and noumenal address of Kapoor's work should not obscure these uncanny experiences which suggest that his vast tolerance of empty space expands the space available into another ongoing disruption of 'time'.

Too often we are summoned by critics to stand before Kapoor's voids, bearing witness to those modernist virtues of verticality that Rosalind Krauss justly describes as the process by which 'apparent disorder is necessarily reabsorbed in the very fact of being bounded'.[5] But the expansion of available space – the making of emptiness – never fails to register a lateral movement, a transitional tremor, that disorders the boundedness of the void. The void slips sideways from the grasp of frame and figure; its visual apprehension as contained absence made whole and present in the eye of the viewer, is attenuated. The enigma of the void is now discernible in the intimation of a movement that obliterates perceptual space and supplements it with a disruptive, disjunctive time through which the spectator must pass – 'reverse, affirm, negate'. It is this transitional temporality, effected by the expansion of emptiness, that Kapoor seeks to inscribe into the very passage of time and movement that makes the exhibition the phenomenological experience that it is. *The Double Mirror* works provide a motif of the material techniques and the metaphorical possibilities of 'making emptiness', which is the subject of this essay. Listen to the artist:

> The curious thing about double mirrors, concave mirrors, when you put them together, is that they don't give you an infinite repeatability... What interests me is that from certain angles and positions there's no image at all in either mirror. I'm very interested in the way they that they seem to reverse, affirm and then negate... To place the viewer with these blinding mirrors in this narrow passage... this transitional space... somehow at an oblique angle to the mirrors' 'visuality' or the viewer's visibility is to be caught in the contest of mirrors. They cancel each other out in one moment and yet demanding that they be looked at from a strange, oblique perspective... Where time and space are seemingly absent, at a standstill... in that narrow passage, paradoxically there is a restlessness, an unease... As I said before, a transitional movement – reverse, affirm, negate.[6]

The tactile experience of transition is caught in the virtual space in between the double mirrors. The perspectival distance between subject and object, or the mimetic balance between the mirror and its reflection, are replaced by a movement of erasure and inversion – 'reverse, affirm, negate'. It is as if the possibility of pictoriality or image-making, associated with visual pleasure, has been unsettled

to reveal emptiness, darkness, blankness, the blind spot. However the purpose of Kapoor's work is not to represent the mediation of light and darkness, or negative and positive space, in a dialectical relationship in which emptiness will travel through the darkening mirror to assume the plenitude of presence. Kapoor stays with the state of transitionality, allowing it the time and space to develop its own affects – anxiety, unease, restlessness – so that viewing becomes part of the process of making the work itself. The spectator's relation to the object involves a process of questioning the underlying conditions through which the work becomes a visual experience in the first place: how can the conceptual void be made visible? how can the perceptual void be spoken?

These questions remain true to Kapoor's purpose. Not true in the mimetic sense of reflecting the 'real' or revealing the perfection of aesthetic form. True, however, in the way of the *homo faber* whose eyes stay true to the process of fabrication – straightening, levelling, smoothing, sharpening – in order to move beyond the measure of the 'maker' or the material, so that 'a man's products may be *more*' – and not only more lasting – 'than he is himself'.[7] Kapoor's sense of making the void *more empty* is the process by which the artist's reach exceeds the cloying grasp of 'personality', refusing to allow the source of the work – its originality or identity – to rest in the shallow signature of style.

Style, at first, celebrates the uniqueness of 'quality', the singular challenge of the author or artist; but once established as a 'name' or a signature, value becomes ever more consensual and commodified. To treat the void as style is to read its emptiness as no more than a plea for

the pictorial; what Clement Greenberg has defined as 'the look of the void':[8] 'The geometrical and modular simplicity may announce and signify the furthest-out, but the fact that the signals are understood for what they want to mean betrays them artistically [...] wraiths of the picture rectangle and the Cubist grid haunt their works, asking to be filled out – and filled out they are, with light-and-dark drawing.'[9] In turning away from the look of the void, we suggest, instead, that the truly made void is fabricated from the 'sign of emptiness'. To speak of the 'sign' of a work is not to substitute theory for practice, nor to consign the visual experience of art to the language of writing. The 'sign of emptiness' can neither be fixed as form, nor preserved as an image or an idea. It is 'true' to the making and the materiality of the object but after its own fashion. It emerges, in Greenberg's terms, when the 'signals' of figuration or technique are prevented from articulating what they *want* to mean; when the void's plea to have its vacancy filled is resisted; when the signature of style can no longer name or claim to control the aesthetic logic of the work. Kapoor's voids, standing before us as sculpted objects – blue powders turning into the colour of far, fetching distance – are distinct from his creation of emptiness.

If you think that you have seen 'emptiness' as that hole at the heart of the material's mass, surrounded by a planished façade, then think again. To see the void as a

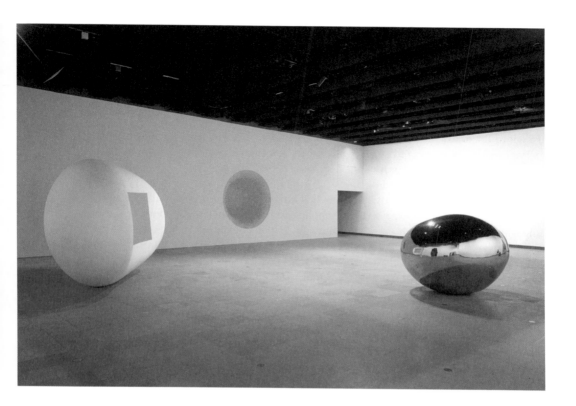

contained negative space indented in the material is only to apprehend its physicality. To figure the depth of the void as providing a perspectival absence within the frame or the *genre* is to linger too long with the pedagogy of manufacture or the technology of taste. The practice of 'true making' occurs only when the material and the non-material tangentially touch. The truly made thing pushes us decisively beyond the illustrational, the 'look of the void'; the sign of emptiness expands the limits of available space. Kapoor says:

> I believe very deeply that works of art, or let's say things in the world, not just works of art, can be truly made. If they are truly made, in the sense of possessing themselves, then they are beautiful. If they are not truly made, the eye is a very quick and very good instrument… The idea of the truly made does not only have to do with truth. It has to do with the meeting of material and non-material… [A] thing exists in the world because it has mythological, psychological and philosophical coherence. That is when a thing is truly made…

> The reason I seem to return to the same material possibilities is, I think, because the polished surface is in fact not different from the pigment. In

the end it has to do with issues that lie below the material, with the fact that materials are there to make something else possible; that is what interests me. The things that are available, or the non-physical things, the intellectual things, the possibilities that are available *through* the material… The material changes… The method of manufacture is not the point. The question is whether or not an object is well and truly made.[10]

To get to the heart of Kapoor's thinking and making we must register the difference between physicality of void space, and truly made emptiness. Let us use Heidegger's beautiful parable of the jug for these purposes.[11] What does the potter make when he shapes the jug? Of what material is the jug made? The potter forms the sides and bottom of the jug in clay to provide the means for it to stand, to be vertical; to make the jug a holding vessel, however, he has to shape the void. 'From start to finish the potter takes hold of the impalpable void and brings it forth as the container in the shape of a containing vessel […] The vessel's thingness does not lie at all in the material of which it consists, but in the void that it holds.' If I might coin a term suited to emptiness, then I would say that in the 'be-holding' of the jug, there is no simply discernible outside (clay) nor a penetrative inside (void), no easily distinguishable negative and positive spaces. These apparent binary oppositions bear a liminal relation to each other. They are held together with the sheer, glancing force with which the surface of a sheet of air intersects the line of the sea's horizon, the elements spliced, stapled together in a slanted slash of a white sail that stands the pressures of wind and water, just precariously out of balance – a tense textile, holding the void, withstanding the vessel. In that impalpable moment or movement in which material and non-material touch in the jug there is the exertion of an oblique relation of force: the clay is rooted by gravity to stand, while the void, enlightened by emptiness, becomes empowered to 'hold' air or water. They come together, in this uncanny relationship, by virtue of the difference that holds them apart; a contest between surfaces, elements, materials or meanings that conjures up one, or the other, through a 'third' dimension. This is the dimension of doubling and displacement: the jug is 'double' in the sense that it is no longer a unitary object but at once a *relation* through clay (material) to void (non-material). And once we restructure the unity of the jug in this way, then the standing (material) and the holding (non-material) are related through an 'otherness', an alterity, an unabsolvable difference. The truly made work find its balance in the fragility of vacillation. It is the recognition of this ambivalent movement of force, this 'doubleness' or 'otherness' of the literal and the metaphoric, the empty and the void, their side-by-side proximity, that inhabits Kapoor's work. Such an articulation through displacement allows us to decipher emptiness as a 'sign', 'where we have really an exteriority of the inward',[12] rather than to pander to the look of the void as it signals its need to be fulfilled.

GHOSTLY GESTURES

I once saw the sign of emptiness rise from the dark void. It was a day of rain and dust as AK and I drove into the stoneyard. You said, 'I want you to see something', pointing

to a shrouded dark stone, its light blinded by dust (*Ghost*, Kilkenny lime stone). As we approach the rough-hewn stone, its irregular mass effortlessly, unconsciously awaits our audience. *Svyambhuv*, the Sanskrit word for the 'self-born' aesthetic (as distinct from rupa, the man-made form imposed through human artifice),[13] has been a long preoccupation of yours and, from one angle, *Ghost* resembles one of those 'irregularly shaped protuberances'.[14] But then, suddenly, the façade belongs to *rupa*. I am always struck by the formality of the openings you cut into your stone pieces. Doorways, elongated windows, thresholds, finely finished portals, lintels with razor-like edges, that contrast with the raw halo of encrustation and crenellation, the chemical activity of the ages, around them. The torqued, ambivalent movement of the stone is unmistakable: *svyambhuv:rupa*, and then, in a flash, *rupa:svyambhuv* – self-made/man-made and then, in an iterative instant, back again, man-made/self-made. Front and back not opposed to each other, but partially turned towards, partly away, from themselves, catching side-long glimpses. A strange diagonal gaze. The whole stone is caught in an act of torsion: turning away from an earlier state, emerging from another time, half-glancing away from us, only partly there, obliquely revealed, a *mise-en-scène* in transition.

Your formal portals and frames are interruptions, interventions in an ongoing history of the material, not a primal past, but the obliquity of the present, just beyond reach, but not-as-yet the future either. In transition, between the material and the non-material... as you put it.

Stand there, you say, just slightly to one side...

I move, at an angle to the stone. I am again puzzled by another aspect of the entrance to the work that has now become obliquely apparent. There is something uncanny about its scale. It is an almost-human opening but not quite made in the image of man, nor in the dimensions of the divine or the measure of the domestic. The entrance does not embrace you; but neither does it evade you: it places you, across from the stone itself, in a corresponding state of transition, or transitivity, of the truly made – not fully human/not wholly natural, the passage between stone and a poetic existence. Ours, now, is that state of 'bewildered calm', as our looking is taken over by an affect of tension and anxiety that Heidegger associates with the impending disclosure of emptiness, as the wholeness of the stone shrinks back or turns back and forth, ambivalently, between its double and displaced lives, *svyambhuv:rupa*. As the one turns to face the other, it encounters a blind spot, the necessary void: 'it discloses these beings in their full but concealed strangeness as what is radically other – with respect to the nothing'.[15]

And then suddenly – with respect to the void – in the emptiness that holds the rock, I see the ghost. It doesn't rise; nor does it descend. It does not allow the eye to seek the satisfactions of origin – does it come from within? from without? from where? Nor does the ghost lend itself to the fixed dimensions of distance and nearness – does it live inside? outside? before? behind? As in Heidegger's jug or Brancusi's *Endless*

Column, 'sky and earth dwell' in the making of *Ghost*.[16] The light of emptiness that emanates from *Ghost*, like the void in the clay or the wind in the sail, falls obliquely, across these material dimensions and divisions: it moves the depth of the stone to the surface, taking the weight off its verticality and holding it, for a moment, in the fine transparency of a film-like column. But then as the dark clouds scud by, the column of light is partially broken, shadow pouring into its emptiness with such a dark presence that it illuminates the deep mirror of the stone. It is, once more, the movement of the material *in and through* the non-material, the ghost *in and out* of the stone, that gives the work its character: like Hamlet's father, *Ghost* walks the night, wafting us to a more 'removed ground'.

ON MOVING GROUND

A 'removed ground', Shakespeare's phrase, is truly made for the appreciation of Kapoor's work. Not, however, if it is understood to refer to the pure ground of theory, or to art's realm of autonomy, the perfectibility of form. But if the phrase is read with an eye to the restless light emitted by *Ghost*, and the bewildered calm of our response to it, then 'a removed ground' makes us aware of a gesture that repeats persistently in Kapoor's works, whether they are the deeply pigmented wall voids or the quicksilver underworlds of the stainless steel floor pieces. A sudden disappearance of surface in a deep, dark hole literally cuts the ground from under our feet; the body loses its direction and density; the eye hovers, horizonless, homeless. Each step we take towards the work places us on moving ground; each time our gaze is suspended between a frame, a lip, of fine luminosity surviving just above the shadow-line, and then all view is lost; vertigo. It is an emptiness more extreme and exploratory than mere vacant or 'negative' space can ever accommodate.

Kapoor's voids force us to recognise that making art out of emptiness is not a process of the figuration of absence or presence, the image of the empty or the full. To fulfil its destiny, without pandering to what Greenberg called 'the look of the void', the work must repeatedly renounce and restore its density through the sign of emptiness that lives in between those contrastive or contradictory states: 'It is on the basis of this fabricated signifier, this vase, that emptiness and fullness as such enter the world, neither more nor less...'[17] And such interstitial spaces can only be represented in the *movement* of quality and quantity within the work's representational core which is displaced by a mode of repetition that circulates at its periphery, disturbing the dimensions of negative or affirmative space, the framed and the free, what is inside and outside. This is a complex thought that addresses Kapoor's own concerns about the true making of his work: 'I seem to be making the same shape, each time with a different purpose', he recently wrote to me, echoing his comment to an interviewer in 1996, 'I am doing the same things that I was doing when I first thought that it might be possible to work as an artist. Some interests have deepened, but really the central issues have remained the same.'[18] How do we understand the 'sameness' of

shape in the service of differing purposes? What is the repetition that accompanies the inventions of the void? These questions make us reconsider what we understand to be the 'identity' of a work.

Take, for instance, *Untitled* (1997), a monolith in stainless steel. Its mirror surface does not turn the world upside down as much as it re-assembles it as a whorled vision of shapes and shards, earth and sky, walls and faces – surfaces that blur together in a gestalt that draws everything into the deep inscape of the great steel box. And yet the darkness of the void is deceptive, its illusion of space quite elusive. For the mirror's magic reduces both the depth and the weight of the world into a skin that floats on the surface of the steel, emphasising the nothingness of the object itself. It is no longer the cavernous 'inside' of the piece that signifies the void; the creation of emptiness is now, like the mirror itself, everywhere and nowhere, as interiority and exteriority fail to preserve their determining dimensions. If the mirror sucks in, it also spits out – it reflects and refluxes. Such a reading illustrates the motility embodied in the reflective surface of the mirror and exemplifies those 'non-physical things, the intellectual things, the possibilities that are available *through* the material'.[19] But this gyration of the mirror's void does not come to terms with the question of repetition of form, the question that Kapoor poses in his description of true making: why the *return* to that void shape, the same shape, and its material possibilities?

To see the void as a sign of emptiness, circulating through Kapoor's oeuvre, takes our enquiry in a metonymic direction. Kapoor's excavations must be read laterally, as hollows that move across materials, from polished surfaces to pigments, functioning like punctuation marks in a narrative process. The artist describes this aspect of voiding:

> There is a history in the stone and through this simple device of excavating the stone it's just as if a whole narrative sequence is suddenly there... I'm trying to formulate a notion of a resident narrative. I'm not in the business of setting out to reveal, that doesn't interest me...[20]

To continue the linguistic metaphor, the 'resident narrative' requires us to imagine a double inscription: the void as shape, as physical presence, may remain the 'same' but, as the sign of emptiness, that something 'other' that animates the material of true making, it is always different. What repeats in the resident narrative, at the point of excavation, is this relationship that shuttles from shape to sign, from the poise of the physical to the restless invention of material. Moving laterally, or diagonally, across from the mirror-void (*Untitled*, 1997) and its metallic vigilance, we are led, retroactively, to another material possibility, the meditative recess of *My Body Your Body* (1993). The narrative of repetition leaves an elliptical trace in the work. As the viewer enters the oblique membrane of pigmented blue, the void speaks of the elusive object of the body: the father's absent body, the mother's missing body, the lover's longed for body, my empty body. Then the work shifts, and from the darkness of loss there emerges a fold of light and longing; a fluctuating form of a rim, a lip,

a lid, a limb, a line of life... a fragile meeting of space and emptiness, and in that ambiguous adoration, the discovery of your body, my body...

> I'm very interested in that condition that seems to be abidingly static and at the same time dynamic. It's hard to name but it's a condition that I just know exists when it happens... and it's there, for instance, in *Ghost*, in *My Body Your Body*. It's as if something is taking part as you look at it... Something that Richard Serra is doing too. I'm interested to frame that effect: it's the effect of an enormous weight... out of balance. An apparently out-of-balance form.[21]

DIAGONAL VISIONS

What is out of balance must not be confused with a loss of balance. Truly made works are apparently out of balance in a sense more profound than any immediate visual experience or physical description can convey. For what is 'out of balance' in form is, ironically, a result of what is out of sight, yet integral, to the transitional, shaping spirit of the material. Kapoor's description of materiality, you will recall, makes it quite clear that 'a polished surface is in fact not different from the pigment. In the end it has to do with issues that lie *below* the material, with the fact that materials are there to make *something else possible*... the non-physical things, the intellectual things, the possibilities that are available *through* the material.' Material, then, is like living tissue, a contingent and relational medium; its transitional powers reside in an on-going temporal process. The process of 'making' does not stop with the manufacture of the object for it is the ambition of the homo faber to make the work that is more than its moment and other than its maker. True making lives on in the invisible, unnamable energy that haunts the double life of the material itself, enabling it to survive beyond what Kapoor calls 'the end of the process':

> at the end of the process... there occurs... a very technical thing and very strange thing, all at once... It's the way in which the stone is not stone, the way the stone becomes something else, becomes light, becomes a proposition, becomes a lens...[22]

The ceremony of passing *through* to something else is not the transmission of the 'essence' of stone through light or lens, nor is it the epiphany of the stone transcending all material forms. Trueness lies not in what pleases the eye, nor in what passes through the host of the hand. True making often finds itself in resisting the physical and the transcendental; in bringing to expression, and keeping open, the in-between temporality, that *something* – the strange sublimity of technique – that locates the object in between the static and the dynamic, in a transitional state:

> I want to mention another artist, Jackson Pollock... There's an extraordinary way in which the drip paintings are in the process of making themselves as you

look at them. As if the all-overness of that continuous play, that continuous depositing, if you like, makes them be, and feel, as if they are in a flux, as if they are moving backwards and forwards, as if they are making themselves, as if they are not finite and, of course, I could go on... I will go on, I think it's really important. You know how Barnett Newman discovered that, as you extend the field in the painting, the eye begins to operate in the same way, pulls in and pushes out... back and forth... side by side...[23]

If form is out of balance – pulling in and pushing out... back and forth – is time out of joint too? The answer lies in that veiled 'something' – the sign of emptiness, the blind spot – that discloses the transitional state of true making. As we are wafted to a removed ground that moves under our very feet, we cannot access the object of art without being obliged 'as the whole of psychic life is obliged, to encircle it or bypass it in order to conceive it'.[24] Once we refuse to fill out the look of the void 'with wraiths of the picture rectangle and the Cubist grid',[25] then, from its emptiness, there emerges a gaze that can hold together those diverse spatial elements and disjunctive temporal qualities that are involved in the performative *movement* of the work – that continuous play, the depositing of measure and meaning, the scale of the drip and the syntax of the all-over. The performance that translates spatial relations into temporal movements empowers art to produce what Richard Serra calls an anti-environment, 'the potential to create its own place and space and to work in contradiction to the spaces and places where it is created [...] to divide or declare its own area.'[26] The true void – out of balance, caught between one temporality and another – becomes such a gathering place that stands in an oblique relation to itself and others. As a 'diagonal' event it is, at once, a meeting place of modes and meanings, and a site of the contentious struggles of perspective and interpretation.

The work that follows the diagonal direction is less an object and more a *mise-en scène* – an anti-environment – that displays the quick change of scene, the rapid transition between the perceptual and the conceptual, those qualities of attention that move us hither and thither in the experience of abstract art. For the process by which, in the artist's words, stone is not about stone, but about something else... about light... about a proposition... is part of a circulatory exchange of difference and similitude, the repetition of the shape and the revision of the sign, that is peculiar to objects in transition. In his famous description of the transitional object, the psychoanalyst D.W. Winnicott suggests that it 'symbolizes the union of two now separate things [...] *at the point in time and space of the initiation of their state of separateness*'.[27] It is, indeed, by conceiving of a condition for the truly made object, where space is conjoined and time separate, and then imagining, vice versa, back and forth, the confluence of time in a contradiction of space, that we can see how Kapoor's work goes beyond the modernist mastery of 'pure form' ('coordination, unity, structure: visible but unseen').[28] Each transitional moment turns stone into light, void into clay, or the sail into a skin that holds wind and water, only because, in each case, they are

joined by the fall of a beat, separated by a cut in time, displayed in an out-of-balance form, displaced in a vacillating movement. Such growth by fluctuation is not an incremental increase in space nor a continuous accumulation of time. The truly made work performs the distinction that Kapoor makes between the didacticism of 'expression' and the divination of 'bringing to expression'; it opens itself to an expansion by emptiness. The void's agonistic articulation of the out-of-balance with the vacillating, transitional temporality resonates with the psychoanalytic concept of introjection: the process by which the human subject transposes 'objects' from the outside to the inside of itself through the passageway of the Unconscious. The emptiness of the void, signifying nothing in itself, occupies an interstitial space akin to the unconscious, in which the union of two now separate things takes place 'at the point in time and space of the initiation of their state of separateness'. The Unconscious is an affective quality of the mind that functions in a way that is notoriously out of balance, articulated in symptoms and symbols and, in its unpunctual displacement of memory and desire, never exactly on time either. This is Nicholas Abraham's reading of the activity of introjection:

> introjection is defined as the process of including the Unconscious in the ego through objectal contacts […] By broadening and enriching the ego, introjection seeks to introduce into it the unconscious, nameless, or repressed […] Thus it is not at all a matter of introjecting the object, as is all too commonly stated, but of introjecting the sum total of the drives, and their vicissitudes as occasioned and mediated by the object […] introjection confers on the object, and on the analyst, the role of mediation towards the unconscious. *Moving back and forth* between 'the narcissistic and the objectal realms'.[29]

The truly made work is thus enriched because it introduces into the expanded field of the object, that displaced movement of 'thirdness', the diagonal relation, that inscribes *something* that remains nameless, that *something* that moves the material beyond itself, towards the other, surviving at the point of invisibility, sustaining the unthought. This is the strange moment when the technical turns into the affrighted reflux of the sublime when the drip painting gathers in order to move back and forth, and the eye, in the extended field, pushes in and out. For in true making, as in the introjective process, the identification with the object is never with the sum of its parts. Its diagonal aspect – the agonistic gathering, the conflictual confluence – is what emerges as *presence*; it represents the vacillation and ambivalence of the material that can never be stabilised or naturalised in the objecthood of art. Like the analyst moves towards the unconscious, the artist of the void mediates our relationship to the emptiness that ensures that the work of true making goes on and on… Like the incorporative relation, it expands by moving back and forth between the self-made and the man-made, as the virtues and vicissitudes of the work continually emerge, displayed as figure at one moment, and then displaced in the living performance of art.

Encircling the void, in this indirect and interruptive movement, returns us to the motif of this essay: the difference between the illusion of space and the creation of emptiness. As Lacan suggests, '…at a given moment one arrives at illusion […] one finds a sensitive spot, a lesion, a locus of pain, a point of reversal […] that point concerns the notion that the illusion of space is different from the creation of emptiness.'[30] You can see it in Giacometti's walking or standing figures, flailing like twists of rope, somewhere between aged wraiths and wizened children. Once again, we are aware of those uncanny dimensions figured in Kapoor's framed portals, almost-human, somewhat out of balance. Kapoor's stone frontages prefigure a transitional life, neither secular nor sacred; and here, in Giacometti's figures, we encounter the marks of transitional being, not-human-enough, and then, suddenly, all-too-human. In the empty space in between stands the figure: veined and ribbed like the relief of a fossil, holding aloft the fragile illusion of a man-shaped space, but only for a moment. Then, in the act of walking or standing, motion and stasis are both unbalanced in the flux of the sculpture. Front and back fibrillate, the body turns and twists (recalling the torsion in *Ghost*), and the image of man leans on air, holding on by a thread. This is the creation of emptiness.

The aura of the void produces a spectral shadow of man: *too much* emptiness to be invisible, *too much* absence to be mere vacancy. An aura that gapes rather than glows. An aura that is like the sail, aligning the vacancy of air with the efflux of water, at an oblique angle, a stapling of sea and sky, a wound in the wind. What is it that holds the body in its diagonal disposition when, in Kapoor's words, '…the body is the stone […] the floor or the space'?[31] What staples the flesh to bone, stone, canvas, paper, in its tryst with what is transitional, the fragile frame of true making? Listen to the void:

> The void is not silent. I have always thought of it more and more as a transitional space, an in-between space. It's very much to do with time. I have always been interested as an artist in how one can somehow *look again* for that *very first moment* of creativity where everything is possible and nothing has actually happened. It's a space of becoming… 'something' that dwells in the presence of the work… that allows it or forces it not to be what it states it is in the first instance.[32]

In voicing the void, Kapoor returns us to the discourse of the diagonal. How does the transitional nature of true making – spatially out of balance, temporally in between – relate to the myth of 'originality'? I have argued that the shape of the void and the sign of emptiness must be conceived of in a logic of doubling; like the transitional object, they are unified at the point in space and time of their separation and differentiation. Such a mode of representation does not contain, deep within its being, an 'object' that unfolds, in its own time, to reveal its unitary presence. Kapoor's elision of the 'first instance' or the 'very first moment' does not lead to a final reckoning in which

all will be revealed. In this instance, presentness is not grace, to take liberties with Michael Fried's striking modernist dictum, for there is no promise in the work of 'a continuous and entire presentness [...] a kind of *instantaneousness...* [because] at every moment the work itself is wholly manifest'.[33] The 'delay' in the presence of the work discloses faces, aspects, elements or media that do not metonymically signify some immanent whole, or some complete, though repressed, narrative.

The process of delay is diagonal in the sense in which each emergent element or aspect of the object evolves its specific locus of signification that will not yield to a more general operation or universal description. These localities of representation instigate a process of repetition and revision in between the material and the non-material, so that nothing can be said of the work that is true for it as a 'whole'. It is the effect of these 'performative particularities' to introject associations, meanings and readings into the experience and objecthood of the work that renders it transitional in the most productive way, by making it 'think beyond what it thinks'. This phrase comes from Emmanuel Lévinas who developed a notion of 'deportation' that resonates usefully with my idea of the transitionality of the truly made work. 'In its relation to what should be its "intentional" correlate, [the object] would thus be *deported*, not culminating, not arriving at an end, at the finish [*a du fini*] ... [It] is the very diachrony of time, non-coincidence, dispossession itself'.[34] The delay that dwells in the work commits us to listening to the void in its moment of deportation, as it passes beyond its intentionality.

I once heard such a voice of the void rise from a wound in a wall. A red gash set at an angle in a featureless white wall, *The Healing of St Thomas*. The wound gathers like a gaping aura, drawing us to it – disciple, artist, writer, viewer – to witness the making of a miraculous rebirth, the Resurrection, through the repetition of a shape, the void, each time for a different purpose. What you've called a 'resident narrative' has both a visual and scriptural resonance. The story of 'Doubting Thomas' from the gospel of St John emphasises the disciple's scepticism towards the resurrection for 'unless I see and touch, I will not believe'. And then, there is Caravaggio's *The Incredulity of St Thomas*, where the disciples gather around the re-born body, their eyes fixed not on the grace of God's son but on Thomas's finger deep in the flesh, while the wound, in a strange repetition of the shape of the void, becomes the eye that sees, the flesh that touches, the mouth that speaks John's words, 'Yes it is Jesus! – and He is divine!'[35] But it is not the ascent of Christ's body, the rectitude of belief, or indeed the 'truth' of the image that makes you place us before this diagonal slash on the wall, this site of spiritual and visual doubt. It is that something else that you are after, that lives below the narrative; that something that stirs but will not reveal itself in the first instance, that something that only comes later, on pain of repetition.

You lead me to the precise position and location of the wound.

Just this red slash, and nothing else, and yet, somehow, the space around it comes alive, making an expanded emptiness, beyond the supporting wall, to bear the wound... I observe.

'That's because it's never central', you say, 'and that is very specific. It's there because of the oblique relationship with the body that I'm after. I want to recall the gash in Christ's side, that's not centred, that's not central… It has to be like that, at an angle, in order to move from the body to the building and then… from the question of dwelling to the problem of doubt… dwelling in doubt… More than anything else it seemed aesthetically logical, but I cannot for the life of me explain why.'[36]

That phrase 'dwelling in doubt', when associated with the slanting gash, reminds me of the obliquity that resides in your concept of creativity, '…"something" that dwells in the presence of the work… that allows it or forces it not to be what it states it is in the first instance.' You lead us through Thomas's doubt to a kind of undecidability, an ambivalence, that lies at the very heart of your work. The first moment of creativity must always be looked for again, so that its priority, its purity, its firstness is deferred. It has to be found again, restored through repetition, reinscribed in another time and place if it is to come alive in the first place. It is this power of delay, this ethic of doubt about what it means to see, to touch, to believe, to make, that gives such force to the red gash on the white wall named after St Thomas. For the doubt that dwells in the work forces it to postpone its presence, to delay its disclosure, not to be what it says in the first instance. What is the lesson of the lesion in Christ's side? What is the meaning of the wound in the wall?

Perhaps, the making of art and the creation of belief share such lagged temporalities – they are narratives of a similar shape, but with different human purposes. For Thomas,[37] the ascent of Christ cannot be fully accomplished on the cross, *sub specie aeternitatis*. It is only achieved in the return of Christ, in the reopening of the wound by the oblique entry of Thomas's finger, and the touching of hands amongst his disciples. In a similar vein, the truly made work does not consist in the triumph of objecthood; it is only when the work enters that third space – 'a transitional space, an in-between space' – that the man-made and the self-made, the material and the non-material gather together and tangentially touch in the fevered movement – hither and thither, back and forth – of doubt. The artist's 'doubt' is not about the surfaces of illusion or the veiled nature of reality. Art sows a deep doubt about the mastery of human historical time. In committing us to look again – retroactively, repetitiously – for what can, for that very reason, never be the first instance or the first moment once it is 're-found', we learn not to disavow the primordial or the primary, but to encircle it, touch it at one remove. In the company of the truly made – the ghostly light, the red wound, the dark fold, the mirrored gyre – we have entered the 'removed ground', glimpsed the sign of emptiness. At first sight it appears to be nothing; at second light, no resurrection or resolution; then, in a third remove, comes the doubter's question. The lesson of the void and the wound lies in putting us in the *position of the question*, that interrogative place which leaves us no option but to incorporate or identify with the object – ourselves, others – through the passageway of what is out of balance, unthought, transitional, doubtful. The apostle and the artist ask the same question each time for a different purpose: does the light dwell in this stone? the void in this colour? the spirit in this flesh?

PETER WOLLEN
ON ART AND FASHION

Addressing the Century:
100 Years of Art and Fashion
1998

Addressing the Century: 100 Years of Art and Fashion, *curated by the writer, filmmaker, curator and film theorist Peter Wollen, whose influential publications include* Signs and Meaning in Cinema *(1969), brought together over 250 works of art, fashion, photography, theatre design and film in celebration of the close relationship between art and fashion throughout the twentieth century. As Wollen explained, the exhibition traced the development of a 'common set of visual and conceptual discoveries'. Opening with Henri Matisse's costumes for the Ballets Russes, the exhibition culminated in a section showcasing the work of contemporary artists, including Lucy Orta and Ann Hamilton.* Addressing the Century *was one of a number of large-scale thematic shows at Hayward Gallery during the 1990s that explored visual art's relationship with parallel art forms, including cinema in* Spellbound: Art and Film *(1996) and sound in* Sonic Boom: The Art of Sound *(2000).*

The line between artist and artisan has always been an indistinct one, ceaselessly renegotiated. On the one hand, it is the job of the artisan to make objects designed for use and convenience, whereas the work of the artist is regarded as non-instrumental – you can't do anything with a painting except look at it – and, when it is successful, it is valued, not simply for the opulence of its materials or its decorative appeal or its technical expertise, although it may share all these qualities with artisanal work, but for its adherence to a set of higher values which have been elaborated by experts in art history and aesthetics. These values, certainly since the time of Kant, have been explicitly defined as non-instrumental, as values of disinterested design, sensibility, style and imagination, removed from the practical concerns of everyday life. Individual works of art are situated and judged in the context of art history and, for their full appreciation, the connoisseur is expected to be able to place them historically, to understand the artistic context in which just such a specific and singular work could be produced, one which should be both original and appropriate to its time.

As a result, a great deal depends on the way in which the history of art is written and its context defined at any specific point. For instance, the boundaries of art were significantly re-defined when posters by Toulouse-Lautrec, collages by Picasso, found objects by Duchamp, assemblages by Johns or Rauschenberg, machines by Tinguely, video installations by Nam June Paik, the props of performances by Beuys or the wrapping of the Pont Neuf by Christo were defined as falling legitimately within the context of art. All these artefacts, however, with the significant exception of Toulouse-Lautrec's posters, respected the criterion of non-utility. They simply pushed the boundaries of art into a number of new areas, far beyond its traditional heartland of drawing, painting and sculpture. The utility of a urinal or a bicycle wheel was drained from it by Duchamp and the machines exhibited by Tinguely served no purpose beyond display. The case of photography, however, was more complex, because it plainly threatened the defensive wall which had separated drawing and

PETER WOLLEN ON ART AND FASHION

painting as art from that of drawing and painting as commercial illustration – the line which Toulouse Lautrec crossed at the end of the last century. Photography of many different kinds has become acceptable within the art museum. Moreover, the boundaries of the artistic context have been broadened retroactively, to include work that was neither regarded nor presented as art at the time when it was first made, a sure sign that our working definition of art is again being reconfigured, even more radically than before.

The design and making of garments has traditionally been viewed as artisanal rather than artistic, like the design and making of ceramics or furniture. Its status, however, has continued to rise during the last two hundred years. The single trait which most significantly distinguishes garments from other useful things is, plainly enough, the intimate nature of the relationship between the garment and its wearer. Paradoxically, it was because of this intimacy that even the most skilled and talented tailors and dress makers were always regarded as servants in the court circles that determined social prestige, placed much lower on the social ladder than painters or architects. Their status did not begin to change until the mid nineteenth century, when Charles Worth, the 'father of haute couture', redefined the nature of that relationship. To begin with, Worth was a man, a couturier, successfully imposing himself within the hitherto female, and therefore low-prestige, world of the dressmaker. Second, Worth was able to get his clients to come to his house, rather than the other way round, just as a patron might visit an artist's studio. Third, Worth proved himself a master not only of formal court clothing, but also of the more witty, fanciful and often historically based show costumes, modelled on famous paintings, commissioned for masquerade balls. The princess Pauline von Metternich went to a ball dressed by Worth as the devil, in a black costume embroidered with silver and crowned with two horns of diamonds. As Diana de Marly put it, 'he was catering for those who liked to be conspicuous'.[1]

Under Worth's leadership, in fact, haute couture became not only a luxury business, the interface between the silk and brocade manufacturers of Lyons and the world of the aristocracy and the Court, but also a vehicle for publicity which favoured both the client and the couturier. Costumes for masquerade balls became the showcase for the designer clothes which significantly enough, had no everyday use but were one-offs worn to give substance to a fantasy and to create a theatrical effect. Moreover, unlike paintings or other domestic objects, these clothes had no lasting market value beyond the original transaction between designer and client, although discarded court dresses would be sold off to American clothes for-hire outlets. They were viewed by their original wearers as ephemeral. In fact, rich clients rarely wore the same dress more than once, however much they had paid for them. In contrast to fashion, however, the prestige of painting was closely bound up with its durability and the historically transcendent values it embodied. In fine art, too, display and fantasy had the upper hand over use and practicality, but fashion could never hope to achieve the status of an art until it overcame its ephemerality, which was closely associated with its theatricality.

At the same time, however, couture entered into a complex two-way relationship with painting, as dress designers thought in terms of visual tableaux and looked to art for inspiration, while artists painted portraits of clients who wore the clothes they had acquired from the couturier. The predominance of the clothed figure as a subject for the artist meant that an ability to paint the texture of fabrics and drapery was a necessary skill both for the historical painter and the portraitist. The couturier, like the painter, needed a particular awareness of human anatomy and a visual flair for images which would flatter the client. Portrait painter and dress designer necessarily inhabited the same visual domain. A society portrait was, in a sense, a collaborative project, on which the painter worked at one remove from the designer. Painters like Degas and Whistler behaved like stylists, choosing exactly what their client ought to wear, fretting over a hat or a fold. Worth's dresses were recorded by a whole spectrum of painters, from Winterhalter and Carolus Duran through to Renoir and Manet. Painters as great as Cézanne and Monet drew on fashion magazines for their imagery. Whistler himself designed the Japonesque dress worn by Mrs Leyland in his 1873 portrait. Conversely, Worth was only the first of a string of couturiers to pride themselves on their achievement as Sunday painters and to seek out the company of artists.

Inevitably, the worlds of art and fashion began to converge. The crucial turning-point came with the Arts and Crafts revival that swept across Europe towards the end of the nineteenth century, a movement that overlapped with the rise of aestheticism and the Rational or Reform Dress movement, which aimed to create and popularise clothing for women which would be hygienic, aesthetic and practical. The right conditions were thus created for a radical change in the nature of clothes design, combined with a further blurring of the line between art and fashion. We can see this clearly in the work of E.W. Godwin, who was put in charge of the fashion department at Liberty's in London at the end of the century, and, especially, in the work of the Wiener Werkstätte in Vienna, with its flourishing department of dress design and its programmatic policy of fostering interchange between the arts. The Hellenic style favoured by Godwin was reflected at the same time in the paintings of Moore, Leighton and Alma-Tadema, who found, so to speak, an expressive precursor of Rational Dress in classical revivalism. Given further impetus by the success of Isadora Duncan's tours of modern dance, for which she wore neo-Greek costume, Hellenism had a crucial impact on fashion soon after the turn of the century. Its mark can be seen directly in Mariano Fortuny's Knossos scarves and the Delphos dress which made its first appearance in 1907, the same year that Paul Poiret launched his neo-classical line known as 'Directoire', inspired by the fashions of the period between the fall of Robespierre and the coronation of Bonaparte.

The Arts and Crafts movement, in its closing years, consciously embarked on a programme of expansion into dress design. The Dutch architect and designer Henry van de Velde described clothing as the movement's 'last conquest', following architecture, furnishing, articles for

Installation view, *Addressing the Century: 100 Years of Art and Fashion*, 1998

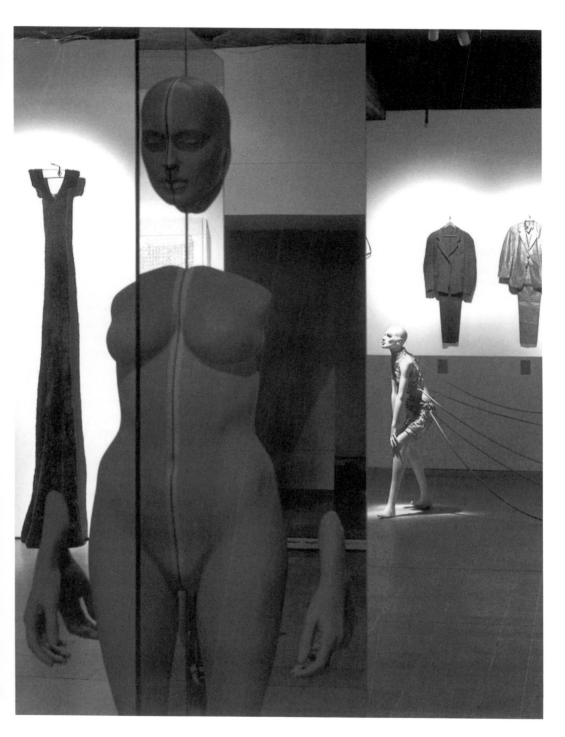

daily use and 'decorative items'. In Austria, the greatest of Viennese *fin de siècle* painters, Gustav Klimt, was directly linked both to the Arts and Crafts movement through his ties to the Wiener Werkstätte, founded in 1903, and to the fashion world through his wife, Emilie Flöge, who was herself a dress designer. Not only did Flöge draw on Klimt's work as a painter, but Klimt himself began to design 'Art Dresses' at around the same time that Poiret made his own decisive break with traditional couture. As Kirk Varnedoe has pointed out, Flöge was quick to understand, with the help of Poiret's innovations, that Reform dress 'could be made appealing on other than just orthopaedic grounds'.[2] Reform dress, in effect, was re-packaged as Neo-Classical. In 1905 the Wiener Werkstätte established its own textile workshop, whose director, Eduard Wimmer-Wisgrill, consciously entered into dialogue with Poiret through his own dress designs. Both Flöge and the Wiener Werkstätte combined the influences of Poiret and Liberty to create designs which reflected the impact of Klimt's painting, the new Paris couture, Reform Dress and elements from folk culture, typical of the Arts and Crafts movement.

The Wiener Werkstätte group's admiration for Poiret was publicly reciprocated by the couturier himself. Poiret visited Vienna in 1911 to show his own collection and to lecture, but, subsequently, enthusiastic about what he had seen, he bought large quantities of fabric from the textile workshop, and then went on to visit Brussels in order to admire the Palais Stoclet, designed by the Viennese architect and Wiener Werkstätte designer Josef Hoffmann. Hoffmann is notorious for designing not simply the palatial home of his client, a wealthy industrialist, but also the clothes which he should wear within it. As a result of these contacts, Poiret eventually set up his own interior design business with a supporting fabric workshop, *L'Ecole Martine*, where he employed uneducated teenage girls to create designs based solely on their own imagination, without any formal design training beyond exposure to existing work that Poiret admired. At the same time, Poiret commissioned early modernist artists, such as Dufy and Derain, to make fabric designs for his couture collections. Throughout his early career, we can detect the competing influences of Hellenism and fauvism in his work, as he sought to combine his preference for flowering, unconstricted lines with the highly saturated colour palette of the fauve painters.

The other decisive influence on Poiret was Orientalism – in this respect his work ran in parallel with Léon Bakst's costume designs for Diaghilev's Ballets Russes, especially *Schéhérazade*, which premiered in Paris in 1910, just after Poiret had returned from a trip to North Africa. 1910 was also the year in which Henri Matisse visited the Islamic art exhibition in Munich, an experience which persuaded him to embark on a series of painting trips to Morocco, which Poiret had also visited. Just as Matisse used the colour and ornamentalism of Moroccan costume as a decorative device in his paintings, so Poiret used the same elements in his couture. By this time the Liberty and Arts and Crafts movement had effectively broken up, to be replaced by the much more amorphous tendency now known as art deco. Poiret stood on the divide between the two periods, but his influence made itself felt in a number of subsequent attempts to bring art together with fashion. Prominent among his

followers were the Bloomsbury-led Omega Workshop group in London, who were directly influenced both by the Ballets Russes and by the example of *L'Ecole Martine*. Roger Fry, the main force behind Omega, had been to Paris in 1912 to organise a show of English art at the Galerie Barbazange, an art gallery sponsored by Poiret and located in the same building as his fashion house. Poiret's work fitted closely with the Bloomsbury mixture of post-impressionist influences with a modernised Arts and Crafts aesthetic.

The Bloomsbury group – Vanessa Bell, Duncan Grant, Roger Fry – were defenders of the radical modernism which developed out of cubism, but never fully absorbed it, broadly remaining within a less ambitious, more decorative tradition. The mainstream of modernism, in contrast, developed in the direction of a rationalist and functionalist aesthetic, obsessed with a geometry of lines, angles and volumes, envisaging the future in terms of a new kind of technological society. Italian futurism, the most extreme of the new avant-garde movements, saw itself as leading the struggle to create a dynamic new culture which would revolutionise clothing as well as painting, poetry, architecture, music, film and even cuisine. Beginning as early as 1913, Giacomo Balla designed brightly coloured, geometrically patterned clothes for both men and women, continuing until the 1930s. In the post-revolutionary Soviet Union, the Russian constructivists – Stepanova, Rodchenko and others – followed a similar course, but with an emphasis on design for mass production, for workers rather than for an elite. In retrospect, these avant-garde artist-designers look wildly utopian in their revolutionary aspirations, but their work makes the Parisian couture of Chanel or Patou seem tame by comparison. Other avant-garde artists of the time, such as Léger and Schlemmer, restricted themselves to designing for the modern ballet, where a visionary approach was acceptable and even desirable.

Haute couture simplified itself radically during the 1920s, broadly in line with the new modernist aesthetic, addressing itself at the same time to a new and wider market extending beyond the traditional elites of a society discredited by the First World War. Artists such as Sonia Delaunay and Natalia Goncharova, who had played an important role in avant-garde movements during the war years, eventually found their way into the world of Parisian couture, where they began to work as designers for the fashion houses of Heim and Myrbor respectively. An artistic approach which had been startlingly innovative in earlier years was now transposed into a more decorative register, while still maintaining elements of the simultaneist and rayonist past. In some respects, the triumph of modernism in the 1920s threatened to drive a wedge between fine art and the decorative arts. which came under increasing pressure from the move towards purist abstraction and a rationalist anti-ornamental aesthetic. The project of fusing the arts and crafts was only possible if both were seen as essentially decorative in nature. The shift towards functionalism encouraged a trend towards more practical sports-oriented clothes in fashion, garments suited to a range of active bodily movements. Rationalism meant a move away from the taste for conspicuous luxury and ornament, which had long been basic values of haute couture.

As Anne Hollander has noted, the 1920s brought with them a trend toward is a more masculine, tailored look, which celebrated the ideal of a fit and healthy body produced by diet, exercise and athleticism.[3] For Hollander, Worth inaugurated a process of long overdue modernisation in the world of high fashion, directly attributable to his typically masculine background in tailoring. This process was carried inexorably onward by the Rational Dress movement, leading, first to Poiret's abolition of the corset and finally, between 1925 and 1935, to the establishment of a new school of couture, which displaced ornament into the realm of accessories, such as the costume jewellery favoured by Chanel. As a consequence, Hollander proposes, 'men and women had visual equality because female dress for the first time was following the masculine example in basic conception', so that women were able 'to look as real as men', rather than appearing as figures of fantasy. In other words, modernisation meant the abolition of extravagant flights of fancy and the rhetorical misrepresentation of the body by clothes which distorted its underlying shape. Clothes became rationalised as the modernist aesthetic had demanded. Under the leadership of female designers, such as Chanel, Grès and Vionnet, haute couture could now be celebrated by Hollander in functionalist terms, for 'the working beauty of the garment in wear'.

Male designers, in contrast, Hollander argued, 'generally continued, as most still do, to emphasize the total visual effect', in the tradition of Worth and Poiret – a contrast, as Hollander puts it, between 'optical' and 'tactile' values. Significantly, there is only one female designer whom Hollander specifically exempts from her general rule that, in the world of fashion, female is to male as tactile is to optical – Elsa Schiaparelli, whom she describes as 'staying always with purely optical excitement'. Schiaparelli rejected the 1920s modernism of Chanel, turning instead to the pictorial counter-tendency of surrealism. She paid homage to Poiret and, like him, surrounded herself with artists – Man Ray, whose career as a fashion photographer had begun working for Poiret, alongside Salvador Dalí and Meret Oppenheim, who was introduced to her by Man Ray. Schiaparelli also experimented with new materials – cellophane, glass, plastic, parachute silk – and deliberately gave exaggerated prominence to accessories. Fantasy in design always gravitates towards the bodily extremes, towards hats, gloves and shoes, which can be extravagantly shaped without affecting the basic form. Schiaparelli never allowed her penchant for optical excitement to detract from an architectural approach to dress. 'The body', she noted, 'must never be forgotten and it must be used as a frame is used in a building. The vagaries of lines and details or any asymmetric effect must have a close connection with this frame.'[4]

The onset of the Second World War created a deep crisis in the world of couture and the post-war recovery did little to close the gap which had emerged between art and fashion, partly for institutional reasons; as New York now replaced Paris as the centre of the art world. Although Jackson Pollock paintings were used as backgrounds for fashion shoots in *Harper's Bazaar*, abstract expressionism as an art movement was far removed, culturally and geographically, from the world of couture. The new painting was resolutely American, distancing itself consciously

from Paris, where couture was still struggling to re-establish itself. Signs of a new *rapprochement* between art and fashion began to re-surface only in the 1950s. The most important new development was the appearance of performance art, a genre which inevitably brought artists back to a preoccupation with clothes. Performance involved the creation of costumes, as designing for dance or theatre had done in the past, but intended now specifically for the artists themselves, worn as a form of self-expression or as an element in a quasi-ritual context. Performance art was a global phenomenon and, during this period, we find self-designed clothes in artists' performances in Japan and Brazil as well as in Europe and North America. Right through into the 1970s, artists involved in performance, such as Jim Dine or Vito Acconci, incorporated clothes in assemblages or, as with Acconci, designed them as art-objects.

The 1960s brought another wave of enormous change in both the art and fashion worlds. In London, New York and Paris, designers responded to the new youth culture and to parallel developments in the art world – especially pop and op art. There was an overdue rejuvenation of Paris couture, as designers like Paco Rabanne and André Courrèges created simple and striking 'Space Age' clothes, angular and geometrical, with contrasting colours or, in Rabanne's case, innovative materials, such as metals and new types of plastic. As Georgina O'Hara put it, 'Rabanne made dresses using pliers instead of needle and thread'.

He described himself as a provocateur and titled his first collection '12 Unwearable Dresses'. In New York, designers illuminated dresses with electric lights, as the performance artist, Atsuko Tanaka, had done in Japan in 1956. Others, such as Rabanne and the artist Harry Gordon used paper as a material for garments, crinkled or printed in pop style. In some respects, particularly through the use of new technologies and the emphasis on strong visual impact, the 1960s carried echoes of Schiaparelli, but in other ways, everything was completely transformed. Pop, op and colour field painting replaced surrealism as the main points of reference in the fashion world, taking us back to the 1920s and the ready-to-wear designs of Rodchenko and Stepanova. There was a similar revival of interest in constructivism within the art world too, as artists looked for new ways of bridging the gap between avant-garde art and popular culture.

The rapprochement between art and couture reached a decisive point in March 1982, when the New York magazine *Artforum* featured on its cover a collaborative work by the Japanese designer Issey Miyake and the bamboo artist Koshige Shochikudo, a fusion of fashion, craftwork and sculpture. The *Artforum* feature on Miyake signalled the beginning of a new relationship between art and couture. Traditional forms of painting and sculpture had lost their automatic hegemony within the art world, giving way to installation work, conceptual art and other non-traditional genres, which gradually began to include the use of clothes. Eventually a new genre in its own right began to emerge – sometimes loosely referred to as 'clothes art'. At the same time couturiers began, not simply to surround themselves with artists,

as Poiret and Schiaparelli had done, but to consider themselves as artists in their own right. The 1960s and 1970s had created the foundation for a thorough-going intersection of the two worlds which would lead eventually to clothes being exhibited as artworks and artists beginning to invade areas, including the world of clothes, previously reserved for designers.

Conversely, in recent years, designers such as Lun*na Menoh and Helen Storey have moved out of fashion into the art world, exhibiting their work directly in galleries and museums – Lun*na Menoh even carries the runway show into an art world setting as an event in her annual Los Angeles shows. In the 1980s, new movements such as 'Wearable Art' and 'Conceptual Clothing' began to take shape alongside the (by now) traditional use of clothing in performance and installation contexts. Artists in these new fields come from both art and craft backgrounds and, in effect, a new type of crossover Arts and Crafts aesthetic has begun to develop, looping back to the beginning of the century, without there being any discernible direct influence. The Japanese designers, in particular – lssey Miyake, Rei Kawakubo at Comme des Garçons, Yohji Yamamoto – come from a tradition in which there is no clear-cut distinction between arts and crafts. Indeed, it is forth is very reason that Japonisme was such a major influence on the development of the original Arts and Crafts movement in Europe. Rei Kawakubo, in particular, tends to see her clothes as elements in a total environment, reminiscent of those created by the Wiener Werkstätte – meticulously designing her shops as if they were art installations, while looking back to modernist designers such as Eileen Gray for inspiration. As she herself put it, 'I try to reflect my approach not just in the clothes, but in the accessories, the shows, the shops, even in my office. You have to see it as a total impression and not just look at the exposed seams and black.'

The Japanese designers also experiment with new materials – Miyake employs technical experts in his Miyake Design Studio to explore the possibilities of new fabrics and new manufacturing technologies. The experimental use of strange and eccentric materials is one of the features now linking art and couture. Ceramic, for instance, has been used by both Tiziana Bendall-Brunella, an artist, and Martin Margiela, a Paris couturier. Other artists and designers are experimenting with woven stainless steel, rubber bands, newspaper, thistledown, wood and glass. A number of artists and designers are also concerned with the reconfiguration of the outline shape of the body through provocatively 'sculptured' clothes. Both Georgina Godley and Rei Kawakubo have designed clothes which distribute concave and convex forms in contradiction to basic body shape. Miyake and Capucci have created clothes which play on the possibilities of metamorphosis, designing garments which fold up flat, or, conversely, using pleats for sculptural effect, expanding flat forms into complex three-dimensional shapes. Martin Margiela makes clothes which reveal the different stages of construction, from sketch to toile to finished garment, a rhetorical strategy known to the Russian formalists as 'laying bare the device'. Margiela has also designed a set of clothes to be eaten up by mould, as a form of auto-destructive art.

Photography and film have long played a crucial role in the world of fashion, not only in publicising clothes but also in crystallising their visual impact for a wide public. Man Ray began his professional career working for Poiret, to whom he had been introduced by Gabrielle Picabia, and already aimed, in his own words, to 'combine art and fashion'. The relationship between couture and photography has remained a close but complex one, establishing a common visual domain between the forms. just as couture had previously established a parallel relationship with society portraiture. Much of today's couture is designed for the camera as well as for the wearer, for visual impact as well as for tactile wearability, and artists are increasingly involved in fashion photography – Cindy Sherman for Comme des Garçons, Nan Goldin for Matsuda. Indeed, in the fashion world, runway shows have become much more performance oriented, at times overlapping with performance art, and this, in turn, encourages the use of video, not simply as a recording medium, but as a creative medium in its own right. At the same time artists use clothes-related performances as a source for their own video art. The aesthetic divide between the two worlds will become increasingly permeable, as the aesthetics of mixed and new media continue to develop.

In her book *Sex and Suits* Anne Hollander suggests that fashion is art because of its ability to create 'complete figural images', bodily shapes both psychologically and physiologically 'real' and 'modern'.[5] Fashion, she proposes, has always had a close relationship with visuality and yet, at the same time, we have a tactile awareness of the clothes we wear or imagine ourselves wearing. Couture, she argues, seeks, at its best, to reconcile these two aesthetics, the optical with the tactile. In the avant-garde of fashion, I would argue, the optical and the tactile are often placed in dynamic tension, rather than reconciled. Moreover, these terms, drawn from the discourse of art history, run in parallel with the distinction conventionally made between the arts and the crafts. This rigorously maintained distinction began to unravel in the 1960s, and its breakdown (often noted under the rubric of 'postmodernism') led to the emergence of a 'third area' in a field previously dominated by painting and sculpture, to be supplemented and indeed challenged by performance, video, and installation. The craft dimension of fine art has been disavowed for most of the century, and now the pendulum is swinging back, in a disturbing return of the repressed. The Kantian doctrine of the disinterestedness of the optical begins to disintegrate. Artists turn to fashion, just as clothes designers turn to the fine arts, in order to explore the dynamic and often conflicting relationship between optical and tactile, fine and applied art, a sense of pure form and a sense of design for use. The dialogue between them is still at an early stage, but its productivity can no longer be denied.

MARCO LIVINGSTONE
ON PATRICK CAULFIELD

Patrick Caulfield
1999

This major monographic exhibition of the work of Patrick Caulfield focused exclusively on the artist's paintings. Spanning his entire career, the exhibition featured 55 paintings produced over four decades, from the early 1960s to the late 1990s. The selection included still lifes, interiors and landscapes executed in Caulfield's bright palette and characteristic clean, bold lines. Co-organised with the British Council, the Hayward Gallery showing was the first stop of an international tour, which later travelled to Luxembourg, Lisbon and New Haven. Alongside this essay by independent writer and curator Marco Livingstone, who has published extensively on pop art and figurative painting, the accompanying catalogue featured an interview with the artist by curator Bryan Robertson.

PERSPECTIVES ON PAINTING: SEVEN ESSAYS ON THE ART OF PATRICK CAULFIELD

Nearly 40 years separate the earliest and most recent works in this exhibition, but they share a deceptive formal simplicity and boldness of impact that mask a subtle intelligence. So cunning are the seductions of Patrick Caulfield's art, with the breezy decorative appeal of its sharp design and the comforting familiarity of its imagery from everyday life, that it can take a little time to realise that all is not what it might seem and that a deep sense of unease can lurk within even the most apparently cheerful of images. It is difficult to resist the charm, and by the time one begins to become aware of the levels of complexity it is too late to return to an innocent state of simple escapist enjoyment.

Caulfield's art is truly 'deceptive' even in the usually negative sense of intending to mislead, for he is certainly a master at taking his audience on a merry chase. An apparent effortlessness, a lightness of touch and a willingness to indulge in humour are all knowingly deployed as means of engaging the viewer's attention, but often with the aim of delivering an unpalatable truth in such a way that the spectator has the impression of having discovered it for himself. The same thoughtful and contemplative process that lies behind the slow production of these pictures, and that makes them such favourites among other artists, is what makes their reception by the viewer so potentially rewarding. On this understanding, it seemed to me best not to attempt here an exhaustive run-through of Caulfield's development, complete with art historical sources,[1] but to concentrate instead on seven representative examples of his paintings so that their often surprising and mysterious nature can be explored in greater depth. Some of what follows can easily be supported by the visual evidence; other remarks are more speculative. None of it is meant to be prescriptive. Like all great painting – and I don't use this term lightly – Caulfield's art actively invites a multiplicity of subjective interpretations. It is precisely the trust placed in the viewer's own intelligence and perceptions that guarantees its continuing life.

I MODERNIST SIGN-PAINTINGS

Portrait of Juan Gris (1963) started life in Caulfield's sketchbooks as a portrait of Paul Cézanne, the progenitor of cubism and regarded by many as the father of twentieth-century painting. His motive in choosing Cézanne was in part to undercut the unquestioning perception of him as the towering figure in the early history of modernism, a slavish acquiescence that had somehow conspired to render his greatness banal. As seen in some of Caulfield's preparatory drawings, bearded and shabbily dressed, stiffly posed and aloof, he also personified the image of the modern artist as bohemian outsider.[2] By the time the portrait was ready to be executed in household gloss paint on board, Cézanne had been escorted out of the picture and his shoes filled by Juan Gris, the Spanish cubist whose decorative and beautifully constructed paintings were already being plundered by Caulfield as a source of inspiration for other paintings such as *Still Life with Dagger* (1963).[3]

The substitution of Cézanne with Gris, indicating a shift from calculated irony to undisguised affection, is itself indicative of the ambivalent emotions embedded within Caulfield's practice as early as his student days. What often begins as a critical gesture bordering on the satirical – for example in his choice of impossibly corny or romantic subjects, or in his appropriation of styles and motifs indicative of the lowest levels of mass taste – is miraculously transformed in his hands – and through the filter of his mind and sensibility – into something overtly pleasurable. A playful contrariness is central to this spirit. For the Royal College of Art final-year project of making a transcription from a famous work of art, Caulfield chose not to do the usual – which in those days generally meant making an abstraction from the composition that drained away all the content of the original picture – but to produce his own version of one of the most passionate paintings of the Romantic movement, Delacroix's *Greece Expiring on the Ruins of Missolonghi* (1827), in a hard-edged style that was completely at odds with the painterly technique of the original but that paradoxically succeeded very well in conveying its propagandistic tone by rephrasing it in the style of a political poster.[4]

It is easy to understand why Caulfield thought first of rendering the image of Cézanne, the master of spatial complexity and the quivering brushstroke, as a flat cut-out shape. It would have made for a good joke: the sensitive and self-questioning genius pinned to the surface with the awkward directness of a naive artist or sign-painter. That he resisted this temptation as too easy a solution gives an early indication of the subtlety of his thinking and the complexity of the emotional textures of his art even at its boldest and most apparently straightforward. Caulfield stops short of the cool wisecracking mentality, the knowing hipness, that serves as a defence against expressing affection or that judges any positive emotion to be a sign of weakness. Instead, he opts to pay homage to the cubist painter whose formal innovations and investigations of pictorial space and flatness so profoundly informed his own aesthetic. The elegant formal attire of a three-piece suit and tie in which he represents Gris is at the furthest possible remove from

the cliché of the bohemian artist: in its place he celebrates the artist as dandy, businessman, respectable member of society quietly going about his business. There are echoes here of another of his artist-heroes, the surrealist René Magritte, who lived unostentatiously in the suburbs of Brussels and presented himself in the conventional disguise of suit and bowler hat in order to give himself the maximum freedom for practising the subversions of his art.

While still at the Royal College of Art, Caulfield found himself in the vanguard of pop art, but he was never comfortable with that label: to his mind it suggested a commitment to mediated styles and consumer images co-opted from contemporary mass culture. Instead he set himself the difficult task of situating himself within a tradition of modern art, and particularly French painting, to which he was greatly attracted but which he was well aware was being superseded by the more radical innovations represented by such movements as American abstract expressionism. Born half a century too late to paint in the manner of Gris or Fernand Léger, yet still inspired by the freshness of their vision, he had to find a way of alluding to their art while creating a distinctly contemporary identity for himself. The concentration on a single, immediately recognisable, motif from everyday life in a work such as *Engagement Ring* (1963), so that it is accorded the dignity and symbolic overtones of a sacramental object, betrays a conscious debt to the 'object-type' beloved of Léger. As early as 1961, in paintings such as *Upright Pines*, which takes a bathroom scale as its main image, Caulfield chose to work in a square format: a notoriously difficult shape but one that has the advantage of sidestepping the immediate landscape and portrait connotations of horizontal and vertical formats. In these works he also countered the usual reliance on relational composition by such strategies as grid structures, centralised compositions and monochromatic grounds.

Patrick Caulfield
Portrait of Juan Gris, 1963

Caulfield's choice of enamel paints and hardboard supports, cheap and readily available materials associated more with the practical work of painter decorators than with fine artists, helped divest his art of any aura of pretension that might have crept into it because of the references to high art. This is certainly the case with his *Portrait of Juan Gris*, painted in jolly playroom colours that convey the optimism of his predecessor's work in humorous opposition to the dourness of his name (which means grey in both French and Spanish). Gris's image is surrounded by shapes that seem to have floated free from his own paintings, where they functioned as spatial devices; accordingly, they appear to have been deliberately severed from their moorings. Now they exist purely as framing elements and as signifiers of pictorial modernity emptied of their previous function and laid out neatly on the surface like freshly pressed linen. Leger's use of a linear reinforcement to the edges of his forms, as a way of transforming flat shapes into convincing signs of three-dimensional objects in space, likewise takes on a sophisticated new life in Caulfield's hands, one that is deliberately at odds with the self-effacing associations with comic strips and colouring books on which he plays.[5] The sparseness of the composition, the almost central placement of the motif, the bright primary colours

of the figure and uninflected ground, the single and dramatically intense yellow which floods the entire surface, the rejection of modelling, even the use of a regular black outline to describe the forms, all contribute to the delivery of a visual punch as strong and uncompromising as anything to be found in the most extreme abstract art of the period.

II THINGS FAR AWAY

Caulfield seems to have decided when he was still in his mid twenties to make life difficult for himself as an artist, to flirt with the most discredited conventions of his chosen medium in order to breathe new life into them. He sought an art that would elicit sensations of pleasure while testing both the viewer's taste and gullibility, to make pictures that were sumptuous and delicious but that could leave a bitter aftertaste. He seduces and repels, gratifies the senses and then spirits the spectator away to some bleak and barren location. He finds poetry and solace in the most unlikely places, to the extent that he will project himself into a setting of crumbling ruins in a desert landscape bathed in red or imagine his position overlooking a series of chimneys placed in improbable proximity to each other.

Noting the seemingly insatiable British love of horses and paintings of horses, he offers an abandoned and ungainly pony-planted firmly in profile on the wall like an unwilling participant in a game of pin-the-tail-on-the-donkey – by way of impertinent compensation. Anyone tempted by modern design and the exotic, or by the romantic allure of the painter's life, will face a stiff challenge when contemplating two paintings of 1964, *Red and White Still Life* and *Corner of the Studio*, which entice the viewer into an enveloping atmosphere of lush colour only to leave him staring into the void. The pictures are so blatantly appetising – and on first glance even celebratory – that it comes as a shock to realise that they appeal in inverse proportion to the despair, ennui or distracted mood that the artist conveys. Most viewers will find themselves pulled in opposite directions by the extremes of their own response.

Nowhere in his work of the 1960s does Caulfield sail as close to the wind as he does in *View of the Bay* (1964). The scene of colourful boats bobbing gently on a deep blue sea dappled with brilliant sunshine, in the protective enclosure of a picturesque Mediterranean harbour, plays shamelessly on the laziest escapist fantasy of an eternal holiday. It is a picture-postcard prettiness – the prettiness of the Fauve-influenced modern art of a painter like Dufy, to which it is all too easy to succumb. By conflating the two sources – the commercial travel brochure with the 'blue-chip' modern art collected by the prosperous bourgeoisie – Caulfield punctures the dream that provides a common bond between them.

The painting may be called a 'view', but a view suggests a real place and this is a made-up location suggestive of a Mediterranean-type environment rather than even a schematised interpretation of an actual town. The distant buildings are conjured up by broken and unfinished outlines, the kind of pictorial shorthand for modernist simplification that one might expect to find displayed on a restaurant mural. The brushstrokes of pure colour that denote the rippling surface of the water are self-confessed degraded variations on impressionist and post-impressionist technique: the kind of mark once presented in evidence of an optical phenomenon observed at first-hand relegated now to a trick of the trade, a mere sleight of hand.

How is it, then, that when the artist has confessed in no uncertain terms to the fact that he has produced nothing more than an elaborate fiction, one which presses all the right buttons and relies for its success on the viewer's willingness to play along, it is possible still to respond to the picture with the same delight one might feel if one really were in the open air, under a clear blue sky, enjoying the vista and the atmosphere of *dolce far niente*? The answer, of course, is that the artist and his audience conspire with each other just long enough to escape the mundane reality of daily life. The painter has whiled away his hours picturing himself far from his studio and freed of the pressures of creating his work. It is in fact that very quality of giving free rein to the imagination that has made the stress of art-making bearable. So it is that the viewer in turn, with a knowing wink, is allowed to luxuriate in the thought of things far away.

278

III RETREATS

By the time Caulfield painted *Inside a Swiss Chalet* in 1969, one of a stunning series of large-scale interiors conceived as intricate linear drawings on monochrome grounds, he had come to favour the depiction of familiar objects and invented places that draw the viewer into an illusion of three-dimensional space solely by means of two-dimensional forms and devices. Five years earlier, with *Corner of the Studio* (1964), he had already invoked a complete room with the sparest means imaginable: two jagged geometric shapes in contrasting colours define the junction of two walls behind the old-fashioned stove that triggers the association with the kind of outmoded romantic artist's studio in which only a non-artist could continue to believe.[6] In paintings such as *Bend in the Road* and *The Well*, both of 1967, he dwelt on images that enabled him to contradict in a playful way the severely flat visual language that he had imposed on himself: the modernist picture plane is visually stretched to the point of being pierced by the imagined boles and openings to which the viewer's gaze is so forcefully directed. The motif of the road receding abruptly into the distance is of such ludicrous banality that one cannot fail to be reminded of the simple perspectival devices featured in how-to-draw manuals. The net effect is like that of a conjuring trick laid bare to the audience: even though there is no secret about how the effect has been obtained, it continues to weave its magic so long as the spectator wishes to succumb to the illusion.

A stubborn literal-mindedness, one that is often humorously at odds with the pictorial fiction being created, is apparent in Caulfield's work from the beginning. It is manifested in the insistence that every form and motif has to be realised as a flat shape, since it exists only on the surface of a painting. In a number of early works it emerges from the presentation of exaggerated brushstrokes and fragmented geometric devices as elements chosen at will. Even the concentration on still-life subjects can be understood in this same context, particularly because of the possibilities afforded for depicting familiar things at actual size. It followed therefore, that when he began to picture larger motifs such as a *Stained Glass Window* or *Battlements*, as he did in 1967 in a pair of paintings representing fragments of church architecture, he felt it necessary to depict them the size that one would expect them to be and to expand accordingly the dimensions of the support. (Having previously relied exclusively on hardboard, which he valued for its resistant surface but which was available in a maximum width of four feet, he now began to paint mainly on canvas.) The linear simplification of the detailing around the window, not to mention the schematic rendering of the stained glass itself as a chequerboard pattern of brilliant primary and secondary colours, is so extreme as to beg the question why the artist should insist on using a one-to-one scale. But of course it is precisely because the motif is shown actual size, so that one responds to it viscerally as if it were the real thing, that the artist has the freedom to play on one's preconceptions. This explains, too, what might at first seem like the window's oddly truncated shape, for it is represented as if seen in passing from below – as would be the case with a real church window – rather than from an 'unnaturally' frontal position. Here, again, Caulfield's deadpan literalness comes very usefully into play.

The transition from still life to architecture, and from imaginary views of outdoor spaces to increasingly intricate recreations of nonexistent interiors, was hastened in the late 1960s by Caulfield's greater confidence in deploying a visual language that had long since been freed from its European influences and become wholly his own. *Inside a Swiss Chalet* and its companion piece *Inside a Weekend Cabin*, also of 1969, are much larger than previous works and much more extreme in their exclusive reliance on a black linear grid, so that the single underlying colour is charged not only with describing the look but also with creating the atmosphere and the emotional tone of the environment. In contrast to this radical simplification of means, the linear drawing itself has assumed an astonishing complexity. The grid is worked out on paper with the care of an architect's impression of a building yet to be constructed, and then enlarged onto a sheet of polythene of the desired dimensions so that it can be transferred to the canvas: it is the scaffolding for the picture itself, not just for a building that exists only in the mind.

Many of the elements used in *Inside a Swiss Chalet* and subsequent interiors such as *Interior with Room Divider* (1971), *Dining Recess* (1972), *Foyer* (1973) and *Cafe Interior: Afternoon* (1973) were adapted very electively from outdated books on interior design, each one prized for its associations and for what it reveals about people's taste and about the spaces we make for ourselves.[7] So persuasive is the detailing of the chalet, like that of the clichéd Swiss hearts cut into the chair backs, and so inviting are the intricate spaces through which one is encouraged to make a mental journey, that one can easily play along and believe in it as a real space. The place is empty and there is no evidence that other people have yet intruded. Various creature comforts have thoughtfully been prepared prior to our arrival. Now it is up to us to bring the place alive, and to complete the work with our own response.

IV UNFINISHED BUSINESS

By the mid 1970s, in pictures of enfolding environments still conceived largely in terms of his characteristic black outlines set against fields of saturated colour, Caulfield had begun to recomplicate his paintings by introducing passages in contrasting styles and techniques. *Paradise Bar* (1974) and *After Lunch* (1975) are the two masterpieces of this change of direction. Intentionally jarring in the way that they break the spell of a single method of interpretation, these alternative ways of picturing the world are nevertheless 'excused' or at least given a *raison d'être* by being presented as pictures within the picture, fictions within the larger fiction that the viewer is asked to accept on trust as standing in for reality. In *Paradise Bar*, a garish mountain landscape in an ersatz approximation of gestural abstraction almost leaps out from across the counter. The artist leaves us in no doubt that this – like the other patently ludicrous stabs at a luxuriant exoticism that one might find in a shabby restaurant, such as the trellis of hanging grapes and the bamboo bar stools – will succeed only briefly in releasing the customers from mundane reality. The prominent credit card symbols pasted onto the glass door are nagging reminders that such little fantasies, no matter

how short-lived, will have to be paid for. By contrast with the imitation of loose brushwork that helps give the game away here, in *After Lunch* a picture-postcard view of the Château de Chillon is brought into focus with such precise realism, within a setting of such caricatural Swissness, that it strikes one paradoxically as false. Closer examination identifies it not as a view through a window but as a photomural appended to a screen in the centre of the room.

The spare pictorial elements that had dominated Caulfield's work for more than a decade – flat coloured shapes edged in a black outline of uniform thickness – had quickly become a signature style that incontrovertibly established his artistic persona. As for many artists, this instant recognisability could be a blessing but also a curse. For Caulfield it was not simply that the use of linear form was becoming a strait-jacket because it had come to be expected from him, nor even that it had led to years of misleading comparisons with the work of American pop artist Roy Lichtenstein, which he admired but by which he had not been influenced. Probably the most troubling aspect for him was that a solution intended as a shorthand for conceptualising an image was becoming so familiar that its function was being taken for granted and no longer being examined. It was a comfortable marriage, but he needed to free himself from a dependence on what he already knew, even at the risk of alienating his friends and possibly even of sacrificing his identity.

The colourful spring daffodils in *Forecourt* (1975), the roses rendered with photographic accuracy in *Still Life: Mother's Day* (1975) and *Study of Roses* (1976), the profuse array of contradictory blossoms attached to the wrong stems in *Entrance* (1975), the odd intrusion of an ornately phallic fountain behind the suggestively sexual still-life display of *Un Gran Bell' Arrosto* (1977) and the facade of Spoleto Cathedral peering improbably into *Office Party* (1977) all perform a similar function to the pictures inserted in contrasting styles into *Paradise Bar* and *After Lunch*. These abrupt changes of pace and idiom, presented dispassionately as if in quotation marks, are there not simply to create different points of interest that animate the picture and direct attention through and around its imaginary spaces. Much as they entertain the eye – and these are certainly among the most ravishingly beautiful of all Caulfield's works – these pictorial interjections also have a more serious and pressing function: to warn the unwary to be on guard and to question all the visual evidence being presented.

Of all the traps laid by the artist, the most extreme is supplied by *Unfinished Painting* (1978). It is a very pretty picture, and an appetising one, too, correlating aesthetic enjoyment with sensations of taste and the satiation of the body's demands. Food and drink are thrust forward with a friendly maternal insistence. The picture's title and the presentation of the white-primed and bare canvas areas as a framing device suggest that it is meant as a sort of lesson in how to construct a picture layer by layer: a recipe in visual form on how to cook up a successful painting. How helpful, how refreshingly honest of the artist to let us in on his procedure. Various artists of Caulfield's generation, including such friends and colleagues as Peter Blake, Howard

Hodgkin and R.B. Kitaj, had been exhibiting unfinished paintings in such a spirit of candour. Now could it be that Caulfield of all people – an artist who so hates visitors seeing paintings before they have been completed that he either empties the studio beforehand or turns the pictures face to the wall – had decided to bare his methods with such bold abandon? Of course not. This is his wittiest and most elaborate game yet, a finished painting posing as an unfinished one. A moment of logical reflection would make it obvious that the precision of the central motif could not have been created as a layer of meticulous detail superimposed, like a translucent film of photographic imagery, on to the schematised blocks of colour traced in black outline that radiate outwards from that image. It is simply another style or method, executed according to its own set of rules, that has been chosen by the artist as the convention that most suits his particular purposes at a given moment. As with every one of Caulfield's pictures, it suggests that an artist's work necessarily constitutes unfinished business – in the sense that the process it initiates is brought to a close only by the viewer's thoughtful response.

V SOMETHING FOR EVERY TASTE

The shameless cacophony of styles orchestrated within single paintings by Caulfield as early as 1979, in imposing canvases such as *Town and Country*, was a natural progression from the introduction only five years earlier of contrasting idioms and procedures to supplement the use of black outline. Freed from his self-imposed constraints, one could say – to put it crudely – that he 'pigged out' on the choices suddenly on offer with the enthusiasm of someone who has finally and vehemently given up on the idea of adhering to a rigid diet. This, in any case, is one of the ways that one can read *Still life: Maroochydore* (1980–81), in which the profuse display of succulent but high-calorie food is more than matched by the compression of an astonishing but surprisingly digestible variety of images and styles into the relatively small surface of a five by five foot canvas. On offer is the geometric abstraction or pattern painting of the two-tone green tablecloth, the schematic rendering of the paired wine bottles as flat shapes, the illusionistic naturalism with which the hanging plate and peppermill screw are rendered, the cubist-inspired *trompe-l'oeil* of the wood grain, the garish painting-by-numbers rendering in the style of Munch of a French landscape copied from a black-and-white postcard, and the relatively painterly rendering of the food itself from the photographic images of recipe postcards, all shown under a rigid shaft of light extracted from the world of Edward Hopper. The colour scheme of emerald green, yellow and flame orange was derived from a postcard of the Australian town whose name is commemorated in the title.

While apparently gorging himself on this *embarras de richesses*, Caulfield manages to maintain his decorum, selectively using the black outline to separate the disparate elements from each other so as not to show any favouritism – in the way that a good host would think of inviting a nice mix of people to a party but ensure that they each have their own space so that they don't end up as warring factions. Caulfield's

attention glides from one image or style to another, but the painting offers no clue as to which styles of painting he most enjoys, nor even which plate of food he would choose if he were offered a surreptitious nibble. Everything is given equal weight. The real satisfaction lies in mastering the different techniques and in rising to the challenge of making them cohere.

Long before Forrest Gump's mother told him that 'Life is like a box of chocolates, you never know what you might get inside',[8] Caulfield found a way of presenting paintings as a luxurious selection of enticing options. Throughout the early 1980s, when he was most assiduously investigating this form of picture-making, he returned habitually and almost invariably to images of food and drink. An equivalence between aesthetic and sensual gratifications is suggested so often and with such conviction – in *Dining/Kitchen/Living* (1980), *Selected Grapes* (1981), *Candle-lit Dinner* (1981–82), *Wine Bar* (1983) and *Green Drink* (1984), among others – that there can be no avoiding it. The food has been prepared, presented with great care and delivered to the table. The drink has been poured and the candle has been lit. All is set for an evening of convivial socialising, but the tables remain empty, the paired chairs unoccupied. Is romance really in the air, or is one destined to spend time alone? Is the atmosphere bathed in a soft caressing light or plunged into sad shadows? The scenes are filled with the signs of *joie-de-vivre* and moments of hedonistic abandon familiar from French paintings stretching from impressionism through to Bonnard and Matisse, but the alienated and slightly desultory atmosphere and even the odd conjunctions of colours – like the lime greens and toreador purples seemingly left over from the local DIY shop – suggest that something may be amiss and that fantasy will suddenly give way to wearisome reality. In *Green Drink* one is left alone, staring vacantly at a bilious liquid and at the even more bilious patterns of wallpaper. The only jugs of wine visible in *Wine Bar* appear to have been converted into lamps or decorations, and the only food on offer, apart from a salad within reach, is unappetisingly advertised in chalk on an otherwise empty blackboard: 'Quiche'. The spectator is left with an increasingly unlikely promise of self-indulgence. Yet for anyone who shares Caulfield's contemplative temperament, that suspended state of unsatisfied desire itself has its own deliciously melancholy appeal.

VI FORBIDDEN PLEASURES

'Feast or famine' is the cliché that springs to mind to describe the dramatic emptying out of Caulfield's pictures in the late 1980s and early 1990s after his prolonged involvement with a surfeit of styles and images. Perhaps after bingeing with such intensity, his appetites were sated and a period of fasting was called for. Or maybe one can ascribe a more prosaic and practical reason for the sudden about-face: that the paintings had become too labour intensive, too slow to make, and another way had to be found to direct the eye around the composition that did not necessitate covering every square inch of the surface with fine detail executed with small brushes.

The severely reductive means employed by Caulfield during this period relate more closely to his paintings of 1963–64, with their selective images set against monochromatic grounds, than any works produced during the interim. There are, of course, substantial differences between these two groups of works that reveal the new paintings to be the product of a lifetime's application. Not least of them is the fact that by 1987 the long-favoured descriptive device of a black outline has finally been eliminated altogether. In smaller pictures such as *Patio* (1988) and *Study* (1992), animated textures are combed into thick grounds of white acrylic paint as a reference to plasterwork on walls but also as something to work both with and against, making the task of painting the image more taxing but also more interesting. There are other fundamental distinctions, too, that characterise the recent works in relation to the early paintings. In almost every case, there is at least one illusionistically rendered object thrust forward from the picture plane so that it appears to have entered 'real' space. Just as revealingly, slivers of light and sometimes circular or oval spotlights create sensations of space and atmosphere that transform what could otherwise be described as a flat decorated surface into a convincing analogue of the world in which we move. The tactility that characterises many of these paintings, in counterpoint to the purely pictorial devices, plays knowingly on our habitual reliance not just on our sight, but on our sense of touch, as a way of establishing our spatial position – especially in dark places or when exhaustion or a sedative such as alcohol have momentarily impaired our vision.

In *Buffet* (1987) food is still presented as the potential reward for the viewer's attention – or to put it another way, fruit is held out as a carrot – but now it is suspended within an atmospheric haze of dense colour that is so engulfing that only a few fragments of the interior space manage to make themselves visible. As in a smoke-filled room, powerful shafts of electric light penetrate the general indistinct darkness; the assertive black silhouette of a lampshade provides a telling counterpoint. Finally, near the top edge, hanging so high up on this large surface that a person of average height would find it at least three feet above eye level, is a meticulously painted life-size facsimile of an exquisite porcelain plate. To expend such care on this particular passage of the painting, knowing that most people will not be able to see it properly, might be thought of as perverse, an act of extreme self-denial on the artist's part but also of pleasures teasingly withheld from the viewer. It is, of course, a wonderful pictorial conceit to present a prime focus of interest almost outside the field of vision represented by the surface of a canvas measuring around nine by seven feet. As always with Caulfield, however, the device also has a metaphorical and emotive purpose, in this case to convey very powerfully the artist's cheerfully pessimistic world view in the year that he turned fifty: that while the good things in life may be tantalisingly in view, they somehow seem always to be just out of reach.

The glass of red wine represented in *Lantern* (1988), or the identical goblet half-filled with another of Caulfield's favourite drinks in *Glass of Whisky* (1987), are more representative of his taste than some of the other motifs featured in the paintings of this period, such as the bouquet of flowers jauntily displayed in *Reception* (1988) or

the mug of lager shown at counter level in a painting named after a Soho pub, *The Blue Posts* (1989). No autobiographical basis can be ascribed to his choice of tobacco pipes on a series of small canvases and panels with relief elements, or in the large *Desk* (1991), since he is a non-smoker, although the choice of this particular motif can be construed as a form of homage to Magritte's paintings bearing such an image alongside the admonition 'Ceci n'est pas une pipe'. And only the most carnivorous diner would be attracted by the sight proffered in *Grill* (1988), as in some restaurant window, of three raw steaks decorated with parsley rather too early for consumption. What all these motifs have in common, however, is that they are symbols of sensual well-being and of the satisfactions that an artist might promise himself as his reward after a long session in the studio or that the rest of the population might look forward to at the end of their own working day.

VII HAPPY HOURS

Trou Normand, the French term appropriated by Caulfield in 1997 as the title for a bar interior, literally translates as 'Normandy hole' but it refers to the glass of Calvados drunk halfway through a meal in order to revive the appetite. Having just visited the Royal Academy's exhibition of the late work of Georges Braque, who divided his time between Paris and Normandy from 1931 to his death in 1963, Caulfield amused himself with the thought that the phrase could also have been a disparaging reference to a poky little bar where the grand old man of cubism might have whiled away the final hours of the day after leaving the studio. The large oil lamp dominating the centre of the picture, rendered with a fanatical eye for detail, was also intended as a reference to Braque, since oil lamps of a similar type are sketchily depicted in the magisterial *Studio* paintings made between 1949 and 1956.[9] The fact that it casts a shadow makes it evident that the room is illuminated not from this source but from the modern lampshades in the top corner. Seen in such proximity to the phoney leaded window, it is presented here as an example of the objects typifying the 'heritage industry' mentality of a 'themed' pub or restaurant: something stripped of its original function and used as a prop connoting tradition and old-fashioned domesticity. Caulfield actually painted it from the motif, bravely and perhaps rather masochistically planting himself for hour upon hour in front of a Victorian lamp that he had in his house but that he had always disliked. Just as he had patiently duplicated some William Morris wallpaper that he found particularly vile in an earlier painting, *Green Drink*, so he considered this laborious task a way of purging himself of an aesthetic response that he found particularly distasteful. When he remarks that the lamp 'was hell to paint',[10] he is referring as much to the emotional as to the technical difficulty of the challenge.

The lateral train of thought that led the artist from what he describes as his 'obtuse' take on a French term, through Braque's imagery – and the circumstances of his life – and finally to the production of a painting that is undeniably his own, provides a striking instance of Caulfield's continuing ability to arrive at memorable pictorial

inventions as the end result of the most surprising and unexpected itineraries. Where others would be tempted to take the path of least resistance, he finds himself temperamentally unable to sustain his enthusiasm for the business of producing another painting unless there are enough challenges to make it interesting. In the case of *Trou Normand*, he explains simply that he needed 'a combination of things to give me a feeling of purpose'.

As has been the case for years, restaurants and bars supply the subject matter of Caulfield's most ambitious recent pictures, but the large and rather sombre canvases he painted in 1996 – such as *Fruit Display, Rust Never Sleeps* and *Happy Hour* – have a gravity and depth (of both feeling and space) that make them among his greatest and most moving works.[11] In purely pictorial terms, they are impressive in their virtuosity. These paintings, most of which are in the difficult square format that Caulfield favoured in his youth, have everything going for them: their spatial complexity and the ambiguities of perspective and subjective description; the orchestration of various light sources and deep shadows that rival the mysterious and unnerving atmosphere of the film noir movies that served as one of their sources of inspiration; the finesse and wit with which the illusionistic and more stylised motifs alike are rendered; and, finally, the immensely gratifying formal arrangement of all these elements interlocked on the immaculate surface. Yet the total impact of each painting is much greater than the sum of these itemised parts. What binds each of them together is the characteristically understated but increasingly irresistible emotional intensity through which Caulfield somehow contrives to make tragicomic paintings about life and death, without pomp or pretension, from the most apparently prosaic of circumstances.

In my experience, these paintings are all the more affecting as ruminations on lost time and mortality because the artist guides us so gently to these conclusions. If one's response is elicited in this way, as a sudden discovery like a thought that has wandered into one's mind when daydreaming distractedly in an anonymous empty space, it has the quality of an epiphany. That is why these images stay so firmly in one's mind and also why, even when one is led to the edge of the abyss, as is sometimes the case, one cannot but be grateful to the artist for producing the sensation in such a satisfying way. Caulfield is enough of a realist to notice that the people most likely to abscond into a pub or cocktail bar at 'happy hour', in search of the quick escape afforded by cheap drinks, are unlikely to be those who are themselves straightforwardly cheerful or untroubled. But his humanity and generosity of spirit, not to mention his brilliant inventiveness as a painter, ensure that for his audience, at least, the hours spent in the company of his expansive art will, indeed, be filled with joy.

MATTHEW HIGGS
ON 1990s BRITISH ART

British Art Show 5
2000

The British Art Show is a national touring exhibition organised by Hayward Gallery that takes place every five years. The first British Art Show was staged in 1979. In 2000, it was curated by a team of three individuals: independent curator Pippa Coles; artist, writer and curator Matthew Higgs; and artist Jacqui Poncelet. British Art Show 5 *featured the work of 57 artists, among them Phyllida Barlow, Martin Creed, Tracey Emin, David Hockney, Sarah Lucas, Paula Rego and Grayson Perry. As Higgs explained in an interview in the exhibition catalogue, the selection was 'not restricted by age or geography', and included 'respected figures, as well as recent graduates'. This broad selection was intended as a deliberate riposte to the previous British Art Show which had been dominated by the Young British Artists (YBAs). After opening in Edinburgh,* British Art Show 5 *toured to venues in Southampton, Cardiff and Birmingham.*

ARS BREVIS, VITA LONGA / SUCCESS CAN BE OVERCOME

This is not an attempt to re-write the tale of British art in the 1990s. Rather it is a highly subjective consideration of some of the issues and concerns that have impacted upon British art and its reception throughout the 1990s. For those with the wherewithal and patience to construct their own spin on the phenomenon that came to be represented via the acronym 'YBA' (Young British Art/Artists), I would refer you instead to some of the more considered – and, it should be said, more reliable – accounts published elsewhere.[1]

If we accept the commonly held, and not altogether unreasonable, assumption that the YBA phenomenon found its initial momentum through the agency of the now 'legendary' exhibition *Freeze*,[2] curated by the artist Damien Hirst in 1988, then one would have thought that it shouldn't be so difficult to negotiate the labyrinthine twists and turns that charted the development of British art throughout the ensuing decade. Yet even now, despite the voluminous literature that surrounds it, there is a striking lack of consensus as to exactly what the legacy of British art's national and international prominence throughout the 1990s is. For those of us who have subsequently become both implicated in and conditioned by its development, the story remains murky, inevitably subject to our own experience of it, and consequently bears little resemblance to its mediation in the press – both popular and otherwise. However, one thing that appears to be generally agreed is that British art is currently in a state of flux.

Writing in a recent issue of the American art magazine *Artforum* dedicated to the 'Best of the '90s', the critic David Rimanelli observed that, '*Freeze* the exhibition that Hirst curated in a forlorn London docklands site in 1988, sent his career and those of his friends into international orbit and created the mythos of Young British Art,

which has sustained many often slender talents right up through the latest "scandal" at the Brooklyn Museum. Only the wilfully ignorant would deny the significance'.[3] Restricted to a single paragraph, Rimanelli's commentary could never hope to articulate fully the complex sequence of events that led to British art's sustained international position throughout the 1990s, yet even in its condensed form it is not so far off the mark. Whilst we might readily agree with Rimanelli that only the 'wilfully ignorant' would deny the short-term significance of both Hirst's gesture and of what followed, we ignore at our peril the divisive long-term consequences of its subsequent dissemination.

For many of those 'fortunate' enough to have been at its initial private view the abiding memory of *Freeze*, apart from the fact that most of the works presented were little more than reconfigurations of earlier modernist strategies (with the notable exception of those by Mat Collishaw, Simon Patterson and Angela Bulloch), was witnessing the glorious spectacle of a neighbouring office development catching fire. This poignant image – a real-life take on Ed Ruscha's painting of the Los Angeles County Museum aflame[4] – simultaneously signalled the end of the 1980s and anticipated the eventual demise of the Thatcher administration that the Docklands re-development had come, so powerfully, to symbolise. However, Rimanelli's most telling observation – with regard to our current predicament – concerns not so much Hirst's role within the story of recent British art as the acknowledgement of the 'slender talents' that have been encouraged and nourished in the euphoria that followed.

We are currently witnessing the inevitable break-up of the grouping of some 20 or so artists associated with the formulation of the YBA: a process that probably began in the mid 1990s – around the time of *British Art Show 4* – but which gained momentum in *Sensation*, the display of Charles Saatchi's collection of recent British art at the Royal Academy in 1997. Clearly the financial success and critical acclaim accorded to some could not be afforded to all. One result of this process has been the emergence of an elite group of some half-a-dozen or so artists – including Hirst, Rachel Whiteread, Sarah Lucas, Douglas Gordon and Gary Hume[5] – who have, by whatever means, found themselves in a position socially, economically and culturally far removed from the apparently egalitarian nature of the nascent scene with which they have traditionally been associated. (Those heady days in the early 1990s when artist-run spaces such as City Racing in London and Transmission in Glasgow seemed to provide a genuine sense of community and commonality.) In their shadow lie many artists, too numerous to list here, who must now confront the – very personal – reality of being consigned to second, or worse, third division status as the international opportunities to exhibit and, more significantly, to be collected, dry up.

This Darwinian struggle – a gladiatorial survival of the fittest, ultimately played out in the auction houses of London and New York – is of course not a new concept, and certainly not one unfamiliar to the art world. Yet its relative novelty – in Britain at

least – and its knock-on effects will have serious implications for contemporary art in Britain. Observers and commentators both at home and abroad tend to agree that the initial generous reception afforded to British art at the outset of the 1990s was incrementally eroded as the decade rolled on, to be replaced by a deeply-entrenched scepticism. The seemingly endless succession of group shows dedicated solely to British art that circumnavigated the globe throughout the 1990s has, paradoxically,[6] had a counter-productive effect, engendering a kind of 'art-lag', a collective weariness with British art that has accelerated its marginalised presence internationally. Whilst the rationale for the exclusion of significant numbers of British artists from recent large-scale international exhibitions such as Manifesta 2, Documenta 10 and the 1999 Venice Biennale[7] is no doubt complex, one can't help feeling that British art has perhaps had its day.

Admittedly this is a fairly bleak picture and I accept that I could be accused of being unduly pessimistic. For it is certainly true that contemporary art's mediation, in Britain at least – via the twin agencies of the popular press and television and their various satellites – continues apace. Likewise British artists continue to figure as permanent fixtures in the lifestyle supplements alongside celebrities drawn from the more traditionally fame-fixated worlds of pop, fashion and sport. It is also true – and the statistics exist to prove it – that more people are visiting contemporary art exhibitions in Britain than ever before: the annual Turner Prize exhibition at London's Tate Gallery posts ever higher attendance figures, the audience for the British Art Show grows with each five year instalment and the income for the Royal Academy's display of *Sensation* broke box-office records for an exhibition dedicated solely to British contemporary art. In 2000 Britain will witness the continued growth in new Lottery-supported institutions dedicated to the visual arts.[8] So on the one hand we could be forgiven for thinking that everything is going to be alright; that the drive – both socially and politically – towards increased accessibility and awareness for the visual arts in Britain is becoming a reality. Yet beyond the media gloss and statistics one can't help feeling that little consideration (or support) has been given to developing and sustaining a culture that questions both the nature and intention of these institutions and of the art they will display – or indeed where the money will come from to ensure their survival.

Martin Creed
Work No. 203, EVERYTHING IS GOING TO BE ALRIGHT, 1999

Writing in the *Guardian* about David Cheskin's photograph of the Queen's visit to the Glasgow home of Susan McCarron, Amanda Foreman stated categorically that it represents '…one of the most important artefacts of the Elizabethan reign. It will reveal more to historians in the next century than any number of articles and newsreels'.[9] Foreman – it could be argued – might have added artworks to her list of possible historical referents, inasmuch as we continue to interpret history through its cultural by-products, whether they be novels, plays, music, paintings, sculptures or video installations. However, Foreman is probably right in suggesting that Cheskin's extraordinary image reveals more about the disparity

and discrepancies existing within British culture at the end of the twentieth century than any number of newsreels, articles – or, for that matter, pickled sharks, bloodied heads and dishevelled beds[10] – could ever hope to. Adrian Searle's brief dissection of this image was one of the most acute pieces of 'art' writing of the late 1990s. His response reveals a desperate attempt to reconcile an increasingly out-moded monarchy (and all it stands for) with its increasingly disenfranchised subjects. Cheskin's image graphically illustrates the irreconcilable economic and cultural divide that persists at the heart of British society, despite what the incumbent government and its agents would like us to believe.

We could have been forgiven for thinking, throughout the 1990s, that it was enough that British artists were – like Susan McCarron's son in Cheskin's photograph – best 'seen and not heard'. Critical dissent – whether by action or by words – was for most of the decade a deeply unfashionable position to avow. Voices of dissent – whether oriented by gender, race, sexual preference, intention or political allegiances – were silenced by their marginalisation. To be actively critical of British art during the decade was to be associated with either the 'Emperor's New Clothes' brigade led by the *Evening Standard*'s Brian Sewell and *Art Review*'s David Lee or worse, to be ostracised from the party, as can be witnessed by the largely dismissive response

to an organisation such as BANK which has challenged head-on – and with some wit – the pomposity of almost every British art institution. This absence of critical engagement and dissent from within is perhaps the most significant legacy of the YBA phenomenon. Curiously, and with no sense of irony – post-*Sensation* – to be actively critical of the current condition of British art, or at least to distance oneself from the very phenomenon that provided so many opportunities for so many 'slender talents' (artists, critics and curators alike) is now potentially the only reasonable position to adopt.

As we have seen, British art was largely exported throughout the 1990s. At home the field was – somewhat inevitably – left open for one man to attempt to establish the branding of British art. The title of the recently published tome *Young British Art: The Saatchi Decade*[11] accurately reflects the collective inability of British institutions to come to terms with the art produced in its own backyard in the 1990s. It is significant that even now we have yet to see substantial exhibitions in British institutions by artists such as Sarah Lucas, Liam Gillick, Douglas Gordon, Angela Bulloch, Gillian Wearing, Cerith Wyn Evans, or BANK, for that matter. That most of these artists, and others like them, elected instead to establish their reputations elsewhere should come as no surprise. That Charles Saatchi could go on record as saying that '90 per cent of the work I buy could be worthless in ten years' time to anyone but me'[12] should not be read as disingenuous. I think he really believes it. His suggestion that a significant proportion of the British art contained within his collection might be simply of – and only of – its time, of interest only to him, signalled not only the overall diminished durability of British art but our limited expectations of it.

Of course not all art produced in Britain during the 1990s could be ascribed to this condition of temporality. Yet for a significant part of the decade an art based on novelty, an art that relied upon both the spectre and spectacle of theatricality, became the dominant form, the common currency of British art that ultimately contaminated the wider perception of all art produced in Britain throughout the 1990s. As the market and the media's thirst for ever more novel commodities grew, many artists increasingly found themselves trapped and undermined by the very novelty that had allowed them their 15 minutes in the limelight. Living in fear of sacrificing its short-term benefits – a few pounds in the bank, the odd article in a respectable journal, a part-time teaching position, invitations to the better parties – notions of development and progress, the very idea of radical shifts or, for that matter, protracted self-reflexive periods of non-production, became anathema for most practitioners. In a reversal of the age-old adage that *ars longa, vita brevis* (art is long, life is short) we might reasonably propose that its antithesis, *ars brevis, vita longa* (art is short, life is long) was more appropriate to much of the art produced in Britain during the 1990s – inasmuch as art's residual effect, its ability to transcend its moment, was seriously compromised – and that life, despite art's temporary physical presence within it, would continue regardless. Likewise theory, the once dominant discourse that underpinned art's developments during the 1970s, 1980s and early 1990s, found itself hopelessly adrift, unable adequately to reflect upon an art that no longer sought its comforting intellectual reassurances.

I can't remember which poet it was, but when he said that 'Success can be overcome', I think he was making the fairly straightforward observation that success is a double-edged sword. Success needs to be monitored, its excesses kept in check, if we are to benefit from its attention and lead productive, meaningful lives. In 2000 *British Art Show 5* finds itself in a quandary, its very rationale questioned by the recent social and political upheavals in Britain. The title of the exhibition – British Art Show – is now more problematic, and paradoxically more pertinent, than at any previous time in the exhibition's history. The very idea of attempting to present a coherent national display of cultural artefacts appears increasingly untenable, increasingly anachronistic. The last British Art Show in 1995–96 took place in a very different social climate. It elected to present the work of only 26 artists, consolidating the careers of a generation of artists – mostly under the age of 35 and mostly based in London – who for the most part continue to dominate the broader reception of British art to this day. In the ensuing five years it has become clear that we can no longer be so confident about this process of consolidation. The effects of the relatively recent change in government and the shifting social and political geographies in England, Scotland, Wales and Northern Ireland have yet to impact tangibly upon cultural life in Britain. Yet it is already apparent that the initial optimism that accompanied Tony Blair's rise to power is increasingly tempered by the mundane reality of New Labour and its often simplistic ambitions for a Creative Britain – a scenario neatly illustrated by the current fiasco that is the Millennium Dome. For better or worse, Britain – and the British Art Show – find themselves in a fragile state of flux.

Yet perhaps this moment of flux, a moment that coincides with the diminished international profile for British art generally, provides us with a useful breathing space, an opportunity to reflect upon and re-evaluate the current status and future potential of British art, a process that *British Art Show 5* is undoubtedly engaged upon. Perhaps the ultimate legacy of *Freeze* is that it graphically illustrated that artists should never rely upon or trust an institutional culture to accommodate and filter their ambitions and desires. The sense of shared responsibilities, the collective desire to make something happen, that fuelled so many artist-led initiatives at the turn of the decade was the determining factor that allowed British art to re-establish itself both nationally and internationally in the 1990s. That this culture allowed itself both to capitulate to, and to be compromised by, the very orthodoxy it set out to challenge, was its greatest failing. Yet 2000 bears witness to a renewed sense of urgency within the artist-led sector. In the face of the new, benign, state and Lottery-funded institutions – with their misplaced emphasis on accessibility and education – the *raison d'être* for artist-led initiatives has never been greater. Recent models, whose founders are all too aware of the sequence of events that undermined their predecessors' efforts, provide us with a blueprint for a renewed sense of locality and community, which might in turn present a revitalised challenge to the orthodoxy and complacency so symptomatic of British art's passage through the 1990s.

Organisations as diverse – in both their intention and administration – as Locus+ in Newcastle, the All Horizon's Club in Liverpool and Glasgow, The Annual Programme in Manchester, Catalyst Arts in Belfast, The Modern Institute in Glasgow, the Proto Academy in Edinburgh, Salon 3, SaliGia, The Pier Trust, BANK (persistently), Arthur R . Rose, dot, Deutsch Britische Freundschaft and the late (and lamented) Info Centre in London, and publications such as *British Mythic, Stop Stop, Inventory, break/flow, Variant, everything, CRASH!* and *mute* provide us with a degree of optimism for British art's development in the forthcoming decade. These organisations, and others like them, address the desires of artists – and the desires of the communities in which they choose to operate – in a manner that suggests a more critical engagement with their participants and audiences alike. Often eschewing accepted means of production and distribution, often operating on shoe-string budgets outside the state-supported funding system, they are engaged in the consideration and promotion of an art that no longer subscribes to the indecent haste and short-termism that determined and overshadowed so much of the art produced in Britain throughout the 1990s.

In some respects, *British Art Show 5* reflects some of these tendencies, in other ways it probably cannot and probably should not attempt to frame practices whose very rationale, whose modus operandi almost denies the possibility of their inclusion in such a survey. Yet a great deal of the art in the current exhibition shares concerns with the intentions of the art promoted by these various agencies – and in many cases is the art that has been persistently supported by them. It could be argued that British art is increasingly conditioned by a more reflexive, more internalised response to current social, economic and political realities. This condition – which might (inadequately) be categorised by the term 'informalism' – is present in the activities of artists as distinct as Chad McCail, Lea Andrews, Jeremy Deller, Lucy McKenzie, Paul Seawright, Kenny Macleod, Runa Islam, Graham Fagen, Martin Creed, Grayson Perry, Hilary Lloyd, Liam Gillick, Jim Lambie, Paul Noble and Wolfgang Tillmans; artists whose works deal, variously, with issues of gender, race, class, sexuality, politics, idealism, boredom and pleasure. As yet, this informal grouping – and others like them- does not provide us with coherent strategies for the future unfolding of visual cultural practice. This is, of course, as it should be. The British Art Show should never be thought of as a debutante's ball or passing out parade. Rather it should be celebrated as a transitional moment around which we can consider and speculate upon the current rationale and future implications for British art. If it is about anything at all, the British Art Show is about potential, and it perhaps offers us a renewed sense of optimism for British art, a new sense of engagement that reinforces the hope that success might, indeed, be overcome.

DAVID TOOP
ON SOUND ART

Sonic Boom:
The Art of Sound
2000

Sonic Boom: The Art of Sound, curated by writer and musician David Toop, was the UK's largest exhibition of sound art to date. Featuring more than 30 international artists including Angela Bulloch, Brian Eno, Ryoji Ikeda and Christian Marclay, the exhibition filled the entire Hayward Gallery with a series of sound installations in which the visitor encountered 'the mechanical and the organic, the electronic and the acoustic, the sculptural and the intangible'. Speaking of the exhibition, Toop has described how he attempted to 'tune' the Hayward Gallery, which he began to see as a 'giant instrument'. Sonic Boom was framed as something of a challenge. 'We think we know how to look', stated the introductory text within the exhibition, 'but do we know how to listen?'

S ound art is not a new invention. 'Composers and painters alike', wrote Karin von Maur in *The Sound of Painting* (1999), 'have frequently gleaned new ideas from an approximation to, or borrowings from, procedures used in the sibling art. This reciprocal relationship runs like a continuous thread through the entire century. Music stood behind the birth of pictorial abstraction and the revolutionary unrest in the arts that, in the years before First World War, pervaded the great art centres from Paris to Moscow and Prague, from London Rome and, finally, New York.'

So sound art – sound combined with visual art practices – is not a novelty. Its relevance seems to grow as the material world fades to the immaterial, fluid condition of music. Despite our design specifications as fully articulated graspers and shapers, we humans are busily constructing an environment that marginalises our own corporeal presence. Our fingers no longer grip; they click and drag. For better or worse, the twenty-first century promises to be an aetherial landscape of images, sounds and disembodied voices, all connected by invisible networks and accessed through increasingly transparent interfaces.

Being a denizen of the aether, music has reacted favourably to this remarkable situation. Downloading music as digital files from the Internet is proving to be as popular as porn and many musicians now create music with computer software that replicates state-of-the-art recording studios. Yet music is as ancient as human culture. A social activity responsible for some of the biggest gatherings of humanity in history, music is matter and aether all at once. The same piece of music that persuades one person to jump up and dance can provoke migraine, grief, sexual arousal or doctoral dissertations in others. Music marks death, marriage and other rites of passage, yet in the digital age musical production and participation are melting into the virtual sphere, leaving only nostalgic echoes of life when it was fleshy, physical and acoustically imperfect.

In this context, the medium of sound is both fascinating and problematic as a communicative tool. Modern city dwellers are immersed in audio to the extent that

music is becoming just one filament in a web of electronic signals and machine noise. This absorption of music into the sonic environment – and the sonic environment into music – was foreseen by a number of significant, if wildly contrasting, twentieth-century composers and musical inventors: Erik Satie, the Italian Futurists, Duke Ellington, John Cage, Karlheinz Stockhausen, space age, bachelor-pad king Juan García Esquivel and the inventor of Muzak, George Owen Squier.

Notes sent by Jean Cocteau to Erik Satie as Satie prepared his musical score for Cocteau's ballet of 1917, *Parade*, included references to elevators, steamship apparatus, dynamos, aeroplanes, the telegraph operator from Los Angeles who marries the detective in the end, gramophones, palatial cinemas and the Brooklyn Bridge. As well as signalling this new intoxication with machines and electric media by incorporating the sounds of a siren, lottery wheel, typewriter and pistol shots, Satie composed a score that integrated popular music forms such as French music-hall, American ragtime and exotica parodies into his own spare and inimitable style. In an antecedent of today's vortex of quotation and digital sampling, Satie even paraphrased an Irving Berlin composition, *That Mysterious Rag* (1911).

Composing *Socrate* in 1918, Satie devised the idea of *musique d'ameublement* or 'furniture music'. 'Two years later, on 8 March 1920', wrote Nancy Perloff in *Art and the Everyday*, 'Satie and Milhaud introduced the idea of background music to the public when they organized a concert at the Galerie Barbazanges in which "furnishing music", made up of popular refrains, was played by a small band during the intermissions.' Their experiment in relegating music to the outer fringes of social activity was not entirely successful, since Satie had to rush around the room, instructing the audience to stop listening.

This emerging and heady sense of convergence – music colliding with the noise of life, art music borrowing from popular songs and jazz, the plastic arts confronting the performing arts as mixed-media – was hugely important to the evolutionary rush of sound work in the twentieth century.

DEEP SILENCE, SPEED, NOISE

Sound is the stuff of music. While the organising principles of music have been disputed, shattered and redefined throughout the past 100 years, sound remains at the core. At the cusp of the twentieth century, Claude Debussy anticipated the future. As a student in 1883, he played 'groaning' chords on the piano, evoking the noise of buses as they drove through Parisian streets. Six years later he heard a Javanese gamelan ensemble perform at the *Paris Exposition* of 1889, one of a series of celebrations of French colonial conquest, and was captivated by the rich vibrating fusion of melody and percussion. Then in 1913, only a few years away from death, he questioned the domestication of sound and its history, 'this magic that anyone can bring from a disk at his will', arguing instead that 'The century of aeroplanes has a right to a music of its own'.

With the First World War imminent, the Italian Futurists grasped the electrical, mechanical and frankly destructive character of European life with a fervour that both swept aside and built on Debussy's hopes and fears. Speed was celebrated, along with the movement of electricity and the sounds of modern war. Luigi Russolo, a painter, wrote his 'Art of Noises' manifesto in the same year as Debussy's plea for a truly modernist music. 'The Italian Futurists could soon be heard berating Italy as the land where museums and ruins were spreading across the cultural landscape like a crop of tombstones', wrote Douglas Kahn in *Noise, Water, Meat* (1999), 'and were leading [the European avant gardes] forward with Marinetti's revelation in 'The Founding and Manifesto of Futurism' that the roaring car is more beautiful than *The Victory of Samothrace.*'

Somehow it is possible to imagine the alchemical work of twentieth-century sound art being forged on transatlantic crossings as ocean liners carried Maurice Ravel or Darius Milhaud on their return voyages from New York to Paris. Heard during nocturnal visits to Harlem's Cotton Club, the sounds of fabulous jazz inventions – sculptural drum kits ringed with Chinese woodblocks and gongs, brass instruments played with plunger mutes and sounding like a forest alive with mythical creatures – melted into Debussy's exoticisms and Satie's quotations and repetitions.

Satie's use of stasis and repetition, heard *in extremis* in *Vexations* (1893) his piano piece of one short phrase repeated 840 times, was a rejection of the grand stories of romanticism. Music was allowed to stand still, to dwell in

Christian Marclay
Guitar Drag, 2000

one place until both performer and listeners were enveloped in trance and each sound was mutated by human perception, rather than the composer's will. With *Vexations*, Satie was creating a kind of machine or installation. 'In order to play this piece 840 times', Satie instructed, 'the performer should prepare beforehand in deep silence and serious immobility.' Beneath the characteristically ambiguous Satie humour was a touch of Zen, a foretaste of robotics.

Rooted in magic, machines that can play music independently of humans invoke that most modern of fears. Like HAL in Stanley Kubrick's *2001: A Space Odyssey*, they ask a chilling but logical question: 'Humans, are they really necessary?' Futurist theorist, poet, activist and pugnacious foghorn Filippo Marinetti posed a similar threat in an essay called 'Multiplied Man and the Reign of the Machine'. 'We look for the creation of a non-human type', he wrote, 'in which moral suffering, goodness of heart, affection and love, those sole corrosive poisons of inexhaustible vital energy, sole interrupters of our powerful bodily electricity, will be abolished [...] This non-human and mechanical being, constructed for an omnipresent velocity, will be naturally cruel, omniscient and combative.'

The noise machines or *intonarumori* invented by Luigi Russolo and constructed with Ugo Piatti just before the outbreak of First World War, embodied a kind of

DAVID TOOP ON SOUND ART

cruelty. Russolo had written with clinical ecstasy about the noises of war in his 'Art of Noises'. The vocal agonies of dying horses and injured men were silently present, after all, in Uccello's *The Rout of San Romano*. Russolo was interested only in modern war, and particularly its technology. So he wrote about the glissandi of falling shells, the harsh repeating ejaculations of machine guns, the tom-cat screams of shrapnel. 'A man who comes from a noisy modern city', wrote Russolo, 'who knows all the noises of the street, of the railway stations, and of the vastly different factories will still find something up there at the front to amaze him. He will still find noises in which he can feel a new and unexpected emotion.' Great boxes amplified by monstrous horns, Russolo's noise machines growled, hummed, whizzed and crackled in acoustic imitation of this chaotic new soundscape unleashed by the industrial revolution. Audiences for *intonarumori* performances in Modena, Milan, Genoa, Paris, Prague and London failed to justify Russolo's optimism, though they confirmed Marinetti's dream of combative non-human types. 'I have the impression of having introduced cows and bulls to their first locomotive', wrote Marinetti, contemptuous of the public derision that the 'Art of Noises' provoked.

The aesthetic barbarism of the *intonarumori* was overshadowed in 1914 by the barbarity of total war. A tour was cancelled, the noise instruments were lost and

Russolo enlisted in the Italian army. In his words, he was 'lucky enough to fight in the midst of the marvellous and grand and tragic symphony of modern war'. Wounded in battle, he was discharged from the army and resumed his public displays of noise in 1921. By 1928, there were hopes that his Noise Harmonium might go into production as the perfect accompaniment for silent movies. Then the talkies took over and all of Russolo's potential backers faded away. For the second time, Russolo was a victim of the progress he celebrated. Now ghosts at the millennial feast, the *intonarumori* stand mute, an intangible beginning for the twentieth and now twenty-first century's fascination with noise, industry and the operations of mechanical and electrical beings.

SPIRIT VOICES ON DEMAND

The men of the Middle Ages were so mechanically minded they could believe that angels were in charge of the mechanisms of the universe: a fourteenth-century Provençal manuscript depicts two winged angels operating the revolving machine of the sky.

JEAN GIMPEL, *THE MEDIEVAL MACHINE*, 1976

The impulse to create sounding machines goes back much further than Russolo and Piatti. 'This imaginal relationship between man and machine was a long time coming', wrote Erik Davis in *TechGnosis: Myth, Magic and Mysticism in the Age of Information* (1999). 'The ground was laid by the mechanistic cosmologists of ancient Greece, and it seized the imagination when tinkerers like [the Alexandrian inventor] Heron started building those fanciful protorobots we call automata – mechanical gods, dolls and birds that fascinated ancient and medieval folks as much as they fascinate kids at Disneyland today.'

In 1650, the Renaissance Jesuit polymath Athanasius Kircher published 1,500 copies of a treatise on music and acoustics called *Musurgia Universalis*. Taking over the role of the angels, Kircher had invented an eccentric collection of mechanical devices that generated, amplified and ordered sound. Floating in a Renaissance netherworld of science and mysticism, Kircher's designs for sound machines included solar-powered singing statues, Aeolian harps powered by the wind, an hydraulic organ that seemed to sound through automata representing Pan and Echo, and spiral tubes that projected sound out of the mouths of statues or eavesdropped on conversations in adjacent rooms. He also built an elementary computer, described by Joscelyn Godwin, researcher in esoteric sound, as 'a "musarithmetic ark" or box of sliders on which the patterns are written, that serves as a composing machine'.

The ventriloquism of speaking statues and articulated masks, used by the priesthood to conjure spirit voices on demand, was a formative stage in the history of automata. In their turn, as Erik Davis suggests, automata were the forerunners of robots, replicants and recording. In eighteenth-century Japan, where an optimistic belief in the robotic

DAVID TOOP ON SOUND ART

future of classic sci-fi still survives today, Dutchmen were entertained by *karakuri* performances staged by live musicians and mechanical dolls. An illustration from a guide to Osaka published in 1798 shows the Takeda theatre, where a Kabuki-style percussion ensemble accompanied a mechanical cockerel banging a large drum.

These mechanical inventions played an important role in technological evolution. 'Just as the European automata of men like Vaucanson anticipated the machines of the Industrial Revolution', wrote Mary Hillier in *Automata & Mechanical Toys* (1976), 'the Japanese performance of *karakuri* was an awakening of automation.' According to Hillier, this example of human-machine interfacing led to improvements in the making of medicines and sugar with the use of treadmill machines.

Similarly, the development of Virtual Reality has been traced to another mechanical musical instrument, the player piano. In *Virtual Worlds* (1992), Benjamin Wooley's exploration of VR simulation, a genealogy is mapped: notions of computer-simulated reality, formulated in the late 1960s by computer graphics pioneer Ivan Sutherland, were inspired by the Link Trainer flight simulator. In turn, the source of inspiration for the Link Trainer was the pianola. Having been born into a family business of mechanical musical instruments, Edwin Link used the pneumatic mechanism of player pianos as a basis for his invention of the first flight trainer in 1930.

A technology that allowed music to be perfectly and repeatedly reproduced until the mechanism broke, mechanical music also anticipated the age of phonography. Playfully sinister creations such as Alexandre Theroude's violin-playing monkey, designed in 1862, were refined and miniaturised for public consumption. A brisk luxury trade in musical boxes, clocks adorned with mechanical singing birds, even musical pictures enhanced by chiming bells, only declined with the advent of First World War as other forms of recorded sound became more widely available. This evolutionary obsolescence inevitably becomes a sign of mutated history within the work of composers arid performers who create with machines, whether Conlan Nancarrow's or James Tenney's compositions for player pianos, Karlheinz Stockhausen's *Zodiac* piece for music boxes or the extraordinary diversity of post-John Cage, post-Grandmaster Flash turntablism that transforms the record deck, its needle and its vinyl records into a phonographic instrument of the past and the future.

AN OCEAN OF SOUND

A gasoline-driven generator in the entrance hall was soon pounding away, its power plugged into the mains. Even this small step immediately brought the building alive… However, in the tape recorders, stereo systems and telephone answering machines, Halloway at last found the noise he needed to break the silence of the city.

J.G. BALLARD, *THE ULTIMATE CITY*, 1976

While twentieth-century robots and androids continued their inexorable march towards the goal of artificial intelligence, speaking machines such as the wireless, the phonograph, the telephone and cinema added new imagery and strange speculations to the interface between human life and invisible mysteries. In *TechGnosis*, Erik Davis describes an incident in 1924, when Mars passed closer than usual to Earth. Activity from many transmitters was temporarily suspended so that 'the Martians' would have clear air through to send messages: 'Radio hackers were treated to a symphony of freak signals', he wrote, 'scientists today would describe the bulk of these sounds as sferics – a wide range of amazing radio noises stirred up by the millions of lightning bolts that crackle through the atmosphere every day. Sceptics would chalk up the rest to the human imagination and its boundless ability to project meaningful patterns into the random static of the universe. But this argument, however true in its own terms, distorts the larger technocultural loop: new technologies of perception and communication open up new spaces, and these spaces are always mapped, on one level or another, through the imagination.'

The music of the past 100 years has been characterised by a feeling of immersion. Musical boundaries have spread until they are no longer clear. Music has become a field, a landscape, an environment, a scent, an ocean. Media such as radio, television and cinema, or more recently, the Internet and the mobile phone, have fostered an image of a boundless ocean of signals. 'Children, parents and grandparents gathered by the Grebe, Radiola, or Aeriola set in the radio room', wrote Gene Fowler and Bill Crawford in *Border Radio* (1867), 'and marvelled at the sounds they heard transported mysteriously from faraway lands… Listeners who bought radio sets were sometimes disappointed, though. Shrieks, grunts, groans and cross talk ruled the airwaves, which were described by some as a hertzian bedlam.'

Humans float in this ocean, this bedlam, their existence and identity represented by icons, cursors, passwords, credit card and PIN numbers, avatars, disembodied voices. In the cinema, we sit in darkness, transported by an intricate fusion of sound and image; playing electronic games we are bombarded by sound effects, hyperactive music and the interactive drama that unfolds or collapses as we frantically thumb the controller button; on mobile phones voices and information travel with us wherever we go; on the Internet we move through endless layers of data flow, often unaware of a geographical source, lost to the idea that we are anywhere other than in indescribable space.

Musicians and sound artists have made significant contributions to the exploration and mapping of this indescribable, entirely unfamiliar space that now envelops humanity. Premiered in 1952, John Cage's composition named *4'33"* required a musician to present a timed performance on an instrument without making a sound. Half a century later, the piece can still stimulate startling results, even though audiences are more aware of the expectations such work demands. For the premiere, an audience sophisticated in its understanding of contemporary music discovered new frontiers of disorientation. 'A local artist finally stood up', wrote David Revill in *Roaring Silence*, his 1992 biography of Cage, 'and suggested with

languid vehemence, "Good people of Woodstock, let's drive these people out of town".' David Tudor, who performed the piece on piano that night, described it as 'one of the most intense listening experiences you can have'. Beyond restlessness, a feeling of being cheated or conned, lies an acute awareness of the immediate sonic environment and its atmosphere. Beyond that lies a plateau of memory and feeling that may have been unexplored within individuals for decades.

Cage's pivotal composition was inspired by Zen Buddhism, by his experience in the Harvard University anechoic chamber where he heard the sounds of his own nervous system and circulating blood and so concluded that silence did not exist, and by the all-black and all-white paintings of Robert Rauschenberg. Rauschenberg called the black paintings 'night plants'. 'Far from echoing Malevich's famous *White On White*', wrote Calvin Tomkins in *Ahead of the Game* (1962), 'Rauschenberg's white paintings have been seen as the purest possible statement of the idea that life (that is to say environment) can enter directly into art; they have also been seen as definitive proof of the impossibility of creating a void (one might have thought science had already proved this, but art takes nothing for granted).' Tomkins quotes Rauschenberg's observation that the white paintings were hypersensitive rather than passive. 'One could look at them', he told an interviewer in 1963, 'and almost see how many people were in the room by the shadows cast, or what time of day it was.'

From such ideas it was a short step to creating sound installations that made their own music. Perhaps music was no longer an issue. As Michael Nyman wrote in *Experimental Music* (1974): 'Cage's piece is hindered by being set in a concert hall, by containing no specific directive for the audience, and by leaving what is heard completely to chance.' Many sound artists who followed Cage were impatient with such hindrances. Composers or musicians were absented from the frame; in some cases, the frame was broken and thrown away. Sounds might generate themselves, through sound sculptures or kinetic machines such as those made by Takis, Pol Bury, Harry Bertoia, Jean Tinguely, Len Lye, Tsai Wen-Ying and the Baschet Brothers. The music of sound sculptures could become a cartography of emergent phenomena: continuous, diffuse, immersive, a conglomerate of inner rhythms that was endlessly engaging, an enactment of a process that seemed to hover on the threshold of nature and culture.

In work that was more conceptual than material, the sounds were foregrounded in the perception of the auditor who discovered an artwork taking place, sometimes without being aware that they were the recipient of art. Sound, after all, can surround us on all sides – in the air, through the ground and within our bodies – yet we can still marginalise its presence. In the late 1960s Max Neuhaus composed a piece called *Listen*. An audience expecting a lecture was put on a bus, their hands were stamped with the word 'listen' and they were driven to distinctive sound environments such as power stations and the subway. Context, as John Latham has said, was half the work. As the identity or imprint of the artist faded into the background, so the experience of the work took over.

Sound without boundaries culminated in a period of intense, often extreme activity: the conceptual and performance work of the Fluxus group; the American free jazz movement that embraced such diverse talents as Ornette Coleman, Albert Ayler, Cecil Taylor and Sun Ra; minimalists and systems composers such as La Monte Young, Terry Riley, Steve Reich, Philip Glass and Charlemagne Palestine; a thriving scene of European-based improvisation groups that included AMM, MEV and the Spontaneous Music Ensemble.

All of this work proposed new relationships between creators and listeners, between structure and performance, between event and venue, between form and time, between the sound object and its environment (and between musicians and their financial masters). John Cage's example had encouraged many musicians to abandon rigid compositional systems and pursue indeterminate or open methods. These new initiatives linked to art movements such as happenings, land art, conceptual art, kinetic sculpture and underground film, even overlapping with psychedelic rock. The Fluxus movement proposed musical events that questioned all definitions of music, using settings that relocated art into unfamiliar, absurd and even impossible environments. Pianos were fed with hay or demolished and guitars were dragged along the streets of New York. As a speculative exercise in absurdity that reversed received expectations of artists as ambassadors of high culture, Walter De Maria's *Art Yard* (1960, New York) portrayed an imaginary scene in which composers such as La Monte Young dug a hole in the ground in front of spectators.

The influence of this type of work, along with the audio ecology researches of R. Murray Schafer and the Vancouver-based World Soundscape Project, contributed to the growth of a loosely defined movement now known as Sound Art or Audio Art. Detaching itself from the organising principles and performance conventions of music, Audio Art explored issues of spatial and environmental articulation, the social and psychosomatic implications of sound or the physics of sound using media that included sound sculptures, performance and site-specific installations.

UNTIL THE PIANO VANISHES

He liked the happy-looking row of electrical meters and the fact that they ticked off in ¾ time, claves time, that the multiple row of pipes with their valves whistled, water whirring through them. He liked the crunching noises when faucets were turned on, the conga-drum pounding of the washroom dryer: the thunder of the coal-bin walls.
OSCAR HIJUELOS, *THE MAMBO KINGS PLAY SONGS OF LOVE*, 1989

The key was listening. In his 1977 manifesto of soundscape ecology, *The Tuning of the World*, R. Murray Schafer argued for the urgent need for a coherent method of auditing the sound environment. 'The soundscape of the world is changing', he wrote, 'modern man is beginning to inhabit a world with an acoustic environment

radically different from any he has hitherto known. These new sounds, which differ in quality and intensity from those of the past, have alerted many researchers to the dangers of an indiscriminate and imperialistic spread of more and larger sounds into every corner of man's life.' Researchers in acoustics, psychoacoustics, structural analysis of language and music, noise abatement and other sonic studies were united in asking two questions, Schafer claimed: 'What is the relationship between man and the sounds of his environment and what happens when those sounds change?'

Conceptual art, land art, ecology and the aftermath of Fluxus performance were pervasive influences on sound works during the 1970s. Many of these works seemed to be spiritual ancestors of both Athanasius Kircher's magic science inventions and Yoko Ono's whimsical conceptual pieces. Annea Lockwood's *Piano Transplant – Pacific Ocean Number 5*, composed in 1972, gave the following instructions: 'Materials: a concert grand piano, a heavy ship's anchor chain. Bolt the chain to the piano's back leg with strong bolts. Set the piano in the surf at the low tide line at Sunset Beach near Santa Cruz, California. Chain the anchor to the piano leg. Open the piano lid. Leave the piano there until it vanishes.'

Frustrated with the confines of the music hall and the educated expectations of new music's small audience, sound art aspired to a closer engagement with the environment and the auditor. Either directly or tangentially, the results were a critique of musical behaviour that was suffocated by tired conventions, even within the so-called avant-garde. Techniques, technology, performance, musical structure and context were all called into question. Just as many painters and sculptors no longer felt locked to a specific medium, sound artists used the musical reference as a starting point rather than a defining category. So Laurie Anderson performed on her Viophonograph, a turntable mounted on a violin and played by a needle in a bow, or played violin while standing on a melting block of ice; Bill Fontana proposed a project that amplified the singing tones produced by traffic crossing the Brooklyn Bridge, then sent a mixed version via satellite to other parts of the world; Alan Lamb recorded the Aeolian humming of telegraph wires in Australia; and David Dunn immersed himself in the emergent systems of bioacoustics. R. Murray Schafer contextualised artistic and scientific approaches to sound within a wider framework of global ecology and social imperatives. At the same time, sound artists were moving out of concert halls and galleries into city streets, office buildings, harbours, wilderness, even into the furthest reaches of the Earth's atmosphere.

Sound artist Felix Hess has described his work as 'my way to find out more about the intelligence of our senses'. In this sense, sound art can be a fanciful form of science as well as an art. The work of Alvin Lucier, in particular, researches acoustical, biological and psychological phenomena, transforming his physical explorations into pieces that are haunting and strange. 'What interests me is sound moving from its source out into space', Alvin Lucier told Michael Parsons in *Resonance* magazine, 'in other words what the three-dimensional quality is. Because sound waves, once they're actually produced, they have to go somewhere, and what they do as they're going interests me a lot.'

The spirit of this approach has its roots in science spanning the years from Debussy to the Futurists. 'This branch of physics has received renewed attention from research workers during the past decade', wrote E.G. Richardson in the 1927 preface to *Sound: A Physical Text Book*, 'stimulated no doubt in part by the European war and by the development of broadcasting.' Musical instruments such as the piano – embodiments of the aesthetic values of European art music –were threatened by challenges from the electrical world of the radio, the phonograph or the Theremin. E.G. Richardson's text book updated the work of late nineteenth-century physicists such as Hermann Helmholtz and John Tyndall and predecessors such as E.F. Chladni, scientists whose researches have been echoed in the music of Lucier, Edgard Varèse and Harry Partch. Tyndall, for example, summarised many experiments in *Sound*, first published in 1867: bowing long monochords, optical illustration of acoustical beat frequencies, the action of fog, hail and snow on sound, echoes from flames, vibrations in metal plates, an analysis of sirens and the 'clang of piano wires'.

Although they were conducted with scientific rigour, the aetherial nature of sound imbued these experiments with an air of mystery. Smelling faintly of the alchemist's laboratory, they were less torrid versions of Raymond Roussel's literary creations. Staged for one week at the Parisian Théâtre Fémina in 1911, Roussel's *Impressions d'Afrique* featured among its scenes the trained earthworm whose undulations in a mica trough dripped mercurial water on to the strings of a zither to produce complex melodies. Roussel's fantastic inventions lay in an interzone between exotic vaudeville, anthropological surrealism, voyeuristic travel narratives and future audio art. A fictive art that was improbable yet tantalisingly possible, the living sound sculptures of *Impressions d'Afrique* touched on sensitive areas of cruelty, dream, perverted science, alien systems and an atavistic social subversion.

GLITCH, BUG NOISE, TRANCE SPACES

In the 1990s, these strands – acoustic science, the art of listening, theatres of the impossible, sentient machines, the phenomenology of perception, the articulation of space – converged with concerns pursued by younger musicians and artists who maintained a certain distance from the worlds of high art and mainstream music. In Japan, for example, the determinedly non-musical sound processes of Minoru Sato and Atsushi Tominaga documented the peripheral bug noise and fugitive crackle of loudspeakers saturated by steam or disconnecting electrodes planted in vibrating window frames. 'When we reflect on the condition that most sound works have been requisitioned by music', Minoru Sato wrote in his catalogue essay for the exhibition *Sonic Perception 1996* in Kawasaki City Museum, 'we are forced to think that the perception/consciousness of the aspect of sound as a phenomenon has not been valued.' Another Japanese composer, Mamoru Fujieda, echoed those sentiments with his claim that 'the common notion that any art form using sound as its material is in itself music has begun to lose validity'.

A new development in sound art during the past ten years has emerged out of a club context. With its ancestry in disco, funk and the techno-pop of Europe and Japan along one line of the family tree, Stockhausen and Pierre Schaeffer on the other, this work evolved from popular dance genres such as house, techno, electro, hip-hop, acid house, industrial and ambient. In 1975, Brian Eno had described ambient music as an environmental tint, a background that could be listened to at various levels of attention or simply ignored. Like Stéphane Mallarmé, who devised a perfume that would use scent to express the essence of his poem 'L'Après-Midi d'un Faune' (just as Debussy had expressed its essence through music), Eno envisaged music as perfume. In the wake of disco, clubs in the 1980s featuring electronic dance music catalysed related feelings amongst its followers, though the results were a dramatic contrast to Eno's meditative sound and video installations. Since DJs were playing the records in dance clubs, layering them, transforming them or blending them into one seamless flow motion, the authorship of individual tracks began to lose importance. Sound in a club was a powerful articulation of space, an extreme expression of musical duration and sonic physicality. Though at the forefront of perception due to its high volume and relentless beats, music was no longer the focal point of socialisation. The idea of sitting in parallel rows, staring at musicians on a distant stage, still endured. The potency of this ritual, however, was fading to a nostalgic memory.

Technology aligned with the nature of clubbing to raise difficult contradictions for musicians still called upon to perform. How could a live performance be meaningful in any traditional sense if the sound had been created through complex sample montage, laborious mathematical calculations and mouse clicks on a laptop computer? Fully immersed in the characteristics of the digital age, recording artists such as Oval, Bernard Gunter, Pole, Christian Fennesz and Sachiko M are the archaeologists of digitisation and its glitches, their music described by Rob Young in *The Wire* as 'an urban environmental music – the cybernetics of everyday life – that reflects the depletion of "natural" rhythms in the city experience, and in the striated plateaux of the virtual domain'. This post-techno universe of clicks, scratches and audible silences drew upon a century of musical innovation yet posited something entirely new: 'as if the ambient soundfields on the Cage-Eno axis', wrote Young, 'have been zoomed in on until we are swimming amid the magnified atoms of sound'.

Many of the old divisions between so-called 'high' and 'low' arts have been blurred by the relationship of sound art and experimental electronica to their more danceable cousins. A hip-hop turntable virtuoso like OJ Disk is capable of working with improvising guitarist Derek Bailey while still retaining his credibility in the underground hip-hop scene. A fascination with the qualities of the record deck – an icon of phonography, a noisemaker, a signifier of phonographic memory, a mechanical device that lends itself to performance, a tool for real-time montage and transformation – has captivated both sound artists and hip-hop DJs, with both categories of turntable artist overlapping in their obsessions with vinyl and stylus. Similarly, digital samplers and scanners entrap ghostly traces of our fragmented,

mediated present through their capture and mutation of snapshots from sound archives and invisible communications.

Yet the club context has its limitations. The narcotic trance environment of a journey on Eurostar, a feast of subliminal sonics, is as likely a venue as any for contemporary sound artists. The noise of streets, strangers, shops, abandoned industrial zones, rivers, airports, stations and unique sound marks, has generated a school of walking sound art. Marked by traces of *4'33"*, radio art and R. Murray Schafer's soundscape diaries, these journeys interleave memory, observation, listening, text and sound in invisible theatres and audible maps.

Sonic Boom scans some of the most vital artists currently working within this expanding field at a critical moment in the evolution of media. None of us know where media arts will go, since their fate is bound up with the uncertain and overheated future of electronic communications. We can only guess. One aspect of sound art that is compelling, at this stage in its history, is the way that dramatic contrasts in working practice and materials can still link to common historical sources. Mechanical or organic, electronic or acoustic, delicate or brutal, hi-tech or ramshackle, solid or intangible, complex or simple, all of the works are linked at a profound level of sonic disturbance. There is a feeling of Frankenstein's laboratory, the inventor's workshop, the temple, the Japanese garden, the junkyard or the underground military bunker. The sounds themselves are mysterious for being unfamiliar, their source often uncertain. A sound may even be present by implication, without being heard. *Sonic Boom* offers a landscape of the imagination, transforming the perception of sound from peripheral sense or discrete spectated event to a total environment for all the senses.

BRIDGET RILEY
ON PAUL KLEE

Paul Klee:
The Nature of Creation
2002

Paul Klee: The Nature of Creation was the first major retrospective of Klee's work to be held in the UK. Selected by the artist Bridget Riley and art historian Robert Kudielka, the exhibition benefitted from what the then Hayward Gallery Director Susan Ferleger Brades described as both 'a scholarly focus and an artist's eye'. Featuring 96 works that ranged from drawings and watercolours to examples of Klee's teaching at the Bauhaus, the exhibition set out to examine the seminal role Klee had in the development of twentieth-century art.

MAKING VISIBLE

Influence is a rather vague term to describe the kind of debt one artist owes another. It can be a case either of straightforward appropriation, which is something every young artist does, even has to do, in one way or another, to get started at all; or a two-sided relationship in the sense that you recognise in another artist something that you have long been searching for without being able to identify or articulate the need. The discovery may relate to only one aspect of the other artist's work, but it will be central to you. In this way Paul Klee was of seminal importance to me because he showed me what abstraction meant.

I first found a clue to Klee's thinking in the *Pedagogical Sketchbook*, which was published while he was teaching at the Bauhaus, and later, in a more amplified form in *The Thinking Eye*, a posthumous collection of his writings. As anybody who has ever looked into these books will understand, I could not find any systematic coherence in either of them. It was only much later that I learned the reason for this confusion. Apart from a few essays, *The Thinking Eye* is a compilation of the notes Klee had used in his teaching over many years and that he had altered, revised and augmented as he went along. Although, as a result, they have no real sequence in themselves, the lack of order did not diminish or deflect the attraction they held for me. In fact it had the opposite effect. The very dispersal of his insights made me aware of the recurrence of a few main points, the most important of these being the distinction between schematic or theoretical abstraction and abstract painting.

In everyday language abstraction refers to the process by which one draws a generalised notion or formula from the particularities of real experience. Abstraction in this sense is the result of an intellectual effort that everyone makes in order to cope with everyday experience. For instance, if I say 'tree' – you have only a word, but it will stand for trees of all sorts, for oaks, poplars, willows, firs, names which in turn are minor abstractions of the infinite variety of real trees. But in visual art this is not the meaning of abstraction, although it has often been confused with it.

The rise of abstract art, especially in the first half of the twentieth century was accompanied by abstracted images from nature, schematic figures and objects, all of which bear witness to the uncertainty of the terrain explored and to the inevitable bewilderment that surrounded the emergence of this new form of art. Klee was the first artist to point out that for the painter the meaning of abstraction lay in the opposite direction to the intellectual effort of abstracting: it is not an end, but the beginning. Every painter starts with elements – lines, colours, forms – which are essentially abstract in relation to the pictorial experience that can be created with them.

Klee's penetration may have been supported by the fact that he himself was not a rigorous abstract painter in the sense that Mondrian was. This may have given him the detachment that enabled him to accept that abstraction had always been at the root of the art of painting. Now that the novelty of abstract art has worn off it is not so difficult to see that Vermeer is more of an abstract painter than many avowed 'abstractionists'. The only really 'new' development of the twentieth century was that the abstractness of picture-making rose to the surface, literally and metaphorically. This was not the result of any wilful decision on the part of artists, but of the historical process in which painting's traditional role of serving a common language of social and religious imagery fell away.

Klee was not, of course, the only painter to be affected by this huge cultural schism. Matisse, Picasso, Braque, Kandinsky and Mondrian all responded to it in their different ways. The awareness of the crisis was deep and widespread and, of all art forms, painting took the lead and followed the most courageous paths. Even so, Klee is unique in that he demonstrated more fully that the elements of painting are not just means to an end, but have distinct characteristics of their own. A huge part of *The Thinking Eye* consists of very precise analyses of what lines, colours and forms *do* once they enter a pictorial field. Long before a line is expressive, it works in specifically plastic ways, taking direction, dividing up areas, delineating or circumscribing forms, and so on. A colour in painting is no longer the colour of something but a hue and a tone either contrasting with other hues and tones or related in shades and gradations. And, very importantly, forms do not act as substitutes for bodies in physical space but are spatial agents in the picture plane.

None of these characteristics can be foreseen. That they will occur cannot be doubted, but precisely how can only be discovered in the context of picture making. It was wonderful to see, during my visit to the Klee Foundation in Bern, clear and abundant evidence of the large part his analytical investigations had played in the preparation of his work. The 'discoveries' that he made were always highly objective, and this of necessity, as I found out in making my own preparatory studies. Klee is the great antidote to the confusion that persists around geometric abstraction and mathematics in painting. A geometric form in the picture plane does not work in terms of geometry. His most striking example is the triangle that in its mathematical definition is the direct connection between three points not on a straight line. But

perceived as a pictorial figure the triangle is charged by the tension between line and point, between a base and a directional thrust. That is to say in painting the triangle displays plastic properties that go beyond mere appearance. In the 1960s, when I started my black and white paintings, I was very much aware of this intrinsic potential in the elements and I used to refer to it as 'energy'.

There is the obvious difference that in my black and white work I turned these energies against formal stability as such. Nevertheless, this was still, in its way, an extension of the rigorous stance that Klee took in his Bauhaus teaching against form as an end: 'Form as movement, as action, is a good thing, active form is good. Form as rest, as end, is bad. Passive, finished form is bad. Formation is good. Form is bad; form is the end, death. Formation is movement, act. Formation is life.'[1] I still hold to this beautiful litany.

However, the plastic energy of form in the picture plane – which I called dynamism – constitutes only one of the many active relationships that eventually make up a painting. Among the 'pure pictorial relations', Klee lists 'light to dark, colour to light and dark, colour to colour, long to short, broad to narrow, sharp to dull, left-right, above below, behind-in front, circle to square to triangle'.[2] When combined, these relationships produce the highly complex sensation that is somewhat bluntly called 'pictorial space'. This has been the most fought-over territory in latter day modern painting. The very notion of pictorial space seems to imply an illusion on the flat surface. It strikes one as very nearly comic now when one thinks that this 'illusion' has been prosecuted with an almost moral fervour ever since the 1950s, that is to say for well over 40 years, as though it were dishonest or something close to fraudulence.

Paul Klee
Vogel-Drama (*Bird Drama*),
1920, No. 93

Klee's 'practical considerations in regard to space' in *The Thinking Eye* expose the vain zealousness that so haunted this debate from the start: 'The spatial character of the plane is imaginary. Often it represents a conflict for the painter. He does not wish to treat the third dimension illusionistically. Today a flat effect is often sought in painting. But if different parts of the plane are given different values, it is hard to avoid a certain effect of depth.'[3] This is the great strength of Klee: you cannot deny pictorial fact – that which is palpably experienced. Any element that enters the picture plane, be it a line, a spot of colour or a tonal shade, is liable to create the sensation of depth. This is so real to our perception that it does not have to be fabricated as an 'illusion'.

If one understands correctly the word visible, as 'that which can be seen', then it follows that the realm of our vision is not confined to what we actually see, but encompasses a wider potential. That is to say there is a range of possibilities, a horizon of aspects latent in any perception to which Klee refers when he defines the aim of his art as 'making visible': 'Art does not reproduce the visible but makes visible.'[4] This is not meant as a revelation in the sense of rendering visible something

1920 93 Vogel-Drama

that was previously unseen, but as the opening up of our vision to the greater and fuller span of the generative force of life. In painting the thing seen is, at best, a factor that gives rise to both the actual perception and to the sensation that places it within our experience.

Perhaps this may be one of the reasons why the great paintings of the past are still able to touch us so directly. To return briefly to Vermeer, he seems to be of quite a different order to his fellow artists in the Netherlands because his paintings are not exhausted by rendering an existing subject matter nor by catching a momentary appearance, they 'make visible' in Klee's sense. With every new encounter Vermeer's paintings seem to begin again, reconstituting their own reality once more and at the same time accommodating our various spontaneous responses.

But this generative force that maintains the great paintings of the past in the present is still veiled by historical costume, as it were, veiled by the particular form of pictorial representation employed. What happens if the aim of 'making visible' is pursued without any commonly recognisable imagery? This question has long concerned me and continues to preoccupy my thinking. As an abstract painter I do not believe in the self-referential object. Even if this could be manufactured –

which I doubt – it would be a dead end. On the other hand, abstract painting cannot stimulate merely subjective associations, there must be a deeper form of recognition.

Although only part of Klee's creative interest is focused on pure abstraction, he nevertheless goes a long way towards clarifying this issue. Recently I was looking with Robert Kudielka, my co-curator for this exhibition, at Klee's drawing *Vogel-Drama (Bird Drama)* (1920). He pointed out to me the dot on the belly of this big cow-like bird on the left saying, 'It's the key to the whole drawing!'. This was enough to release the magic of visibility contained in a work that had previously been opaque. I immediately saw the connection between this cross-eyed creature and the small crowd of long-necked birds leering at her; noticed the significance of the mound with sprouting shoots on the extreme left in contrast to the barren heaps below the gossiping birds. Gradually even the right hand side of the drawing became clearer: the flash-like black arrow and the small bird which appears gleefully to blurt out the whole story – and perhaps was responsible for this entire comedy in the first place, who knows?

However, it is not so much the discovery of a way of deciphering this drawing that matters. It is rather the form in which Klee articulates a rather complex group of sensations that is important – sensations that, by the way, are also about creation. He articulates these so fully and precisely that one wants to return to the drawing over and over again, just for the joy of seeing it become visible once more. Above all a visual work of art seems to be capable of providing the pleasure of participating in the process that generates the visible. Or, as Klee says: 'The picture has no particular purpose. It only has the purpose of making us happy. That is something very different from a relationship to external life, and so it must be organized differently. We want to see an achievement in our picture, a particular achievement. It should be something that preoccupies us, something we wish to see frequently and possess in the end. It is only then that we can know whether it makes us happy.'[5]

MARINA WARNER
ON ART AND ILLUSION

Eyes, Lies and Illusions:
Optical Wizardry through Time
2004

Eyes, Lies and Illusions: Optical Wizardry through Time explored the art and artifice of optical invention from the Renaissance to the present day. The exhibition drew from the collection of German experimental filmmaker Werner Nekes, who had participated in the Hayward Gallery exhibition Film as Film: Formal Experiment in Film 1910–1975 *in 1979.* Eyes, Lies and Illusions *featured over 1,000 items from Nekes's collection, among them antique zoetropes and eighteenth-century peep boxes. These historical items were complemented by the work of eight contemporary artists whose work dealt with illusion and perceptual paradox. The eight artists were: Christian Boltanski, Carsten Höller, Ann Veronica Janssens, Anthony McCall, Tony Oursler, Markus Raetx, Alfons Schilling and Ludwig Wilding. Writer, critic and cultural historian Marina Warner – whose publications include* Phantasmagoria: Spirit Visions, Metaphors and Media *(2006) – acted as the 'curatorial adviser' on this exhibition, and contributed the following essay to the catalogue.*

CAMERA LUCIDA

And the same objects appear straight when looked at out of the water, and crooked when in the water; and the concave becomes convex, owing to the illusion about colours to which sight is liable. Thus every sort of confusion is revealed within us; and this is that weakness of the human mind on which the art of conjuring and of deceiving by light and shadow and other ingenious devices imposes, having an effect upon us like magic.

PLATO, *THE REPUBLIC*[1]

Only appearances are fertile; they are gateways to the primordial. Every artist owes his existence to such mirages. The ponderous illusions of solidity, the non-existence of things, is what the artist takes for 'materials'.

ROBERT SMITHSON, *INCIDENTS OF MIRROR-TRAVEL IN THE YUCATAN,* 1969[2]

THE ENCHANTED ENIGMA OF APPEARANCES

In the medieval Christian tradition, the Devil is a mimic, an actor, a performance artist and he imitates the wonders of nature and the divine work of creation. His medium is illusion. Unlike God, the Fathers of the Church argued, the Devil cannot perform real miracles or really alter phenomena. He is the mere ape of God, the master of lies, of imitating and simulating and pretending – but he is impotent when it comes to transforming substance and matter. He can only conjure visions as illusions, as he did when, in the person of Mephistopheles, he summoned the pageant of the deadly sins for Doctor Faustus and then seduced him with the bewitching appearance of Helen of Troy.

The Devil summons images in the mind's eye, playing on desires and weaknesses. He toys with us, especially when creating spectacles that are not there, for the word 'illusion' itself comes from '*ludere*', 'to play' in Latin. Conjurors mimic his tricks: an early Christian Father, in the midst of furiously denouncing magicians, gives a surprisingly vivid account of their stratagems, of the lamps and mirrors or basins of water they used, how they even conjured the stars by sticking fish scales or the skins of sea horses to the ceiling.[3] Writers on dreams warned that the sleeping mind could suffer delusions too: the suffocating *succubi, incubi* and *ephialtes* of pagan mythology were borrowed into Christian belief and flourished there as nightmares inflicted by personal demons.

'Dreams are toys…' exclaims Antilochus in *The Winter's Tale*, when he's frightened by the apparition of Hermione in the night.[4] Toys used not to be mere trifles for children only, but belonged in that country of uncertainty where human perception keeps its precarious existence. From the first showings of magic lantern slides, optical illusions were ascribed to the Devil's mischief. In the mid seventeenth century, when the Jesuit polymath Athanasius Kircher began experimenting with shadows, lenses and reflections, he made images of devils with pitchforks, Mister Death brandishing his scythe, a soul burning in purgatory, and other supernatural scenes, as if the new technology inevitably involved phantasms and spectres.[5]

In the era of faith, magic was carefully distinguished according to three categories: first, miracles from God by which the laws of physics were suspended; secondly, Natural Magic, or the wonderful properties of earthly things; and last the illusory work of the Devil. But they were indeed difficult to tell apart, and inquisitors and witch-finders, early scientists and doctors of medicine struggled in different ways to do so.[6] Optical illusions are not supernatural, however, as Kircher was intent on demonstrating through his experiments. But illusions also kept disrupting the boundaries between reality and fantasy. Demonstrating tricks of perception, especially through the use of mirrors (the art of catoptrics), Kircher showed how he could manipulate the natural properties of light and play on the limits of human faculties to create seductive and wonderful delusions – the spell of the visible. The shows held by Kircher in the Jesuit College in Rome won him a risky reputation for 'magical enchantments': his ingenuity even inspired him to paint the slides with chemicals so that they changed colour under the heat of the lamp.

So running through the history of magic and its attendant anxieties runs a parallel history of optics: if the Devil was able to conjure appearances whereas God truly performed prodigies, it was imperative to establish the truth status of the vision.

The collection that Werner Nekes has made over the last 30 years gives fascinating insight into the enchanted enigma of appearances, and into the history of optical investigation into these mysteries. It's a rich repository of human thought about vision and all that it implies. It includes the whole range of optical devices, playing with every kind of effect from supernatural apparitions to visual puns and cracker

fillers, from the highest accomplishments of human intelligence to the most light-hearted eye-twisters or visual jokes. His assorted wonders of instruments, images, machines, toys, illusions and effects span more than five centuries of human ingenuity and invention at its most lively, ranging from an exquisite prism said to have belonged to the philosopher Blaise Pascal to an 1898 automated flip book-cum-peep-show of a female dancer dimpling and flirting.

'The soul never thinks without a mental image', declared Aristotle in his work on the soul, using for soul 'psyche', and for picture the word 'phantasma'.[7] Trying to enhance human physical capacities with lenses and apparatus of various kinds has obviously been a strong motive behind optical inventions, but the desire to reproduce, and hence retain for analysis, mental imagining and the products of *fantasia* has been an equally powerful, though less discussed, engine behind inquiry into the working of eye and brain. For example, Robert Fludd, an Oxford philosopher and esoteric Neoplatonist of the generation before Kircher, imagined the 'eye of the imagination' as a prototype film projector, beaming images onto a screen floating in virtual space, somewhere at the back of the eyes of the body.[8] Descartes declared, 'First it is the soul that sees, not the eye...', and this primacy of the imagination offered some explanation for dreams and visions and apparitions.[9]

Athanasius Kircher
First printed illustration of a
magic lantern projection, in *Ars
Lucis et Umbrae* (*The Great
Art of Light and Darks*), 1671

The veridical or truth-telling status of visual phenomena constitutes an acute puzzle precisely because we cannot think without pictures and these do not always represent objects that exist in the sensory world. In the field of optics, many instruments were created to analyse and reproduce vision, such as the *camera lucida*, the device which projects a reflected image onto the artist's paper or canvas.[10] But optics also reflects ideas about consciousness at any given period; it expresses the potential of the inward eye for every generation, the concepts of cognition and mental projection, and the irrepressible tendency of the mind to assemble random marks into intelligible data.

In 1784, the landscape painter Alexander Cozens advised fellow artists to follow the promptings of fantasy and create images from blots of ink on crumpled paper: this astonishingly modern idea about chance and composition echoed Leonardo da Vinci's practice nearly three centuries earlier. Leonardo was in fact quoting his fellow artist Botticelli: 'Our Botticelli said [...] by merely throwing a sponge full of diverse colours at a wall, it left a stain on that wall where a fine landscape was seen.'[11] But Cozens arrived at his 'New Method' on his own, without prior knowledge of his Renaissance precursors, and made startlingly expressionist images.[12] Athanasius Kircher collected images made by chance, stones with images of Christ and slices of agate forming mist-wreathed Chinese landscapes. Werner Nekes has a rare album of 1885 filled with drawings of imps and devils which were doodled by workmen following the drips and splashes of coffee on the walls they were plastering.[13]

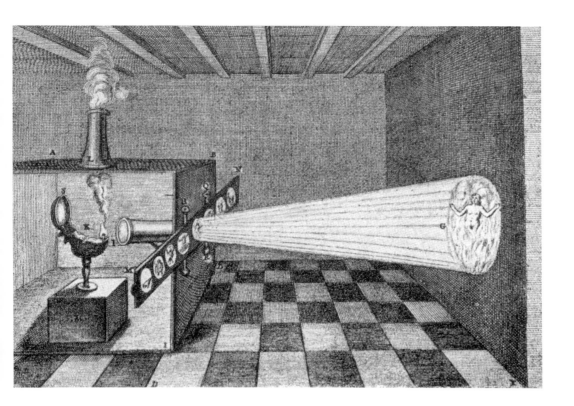

Illusory perceptions later even entered mainstream medical practice, when in the 1920s in Zurich the psychiatrist Hermann Rorschach was inspired by the children's game of cloud-gazing to create a series of ink-blots as a tool of clinical diagnosis. Initially received with some scepticism, Rorschach tests have shown remarkable powers of survival, and remained in use in psychological practice in the United States until very recently, even though Rorschach was simply adapting ancient methods of fortune-telling: seeing the tall dark stranger in tea leaves or coffee grounds.[14] But he devised his method because it was increasingly accepted that vision depended on the observer's subjective perception, and could consequently uncover hidden aspects of the innermost unconscious self.

Ever since Descartes, questions about the percipient, subjectivity and objectivity, and the nature of appearances, have grown more acute, and the philosophical dilemmas of the seventeenth century prepared the ground for current intense speculation about the interplay of perception and reality itself. The concurrent crisis of doubt in the reliability of perception led to problems about what is true and what is false, and the answers furnished by religious faith did not suffice. This is the paradox that Alice puzzles over: 'Now, Kitty, let's consider who it was that dreamed it all […] You see, Kitty, it *must* have been either me or the Red King. He was part of my dream,

of course – but then I was part of his dream, too!'[15] This perplexity has become a *locus classicus* in contemporary consciousness, and it involves the very nature and experience of illusion.

Werner Nekes's collection plays a range of effects as if on a giant organ of visual phenomena, from profound investment in the objective truth of vision to an equally strong engagement with radical subjectivity. As we move nearer our era his artefacts and devices reveal two strong tendencies: first, the media of visual trickery, deception and illusion move away from ever more intense techniques of scientific scrutiny towards entertainment, as instruments of knowledge become part of show business. Few traces linger of the old fears about the Devil's juggling and chicanery. Secondly, while the direction of illusionism tends so vigorously towards distraction and pleasure, the media that thrive on its polymorphous potential raise Alice's question: that deeply troubling spectre of visual ambiguity. The perfection of visual technologies has destabilised experience until we cannot be sure if we are not the dreamers but the dreamed, as in a recursive fable by Jorge Luis Borges. On television in the United States, footage sometimes carries the heading, 'Metaphorical Images', to warn that the film, however real, actual and immediate it appears, does not communicate what is actually occurring. As *The Matrix* films dramatise, and as Slavoj Žižek has repeated, illusion has turned us into wanderers in 'the desert of the real'.[16]

CASTLES IN THE AIR, TRICKS OF THE LIGHT

The instruments of optics – from the *camera obscura* to the endoscope a doctor uses to examine the body from the inside – have become part of ourselves, extensions of our bodies and our consciousness. We are creatures of visual prostheses, and not just glasses or lenses. We grow up with and inside illusions and learn to inhabit them unknowingly. Far more than seven types of ambiguity work their mischief in the field of vision, and the enigmas of appearance are manifold: from reflections in a mirror to mirages in the desert or at sea, light plays tricks on the observer, and the observer's own perceptions shape the images transmitted by light rays and the sense they make.

But there is no need to travel to the North Pole or to the Sahara to experience the illusions of *fata morgana* and a delightful queering of perception. Look around you in a lighted space and everything in it may look present and material and real; but even the most ordinary interior and the most familiar exterior enter your eyes through a complex of optical effects which you have learned to interpret and many illusions have become so naturalised as to be invisible. Noticing such tricks the eye performs on a daily basis would stall business; training the mind to see its own ceaseless activity of editing, erasure and comprehension in order to move about in the world of appearances would bring ordinary responses to a standstill. We soon learn to read perspective as we make our way through our lives, though it plays tricks on us: at the most simple level, parallel lines only seem to travel towards

each other, as there is no vanishing point except in the observer's mind. But far less obviously, who has not seen the full moon floating huge and near above the line of the horizon? This is one of the most beautiful and familiar illusions, as any camera will reveal. In the resulting photograph, the moon is there in the sky, the same remote, small size as ever.

Reflection and refraction set up eye-beam-twisting riddles, which we adapt ourselves to slip through, unharmed. Nature itself has evolved using optical strategies: the camouflage of chameleons and stick insects is a form of illusion, while the *ocelli*, or eyes, which appear on the wings of butterflies, deceive predators into imagining they are dealing with a much larger and fiercer creature.

The laws of perspective, which were developed in the Renaissance, resist these magical ambiguities, situating an observer securely in three-dimensional space, and appearing to offer a stable structure for the relations of things seen through the human eye: as distance grows greater, so objects become smaller from the observer's vantage point, parallel lines seem to meet, the view from any point commands a vanishing point on its farthest reaches, and so on. The architects and artists of the Renaissance, often very mathematically inclined (Francesco di Giorgio, Piero della Francesca, Uccello, Alberti, Leonardo), explored this lucid, commanding individual viewpoint. But paradoxically, fullness of control over the field of vision engendered early marvels of illusion. Around 1655–60, Samuel van Hoogstraten made an extraordinary peep-show, a compact box less than a metre deep, in which his use of perspective is so cunning that when you put your eye to the peepholes, the doors inside open onto a deep enfilade of rooms, as in a typical painting of a Dutch interior, with more apertures opening on to scenes glimpsed beyond those chambers.[17]

Anamorphosis is perspective's dark double, an unintelligible distortion of elongated or swirled smears of lines and shapes that only reassembles itself as a coherent image when viewed from a particular extreme angle, or in a convex or trapezoid mirror.[18] An image then comes together – occasionally of a devil grinning at the mischief the trickery causes, at the cleverness of the fraud by which cogency lies concealed in nonsense.

So the distinction between (true) optical phenomena and (false) optical trickery is not altogether clear or easy to establish, and the question of illusion haunts both enterprises. Descartes held perspective to be a form of illusion, and Jean-François Nicéron, another French philosopher of optics, even thought it a kind of magic.[19]

ILLUSIONISTS OF MODERN LIFE

Anxiety about the unreliability of vision continued long after most believers in the Devil's antics had faded away, and after the seventeenth century it spurred closer analysis of the human faculties, especially sight. As optical knowledge

expanded, the numinous and diabolical associations of optical effects began to fade; gradually, observational science established human idiosyncrasies. Investigators and experimenters like David Brewster (1781–1868) in Scotland, a friend of Sir Walter Scott and a keen expositor of Natural Magic,[20] Peter Mark Roget (1779–1869) in England, and Joseph Plateau (1801–83) in Belgium researched and analysed the limits and idiosyncrasies of perception – how turning wheels seem to reverse direction, how a whole scene can be seen through a narrow slit, how the eyes in a portrait seem to follow the viewer round a room, how a bright object lingers on the retina even when the eyes are closed, often glowing in its complementary colour – as in 'persistence of vision'. Understanding such ways of seeing – the modes of human perception – opened the way to the 'philosophical toy', devices that played with the vagaries of visual capacity and conjured illusions. Inventors gave them grandiloquent Greek names to stress the seriousness behind their playfulness: the praxinoscope, the phenakistiscope. In 1817, Brewster angled four mirrors in a cylinder with some pieces of coloured glass and by shaking it produced magical symmetries and glorious tumblings of regular patterns, and called his creation a kaleidoscope from the words *kalos* (beautiful) and *eidos* (form). (How would we now describe effects in literature or theatre or painting without the metaphor 'kaleidoscopic'?) Brewster was building on the research of Charles Wheatstone who was working on stereoscopy (the illusion of depths created by binocular sight). The stereoscope followed – not quite a toy, not quite a scientific instrument, it became one of the most popular pastimes in the Victorian home, with viewers opening up vistas on new and distant lands through explorers' photography.

These discoveries also led to the society of surveillance on the one hand, and of mass media on the other. But it is also the case that the panoptical devices and modern visual prostheses created a mass of popular illusions that no longer alarmed their consumers, but amused them hugely. These were diversions and spectacles, and they were pure pleasure. In 1827, John Ayrton Paris, for example, created the thaumatrope (from Greek 'wonder' combined with 'motion'), a round disc threaded on a string with one picture on one side and another on the reverse; when the disc was spun, the images merged. This was the first device to tune into the 'critical fusion frequency' of human visual perception, the speed at which the brain no longer grasps individual still images but superimposes one on the other. Spin the disc, and the canary on one side will appear in the cage on the other. The thaumatrope was one of the devices crucial to the development of moving pictures, which would eventually give the impression of life itself flowing past when projected onto a screen at the rate of 24 frames a second.

Other instruments followed, working in the grain of delusion in order to enchant with illusion. Visual devices, large and small, emanated from inventors and manufacturers for the modern urban crowd in the new large metropoles. In London, Edinburgh, Paris and Berlin, the rising classes of working men and women as well as the leisured hedonistic bourgeoisie made up new spending audiences presiding over the emancipation of fantasy from priestcraft. They made it possible to treat phantoms and deceptions, which had been seen as the treacherous swamp of

diabolical traps and connivance, as sources of amusement. Phantasmagoria shows, for example, began touring Europe at the end of the eighteenth century: in the wake of the Terror in France, the brilliant impresario, balloonist and cinematic pioneer, Etienne-Gaspard Robertson, inaugurated the thrills of the horror movies when he projected spectres onto smoke – including the severed head of Danton, a recent victim of the guillotine.

The history of optical illusion thus travels a course from a religious belief in magic to the start of mass media entertainment, and at every step of the way the potential for tricking the eye and inventing new diversions (from pop-up books to the movies) marches in time to the progressive understanding of vision, its function and, above all, its propensities. As one conjuror writes, 'to deceive, you must know what your audience is thinking'.[21]

The Victorian audience was travelling vicariously in the footsteps of explorers who continued to open up continents: the natural magic of the lantern slide beamed natural wonders, waterfalls in Africa, volcanoes in South America, kangaroos in Australia, icebergs in the Arctic Circle. Many different kinds of shows, inheritors of the ambulant magic lanternists, revealed worlds near and far through colossal and spectacular illusions. In 1821, in order to make a panoramic painting of London, the Hull-born artist Thomas Hornor climbed to the apex of the cross on the pinnacle that crowns the dome of St Paul's Cathedral, and there he built himself a craw's nest, a fantastic platform of lashed timbers with a cabin secured to it by overhead ropes, themselves tied to a tepee-like superstructure. From this, where Hornor bivouacked for the time it took, he made a 360-degree picture of London. He used a telescope to examine details, and calculated the perspective not only to unfold the vista on the curved walls of the panorama, but to position the viewer convincingly in the scene.

This brings us to another distinction, between the thing seen and its image. Through his prodigious feat of endurance and engineering and survival, Hornor in his eyrie did indeed command a stable view of London such as even the new sport of ballooning did not offer. But his fixed Olympian vantage point did not unfold an illusion. The crow's nest, the telescope, the geometry, enhanced the field of vision that lay around him but did not dupe it. The picture he made nevertheless turned his experience into a rich *trompe l'oeil* for his audience who later flocked to this truly popular marvel of early Victorian ingenuity.

In Edinburgh in 1835, Maria Theresa Short, daughter of an optical instrument maker, created one of the very first popular, public *camera obscuras*. It is still open, on Castle Hill, and it captures through a periscope and angled lenses the thronged and vital scene of the streets below, projected by natural light rays alone onto a white convex dish. Buildings below materialise there in every detail, miniaturised; tiny figures scurry, tiny buses grind silently over the cobbles. This method of casting an image of the world outside onto the inner wall of a darkened and enclosed space through a pinhole aperture was known in antiquity, and was used by sixteenth-

century astronomers, for example, to observe sunspots. But it had not been adapted to entertain the crowd, as in 'Short's Observatory'. The projection is still an astonishing effect and it brings into being, with no more magic than a series of angled lenses, ancient dreams of summoning absent sights through gazing into a bowl of water or oracular mirror.[22]

NECESSARY ANGELS

As Umberto Eco wittily dramatises in *The Name of the Rose*, the first grinders of lenses for spectacles were aiming primarily at redressing poor eyesight and at enhancing visual experience of the world as it offers itself to human eyes. But after prosthetic devices were adapted to spectacular entertainments, they also became involved with the secondary enterprise – expressing fantasy and communicating inward vision – wittingly or unwittingly. Just as the telegraph carrying disembodied voices through the air furnished a medium for spiritualist communications with the dead, so photographers attempted to capture phantoms invisible to bodily eyes, and to project states of mind onto sensitised plates. At the turn of the century in Paris, Doctor Hippolyte Baraduc published photographs of his moods in a volume called *The Human Soul. Its Movements, Its Lights, and the Iconography of the Fluidic Invisible*.[23] Flares of light in diffuse vortices appeared on tiny prints taken without camera or lens by direct application of a sensitised plate, he said, to his own or his medium's brow.

In this kind of 'psychic research', modern spectacle, visual technologies and the latest physics fused: the newly discovered properties of electricity gave showmen the chance to create fantastic illusions. In 1900 in Paris, the architect-inventor Eugène Henard created a *Palais des Mirages* from mirrors revolving in a dazzling barrage of the latest electric light bulbs; the mirrors' rotation allowed for enchanted changes of scenery (from a Hindu temple in a twilit forest to an Arabian palace).[24]

The heyday of magic illusionism blazed throughout the second half of the nineteenth century, when Halls of Mirrors made people burst out laughing at their own freakiness, and the Davenport Brothers, bound hand and foot to chairs, could rise in the air in front of enraptured audiences. Through stagecraft, deploying a series of reflections, a spectre could float up above the stage and right out into the auditorium (this was a popular trick called 'Dr Pepper's Ghost' after the showman who toured it). The phenomenal Harry Houdini could make an elephant disappear in full view of a vast crowd in Madison Square Garden (using a cunningly mirrored and folding cabinet). During the rise of women's movements, especially the suffragette campaign, many conjurors specialised in cutting ladies in half or making them vanish altogether.[25]

The profusion of instruments for sleight of hand and eye in Werner Nekes's collection tells several stories at different levels, and one of the most fascinating and important

MARINA WARNER ON ART AND ILLUSION

recounts the slow conquest of motion and its representation. Animation is the very sign of the presence of life: the quickening of the spirit moving within inert matter. In antiquity, one or two magicians in Alexandria had made automata, like the golden handmaidens of the god Hephaistos – proto-Stepford-Wives who waited on him in the Underworld. But these simulacra were rare indeed. It was not until the magical arts of cinema that classical myths about animating statues or bringing images to life were realised.

Underneath all the multifarious variety of optical devices in the Nekes collection runs a single overarching dynamic: deception grows in the ground of understanding, so the more that is known about the way the mind works, the more possible it becomes to slip under its defences and conjure illusions. These give delight, but the pleasure in being deceived keeps pace with the pleasure in knowing how the deception works, and the one is ceaselessly trying to outpace the other.

By analysing the capacity and the limits of human vision, pioneers of cinema realised that motion could be reproduced in images, and an audience can watch apparent live action and movement taking place as if for real and in real time. Stop-frame photography, as in the experiments of Etienne-Jules Marey and Eadweard Muybridge, broke the ground. The illusion of the movies did not only inaugurate a victory over art's stasis but also over the communication of time itself. Robert Paul was an inventor who read H.G. Wells's story *The Time Machine* when it appeared in 1895 and visited him immediately to suggest telling the story with moving images. Paul was struck by the kind of effects peep-shows were using to amuse audiences, and was applying for a patent for an early kind of cinema that would give spectators 'the sensation of voyaging upon a machine through time' by simultaneously projecting pictures with several 'powerful lanterns'. They were to be viewed from different platforms, and the projectors mounted on trolleys and other devices to create dissolves and glides and fades and flashbacks and other, amazingly prescient ideas for effects of movement: 'It sought to liberate the spectator from the instant of Now.'[26]

The astronomer Camille Flammarion, an enthusiastic psychic researcher as well as a popular science fiction writer, had published a novella in 1873 about a comet called 'Lumen' in which he imagined travelling on a ray of light all the way back through that beam's history.[27] When the first newsreels began with the Kinetoscope, audiences experienced something that has become so familiar as to be banal, but was then prodigious: time past unfolding in time present events that had taken place beamed forward into space-time. It seemed that Flammarion's fantasy was fulfilled: light carried the past and transported it into the future.

Around half a century after the optical breakthrough of the thaumatrope, around a century after Robertson's Phantasmagoria and 350 years after Kircher had enthralled his guests in Rome, new instruments of light and shadow were making it possible to leap over the limits of reality as it had hitherto existed, recapture lost time, and

reproduce the unfolding of time itself through the illusion of motion. Robert Paul's invention was never built, but he made the crucial connection of the movies with time machines.[28]

The coming of the camcorder has transformed the relationship between reality and image. By installing the spectral enigmas of appearance as familiar features of existence today, it has further destabilised those ancient boundaries between illusion and its opposite. In compelling video works of the early 1970s (*Organic Honey's Vertical Roll*; *Organic Honey's Visual Telepathy*), the New York performance artist Joan Jonas plays with the eerie doubling of the self in space and time that new video technologies have made possible. She adopted Organic Honey as her video alter ego, a fantastically masked, jewelled persona of extreme female seductiveness: the self as image, reality as simulation.[29]

Optical media of communication now available have opened paths to new forms of beauty in reflection and projection, distortion and illusion, and have installed a form of doubled identity. When Tony Oursler projects lopsided spectral faces uttering messages from the ether, or angels ascend through streaming water in Bill Viola's films, or Gary Hill materialises eerie apparitions that loom and then fade, they are claiming this territory for art in our era, and pressing optics into the service of a new metaphysics. They are glimpsing – and attempting to make appear – that 'angel of reality' who declared, in Wallace Stevens's poem:

> I am the necessary angel of the earth,
> Since, in my sight, you see the earth again[30]

The taming of illusion has only begun with deeper understanding and ever more ingenious techniques of simulation: even in the conditions of bourgeois home projection and mass entertainment there has remained something stubbornly weird – or, in that overused word, uncanny – about the images optical devices can create, especially since the advent of the cinema. The world accessible to the senses began to fall away a very long time ago, perhaps in Plato's cave; it began turning into an insubstantial pageant of optical illusion, placing the observer in the dislocating yet oddly pleasurable situation of not knowing where reality begins and ends.

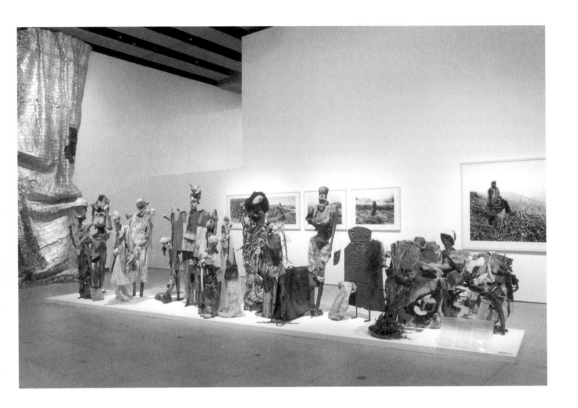

streets. Laughter and voices ring through the neighbourhoods and children run down streets paying no heed to cars. Horns blare constantly. Life is lived outdoors, with no uncalled-for shame, and nothing that goes on behind the walls – non-existent in poorer neighbourhoods – is a secret to anyone. It is this inevitable 'scandal', in its physical, social or economic aspects, that constitutes the very essence of Africa. Modesty, for it does exist, is found elsewhere – in all that is not said, in all that is kept for your nearest, your dearest and the gods.

OF SILENCE AND WORDS

On a continent where voice is a privileged means of expression, creativity does not speak. Or rather, long refused to. This silence might have been an act of defence and timidity, a sign of the stupor which the world kept on producing with its speeches and machines. A refusal to lay itself bare, to give in to rules devised for and by others. A refusal to partake in self-comment: 'one does not recount oneself, one lives.' As a result, others decided to try and decipher this history dating back to the dawn of time, traced in the rock paintings of Brandberg, Namibia, and other sites. A few thousand years down the line, Egyptologist Jean-François Champollion was confident he could

decipher the message in the Rosetta stone. Then came the masks. But Africa remained silent. Resolutely, fiercely silent.

The objects refused to reveal their secrets. After all, what is a mask that refuses to dance, apart from a pretty sculpture? All interpretations contain an inherent misunderstanding. A silent mask cannot contradict an interpreter, it just lets him comment. This millennial misunderstanding came to a climax with the attempt to decipher the world of artistic creation through a single perspective: the history of (Western) art. Due to its silence, African creativity was sent into an obscure, ill-defined limbo. From the start of colonisation – ever since the African Middle Ages in fact – pure, authentic, identifiable indigenous creativity ceased to exist. Africa was already in the throes of transformations that would only be gauged much later. The method claiming that the only true African creativity was the one corresponding to our fantasies, however, held fast, backed by researchers on Africa who started producing increasing amounts of scholarly literature on the subject from the nineteenth century onwards. Yet the creators of the objects stayed silent, almost indifferent to all that could be said about them. Invisible. It was the surrealists who wanted to prevent colonial exhibitions, not the 'natives'. Neither Senghor, nor Césaire,[9] nor any of the other people who rebelled in the name of an original Africa, could affirm the meaning of a sacred object's 'charge'. Faced with the creators' constant silence, the productions were catalogued and labelled according to this or that person's interpretations, and stored away in European ethnological museums.

A few centuries on, African artists (for we can now call them this) are no more loquacious than their elders. They have learned the need to speak, of course, or rather they have unlearned remaining silent. But the discourses their voices convey are mere decoys, *trompe-l'oeil* theories. Some artists have even turned into perfect forgers, delivering the conventional discourse to anyone who wants to hear it, endlessly replaying the Hegelian dialectic of master and slave. Deep down they remember that some things should be left unsaid and that objects have a meaning and an origin no analysis can erase. For the last 15 years a bitter-sweet comedy has thus been played out involving – a side-effect of globalisation – an increasingly large number of players. Indeed, we should here stress one of the many paradoxes of this globalisation which, in its bid to make us all the same – single consumers of a single market – spawned the most striking return to nationalism of the late-twentieth century. People think they have a better understanding of each other, when in fact they have forgotten the very essence of what understanding means.

Many African artists, however, stay silent. Even though they are today offered what was once forbidden. They travel the world and present the fruits of their quest to a public that changes daily. They are famous. Recognised? Maybe so. But this matters little to them. Only yesterday an artist who had studied in the Fine Art college of a major European capital and spoke the language of what would end up as his adopted country was viewed suspiciously by those seeking the authentic African. Terms like 'scholarly art', 'international art' and whatever else have evolved. Now and then I have

found myself debating these themes with a number of artists. Their response has never varied. They care little about the labels pinned on them. All that matters is for their work to be seen. African artists can be indifferent to the way the surrounding world sees them because, deep down, they pursue a different goal, think different thoughts and speak a different language. Their refusal to raise their voices amidst the throng is not a throwback to the timidity passed on from other eras, it marks their deliberate will to master their own space – that precious and unique space that is the hearth of all creation worthy of the name. This now all too long-forgotten silence is, in my view, the best way to approach African creativity. Everything starts and finishes with this silence.

Endless silences of mosques and sacred forests; oneness of spirit and its environment; the silence of prayer, when men suddenly stop in the middle of a crowded pavement and throw themselves to the ground facing Mecca. For you don't just have to be within the walls of a mosque for His word to be audible. Africa is without doubt the kingdom of immateriality. Admittedly, ever since the Middle Ages the empires have built palaces made of earth, as though to stress the transitory nature of all things; the mass industrialisation that transformed the face of nineteenth-century Europe did not travel this far. Even in cities like Johannesburg, Lagos or Cairo the order is provisional and there is a constant feeling of being in a pre-industrial world. One where men have not yet been replaced by machines and, given the extent to which bartering still represents a founding element of society, the virtuality of the stock markets has no established rights. The importance of giving your word, of trading words, of this silent word only revealed to those who can hear it.

The partition of Africa, like that of Berlin after the Second World War, was an aberration. Peoples who had been cousins or brothers, whose lands had known no borders other than the line of sight, found themselves separated from one day to the next. Drawn and quartered. Yet words still travel beyond these absurd frontiers. They transcend the cold materiality of politics. On my way back from Ghana one day, I found the border to Lomé closed. The Togolese customs officers I spoke to across the barbed wire of no-man's land told me their border was still open, that the problem came from Ghana's side. I had to be in Cotonou early the next morning. Just then, a stranger approached and told me to follow him. We walked through a maze of buildings for a few minutes that seemed like hours and reached the side of a road. He pointed to the pavement on the other side. That's Togo! To confine African nations within borders is futile. The history of Europe in the past few centuries is an African history, whether one likes it or not. Just as African history is resolutely European. The conscious or unconscious refusal to accept this has often turned African artists unwittingly into suspects. We have seen how much simpler and easier it is to be able to situate human beings, store them away in intelligible pigeonholes. But what happens when one of them no longer lays himself open to easy interpretation? He becomes a hybrid, alienated, incapable being, unfit to represent those who, unlike him, stayed 'back home'. He is suspected, if only unconsciously, of treason. His creativity no longer holds the emblematic value of his land. He is sometimes ranked alongside the workers who travel elsewhere to look for what cannot be found at home. The Diaspora

artist, for this is what this mutant will now be called, has no refuge but silence. Take the Mauritanian filmmaker Abderramane Sissako, for example, who told me how he decided to make films. When he was ten years old, his family moved from Mauritania to Senegal. A new country, where he did not understand the language. He could not join in with the other children's games because they instantly saw him as the foreigner. So he decided to watch, and keep silent.

Europe, or more broadly speaking, the West, is not the promised land people would like to believe. I have met numerous African artists who say they never want to leave their native land. Others have left – it's true. But I believe it would be a mistake to put their move just down to material contingencies. There are many reasons for leaving beyond the obvious political and economic ones: no longer being able to share, in the case of contemporary artists, for example, your inner language with the people around you. Realising that you will have to go elsewhere to find a silence that corresponds to you. This is no doubt what being contemporary is all about. Artists share the same quality of silence, expressed according to different accents and sensibilities, and through these silences their background and vision of the world appear. It can sometimes be easier to get along with a perfect stranger than the people we grew up with. Migration then becomes a kind of necessary evil that makes moments from the past echo inside you. It gives you a better comprehension of the things that sometimes baffle you. It's not untrue to say that self-discovery is easier in a foreign setting. The collective silence becomes replaced by a more personal, egotistical silence which, for artists, can sometimes be salvational.

The art critic Pierre Restany claimed that the artist should never be cut off from life. If there is one thing Africans cannot cut themselves off from, it's life. Whatever they do, whichever ivory towers they try to surround themselves with, there will always be an aunt, brother or cousin to remind them that life is lived on Earth and that its demands, however prosaic, are the top priority. Hence their occasional need to place some distance between themselves and this excessively familial silence with which they are sometimes one. This distance is not necessarily physical, and this is why they are able to avoid over-hasty conclusions. Being in Hamburg, Amsterdam, New York or Paris no doubt fulfils the same need as building a studio away from the family home. It is doubtless the indispensable condition for a project to mature. You have to be in the appropriate state to receive, filter and digest the multiple signs in our saturated lives before releasing them in other forms. Streets, walls, a conversation you didn't think you'd remember, a book, a stadium, television and radio shows… we are all of us children of lands that leave their marks on us forever. All movement has an origin. The place where we love, laugh and cry is the raw material from which the first raw movements spring. It plays a full and inevitable part in the gestation and birth of art. It pre-determines and shapes the work, as it were. And its influence can be seen in insignificant yet determining details.

The real challenge is to manage to capture this energy sheltering behind the unsayable. If you had to find something all African artists have in common, you

would probably notice that they all draw from the materials they grew up with, each in their own way. Our five senses are the gateways to the soul. Art – in Africa as elsewhere – can only be its most sensitive, human and imperfectly completed translation. Its quest, I believe, is translated in the search for the self. The silent communion of shisha-smokers on the pavements of Cairo has no purpose other than that, silence and communion. The silence forged in the bosom of childhood develops later in artists and becomes a metaphor. It is the attempt to solve what Ernst Bloch called 'the problem of the We in itself'.[10] The We of community, the We of art, the We of the collectivity we live and dream in. What are these different 'We's' made of and, for an artist, how to translate them into a work that testifies to one's singular belonging to the world? This is the question. But let there be no misconception: stating one's belonging does not amount to proclaiming one's Africanness. Africanness is self-evident. A fact. A fundamental that can be kept silent. What shows through is the sense of this Africanness. What makes a work open, legible to all, is that it contains a slice, no matter how tiny, of ourselves.

OF CONTEMPORANEITY

Questions on contemporary African art have developed hard and fast since the early 1990s. The origins of local quests for modernist practices can be traced back to mid-to-late-nineteenth-century inceptions of resistance to colonial rule by elite black intellectuals in the cities of West Africa. And the history of these debates goes back to the African independences, when the new states tried to define their own aesthetics. But this art, which could be called 'modern art', was restricted by political and aesthetic questions. The primary aim of the schools founded at the time, like the Dakar school, was self-assertion. Being an African artist had to mean something. Intellectuals like the historian Cheik Anta Diop, one of the celebrators of Afrocentrism,[11] went so far as to advocate a social and functional art. Since then, African creativity has tried to break free from the exogenous and often Western gaze in which it was imprisoned. But not until the late 1980s did a structured debate on the nature of this creativity begin to emerge.

In 1989, the *Magiciens de la terre* exhibition at the Centre Pompidou in Paris sparked things off by proposing a definition of contemporary creation that fuelled many years of debate. Since then, numerous other exhibitions have been held in the United States, Europe and Japan, displaying other visions. A split appeared between English-speaking, French-speaking and Arabic-speaking visions – though the latter have been kept out of the major debates – that revealed ideological divides among young exhibition curators, a number of whom, notably, were African. Nevertheless, and despite the odd isolated attempt, it seemed a hopeless gamble to want to approach this creation in a purely aesthetic manner, without all the historical, political and ideological trappings. Doubtless for many reasons, the most obvious in my opinion being that you cannot think a continent without taking into account its complexity. Africa is not a country!

For even though the last decade has witnessed an interesting evolution in the approach to African art, the same theoretical stumbling blocks still stand firm. That some artists from the continent have managed to make a small space for themselves on the international circuit cannot suffice. Until today, the possible unity of a contemporary African creativity had still not been tackled head on. The exhibitions dotted over the last decade have mainly striven to define historical and thematic frameworks focusing on context more than aesthetics or sources of inspiration, political problems rather than creative processes. The time had come to tackle the contemporary fact as such, i.e. look first at the work, then envisage the intellectual context that produced it. This is where a continent-wide vision of creativity can be justified. We have seen the contradictory currents that ripple across contemporary Africa: from the end of apartheid in South Africa to the land disputes in Zimbabwe; from learning peace in Angola and Mozambique to the explosions coursing through Central Africa; from the upsurge in religious fundamentalism in the North to the apprenticeship of what, for want of a better word, we will call democracy. Several questions underlie the spirit of the *Africa Remix* exhibition: What is Africa? What does contemporaneity represent within this geographical entity? How is it defined?

It is these aesthetic and intellectual shifts of identity that the artists in *Africa Remix* express. This is why we needed to avoid reproducing Western classifications that have split creativity into distinct disciplines. To show the contemporaneity of Africa without including music, film or literature would be like looking at a global phenomenon through tunnel vision. *Africa Remix* is multi-disciplinary because creativity is multi-disciplinary; because Africa has always considered creativity in its entirety, by integrating – in an often cosmogonic totality – all creative forms and disciplines. Art, as Jean-Hubert Martin wrote, has remained magic. And while the West killed God in order to enter the modern age, Africans have too many gods – it would be pointless to kill them all now. Some of the artists will no doubt deny it, but it seems to me that in each presented work the spirit, in the broadest sense of the word, is fully visible. Perhaps this is what André Malraux called 'dialoguing with masks', i.e. transforming what was into something else. For the majority of artists in *Africa Remix*, the Africa that was – the myth some people still feel nostalgic for – ceased to exist long ago. They have exchanged the dreamland for the real land, though nonetheless still virtual. A land they recompose each in their own way, with their own sensibility.

The secret of a work of art that achieves its aim is that it speaks to us. Whichever language the artist has chosen to use, whatever very personal accents it contains, the work will touch the part of ourselves that defines humanity. This is no doubt why it has not always been easy to tackle contemporaneity in Africa. It is not about forms, it's about accents. The debates on post-colonialism that some commentators on African creativity have held over the past few years strike me as answering questions that are no longer an issue. While historical understanding now throws light on our perception of the culture of the continent taken as a whole, it is no longer of any use to us when it comes to understanding the process the artists have consciously or unconsciously brought into play. Indeed, African creativity of the latter half of the twentieth century

SIMON NJAMI ON CONTEMPORARY AFRICAN ART

has gone through so many different phases that it is important to avoid confusion when approaching the contemporary phenomenon.

There are roughly three stages in the metamorphosis, or 'finding a voice' of African artists. The first was the sometimes extreme celebration of their roots, which corresponded to the period directly following the independences. Artists wanted to show and assert their Africanness, and make use of the virtual library of symbolism to show they were finally free of all colonial influence. The second stage, which fell between the late 1970s and the late 1980s, was a period of denial. Artists had felt so trapped within the narrow limits of their origins that they needed to get away from the images that others created of them. This is when you would hear people say, 'I am not an African. I am an artist'. This declaration was a cry. It expressed the will finally to be perceived as people in their own right, participating in the artistic creativity of the planet just like anyone else, not as exotic beings turning up to confront a world that is not their own. The third stage, the one that *Africa Remix* proposes to illustrate, bears witness to a certain maturity and appeasement, where artists have no need to prove anything through their work. The stakes have changed. They are no longer essentially ethnic, though no one can disown their roots, they are aesthetic and political. The quest remains, but its nature has changed.

Their quest today is existential. It is a quest where space and territory – as a shaper of individuality – intervene naturally. But the notions of space and territory no longer correspond to tangible borders. They no longer apply to an enclosed political or geographical space. This is why we have divided *Africa Remix* into three parts – identity and history, body and soul, city and land. Again, this should not be seen as a classification, but rather as an attempt to understand which forces are at work in contemporary African art, which recurring elements leave traces in each of the works on show. For we have had ample time to learn that contemporaneity, African or not, cannot be restricted to a single, global definition. It inevitably passes through individual filters. It reveals itself as recognition of the other. The artists brought together in *Africa Remix* are here because they all have something in common. From one end of Africa to another, artists share ambitions and doubts that don't necessarily find an echo in their own societies. One could say that this contemporaneity is sometimes orphaned, in that the questions it raises and the ways it chooses to answer them do not always match the collective sensibility of the artists' own countries. The notion of interdict, for example, now meaningless in the West, is still highly prevalent in societies that have by and large stayed very close to ancestral traditions and organisations.

But here too we must avoid confusion. Different forms of contemporaneity co-exist without necessarily echoing each other. A distinction could be made between collective contemporaneity, on the one hand, and elective contemporaneity on the other. I confess to long having only concerned myself with the latter. Collective contemporaneity is a daily phenomenon that crosses all levels of African societies. It is not bothered with the urban or the rural and responds to an atavistic need to create. Its themes and aesthetic require a special initiation. It is societal. It is often rooted

in the deep sources of a culture which it transforms in ways sometimes perceived by purists as acts of treason. It is innovative in that it shakes up established rules without taking environment into account. It can draw its sources from religion, daily life or tradition. It can look as though its sole aim is to exist. This contemporaneity is not concerned by the international market principle that drives artists to seek out museums and galleries, even though it is frequently found exhibited alongside the other form of creativity, the one I have called elective contemporaneity.

Elective contemporaneity is not fuelled solely by environment. A generational phenomenon, no doubt, it keeps its feet on a specific ground and its senses plugged into world movements. It is often politicised and individualistic, for its artists have noted the failure of politics and ideologies and take a nostalgic, rather than romantic, look at the world. They do not have a lost paradise. There is no longer a place on this planet that does not remind them of their unique, special condition, while making them feel they belong to a greater whole – a whole of which they are elements but which can never be fully comprehended. For contemporaneity is and always has been history on the move. A history that we witness, or engender perhaps, but whose finality we cannot ponder. A history that makes us rethink ourselves, not in reference to one fixed, outmoded identity, but as protean beings with multiple, changeable identities.

The necessary synthesis of the past and projection into the future are problematic undertakings. We will carry on, feeling our way. We will always try to understand the incomprehensible, grasp the intangible. But don't get me wrong, *Africa Remix* is above all a contemporary art exhibition. To broach contemporaneity in Africa, however, inevitably leads to a re-reading of history. It also involves creating a theoretical framework that will make the different aspects of the exhibition accessible to a broad public. This is why, instead of tackling for the umpteenth time the question of the existence of a homogeneous collective African creativity, the curators decided to focus on the artists and their productions. To highlight the individuals rather than drown them in a debate that does not necessarily concern them. It is through the works, and the works alone, that the answers will transpire, or at least the routes towards renewed reflection.

Let us nonetheless keep in mind this capacity to bounce back, to recycle life and turn old things or ancient ideas into avant-garde works. Let us remember these words of Ernst Bloch: 'We are poor, we have unlearned how to play. We have forgotten it, our hands have unlearned how to dabble.'[12] African artists still 'dabble', not in the conventional sense of the word, but in the noble sense of *bricolage* that Bloch intended, which involves a relationship with matter and 'know-how'. Perhaps through this *bricolage* we will finally manage at least to feel – if not understand – what we still call, for lack of a better term, contemporary African art.

Translated from the French by Gail de Courcy-Ireland

TACITA DEAN
ON CURATING

An Aside
2005

The Hayward Gallery Touring exhibition An Aside, *curated by the artist Tacita Dean, featured 75 works by 17 artists, among them Eileen Agar, Joseph Beuys, Peter Fischli and David Weiss, Rodney Graham, Roni Horn, Paul Nash, Gerhard Richter and Kurt Schwitters. Dean arrived at the works in the show through what she has described as an 'experimental journey', a 'meandering' and 'associative' thought process, where the selection of each work led intuitively to the next. The accompanying catalogue featured a text by Dean, which mapped some of the connections – both intuitive and formal – between the works. Two extracts, or 'asides', from that longer text are featured here.* An Aside *opened at Camden Arts Centre, London, and toured to The Fruitmarket Gallery, Edinburgh and Glynn Vivian Art Gallery, Swansea. It was one of a long line of artist-curated shows organised by Hayward Gallery Touring in collaboration with Camden Arts Centre, which had previously included Richard Wentworth's* Thinking Aloud *in 1998–99 and Susan Hiller's* Dream Machines *in 2000.*

STILL LIFE IN THE LANDSCAPE

I am sitting in a Berlin cafe with a Japanese curator talking about a project in Vienna. She begins to tell me about this photograph she has recently seen by Rodney Graham. It was an image, she says, of a typewriter in a winter landscape. This description immediately conjures up for me an old postcard I found of children playing with cotton wool snowballs frozen in a *mise-en-scène* of sprinkled whiteness.

The point was I recognised the description of this work from something Rodney had told me some time before: he had just made three new works very intensively over the previous summer, and one of them, the film *Rheinmetall/Victoria 8* (2003), had reminded him of one of my own films, *Sound Mirrors* (1999), in its formal and studied observation of a particular thing. He had found the typewriter in a second-hand shop in Vancouver: it was absolutely virgin, mint, never been used, and was manufactured in Germany in the early 1930s. So was it an import or had it been hand-carried to Canada, and, if so, under what circumstances? It had the owner's name engraved on it: V. Balke.

It must have been a delirious discovery for Rodney: an object embodying such potential, undefiled by use; an object that is obsolete but still brand new – preserved in a way that typewriters never are untouched by its ink not known by its ribbon. What would be the overriding desire with such an anachronistic newness? To merely use it would be unsatisfactory, and not to touch it would be a fetish. So Rodney sieved flour over the pristine piece of design perfection, which was already lost to its function and to its time, and in doing so made its obsolescence actual by attrition more radical than time itself: flour as dust, flour to clog, flour to transform. And what

340

happens is its metamorphosis becomes a poem. Its original purity as an object meets the purity of the snow as it gathers in conical piles on the keys, or slips like drifts from the curvature of the body, and we lose our reference to it as a once functional object destined for a glass case in a design museum, and watch it become a still life in a winter's landscape.

In 1930, a manifesto was signed declaring the rise of a new era in Ikebana – the art of Japanese flower arranging. The signatories rejected the restrictive, traditional and formal considerations that had typified the Buddhist monks' art since the sixth century and introduced a radical freestyle and liberalness that extended to the use of hitherto forbidden materials. Suddenly feathers, driftwood and whole tree trunks were incorporated and its asymmetrical triangular form, which was its spiritual foundation, was scandalously subverted. Soon, it became lost to home decoration as flower arrangers began using plastics, glass and metal in their work. But one woman took the freestyle further, and developed her own tradition, which she called *nõ-no ikebana*. She took it back to the countryside, and used roots and vegetables, and plants allied to old style agriculture. Her name was Toshie Yokoi and she travelled with her husband, a geologist, around Japan and taught her art exclusively to the women of the rural farming communities.

Sharon Lockhart's film *NÕ* (2003) is an autumn elegy about time, perspective and labour in a landscape that is changing colour. Russet-edged trees, on the point of transformation and seasonal flux, form a band between the evergreenness of the mountains behind and the seeming dying whiteness of the grasses in front. There is a soundtrack of rural quietness. This is the background.

In front of this, the landscape is also changing colour, but through the labour of the farmers who cover the field with straw in preparation for winter, turning the blackness of the ploughed field into the sprinkled brownness of its final manifestation. The fertile season has passed and everything that was ripe and fecund has fallen and been gathered, and now is the time for preparation: that is, the concentrated choreographed preparation that is the allegory of this film. This is the foreground.

A male farmer and a female farmer, working in harmony and cycle, bring and place piles of straw into both the projected picture plane to fill the middle ground with three separate piles that form a row, and then, moving nearer to us, make three more piles, less high but as high. Into the plane and onto the plain they walk, closing into the foreground as they build up three more piles, and then three more until there are 12 mounds in total, evenly placed and pictorially even in size, sitting in the ploughed field and picture space. Decaying matter – *nature morte* – still life in the landscape. And then the male farmer and the female farmer start raking the piles flat, covering every part of the black mud with hay, and working their way back into the plane and across the plain.

Event in the plane – event on the plain – *Event on the Downs* (1934).

Paul Nash believed the unconscious worked often in puns, enabling us to endow new significance to accidental resemblances that exist between things. He worked like this across the picture plane in his paintings too, drawing meaning from the matching of objects in the foreground with those in the background: a standing stone with a tree on the horizon, a sphere on a pillar with the full moon, and perhaps a tree stump with a cliff or a cloud.

For him, such relationships existed in the world of the found object, specifically the found natural object. He borrowed from surrealism something of the belief that it was his action of finding an object that meant it existed; that it was somehow the confirmation of an unconscious desire. He once wrote about finding a pair of flints by chance, side by side, in the grass of the South Downs that were 'inseparable complements', and 'in true relation', but which would never have known of each other but for his intervention. So what of the tree stump and the tennis ball? Were they too born of such a chance meeting? Paul Nash would never go too far down that road. His groupings were also imaginative, pictorial and deliberate: 'It is a matter of give and take – or, rather, of take and give.'[1]

Inanimate natural objects were personages for him: protagonists in an animistic landscape. They did not merely assume resemblances to animals or humans, but embodied something of their actual creatural animation. His places were spiritual, and the land in his paintings and photographs was old land: the land of standing stone sentinels, monoliths and megaliths: the land of Avebury and Stonehenge. Fallen trees became monster objects because they were laid bare, and had become inanimate as a result of their deadness: vessels for the roaming anima. They could exist on a new spiritual plane, divulging new personalities. But fallen trees, cut trees and tree stumps have also meant fallen humanity and death to those who witnessed the First World War, and saw not only a generation brutally felled, but also a landscape purged of all natural life.

Paul Nash
Event on the Downs, 1934

And then there was the call to abstraction: tennis ball abstraction, sitting in its spherical pureness beside its organic counterpart. Why is the companionship of these two objects so compelling, as they sit side by side in the foreground of a landscape that feels drained of its colour under the grey monochrome sky? And what about the cloud as flint and the forked track? It is precisely because the riddle is insoluble that we are held by its stillness.

SWANAGE

In 1935, Eileen Agar met Paul Nash while on holiday in Swanage in Dorset. They began a long and passionate love affair, which lasted ten years, almost until his death. What they shared, above the common concerns of artists, was a love of beachcombing, and it was then that Nash introduced Agar to the surrealist idea of

the 'found object'. On one such walk in Lulworth Cove, Agar dug up an old anchor chain covered in barnacles, shells and pebbles, which immediately became for them a snaky monster with a bird's beak: a snake as bird: a bird snake. They both photographed it, and significantly, they shared it, each using it later in their own separate works. The snaky monster, renamed Seashore Monster by Nash, must have become a significant personage in their mutual vocabulary: a personage in what we can only imagine must have been a very charged, erotic language which began that July as the pair combed the Dorset beaches for significant found objects in the early moments of being in love.

On the far right-hand side of Nash's photo-collage, *Swanage*, is the Seashore Monster, cut out against the sky with its back to the sun, looking out of the picture frame. When I chose *Swanage* for this exhibition, it was because I liked the way it was peopled by the personages whom I was beginning to recognise from Paul Nash's photographs, particularly *Lon-gom-pa* (1934-36), the stick man, apparently named after a Tibetan lama with famously long legs, and his *Marsh Personage* (1934). Now I look at *Swanage* with different eyes, knowing Agar's part in it, and imagine something of the atmosphere in which it was made. And although it may appear an unlikely love poem, it has a sexual tension that must bear something of the memory of discovering the Seashore Monster in the sand.

ANTHONY VIDLER
ON ANTONY GORMLEY

Antony Gormley:
Blind Light
2007

For this exhibition, the artist's first major showing in a public gallery in London, Antony Gormley presented a series of large-scale installations, including several newly commissioned works that dramatically engaged with Hayward Gallery's architecture. Taking the body as its point of departure, the exhibition explored the ways in which we orient ourselves spatially; how we react when disoriented and how we relate to architecture and the built environment. Alongside large-scale new commissions, the exhibition featured the artist's earlier sculptures, drawings, prints and photographs. It also took Gormley's work beyond the gallery with the ambitious project Event Horizon, *which featured 30 life-size bronze casts of the artist's body sited on the rooftops of surrounding buildings and on Waterloo Bridge, each one visible from the gallery's sculpture terraces. Architectural theorist Anthony Vidler – author of* The Architectural Uncanny: Essays in the Modern Unhomely *(1992) – contributed the following essay to the exhibition's catalogue, which also featured contributions from poet and literary critic Susan Stewart and art historian W.J.T. Mitchell.*

UNCANNY SCULPTURE

T he figuration of the human body in sculpture has always held within it something of the uncanny. From ancient Greece to the present, the sculptural figure, whether considered as magical talisman to ward off danger or propitiate the gods, or more recently as the disturbing double or imago, has been seen either as a defence against, or an uninvited guest of, unseen forces. Romantic philosophers identified the presence of the uncanny in early Greek sculpture: Schelling, writing of the sculptures from the Temple of Aphiai at Aegina, saw in their attempt to configure a representation of the gods in human form, 'something extra-human or nonhuman – something strange', that he qualified as a 'certain uncanny character'.[1]

It was Freud, however, who unearthed this ancient feeling of anxiety for the modern, secularised world. Writing during the terrifying years of the First World War, he was concerned to identify this feeling of slight unease, as against stronger feelings of terror, in Western literature and art; what had been a simple enough evocation of nervousness in the stories of E.T.A. Hoffmann became, in Freud's hands, a developed theory of anxiety and a grounding of the general aesthetics of the 'sublime' as espoused throughout the nineteenth century. Freud associated the uncanny with fear of castration, the death-drive or the desire to return to the womb, and found it in the terror of the evil eye, the fear of loss of sight and, above all, the double. The definition he employed was that of Schelling – the uncanny as 'something that had been repressed but which suddenly returned'. The shock of 'return' was especially associated with the double, or the doppelgänger: the sudden apparition of the ghost of the self.

Over the last two decades, the sculpture of Antony Gormley, fabricated out of casts, actual or abstracted, of the human figure, has explored many of these aspects of anxiety, placing his (or by extension, our) doubles in spatial juxtapositions and extraordinary positions that stimulate that sudden shock of realisation associated with the uncanny. From figures in space to figures making their own space, his work has gradually developed to encounter, then embrace, and finally to construct what we would call the 'architectural' in its broadest connotations. This encounter of sculpture, of the cast figure with and in space, itself produces a new kind of space: one that, rather than waiting to be occupied by human presences, as in traditional architectural space, possesses all the attributes of occupied space from the outset. Thus occupied this space is, in the deformations that stem from Gormley's figural positions, a space of uncanny dimensions: a 'double' space that disturbs precisely because it proposes an occupation before our own subject-inhabitation, and an occupation that further responds not so much to any possible occupation we might imagine, but one of ourselves distorted, positioned and transported into a world that would be, in everyday life, unimaginable.

In this exhibition Gormley activates a range of bodily-spatial intersections, some drawn from his earlier work, some entirely new, in order to pose a set of inserted spaces within the constraints of a pre-existing architectural matrix to evoke the potentiality of alternative modes of spatial and bodily occupation. Against the strict and regulated interiors of late brutalist architecture, with its enclosed sequence of dark and artificially lit concrete-walled volumes, Gormley has constructed an 'other' architecture formed of space-filling and space-articulating sculptures, each moment in the sequence both resisting and extending traditional architectural codes.

FIGURAL SPACE: *DRAWN* (2000/2007)

The figures, for surely they are figures with their splayed legs and outstretched arms, are pressed into the corners of the room, for surely it is a room, with its four white walls, top-lit ceiling and painted white floor. Four of the figures lie awkwardly on the floor, their arms and legs following the right angles of the corner; four others defy gravity and press themselves into the corners of the ceiling. All eight are geometrically distorted to align with the right angles of the corners. Closer inspection reveals that they are all the same figure, deployed in different ways as if to emphasise the geometrical coordinates of the room. The room is white, the figures black, and taken as a whole composition, the figures construct a space within the space of the room, pointing towards each other from their corners, sometimes with their legs, sometimes with their arms, as if intimating an organic interior to an otherwise abstract exterior.

The apparently effortless appearance of these contorted figures in the space, their clear geometries and their seeming obedience to the laws of its geometry, however, belies the radically contradictory nature of their presence. For in a number of

fundamental ways, some concerned with architecture, and others with sculpture, these figures contest the commonplaces of both disciplines.

Firstly, the traditional role of architectural space is to house the human body; its dimensions, its scale, its relationship to the vertical and horizontal, its enclosing surfaces, are all calculated to enclose, shelter and comfortably accommodate the figure, whether upright and still or in movement. The grid of top lighting in the space under consideration affirms this role, attesting to the difference between surfaces used as floors, walls and ceilings. When architects design spaces, they trace their outlines in three dimensions with these distinctions firmly in mind; they attribute roles to their surfaces according to imagined bodies, upright, standing, walking or running, circulating through and utilising their spaces, in a virtual enactment of future occupation. Architectural space is, in this sense, constituted, stabilised and given authority by reference to such bodies.

Here, however, the bodies are suddenly displaced from their proper spatial role, into a space that no architect (unless designing according to gravity-free rules) could imagine. The position of the eight figures indeed challenges all regular coordinates of verticality and horizontality, constituting an alternative space within the regular architectural space, one that turns incessantly in every dimension, thus placing our own observing and participating bodies (subject to the normal rules of architectural space) in precarious suspension.

Antony Gormley, *Drawn*, 2000/2007. Installation view, *Antony Gormley: Blind Light*, 2007

Secondly, these figures are placed in conscious opposition to the normal rules of architectural perception. These rules guarantee that surfaces are recognised as walls, floors and ceilings in relation to their vertical and horizontal intersections – the lines, so to speak, that are delineated by planes coming together at right angles. But these figures accentuate a little-observed aspect of spatial geometry – the interior corners. They act as markers of the points from which this geometry is projected, the origins of the lines articulating the intersection of surfaces. As such, they are markers of normally unseen and unnoticed spatial origins – much as if they were the residue of the architect's drawing techniques, the little crosses that allowed for the setting-up of the projection in the first place. And while outside corners – like the much discussed corners of Mies van der Rohe's IIT buildings, with their careful representation of intersecting steel members – are often inspected in architecture as evidence of the architect's mastery of formal and technical demands, inside corners are generally overlooked, more the difficult repositories of dust and the uninhabitable realms of the space than any contribution to its architectonic value. And it is this very uninhabitability of the inside corner that the inserted figures challenge, as if they had quite comfortably taken up residence in a space normally forbidden to the body.

Thirdly, these figures are to all intents and purposes bodies, or rather those surrogates for bodies generally called sculptures. Here it is that a second set of conventions is defied. For the classical Western figure sculpture, like the classical Western body,

348 ANTHONY VIDLER ON ANTONY GORMLEY

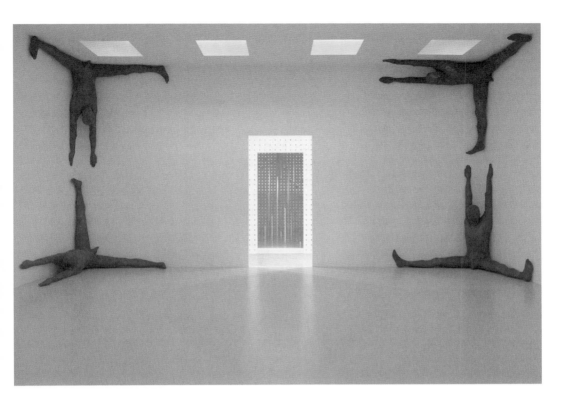

is upright, and defines a space for itself much like the body it represents, an all-round space implying possible movement and calling for the rotating movement of the spectator. It was Adolf Hildebrand in the late nineteenth century who first considered the demands that sculpture places on space and, hence, on the observer. Distinguishing between the spatial implications of bas-reliefs (frontal vision) and freestanding sculptures (all-round vision) he set out the grounds for a modern spatial psychology, one that would take hold in all the arts after 1900. These figures, however, are pressed into service to the space: they conform to its geometrical demands rather than posing their own, and they certainly cannot be seen in the round. They, then, are certainly not sculptures in the classical sense, despite their apparent realism. In this context our figures demand an impossible space both from the viewer and for themselves as sculptures: fully in the round yet pressed into the wall as bas-reliefs, they allow of no circular motion around them, constrained as they are to the geometrical limits of the space they both articulate and are bonded to.

But of course, we know that these figures are in fact not sculptures, modelled or carved in the traditional sense, but figures resulting from casts of actual bodies, in this instance of the sculptor himself, and thus positive replicas of the negative hollow space left by a body that once occupied a plaster cocoon where casting might be a

recognised sculptural technique, it is generally a process that reproduces a solid model, and not a living, breathing body the absence of which creates a void filled by the molten metal.

Here a solid reproduces a void, much in the same way that, say, Rachel Whiteread's *House* (1993) cast the negative imprint of a space in solid impermeable form. Perhaps these figures are, so to speak, the expelled inhabitants of such a house, inhabitants of a world in reverse. Architects in the modern period have often imagined 'space' as a positive entity to be sculpted and moulded as if in clay or plaster – Pier Luigi Moretti even cast models of classic buildings demonstrating the properties of space in a three-dimensional reversal of figure and ground. Gormley's figures are somewhat of the same genre, with the exception that they are deployed in real space, articulating in this way a strange dialectic between inside-out and outside-in.

The great puzzle for the German art historian J.J. Winckelmann was how to get inside a sculpture. Obsessively he would circle the body, calibrating its convexities and concavities, sometimes heightening the effect of the shadows by using candlelight, always asking the mute stone for an answer to the interior meaning, the 'ideal' of human figuration exemplified by the outer surface. How else, he reasoned, could the Greek sculptor have achieved such perfection in the imitation of the figure, if he had not held in his mind some ideal model, which, imprisoned within the block, might be revealed by his work? Later critics drew the comparison between the sculpture and the equally mysterious mummies being disinterred in Egypt. One might imagine that the ideal inner body was hidden within layers of cloth and wax, as if one could peel the sculpture like an onion to reveal its hidden perfection. Gormley, by casting his own body, has in a way duplicated and articulated this analytic perception, but now again in reverse mode; the ideal starting-point of the sculpture is real, and its cast intimates an ideal that is ever embedded in the living model.

INFINITE SPACE: *ANOTHER PLACE* (1997)/*EVENT HORIZON* (2007)

The figures, their backs turned to us, are spaced in irregular lines across the field of view, their feet in the water, their multiplied dark forms stretching towards the horizon. Neither bathers nor a holiday crowd by the beach, they seem more like observers, keeping watch for the appearance of something that we might miss through inattention or lack of time. They are timeless and will evidently watch for us through eternity, their shadows seamed on the folded surface of the water by the setting and rising sun. We have the impression that even if nothing should appear, they would still be standing, like primitive dolmens, those standing stones that Hegel saw as the origin of architecture, the first columns, symbolic of the figure later to be sculpted in the classical age.

The self-conscious placement of figures in the landscape – whether as actors playing the part of a 'hermit' or 'monk' or as pictorial conventions in painting – was a favourite

pastime in the late eighteenth century. As the critic John Barrell has reminded us, such figures, placed for aesthetic or historical effect, were in some way stand-ins for the figures that actually populated the working landscape – beggars, peasants, labourers – that would spoil the real view from the great house. Even as ha-has were invented to allow the expanded view of the landowners territory, uninterrupted by inconvenient hedges and fences, so the figures in the landscape needed aesthetic control, scotomisation and re-engineering. There were some figures, however, that were less the fashion accessories of aristocratic picnics and more the projections of the individual's imagined self. Thus the mysterious observers depicted in Caspar David Friedrich's paintings of landscape vertigo with their backs turned to the viewer, in shadow, as if inviting the viewer to enter into their bodies and share the objects of their gaze.

In *Another Place*, the deployment of Gormley's figures across the horizon of the viewer's gaze, however, also produces the effect of a panorama, one that reminds us of the early nineteenth-century panoramas with their intimations of 360-degree vision. In particular, we might see the image of Friedrich's painterly panorama of the solitary figure on the beach, his *Monk by the Sea* (*Mönch am Meer*, 1809).This figure is also turned with his back to us, almost a black shadow against the horizon of grey sea and turbulent clouds, inviting us, as with many of Friedrich's figures, to step into the picture and substitute ourselves for the shadowy presences that looked out at their infinite landscapes. In Gormley's picture, however, the isolated figure of the meditative Romantic subject is replicated in many figures; the individual replaced by the multitude, but a multitude composed of single individuals, each one with its own position in the picture, and a ready substitute for our own modern subject-hood.

Heinrich von Kleist observed of Friedrich's painting that one looked at its intimidating vastness as if one's eyelids had been stripped bare, marking the sublime terror of nature's infinity by the equally terrifying isolation of the individual subject. Now, with the sublime divested somewhat of its originating awe, we have company as we contemplate the universe; but yet a company still returning to its monadic origins, self-enclosed in the endless replication of single selves.

For this Hayward exhibition, Gormley has reversed the vision of his watchers. In *Event Horizon* the standing figures, mounted on the tops of surrounding buildings, look towards the gallery to form a perimeter of viewers, viewing the site of the exhibition. As a panorama, enclosing a broad urban circle around the Hayward, these figures at once silently guard and monitor the collective community of figures assembled within the gallery. Whereas in *Another Place*, we are, so to speak, outside the circle of the panorama, looking in and uncertain of the object of the figures vision, now we are at the centre, the very object of the watchers' attention.

It was common in Roman building, and in its revival in the Renaissance, to stand figures of the gods and heroes on the balustrades of public buildings and private palaces. Looking out to the city or the countryside, these statues not only variegated

the profile of the building, linking it to the urban or rural landscape, but also in a sense protected the owner from harm, acting as sentinels and stand-ins in the same way as their modern equivalent, the surveillance camera, provides an artificial eye in the absence of the inhabitant. In *Event Horizon* Gormley has established the inverse of this outward looking presence, substituting a multiplicity of guardians overlooking and verifying the contents of the gallery. By implication this establishes the exhibition in a double circle, the first within the walls of the Hayward, the second deeply embedded in the city itself. If this were a Greek foundation, the Hayward would be the treasury and the ring of watchers the guardians of the 'polis'. In the modern condition, however, the appearance of these sombre figures, silhouetted against the sky, taking charge of rooftop after rooftop like so many alien bodies precipitated from outer space, gives pause to any sense of security. If the watchers are tied to their compatriots in the gallery, they are also occupying the city and controlling the space of the viewer – if not abrogating that space to themselves. Where are we in this equation, if not subjected to a gaze we cannot reciprocate, and that refuses to see us? In Lacan's words, 'The picture, certainly, is in my eye. But I am not in the picture'.[2]

SOLID SPACE: *FIELD FOR THE BRITISH ISLES* (1993)/ *ALLOTMENT II* (1996)/*SPACE STATION* (2007)

In *Field*, the seemingly innumerable multitude of figures are pressed together in a mass – no one the same, yet all similar. Crude clay versions of the human with roughly moulded bodies, vestigial heads, and no limbs; but their eyes, deeply pierced, look mutely ahead towards us, seemingly inquisitive, perhaps appealing, calling for something from us, or even demanding, if not threatening. Their mass is certainly threatening, as it pours like some terrifying and endlessly enlarging blob through the spaces of the gallery. Indeed, the river of figures fills the space completely, pushing against walls that can hardly contain it. Fired in clay, this mass has the air of a burial pit, the figures created to accompany some ancient ruler to the nether world. Yet the animation of the figures, some with head cocked to one side, others sunk in thought, still others looking steadfastly ahead, all gestures apparently intimated with a simple pressure of the fingers in the clay, gives us the sense that the mass is still very much alive.

We know the story of their making: a collective work, thousands made in a week by a whole village or community, the community replicating itself several times over and gathering itself together in miniature. This is then a collectively fabricated mass, a multitude with an origin. Assembled *en masse* in the gallery, this collective has the force to create its own space; if the traditional gallery is a void for the display of single works, then this is a gallery transformed into the negative space of a solid mass. Le Corbusier spoke of the fundamental elements of architecture as 'volume, mass, and surface', and invented an abstract language where volumes became masses on the outside, articulated by their surfaces inside and out. Here the mass, constituting itself as an architectural force, has invaded the volume and,

pressing up against its surfaces, challenges its solidity. Figures, the stand-ins for individuals, arrayed as a collective, have become architecture in and for themselves.

There are other figures of architecture in Gormley's work. In *Allotment II* these are figures literally constructed out of the dimensions of individual subjects, proportionally and geometrically formed as standing monoliths with cubes for heads and holes for ears, mouths and sexual organs. With no eyes to see but only orifices to hear, taste and feel, these figures inhabit their rooms, silently communing in space. Lacan spoke of the painful origins of architecture in the figure of Daphne transformed into a tree; here the body is rendered sightless and mute by its reduction, or rather return, to geometry. Like the monument erected in his Weimar garden by Goethe, that cube surmounted by a sphere said to be characterised by J.G. Herder as 'stone with a head on it', they at once figure the origins of architecture and sculpture.

In the Hayward, Gormley inserts two versions of these space-filling mechanisms, *Space Station* (2007) and *Hatch* (2007). *Space Station*, with the double implication of the name indicating its origins from space as well as its operation as a station-point in space, seems to grow from a single unit, as if a three-dimensional pixel had accumulated in order to fill a prescribed volume, with the sense that even this volume would be soon uncontainable within the restraining walls of the gallery. Like some uncontrollable phantom from an early horror film, now articulated as a precise structure of DNA elements, *Space Station* hovers in the first gallery of the exhibition, a warning that the space of Gormley's installation, however articulated by figures of a more or less humanoid form, and despite our knowledge that they are for the most part cast from Gormley himself, will not be entirely for our own occupation and enjoyment. *Hatch*, by contrast, takes up the regular coordinates of a spatial grid – the virtual grid that inhabits every geometrically defined volume – and makes them tangible in a forest of material lines. Whether or not the resulting space is actually inhabitable by a viewer, the struts and beams of this grid are clear indications that, to paraphrase Lacan, 'The space, certainly, is in my eye. But I am not in the space'.

ORIGINAL SPACE

In each of these cases, the figures in the corners of interior space and the figures standing in exterior space, space itself has been reinvented by the self-conscious transformation of the body as a surrogate for the figure that, in the first place, constituted space itself. Here we might hazard the proposition that Gormley has, so to speak, retraced the origins of architectural space and in the process reinvented it for a present that has not yet fully appropriated, much less exhausted, the potentialities of that idea of abstract space we have called 'modern' since the end of the nineteenth century.

For the idea of architectural space was an essentially modern idea that emerged with force at the turn of the twentieth century, invested with all the power of a new

psychology of the subject's relation to the object. Where the space of a Descartes or a Kant was stable, universal and mathematical in its certainty of position and placement, the space of the late nineteenth century was an uncertain realm of projection and introjection, relative at every moment to the psychic life of the subject; it was a space created by and for the subject, whether moving in dance or poised in momentary stillness. The *Spielraum* or space of play envisaged by Heinrich Wölfflin, was even given a history, as Alois Riegl traced the effects in art of the emergence of Roman distant vision from the haptic, close-up vision of the Egyptians and the middle-vision of the Greeks, each stage of development forcing a new viewpoint of the observer and thus a new form of appearance for the object.

In the context of our discussion, it is not incidental that this new idea of space was a direct product of the sculptural imagination. From Winckelmann's careful tracing of the contours and surfaces of classical sculpture in the mid eighteenth century, to Adolf Hildebrand's analysis of the relation between vision, space and sculptural object at the end of the nineteenth, an idea of the space formed by and for sculpture developed that was to dominate spatial theory for the first half of the twentieth century. The sculpture, so to speak, stood in for the viewing subject as a surrogate, demonstrating the principles of spatial experience – Étienne Bonnot de Condillac's sculpture of sensations now animated by psychological forces.

From this new sense of space emerged a new history of architecture that authorised the attempt to constitute a new architecture. Out of the anthropomorphic tradition established by Vitruvius and confirmed by the Renaissance, a tradition given historicist dimensions by Hegel, was developed an idea of transcendent abstraction, one that overcame the particularism and nostalgia of the historical styles, in order to posit a universal language of form in itself. Critics have accused this vision of having abandoned the human, together with the figural symbolism that once gave architecture meaning. Yet whether expressionist in its literal depiction of subjective movement or purist in its abstract intimations of psychic states, this architecture relied on the fundamental premise of a new subject. What has been interpreted as vulgar functionalism was in reality the sculpting of space around the hypothetical subject, but now with all its bodily attributes supplemented by recognition of its mental states.

With uncanny precision Gormley's figures re-enact these absent bodies, but in a way that goes beyond the simple reintroduction of the anthropomorphic into modern abstraction. Figures that are bodies, bodies that are casts of bodies, bodies that reformulate the spatial dimensions of inside and outside, are figures that make architecture in and by themselves, throwing our own subjective visions of interiors and landscapes into doubt, but also projecting them into new potentialities. Inhabiting Gormley's figures as subjects, we are, one by one and together, constructed as architects of our own spaces and thus invested with the analytical and constructive power both to think as well as to create space. That this space resists and is critical of the world as it is while proposing a possible world

that is inclusive of, and reciprocally responsible to society and nature is perhaps the most we can hope for from sculpture today.

BLUR SPACE: *BLIND LIGHT* (2007)

Each time the word *unheimlich* appears in Freud's text – and not only in the essay of this title, *Das Unheimlich* – one can localise an uncontrollable undecidability in the axiomatics, the epistemology, the logic, the order of the discourse and of the thetic or theoretic statements.[3]

Gormley goes one step further to contest the very limits of spatial definition in such a way as to dissolve the uncanny effects of sculptural installation and to transfer those effects to the nature of space itself. In *Blind Light*, he constructs space as a sculpture, making its form, normally virtual and only sensed through the forms of its enclosure and occupation, tangible and tactile through the operation of light on moisture that is both space and space-filling. Here he reprises, with significant modification, experiments in ambiguous space by architects over the last decade, first in the play of translucencies and opacities initiated by Rem Koolhaas in his competition project for the Bibliothèque Nationale in Paris of 1989 and, more recently, extended by the architects Diller Scofidio + Renfro in their installation for Expo 2002 in Switzerland.

In the summer of 2002 in the lake at Yverdon-les-Bains, Switzerland, the architects Diller Scofidio + Renfro installed a building constructed out of a steel frame equipped with thousands of small nozzles that projected droplets of purified water into the air. The result was, in the architects' words, a 'blur', or 'cloud' that hovered above the surface of the lake. Its form was ovoid in still weather, and elongated and distributed across water and land in windy weather. It was approached by narrow steel bridges across which visitors passed, dressed in plastic raincoats. Entering the 'cloud', visitors gradually lost all sense of open space, and were absorbed into the atmosphere of a palpable but opaque, translucent space. Bodies disappeared and reappeared; lights shone momentarily, then were blotted out; the stairs to the upper level were now seen, now obscured. In this moist cloud, all confidence in the clarity of an architectural space was lost together with that of the visiting subject's body. All was absorbed into light and mist.

The building fundamentally destabilised the common version of architectural space as an open *Spielraum*, a humanist playroom, or a functional layout, and rendered space as a positive rather than a negative force. The body, commonly reinforced by architectural space, was progressively lost and itself became a blur. 'Lost in space' became a reality, and the sense of disorientation accompanying a visit to the Blur Building was, for most visitors, a (slightly) terrifying experience. The emergence and disappearance of others in the mist, like the double glimpsed and then lost in a mirror, was disturbing, if not uncanny.

Five years later, Antony Gormley has taken this experience inside, enclosing it in a translucent cubic volume in the Hayward. But where the Diller Scofidio + Renfro installation was in the open air, subject to all the vicissitudes of wind, temperature and atmospheric pressure, now the experiment is controlled – with temperature and density held at a precise level and the resulting viscosity of the space-filling moisture – the captured cloud – constant. Bodies enter the enclosure, and are progressively lost to view, even as each body loses its sense of sight; the haptic sense replaces the optic sense, as if reversing centuries of visual evolution, and body and mind lose their way in a deliberately disorientating, coolly refrigerated and mistily obscure space. The coolness, the loss of vision and the impossibility of orientation all reinforce the artificial nature of the experiment. But unlike the *Skinner Boxes* of the 1950s, those black boxes for psychological experimentation, Gormley's installation plays with psychological themes without instrumental programme; rather the sensation of losing spatial coordination is experienced as a positive and enriching state – one that liberates the body from its normal conditions of responding to verticality, horizontality and clear boundaries. Sculpture and architecture here absorb each other with reciprocal cannibalism, to produce a space that is, in itself and for itself, truly autonomous; an autonomy that allows the body to assume an alternative state, half concrete, half virtual, and suspended between the two. Such a suspension, somewhere between the traditional 'utopia' of no place and the modernist 'utopia' of 'good place', might conceivably provide the conditions for a rethinking of both: an experience of 'neither/nor' in a way that, through its very ambiguity, opens a space for an uncanny that is no longer an anxiety, but a form of individual and social projection beyond the confines of the real. Here, the elusive figures in the cloud join with the watchers on the horizon as a virtual model of a possible urban contract: between those we know we are, and those we know we are not; between others and ourselves.

KAJA SILVERMAN
ON PAINTING FROM PHOTOGRAPHS

The Painting of Modern Life:
1960s to Now
2007

The Painting of Modern Life surveyed the use and translation of photographic images in contemporary painting, from the 1960s to the present day. Featuring the work of artists including Vija Celmins, Marlene Dumas, Gerhard Richter, Luc Tuymans and Andy Warhol, The Painting of Modern Life *explored the diverse ways in which artists have employed snapshots, news images, family portraits and archival photography as source material for works that address ordinary life as well as historical events. American art historian and theorist Kaja Silverman contributed the following text to the catalogue, which was originally accompanied by texts by British art critic Martin Herbert, poet and art critic Barry Schwabsky, curator Carolyn Christov-Bakargiev and the exhibition's curator Ralph Rugoff.*

PHOTOGRAPHY BY OTHER MEANS

In a 1986 conversation with Gerhard Richter, art historian Benjamin Buchloh suggested that there is something contradictory about the fact that Richter produces figurative as well as abstract paintings. The artist responded, 'I don't really know what you mean by the contradiction between figurative and abstract painting.'[1] This is an astonishing claim, particularly given the fact that Richter bases his figurative paintings on photographs. What is abstraction, if not one long assault upon figuration? And what is photography, if not the primary medium through which figuration has fought back?

An abstract painting, we have been taught, is autonomous. It does not stand for something else; it is, rather, a thing unto itself. Its essence also resides in its material properties. It helps us to locate this essence by turning insistently back upon itself – by being reflexive or self-conscious. Finally, an abstract painting is flat; it abolishes the perspectival illusion of three-dimensional space. The photographic image, on the other hand, offers a representation of something else. It generally does so iconically – by providing a 'likeness' of the latter. But even when a photograph does not offer an intelligible image, it points stubbornly outward, since it depends for its existence upon the transmission of light between a material form and the camera. Last, but not least, the photographic image draws upon the system of perspective in order to project a three-dimensional space. As a result, it often seems to be 'transparent' – to open directly onto the world.

Because of the radicality of these divergences, one is inclined to dismiss Richter's claim as a simple provocation. But the painter is not sparring with the critic; as his art practice consistently shows, he really doesn't see abstract painting and photographic figuration as contradictory forms. This is not because he is blind to what distinguishes them from each other, or ignorant of the battles that have been fought on their behalf. It is, rather, because differences do not translate into oppositions for Richter. He has

KAJA SILVERMAN ON PAINTING FROM PHOTOGRAPHS

a profound aversion to binary formulations, both within the domain of politics and that of art, and he cannot encounter one without attempting to dismantle it. In 1961, he crossed the boundary separating East and West Germany – a boundary that in the same year hardened into a wall. And in the early 1960s, Richter began bridging another divide: that separating abstract painting from photographic figuration. He did so by painting canvases based upon photographs, and then – while the pigment was still wet – working over their surfaces with a squeegee.[2] The works that resulted from this two-step process, which Richter calls his 'photo pictures', are often experienced by their viewers as 'blurs'. This is in part because they soften outlines and eliminate many of the details available in the original image. But the indeterminacy of many of Richter's photo pictures also has another source: they bring together abstract painting and photographic figuration without abolishing the distinction between them. They are consequently invitations to see double.

Unholy as this alliance may seem, Richter was not the first to bless it; Andy Warhol married abstract painting to photographic figuration one year before Richter painted *Mouth* (1963), the first of his photo pictures. The double vision for which Warhol is most famous is, however, ironic in nature. In early silkscreens like *192 One Dollar Bills* (1962) and *Thirty Are Better Than One* (1963), the American artist uses painting to establish a bemused distance from photography, and photography to do the same with painting. And although this is a reversible relationship, and one in which the partners can switch positions at a dizzying speed, it is not equal; one term always passes ironic judgment on the other. Richter went through a brief phase as a pop artist, but he soon stopped passing this, or any other kind of judgment. The duality at the heart of most of his photo pictures is non-hierarchical – a relationship between equals. Each also points toward, and finds itself within, the other. The artist described how this relationship works in a 1965 note: 'Like the photograph I make a statement about real space, but when I do so I am painting, and this gives rise to a special kind of space that arises from the interpenetration and tension between the thing represented and the pictorial space.'[3]

The first version of *Motorboot* (*Motor Boat*), a photo picture from the same year, provides a particularly striking example of this 'interpenetration' and 'tension'. The photograph from which it derives shows four people speeding across a lake in a motorboat. Their clothing indicates that they are wealthy and on holiday, and their gestures and smiles show how delighted they are to be rich vacationers. But their emotional display is so theatrical that it is ripe for parody, and Richter does not fail to take advantage of this in the painting he produces from it. With his blurring utensil, he broadens the smiles on the faces of the human figures, transforming them into caricatures of themselves.

The attentive viewer is likely to remain standing in front of this canvas a long time after he or she 'gets' this 'joke', though, because it combines two different kinds of space. In the photograph with which the painting is in dialogue, the choppy waves produced by the boat stretch out behind it, as a kind of receding prospect. They thus

convey a powerful sense of three-dimensionality. The waves also have a prominent place in *Motor Boat*, but by working them over systematically with his squeegee, Richter both de-articulates them and foregrounds the texture of the paint. This has a flattening effect upon the aquatic prospect. The artist also softens the outlines and details of three of the human figures. However, he leaves the head and torso of the woman in the foreground of the photograph largely untouched, so that she continues to seem closer to us than the other figures. As a result, *Motor Boat* does not abolish depth-of-field. Instead, it makes room within the same canvas for two- and three--dimensionality. The waves are simultaneously 'behind' and 'above' the speeding boat and its human occupants, something that makes for an unsettling – but also a highly pleasurable – viewing experience.

Most of Richter's works do not even promote this degree of merriment. They also make it harder to say where photography ends and painting begins. Unlike Warhol's depiction's of Brillo pads and Campbell's soup cans, the object in Richter's *Folding Dryer* (1962) is not a full-fledged commodity. It lacks name recognition, so it cannot be evoked through its packaging, and there are no secondary gains to be realised from purchasing such a humble object. Those responsible for the advertisement have consequently mobilised an antiquated notion – 'use-value'. Richter does not pull rank either on the advert or the folding dryer; he adheres closely to the source photograph in his painting of it, and he suggests that the object really is 'useful' by cropping off everything below the sentence in which this word appears. In *Woman with Umbrella* (1964), he shields a grieving Jacqueline Kennedy from the glare of media publicity by turning her into an anonymous woman; making her emotions unreadable; and drawing a delicate veil over her body with his squeegee. In *Nurses* (1965), Richter corresponds with the window slats in the back of his source photograph through the horizontal strokes of his blurring device. He also uses this technique to harmonise the women with their environment and bind them even closer together.

Gerhard Richter
Motorboot (1. Fassung)
(Motor Boat, 1. version), 1965

Richter does more than dismantle the opposition between abstract painting and photographic figuration; he also bridges the gap separating art from the world. He accomplishes both of these undertakings in the same way: by creating analogies. I take the word 'analogy' from Richter himself, who uses it often in his interviews and writings.[4] It is his name for a special kind of relationship, and one that has become more capacious with each new development in his artmaking. An analogy brings two or more things together on the basis of their lesser or greater resemblance. I say 'lesser or greater' because although in some of Richter's analogies similarity and difference are evenly balanced, in others similarity outweighs difference, or difference, similarity. But regardless of the form they take, these couplings neutralise the two principles by means of which we are accustomed to think: identity and antithesis. As Richter helps us to understand, an analogy is a very different thing from a metaphor. The latter entails the temporary substitution of one thing for another. This is a profoundly undemocratic relationship, not only because the former

is only a stand-in for the latter, but also because it has only a provisional reality. In an analogy, on the other hand, both terms are on an equal footing, ontologically and semiotically. They also belong to each other at the most profound level of their being. Richter does not produce them; rather, he waits for them to emerge. 'Letting a thing come, rather than creating it', he writes in a note from 1985, 'no assertions, constructions, inventions, ideologies – in order to gain access to all that is genuine, richer, more alive: to what is beyond my understanding.'[5]

Richter grew up in a world of stark oppositions. Shortly after crossing the border separating East and West Germany, he was confronted with another set of polarities. The antinomies that were his daily bread in East Germany were of course those distinguishing it from West Germany – communism versus capitalism, and Eastern Europe versus Western Europe. Those he was asked to digest after settling in the West were internal to West Germany; they pitted the generation who grew up after the Second World War against those responsible for it, and Leftists of all stripes against the State, the military and the social and economic establishment. Richter's response to this 'either/or' thinking, which he calls 'ideology', was to debinarise difference. He turned for this purpose not just to analogy, but to a particular kind of analogy: one in which there is the smallest possible difference. He found the model for it in photography.

This might seem a baffling claim. The 'logos' in 'analogy' links the latter firmly to language and reason. Everyday usage does the same; we turn to analogy when we want to clarify an obscure point, or establish the structural equivalence of two or more things. Photography, on the other hand, is a visual form, and one appealing more to belief than to reason. The ways in which this medium has been theorised also make it difficult to see how it could perform the role Richter attributes to it. For 'realists', like French film critic André Bazin and the late French philosopher and critic Roland Barthes, a photographic image is a trace of, and perhaps even ontologically identical with, what it depicts; there is consequently insufficient distance between the two for them to constitute an analogy.[6] Those who distinguish between the two, on the other hand, generally do so absolutely. No matter how closely a photograph approximates its referent, it is ultimately a separate entity; whereas the second of these terms is real, the first is 'only' a representation. And the more striking the resemblances between a photograph and its referent, this argument goes, the more emphatically we must distinguish between them, because there is no more powerful form of ideological mystification than similarity.[7]

In Richter's view, however, the photograph inhabits the same world as its referent – the world of forms. Neither takes priority over, or constitutes a replacement for, the other; instead, the two relate the same way all other forms do: by corresponding with each other. The correspondences between a photograph and its referent are extraordinarily abundant – so much so that one can be seduced into believing that if the former were enlarged, it would match up point-for-point with the latter. This does not mean, however, that the photograph is a false pretender. It means, rather, that it is photography's essence to be *almost nature*. The small but decisive difference that separates it from the referent is also not a defect, but rather the precondition for relationality. Although it is through their resemblances that the two correspond, it is only because they are at the same time distinct from each other that they are able to do so. It is also only by turning to one that we can approach the other.

Part of what drives Richter to paint his photo pictures is his desire to show us the marginal difference separating a photograph from its referent. As he wrote in the mid 1960s: 'Perhaps because I'm sorry for the photograph, because it has such a miserable existence even though it is such a perfect picture, I would like to make it valid, make it visible – just *make* it.'[8] But by rendering the special kind of analogy that links a photograph to its referent visible, Richter also teaches us to think another way about other kinds of difference. As should be evident by now, it is through an implicitly photographic analogy that the artist brings together abstract painting and photographic figuration. He begins his photo pictures by painting a figurative analogue of a photograph. He then uses a blurring device to produce an abstract analogue of this figurative analogue. Whereas the second of the analogies I have just described operates within the frame of the photo picture, the first links the photo picture to something outside itself, just as a photograph does. The resulting canvases consequently do even more than analogise abstract painting and photographic figuration; they also analogise photography's own way of

analogising. It is for this reason, I believe, that Richter claims to paint like a camera. The analogical value of the photographic image is not exhausted once we have explored its relationship to its referent. It moves through time, in search of other 'kin'. Although these analogies are not of our making, they remain latent until we recognise them. Fortunately for us, photographs do not passively await this recognition; instead, they actively solicit it by, as Richter says, dropping 'onto our doormats', like advertising flyers.[9] This is another of the reasons why they are so important for Richter, and why he emphasises both their agency and their authorlessness. The kinds of analogies I have just described closely resemble what Walter Benjamin calls 'dialectical images'.[10] They connect our present to specific moments from the past. They also do so in the face of powerful opposition; we do not want to acknowledge the affinities upon which they insist. Our resistance strengthens the link between us and our predecessors, since what we call 'history' has been one long refusal to open the book of life.[11] Over the centuries, the pile of unacknowledged analogies has grown ever higher, impeding our vision and our capacity to change.

But although the past prefigures the present, it does not predetermine it. It shows us not who we are, or even who we will be, but rather who we are in the process of becoming. It does so in the hope that we will prevent this particular analogy from being realised. If we do so, we will not only free ourselves from the repetitive compulsion of history, but also change the 'specific character' of the past by generating an altogether different analogy.[12] It is to this mysterious reciprocity between what is, and what has been, that Benjamin refers when he writes: 'The past carries with it a temporal index by which it is referred to redemption. There is a secret agreement between past generations and the present one. Our coming was expected on Earth. Like every generation that preceded us, we have been endowed with a *weak* Messianic power, a power to which the past has a claim.'[13]

There are some important differences, though, between Benjamin's notion of redemption and Richter's. Benjamin wrote the above words in the mid 1930s, when it was still possible to think of a generation as a possible engine for social redemption. By 1988, this illusion had been utterly dissipated – as much by the events of the1960s and 1970s, as by those of the 1930s and 1940s. It had become painfully evident that the force from which the past needs to be rescued is not social or economic, but rather psychic in nature. This force is what Sigmund Freud called the 'death drive', and it threatens us from the inside, as well as the outside.[14] In 1986 Richter wrote: 'Crime fills the world, so absolutely that we could go insane out of sheer despair' – a passage that could have been lifted directly out of Freud's book *Civilization and its Discontents*. Richter continued: '(Not only in systems based on torture, and in concentration camps: in civilized countries, too, it is a constant reality… Every day, people are maltreated, raped, beaten, humiliated, tormented and murdered – cruel, inhuman, inconceivable.) Our horror, which we feel every time we succumb or are forced to succumb to the perception of atrocity… feeds not only on the fear that it might affect ourselves but on the certainty that the same murderous cruelty operates and lies ready to act within every one of us.'[15] As Richter intimates, the second of these fears is even greater than

the first; most of us will go to far greater lengths to avoid thinking about our capacity to injure others than theirs to injure us. But this fear protects us from something even more unthinkable: our own mortality.

Only at the moment of our death will a period be inserted into the sentence of our life, thereby fixing its meaning. Since until that moment we will remain in a state of perpetual becoming, this futural relationship to ourselves makes it possible for us to change. It also links us while we are alive to every other living creature or thing, ranging from those who most closely resemble us, to those who seem most alien. It is consequently the most capacious and enabling of all analogies. The death drive is the powerful force within us that seeks to override this limit. Until we learn to live in a way that takes cognisance of our mortality – to be oriented 'towards death' – all of our attempts to devise a more equitable society will end in failure. If death is the *eidos*, or form, of the photographic image as Roland Barthes has argued,[16] that is not only because it says 'this was', but also because it establishes such an intimate relationship between this past and our future.

Richter is not the only artist who views photography in these terms. Vija Celmins abandoned abstract expressionism in the mid 1960s because she wanted 'to go back to looking at something outside of [herself]'.[17] She began her career as a figurative artist by painting the objects in her studio (an electrical fan, a hot-plate, a space-heater), but she soon began producing photo pictures. Construing the turn to photography as a step away from the world, fellow painter Chuck Close asked her in a 1991 interview why she puts an 'artificial layer' between herself and what she looks at. Celmins responded that a photograph is neither artificial nor a layer, but rather a bridge to the material world. She told Close that photographs permit her to 'unite' physical objects with the 'two-dimensional plane' of her paintings. She also maintained that her paintings have an enlivening effect upon the photographs – that they put the latter 'back in the real world – in real time'.[18]

In a published conversation with sculptor Robert Gober, Celmins confides that she is also in love with the 'look' of photographs, and that she wants to produce a similar look in her paintings.[19] As we can see from her photo pictures, 'look' means both 'appearance' and 'vision'. At the outset, Celmins was primarily focused on the first of these meanings; unlike *Fan* (1964), where the paint is thick and the colours dense, *Flying Fortress* (1966), *Time Magazine Cover* (1965) and *Explosion at Sea* (1966) are grisaille, and the brushstrokes as small and unobtrusive as the grain of a good-quality photograph. But in the 1970s, when she was teaching at University of California, Irvine, Celmins began to think of the camera more as something to 'see through' than as an image-making device. She balanced her camera on the steering wheel while driving on the freeway, so she could gaze at her surroundings through the viewfinder.[20]

Celmins shot a vast number of photographs during these trips, and more later, while living in Venice, California, but she didn't pay much attention to them, because she

thought that she had already seen what they had to offer. But when she examined them later, she found herself as surprised by and as 'enamoured' with their look as she had earlier been with the found photographs. The world opens itself differently to the camera than to the human eye, and this difference does not disappear when we peer through the viewfinder. It is able to see what our narcissism prevents us from seeing – the similarities connecting us to everything else, which make us part of a larger totality.

There is an even narrower margin of difference between Celmins's paintings and their source photographs than there is in Richter's – no irony, no authorial commentary and no 'blur'. It is surprising that she should have chosen to handle photographs in this way in the heyday of pop art, but it becomes downright astonishing when we consider the biographically significant subject matter of many of her photo pictures – German military planes from the Second World War; a German car from the same period; an explosion at sea. She was born in 1938 in Latvia, a country that was occupied first by the Red Army, then by the German army, and then again by the Russians. Her family fled to Germany in 1944, before the Russian army reinvaded Latvia, and they lived in Esslingen for four years before relocating to the United States in 1948. Like her giant pencils and erasers, her burning houses and military planes resemble those she saw as a child.[21]

However, it is precisely *because* of this history that Celmins refuses to distance herself from the military planes. She knows that they are things in the world, not agents of destruction – that *we* are the source of the violence we attribute to *them*. She also knows that this violence has no respect for borders, and that we cannot oppose it without participating in it. The will to destroy inhabits every psyche, and there is only one way to tame it: through the miracle of analogy.[22] Celmins helps us to see that we are all both bombardier and victim by giving her paintings of planes generic rather than historically specific titles, for instance, her 1966 works *Flying Fortress* and *Suspended Plane*. She also shows them to us from the perspective of a neighbouring plane, and she invites us to look *down* at her burning houses, like a military pilot at the end of a successful mission.

Both Celmins and Richter are in dialogue with Andy Warhol. Celmins's *Time Magazine Cover* analogises Warhol's *Race Riot* (1963) and her *Burning Man* (1968) references his silkscreens of automobile crashes and other disasters. Richter's photo pictures of toilet paper rolls, kitchen chairs and a drying rack relate in a similar way to Warhol's Brillo boxes and Campbell's soup cans, and his painting of Jacqueline Kennedy corresponds with the American artist's *Jackie*. This is a surprising dialogue, not only because irony is as alien to Celmins as it is to Richter, but also because Warhol seems more interested in 'sameness' than he is in similarity. His work is informed by Walter Benjamin in his famous essay, 'The Work of Art in the Age of Mechanical Reproduction' (1936). According to this argument, a photograph is one of a potentially infinite number of identical and unauthorised copies. It does not refer back to an 'original', and it lacks everything that gives a traditional artwork its aura: singularity, the patina of age, the traces of the artist's hand, and embeddedness in a particular place.

However, Warhol uses the silkscreen process to introduce random differences into multiple copies of the same photograph, thereby undercutting the claim that they are all 'identical', and although he treats the photographic image as a simulacrum, he does not so much jettison as redefine its referentiality. As he himself notes, his portraits gesture toward a psychic reality. 'I usually accept people on the basis of their self-images', he writes in *The Philosophy of Andy Warhol*, 'because their self-images have more to do with the way they think than their objective-images do.'[23] Warhol also uses the concept of 'sameness' to level the distinctions between the rich and the poor, the famous and the unknown, and the 'high' and the 'low'. 'What's great about this country is that America started the tradition where the richest consumers buy essentially the same things as the poorest', he observes in *The Philosophy*, 'You can be watching TV and see CocaCola, and you can know that the President drinks Coke, Liz Taylor drinks Coke, and just think, you can drink Coke […] All the Cokes are the same and all the Cokes are good.'[24] When Warhol reintroduces 'difference', as he does in many of his works, it is as a *formal* category, rather than one distinguishing one person or thing from another. The word 'gold' in the title *Gold Marilyn* refers to the colour of the painting, instead of Marilyn Monroe, and the adjective 'big' in *Big Electric Chair* to the size of the canvas, instead of the chair.

Mortality is also *the* theme for Warhol, just as it is for Richter and Celmins. In the hilarious 'Death: Everything About It' chapter in *The Philosophy*, he writes: 'I'm so sorry to hear about it. I just thought that things were magic and that it would never happen… I don't believe in it because you're not around to know that it's happened.'[25] By reproducing and silkscreening photographs of car crashes and other fatal accidents, Warhol attempts to *show* us what Freud *tells* us: the most standard way of disavowing one's mortality is to adopt a spectatorial relationship to death. He also tries to break the spell of this relationship by multiplying and tinting the photographs, inserting them into decorative panels, and giving them trivialising and overtly commodifying titles. But irony is powerless when it comes to mortality; its double-talk quickly devolves into divided belief ('yes, I know I will die, but all the same…').

Warhol clearly understood this, because he ends 'Death: Everything About It' with an uncharacteristically direct acknowledgement: 'I can't say anything about it because I'm not prepared for it.'[26] He also produced one series of works that is a powerful generator of analogical thought. In his *Electric Chair* silkscreens, Warhol installs us in the place reserved for witnesses in an American execution chamber, but without showing us what we have come to see. We wait and wait, but no 'criminal' materialises. The electric chair remains empty, and its emptiness calls out for an occupant. Since we are alone in the execution chamber, we are the only ones who can fill this void. Death finally stops being a spectator sport.

JANE RENDELL
ON ART AND ARCHITECTURE

Psycho Buildings:
Artists Take On Architecture
2008

Psycho Buildings: Artists Take On Architecture marked Hayward Gallery's 40th anniversary as one of the world's most architecturally unique exhibition venues. The exhibition featured ten artists – including Michael Beutler, Mike Nelson, Ernesto Neto and Rachel Whiteread – who create habitat-like structures and architectural environments that are perceptual and psychological spaces as much as physical ones. Visitors were invited to immerse themselves in atmospheric and unsettling installations that explored and questioned the way we relate to our surroundings. Among the works in the exhibition was a boating lake constructed by Austrian art collective Gelitin. Situated on one of the outdoor sculpture terraces, this work allowed visitors to row across the London skyline. Writer, critic and architectural historian Jane Rendell was one of a number of contributors to the catalogue, which also featured texts by Brian Dillon, Tom Morton, Iain Sinclair and the exhibition's curator Ralph Rugoff.

ART'S USE OF ARCHITECTURE: PLACE, SITE AND SETTING

Art and architecture are frequently differentiated in terms of their relationship to 'function' or 'use'. Unlike architecture, art may not be useful in pragmatic terms, for example in responding directly to social needs, providing shelter or somewhere in which to perform open-heart surgery, but we could say that art provides a place for other kinds of function – self-reflection, critical thinking and social change. If we consider this expanded version of the term function in relation to architecture, we realise that architecture is seldom given the opportunity to consider the construction of critical concept – and spatial relations as its most important purpose. Architecture's potential is most often realised in contemporary art, especially in current works that, in reworking architectural forms within the gallery setting, decontextualise architecture. In this way, they allow a new way of responding to architecture, one that draws attention to those qualities that are often overlooked.

There are many possible ways of framing an exhibition such as *Psycho Buildings*, which comprises architectural works by a diverse range of international artists practicing today. This essay looks backwards to the 1960s in order to draw attention to a number of architectural themes that emerge in the art of that period. These include architecture's role in producing place, critiquing site and imagining settings.[1] These interests figured as key aspects of the art of the 1960s, but also continue to preoccupy contemporary artists engaged in architectural investigations, albeit in ways that are being continually revised, reworked and rethought.

SCULPTURE AS PLACE

In February 1966, in his essay 'Notes on Sculpture, Parts 1 and 2', artist Robert Morris argued that, unlike pictorial work, sculpture was not illusionist but had a 'literal nature', and that clearer distinctions needed to be made between sculpture's 'tactile nature' and the 'optical sensibilities involved in painting'.[2] In June of the same year, art critic David Antin wrote that sculpture was 'a specific space in which the observer is thrust, namely it is a place'.[3] Again, in October the same year, critic David Bourdon quoted artist Carl André's account of the development of modern sculpture from form, through structure, to place, and noted André's statement on *Cuts*, his show in March 1967 at the Dwan Gallery in Los Angeles, 'I now see the material as the cut in space'.[4] For artist Dennis Oppenheim, 1967 was *the year* when the 'notion of sculpture as place was manifest'.[5] In the same issue of *Artforum* in Part 2 of his 'Notes on Sculpture', Morris, following sculptor Tony Smith, took up the question of scale and located minimalist work at a human scale between the private object and public monument, as one term in an expanded situation.[6]

The architectural installations of Brazilian artist Hélio Oiticica from this period combine an interest in the formal qualities of architectural structures – open and closed, formal and informal – with different kinds of sensual experience. Oiticica's early works, such as *Bolides Caixas* (1963) – are tiny environments, boxes made of painted plywood, too small to be inhabited. Considered in relation to the inhabitable scale of the open mazes of hanging coloured panels comprising *Nucleos* (1960–66), the saturated hues of the closed cabins of the *Penetrables* (1961) – and the *Parangoles* (1964–71), incorporating various fabrics – capes, flags, banners and tents – designed to be worn while dancing, it is possible to think of his early work as a model for his later structures. The political relevance of the cultural sensuality of Oiticica's fabrications is perhaps most clear in *Tropicália* (1967) where a setting composed of a closed wooden labyrinthine structure with various fabrics, plants, parrots and sand, installed at the Museu de Arte Moderna in Rio de Janeiro, had to be 'penetrated' in order to be experienced.[7]

Over a similar time period, Dan Graham was also critiquing architecture's forms and value systems from the suburban – in photo-essays like his 1967 *Homes for America* – to the corporate, in the construction of his pavilion projects.[8] Graham's first outdoor pavilion work, *Two Adjacent Pavilions*, was first shown at Documenta 7, Kassel, in 1982. The twin pavilions had identical walls of two-way mirror glass, but there was a transparent glass ceiling in one and a dark ceiling in the other, resulting in the construction of two quite different experiences. Since two-way mirror glass can appear transparent or reflective depending on light levels, when the sun was shining, the viewers under the transparent ceiling were able to see themselves reflected in the mirrored walls and at the same time be seen by viewers outside, while those under the dark ceiling looked at the outside world rather than their own reflections, and could hardly be viewed from the outside.

Graham explored the potential of the pavilion form and two-way mirror glass in numerous other site-specific projects. In *Rooftop Urban Park Project*, a small urban park constructed on the roof of the Dia building in Chelsea, New York, in the 1980s, the pavilion consisted of a glass rectangle surrounding a cylindrical form also constructed of glass. Due to different lighting conditions, at times the viewer could look through the pavilion and see the grids of the façades of the downtown steel and glass skyscrapers on the skyline. At other times, they were confronted by their own reflection, looking back. Like many other works by Graham, *Two-Way Mirror Cylinder Inside Cube* (1981–91) combines the cube and cylinder. The cube references the grid of the city and modernist architecture, while the cylinder refers to the water towers perched on the surrounding roofs, while also relating the surface of the body to the horizon line.[9] The work questions the limits of the gallery – architecturally and institutionally – but also follows Graham's provocation of the viewer's critical as well as his/her physical engagement.

In art critic Hal Foster's reading of minimalism, the sculpture is 'off the pedestal' in relation to the viewer, 'repositioned among objects and redefined in terms of place'.[10] He argues that in order to create a direct physical relationship with the viewer, minimalism replaced the idealist Cartesian 'I think' and the abstract expressionist 'I express' with 'I perceive'.[11] Refusing the distinction between the perceptual experience offered by minimalism and the intellectual challenge posed by conceptualism, in demanding that the viewer operate not just perceptually, but also conceptually, artists like Oiticica and Graham set the scene for the development of what has come to be described as post-minimalism. Their sculptures investigate the relation between viewer and work, not only through the literal physical experience of the here and now, but also by exploring processes that are abstract and ideological as well as visibly and tangibly present.

Dan Graham
Two Adjacent Pavilions, 1978–81

ARCHITECTURE AS THE SITE OF INSTITUTIONAL CRITIQUE

Robert Smithson described the shift in his own artistic practice at this time from an interest in specific objects to a more relational way of 'seeing' the world, where the works 'became a preoccupation with place'.[12] Exploring architecture through his interest in entropy, his *Partially Buried Woodshed* (1970) was intended to demonstrate this principle of disintegration through the dumping of earth on top of an empty shed until it collapsed. Smithson also documented entropy in existing architecture in works such as *A Tour of the Monuments of Passaic, New Jersey* (1967) and *Hotel Palenque* (1969).[13] The former, a photo-essay, describes the material qualities of entropy in enormous industrial structures that at the time of their construction were already deteriorating. The latter, originally a lecture to architecture students, now a slide installation and sound recording, outlines Smithson's concept of a 'ruin in reverse', through his visit to a Mexican hotel which was decaying while also being renovated, enacting 'places of little

organisation and no direction', as Smithson described the space between site and non-site.[14] Smithson's consideration of the dialectical relation between the site of the work and the non-site of the documentation of the work in the gallery presents the spatial aspect of his art as key to understanding his critique of art and architecture.[15]

In the early 1970s, Michael Asher's work utilised the principle of material subtraction to focus critical attention on the institutional role of architecture from an experiential perspective. For his untitled work at the Claire Copley Gallery, Los Angeles, in 1974, he removed the partition between the office and exhibition space, revealing the usually hidden operations that allow the gallery to function economically to the viewer, but also exposing the viewer to the curator, thus making both subjects conscious of their activities as producers and consumers of art.[16] For his 1976 installation at the Clocktower Gallery of the Institute for Art and Urban Resources in New York, Asher removed all the windows and doors connecting the gallery to the external environment. This opened the interior to fluctuations in temperature, direct light and moisture, thus using perceptual change to promote critical reflection on the limits of art and the viewing experience.[17]

These types of disruptions have been extended into contexts other than galleries. Built structures, which tend to represent the value systems of dominant cultures, have provided opportunities for critical art practitioners to make visible structures of oppression. Gordon Matta-Clark's anarchitecture is perhaps the clearest expression of insertions into architecture, which operate through negation – performative acts of destruction or building cuts – which in turn create new temporary architectures. For example, in *Splitting* (1974) Matta-Clark sawed two parallel slices through a wood-frame house in Englewood, New Jersey, removing the material between the two cuts, and in *Day's End* (1975) he removed part of the floor and roof of a derelict pier in Manhattan. In *Conical Intersect* (1975), for the Biennale de Paris, Matta-Clark cut a large cone-shaped hole through two seventeenth-century townhouses, which were to be knocked down to construct the Centre Georges Pompidou. But his most explosive act against architecture and its associated institutions must be his 'participation' in an exhibition alongside well-known architects in 1976 at the Institute of Architecture and Urban Studies in New York: on the afternoon of the exhibition's private view he shot out all the institute's windows with a BB gun as a means of linking the abstraction of modernist architecture with its production of disastrous urban housing projects, the façades of which typically featured shattered windows.

Matta-Clark's work focuses attention on the ambivalence of the attraction between art and architecture, where the fascination is not without repulsion. Architecture's curiosity about art is in no small way connected with the perception of art as a potentially subversive activity, whose relative freedom from economic pressures and social demands can make it appear superfluous; while the appeal of architecture's so-called purposefulness for art, its cultural and functional role, reveals its more sinister side in the potentially despotic aspect of the control and power considered integral to the identity of the architect.

THE SETTING

Art critic Claire Bishop has argued that installation art is best understood in terms of its treatment of the viewing subject – perceptually, politically and psychologically.[18] For this reason, it might be that *Psycho Buildings'* predecessors lie in the use of the gallery as a performance space that dissolves the boundaries between subject and object. In his essay 'The Work of Art in the Age of Mechanical Reproduction' (1936), Walter Benjamin differentiated between concentration as the optical mode of viewing a painting, in which the work absorbs the viewer, and distraction as the tactile experience of architecture, in which the viewer absorbs the work.[19] The insertion of structures, objects, sounds and texts into the gallery context has produced complex architectural scenes, which both absorb and are absorbed by the viewer. They invite a viewer to move through the work, drawing out meanings over time. And, through varying modes of interaction, they involve activities that draw on personal memories, cultural references and imagined scenarios.

Kurt Schwitters's *Merzbau*[20] and the phenomenon of the 'total installation' described by Ilya Kabakov, provide environments that immerse their viewers in alternative worlds through the production of narrative and theatrical settings, which involve the viewer in fictional constructions as well as sensual and visual experience.[21] This might include inviting the viewer to imagine an 'elsewhere', when the gallery is arranged to replicate another place – as is the case with Lucas Samaras's *Room* (1964), for which the artist transported his bedroom-studio from his parents' home in New Jersey to the Green Gallery on West 57th Street in New York.

An act of duplication might also involve some invention, as in Paul Thek's carefully choreographed and symbolic 'processions' or 'ensembles' – ritualised architectural spaces – such as *Pyramid/A Work in Progress* (1971–72), which recreated the artist's working environment and included a boat, bathtub, piano and other items.[22] An installation might also be a hybrid fabrication, part fact and part fiction, where fantasy blends with the everyday, and reality departs due to the miniaturised way in which it is repeated; for instance, in the feminist works comprising *Womanhouse* (1972) a project organised by Miriam Shapiro and Judy Chicago in an old Hollywood mansion.[23]

The interest in architecture here can be distinguished from the minimalist and conceptual art of the 1960s and 1970s in terms of the complex forms of occupation that the work requires in order *to function* or to be used. This highlights a specific articulation of, in Umberto Eco's words, the 'open work', where the viewer is invited to imaginatively complete the work. In his important essay, 'The Poetics of the Open Work' (1962), which prefigures the discussion of relational aesthetics by some 30 years, Eco shifts the grounds of viewer experience from contemplation to use.[24] In demanding imaginative as well as perceptual and conceptual modes of use, these works are inhabited both consciously and unconsciously.

It may be helpful therefore to consider *Psycho Buildings* in relation to the psychoanalytical notion of 'setting', a term used to describe the main conditions of treatment within which the psychoanalytic encounter occurs. Following Sigmund Freud, these conditions include 'arrangements' about time and money, as well as 'certain ceremonials' governing the physical positions of analysand (lying on a couch and speaking) and analyst (sitting behind the analysand on a chair and listening).[25] Coined by Donald Winnicott, 'as the sum of all the details of management that are more or less accepted by all psychoanalysts',[26] the term has been modified by other analysts. In the work of José Bleger, the setting comprises both the process of psychoanalysis and the non-process or frame, which provides a set of constants, or limits, to the 'behaviours' that occur within it.[27] And, in terms of its spatial configuration, Jean Laplanche considers the setting a double-walled tub.[28] For André Green, it is a casing or casket that holds the 'jewel' of the psychoanalytic process.[29]

Green has drawn attention to the setting not as a static tableau, but as a psychoanalytic apparatus; not as a representation of psychic structure, but as an expression of it. For Green, the position of the consulting room between inside and outside relates to its

function as a transitional space between analyst and analysand, as does its typology as a closed space different from both inner and outer worlds: 'The consulting room [...] is different from the outside space, and it is different, from what we can imagine, from inner space. It has a specificity of its own.'[30] In Green's work the setting is a 'homologue' for what he calls the third element in analysis, the 'analytic object', which is formed through the analytic association between analyst and analysand.[31] 'The analytic object', Green argues, 'is neither internal (to the analys and or to the analyst), nor external (to either the one or the other), but is situated between the two [...] in the intermediate area of potential space, the space of "overlap" demarcated by the analytic setting.'[32]

In many ways, the closed space of the gallery operates as a setting for an encounter between user and artwork, involving the process of engaging with a work and the non-process or frame in which one is 'invited' to engage with the work. This setting includes then the frame of the physical space of the gallery: the hours of opening, admission fees, provision of refreshments and facilities, the presence of invigilators, and rules of occupation, as well as the process of encountering art. As 'analytic object', the architecture of the artwork provokes a response in the user that is not only physical or conceptual but also psychic. The contemporary artworks in *Psycho Buildings*, in engaging with the psychic dimension of architecture, are best understood with reference to the setting as a spatial term that frames the provocation of transference – the work of psychoanalysis. Through spatial processes of displacement and disorientation, uncanny experiences associated with repetition and play indicate the presence of the unconscious in the unexpected dimensions conjured by these works.

In choosing to highlight the 1960s as the most relevant precedent for this show, what has been suggested? In the art of the 1960s, architecture often featured as the gallery, with its institutional structure, material limitation and cosy relation with commerce, but it also operated as a mediating threshold between private lives and public concerns through which individuals related to the wider environment. Through the late 1970s and into the 1980s, the art world's interest in architecture appeared to diminish; art's criticality pointed in a different direction, towards a sceptical questioning, sometimes an ambivalent celebration, of mass consumption, visual spectacle and the commodification of art. But the return of architecture in the art of the late 1990s and 2000s is not a repetition of the work of the 1960s and 1970s. There is still a fascination with architecture's dark side, with its ability to control and order, but the manifestation of power affects the viewer both consciously and unconsciously. Artists in *Psycho Buildings* explore architecture's psyche, through the production of places, sites and settings, which engender spatial experiences that connect the viewer psychically, as well as perceptually and conceptually, to broader social issues and cultural phenomena.

GRAYSON PERRY
ON BRITAIN'S FORGOTTEN POST-WAR ART

Unpopular Culture
2008

This exhibition curated by Turner Prize-winning artist Grayson Perry featured works borrowed entirely from the Arts Council Collection. Perry's very personal selection focused on works produced between 1940 and 1980 that reflected post-war, pre-Thatcherite Britain. These included photographs, paintings, drawings and sculptures by artists such as Kenneth Armitage, John Bratby, Lynn Chadwick, Barbara Hepworth, Martin Parr, Tony Ray-Jones and William Scott. Writing in the exhibition catalogue, the poet Blake Morrison described the selection as 'muted, modest, wary, even at times slightly dour', while to Perry the show offered a picture of a time that was 'more reflective, more civic and more humane'. The exhibition opened at the De La Warr Pavilion, Bexhill-on-Sea, and toured to venues in Preston, Durham, Southampton, Aberystwyth, Scarborough, Wakefield and Bath.

I hardly ever go to Tate Modern; it has become too popular for me. I can't see the art for backpacks and buggies. It is always full of snapping tourists, screaming school parties and families visiting London for the day. In the noughties, contemporary art, or at least going to contemporary art galleries, has attained mass appeal. The latest art is often sensational, big, loud, shocking, funny. It is a thrill ride for the people, literally in the case of Carsten Höller's helter-skelters in Tate Modern's Turbine Hall. But I look back to only a quarter of a century ago, when I left art college, and I see contemporary art was a grim, socialist rather than popular, business. Being an artist seemed to be about residencies in coalmines and knitting pro-abortion banners. Being involved with contemporary art felt like living in an inbred backwater rarely visited by the average citizen or the mainstream media. When they did take notice, it was only to confirm outdated prejudices and snigger at the freak show where sculptures were full of holes and a pile of bricks cost as much as a luxury car.

So when the Arts Council Collection asked me to select a touring exhibition of works from their holdings, I had the shrill voice of twenty-first century contemporary art ringing in my ears as it clamoured for attention in our crowded cultural landscape. I was also aware of the remnants of hostility to fine art from *Daily Mail* Britain who still see art as an elitist con. As I trawled through the Arts Council Collection catalogues, illustrating around 7,500 pieces, I found myself drawn to art from the earlier part of the Collection; works that could be characterised as subtle, sensitive, lyrical and quiet. My choices fell into three distinct categories: figurative painting, bronze sculpture and documentary photography. What bound these three groups of work together were the period of their inception – on the whole the works date from 1940 until about 1980 – and also a more ineffable sense of mood. A lack of intellectual audacity and visual showmanship may have excluded some of these artists from the headlines of art history, but for me, as a group these artists speak eloquently of Britain in a *time* between the trauma of the Second World War and the onset of Thatcherite selfish capitalism, a time between the Blitz and the contemporary

bombardment by media and marketing. I may be reactionary or nostalgic, but for me these artworks conjure up an age before our experience of ourselves was muffled completely by the commercial and sophisticated intermediaries of television, advertising and digital communications.

My title for the exhibition, *Unpopular Culture*, stems from a notion that, unlike today, in Britain during the period represented by this show, stories about art did not feature daily in the broadsheets nor did contemporary artists crop up frequently in gossip columns. If you had asked a taxi driver in the 1950s to name a British artist, they would probably have struggled to name one. If they could have, it would most likely have been John Bratby, who lived his life in public and vigorously pursued publicity. Artists like Henry Moore and Barbara Hepworth were becoming well known on an international stage. On the whole though, it was a time when modern art did not attract the masses and was seen as an even more rarefied activity, practised and appreciated by other-worldly bohemians and intellectuals. Falling in the middle of this period, British pop art did enjoy a flurry of fame but I have not included any work by artists such as Peter Blake, David Hockney or Richard Hamilton. This is partly due to a suspicion that the swinging Sixties, in all its groovy glory, was really only enjoyed by a minority, and partly because I'm a bit tired of the hackneyed nostalgia for a psychedelic, World Cup-winning, Mini-driving, miniskirt-wearing, Beatles-loving supposed golden age. Perhaps I'm guilty of autobiography as analysis, but I was born in 1960 and I am sure I am not the only one for whom the Fab Four were but distant black-and-white spectres on *Top of the Pops*. In an article in the *Guardian*, Liz Jobey describes photographer Tony Ray-Jones's return to Britain after five years in the United States in 1966 to find London swinging but the rest of Britain still clearly divided by class and tradition. In the decade of cultural revolution, I never went into an art gallery and didn't even know that homosexuality or recreational drugs existed.

To me, the 1960s blend with the preceding decade, a period that I see in clichéd terms of austerity and anxiety. In 1950, Cyril Connolly in his closing editorial of the magazine *Horizon* famously summed-up the gloomy intimations of mortality in the national post-war psyche when he said, 'From now on an artist will be judged only by the resonance of his solitude and the quality of his despair.' He was thinking of that poster boy of gruesome angst, Francis Bacon. This nuclear age disquiet was famously described by Herbert Read in the catalogue for the British Pavilion at the 1952 Venice Biennale, which featured sculptures by Lynn Chadwick and Kenneth Armitage: 'Images of flight, of ragged claws "scuttling across the floors of silent seas" of excoriated flesh, frustrated sex, the geometry of fear.'

Looking at the works in *Unpopular Culture*, thinking of the past, I feel ambivalent. In the photographs and paintings there is a strand of urban proletarian subject matter, the working class at play. Alan Lowndes, L.S. Lowry, David Hepher, William Roberts, Tony Ray-Jones and Patrick Ward show us glimpses of a lost world of close-knit communities but also gritty domestic horrors. I see littered in the compositions

my own memories of fetes, jolly singsongs and days out in Southend, but also in the worried, weathered faces I recall poverty and intolerance. Their poignancy for me tempered perhaps by a feeling of voyeurism towards the working classes, an uncomfortable remnant of my own class travelling and abandonment of my roots.

There is, I think, a uniquely British thread of hushed romanticism in the paintings of Elinor Bellingham Smith, Paul Nash, Victor Pasmore, John Piper, Alan Reynolds and Leonard Rosoman. They know how to make a virtue of grey as only a Briton can. I find, in these pictures, an attractive humility and elegance, qualities that might be described today as not being media friendly, but which I wish to celebrate.

No matter how hard I try to supplant the thought, the principle association the sculptures I have selected bring to my mind is with childhood trips to concrete New Towns and their architecture of catastrophic optimism. Each bronze is to me an evocation of a guano-spattered plinth on a windswept shopping centre. It was modern art in a public place with no agenda of regeneration. A lot of the modernist architecture of the 1950s and 1960s now seems quaint compared to the behemoths of brutalism and post-modernism that were to follow, and in the same way I now enjoy these sculptures of the period for their poetry, tradition and restraint compared to the noisy free-for-all that was to come. They are solid and soulful in a way that deserves our fond appreciation, just as grandee art historian Kenneth Clark demonstrates when he spontaneously pats the head of a Henry Moore maquette as he crosses his study in his landmark series of television programmes, *Civilisation*.

The paintings and sculptures that I have selected for *Unpopular Culture* are nearly all figurative. This is a purely personal bias. Abstract art reminds me too much of beardy art lecturers with grey chest hair poking out of their denim shirts as they spout vague unchallengeable tosh. I associate abstraction with unreconstructed machismo. This prompts me to say that I am sorry there are not more women artists in this show, but the gender imbalance is representative of the holdings of the Collection, which in turn probably reflects the art world of the time.

I have made two works in reply to my selections. They are responses of mood but both refer to one or more specific works. The pot *Queen's Bitter* (2007) picks up on the colours of Jack Smith's *After the Meal* (1952), the painting that I feel is central to the tone of this exhibition. My main influences, though, were the photographs, especially the ethnographic studies of Britain by Tony Ray-Jones and Patrick Ward. These remind me of a more innocent Britain of clubs and hobbies, of 'Knees up Mother Brown' and Mackeson stout. I think of *Queen's Bitter* as a kind of apprentice piece dedicated to beery Britain in the second Elizabethan age. The second piece, *Head of a Fallen Giant* (2007–08), formally relates to the sculptures of William Turnbull and Eduardo Paolozzi via Damien Hirst. It is a large, war-like bronze skull; its subject is the changing face of Britain in the second half of the twentieth century. Perhaps because of multiculturalism, there has been much debate in the

Tony Ray-Jones
Blackpool, 1968

media in the last few years about what Britishness is. Some of the artists in this show, such as John Piper, had a great passion for our national heritage. The work of others, such as Frank Auerbach, Paul Nash or Bryan Wynter, is emotionally linked to specific British places – Camden, Dymchurch and Cornwall – and I can think of no more British an eye than that of Martin Parr. In response, I offer an ethnographic artefact, a voodoo relic of a once huge empire encrusted with a boiled-down essence of itself in the form of tourist tat. Routemasters, the three lions, Beefeaters, Big Ben, Tower Bridge, Bulldogs, all hallowed tribal symbols. Symbols that Brits hold more dear than blinging diamonds, I hope.

I have also designed a headscarf, which is for me a symbol of womanhood in the period represented by the works in the show – worn to preserve a shampoo and set from the northern damp until the evening visit to the working-men's club, and also sported by the Queen, out tramping the heather in Balmoral. Now, of course, the headscarf has a whole different set of meanings in modern multi-faith Britain.

Putting this show together has been an enjoyable experience. I have chosen chiefly to please myself, but in so doing I have perhaps betrayed my attitude to trends in society and contemporary art. My choices are as much about today as the period of their making. Through my selections, I seem to be presenting an exhibition that is defiantly not a quick fix of visual stimulation for an adrenaline addicted consumer. *Unpopular Culture* is perhaps a picture of British culture when life was slower and when, maybe, we were more reflective, more civic and more humane.

STEPHANIE ROSENTHAL
ON PERFORMANCE ART

Move: Choreographing You.
Art and Dance since the 1960s
2010

Move: Choreographing You explored the interaction between art and dance from the 1960s to the present. The exhibition featured works by artists including Robert Morris, Bruce Nauman and Lygia Clark, as well as more recent works by artists such as Mike Kelley and Pablo Bronstein, where choreography is often an analogy for the way that external powers control the physical, psychological and spatial aspects of our lives. A programme of live dance took place alongside the exhibition, with some events taking place within the exhibition itself. Move: Choreographing You *was accompanied by a catalogue featuring texts by dancers, writers and theorists including Susan Leigh Foster, André Lepecki and Peggy Phelan. The essay by the exhibition's curator Stephanie Rosenthal is reproduced here.*

CHOREOGRAPHIES IN THE VISUAL ARTS

Venice Biennale, 12 June 2009. I am at the Arsenale in front of the installation *The Fact of Matter* by the choreographer and dancer William Forsythe. Rings suspended at various heights invite me to float through the room, using hands and feet to swing from one to the next. I am reasonably fit, which makes the first part fairly easy. I move quickly from ring to ring without the need to think twice about taking the path that requires the least effort, because I possess the strength. As my strength begins to wane, I try to use my reserves effectively, switching hands and feet with strategic smarts in order to traverse the room as quickly as possible. When my strength fades in earnest, I lack the energy to think strategically and switch to mere perseverance, and finally I reach the goal. With my feet back on the ground, I feel as though I were flying – my arms and legs appear to be lifting off – I had escaped gravity for a moment. The tension in my muscles abates, and I perceive changes in my own body with great clarity.

Since the late 1990s, Forsythe has created installations that engage with the fundamental questions of choreography. These 'choreographic objects' have been shown in exhibitions, biennials and festivals worldwide over the past decade. Forsythe is not the only choreographer who has suddenly been embraced by the world of visual arts – La Ribot, Boris Charmatz and many others are regularly showing in art exhibitions internationally. Increasing numbers of artists, notably Tacita Dean, Pablo Bronstein and Kelly Nipper to name a few, are discovering an interest in dance and choreography and are integrating it into their work, either in the form of performance, or in their video or film works. Forysthe asks whether choreography can elaborate an expression of its principles that is independent of the body:

Denigrated by centuries of ideological assault, the body in motion [...] is still subtly relegated to the domain of raw sense: precognitive, illiterate. Fortunately,

choreographic thinking, being what it is, proves useful in mobilizing language to dismantle the constraints of this degraded station by imagining other physical models of thought that circumvent this misconception. What else, besides the body, could physical thinking look like?[1]

The answer to this question can be found in the 'choreographic object' – sculptures and installations that Forsythe sees as materialisations of choreographic thinking. In an extension of Forsythe's ideas, I will argue that certain installations represent a form of choreography, works where the visual arts and dance interpenetrate and the categories dissolve.

What may seem new to us today has roots that go as far back as the mid twentieth century. In 1958, the American artist and creator of the happening, Allan Kaprow, concluded his essay 'The Legacy of Jackson Pollock' with the words:

> Young artists of today need no longer say, 'I am a painter' or 'a poet' or 'a dancer'. They are simply 'artists'. All of life will be open to them. They will discover out of ordinary things the meaning of ordinariness. They will not try to make them extraordinary but will only state their real meaning. But out of nothing they will devise the extraordinary and then maybe nothingness as well. People will be delighted of horrified, critics will be confused or amused, but these, I am certain, will be the alchemies of the 1960s.

These words represent an attitude shared by an entire generation of artists after the end of Second World War, when different forms of art entered into an often seamless fusion. In keeping with Kaprow's euphoric assertion, this essay attempts to outline those borderline areas where the visual arts and dance become indistinguishable in the context of the art exhibition: the intersections between installation or sculpture and choreography.

Our traditional Western conception of what unites art and dance is primarily based on the ways in which dance has been treated as a motif in sculptures, paintings and films, as well as on the scenarios that artists have produced for choreographies. Accordingly, exhibitions and discussions in books consider the relationship between art and dance largely on the level of representation.[2] To Kaprow, however, Pollock's *Action Paintings* take a step towards the 'environment':

> The space of these creations is not clearly palpable as such. We can become entangled in the web to some extent and by moving in and out of the skein of lines and splashings can experience a kind of spatial extension [...] But what I believe is clearly discernible is that the entire painting comes out at us (we are participants rather than observers), right into the room.[3]

By virtue of their large dimensions, the paintings turn the viewer into a participant. Pollock's creative process is defined by a rhythmical movement across the canvas,

an action evidenced by the lines of paint: the emphasis is not on the result but on the process. The traces of paint render movement palpable to the viewer. Hans Namuth's film of Pollock working supports this reading: the artist's canvas appears as a stage, the act of painting as a dance. At almost the same time, Kazuo Shiraga, a co-founder of the Japanese Gutai group, also brought movement into his work. Suspended from a rope, he slid his naked feet across the canvas after dipping them in paint, leaving the traces of his circular movements. In another work, he wiggled his way through mud, imprinting his movements into the ground and turning the world into his canvas. Finally, in Yves Klein's *Anthropometries*, female bodies became brushes, the artist their choreographer. In each instance, the process is just as important as the result. Traces of paint record movement and thus convey it to the viewer. This renders them a form of choreography.

I understand choreography to be any descriptive notation or, in the wider sense, prescription of movement. With this definition I follow Susan Leigh Foster's essay in this publication, as well as William Forsythe's notion that choreography is 'a class of ideas', with the idea being 'a thought or suggestion as to a possible course of action'.[4]

SIMONE FORTI: DANCE CONSTRUCTIONS

Dancers perform choreography by Anita Pace for Mike Kelley's *Test Room* (1999). Installation view, *Move: Choreographing You*, 2010

One could argue that since the late 1950s the term 'choreography' has also been applicable to painting, sculpture and installation art. Works of art invite visitors to an exhibition to perform certain movements, effectively creating a choreography for them. Movement becomes an element of the artwork by virtue either of the traces it leaves on the canvas or of the interaction between viewer and work. My interest, then, is in the ways in which artists strategically employ choreography in their installations and sculptures.

The choreographer, performance artist and writer Simone Forti created works that would prove seminal to this development. In 1959, she and her husband, the artist Robert Morris, moved from California to New York. In California they had attended the workshops of Anna Halprin – one of the leading dance figures at this time. The works Forti created in New York became seminal for the development of dance.[5] *See-Saw*, for example, was first performed in 1960, at the Reuben Gallery, New York, a hot spot of the artistic avant-garde co-founded by Kaprow. It was here, a year earlier, that Kaprow had realised his *18 Happenings in 6 Parts*, establishing the happening as a concept.

See-Saw consisted of a simple instruction:

> This piece, performed by a man and a woman, is about twenty minutes long. It requires a plank about eight feet long, and a saw-horse, used together as a

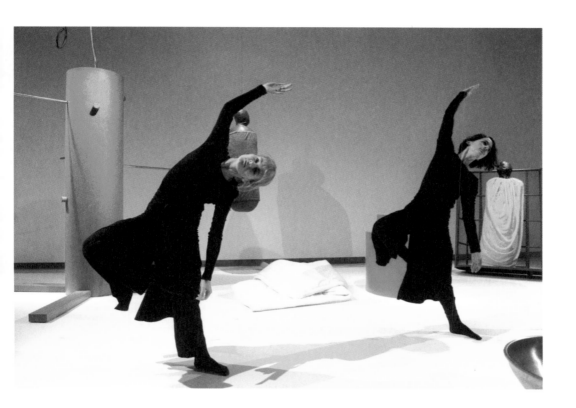

see-saw. At each end of the plank, three hooks correspond to hooks placed in the two opposite walls. Elastics are attached from the hooks in the wall to the hook in the boards, forming a long line from the wall to wall which zigs and zags as the see-saw shifts balance back and forth. Attached to the bottom of one side of the see-saw is a noise-making toy that goes 'moo' every time it is tipped.[6]

There must have been a lot of laughter when Morris and Yvonne Rainer first rehearsed the piece with Forti. And it was a historic moment, too. They were suddenly able to say: 'This is dance! Forget everything you've seen on the stage until now.' There were no predefined structures: instead, the dancers followed a 'task line'. During every performance, they had to tackle anew the task that they had set themselves: the see-saw became the choreographic basis and the point of departure for their improvisation. Everyday movements became dance, and dance became everyday: life and art united.

Similarly, *Slant Board*, which Forti first presented in 1961 as part of *Five Dance Constructions and Some Other Things*, used a wooden structure to test new forms of movement in subtle ways:

The piece begins when three or possibly four people, wearing tennis shoes for traction, get on the ramp... The movement should not be hurried, but calm, and as continuous as possible. The activity of moving around on such a steep surface can be strenuous even when done casually. If a performer needs to rest, she may do so by using the ropes in any way she can to assume a restful position. But the performers must stay on the board for the duration of the piece.[7]

This performance, too, took place not on a stage but in a gallery-like room.

Forti's dance constructions enabled the dancers to test the gravitational heft and physical capabilities of their bodies: their movements are only slightly stylised and dance is reduced to its basic vocabulary. Forti, in parallel with choreographers from the Judson Dance Theater,[8] among them many of Merce Cunningham's students, explored these alternative farms of movement, calling the traditional parameters of dance into question.

Only a short time earlier, expressive dance had dominated the scene. Choreographers such as Martha Graham (1894–1991) had championed the primacy of emotion over movement. The young generation now sought to sever the cohesion between movement and music, to make more room for randomness and improvisation, and to explore new com positional procedures. Rather than the 'emotionalexpressive force of movement', at issue was a 'plastic-fluctuating creative force'.[9] The repetition of simple sequences of movements became a popular device – one of numerous parallels between dance and Minimalism in the visual arts.[10] Choreographers now examined the physical features of the body, its relation to the space and time of movement. They left the stage, realising their performances instead in places such as the Reuben Gallery, the Judson Memorial Church or in the urban space – sites that dissolved the classical theatrical situation and allowed the audience to form a circle around the performance rather than sitting in row of seats frontally facing a stage. Other examples of this phenomenon include pieces by Steve Paxton. Robert Rauschenberg and Deborah Hay,[11] as well as Rainer, who, in works such as *Room Service* (1963), *Parts of Some Sextets* (1965) or *The Mind Is A Muscle* (1968), used 'found objects' such as mattresses, car tyres, chairs, ladders, etc.[12] Some of these choreographies recall gymnastic exercises: the dancers drop from a high bar or vault over piles of mattresses. Rainer emphasised the role played by the objects in this context: they enabled the dancers to 'move or be moved by some *thing* rather than by oneself'.[13]

Forti, who from the early 1960s worked with large, simple wooden structures, would exercise a vital influence over artists such as Morris. She saw these structures, which she had asked Morris to build for her. not as sculptures but as purely pragmatic 'movement apparatuses'. They often suggest gymnastics or playground equipment: everyday sequences of movement came front and centre. fusing life and art. This credo – and a love of improvisation – also informed work being done in other fields, such as music (John Cage) or the visual arts (Kaprow). causing a revolution in the New York arts scene of the 1960s.

Kaprow wanted participants. not spectators, for his art. Pollock's Action Paintings created the first spark: 'Pollock [...] left us at the point where we must become preoccupied with and even dazzled by the space and objects of our everyday life, either our bodies, clothes, rooms, or, if needed, the vastness of Forty-second Street.'[14] Kaprow saw himself as an 'Un-Artist/Non-Artist'.[15] With his happenings, he stepped outside the arts scene and into public space. Through artists such as Forti, Rainer and Robert Whitman, he was in touch with the Judson Dance Theater. Unlike his later happenings, the *18 Happenings in 6 Parts* were based on a detailed script running to around 50 pages. In this context is interesting to note that these sequences of movements. though highly stylised, evinced a simplicity and a proximity to everyday life that reveal significant parallels with the later works of the Judson Dance Theater.

The interest – shared by an entire generation of visual artists – in the unique event. in playfulness and an exploration of one's own body, was reflected in the development in postmodern dance. The critique of the reification, and hence commodification, of the work of art reached a climax. No wonder, then, that artists welcomed dance as a way to elude the art market, and capitalism with it. Both conceptual art and minimalism lent expression to this desire by changing the status of the work of art: while some bade farewell to objecthood, turning the idea into the work, others emphasised it. The works discussed here build a bridge between these two approaches.

THE VISITOR STARTS TO DANCE

I'd rather break my arm falling off a platform than spend an hour in detached contemplation of a Matisse.
ROBERT MORRIS, 1971[16]

In all the pieces discussed so far, the performers were either trained dancers or fellow artists. A clear distinction was still made between performers and audience, although the way in which the latter was positioned already assigned it a completely new role. One exception was the choreographer Trisha Brown's *The Stream* (1970): she placed her work in public space – right in the middle of New York's Union Square – making it available to a general audience. Arranged inside a U-shaped wooden structure were pots and pans filled with water. Passers-by could either step into the water or swerve to avoid it.[17] Artists such as Rainer also considered the role of the spectator; not for nothing does Carrie Lambert-Beatty call Rainer a 'sculptor of spectatorship'.[18]

It was Morris who took the decisive step in 1971, creating. in an installation for the Tate Gallery in London, what was explicitly a choreography for the exhibition space. The visitor was to experience the show through his own body: 'The show is more environmental than object-like, offers more possibility – or even necessity –

of physically moving over, in, around, rather than detached viewing.'[19] He staged a course of sculptures made from a variety of simple materials such as wood or metal in the Tate's Duveen Galleries. thus realising a choreography that required neither instructions nor rehearsals but allowed visitors to experience the work through their own bodies. 'The works were based on progressive physical difficulty as one proceeded toward the end of the space', he commented.[20] There were slanted wooden surfaces to be ascended with the help of ropes. tunnels to be crawled through. see-saws and parallel bars to be balanced on, and a wheel that let visitors roll upside down. In contrast to Forti's works, his installation turned the audience into dancers. His sketches demonstrate the precision with which he balanced the arrangement of the objects, which made use of the entire length of the hall. The fact that the show had to be closed after only four days for safety reasons is evidence that Morris had succeeded in realising sculptures as 'instructions to act'.

We can draw a direct line from Morris's Tate exhibition to Forti's earlier choreographies. In the late 1950s, Morris had occasionally accompanied his wife to Anna Halprin's workshops in San Francisco.[21] Forti recalls:

> I remember vividly the movement Bob did on this particular day. He had observed a rock. Then he lay down on the ground. Over a period of about three minutes he became more and more compact until the edges of him were off the ground, and just the point under his center of gravity remained on the ground.[22]

It is as though Morris had become his own sculpture. At the Judson Memorial Church, he realised choreographies such as *Arizona* (1963) and *Site* (1964), whose central motif was the act of moving heavy sheets of plywood.[23] In these dance pieces he tested what would later become the foundations of his installation; at the same time. he created his early minimalist works such as *Untitled (Slab)* (1962).

What Morris and other artists learned from dance was the presence of the body on a visual and physical level:

> My involvement in theatre has been with the body in motion […] In retrospect this seems a constant value which was preserved. From the beginning I wanted to avoid the pulled-up, turned-out, anti-gravitational qualities that not only give a body definition and role as 'dancer' but qualify and delimit the movement available to it. The challenge was to find alternative movement.[24]

Other choreographers with the Judson Dance Theater left a lasting impression on Morris's work, as did Yvonne Rainer, with whom he was romantically involved off and on between 1964 and 1971. As Richard Serra said, Rainer's performance led to a new conception of the body in art: 'the body's movement not being predicated totally on image or sight or optical awareness, but on physical awareness in relation to space, place, time, movement'.[25]

BRUCE NAUMAN AND DAN GRAHAM: 'A SORT OF DANCE'

The works of Bruce Nauman and Dan Graham can likewise be considered in this context. In the 1960s, Nauman approached sculpture via dance and performance art, testing the limits of his own body and inviting the viewer to do the same in works such as *Corridor Installation (Nick Wilder Installation)* (1970) or *Green Light Corridor* (1970). He undertook experiments on himself resembling those of the Californian choreographers, focusing on spontaneous, unpretentious, everyday movements. In his early performance pieces from the 1960s, objects not unlike Forti's constructions invited specific movements: 'An awareness of yourself comes from a certain amount of activity and you can't get it from just thinking about yourself. You do exercises, you have certain kinds of awareness that you don't have if you read books.'[26] By the late 1960s, his performances had come to consist of action pure and simple, no longer involving objects. He also recorded movement studies on film or video. In works such as *Dance or Exercise on the Perimeter of a Square, 1967–8, Slow Angle Walk (Beckett Walk)* (1968) and *Bouncing in the Corner* (1968), he repeated certain movements to the point of exhaustion. At the time, Nauman talked to the choreographer Meredith Monk. 'Meredith Monk […] had thought about or seen some of my work and recognized it […] I thought of them as dance problems without being a dancer, being interested in the kinds of tension that arise when you try to balance and can't. Or do something for a long time and get tired.'[27] He also recalls that it 'was really good to talk to someone about it. Because I guess I thought of what I was doing as a sort of dance because l was familiar with some of the things that Cunningham and others had done, where you can take any simple movement and make it into a dance just by presenting it as a dance.'[28]

Soon after his performances and works on film and video, Nauman began to make simple corridors constructed from plywood panels. These works, which fused performance and sculpture, ranged from single corridors to multiple corridors connected to produce the appearance of labyrinths, some of them with integrated video recording systems. With its narrow interior spaces, which could, in some parts, only be traversed by walking sideways and its green lighting and sound-absorbing walls, *Green Light Corridor* (1970) created a very specific – to some visitors, claustrophobic – situation that generated a heightened perception of the body.

Although his corridors solicited the audience's participation, the visitor-participant could not alter the fundamental structure of the work in any way.[29] Nauman deliberately controlled his audience:

> All you could really do was just walk in and walk out and it really limited the kinds of things that you could do […] Because I don't like the idea of free manipulation […] I really had some more specific kinds of experiences in mind and […] I wanted to make kind of play experiences unavailable, just by the preciseness of the area.[30]

The extent to which the artists permitted participation varied from work to work, and was not always subject to their control.

Nauman remembers, for example. how dissatisfied Morris was that the audience completely changed one of his works when he had not intended this to happen.[31] The artists recognised the important point that participation might also take place purely in the imagination.[32]

Dan Graham, too, closely studied the perception of the body in the early 1970s. Forti's influence on him was decisive.[33] In works such as *Helix/Spiral* (1973), realised in collaboration with Forti, he called into question conventional notions of pace, image and visual perception. His filmic performances often aimed at observing and discovering himself and the other in space. He uses the camera and/or the monitor to achieve a defamiliarising effect. The user sees a time-delayed and distanced representation of his own movements. Once again, simple movements play a central role; lifted out of their context, they can be perceived in their essence.[34]

Morris, Nauman and Graham, unlike Forti, turn exhibition visitors into dancers. 'I wanted a situation where people could use their bodies as well as their eyes', Morris wrote.[35] The formats and sizes of his works enabled an experience of the body in its concrete existence in space; with this aim, Morris also described a central desideratum of Minimalism;[36] the primacy of the co-presence of work and viewer over the internal structure of the artwork is considered a constitutive feature of minimal art.

This situation-specificity of the experience of art prompted the critic Michael Fried to charge the artists with 'theatricality', calling instead for the creation of a lasting and timeless presence.[37] But Morris saw his works as bridges leading to a more intense perception of the viewer's own body.

> From the body relating to the spaces of the Tate via my alterations of the architectural elements of passages and surfaces to the body relating to its own conditions [...] the progression is from the manipulation of objects, to constructions which adjust to the body's presence, to situations where people can become more aware of themselves and their own experience.[38]

LYGIA CLARK: CONNECTING INTERIOR AND EXTERIOR WORLDS

At around the same time, the Brazilian artist Lygia Clark developed an interest in the interrelation between human being and object, which led to her belief that her sculptures truly existed only in interaction with the viewer:

> Deep down, the object is not the most important thing. The thought – the meaning which it lends to the object, to the act, is what matters: That which goes from us to the object [...] In my work, if the spectator does not propose himself toward the experience, the work does not exist.[39]

The results were works such as the *Máscaras sensoriais* (*Sensory Masks*, 1967), *Pedra e ar* (*Rock and Air*, 1966), or *Camisa-de-força* (*Straight Jacket*, 1969), most of which were simple constructions made of plain materials that offered sensual surfaces. Clark describes her *Straight Jacket* as follows:

> Stones and six nylon sacking bags. One of the bags covers the head. On the bottom end of the bag, connected to it by an elastic band, a smaller bag with a stone inside it. At each side of the large bag, another bag covers each arm, and a little bag containing stones hangs from each of them by an elastic band.[40]

This description must be read as an instruction to the viewer, who is to slip into the objects as if into a piece of apparel. This contact with the body, Clark believed, was of central importance: her works were designed to stimulate a re-evaluation of everyday routine movements. The sensuality of her works speaks to an erotic life and experience of the body very different from the experience of the Americans. In the late 1970s, her interests led her to the 'Relational Objects' that she employed in her therapeutic practice, using them to unleash emotions that would enable patients to experience a new sense of union with the world. Rather than turning the human body into a sculpture, she sought to create an opportunity for the members of her audience to experience their own bodies and the effects that objects have on them.

In 1969, Clark realised *The House is the Body*: a series of narrow rooms defined by various materials – fabric, rubber, plastic, hair – into which visitors were able to enter in fixed succession, as if passing through the human body. The rooms were entitled 'Penetration', 'Ovulation', 'Germination' and 'Expulsion'. In this and other works, it was important to Clark that the viewer should be able to perceive the work with their various senses. As Guy Brett wrote:

> Clark's innovation had far-reaching implications. According to a perceptive recent analysis of the nature of 'visuality' in modern western culture, our current ways of seeing have been decisively influenced by a historical process whose effect has been 'to sunder the act of seeing from the physical body of the observer, to decorporeatize vision.' [...] It becomes fascinating to interpret Lygia Clark's experiments in the 1960s as a pioneering attempt to re-integrate visual perception with the body as a whole, to reconnect the interior and the exterior world, and the knower and the known.[41]

Like Clark's works, the *Paßstücke* (Adaptives) that the Austrian artist Franz West began to realise in the 1970s turn viewers into participants, inviting us to adapt the sculpture to our own bodies or to connect with them by means of movement. As Åsmund Thorkildsen has remarked, West, like Clark, changed the relationship between object and viewer, opening up new levels of perception. In some cases, she exhibited photographs or films that offered instructions: paraphernalia that we can thus read as choreographies of sorts. The artist himself, his friends and dancers,

served as interpreters. An even subtler realisation of the same intention can be found in his pieces of furniture, which explicitly instructed the user to perform certain actions.

Between 1963 and 1969, Franz Erhard Walther created his *1. Werksatz (First Work Set)*: an ensemble of fabric objects to be engaged by the beholder. His *2. Werksatz (Second Work Set)* consisted of metal walk-in objects such as *Standing Piece in Two Sections* (1974). In what he called 'work-actions' and 'work-presentations', Walther invited the members of his audience to experience sensual perception through their own bodies. His main interest with these works, distinct from Clark, was in the question of the extent to which the viewer's body is itself the sculpture.

CHOREOGRAPHIC OBJECTS

By creating works that demand physical exertion, these artists championed the idea of experiencing the world with the entire body. In a variety of ways. this generated a new awareness that we do not perceive with our eyes alone. They realised 'choreographic objects', as Forsythe calls them, as 'an alternative site for the understanding of potential instigation and organization of action to reside'.[42] These works draw our attention to the fact that objects are not self-sufficient entities, or as dancer and choreographer Rudolf Laban put it in his book *The Language of Movement* (1966): 'Movement is, so to speak, living architecture – living in the sense of changing emplacements as well as changing cohesion.'[43] By prompting viewers to experience the works with their own bodies, these 'continuous exchanges and movement' are rendered evident and palpable, changing our understanding of art in profound and lasting ways that become applicable to other situation as well. As Morris writes:

> We've become blind from so much seeing. Time to press up against things, squeeze around, crawl over – not so much out of a childish naïveté to return to the playground, but more to acknowledge that the world begins to exist at the limits of our skin and what goes on at that interface between the physical self and external conditions doesn't detach us like the detached glance.[44]

PERCEPTION AS ACTION

In the mid twentieth century, the question of the role played by the body in our perception of our environment was raised in many areas. After the Second World War, artists seemed to have returned to existential questions such as the relationship to one's own body. The interest in Zen Buddhism, primitive cultures and phenomenology, as well as the Hippie movement, were to a certain degree all rooted in the same origin: the desire for a more primordial experience of the world.

In his *Phenomenology of Perception* (1945; the first English translation was available in 1962), Maurice Merleau-Ponty argues that 'the world surrounds and engenders us' and that we ought to stop 'seeing the world as a counterpart'.[45] Unlike, say, Kant or Descartes, Merleau-Ponty considered the human body our decisive connection to the world. It is, he writes, not only 'our anchor in the world'[46] but also, more importantly, 'that by which it is possible for us to have a world at all'.[47] In his *Gestalt Therapy*, which became very fashionable, Frederick Perls likewise examined the phenomenon of body-consciousness. This lent his book great interest in the eyes of Morris and Nauman.[48] John Dewey's *Art as Experience* and John Huizinga's *Homo Ludens*, both written in 1934, were also frequently mentioned by artists who accorded great importance to the playful approach to the world and the experiential gain offered by art. The desire arose to question the status of art and to redefine its mission in society. In the 1960s, happenings, conceptual art and minimalism made this desire a central issue. This development culminated in the wish to re-evaluate the action of the exhibition visitor. In dance, this was nothing new: the object of perception was already immaterial, being constituted 'on site and in the act of the materiality of the body'.[49]

In his book *Action in Perception*, Alva Noë describes perception as already being an action: 'Perceiving is a way of acting. Perception is not something that happens to us, or in us. It is something we do... The world makes itself available to the perceiver through physical movement and ionteraction.'[50] He also argued that:

> seeing is much more like touching than it is like depicting. Consider the bottle again, which you touch with eyes closed. The bottle is there in your hands. By moving your hands, by palpation, you encounter its shape. Vision acquires content in exactly this way. You aren't given the visual world all at once. You are in the world, and through skillful visual probing – what Merleau-Ponty called 'palpation with the eyes' – you bring yourself into contact with it. You discern its structure and so, in that sense, represent it. Vision is touch-like. Like touch, vision is active.[51]

SOCIAL CHOREOGRAPHY

The 'choreographic' art of Morris, Nauman, Clark, West and Walther was defined by sequences of movement guided by sculptures or installations. These works intensified viewers' experiences of their bodies, changing their understanding of what perception means. Viewers – whom we should now call users – became components of the work. These shifts simultaneously emphasised and cancelled the objecthood of the work. On the one hand, sculpture was reconceived as a solicitation to action – in contradistinction to the auratic and untouchable work of art. On the other. the focus on action and movement entirely dissolved the objecthood of art. This second aspect, in particular, owed much to the engagement with dance.

Two generations later, artists such as Mike Kelley, Pablo Bronstein and Tania Bruguera were able to presuppose this engagement as a given. Their interest in choreography focused on degenerated, artificial, or manipulated patterns of behaviour. Choreography became the image of our own world, with its external powers controlling the physical, psychological and spatial aspects of our action. It thus became a mirror of socio-political structure and mechanisms of manipulation. In his book on *Social Choreography*, Andrew Hewitt has shown 'how choreography has served not only as a secondary metaphor for modernity but also as a structuring blueprint for thinking and effecting modern social organization'.[52]

Mike Kelley's work *Adaptation: Test Room Containing Multiple Stimuli Known to Elicit Curiosity and Manipulatory Responses* (1999/2010) examines forms of human behaviour such as aggression and the exaggerated need for physical affection, as well as strategies of manipulation. Among his references are the psychologist and behavioural researcher Harry Harlow, the choreographer Martha Graham, the artist Isamu Noguchi and the scholar of aggression Albert Bandura. All of them share an interest in primitive human actions that resemble the behaviour of children or animals. Harlow studied the mother-child relationship in baby monkeys, using simulacra that were reminiscent of children's or a dog's toys. Kelley borrows the shapes of Harlow's objects for his own sculptures, bringing them to the size and dressing them in the colours of Noguchi's sceneries for Graham from the 1940s, which, in turn, drew on the primitive sculptures created, for instance, by Max Ernst or Oskar Schlemmer. We can read Kelley's objects as paying homage to modernity: their colours recall both Piet Mondrian's paintings and the figures in Schlemmer's *Triadic Ballet* (1922). The objects are placeholders: in Harlow's experiments, for the mother who offers either warmth or food; in Kelley, for human emotions that require a sympathetic body. They are simulacra representing the human need for love and its flipside, aggression. In Kelley, they quench the human longing for affect.

An integral part of the work is a film that shows a choreography for two dancers by Anita Pace, as well as four performers (two women and two men) who interrupt this choreography. The two women carry out actions towards the objects that alternate between aggression and affection; two men, sometimes in monkey costumes, sometimes in street clothes, imitate the behaviour of monkeys. Both sequences of actions gesture toward primitive forms of behaviour in humans. Whereas Graham was the inspiration for Pace's choreography, the actions of the performers were inspired by Bandura's scientific films. Bandura studied the interrelation between aggression in childhood and the consumption of violent television programmes. Kelley is interested in Graham's use of simple and direct movements that are often the expression of an internal emotional structure. Like Bandura and Harlow, Kelley also examines human behaviour. In the original (1999) version of *Test Room...* a cage enclosed the sculptures, over which a ramp was provided for observers. In the later adaptation, Kelley released the objects from the cage. The choreography was now performed live and not only played on film; the visitors were given the

opportunity to interact with the objects themselves. The choreography became a more central part of the ensemble and lent expression to the manipulation to which human behaviour is subject.

Kelley turns the user into the test subject. He is able to train his muscles as though at a gym, or, like a dancer, use the objects as action instructions or movement aids. At the same time, however, he also becomes a behavioural researcher observing himself. Central to the work is not the invitation to use the objects, but the challenge to reflect on what this invitation could mean, and lays bare our degenerated society. Kelley also adds another layer – one in which we become aware of how we are manipulated. The participant becomes the viewer of his own participation; to question this process critically is part of his role. In Kelley's work, we can experience not only our own bodies, but also what manipulation and heteronomy feel like.

Rather than delivering a moralistic lecture, Kelley offers no explanation and no way out. The people in the film learn nothing from their interaction with the objects and remain isolated and incapable of communication. As in his earlier work *Educational Complex* (1995), Kelley exhibits 'our true, chaotic social conditions, rather than some idealized dream of wholeness'.[53] Unlike the artists of the 1960s and 1970s, Kelley's interest is not in liberating, or raising awareness of the body, but rather in elaborating its state of being controlled.

CHOREOGRAPHY AS EXPRESSION OF MANIPULATION

Other artists, similarly, employ choreography as a means to, as well as an expression of, manipulation. The British artist Pablo Bronstein has realised drawings, paintings, installations and performances in which he combines mechanisms of dance with architecture and queer politics, with a primary focus on social codes and stereotypes.

Bronstein specifically refers to the early baroque era and the concept of *sprezzatura* coined by Baldassare Castiglione. *Sprezzatura* describes an elegant courtly attitude that, despite conforming to a canon of precise rules, aims to seem natural and uncontrived. As Bronstein explains, however, 'I am not interested in its courtly manifestation, more the legacy and how it developed through baroque into classical ballet'.[54] He confronts sequences of movements that match the criteria of *sprezzatura* with the canonical movements of contemporary dance, where natural and seemingly prosaic movements that are not too distant from those of everyday life and deliberately subjected to gravity have been predominant since the Judson Dance Theater's work. The sweating and heavily breathing body is accepted as an inevitable consequence of physical exertion; there is no need to hide it. Bronstein, by contrast, calls the concept of a 'natural movement' into question: 'I've been interested in pedestrian movement for a while, which is based in postmodern danced history. My work balances two ideas of "natural" or artificial behaviour.'[55]

In *Magnificent Triumphal Arch in Pompeian Colour* (2010), Bronstein places an architectonic arch in the centre of the room. The ornamented structure gestures towards the architecture of public squares. Architecture, like movement, embodies different social and political values:

> There are buildings that exist entirely within the paradigm of power and structure, and are perceived as truthful, honest, or better still, are not perceived at all. They are so within the convention that they are comparable to learnt codes of behaviour that are perceived as natural – 'normal' gender-specific behaviour of mannerisms.[56]

The arch through which the performers can step during the exhibition creates a disruption or knot in their everyday movements: the straight line (which matches the style derived from the Judson Dance Theater) becomes the flourish (movement inspired by *sprezzatura*). Bronstein's choreography represents everyday movement without being everyday movement; the performers act in accordance with the precepts of *sprezzatura*, which, to present-day eyes, looks contrived, mannered and affected. 'The body politics of *sprezzatura* would be codified as queer politics now… I love order and power and how you actually subvert power by sexualising it.'[57]

Bronstein's works refer to the intersection between architecture and dance as a way to address the issue of politicised space. The arch in the room defines not a transition from indoors to outdoors but, more simply, from one form of behaviour to another; it is an indicator of change or being different. The disruption takes place in the action, triggered by an architectonic form. We are thus under the direction of an architectonic element that points to the architecture of public urban space – and, more abstractly, under that of the social system for which the arch stands. Choreography lends form to such manipulative strategies.

Lack of control over one's own body is the subject of João Penalva's work *Widow Simone (Entr'acte, 20 Years)* (1996). In what seems like a documentary in a variety of media, he tells the story of a dancer who has performed the role of Widow Simone in the ballet *La Fille Mal Gardée* for more than 20 years and yet does not have the right to transmit the choreographies to others or, in this case, to teach the artist himself. The dancer, that is to say, is a mere puppet: an object.[58]

As André Lepecki points out, control is also a central aspect in Tania Bruguera's work *Untitled (Kassel)* (2002). On the one hand, she choreographs the movement within and outside of her installation; on the other, she reveals the extent to which our environment choreographs us. Blindingly bright lights suggest the floodlit atmosphere of a camp or prison. The loading of guns and the sound of heavy boots marching along an elevated catwalk heighten the sense of oppression and imprisonment.

In Isaac Julien's nine-screen installation *TEN THOUSAND WAVES* (2010), people slosh like water from continent to continent – not always of their volition, but forced

by political or economic circumstances. This work examines a more abstract form of choreography; at the same time, the editing and the way in which the installation directs the viewer conforms to a subtle choreography of its own.[59]

In her work *Walk the Chair* (2010), the choreographer La Ribot gives the visitor a free choice between spectatorship and participation. Scattered across the gallery space are folding chairs with a variety of seat cushions. If visitors accept the invitation to sit down, they become both spectators and performers. The chairs themselves bear instructions for movement: reading the sentences inscribed on them requires turning and lifting them, folding them up and unfolding them again. Visitors determine their own role, taking responsibility for their actions; La Ribot merely creates the initial situation.[60]

SPACES OF ACTION

The works of Tino Sehgal and Xavier Le Roy confront the visitor not with an object but with an interpersonal situation. In works such as *Instead of Allowing Some Thing to Rise Up to Your Face Dancing Bruce and Dan and Other Things* (2000), Sehgal attaches central importance to the interaction between 'interpreter' and viewer. He employs choreography in very precise ways as a sculptural means. Despite their performative character, his works are considered sculptural pieces that exist for a certain period of time and then disappear when the performing artist is gone. Sehgal choreographs the movements of his interpreters in such a way that they acquire a semblance of objecthood. He achieves this effect by enjoining his dancers to move gradually, almost as though in slow motion: rather than moving through the room, moreover, the interpreters lie on the floor. The work thus requires a different form of observation from that employed when watching a performance. In the case of *Instead of Allowing...*, the sequence of movements borrows from works by Nauman and Graham.[61]

The interpreter is the work of art: the visitor, the beholder. The relationship between the two is a decisive element of the work. Sehgal's works are in constant flux due to (however minimal) modifications of the interpretation, but more importantly, by virtue of the particular response of each individual viewer. Nonetheless, he succeeds in lending these ephemeral events a 'work- and object-like status'.[62] Accordingly, he requires that his pieces, like paintings or sculptures, should be on view for the entire duration of an exhibition. In 1970, Nauman framed the idea of leaving an entire exhibition room to a dancer for a certain period of time every day; he penned a clear set of instructions:

> The dancer, dressed either in street clothes or in training wear, enters the large room of a gallery. The attendants clear this room: they merely permit the spectators to watch through the door. The dancer walks through the room, slightly ducked, as though the ceiling were about 30 centimetres below his

own height: he looks straight ahead, without establishing direct eye contact with the audience [...] After completing the performance, the dancer leaves the room; the attendants permit the audience to enter again.[63]

In Sehgal's work, however, the viewer is not excluded from the room; to the contrary, his presence is of decisive importance. The focus is on what takes place in the interaction between work and viewer. The interpreter in *Instead of Allowing...* involves the visitor by looking directly at him, with his hands forming a rectangle as though holding an imaginary camera.[64] The involvement of the viewer is even more immediate in works such as *This Is Good* (2001), where he becomes a protagonist, for it is him alone to whom the interpreter's performance is addressed. In *This Is Good*, Sehgal defines a specific choreography for the museum attendants, who in turn become a choreographic means in the hands of the visitor. The actions of the attendant, unfamiliar in the museum context, solicit new actions on the part of the visitor. Dorothea von Hantelmann points out the fundamental shift that takes place in Sehgal's oeuvre:

> Sehgal's works do not employ material objects at all. Instead, they insist on the specific features of the moving (acting and speaking) body and the possibilities it offers to engender meaning. It is this principle that marks their essential innovative position [...] It is not only – and perhaps not even primarily – what these choreographies represent on, say, a metaphorical, allegorical, or expressive level that matters; what is decisive, rather, is the fact that this body-medium can take place in the context of the visual arts, with its focus on objects, that it can exist and circulate as a work of visual art.[65]

Unlike conceptual art, then, Sehgal's work is directed not against art as a commodity, but against the form of the commodity itself. His is a critique of 'a social model of production in which matter is transformed into (capital or consumer) goods, a model the visual arts reproduce'.[66]

What Hantelmann writes about Sehgal also applies to Xavier Le Roy and his work *Production* (2010), developed in collaboration with Mårten Spångberg: 'The fact that the works are produced in different fashion ultimately also engenders a different beholder: a visitor who is not a receptive entity but instead an agent who exercises creative and responsible influence over the work.'[67] In LeRoy and Spångberg's view, choreography consists of 'artificially staged action(s) and/or situation(s)',[68] and this is exactly what they realise, with the help of trained dancers, for the entire duration of an exhibition. The action, as such, is the work. They call the dancers with whom they work 'participants', for it is ultimately they who determine their actions, Le Roy and Spångberg having defined the parameters and 'choreographed the space of action'. Such a space is opened up to the visitors as well: the performers invite them to participate in a conversation about work – a choreography of intellectual exchange. In collaboration with the performers, Le Roy and Spångberg have developed methods that help stimulate the visitor's interest in this communication. The

exchange between them can range from a short dialogue to a guided tour of the entire exhibition. It can begin with a conversation that is individual in each instance, addressing the visitor's views and reflecting the performers' very personal opinions. But the exchange can also begin with the execution of a piece of choreography. The result is a dialogue – whether physical or verbal – about questions of choreography, as if sculpting a thought process. The participants in Le Roy and Spångberg's work become 'living sculptures' who exist only at the moment of conversation. Clark spoke of a 'communal body'; what they create is something similar: a body created by communication.[69] Comparable to the bodies that shift on top of one another and become 'entangled' in Forti's *Huddle* (1961), their work accumulates ideas. At its centre stands the human being, his physical presence, gestures, language – and not the dancer, exhibition visitor or artist. The work is about an exchange of ideas between individuals in a concrete, material and present situation – an important act of reflective assurance in a time of virtual worlds.

As Michael Kliën writes: 'Choreography is everywhere, always, in everything. I no longer see in pictures. I see movement and interrelation, exchange and communication between bodies and ideas.'[70] We are only beginning to discover the extent to which dance and the visual arts inspire one another and shape our view of the environment in which we live. An engagement with choreography seems to offer us the opportunity to free art – and hence the world – from the predominance of the object. Sehgal, Le Roy and Spångberg stage 'the becoming-objects of actions'[71] – which is to say, precisely what Forsythe defined as the form of choreography that defined the beginning of the twenty-first century. The focus of attention is on human action, and this may also explain the recent surge in popularity that choreography has enjoyed in a great variety of fields. It is connected to the call for self-determination in action and the conviction that art can guide us in this self-determination. The museum is no longer conceived merely as a place where objects are on view, but also as a site where 'values and ideologies are represented in works of art'.[72] The critical engagement with choreography provides the visual arts with strategies that allow it to show people that they are responsible for their own actions – that they can, may and must act according to their own will.

ALI SMITH
ON TRACEY EMIN

Tracey Emin:
Love Is What You Want
2011

Since the early 1990s, Tracey Emin has used her own life as the starting point for her art, exposing the intimate details of her personal history. Disarmingly frank and yet often profoundly private, much of Emin's art is animated by her playful and ironic wit. This major retrospective exhibition featured painting, drawing, photography, textiles, video and sculpture, in works by turns tough, romantic, desperate, angry, funny and full of longing. Seldom-seen early works and recent large-scale installations were shown together with a new series of outdoor sculptures created especially for Hayward Gallery. The exhibition was accompanied by a comprehensive monograph featuring texts by art historian Michael Corris, writer and academic Jennifer Doyle, Hayward Gallery curator Cliff Lauson, as well as the following text by award-winning novelist Ali Smith.

EMIN'S EMENDATION

A *cunt is a rose is a cunt.* This is the title of an Emin monoprint from the year 2000. It's a reclining female nude, legs and torso neatly nicked off above the chest and at ankle and shin level, a body sloping backwards from the raised legs downwards, so that, held vibrant and prominent right at the centre of the drawing, there's not just the vibrating smudge and scribble of female genitalia but also a sense of something solid emerging from it, a shape cut in air, made by the crook of the upper knee and the line of the lower thigh.

A cunt is a rose is a cunt is Emin's reworking of the famous/notorious line from a 1913 poem called 'Sacred Emily' written by Gertrude Stein: 'Rose is a rose is a rose is a rose.' It was probably in turn inspired by Juliet's comment on Romeo's name, three hundred years before Stein: 'What's in a name? – That which we call a rose / By any other name would smell as sweet' (and Shakespeare was a writer not averse to the odd pun on the word *cunt* himself). What would Stein, the great literary structural experimenter, have made of Emin's emendation? Here's what she said in 1935 when some students in Chicago questioned her about it (the public liked to make fun of Stein, who endured a lot of ridicule right across the high art-low art spectrum for the risks she took with structures and her serious playfulness with syntax):

Now listen. Can't you see that when the language was new – as it was with Chaucer and Homer – the poet could use the name of a thing and the thing was really there. He could say 'O moon', 'O sea', 'O love', and the moon and the sea and the love were really there. And can't you see that after hundreds of years had gone by and thousands of poems had been written, he could call on those words and find that they were just wornout literary words. The excitingness of pure being had withdrawn from them; they were just

ALI SMITH ON TRACEY EMIN

rather stale literary words. Now the poet has to work in the excitingness of pure being; he has to get back that intensity into the language. We all know that it's hard to write poetry in a late age; and we know that you have to put some strangeness, as something unexpected, into the structure of the sentence in order to bring back vitality […] Now you all have seen hundreds of poems about roses and you know in your bones that the rose is not there. All those songs that sopranos sing as encores about 'I have a garden! oh, what a garden!' […] Now listen! I'm no fool. I know that in daily life we don't go around saying 'is a… is a… is a…' Yes, I'm no fool; but I think that in that line the rose is red for the first time in English poetry for a hundred years.[1]

The 'can't-you-see?' of this. The insistence on *listen*. The repeating immediacy – now, now, now. The emphasis on the importance and excitement of aliveness; the intensity. The focus on strangeness; the understanding that something strange introduced into the structure of things renews things: Stein's isn't a bad lens through which to see Emin's own practice. For Emin a word like 'cunt' is excitingly multiple. In her work it ranges across the whole spectrum of resonance, from affirmation, celebration, punchy frankness to unpleasantness, insult and mundanity, via the still-thrilling buzz of the just-not-said, and all simultaneously, all in the swivel of a repetition, the shape a word cuts in time. There's also, here, the cheek, the wit of her retake on Stein's rose, since for sure Stein knows that a rose means more than just a rose. 'And then later', Stein says of her ring of words, 'what did I do? I caressed completely caressed and addressed a noun.' Emin, too, is a caresser and addresser when it comes to verbal and conceptual certainties and ambiguities.

Inherent ambiguity is something she's well aware of if you look at the photograph, from the same year as *A cunt is a rose is a cunt*, called *I've got it all* (2000), where she sits with her legs splayed open, clutching notes and coins to her cunt either as if the cash is exploding out of her in fairground fecundity, spilling out like she's a giant fruit machine, or she's in the act of cramming it into herself. The title in tandem with the portrait, a brilliant ambiguity in itself, is a comment on worth, filthy lucre, on what success is, on a kind of double-edged state that's part desperation and part reassurance. It's worth comparing this picture to her appliqué blanket of two years later. In a similar image, and under huge lettering reading 'Something's Wrong', with the phrase 'terably wrong' much smaller, like an echo, and sewn to read backwards above it (a demonstration of terribleness in its own misspell of terrible), a weird uncountried coinage spills out between the legs of a painfully contorted woman.

There's a material bleed in this, a loss of worth, in the coming together of cunt and money. Throughout her work Emin addresses the wrongness of things. Her versatile figuring of 'cunt', both verbally and visually, focuses on the repeated motifs of lost foetus and abused child or woman, and at the same time there's the robustness, the witty taking-to-task of jargon in her video work *Tracey Emin's*

CV. Cunt Vernacular (1997). Here she emends the concept of curriculum vitae and gives what's happened to her in her life its own very local (and crucially generational) idiom, one that's much deeper than surface appearance, as the film makes clear, panning round Emin's detritus-strewn flat as her voice-over lists the happenings in her life so far, then ending with the date of the death of her grandmother, with a view of Emin herself crouched, foetal, naked on the floor, and her mother, the next generation, sitting above her on the couch.

The thing about Emin is, she's really good with words. Maybe no one, until now, has so energised, understood, made visible, the possibilities of this particular, powerful word: *cunt*. Partly such energising is art's responsibility, one that works, by means of what W.G. Sebald calls 'keeping faith with unsocial, banned language',[2] to question, understand and, with any luck, transcend the proscriptions and the inarticulacies of whatever time we happen to live in. There's a parallel in Emin's punk insertion of the word 'fucking' into the construct 'red, white and blue' in her neon of 2002, *Red, White, and Fucking Blue*, where the word 'Red' is red neon, the word 'White' and the '&' are white neon, and the words 'Fucking' and 'Blue' are blue neon, and suggest everything that could make you feel blue (in all senses of the word) in the cliché of the concept of being British. Plus, there's her general democratising, the total unpretentiousness – for instance, in one of her Princess Diana monoprints of 1999, where she writes 'Regardless of class or status no woman deserves what thoes cunts put you through – LOVE WAS ON YOUR SIDE.' With Emin, art is about articulation: its questions, impossibilities and, above all, the fluidity and changeability of register.

At the same time it's really very British, reminiscent of something a bit Lawrentian. Mellors, the close-to-nature gamekeeper in *Lady Chatterley's Lover* (1928) – a novel that's all about chatter, and the upper, the lower, the chattering classes – can switch rhetorical registers with ease, talking to his penis one minute ('Ay, th' cheek on thee! Cunt, that's what tha're after. Tell lady Jane tha wants cunt'), the next minute laughingly aphoristic to Constance Chatterley ('Blest be the tie that binds our hearts in kindred love'). Something in this resembles the versatile split-second shift from cloy to edge, from acrid to sentiment and back again, in Emin's work; the neon *Be Faithful to your dreams* (1998) next to *Good Smile Great Come* (2000) next to *MY CUNT IS WET WITH FEAR* (1998) next to *Love is What You Want* (2011). (I also love that elsewhere in her work Emin has played this last one as *Love Is What You Wont*.)

Something in it is prefigured, too, in work by groundbreaking writers like Angela Carter, a genius of verbal and narrative reclamation and emendation, and the American post-beat writer Kathy Acker, whose seminal, anarchic 1978 novel *Blood and Guts in High School* is also a work of words and pictures with its graphic genital line drawings, including one of the labia labelled underneath in typewriter typeface 'My cunt red ugh'. (Acker was influenced, in turn, by the

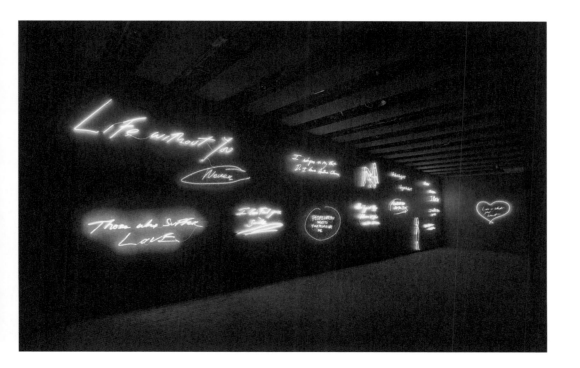

1960s and 1970s feminist performance artists, for instance Carolee Schneemann, one of whose practices was to pull a rolled scroll out of her vagina then read out what was written on it.) Somehow Emin goes beyond: with her it's as if Warhol and Valerie Solanas were rolled into the same person, but minus his posture of obliquity and spaciness, minus the violent fixity of her political focus. Something else, something unexpected and difficult to articulate happens. As Jennifer Doyle says, about looking at Emin's repeated graphic versions of what Courbet calls 'the origin of the world', 'I couldn't help but think: "Isn't this how Judy Chicago and Georgia O'Keeffe are supposed to make me feel (but don't)?"'[3]

'It's about a tremendously physical feeling', Emin says about her neon *MY CUNT IS WET WITH FEAR*. 'To be so aware of what's going to happen and so afraid, but also so excited by it that it makes you wet. But anyway, if I said my vagina is wet with fear it wouldn't sound so good would it? And, Henry Miller said that cunt is a fair enough word to use as long as there is something in front of it and something behind it. And yes, sex can be brutal.'[4] Emin's ear for the right word in the right place, and for the resonances of 'rightness' and 'wrongness' in word and place, are at the basis of her art.

Take her play on meaning in the pair of neons, *Is Anal Sex Legal* and *Is Legal Sex Anal*, both 1998, so simple and so complex at once, so centrally about how (and

where) words mean, and so witty about proscription, with shades too of Lewis Carroll's Alice lazily falling down the rabbit hole, in a swoon, pondering do cats eat bats, do bats eat cats? 'And what is the use of a book', thought Alice, 'without pictures or conversation?' Emin – while she brings straight to the surface all the things, including survival, Freudian strangeness, child/adult sexualities and innocences, which go unsaid or remain subconscious in the work of a writer like Carroll – is drawn to the place where meaning and consumption come together, fascinated by the conversation that happens when words and pictures meet, a dialogue most of us come across as soon as we first look at books. 'I love writing', she says. 'I think every artist has a backbone to what they do. For some it could be photography, painting, the ability to make a formal sculpture stand, but for me it's writing.'[5] For her, art is language and, as she put it in the press release for her very first show, 'art has always been, a lot of the time, a mysterious coded language. And I'm just not a coded person… What you see is what I am.'

This unpretentiousness has made Emin a national symbol. Her uncodedness, her frankness, her direct use of her own life in her work, have made her a repository, in the media and to some extent in the general public's eye, for all that's contentious in contemporary art. It's easy to dismiss, simplistically, her complex and redolent use of self-portraiture as ego-posturing. But the thing is, there's no pinning her down. There's no reducing Emin. No matter how – or how much – the media strings her up (one minute lunatic, the next the new William Blake), her work engages the nation, and has engaged it now for more than 20 years, in a dialogue about art and life and the crossovers between both. It does this at what might be called a language-sensitive place. It's a place directly about consideration, not just of the worth and meaning of words and things, but the worth of the human state, the worth of the self.

She is multitalented, multifaceted; aesthetically endlessly versatile; there's no form she won't try. This aesthetic energy is a form of efflorescence worth celebrating; a fecundity in itself. Energy, Blake said, is eternal delight; it's maybe not emphasised enough, the sheer delight to be found in Emin's energy, in the play of her ambiguities, in the way she tells it. Somehow nothing circumscribes her. That's a delight in itself.

*

From Blake's illuminated books to Stevie Smith's strange, pithy little illustrated verses, from Fra Angelico to Magritte's not-pipe; from the terrible increasing tension in Charlotte Salomon's *Leben? oder Theater?* to Gilbert & George's *Dirty Words Pictures*: artists and writers have worked for centuries with what happens when text and visual art come together. For Emin, it's another of her many modes of dialogue. In one of her monoprints, a girl wearing high-heeled shoes, with a smudge for a face, stands next to the words 'dog' and 'brains'. Is she saying it about herself? Is she hearing it said about herself? The instability makes something momentary into something piercing and shaming.

In her book *those who suffer love* (2009), eleven monoprints by Emin of a woman masturbating accompany the text like a restless flickerbook; but the repeated shifts of the body up against the text make the text come alive, while the text itself, sometimes banal, sometimes funny, sometimes anguished, rubs up against the body to make the whole thing both pathetic and satisfying. Its title, a statement in its own right and an adjectival phrase, is a typical Emin reflexive. Considered carefully, it becomes more than itself, in the same way that the title of her celebrated tent-work, *Everyone I Have Ever Slept With 1963–1995* (1995) played on the phrase's colloquial sexual meaning and was mischievously, seriously, quite literally, a list of everybody she had ever gone to sleep next to (including herself).

In Rembrandt's *Belshazzar's Feast* (1636–38), Belshazzar and his coterie turn and see, as it were, the writing on the wall. The words are all aglow with ancient holy neon. They're being written in the air, as the figures watch, amazed, by a divine and knowing hand. They tell Belshazzar and his guests that what Belshazzar has done in the past is about to dictate his future. Critics have noticed, over the centuries, that Rembrandt seems to have mistranscribed one of the Hebrew characters, and also that, where Hebrew is usually written from right to left, Rembrandt instead has placed his words in columns that read oddly, from up to down. Did Rembrandt make a mistake? Rembrandt? Or is what's happening here an enactment of the words appearing as if by magic in sheer immediacy; an enactment of the strangeness, the vivid otherness of the message; a proof of the momentariness, the volatility of words that any second may fade; and a suggestion that something's being rewritten as we watch, something's been thrown into the air, things are not quite as they should be.

When Emin uses only one 'S' in her embroidered transcribing of the word 'PICASO' in *So Picaso* (2008), and places a jaunty nude below the word, something equally immediate happens. A whole new Picasso, a whole other possibility of the notion of Picasso, happens. A different Picasso. Is there such a thing as correct art, or a correct artist? What happens when you put concepts of correctness, incorrectness and art together?

The missing letter makes you look twice, look again. It makes you wonder if it's a mistake or a retake. It makes you resee, reread what you're seeing. Emin, by leaving something out, or by turning a letter back to front, by adding something extra, by splitting a word into its component parts, returns you to the word so that the eye is reminded to be open – the mind too – in an engagement about whether something really says what it seems to say, really means what it seems to mean.

Monoprint is one of her favourite forms: 'it's a very quick way to make a drawing', she says in an interview in 1997. 'You ink up a sheet of glass, place the paper on top of the ink, draw through the back of the paper, and there you have it. Each one

can take less than a minute. I like it a lot because of its magic – you never know what the print's going to be like when you turn it over.' It also means you can't change what you've made, that each one is unique, carrying its own instability and speed in its outcome. It acts as a mirror of itself. In a way, the monoprint is a perfect exercise in what Stein called 'the excitingness of pure being', a live form, a thing caught exactly at its moment of coming into being. Emin herself compares the technique to the literary one of stream of consciousness. Her visual use of language often consciously suggests energy, haste, the trouble of something lost or missing or difficult to decipher – above all suggests human input on a set system, a hotness and urgency, articulation as a kind of smudge-work.

Emin's blankets are voice-works. It's as if they were hung out and caught language as it passed through them, from tiny detail to huge declaration (it's one of the brilliances in Emin, that she seems to speak with one voice at the same time as with many – the voices of self, selves, the dead and the still-alive; in one of her video installations she actually gives voice, as it were, to Munch's silent synaesthetic *The Scream*, and it's as if her work repeatedly asks the question 'Can you hear me?'). *Helter Fucking Skelter* (2001) self-deprecatorily addresses its own paranoia – 'I FIND YOUR ATITUDE A LITTLE BIT NEGATIVE' – as it descends to its last word and its definition of a helter skelter: 'IT'S A SPIRIAL WHITCH GOES DOWN'. The word 'pysco' in *Pysco Slut* (1999) leaves the word 'slut' questionable too.

Her grammar and spelling are part of her working mode to such an extent that tidying them would be as detrimental to both rhythm and sense as removing the dashes from Emily Dickinson's poetry. Her use of handwriting is like a brand (in both senses, of 'burning' and 'logo') of authenticity, something so intimate as to be barely an inch away from threatening; at the very least unsettling. The bright electric neon of *FUCK OFF AND DIE YOU SLAG* (2002) is like seeing a nightclub sign but through a unique subjective eye, one with specific, world-altering knowledge and insight about what such a sign, though it might simply say the name of a club, is also saying.

Emin also celebrates the visual rethink, the visible edit. The neon *Not so Difficult to Understand* (2002) has a line through it, crossing the whole thing out, both cancelling understanding *and* the ease of understanding, while enacting the process of trying to make out what the words actually say. From her earliest monoprints, Emin has worked with the unreadable nature of things, worked to excite the impulse to decipher, to engage, to reflect, to mirror. The word 'you' saturates her work. She is always in dialogue: sometimes with others, sometimes with the self, sometimes with all the selves it's possible for a single self to be. There's life in argument, is what the video installation *The Interview* (1999) asserts; in it a version of herself interviews another version of herself; the selves sit at opposite ends of a couch and have an argument made possible only by edit. It's dry and funny. (It's often forgotten or overlooked about Emin how very funny she is.)

One recent collaboration, or dialogue, was with the late Louise Bourgeois (*Do Not Abandon Me*, 2011). To Bourgeois's gouache torsos of men and women in states of fertility Emin adds Lilliputian figures clambering on and over the bodies enacting states of loss, love, despair (a woman hangs off the erect penis of one torso) and adoration; moving, pathetic and ironic by turn (in one image, bible-turbaned figures kneel at the foot of another crucified on an erect phallus). She fills one torso so full of words that the word 'SQUEEZED' is literally squeezed into two parts up against the body's contour.

But what the collaboration most clearly reveals is Emin's urge towards narrative and story. Explicit narrative is her impetus. Here she shifts each torso, by her addition, into a relationship that's distinctly dialogic and, because of this, the work transcends symbol, as if something *more real* has graffitied itself directly onto symbolic fecundity.

*

I wonder if, along with *My Bed* and the now lost *Everyone I Have Ever Slept With 1963–1995* (which burned in the Momart fire of 2004, and which Emin refuses to remake), one of Emin's most enduring images over time will prove to be the photograph *Monument Valley (Grand Scale)* (1995–97). In it, the artist is off-centre, sitting in the desert on an old bright-green chair whose sides are lined with orange piping, so much in the foreground that the great slabs of Monument rock are miniaturised behind her, with the wide blue sky above her only slightly scuffed with clouds, the word 'THANKS' appearing from behind her right leg and a book called *Exploration of the Soul* in her hands, open as if she's about to give a reading. She's looking straight at us. Her gaze is direct but distanced – shrewd, serious. There's both silence and the promise of voice in it. There's a waiting, a discrete openness.

The original version of this picture had a different title: *Outside Myself* (1994). The book she's reading from is one she wrote in ten days, an autobiographical work written with the considered rawness for which Emin has now become known. In the early 1990s she toured America, giving readings to anyone who came to hear, sitting on her travelling storyteller chair, which was a gift to her from her grandmother (originally belonging to her great-grandmother), which she patched with the names of the places she visited, like a suitcase. The chair is now an exhibit in its own right (*There's a lot of money in choirs*, 1994). It's a dialogue itself in the form of a chair, one that holds its own narrative shape between Emin and her grandmothers, between past and present histories.

The work is about a girl who comes of age via the legends of her English mother and her Turkish-Cypriot father, their material ups and downs, then the girl's own horrific early sexualisation, first by abuse, then by rape, at the age of 13, at the hands of a local man, someone well known for having 'broken in girls'.

'When I got in, my mum said, "Tracey, what's wrong with you?" I showed her my coat, the dirt and the stains, and told her "I'm not a virgin any more." She didn't call the police or make any fuss. She just washed my coat and everything carried on as normal, as though nothing had happened.'

Exploration of the Soul ends with the story of Emin at the age of seven going to a children's party, from which she is sent home because 'you don't have an invitation'. The next morning the child Emin asks her mother, 'What's an invitation?' It is a model fable of exclusion, of how language itself is used to exclude.

Emin is a great recycler. Much of *Exploration of the Soul* appears again in her book of 'memoirs and confessions' *Strangeland* (2005), a work of echo and resonance and rewrite, in which – as in her video-poem *Why I never become a dancer* (1995) – Emin works with a repeating structure, one that shifts from abjection to empowerment and transformation. In it she declares 'You don't have to be born with balls to have balls.' Its themes are exclusion and abuse and what happens to these when they are made to face off with notions of delicacy and tenacious self-worth.

'Paul, do you remember the mercury? We would sit at the top of the stairs – four flights, skinny and wooden – and we would roll the mercury out of the bottle. Tiny little silver balls, forming and reforming.' Her writing, like all her work, examines form and re-form, and the dual impetus in things to split apart, to come together. By her own authority, Emin writes with a gift of fused subjectivity and objectivity reminiscent of a writer like Nell Dunn (the titles of whose 1960s novels *Up the Junction* and *Poor Cow* read now almost like the titles of Emin works). Dunn, an upper-class girl who decamped to south London and wrote with what proved to be a transformative lack of judgementalism about the working classes, has a talent for fusing roughness and beauty into something at once fragmentary and whole, seen from both outside and inside simultaneously. Emin has come by her skill by different routes. 'I'm not English, that's for sure... A part of me comes from another place.' Her fused English and Turkish-Cypriot inheritance and her double-edged role as both artist and model allow her always to perceive 'another place' in 'this'.

'Instead of feeling on the outside, I realised that there was an outside and it was called "being an artist".' *Strangeland*'s first image, of her birth, is an infant vision between death and life, somehow wrong, voiceless: 'When I was born they thought I was dead. Paul arrived first, ten minutes before me [...] I just rolled out, small and yellow [...] I somehow felt a mistake had been made. I couldn't scream or cry or argue my case [...] They put me into a little glass box and slowly I came round.' Its final image, of the adult Emin in Egypt longing to smash through the glass case in a tomb and take into her arms a 'tiny mummified foetus' is one of sheer empathy. 'Dead for thousands of years, not completely formed, but he

had soul. He still had soul', writes the artist who knows what spirit is, who can go from the word 'DRUNK' to the word 'SOUL', from inebriation to metaphysic, in the space of a single strip of material, and hold them both in equal measure (*Drunk to the bottom of my soul*, 2002).

It's all about connection. It's one word after another, with Emin. Give her a beach hut and she'll take a mile, no, thousands of miles: she'll send the hut to sea, to New York, she'll give it a whole other story. Give her a blanket and she'll make it speak. Give her the fabric of things and she'll find voice in it. Give her a cliché and she'll take it apart to give it back its full original whack of power again. Give her words, she'll write them backwards and forwards; she'll send them off in all directions; she'll work them into everything; she'll put them where you least expect. She'll make you wonder what they mean; she'll show you they're right and they're wrong. She'll take them to pieces then sew them back together again. She'll light them up.

CHRISSIE ILES
ON PIPILOTTI RIST

Pipilotti Rist:
Eyeball Massage
2011

413

In her own words, Swiss artist Pipilotti Rist uses moving images to 'discover new ways of configuring the world, both the world outside and the world within'. Pipilotti Rist: Eyeball Massage was the artist's first survey show in the UK. Spanning her entire career, it featured single-channel videos, sculptures, photographs, wallpapers and video installations, as well as two site-specific works created for Hayward Gallery. In Eyeball Massage, Rist's works were projected onto the floor and ceiling, as well as onto walls, floating screens and objects, and unexpected places outside the gallery. Writer, academic and curator Chrissie Iles contributed the following text to the exhibition catalogue, which was accompanied by essays by Konrad Bitterli, Elisabeth Bronfen, Stefanie Müller and the exhibition's curator Stephanie Rosenthal.

YOU ARE A QUEEN: THE SELFLESS SPACES OF PIPILOTTI RIST

Now man is beginning to wear his brain outside his skull and his nerves outside his skin.
MARSHALL McLUHAN

I would love to drill through our skulls and sew our brains together.
PIPILOTTI RIST

The sensual sensory environments of Pipilotti Rist, communal experiences described as a kind of hypnotic waking dream, articulate the arc between the technological utopia of the 1960s global village and a present in which the world is at once immersively interconnected and utterly fragmented. Rist's installations occupy a unique position within this transition. Emerging out of a complex narrative moment in video art at the end of the 1980s, her installations internalised both an engagement with the politics of the female body, landscape, fairy-tales and myths, and the use of tableaux that combined projections and video monitors with objects such as domestic furniture, tree branches, clothing and books.

The colourful extravagance that defines Rist's installations also belongs to that era's voluptuous moment of the body before digitisation and air-brushing, just as her positioning of the camera extremely close to the body (and sometimes inside it) began at a point when such a level of tactile real-time technological intimacy was still unthinkable as an everyday occurrence. At the same time, she anticipated its ubiquity with startling precision, developing the grammar of her work during the 1990s, when the current preoccupation with bodily presence and a new kind of communality first took root.

CHRISSIE ILES ON PIPILOTTI RIST

In Rist's work, this sense of communality is produced by the creation of an all-encompassing projective environment in which the female body occupies a central role. That body is made available to the viewer within an environment as seductive as the imagery on screen, whose arrangement often pulls the viewer downwards to a sitting or lying position on carpets, cushions, beds or soft, organically-shaped viewing platforms, from which to look upwards at voluminous images that bleed across the walls or ceiling of the gallery. In some works, the viewer stands looking down onto a floor projection, or at moving images projected onto small sculptural objects – a book, velvet cushions or handbags. In other pieces, the furniture and objects in the room render it a literal metaphor for another space – a kitchen, a sitting room, a bar, a child's bedroom. In each case, the environment is female, and the position to which the viewer surrenders themselves becomes a critical part of the artwork's meaning.

Rist's environments disperse the vertical plane of painting into another kind of pictorial space, displacing the site of the work from the singular, discrete object to the multiple surfaces of the filmed and physically present body. Her implication of the viewer within this pictorial space through her encouragement of a horizontality of viewing challenges what Rosalind Krauss describes as 'the myths of human erectness and "pure visuality"'.[1] Horizontality, a plane outside the human body's own axis, makes the pure visuality on which modernist painterly values depend impossible. Rist's understanding of this fact is reflected in her repeated use of horizontality in her camera work, along with her tipping of the body and the landscape not only sideways but also upside down, invoking a sense of floating, weightlessness that challenges the gravitational reality of both the body and the space that surrounds it. Her involvement of the viewer in a tactile mimicking of her camera's gaze shifts the museum space from what Krauss terms 'a public space within which one is disincarnated, one where carnal conditions don't count, an ideal space' into an eroticised space within which the viewer's voyeuristic gaze is made permissible.[2] The female body that becomes the subject of our gaze is not, however, diminished by it.

Rist's bodies are almost always naked, confidently sensual, erotic and available on their own terms. Rist turns the shame, furtiveness and embarrassment of viewing Marcel Duchamp's *Étant donnés: 1. La chute d'eau, 2. Le gaz d'éclairage* (*Given: 1. The Waterfall, 2. The Illuminating Gas*) (1946–66), described by some as the last nude in art, inside out, in a gesture that both directly quotes Duchamp's masterpiece and refuses to perpetuate its misogyny. If *Étant donnés* can be argued to be the final moment of the nineteenth-century history of the female nude in painting, Rist deals that male-dominated history a definitive blow.

Duchamp positioned the large wooden doors of *Étant donnés* so that those approaching the work around a corner might find someone already looking through the two peepholes at the spreadeagled naked female inside, thus always rendering that viewer nervous of being discovered in their voyeuristic act, and thereby creating

a second layer of voyeurism. The heavy doors form both a threshold and a barrier to the erotic tableau within, which is, in turn, framed by a hole knocked into a brick wall beyond them. The ragged frame of the hole in the wall is translated, in Rist's video projections, into a sensual organic shape inside which the female body undulates as the camera moves across the surface of her skin, bringing every detail of it close to the viewer on a scale so large that it erases the distance and secrecy upon which Duchamp's body, and voyeurism, depend.

Rist uses this organic frame in several of her video images, usually projecting it on the ceiling or on the floor. In *Gravity Be My Friend* (2004), the shape on the ceiling is echoed by an identical sculptural form on the floor, made of layers of fabric, across which viewers lie in order to view the image above. Rist's shape suggests the same rupturing of an architectural membrane as Duchamp's hole in the brick wall, and, in the case of *Selbstlos im Lavabad* (*Selfless in the Bath of Lava*) (1994), echoes it literally, in a small shape cut out of the wooden floor of MoMA PS1 in New York, inside of which a tiny video shows Rist standing naked looking up at the viewer, her arms outstretched, talking, against a background of exploding volcanic lava. The ancient symbolism of fire as fertility, female creativity and vital energy is underlined by the lava, whose eruption evokes not only an erotic climax, but also the beginnings of the Earth.

<div align="right">Pipilotti Rist

Selbstlos im Lavabad (Selfless

in the Bath of Lava), 1994</div>

If Rist's organic frame resites the hole in Duchamp's brick wall as a portal rather than a barrier, *Regenfrau* (*I Am Called a Plant*), (1999) recuperates Duchamp's naked female body inside it from a corpse to a living, sentient being. The video, projected onto a large wall of white kitchen units, shows a naked female body lying in the grass, her pink hair and skin wet from rain, which can be seen and heard falling onto the sodden ground, making tiny ripples in a puddle nearby. The camera moves slowly across the body, examining it in extreme close-up and caressing its form as it traverses every nook and cranny, yielding to the viewer everything that Duchamp's *Étant donnés* refuses. But this satisfying access to every inch of the young woman is undermined by the unsettling observation of her quiet muttering and deadpan eyes as she lies motionless in the grass, and by her unearthly silvery – white skin, whose unnatural tone echoes the whiteness of Duchamp's mannequin-like body, and whose cold wetness suggests the lifelessness of *Étant donnés*. Both bodies recall David Joselit's observations regarding the scandal surrounding Manet's *Olympia* (1863), whose white body 'notoriously appears as a kind of after-image, almost a "milky way" of sallow, undifferentiated flesh'.[3] There is no longer a need for an individualised body, Joselit argues, because, as a prostitute, the young woman's personality is subsumed by her role as a commodity. Rist's young woman assumes a similar deathly pallor, as though drained of life by the oppressive wifely demands of the pristine white kitchen units from which she appears to have escaped. But it is almost as though the caresses of Rist's redemptive camera resuscitate her, as she eventually rises from her grassy bed and walks slowly out of the frame, and out of the room.

CHRISSIE ILES ON PIPILOTTI RIST

The full-blown sensuality of Rist's gentle bodies is, on one level, political. Its impact recalls Carolee Schneemann's observation in her notebook in the early 1960s that, 'I assume the senses crave sources of maximum information, that the eye benefits by exercise, stretch and expansion towards materials of complexity and substance; that conditions which alert the total sensibility […] extend in sight and response the basic responsive range of empathetic-kinaesthetic vitality'.[4] For Schneemann, whose explicitly erotic, sensual body-centric performances, photographs and collages were a direct response to the male-dominated language of the abstract expressionist painting that surrounded her, it was clear that 'in learning, our best developments grow from works that initially strike us as "too much" […] which are intriguing, demanding, that lead us to experiences which we feel we cannot encompass'. Describing her early drawings, she wrote 'the sequence accelerated with an enormous mouth, a wavering moist sun, a toilet bowl, a cup of milk […] the body is the eye […] sensations received visually take hold in the total organism'.[5]

Schneemann's description resonates with Rist's visual vocabulary of enormous mouths, feet, breasts, fruit, leaves, flowers, cows, vaginas, water and blood. Rist's extensive use of water – rain, a swimming pool, rivers, streams, the sea – as a container for the female body evokes the symbolism of water as a primordial

state of being, and as a metaphor for the unconscious. The fusion of the body with flowers, twigs, tree trunks, grass and earth in and around water echoes the films of Ana Mendieta, in particular *Untitled (Flower Person)*, (1975), in which a pile of white peonies in the shape of Mendieta's signature *silueta* body form floats along the river.

The influence of women artists' assertion of the female body as both a medium and a subject in the 1960s and 1970s can be found throughout Rist's work. Schneemann, Joan Jonas, Yoko Ono, Ana Mendieta and many others legitimised the role of female experience by creating internal, feminine performative rituals of the body that transformed the male-dominated sculptural issues of scale, size and materiality into an enquiry into the relationship between real and symbolic space. In one of the six small video images in Rist's *Yoghurt On Skin – Velvet On TV* (1994), the camera grazes the surface of pubic hair and a shot of bloodied underwear appears. In the other five videos, the camera moves gracefully across the floor of the ocean, a young girl smiles as she rises out of a swimming pool, we see a close-up of a heavily made-up eye opening and closing, and the breasts of a woman seen from underneath while swimming. In *Ginas Mobile* (2007), where the consequence of Schneemann's groundbreaking work is perhaps most clearly evident, a video in which the camera moves slowly around the surface of several vaginas filmed in extreme close-up is projected onto the milky transparent surface of a large Plexiglas teardrop hanging from a wooden branch, and reflected onto the surface of a copper sphere hanging on the opposite end. Rist confronts the taboo of the explicitly depicted vulva to which Duchamp could only dare to allude, and which Valie Export exposed live in her performance *Action Pants – Genital Panic* (1969) in a cinema at a film festival in Munich. If Export confronted the largely male film audience with the anxiety-laden reality of what they were happy to see idealised on the cinema screen, Rist confronts her audience at one remove, yet with equal boldness. The vulvic images are looped, and their perpetual presence, rendered more concrete by their sculptural form and its reflection, delivers the reality of what is hard to face as a thing of glistening beauty, shot in explicit, almost forensic detail. Rist's use of a tiny surveillance camera seizes ownership of that camera's role as a hidden voyeuristic presence, transforming it by implication into a tool of erotic bodily enquiry of women, by a woman, for women, as well as for an all-inclusive audience for whom definitions of gender can become permeable and fluid.

The sensuality of Rist's camera is the key to her revelation of the surface and crevices of the body as an object of pleasure rather than fear. Its gentle probing never appears intrusive. It builds on films such as Yoko Ono and John Lennon's *Fly* (1970), in which the camera follows a fly close-up as it moves across the body of a naked female lying on a bed, moving across her thighs, nipples, earlobe and arms, and into the forest of her pubic hair. The soundtrack, of Ono singing to herself in the role of the persona of the fly, underlines the autobiographical nature of the film, in which Ono felt herself to be both the naked woman and the fly.

Rist's camera takes a similarly autobiographical approach to the physical and emotional geography of the body. The boldness with which she confronts her desire for erotic, emotional and social freedom encourages, in turn, boldness in the viewer, not only to look at her bodies, including the artist's own, writ large, but to do so within a communal setting, alongside groups of strangers. The anonymity of the porn cinema is replaced by another kind of shared eroticised space, in which a woman is behind the camera, controlling her own erogenous zones, and the conditions under which she shares them with others. Rist has stated that 'for me it is paramount that the camera and the object are both on the same level of power'.[6] Rist's democratic approach undercuts the objectification of the female body that occurs in the power relations that are inherent in the dominant forms of cinema, transforming it into a form of scopophilia that positions the female as a sexual, desiring subject and assumes an audience of mixed gender and sexuality. Her use of the camera as a kind of mirror recalls Joan Jonas's performance *Mirror Check* (1970), in which Jonas stood naked in front of an audience and slowly moved a mirror around her body, closely examining its surface through its reflection. Rist's camera adopts a similarly active role, splitting the gaze apart by refusing the singular frontal perspective of the viewer, and taking control of the body's representation.

The democracy of Rist's camera also shapes the treatment of her imagery. Landscape takes on the same luscious, erotic quality that defines her bodies: leaves, flower petals, fruit, water, grass, tree trunks and branches are caressed and stroked, floating in the air and under water, and filmed horizontally, upside down and gently rotating in space. Rist's acute angles and flowing camerawork dismantle the singular authority of the lens and, in turn, the gaze. The spatial complexity of her installations is structured by the camera angles through which the body is described, and their relationship to architectural space. As Robert L. Schwarz has observed, space is body-centred, and we learn to think from the body outwards. For the infant, Schwarz argues, the notion of space begins with its transition from the crib to the room, and each room of the house is a space in itself, limited by the floor, the walls and the ceiling.[7] Rist's large-scale projections make us aware of the physical limits of the space that contains them, just as they attempt to dissolve them.

The idea that Rist proposes a space without walls is rooted in a desire 'to escape one's own loneliness and the isolation of one's body, and to enter into a shared mental bubble with others'.[8] She goes on to describe her interest in suspending gravity and encouraging viewers to lie down and relax their muscles: 'all our thoughts, everything we see and are afraid of, is reflected in our muscle tone'.[9] This sense of unboundedness is intensified through collapsing the distance between the viewer's body and the projected body, whose surface is recorded by placing the camera so close that it almost touches it. The overwhelming scale of the resulting image evokes the infant's experience of the maternal body: large, voluptuous, fragmented and at the same time all-encompassing.

Rist's communally experienced installations evoke the psychedelic cinematic environments of the 1960s, in particular Stan VanDerBeek's *Movie Drome* (1963), a dome structure within which participants lay on their backs and watched an array of films projected onto the ceiling and interior walls, using multiple projectors. *Movie Drome* was conceived out of a Marshall McLuhan-esque impulse; as McLuhan observed, 'we only see each other through the subconsciousness of some other system'.[10] Ken Kesey had a similar idea. As Tom Wolfe reported, 'This was going to be a great geodesic dome on top of a cylindrical shaft […] the dome would have a great foam-rubber floor they could lie down on. Sunk down into the foam rubber, below floor level, would be movie projectors, videotape projectors, light projectors. People could take LSD […] and lie back and experience what they would, enclosed and submerged in a planet of lights and sounds'.[11]

These utopian spaces were generated by what McLuhan describes as a new technological environment 'that compels commitment and participation; we have become irrevocably involved with, and responsible for, each other. We have now become aware of the possibility of arranging the entire human environment as a work of art'.[12] For McLuhan, in television 'you are the screen. The images wrap around you. You are the vanishing point'.[13] Rist's installations emerged in the 1990s at the moment of television's imminent disappearance, inheriting and using its anti-cinematic language of abrupt zooms, flash cuts and elliptical editing, and constructing a new kind of communal viewing space that filled the void that its demise as a singular, powerful, shared experience created.

This anticipation of a newer technological moment links Rist's work to that of Dada, whose performative experiments in the public sphere, as Leah Dickerman argues, 'engaged with the terms of a new modern media culture' a decade before it entered common cultural parlance.[14] Dickerman describes Johannes Baader, one of Dada's main protagonists, as 'a media prankster par excellence'. Like Rist, Dada lamented the imminent loss of collective ritual and a sense of community that Rist's installations attempt to reanimate.

The immediate precursor for Rist's utopian project is arguably Susan Hiller, whose video installations *Belshazzar's Feast* (1984) and *An Entertainment* (1990) both address the psychic resonance of collective ritual. Like Rist, Hiller makes visible images that are marginalised by the dominant culture; in Hiller's *Belshazzar's Feast* they appear as imagined fragments from dreams, re-experienced around the hearth of the domestic living room or the fire, while in *An Entertainment* the collective memory of Punch and Judy, a Victorian children's puppet show, is evoked through recreating its violent moments in large projections that amplify its sinister imagery and resituate the viewer as a spectator of forgotten childish terror. Bill Viola's video installation *The Sleep of Reason* (1984) similarly evokes the anxiety of the unconscious, in an all-surrounding projective installation that periodically floods a domestic space, symbolised by a wooden chest on which is placed a lamp, a vase of flowers and a video monitor showing a sleeping man, with large projected images of nightmarish subjects: buildings on fire, dogs on the attack, an enormous owl flying into light.

If Hiller and Viola depict the anxiety and violence of the individual and collective unconscious, Rist's work reveals its opposite. Though anxiety appears – in a fear of emotional commitment in *Sip My Ocean* (1996), for example, or of being trapped inside a domestic space in *Open My Glade* (2000) and *Regenfrau (I Am Called A Plant)* – it is overwhelmed by a dreamlike sensuality that imagines the absence of fear, restriction, power structures and social strictures. One of Rist's most recent works, *Funkenbildung der domestizierten Synapsen (Sparking Of The Domesticated Synapses)* (2010), depicts a mature, mellow imagery in which this desire seems more muted. Hands slowly dry a pottery vase, lit in silent, dark chiaroscuro, rather than the bright acidic colours she used previously. The hands softly reach into straw and lift out one speckled egg, and then another, to which small feathers are attached. They pick off the petals of a large yellow poppy, and place a bunch of white tulips in a vase, caressing the leaves. Water splashes into a crystal-glass vase, and the hands wash the stems of the flowers. The lighting and filmic treatment of the objects ground the imagery in a more concrete form than the floating weightlessness of earlier works. The domestic contentment implied by Rist's imagery suggests another kind of utopian space, not eroticised, but equally sensual and free of anxiety. The performance of identity that forms the grammar of her work implicates the viewer in a different tone of spatial communality, in which the scopophiliac impulse shifts from the skin of the body to its complex relationship with symbolic objects of domestic nurturing. This nurturing forms the underpinning of Rist's art through its engagement with the viewer, whether it be in the creation of potential liberatory bodily states, creating the possibility of a psychological openness of shared experience, or in the attempted rescue of the body from the narrative of violence and shame.

WILL SELF
ON GEORGE CONDO

George Condo:
Mental States
2011

George Condo: Mental States, the first major retrospective of the American artist, surveyed three decades of Condo's paintings. The exhibition focused on the artist's 'imaginary portraits' – paintings in which Condo combines naturalistic detail with elements of the absurd and the grotesque to depict a range of tragicomic, desperate characters. 'They may not be pretty', Condo has said, 'but I think we can all see ourselves in these pictures.' Mental States was divided into three main sections – Portraiture, Mania and Melancholia, and Abstract-Figuration – and featured 80 works. Alongside this text by novelist and journalist Will Self, the exhibition catalogue featured contributions by short-story writer David Means, curator Laura Hoptman and the exhibition's curator Ralph Rugoff.

BELIEVING IN THE COW: THE PSYCHOPATHOANATHEMAS PRONOUNCED BY GEORGE CONDO

Somewhere in the voluminous writings of Oliver Sacks, the valetudinarian neurologist and savant, he describes following a woman with Tourette's Syndrome along a busy Manhattan street. Every single person the Tourettic woman passed she was compelled to imitate; and this was not merely an assumption of facial expression – nor yet merely of gait or mannerism or voice – but an impersonation *tout ensemble*: an entire assumption of the other, which seemed – to Sacks – to capture the totality of what might well be these passers-by's very being. Worse was to come, for when the woman reached the end of the block, she dived into an alleyway, and there, isolated, she regurgitated all of these moues, grimaces and postures in a frenzied twitchery – a spew of other psyches.

To me, the portraiture of George Condo is an analogue of this neurological syndrome, sparking in the realm of the aesthetic. His portraits are carried through the delusory streets of our cities, which themselves are dystopic conurbations, upon which are imposed the grid-pattern of the rational, the profitable, the notionally secure. The portraits pass and re-pass one another… they *come and go / Talking of Michelangelo*… they bow and curtsy to one another, but this formality, imposed by the gallery context, their mounting and framing, is disavowed by their festination and akinesia, their start and their stop, and their hopelessly involuntary mimicry, one of the other, that yet seems perversely willed.

If I locate the primary lesion of Condo's cortical portraiture – that stretched point where oil paint touches then binds to a surface – in the addendum of the nineteenth century – a period extending from John Ruskin's attack upon the proto-impressionism of James McNeill Whistler (1878), to the final revisions made by the Swiss psychiatrist Eugen Bleuler to his textbook on schizophrenia (his own coinage), in 1937 – it is because here we can locate the fulcrum upon which the great

antinomies of the twentieth century uneasily tilt: subjectivism and objectivism, existentialism and universality, impressionism and modernism.

Ruskin accused Whistler, *vide* the latter's *Nocturne in Black and Gold: The Falling Rocket* (1874) of 'flinging a pot of paint in the public's face'. That Whistler promptly sued and won damages of a farthing is an ironic overture to the soaring sarcasms of the coming *siècle*, but that the paint stuck on the public's face is indisputable, and it is this emulsive mask that Condo so strikingly depicts. For G.K. Chesterton, writing in his *Autobiography* (published a year before Bleuler's recognition of the physical aetiology of symptoms he had previously identified as neurotic), Whistler's assault upon the public was a corrosive acid attack: 'it illustrated skepticism in the sense of subjectivism. Its principle was that if all that could be seen of a cow was a white line and a purple shadow, we should only render the line and the shadow; in a sense we should only believe in the line and the shadow, rather than in the cow.'

Chesterton – himself a trained artist who specialised in caricature – had viewed Whistler's education of a generation of English impressionists with mounting dismay. By encouraging this visual method, the way was being paved towards a peculiarly occidental conception of *maya*: 'The philosophy of impressionism is necessarily close to the philosophy of illusion', Chesterton continued dolefully. 'And this atmosphere tended to contribute, however indirectly, to a certain mood of unreality and sterile isolation that settled at this time upon me; and I think upon many others.'

Chesterton himself may have shaken off this bewildering intimation of Turgenev's 'white void' (the physical correlate of which could be said to be the un-primed canvas), and pursued through his religious faith a 'submerged sunrise of wonder'. However, the 'many others' were, I think, stranded with me, in the crepuscular gallery, in the gelid moment.[1] Undoubtedly, Chesterton could not have foreseen the persistence of this 'mood of unreality' and its accompanying posture of 'sterile isolation' at the time of his spiritual crisis in the early 1900s. But to retain a belief that the change in the wind was only strange weather rather than climactic until 1936 points towards our own enduring astonishment at the pervasive subjectivism of twentieth and now twenty-first-century figurative art, which, no matter how devoutly we desire it, can never again be tempered by unfeigned authenticity.

The stop-motion photography that fed through Eadweard Muybridge and the zoetrope then wove into the digitised simulcast of the visible world that floats off-planet, tethered by fibre-optic cabling, found its truest subject matter in the motion-stop of the successive waves of troops going over the top of First World War trenches. As Paul Fussell so persuasively argues in 'The Great War and Modern Memory', after the optimistic leave-taking bogged down in the Gotterdammerung of entrenched warfare, the mode of all art pertained towards irony; but within this, figurative painting became much more ironic, and dramatically so. The young and perfect bodies jerking and ticcing on the barbed wire as the bullets

rhythmically struck them were, of course, only an extreme and specialised form of the mechanised torture imposed on the human form by compulsive industrialisation – that much was understood.

If Condo had been official war artist – and in a way, I suppose he is – he would probably have left these images, as poignant and revelatory as they are, to the hand-cranked machines mounted on tripods that *took in* bullets of light. Instead, there were the Madonna of Albert, the Angel of Mons and the Crucified Canadian to depict – although no life models were available.[2] For Condo's portraiture has packed into its dense layering all this archaeology of the recent past: to allow the eye to rest upon the furrowed surfaces of these canvases is to risk the possibility of an unexploded shell, or a human femur, working its way to the surface of consciousness. To rest a cheek against that pillow of perma-tanned skin is to be exposed to napalm, still bubbling.

But more bizarre, perhaps, even than the moral vortex of the First World War (and its follow up sucker-punch, the Second), were its sequelae: the Spanish Flu pandemic of 1918–19 and the encephalitis lethargica epidemic of 1917–27. It is here, in the viral mosh pit, where competing ideologies of determinism – psychic and physical, Freudian and neurological – did battle over souls that could no longer be said to exist, that impressionism battened on to the human form itself, producing an art at once discorporate and worryingly kinetic – features bisected, then rotated around axes, the nervous system jerking frenetically, an object lesson in causality alone.

Installation view, *George Condo: Mental States*, 2011

This, then:

> In the language of schizophrenia, stupor, rigidity and flexion – the hallmarks of parkinsonism – become autism 'a complete and constant exclusion of the outer world' and the pivot of Bleuler's theory. Akinetic attacks become 'thought-blocking' and ambivalence; echophenomena and plastic rigidity – called waxy flexibility – 'command automatism' and evidence of abulia or deranged will; emotionalism 'inappropriate affect' and loss of facial mimicry 'lack of affect' etc.[3]

Writing a medico-social history of the notorious Colney Hatch Asylum in North London (which gives its name to the slang expression 'the booby hatch'), Richard Hunter and Ida Macalpine return again and again to this parallelism of symptoms: the neurotic embellishing the neurological, the neurological becoming the template for neurotic mimicry, so that eventually all the inmates of the asylum came to display the same stereotypic range of tics, grimaces, starts, stops and spasms. For me, Condo's portraiture captures a further parallelism: the way in which the modern urban context has itself become a dumping ground for a mass of individuals who exhibit these twisted physiognomies and vacant gazes. We have all been discharged from the booby hatch into the 'care' of the community.

WILL SELF ON GEORGE CONDO

For it would be too comforting to view these works through the one-way funhouse mirror of Freudianism, and so apprehend Condo's glosses on the human as atavistic zoomorphs or chimeras, sliced and diced together on the Pangaea of Dr Moreau (a continental landmass off which all psychoanalysts maintain private islands). Nor can we assuage our own anxieties by pronouncing psychopathoanathema on these slick or turgid heads – the puce and the orange, which float, dreamlike on those scumbled and abraded backgrounds whereby the pictorial space is enlarged then occluded by the very act of its rendering. Nor can we find crude, sturdy dialectics in the juxtaposition of a mincing maid-of-all-trades and a recumbent suit, his chest ejaculating Pernod, possibly (*The Way We Were*, 2008); besides, there ought always to be clowns – Pierrot exiled to inner space, Columbine fed through the wringer, Harlequin up for kiddie-fiddling – and those archimandrites, ornate, insectoid, ultraviolet or ultraviolent (*The Introvert*, 1984). All of this is a given.

But as I say: the time was right, and the place was right. The modernist and surrealist sappers dug a deep trench in time, with enfilades travelling close to the enemy positions – as far as the United States in the 1960s, where the collapsing tidal wave of the avant-garde ran West, its manifest destiny being to allow all this scurf – carney hucksters, amateur porn performers, Krazy Kats, Bukowski bums-with-bindles and the hanged ejaculators out of Joyce's night town by way of Burroughs's Tangier – to wash up on the desert floor, so much wrack zigzagging across the sands of the twentieth century's terminal beach. And so, as Aldous Huxley riffed on the Sierra: Condo's line describes civilisation's graph of boom and bust.

In as much as the frenzied scratch and impact of *Mental States (4)* (2000) or *Nothing is Important* (1985) share a municipal boundary with Interzone, so Condo's formal heads – their geometry inevitably twisted through the horizontal or vertical place, their features melded, moulded and padded with throw-cushion eyes – evoke the Rubik's Cube, that quintessential 'feely' of his – and my own – youth: a don't-bother-to-inquire-within tool that substituted digital manipulation of surfaces slick and trivial for the Promethean failures of the Space Programme.

And in as much as the painter's brushstrokes have yanked and draggled at these hardened, regularised features – smearing them into blobs – so the heads achieve a mythopoeic status, taking their place in that terrain of mesquite and manna, where the freeway runs arrow-straight through Nevada and on to Nazareth. Whence comes the hieratical affect of *The Objective Idealist* (1994) and *The Psychoanalytic Puppeteer Losing His Mind* (1994), which seem to me to be visual correlates of Bob Dylan's epochal quatrain from 'Tombstone Blues':

> Now I wish I could give Brother Bill his great thrill
> I would set him in chains at the top of the hill
> Then send out for some pillars and Cecil B. DeMille
> He could die happily ever after

Recall: the jerking figures on the wire, the hand-cranking of voyeur Death. But Condo understands that in public we cannot prevent ourselves from looking instinctively to the face. We look and look away, seeking confirmation of our essential comity, while doing battle with the deep-seated awareness of our alienation, each from the other. And so the portraits are carried towards us along the sidewalk, and so we feel compelled to mimic these Tourettic features.

Condo's mirror-shiny cast heads (for which *The Alcoholic* (2002), stands sentinel) would be more suitable *tosches* for Freud's consulting room than his much revered (by his atheistic followers) collection of ancient votive statuary. Condo's heads resemble aluminium coprolites, aspirations voided aeons in the future by alien space travellers who will come here hence and leave disappointed in the distant past. For Condo, chronoclasm (the retrospective alteration of events so as to create an impossible present: Picasso alive, well, and working at Pixar), is of the order of things.

And it is also necessary to understand the dramatic arc of caricature when considering Condo's portraiture, for while he is undoubtedly a caricaturist, his is not the distortion and exaggeration of pre-acknowledged stereotypes in order to flatter the prejudices of a paying public. Rather, Condo is a caricaturist in the same way that Hogarth was when he composed his *Characters and Caricaturas* (1743), a dense jostling of heads at all aspects and angles, a pattern book of the psyche-as-physiognomy, designed – in all seriousness – to establish the artist's ability to convey all manner of expression. Just as satire, far from being a

flippant undertaking, is the most serious of all artistic modes, so caricature is a profoundly important and magnifying window into the human soul. Hogarth's original caricatures became tailored to fit occasions, moral narratives, the guying of the named personage... and so it goes on, down to every hack animator and newspaper cartoonist.

Condo's caricature is different: it is a post-impressionist caricature, which asserts that if all that can be seen of a cow is a white line and a purple shadow, he will only render the line and the shadow, while making absolutely certain that it remains recognisably a cow. It is a truism of literary history that narrative art has declined in social status throughout the ages: the first epics concerned the gods, the next the heroes; thence came emperors and kings, after them nobles and aristocrats. By the time the novel form was crystallised in the social laboratory of the nineteenth century its subjects were irredeemably bourgeois, while in the last century nothing but men and women of the people would do.

As it has been to the fictive, so it was to the visual, so that for serious artists of Condo's generation (such as Condo himself) there can be no portraiture at all unless it includes, unflinching, the bat ears and the tiaras, the cutesy blobs of the eternally neotenous, these chimeras of love... and plastic. Condo's portraiture takes place with an assumed discourse between high and low art, between high and low class: the Queen orders the meal deal at Burger King while Bacon and Crumb make out in the rest room at the feet of George Dyer, dying happily ever after. But this *is* how we have come to see people (*The Chinese Woman*, 2001), how we take them in. Sophisticated as we may believe ourselves to be, our observational methodology remains at the level of cut and paste; there is no unifying principle, nothing – in the Coleridgean formulation – 'esemplastic'. In Condo, as in life, everything fissions: eyes head west, teeth south; still, everything will be *OK* so long as a burnished gold ephod is sported fetchingly by a golem of baubles (*Smiling Pod Portrait*, 1996).

If these seem overly gnomic readings of Condo's works, don't let them be. Even though I cannot bear to look in your eyes for too long, I suspect you may be quite like me: paradoxically, we may find common ground in our mutual alienation, while freely subscribing to the strict rules that govern our shared anomie. To stand before these portraits is to take one's place in an agora at once kinetic and gnawingly passive. As Sweeney, erect, looked upon *the sickle motion of the thighs*, repelled and attracted, so we look, detumescent, upon the hammer-and-sickle motif of *Nude Homeless Drinker* (1999) as he pummels himself into oblivion.

Just as it took photography to corral Stubbs's bounding horses, so it takes the portraiture of Condo to call our attention to how mummified we have become – in our own bodies. These are our tics and grimaces, our bradykinesia and bradyphrenia, our festination and akinesia. Is it all the result of civilisation's neurosis, its conscription of repression, its massed ranks of the idiopathic? Or are

our symptoms only the result of a wholesale corruption of its *substantia nigra*? The twentieth century saw the complete conundrum of physical and psychological pathologies, so that only an art that can locate the body in such a space/time frame (let alone a gilt one) can be authoritative.

It is above all this authority that typifies Condo's portraiture for me. For pictures that should be shocking, disturbing – those signature ears, elephantine even though no one is listening – are in point of fact quite simple and plainly declarative, thus: *Lord Gorilla*, 2002.

DAVE EGGERS
TALKS TO
DAVID SHRIGLEY

David Shrigley:
Brain Activity
2012

431

British artist David Shrigley is best known for his humorous drawings
that make witty and wry observations of everyday life. This exhibition,
which covered the entirety of Shrigley's career from the mid 1990s to the
present day, featured handwritten texts, photographs, books, sculptures,
animations, paintings and music. Occupying the entirety of the upper
galleries of Hayward Gallery, the show also included new artworks, site-
specific installations, and the London premiere of his first (and last) operatic
collaboration Pass the Spoon. *The exhibition was accompanied by a catalogue*
that included the following interview with the artist by novelist Dave Eggers
as well as and an essay by art critic Martin Herbert and Hayward Gallery
Senior Curator Cliff Lauson.

A LONG-DISTANCE CONVERSATION BETWEEN
DAVE EGGERS AND DAVID SHRIGLEY

The following talk occurred on 27 September 2011. It was conducted via Skype and was the third time I had ever used that technology. I was surprised by how well it worked, and was also surprised that David Shrigley appeared so clean-cut and sane. Like most people who have loved his art, I assumed he was a much more bizarre and un-hinged man. But he proved to be very presentable and polite.
DAVE EGGERS

I don't think Dave really knows how to use Skype. He perhaps didn't realise that I could see him as well as him seeing me: he had the camera pointing at an odd angle so I could only see the top half of his head and the wall behind him for most of the conversation. Anyway, it was nice to talk to him.
DAVID SHRIGLEY

 DE: Are you in Glasgow?
DS: Yeah, I'm in my office.
 DE: What's that screen behind you?
DS: That's my drawing board.
 DE: You draw on a vertical surface like that?
DS: Yeah, it's an ergonomic prescription. I have a back problem.
 DE: I do, too. What part of the back is it for you? Let's talk about our back
 problems.
DS: Well, I have a lower back problem. I have ergonomic furniture as part of my treatment. Part of the furniture is this drawing board, which is at a good angle, and I have this chair I'm sitting on there, Which is kind of high up, and I've got a computer which is really high up. And I do yoga.
 DE: That is hugely surprising to me.

DS: I was there today, doing yoga. Sweating and grunting. And you know, I go on yoga holidays with my wife.

> **DE:** See, between your clean-cut appearance and the yoga, my perceptions have been totally upended. I thought you'd be doing this interview from a bar somewhere, where you'd be in the corner, drunk and filthy. One would presume it's much more of a fringe personality who is creating the artwork you create. The person responsible for your drawings is not necessarily the person that's doing yoga.

DS: Yeah, yeah. When I'm talking about doing yoga, I feel like I'm talking about somebody else anyway. When people are talking about you, and writing about you and your work, it seems like they're writing about somebody else. So I suppose it's only right and proper that I should be writing from the point of view of somebody else as well. And also, I don't really understand why anybody is really that interested in me either. I think the parts that I create are more interesting. They generally are kind of, you know, slightly psychotic, dysfunctional, sociopaths.

> **DE:** You've said before that when you're drawing, you're taking on a role. That is, that there's a persona, almost, that you've generated who is behind your work. That's something that not everyone knows about or assumes – that the artist is often shaping a persona that's different than the artist's everyday self. But I wonder how you get to the place where you create. The drawings, at their best, I think, have a desperateness to them that I like to assume you're only reaching after drinking heavily, or being depressed, or being alone at 4 a.m.

DS: Well, I'm quite disciplined about the way that I go about using my brain in that light. I'm always totally sober. There's a specific amount of caffeine and sugar and nutrition and work at a certain time, I suppose, to get stuff done. But yeah, it's kind of late in the evening I tend to get quite a lot of stuff done, and also earlier in the day. As well as, you get to your 40s and suddenly you realise you've got to eat stuff otherwise you get really grumpy. There's a certain zone that you get into that you're kind of almost not really thinking anymore, but it just feels like it's all pouring out of you like water out of a jug. But it's not necessarily any good. Sometimes it's terrible. But yeah, I do have those moments. But I'm also quite a type B person in the sense that if I had a glass of wine, that's it, game over. I'm going upstairs to watch *CSI: Miami*.

> **DE:** I think, though, that the viewer gets the experience that you are having fun, and that's fairly rare. I think it's what the viewer responds to with your stuff. It seems like a train of thought that actually reflects what goes through our minds, and that you're not self-censoring. But you must edit.

DS: I guess there's only 25 per cent of the stuff that I make that makes it, that doesn't go in the garbage or the recycling. I throw a lot away. My attitude towards it is very free, because I know there's only a one-in-four chance that I'll keep the drawing in question. And at that point you're not really worried too much about making a mess of it.

> **DE:** But the mess of it is part of what works with what you do. The drawings are somehow funnier because of the awkwardness or the crudeness, and the crossings-out. You can't improve upon how sort of perfect that mix is, between

the text and these awkward figures, with their terrible hair, and their bones that don't go in the right direction, the overlapping lines. Do you remember the moment when you arrived at your style?

DS: I've always sort of drawn in that way, and that's just my handwriting, that kind of drawing. That's kind of the drawing that you use just to describe something to somebody. You say 'I saw somebody that looked a bit like this' and you just do a drawing. It's not the kind of drawing where you're trying to get their eyes in the right place, you're just trying to tell somebody something as directly as possible. I guess that's what that kind of drawing is, it's kind of a non-drawing, in a way. It's somewhere between handwriting and drawing. At a certain point I realised that I just wasn't interested in objective drawing. I think my work has become quite stylised and I'm only interested in a certain thing. But then again there are also certain rules to what I do, like I'm not allowed to re-draw or anything, it just is what it is. It's not like I'm trying to consciously achieve a style, I guess, although I'm sure there is some kind of manner to it.

> **DE:** Between the casualness of the work, and the fact that it's funny – these are art world no-nos.

DS: I know a lot of people still don't see my work as serious, because it's funny. But then again, I've come to realise that the opposite of seriousness is not humour. The opposite of seriousness is incompetence. It's somebody who isn't really engaged with what they're doing. And the opposite of humour is maybe sadness.

> **DE:** The art world does tend to attract a very self-serious type of person. I noticed that when I was in art school myself, and then when I worked at an art gallery. I tend to think that there's a fear of acknowledging the inherent absurdity of, say, sticking a urinal on a plinth and calling it art. Duchamp knew it was absurd, and very funny, but I've been around a lot of art-world people who treat Duchamp with great seriousness, when that's sort of the opposite of his purpose as an artist. It's as if to crack a smile would be to diminish the importance of the work.

David Shrigley
I'm Dead, 2010

DS: For me, humour is kind of volatile. I don't think you'd ever judge a writer any differently according to the humour in their work, but they do that with fine artists. Quite obviously I don't really agree with that.

> **DE:** It's a weird no-humour zone, right? It's a strange thing to remove humour completely from all visual art, but it has been removed from 95 per cent of it, as if humour was some very tangential or superfluous part of the human experience as opposed to being very central.

DS: I agree. I guess the odd thing for me is that I am kind of a real cartoonist, as well as being a real fine artist, in the sense that my work is filed under humour in the bookshop, sometimes as well as being filed under art. And also a lot of people who look at the work think I'm just one of those comic-book type dudes. Which is nice, but I guess I've got a foot in either camp, as it were. To be honest, in terms of the way my work is received, I feel like I'm taken far more seriously than I should be anyway.

> **DE:** In your last few books, though, there's a real mix of the outright funny stuff and then a lot of stuff that's I think much more pained and political. Humour

that I like comes from a place of anger, exasperation. I was re-reading a lot of Vonnegut recently, and then I was looking through your drawings and there was a similar sense of humour – a dark humour that comes from a place of frustration, of wanting better for humanity.

DS: Well, I suppose it's a cathartic thing. It enables you to say what you want to say, and vent your anger about just the lunatic, idiot world we live in. I think I'm a much saner person because I'm able to be an artist, or be a kind of artist that I am, where you can make work about how horrible people are, and how unacceptable it is that they are so horrible and how unacceptable it is that people accept how horrible these people are. I kind of assume that's a given for everybody, that everybody feels that there are quite a number of aspects of contemporary life in an advanced capitalist society that are really unacceptable, but what can we do to change it? Make stupid drawings I suppose.

DE: That's step one, right? In the revolutionary handbook, make stupid drawings.

DS: The thing is, I was actually given the opportunity to make political cartoons for this magazine called the *New Statesman*, in the UK, and I did straight political cartoons for 18 months. But then I stopped doing it because it became a bit contrived, because it was all too brief and I was having to draw pictures of David Cameron and Tony Blair and other politicians, and I just can't do that. I'm not a regular caricaturist.

I really liked the fact that I was able to make that political commentary, but I guess the way that in my mind politics manifests itself is what I'm good at, which is not necessarily doing caricatures of... really direct and topical things. So I'd like to do things to change the world, but I'm not really quite sure what I'm supposed to do.

>DE: There are some drawings in this exhibtion where I think they're going to have a punch line at the end of some kind. But then there is no punch line. Are there certain days when you're just despairing and can't bring yourself to make it funny?

DS: It's not really despairing, but more about the process of making the work. I have a discipline of making the work, and it involves just drawing every day. Sometimes they're good and sometimes they're rubbish. But the only important thing is that I did it. From that practical point of view, I don't worry. I have good days and bad days like everybody.

>DE: Let's talk about art school. Was your work accepted in school? Were you encouraged? I would think we were studying art at the same time and, because I came from the cartoon world, I wasn't made very welcome.

DS: My experience of art school in Glasgow, where I studied, was that in the end, people didn't really get what I did. I think that they thought I was doing something inappropriate, or maybe that I wasn't a serious artist. Ultimately, I wasn't taken seriously at art school and wasn't seen as being a very good artist as such. I left with quite a poor mark. We get marks for our degrees, for when you study art. And I got kind of the mark that you get for turning up. I didn't get the mark that you get if you're actually talented. So when I left art school I was pretty pissed off with the establishment as I saw it, which was basically my teachers at art school. But I'm not really angry with them, I just think they didn't really know anything about art. But I was really quite arrogant, anyway, I think I felt that I knew better than they did. I think that's why I made the real decision to become a cartoonist I suppose, because it was quite a gesture, a game of fine art as I saw it.

>DE: And that interaction with the world of fine art is important in your stuff. I don't think I've seen your originals in a gallery, come to think of it. I've only seen your work in books, and was surprised when I learned you had gallery shows and all that. Do you think that the book medium sort of gets around some of the exclusivity that's inherent in the art world?

DS: I think it does. I guess everybody knows how to read a book, but not everybody knows how to walk around an art gallery. When you're in Chelsea in New York, when you're walking around the Phillips auction house, it's a really intimidating experience for people who might like art, or might want to have an appreciation of art, but they don't feel very welcomed there. Whereas, if you take a book off of a bookshelf in a bookstore then obviously you know what to do with it. You're not really sure whether you should smile or laugh in the art gallery, or whether you're allowed to rub your chin, or scratch your head, or whatever. For the likes of my sister, for example, she wouldn't feel very comfortable at some fancy gallery in New York, and wouldn't really know what to do. She'd sort of look around and look at her watch and fiddle with her Blackberry, I suppose. But books are accessible.

>DE: But galleries are part of it for you.

DS: I guess, because that's what pays my mortgage. That's why I don't have to teach at the art school, because the original drawings sell and I don't have to have a job. I think I'd rather be judged by a book than some exhibitions. But I guess also, I make sculptural work because I have exhibitions I suppose, and if I never had any exhibitions and just made books, I probably wouldn't make any sculptures.

DE: How long have you been doing the sculptures?

DS: Ever since I was at art school. I've always made stuff for as long as I've made drawings I suppose. I've been making some ceramics in my studio, a lot of the sculpture I do is ceramic now. Like casts and push moulds, and quite primitive mould-making but with ceramics and then glazed. I guess I make ceramics because it's a bit crafty and it sort of seems to fit somehow aesthetically with my graphic work. And ceramics are somehow a little bit unsophisticated, which I sort of feel is my style.

DE: That unsophisticated aspect of your work is kind of a nice place to be, I would think. It seems really liberating. I know you identify with cartoonists, but then again, cartoonists actually are expected to polish their work. Most cartoonists are very tidy, very practiced and professional.

DS: Yeah, I'm always interested in real cartoonists, and I look through their books and stuff. I identify with them I guess. Maybe it's about nihilism or something. When I meet fine artists, I never really feel like… you know, you meet people and some of them you get on with and some of them you don't. But I feel that I don't generally feel very sympathetic with gallery artists, even though I might like them. But then when I'm in a show about comic books and cartoons, I feel very sympathetic with all these people because their work is about exactly what I'm interested in, which is usually just violence and sexual beings – that kind of thing. Most times people ask 'Who are your favourite artists?' And one or two cartoonists would come to mind. But in a way, I feel like I have a lot more fun than they do, because I can do whatever I like, and it doesn't have to be anything . The rules are that I don't have to do it again, I can do it once, and in that way I am totally free. I feel lucky in that respect.

DE: Do you keep a notebook? When you're out and about, are you writing things down?

DS: You want to see it?

DE: Yeah.

DS: Here it is. [DS shows the notebook via Skype] It's just a heading that says 'Beer'. I'm not quite sure what that means. But I have a Moleskine book like everybody else.

DE: How often are you transferring ideas from the notebook as opposed to just sitting and spontaneously doing stuff?

DS: Well I guess I've got a notebook. You know, if I'm on the bus or something, I can just write stuff down. But it's not very often, to be honest, that I actually use stuff from the notebook. It's just that there are certain statements that come into your life that you just want to write down. You don't want to waste those thoughts somehow, even though I'm not really quite sure what currency they are. I think they're healthy things to have. But I don't keep a diary. And I don't do a blog. I just do Twitter, which I suppose is a bit like a diary, isn't it?

DE: I didn't know you did that. I still haven't figured out how to follow those things.

DS: So you don't have a publicist who basically says, 'Do you do Twitter?'

DE: No, no.

DS: And you say 'I don't want to do Twitter', and they say, 'Well that's OK', and then they send you this YouTube video that's basically a small infomercial about the merits of social networking, and how you're a total buffoon who doesn't have any actual kind of commercial product to sell. And so, basically that was about a year ago, and I've been doing Twitter ever since. It's just kind of rubbish, but I understand it. It's like a diary but, then again, it's also really vain and horrible in a way as well. You're just telling people stuff and I can't really respond to everything that everybody writes to me.

 DE: It would be a great burden.

DS: Yeah, but she's a nice lady, that publicist. She might get fired if I don't do it.

 DE: So you're saving someone's job. You're contributing to the economy. You're a job creator. That's very noble of you.

DS: She worked really hard to get that job and I don't want to mess it up for her.

 DE: It's all out of generosity and kindness that you do these things.

DS: Yeah.

 DE: So we should wrap up soon, and I'm thinking because we're about to say goodbye, I really want to know about something. It's the way that you say goodbye. It seems like there's a new British thing, that when you say 'goodbye' on the phone, you say 'byeeeee'. You don't say just a simple, quick, even-toned 'goodbye'. It's more like a long, fading 'byeeeee' – it rises up and away like a kite. And I swear this has happened in the last ten years. Every British person I know does this. Was there some sort of mandate that came down from a central office that told you all how to do it? It really seems like a recent phenomenon. At the same time that every American began calling everything 'amazing', you guys started doing the kite flying 'byeeeee'.

DS: Yeah, I guess I do that. But I also say 'Cheerio' to people.

 DE: No you do not. Have you really said this?

DS: Yeah, I say 'Cheerio' to everybody. That's just the way I say goodbye to people. It's quite Scottish actually, to say 'Cheerio' or 'Cheery bye'.

 DE: 'Cheery bye'? What is that? What does that mean? That's terrible, that shouldn't be allowed. I thought the Scottish were prouder than that.

DS: The Scottish have no shame. I'm actually English as well. I grew up in England so, I have an English accent, as you may recognise. So I'm sort of a politically Scottish, for 23 years, but I'm ethnically English.

 DE: I've never heard 'ethnically English' before. I like it.

DS: I like saying it.

 DE: See, now we're sounding smart. This will be the best interview ever. And when we transcribe it, we'll make ourselves sound smarter.

DS: We'll get a third party to do that.

 DE: It will be incredible. Okay, now it's time for you to say your 'byeeeee'.

DS: Byeeeee.

 DE: Yup. That's how it's done. Perfect.

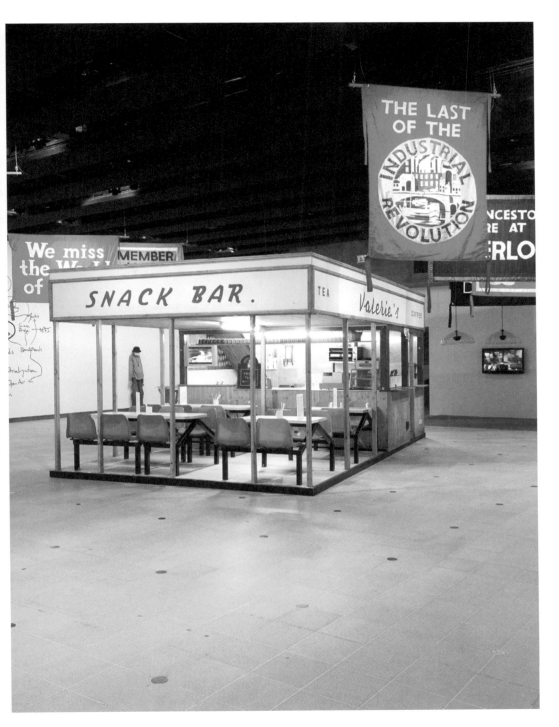

position and political clout of the National Union of Mineworkers (NUM) and forcing young people to migrate from the villages in droves. The once mighty NUM is a shadow of its former self. It has become a dramatic example of the long secular decline of organised trade unionism in the decades since.

Deller thoroughly mastered the detailed unfolding of the historical event itself, managing to bring together different scenes of the struggle into the same frame. He was fully aware of the wider issues thrown up by the conflict, but he chose to focus on one key theme and to engage with the strike through this question. He called Orgreave a 'civil war' – it was not an idly-chosen title – because of the way the strike divided the mining community. The wider politics of the strike, the successes and failures of the tactics adopted, and the shocking scenes of miners locked in physical battle with the police, were all essential ingredients of the story. But what grabbed, and disturbed, him most was the spectacle of two warring sections of 'the people' ranged against one another. This doesn't suit Deller's political imaginary at all.

In Deller's re-enactment these 'participants' are his 'subjects' as well as his 'subject matter', in all their varied roles and positions. He is extremely sensitive about what he was asking the miners to do and wouldn't have proceeded had they raised objections. However, having secured their agreement, he was determined to feature both sides – the striking miners and the police, some of whom had once been miners themselves.

Perhaps as a result of the multiplicity of practices he uses, his inveterate curiosity and eclectic inclusiveness, Deller's work is sometimes criticised for not being sufficiently concerned with the aesthetic dimension. However, when questioned about any aspect, the first thing he refers to is how it did, could or should look. The rich visual palimpsest of the Orgreave project's accompanying book – *The English Civil War Part II* (2002) – astonishes by its pictorial success in capturing on the page the drama, turbulence and sense of conflict.[2] Every photo, image or drawing is on the move. One aesthetic dimension many critics seem to miss in Deller's work is his sense of humour. He is wittily anarchic, deadpan, the joke often carried in the ironic lateral connections he draws between what is actually in the image, what it's really 'about', and its title. An installation with papers, drawings and poetry by fans of the band Manic Street Preachers is called *The Uses of Literacy* (1997) – rattling the canon with a gentle riposte to the dubious account of youth culture in Richard Hoggart's 1957 book of the same name. The slapstick antics of anonymous performers, who try to take off their pullovers while avoiding tripping over displays, with its send-up of the solemnity and self-importance of the gallery space, is entitled – another sly reference to 'management speak' – *Risk Assessment* (2008).

Asked specifically what his aesthetic considerations were in the installation of a wrecked Iraqi car as part of *It Is What It Is*, he says it had to be 'recognisable'; the audience were not to be left in any uncertainty about what it was – he is not into conceptual puzzles. Put plainly, the car 'is what it is': manifestly, eloquently, materially there – a burnt out hulk, pulled around on the back of a trailer because its

self-propelling days are over, destroyed in a flash in a country most Americans know nothing about, on a street they have never heard of. The other aesthetic judgement he makes is that 'it must be "ugly"'. The word is uncompromising and, emotionally, highly charged. There is no question about where it is coming from or pointing to. Deller was alarmed by the reckless decision to invade Iraq, the chicanery that got us into the mess and the reversion of Britain to its ancient imperial role. He was transfixed for months by the war that followed. However, the 'romance' or 'adventure' of war couldn't have been further from his mind. Does the emotional pressure behind that word 'ugly' offer a tiny opening through which 'the political', in a more conventional sense, could slip into the frame? Perhaps. What he says about the work is that the point was 'not to make an anti-war statement, which you might be surprised to hear is what we were trying to avoid'.

Often, the authorial 'voice' has been consciously absented in these works. He makes a brief presentation in the published volumes that document a project, or interviews key participants, but these fragments, though highly intelligent and incisive, don't give much away. Though the subject is politically explosive, the foreword to the book of *It Is What It Is* is factual and descriptive.[3] The images are far more eloquently suggestive. A group of Iraqi men (but no women) look casually over the books displayed on the pavement at the book market in Al-Mutanabbi street, the informal cultural centre of Baghdad, where the car was destroyed in a car-bombing that left 38 dead and hundreds injured. They seem to anticipate the pleasure of reading, and the books invite them to do so. Then, the ravaging bomb-blast, buildings ripped apart, the shattered 'ugly' hulk of the car in what is left of its space, the smoke and rubble, the shock and awe.

If there is more to be said, the burden of the argument was carried, in both the original installation of *It Is What It Is* is in New Museum, New York, and Hammer Museum, Los Angeles, and in the related tour across the US, by 'open-ended conversations led by invited journalists, Iraqi refugees, soldiers and scholars with first hand experience of Iraq'.[4] Two principal conversationalists – an army reservist, Jonathan Harvey, and an Iraqi journalist, Esam Pasha, each with a different position on the war – accompanied the car through 14 public spaces in cities and towns. Their role was not to persuade or protest but to engage the public and 'spark conversations on the war, Iraq, its culture and myriad other topics'.[5] Deller describes the team objective as to instigate 'a more random version of what had already taken place in the museum'.[6] The more random, one feels, the better.

Peace activists gave the team the hardest time because they had risked open opposition to the war in the early days when public opinion was more bitterly divided; they must have seen the tour as a bit of a soft option. However, many Americans of every shade of opinion and walk of life did engage with the work. Did the tour provoke and outrage? Did it spark violence? Did it change minds and hearts? In many interviews, the simplicities and pieties run out and a more uncertain, tentative, inquiring tone emerges. Jonathan Harvey himself says, 'As a citizen I

want my government to do good in the world. As a member of the armed forces, if my country decides to go to war then I want to do it effectively, to do good with the least amount of harm. As a soldier, I want the leadership to make a decision. I am one of the people that implements it so I want good reasons and a good plan.' But there are no Damascene conversions. As Deller says, 'My motivation was simply to see what reactions the car would provoke as it toured across the country'.

In searching for an answer to the conundrum about Deller's political imaginary, we have been driven to defining what it is negatively – in terms of what it is not. However, there are some positives that can help us. There are artistic traditions to which Deller's work belongs, though the relationships seem indirect. The Situationists staged shocking events for the purpose of shattering the carapace of what Guy Debord called 'the society of the spectacle'.[7] The cover of his book, with cinema fans in serried ranks all looking at the screen through those ridiculous red-and-green cardboard spectacles to get an early, and over-rated, 3D effect, contrasts with the more sophisticated forms of technological desire that disfigure our screens and billboards today. Deller creates situations, but he is not a 'Situationist'.

Later, in the 1960s and 1970s, political activists staged 'happenings' designed to disrupt the even, unquestioning tenor of what Henri Lefebvre called 'everyday life', in order to provoke audiences to abandon the routine, common sense and the taken-for-granted, and think more critically.[8] The 'sit-in' protests in 1968 belonged to the same disruptive genre. Contemporary political groups like UK Uncut, the campaign against the government's austerity programme, have been using these tactics to extraordinarily good effect – in unannounced 'occupations' of banks and shops like Topshop, Boots and Vodafone. More generally, the performative element, intended to undermine the gap between performers and audiences is now integral to the lexicon of contemporary theatre, drama and the visual arts. There are traces of all these in Deller's work. What is not clear is whether his main objective is to shatter, disrupt, provoke, enlist or even change minds.

In a wide-ranging, informative and scholarly article, 'The Poets Of Their Own Affairs' – a review of Deller and Alan Kane's exhibition *Folk Archive* (2005) – Jeremy Millar maps this work onto the controversial tradition of British Folk Art. He begins with the Romantic poets' veneration for '…men endowed with highest gifts/ The vision and the faculty divine'.[9] Deller would never use this language, but it isn't as distant from his preoccupations and investments as it may at first seem. Millar tracks the tradition of accessible forms of creativity, through phenomena like the trade shows associated with the 'Arts and Crafts' held at the Whitechapel Gallery (at that time, 'firmly rooted in its traditional working-class location'), such as *Design and Workmanship in Printing* (1915); and Arts Council exhibitions, for example *Black Eyes & Lemonade* (1951); through to books such as Barbara Jones's *The Unsophisticated Arts* (1951) and Marx and Lambert's *English Popular Art* (1951), both of which were associated with the Festival of Britain and designed 'to consolidate a sense of Englishness after the ravages of war'.[10] Millar also considers

the movements designed to actually create 'new' popular art; for example, the work of The Independent Group (for whose work Deller once made a fake poster), and Richard Hamilton's pop collages and his 'brief and epigrammatic definition of Popular Art'.[11] Deller and Kane's work clearly has strong connections to and positive identifications with this long popular tradition.

'Folk art' is, of course, notoriously difficult to define. Its boundaries appear infinitely expandable. Who actually are 'the folk' and is what they produce 'art'? Does it include popular activities, pastimes and festivities such as travelling fairs, marches, bands and shows? 'Folk' has been associated with handicrafts and the countryside, but can it embrace urban life, manufactured artefacts and, by extension, as Deller and Kane suggest, imported things? More worryingly, is it irrevocably backward-looking, nostalgic for times past and, in the end, rooted in a conservative world view? Is it intrinsically hostile to innovation and change?

This does not sound like Deller or his work and, in fact, when offered the description 'folk' artist, he almost always prefers 'vernacular'. *Procession* (2009), the series of street events he staged in Manchester, testifies to the wide, irreverent, quirky and idiosyncratic inclusiveness with which he approaches 'folk' work. The Shree Muktajeevan Pipe Band (Indian members wear sporran and kilt), the winning schools' float, the World of Twist band fans, a horse-drawn funeral cortège, a ramblers walk across private property near Bowden Quarry, the Stalybridge Carnival Queen competition – solemnity has been banished from the scene. 'For me', he says, 'a procession can act as a snapshot of a time and place and I wanted this one to be as strange, messy and beautiful as daily life in this city is.'[12]

He turns naturally to the everyday lives of people – he respects their traditions and loves the diversity of what they do and produce. But he is not an antiquarian. The objects he lights on may be old but he 'reads' them through the lens of the ideas and experiences of his own time. He is irreversibly engaged with the 'contemporary vernacular'. His work is saturated with the world of British rock and popular music, across a very wide range: Happy Mondays, Brian Epstein and The Beatles, The Kinks, Depeche Mode and Steel Harmony. He is also an accomplished and knowledgeable DJ.

Undoubtedly, his attachment to the 'contemporary vernacular' has much to do with a particular idea of 'Englishness'. 'Englishness' is a shifty and dangerous signifier. Politicians mercilessly exploit the concept's ambiguities to fill out that empty void referred to as 'values'. It is supposed to be the glue that holds the nation together, across class, gender and ethnic difference. It has been 'eternalised', as if it has existed since time began and emerged fully formed out of the North Sea; it has been essentialised, as if there is only one brand; and it has been remorselessly imperialised, racialised and, in recent years, colonised (mainly by the far Right). However, Deller's use of the idea is never celebratory. He cares deeply about his country but he mourns its failures to confront the challenges which face it.

There is not much of a radical version of the English 'national-popular' around these days, but in the early nineteenth century there was a strong strand of radical populism – rooted in an appeal to working people to claim the rights of 'free-born Englishmen' (though elsewhere 'men' [sic] ruled by the English were not 'free').[13] Even then, the contradictions inherent in the notion could be seen in William Cobbett's passionate defence of common land against enclosure and his hatred of political corruption and hypocrisy on one side, coupled on the other with the chauvinism and racism revealed in his diatribes against Africans.[14]

Deller does not have much truck with that kind of nationalism. But there is something deeper in the 'vernacular' that profoundly animates his imagination. It is this idea: that people who are sometimes considered to be unimportant, not worth listening to, matter. They are creative but often have their creativity denied or taken away from them. He believes they should be valued for what they are – their voices heard, their practices celebrated – and that one way of doing that is to redeploy them as sources of new artistic work in a modern idiom. In *Folk Archive* he described the qualities he is looking for in this work of excavation and reappropriation: 'humour, modernity, insight, a unique voice or perspective, motifs we recognise and ones we don't, attempts to tackle ambitious subjects, refreshing directness of effectiveness, endeavours beyond normal expectations, pathos or just something extra'.[15] There isn't much that is 'traditionalist', populist or chauvinistic about that. The vernacular artist must make work, of whatever kind, which enables these qualities to find expression.

Jeremy Deller constantly returns to another idea that shapes his practice: 'openness'. Openness carries all sorts of trendy baggage these days, but for him – despite his sense of irony – it is a matter of deadly seriousness. This is why his political imaginary is fundamentally egalitarian, unswervingly turned towards the popular, and democratic. These are not well-thought-through nor widely-represented values in the hard-edged, elite-driven, market-oriented, possessive individualist contemporary political world, but their inscription in his work is 'political' for all that. It is a politics for a so-called non-political age. And Jeremy Deller is busy at work on giving it artistic form.

RALPH RUGOFF
ON INVISIBLE ART

*Invisible: Art about
the Unseen 1957–2012*
2012

449

Invisible: Art about the Unseen 1957–2012 brought together works made during the last half century that explore ideas related to the invisible and the hidden. Among the 26 artists featured in the exhibition were Yves Klein, Yoko Ono and Andy Warhol, as well as artists from a younger generation, including Teresa Margolles, Gianni Motti and Song Dong who have expanded on their legacy. While many of the works in Invisible *directed attention towards the unwritten rules and conventions that shape our understanding of art, others invoked invisibility to explore the limits of our perceptual capacities, or used it as a metaphor for the suppression of information, or the marginalisation of social groups.*

I t is possible – and this is certainly open to debate – that the history of what we might call 'invisible art' began on 14 May 1957. On that date at Galerie Colette Allendy in Paris, Yves Klein opened an exhibition that included a seemingly empty room. According to the artist, however, the white walls of that space were infused with the presence of 'pictorial sensibility in the raw state'.[1] Klein's presentation of blank walls as an artwork arguably kicked off a low-profile tradition that has gone on to span seven decades. *Invisible: Art about the Unseen, 1957–2012* brings together key moments from this rich history in order to reflect on the myriad motives and agendas that have led artists to engage the invisible, the unseen and the hidden.

Klein famously went on to explore the invisible in numerous ways. Working with Jean Tinguely in 1958, he investigated the possibility of making sculptures out of air. And until his death in 1962, he collaborated with architects and engineers on a utopian scheme for creating an architecture *de l'air*. Klein envisioned collective habitats protected from the elements by invisible walls and ceilings created with jets of forced air. To his thinking, air architecture would not only nurture 'a constant awareness of space', but would help dissolve repressive social mores and conventions. Humanity would live in a state of grace, free from concealment and secrets.

Klein, who applied for a patent for his 'air roof', regarded air architecture as a hugely significant project, but in terms of the history of invisible art, his empty 1958 exhibition at the Galerie Iris Clert created a more far-reaching legacy. Entitled *The Specialisation of Sensibility in the Raw Material State of Stabilised Pictorial Sensibility*, also known as *The Void*, it consisted of an apparently unoccupied gallery in which every surface had been painted white. Klein, however, maintained that the space was actually saturated with a force field so tangible that some people were unable to enter the exhibition 'as if an invisible wall prevented them'. Other visitors may have been unable to enter the gallery simply because the exhibition's widespread press coverage ensured the presence of a constant crowd of spectators searching for something to look at.

The Void, which has provoked hugely divergent interpretations over the years, is a landmark in the history of the invisible, but its impact for subsequent art has had

less to do with Klein's stated concerns than with its form: its audacious framing of empty space as a work of art. Its influence was paralleled, meanwhile, by another set of developments that anticipated Klein's sustained romance with the unseen. In the summer of 1951, Robert Rauschenberg had produced a series of *White Paintings* while ensconced as part of the artistic community at Black Mountain College, near Asheville, North Carolina. These modular monochrome canvases were the antithesis of the abstract expressionist painting that then reigned in New York. The composer John Cage, a colleague and collaborator of Rauschenberg at Black Mountain College, described their uninflected surfaces as 'landing strips' for ambient light and shadow. (Partly inspired by their example, Cage composed his famous *4'33"* in 1952, a work which involved a pianist sitting motionless at a piano for four minutes and 33 seconds, so that the only 'music' the audience heard was the incidental sounds in the environment.) In 1953, Rauschenberg began exploring ways to create drawings without images, which he initially did by making drawings and then erasing them. Unsatisfied with the results, he eventually determined that he needed to erase something that was already considered a substantial work of art. He ended up persuading Willem de Kooning, one of the giants of the New York School of painting, to give him a drawing for this purpose. The result, after a month of hard work with a rubber, was *Erased De Kooning Drawing* (1953), a contrarian masterpiece created by making an existing work invisible.

Not coincidentally, both Rauschenberg and Cage had been influenced by the thinking and art of Marcel Duchamp. Duchamp, who took exception to what he called 'retinal art' – the idea that art was primarily aimed at the eye – had made a sculpture out of air and glass in 1919 – *50 cc of Paris Air*, which consisted only of a glass ampoule that, despite its title, may have contained something more like 125 cubic centimetres of air. In other works from around this time, Duchamp made reference to invisible phenomena including radio waves, X-rays, magnetism, and the fourth dimension. Besides reflecting his antagonism towards 'retinal art', these works also drew on the general interest at the time in the unseen dimensions of existence, which physics and other sciences were then dramatically revealing. Reflecting back on that period in an essay on Duchamp and Francis Picabia written in 1949, Gabrielle Buffet-Picabia observed, 'It would seem, moreover, that in every field, a principle direction of the twentieth century was the attempt to capture the "non-perceptible"'.

Beyond Duchamp's intrigue with the unseen, his most profound impact on the future of invisible art was his notion that an artwork is only ever fully realised in the mind of its audience. In a speech to the American Federation of Artists in 1957, Duchamp declared that 'the creative act is not performed by the artist alone; the spectator brings the work in contact with the external world by deciphering and interpreting its inner qualifications and thus adds his (her) contribution to the creative act'. This creative work undertaken by the audience ensures that even the most conspicuously visible types of art have an added, unseen dimension. It may also lead us to wonder whether art necessarily requires a physical object. It is worth recalling here the exemplary practice of St Petersburg's Hermitage Museum during the Second World

War: having stashed its invaluable art collection for safe-keeping, the museum continued to operate its programme of guided tours, with docents describing the absent art from memory whilst leading soldiers through rooms occupied only by empty frames and plinths.

In the early 1960s, only a few years after Duchamp's memorable speech, Yoko Ono invented a new art form that specifically addressed the viewer's imagination as its intended site of creation. In 1962 at the Sogetsu Art Center in Tokyo, she displayed a series of *Instruction Paintings* that consisted of paper sheets with typed 'instructions' that asked the reader to think about particular actions, images and imaginary scenarios. Ono explained that her *Instruction Paintings* 'can be realised by different people in many different ways. This allows infinite transformation of the work that the artist himself cannot foresee'. Ono's works, whose realisation could only take place in the mind of its reader, entailed a radical departure from traditional ideas about the role of the artist. They also moved away from the conventional requirement that art take visual form. On the contrary, her instruction paintings, in her words, made 'it possible to explore the invisible, the world beyond the concept of time and space'.[2] Ono's text pieces looked forward to aspects of conceptual art, which in the late 1960s would usher in, to borrow Lucy Lippard's sweeping phrase, a 'dematerialisation of art'. Yet even before conceptual art came of age, the idea of invisibility was already in the air, turning up in some unlikely places. In 1963, Andy Warhol, who was already well on his way to becoming a highly visible media celebrity, produced a couple of 'pornographic' paintings, using fluorescent inks, that appeared to be blank canvases, revealing their hidden content only when seen under ultraviolet light. These works, along with films like *Blow Job* (1963) (which depicts only the face of a man on the receiving end of the eponymous sex act) were provocations that Warhol aimed at the harsh anti-pornography laws of the time, which tightly controlled what could be made visible and what had to be left unseen.

In the sphere of public art, meanwhile, disillusionment with traditional political monuments gave birth to what art historian Sergiusz Michalski has called a 'new art form: monuments which tried to attain invisibility as a way of engendering reflection on the limitations of monumental imagery'.[3] Curiously, Claes Oldenburg, better known for his 'soft' sculptures of everyday objects, played a pioneering role in this area. His *Proposed Underground Memorial and Tomb for President John F. Kennedy* (1965) called for a huge hollow casting based on a photograph of the assassinated President to be buried head-down; a tiny hole in the ground offering a view into the statue's interior would provide the only access point for would-be spectators. For *Placid Civic Monument* (1967) the artist hired a crew of municipal gravediggers to dig a hole in New York's Central Park, just behind the Metropolitan Museum of Art. Made at a moment when the Vietnam War was escalating, the rectangular pit briefly conjured an inverted plinth as well as an open grave before it was filled in only hours after being dug. The provocative low profile of Oldenburg's 'counter-monuments', and the idea of conjuring trauma and tragedy through absence, would be taken up 20

years later in commemorative projects addressing the holocaust and civil violence by artists such as Horst Hoheisel, Jochen Gerz and Teresa Margolles.

By the second half of the 1960s, a growing number of artists associated with different strains of conceptual art began producing work that defied the conventional notion that an art object is something you can look at. In 1967, Michael Baldwin, co-founder with Terry Atkinson of the British collective Art & Language, published an article in *Arts* magazine entitled 'Remarks on Air Conditioning: An Extravaganza of Blandness', proposing that a volume of air in an empty, air-conditioned gallery could constitute a work of art. Physically realised in 1972 at the Visual Arts Gallery in New York, Art & Language's *The Air-Conditioning Show* was accompanied by a lengthy and difficult text making the case for its status as art; given that there was nothing else to look at in the gallery, the reading of the text essentially comprised the viewing of the artwork. As Baldwin explained: 'We wanted to suggest that fundamental to cultural production is description: that things are noticed and attended to not in virtue of some "naturally" obvious assertiveness but in respect of culturally, instrumentally and materially conditioned discursive activity.'[4]

This 'critical' wing of conceptual art tended to focus on the institutional frameworks and structures that shape the production and presentation of artworks. Across the Atlantic, Los Angeles-based artist Michael Asher produced a series of works between 1966 and 1969 that used industrial air blowers to create 'walls', 'curtains', and 'columns' of accelerated air that were placed in relation to particular elements in a gallery's architecture in order to subtly modify, and perhaps make more self-conscious, the visitor's experience of moving through the exhibition space. For a 1974 show at Claire Copley Gallery in Los Angeles, Asher's sole intervention consisted of taking out the walls that separated the gallery office from the exhibition space. Rather than merely presenting an empty gallery, Asher's piece – by revealing the otherwise unseen work of the gallerist at her desk – put on display issues related to labour and the selling of art. As Asher's work makes evident, the display of a vacant gallery – rather than merely being a display of 'nothingness' – always involves specific concerns about a particular context and set of intentions.

The impulse to move away from making tangible objects also comprised a form of resistance to what many artists at that time saw as the increasing power of the marketplace to determine the significance of works of art. It may also have been a response, in part at least, to the emergence of a burgeoning 'culture industry' fuelled by mass media and advertising. Against the background of a society where images held sway, artists like Barry Le Va maintained that 'content is something that can't be seen'.[5] Lawrence Weiner, meanwhile, formulated a radical 'declaration of intent' regarding the execution of his own language-based art, that included the stipulation that once conceived, a work did not have to be made. The proposition that an artwork does not have to take material form – that its being 'built' is merely an option – calls into question the prerogatives of ownership. By limiting their work to a purely speculative

or theoretical condition, artists might defy the exclusivity and control usually exercised by those who can afford to possess it, whether institutions or individuals.

At the same time, the development of intangible artworks signalled a shift away from the notion of the art object as a self-contained repository of meaning. It also re-directed attention from the artist's role as 'author' to that of the 'receiver' – a term that perhaps connotes too passive a position, especially as some of the most compelling invisible art from this period invited very active (mental) participation from its audience. This was certainly the case with the work of Robert Barry. For his *Inert Gas Series* (1969), Barry released commercially available 'noble' gases, such as helium and neon, into the atmosphere at sites around southern California. With regards to his using an undetectable material to create an environmental sculpture of immeasurable dimensions, Barry remarked that an audience's 'understanding of the work and appreciation really had to be totally mental. One would have to use one's imagination'.[6] Indeed, Barry's photographic documentation of these works – banal images of the different sites where he released gases – leaves everything to the imagination, while underscoring the limitations of visual representation (in addition, Barry publicised his actions with a poster advertising an exhibition of the *Inert Gas Series* at Seth Siegelaub's Gallery – an 'invisible' gallery which existed only as a telephone number and an answering machine).

In the late 1960s, Barry produced gallery-based works using a range of immaterial media, including electromagnetism, radio waves and ultrasonic sound – forms of energy that, as he noted, 'exist outside the narrow arbitrary limits of our own senses'.[7] In some of these works, visitor participation was involuntary: in the *Carrier Wave* pieces of 1968, for instance, which consisted of radio waves generated by a hand-engineered transmitter, the (invisible) form of the piece was affected by the presence of people in the gallery, inasmuch as radio waves can be absorbed, reflected and refracted by the human body.

Barry summed up another approach to the unseen with his 1969 *Telepathic Piece*, which appeared only as a bracketed statement in an exhibition catalogue:

> During the exhibition, I will try to communicate telepathically a work of art, the nature of which is a series of thoughts that are not applicable to language or image.[8]

Barry's paradoxical communication ostensibly prepares us to receive an impossible message: what kind of 'thoughts', after all, can exist outside of verbal and visual representation? Much of Barry's invisible art plays on this kind of dialogue between presence and absence. It conjures the unknowable as a space of possibility that defies our desire to pin down meanings and fix things in place. At the same time, it underscores the subjective nature of interpretation. Interviewed in the catalogue for the exhibition Prospect 69 at the Dusseldorf Kunsthalle, Barry stated that his piece in the show 'consists of the ideas that people will have from reading this interview [...] The piece in its entirety is unknowable because it exists in the minds of so many people. Each person can really know that part which is in his own mind'.[9]

The motif of absence also played a key role in the work of James Lee Byars, who – not unlike Klein – persistently questioned the relationship between physicality and immateriality. In his minimal and ephemeral performances and installations, Byars regularly conjured absence by evoking his own mortality (in the 1970s he would organise a 'Death Lottery' to prematurely mark his own demise, and once invited Salvador Dalí to Hollywood to film his death, an invitation Dalí refused). In 1969, at the Eugenia Butler Gallery in Los Angeles, the artist presented *This Is the Ghost of James Lee Byars Calling*, an installation that consisted of a red room with a small hole in the ceiling providing the only source of light. Like a commemorative exercise aimed at reconstructing the presence of the absent artist, participants were invited to read aloud letters sent into the gallery by various acquaintances, describing Byars. Left to mentally shuffle through the competing descriptions, visitors to the exhibition could only arrive at an inconclusive portrait of their unseen subject.[10]

Byars's approach in this work is a long way from Klein's notion of filling a space with 'immaterial sensibility', as it foregrounds an elusive absence, rather than an occult presence. In the 1970s, Chris Burden created a number of works that further developed the motif of the artist's absence as a carrier of content, in lieu of conventional sculptural form. For his first performance, *Five-Day Locker Piece* (1971), Burden spent five consecutive days concealed from view while remaining inside a 2 x 2 x 3-foot locker at the University of California, Irvine. Later that same year for a performance entitled *You'll Never See My Face in Kansas City*, he sat without moving for three hours behind a panel that concealed his neck and head; in conjunction with the performance, he wore a ski mask at all times during the three days he spent in Kansas City. Burden's interest in hiding reached a climax with his 1975 exhibition *White Light/White Heat*, for which the artist spent three weeks at the Ronald Feldman Gallery in New York lying on an elevated platform, high enough so that visitors could not see him if he remained in a prone position at the back of the platform. Burden commented at the time that he was curious to discover whether visitors to the gallery would be able to sense his presence even if they could not actually observe him. But rather than comprising an eccentric experiment testing uncharted areas of human perception, *White Light/White Heat* seems more like a calculated gesture that replaces the avant-garde's traditional hostility towards its audience with a passive-aggressive withholding. Burden had already received extensive press coverage in his brief career, appearing in *Time* magazine as well as on the cover of *Artforum*, and his unseen presence in the gallery might well have been aimed at frustrating visitors drawn by his notoriety.

A year before Burden's exhibition, London-based artist Gustav Metzger had proposed a worldwide withholding of artistic production. Driven by his conviction that capitalism had 'smothered' art (and had made 'real art' invisible), Metzger formulated his proposal *Art Strike 1977–1980*, which called for a three-year period during which 'artists will not produce work, sell work, permit work to go on exhibitions, and [will] refuse collaboration with any part of the publicity machinery of the art world'.[11] Metzger's proposal for global action was never realised, but a little over a decade

later in New York, artist Tehching Hsieh created a personal, and markedly different, version of an art strike. On New Year's Eve in 1986, Hsieh began his *Tehching Hsieh 1986–1999*, a type of invisible performance during which, as he declared in a signed statement, he would continue to make art but would not show it. Rather than making a political statement, Hsieh's undertaking seems closer to an exercise in humility, an ego-stripping practice designed to force artist and audience alike to rethink the desire to exhibit, and to question the value we place on public approbation in general. Designed so that it concluded on the artist's 50th birthday and the end of the millennium, *Tehching Hsieh 1986–1999* offered the tonic example of someone acting from an unseen but deeply felt system of values, rather than seeking the measure of himself from the external world.

Over the past 20 years, artists have continued to experiment with the idea of invisible art, fashioning new approaches and exploring conceptual territories that range from the philosophical to the pointedly humorous, from the meditative to the political. Perhaps more than any other artist during this period, Bruno Jakob has concentrated on the invisible as the central focus of his work. A painter, Jakob has developed several methods of making invisible pictures: instead of pigment, he paints with various types of water, as well as 'unseen colours'. He has exposed canvases to rain and sun, and has used them to record the faint trails left by snails. Suggesting a link to photographic processes, he has also brought canvases into close proximity with individual people and animals in order to capture some transferable form of their energy. As might be expected, most of his canvases and drawings look more or less blank, yet rather

Tom Friedman, *Untitled (A Curse)*, 1992. Installation view, *Invisible: Art about the Unseen 1957–2012*, 2012

than being characterised by a lack of visible elements, Jakob's work is built around the disappearance of images: the canvas is the scene of a vanishing (as the pictures he has drawn with water have evaporated). We are left to reconstruct their different subjects by responding to the titles of the works, the lists of materials used, and the faint traces of activity left on paper or canvas.

Our experience of Jakob's art is inseparable from our knowledge of how it is made. The same holds true for an astonishing trio of works that Tom Friedman created in 1992 during a flurry of invisible activity. Friedman's *Untitled (A Curse)* appears at first (and even second) glance to consist only of an unoccupied plinth, yet this sculpture enacts a distinctly non-utopian revival of Klein's practice of 'sensibilising' empty space. Subcontracting the mystical aspect of producing such a work, Friedman hired a practicing witch and instructed her to cast a curse on a spherical area, 11 inches in diameter and positioned 11 inches over the surface of the plinth. For another invisible work begun in the same year (and completed five years later), the artist spent 1,000 hours staring at an 82.6-centimetre-square piece of paper, whose blank surface, after all that invisible labour, remains visibly unaltered. Finally, for *11 x 22 x .005*, Friedman assiduously erased a *Playboy* magazine centrefold, reducing it to a blank and slightly creased piece of glossy paper. In revisiting Rauschenberg's *Erased De Kooning Drawing*, the artist pointedly targeted not at an artwork but a

mass media image designed to solicit and exploit voyeuristic impulses – something designed to be stared at, in other words, which he has rendered invisible with a repetitive action that in light of the material, suggests a kind of all-consuming masturbation.

Like Jakob's, these works draw attention to the way that our interpretation and experience of an artwork is often contingent on information that exists apart from the object itself. They also invoke questions about the relative importance of veracity. We cannot ever really know whether Friedman did, in fact, stare at that piece of paper for 1,000 hours, but perhaps that very uncertainty is a key element of our experience of this kind of art. Since we cannot definitively disprove any of the artist's claims, issues of truth or belief may be beside the point: the speculative idea alone, regardless of its verifiability, seems to offer all the purchase that we require.

In some instances, the use of invisible media accommodates an intensely personal and private form of artistic practice. In 1995 Song Dong began a daily routine of writing diary entries with water on a stone tablet, a ritual he has documented with

photographs ever since. As a child in a family of modest means, he had been taught by his father to practice calligraphy in this way, to save paper and ink. Over the years, his invisible diary writing has become a meditative means of expressing his feelings and thoughts in total privacy, without leaving any legible record. At the same time, it reflects the ephemeral nature of much of the work associated with the Apartment Art movement that emerged in China in the 1990s, at a time when artists had limited material resources and exhibition opportunities.

Other artists have explored the invisible while addressing large-scale political and social scenarios. As if repurposing Robert Barry's *Telepathic Piece* (1969) as a form of social protest, Gianni Motti organised a public performance in Bogotá, Columbia, in 1992 in which he attempted to telepathically communicate a message urging the country's unpopular president to resign. Entitled *Nada por la Fuerza, Todo con la Mente* (*Nothing with Force, Everything with the Mind*), Motti's invisible message was documented only through its coverage by Colombian newspapers. Teresa Margolles, as part of her ongoing attempts to commemorate and draw attention to the epidemic of civil violence in Mexico, caused in large part by drug cartels and the climate of political corruption they have instigated, has created several installations in which otherwise empty rooms are humidified with water that has been used to wash bodies in a Mexico City morgue. Eschewing visual forms of representing the victims of violence, Margolles instead creates a much more intimate experience of human tragedy as visitors feel the moist air on their skin and mentally conjure their connection to the absent bodies of the dead.

Glenn Ligon, whose work has often critically scanned American cultural history and identity, obliquely comments on the representation of race in *He Tells Me I Am His Own* (2005), a Cibachrome print that resembles a piece of blank photographic paper. With its title borrowed from the popular 1912 hymn, 'In the Garden', which describes a personal encounter with Jesus Christ, Ligon's picture of whiteness calls to mind the way that the divine presence is frequently represented in movies, as well as in Christian theatre, as a blinding light. *He Tells Me I Am His Own* quietly prompts us to reflect on how such conventions are never neutral, but express and reinforce the biases of the (white) culture that produces them. Roman Ondak's *More Silent than Ever* (2006) addresses another oppressive social landscape: the pervasive culture of surveillance that existed under the former Communist regimes in Eastern Europe. Ondak's installation consists only of an empty room with a single entrance and exit, and a wall label indicating the presence of a concealed listening device. Whether or not we choose to take this text at face value, we are led to at least consider the possibility of surveillance, and it is precisely this diffuse state of uncertainty, rather than full-blown paranoia, that effectively recalls the atmosphere of doubt that infects everyday situations in societies that spy on their own citizens.

I hope it is clear by now that there is no limit to the potential meanings constructed around invisibility in art. Works that seemingly share a similar blankness turn out to conjure and convey remarkably varied content. An empty room or unoccupied plinth

can successively operate as a sign of mystical sensibility, a haunting absence, or a cursed presence. The difference does not have to do with the inherent characteristics of the object – something that invisible art makes obvious – but with how it is positioned within a larger symbolic network. Invisible art thus helps us to grasp more clearly the acute contingency of art's meaning (and it is worth noting in this regard that before we can 'see' an invisible work, it must first be framed as such by one means or another).

Rather than merely comprising a conceptual end game or a rhetorical prank designed to flout the expectations of gallery visitors, invisible works of art have played a critical role in expanding the limits of contemporary art over the past half century, while calling into question how such limits are maintained and function. In presenting paintings, sculptures and photographs that cannot be seen, artists have asked us to think differently about what engaging with a work of art entails. Clearly, it is not just about looking at something. Art is about paying attention, and invisible art asks us to pay attention in a different way. It invites us to forego 'the complacency of seeing', to borrow Leonie von Oppenheim's phrase, and to instead observe the ways in which our perception, far from being unmediated, is shaped by various kinds of filters, including our presumptions and assumptions, our cultural conditioning and personal history, and the institutional structures, both physical and immaterial, that shape our relationship to art.

In the process, this kind of work leads us to wonder about our usual criteria for engaging with pictures and sculptures, and whether they may miss the mark. If we ignore any part of what art has to offer us, we effectively render it invisible. With our ceaseless merry-go-round of international art fairs and the headline-grabbing spectacle of auction houses selling works for mind-boggling sums, have we not already rendered invisible a great deal of contemporary art? Or consider the way that museum buildings are now often designed as architectural showpieces that attract more attention than the artworks they house. Under these conditions, art disappears as a mere backdrop for flamboyant displays of social capital. In such a context the idea of invisible art can be a much-needed tonic. It can provoke us to see through the art world's extravagance and pretence, and to remind us that the meaning of art is not framed by physical objects, but develops through our responses to a given work, our feelings and thoughts and all that we make of them. Whether visible or not, art ultimately comes to life in our memories and in our conversations with others, where it activates and illuminates countless other cultural references. That invisible process is the actuality of art, to which we may draw closer through engaging with works like those in this exhibition.

ANNE WAGNER
ON ART AND LIGHT

Light Show
2013

Light Show *brought together sculptures and installations that use artificial light to transform space and to influence and alter perception. Making use of materials ranging from off-the-shelf fixtures to computer-controlled lighting, the works stimulated many different – and often surprising – responses. Visitors were invited to wonder at, contemplate, investigate and, in some cases, to interact with illumination as both a phenomenon and a versatile artistic medium. Among the 22 artists exhibited in* Light Show *were David Batchelor, Olafur Eliasson, Dan Flavin, Nancy Holt, Jenny Holzer, Philippe Parreno and James Turrell. The exhibition was accompanied by a catalogue that featured a range of contributions by authors including the science writer Philip Ball and art historian, critic and curator Anne Wagner.*

VISION MADE VISIBLE

This is an essay that aims to characterise the nature and intentions of light art over the course of the 100 years or so this genre has been in existence. The brush it uses is necessarily broad, given the scope of the topic, but even so, the effort seems worth making if it brings one central difference between early and contemporary light art into view. That difference, to anticipate the essay's conclusion, is a matter of effects and aims. These are inevitably diverse, yet most recent light works still seem to share the recognition that an audience possessed of vision is equipped with a faculty that is mutable and profoundly bodily, yet at the same time more than merely personal; it is also interpretive, situational, historical and cultural. These qualities, so artists have implicitly argued, can be made vivid, made visible, if light can be shown to have a poetics that can be put to active use.

An essential precondition of the human faculty of vision, light began to be understood, produced and controlled in whole new ways in the twentieth century. Technologies developed in the 1800s – gas and electricity – were the first to generate cheap and reliable sources of illumination, and thus helped to enable the use of light as both a vehicle of mass communication and an artistic medium, in each case with unprecedented results.[1] In earlier centuries, calculated effects of light and space had been crucial to the experience of religious buildings and public spectacles, but in the fine arts, light had served mostly as a formal and emotive vehicle, vivifying sculptural surfaces and providing the template for many of the most dramatic of painting's depicted effects. Light, and its antonym, darkness, created the art object's atmosphere, in every sense of that word. They summoned its central illusions, which so strikingly render the impression of time's passage and the sensation of physical depth.

The changes in this state of things began to arrive in the wake of First World War. They involved the idea that, in the face of the new visual powers and experiences

that result from artificial illumination, human vision would inevitably be subject to change.[2] The issue, for at least some artists, has been how the enormous explosion of visual experiences and technologies would matter to their art, if at all. When they deployed light, they could not help but confront its relationship to time and vision; the diverse implications of their interconnection became a subject in itself. If the nineteenth century offered a 'New Painting', in the guise of impressionism, in the twentieth century nothing less than a 'New Vision' seemed to come into view, in large part the product of the pedagogical and technological awareness championed at the Bauhaus, first in its Dessau studios, and then, following the school's forced closure, in the United States.

Soon after he joined the Bauhaus faculty in 1923, the Hungarian photographer László Moholy-Nagy (1895–1946) began to try to represent this New Vision – the phrase became his watchword – and to present its developmental logic since the invention of photography as a forsaking of pigment for the medium of light.[3]

From representation to optical experience: the energies propelling this logic were not to be understood as merely subjective, the province of each individual spectator exercising the faculty of sight. On the contrary, Moholy-Nagy maintained that objective factors – the 'material qualities of the optical medium of expression' – determine visual experience. And when that optical medium is black-and-white photography, the logic of its light-sensitive process leads directly to its ability to stand in for light. If Moholy-Nagy's work takes up light's 'material qualities', it does so by capturing its powers of erasure and exposure, its affinity for edge and outline, its untrustworthy revelation of depth. This is a materiality dedicated to black and white as its default condition, marking out both visual and spatial extremes.

The artist first put these concepts to work in mechanically generated images he termed photograms, works produced by illuminating objects positioned on or just above photosensitive paper.[4] To understand the procedure behind them is to grasp how Moholy-Nagy mined the possibility of pushing chiaroscuro towards emptiness, and defamiliarising the mundane objects afloat in its space. They were the first of his works to exemplify the New Vision: active, unsettling, they tied transparency to space, fragmentation, speed and disembodiment. If this way of seeing is new, it thrives on blindness as much as sight. And it led its inventor to experiment with projecting light and shadow in space.

Beginning in the early 1920s, Moholy-Nagy put his mind to devising a machine-powered display of moving artificial light. The apparatus that resulted – by now twice reconstructed, as befits its legendary status – is a quasi-sculptural construction fabricated from moveable planes of metal and glass. Its language is urban, architectural, as if to broadcast messages to and from a city on the move. And so it did. Spot lit, it was set into motion (its components were mounted on a set of turning axes) like a mechanical organ playing an updated fugue.[5] The effect is utterly theatrical, with spectators composing an 'audience' on which the light

and shadows fall. Little wonder that Moholy-Nagy first presented it in Paris in 1930 bearing the title *Light Prop for an Electric Stage (Lichtrequisit einer elektrischen Bühne)*. Two years later, it became the centrepiece of the artist's first film, *A Light-Play Black White Grey (Ein Lichtspiel schwarz weiss grau)*, its initially modest staging of shadow now augmented by the injection of special effects.[6] The effect produced is dizzyingly antic, a splintering geometry of light and dark.

Later, in 1969, *Light Prop* was renamed *Light-Space Modulator*, and under this title its first replica was produced the following year.[7] The name change seems significant: it is as if an object that was initially quick to acknowledge its artificial, even theatrical, status was later asked to assume another identity, as an agent of perceptual change. Yet it is considerably more plausible to assume that by then, with Moholy-Nagy dead for almost a quarter-century, his work was not a catalyst so much as a recovered memory, a forgotten prototype in which 1960s critics and historians could recognise a kindred aim.

Yet this intuition was only partly right. There is no doubt that Moholy-Nagy's experiments with artificial illumination remain landmarks, yet their effects inevitably seem restricted compared to those deployed by the diverse set of artists who followed. These occupy his 'electric stage' with a considerably wider range of aims and effects than he could or would have conveyed.

Thus our task demands making sense of that diversity, the sort of sense that, if it begins with basic demographics, moves on to other matters. For if it is crucial to note that artists using light today are both male and female; and that their national origins span several continents; and they range in age from the generation born in the 1920s to the cohort born in the 1980s, what is more important is that, though they too mine the effects of artificial illumination, their goals have changed. The aim is not so much to invent a 'new vision' consciously adapted to 'modern' experience, to speed and the city; nor do they see artificial light as a modern emblem, the sign and symptom of technological change.

One reason it still seems useful to remember Moholy-Nagy's practice is because it helps us to think about what is different, or might be different, today. Is it possible that the experience of time and light has changed since then? In interwar Europe, the transformative goals of 'New Vision' were to be actively, even passionately, embraced. Since then, ambivalence has wormed its way in. Artists seem to have become less prepared to put blind trust in technological vision or to find 'illumination' only in the otherworldly glow of the screens that surround us. These have emerged as our 'personal' devices, the technologies that, in the words of David Cronenberg, are the ones 'you take to bed with you'.[8]

The question here is not where these changes have come from, but whether a new set of principles concerning light and vision have come to govern light art since its return, so to speak, in the years since the 1960s. By the end of that decade not

only had the *Light-Space Modulator* been remade for exhibition, but a series of exhibitions – shows staged in both US and European museums with titles like *Kunst Licht Kunst* (1966), *Light, Motion and Space* (1967) and *Light: Object and Image* (1968) – had begun describing the new landscape, or lightscape, initiating a process that is still ongoing.[9] Nor is its end in sight, given the sheer proliferation of art using light in the last 40 years or so, as opposed to the half-century before. Where there's light, there's heat, or so the saying goes. To it should be added a rider: where there's light, there is also vision and time. Since the 1960s, this trio has again emerged as a key concern of ambitious artists, with some of the reasons for its new centrality set down by the artist Nancy Holt in 1973. Her list, entitled *Vision*, was first published as a contribution to Lucy Lippard's 1973 catalogue, *c. 7,500*.[10]

This was a moment when the artist's list – half poem, half manifesto – was often presented as a work in itself. Like Richard Serra before her, Holt proved herself a master of the form. But while his subject was sculpture and all that can be done to make it ('to roll to crease to fold to store'), hers was vision – vision as it can be manipulated, and thus made the object of the artist's labour and thought.[11] Vision, she writes, is or has been 'fixed', 'concentrated', 'demarcated', 'located' and 'concretized', 're-focused' and 'circumscribed'. It is or has been 'reconnected', 'delimited', 'designated', 'made visible', 'made actual', 'made definite'. All these terms are governed by a shared implication that there is a yawning gap between the illumination offered by nature and that invented by man. Holt's notion of the latter sees it as being acted upon by some unnamed force or agent – the artist, perhaps, though this is never made clear. The closest Holt comes to identifying this catalyst is in speaking of 'vision designated by things as they exist in the world'; in retrospect this seems close enough.

To 'designate' vision is to make it visible, actual, concrete. Again, the adjectives are Holt's. But what seems striking in retrospect is how much purchase they seem to have on the shared purposes of light art, then and since. Consider, for example, the work of Dan Flavin, which from the outset staked a claim on an 'actually existing vision', to be summoned by the studied deployment of store-bought fixtures, and thus of store-bought light.[12] The artist's use of the variously soft and vibrant hues of fluorescent tubing – the commercially-available fixtures he bought off the shelf – insistently brought the experiential effects of various 'elsewheres' (the garage, the workshop, the warehouse) into the physical space of the gallery. Most often, the result is perceptually confounding. Our eyes begin to ache uncomfortably, and our ability to see is exposed as a function, first, of where we stand and move within the gallery; second, of how long we have stood there; and third, of what we have just seen in the moment before. It sometimes matters what we wear to look at a Flavin (say, we are wearing white when looking at an ultraviolet installation), and it always matters what we look at next. Flavin's works are utterly a function of artifice, so much so that, within their compass, time and light no longer work together; we are no longer able to read the one from the other, and vice versa. What's the point of telling time when the clock being looked to is an artificial sun?

When Holt first drew up her 1973 list, she was undoubtedly thinking of Flavin's works. This seems inevitable, given their visibility at the time, not only as the focus of both regular gallery exhibitions and major museum presentations in the United States and abroad, but also given that their author played such a notoriously argumentative art-world role. Yet Holt was also clearly speaking from her growing sense of light as a medium, and her efforts to realise what she termed the 'concretization of sight'. This is a concept that if it is explored most thoroughly in her *Holes of Light* (1973), and its accompanying documentation also shaped much of her art.

An installation that depends on artificial illumination, *Holes of Light* operates by channelling and thus shaping light's fall. Its method is simple: two brilliant quartz lamps are mounted on opposite walls of a gallery, which in turn has been divided by a temporary wall through which have been cut a diagonal line of eight circles. Each of these is ten inches in diameter, and each creates an orb of bright light that is double the size of its generating hole. Yet, because the room divider is shorter than the walls of the gallery, none of these light circles appears crisply defined. Although each is the product of a distinct light/dark alternation, ambient light erodes its curves. The 16 bright pools thus each take on an oddly hazy, elusively optical appearance that the artist has bordered with a pencil trace. It is as if the eponymous holes have been cut so as to measure light's immeasurability, and thus to undermine the precision of the work's own precisely-cut apertures. As a result, Holt's 'holes of light' become cloud-like; capable of softening, even obscuring, our sight.

The fact that the great majority of Holt's light works were produced out of doors gives *Holes of Light* its own particular role in her work. As an installation, it makes vision visible under what we might call laboratory conditions, a set of rules drawn up to test out phenomenological questions of light's incidence and play. Holt's outdoor works, by contrast, harness perceptual experience in aid of a different sort of vision – a vision consciously 'located' in a conceptually expansive cosmos large enough to measure planetary time. This is nowhere more vivid than in her brilliant *Sun Tunnels*. Sited in the barren grandeur of the Great Basin Desert, Utah, the three-year project was completed in 1976. Like an enormous camera or a cosmic sundial, the sunlight caught in the work measured the annual activity of the heavens, both sun and stars.

It bears insisting that for an artist like Moholy-Nagy, the sun was not a concern. Like other artists of his generation, he would have concurred with the Futurist ambition telegraphed so concisely by the title of the 1913 opera *Victory over the Sun*.[13] Moholy-Nagy's ideal field of operations was urban and nocturnal; if light was to be confined to the interior, the artist preferred light shows, projections and film. Light and spectacle went together, and his goal was to find a way to mobilise their hyperbolic opticality for a spectator whose assigned role asked only that she look.

Carlos Cruz-Diez,
Chromosaturation, 1965–2013.
Installation view, *Light Show*, 2013

ANNE WAGNER ON ART AND LIGHT

By contrast, to consider the range of light works produced since the 1960s is to see that the viewer's share is considerably expanded. She now moves, thinks, observes and remembers. She is often asked to understand light and its sources not only as having a history, but also as summoning the terms in which artificial light has been put to social use. When Philippe Parreno, for example, constructs (or reconstructs) a theatre marquee, whose time-bound typology he has been exploring since 2008, he uses it not only to enhance a real-life doorway, but also to recall the sense of splendid artifice that characterised the great movie palaces of a long-lost day. And when, in 1973, Anthony McCall adapted straightforward animation techniques to simulate the projection of a movie – the work that resulted was his foundational *Line Describing a Cone* – he too addressed the deep-seated semantics of the cinema, transforming its signature projection into a slowly forming and deceptively tactile cone of light. And in this case, a work that began life as a structural analysis of film's fundamental components – the projector and its changing cone of light – has become in the course of its recent screenings a memorial to cinema's now-vanished past.

One way to characterise the transformation represented by McCall and Parreno is in terms of what seems to be a growing recognition of the metaphoric capacities of light. Not only does it illumine, it also represents – and does so with often deceptive force. The long-established association between light and knowledge had already become unfixed by the 1920s: since that time, light has been revealed as an untrustworthy agent, capable of deceptions both large and small.

Among recent artists, it is perhaps Ceal Floyer who has specialised with greatest concentration on producing gestures that, despite their small scale, manage to communicate something of this experiential complexity. *Light Switch* (1992–99) does nothing more emphatic than to use a standard carrousel projector and 35 millimetre slide to cast an unchanging light patch alongside a nearby door. It is only on approaching its steady brightness that the viewer can see that the slide represents the switch of the work's title. And, of course, it summons other 'switches' too, more conceptual in kind: above all, there is the linkage we are asked to make between the obvious source of the light and the considerably subtler implications of its projected image. It is as if the impossible tripping of this non-existent switch would dispel our accustomed understanding of how artificial light occupies our space. Is it too just an image, after all?

To encounter *Throw* (1997), another of Floyer's utterly minimal pieces, is to become acquainted with her rendering of two separate meanings that inhabit the title word. On the one hand, a light, like a voice, has 'throw' – which is to say that it projects according to its strength. On the other, if a speaker were to 'throw light' on an obscure subject, she would make it clear. By contrast, the light that comes from Floyer's *Throw* does neither. Instead, the work revels in its rendering of light as a splotch or splatter whose outline has cartoon-like force. The result is a pun conflating light, language and modernist painting: we are back again with Jackson

Pollock's splatters and pours, though now equipped with the contradictory effects of violence and humour that occur when the language of light is made concrete. Perhaps here, in the seamless overlay of effects that are both immaterial and yet so sensually present, comes the complexity that light art before the 1960s did not seem to possess. These are the contradictions that animated Olafur Eliasson's *The Weather Project*, the unforgettably monumental, yet coldly illusory, sun that dominated Tate Modern's Turbine Hall from October to March 2003–04. The sheer scale and artifice of the work, though not literally cinematic, inevitably take us back to Moholy-Nagy's preoccupation with a cinematically urban spectacle, though only to insist that if Eliasson's spectacle should also be understood as urban, this quality is above all the effect of the enormous audience – more than 2.3 million visitors – it attracted in the course of its run.[14] That, and the pre-coding of their beachside behaviours inside a space set aglow by a stone-cold sun. Throughout all of this, they saw themselves seeing – and thus sensing – because Eliasson's design had replaced the hall's workaday ceiling with a mirrored skin.

As technologically precise as it was socially compelling, *The Weather Project* is one of those outsized works that, despite (or because of) their obvious complexity and ambition, can serve as what might be called a 'representative' work. What it stands for is a newly analytical and newly social aspect of light work, initiated in the perceptual awareness urged on gallery-goers since the 1960s, and increasing ever since. If such pieces succeed in making vision visible, the result is viewers who are asked to develop an awareness of what it means to inhabit that role. We are asked, as Eliasson once put it, to 'see ourselves sensing', with his revision of Holt's concept pointing to the potential of self-conscious sight. This form of vision is spatial and sensual, and often occurs alongside other viewers whose presence we cannot ignore.[15] In achieving effects that are social and metaphorical, bodily and temporal, the light art of recent decades seems to have abandoned 'new' vision so as to represent something of the complexity that already inheres in human powers of sight.

To put it another way, a great deal of writing exists on the painting and sculpture of so-called 'outsider artists', but not as much has been said about the inherent paradoxes of photographs produced in this milieu (non-documentary, non-journalistic photographs) and these are exactly the questions posed here. For the purposes of this essay: if photography is sometimes the form with the *documentary tendency*, then *outsider* photography is the *counter-narrative* of that tendency to document. Or: the 'outside' work has all the paradoxes and convolutions of the 'inside' work, is just as philosophically impure, so that the 'real' it documents is never the 'real' we suspect we will find.

And: the conventional approach to discussing what goes by the name of 'outsider art' involves a preoccupation with the biography of the artist, sometimes at the expense of the work. Perhaps the biography fetish has to do, in part, with consigning the makers of this work to the categories of extremity that would make possible the elusive transit around the symbolising field of culture. These artists can't possibly be speaking *inside* of culture! Because the work is too far out, too extreme, too intense! In the appreciation of so-called outsider work, our voyeuristic desire to gaze at the biography often eclipses our engagement with the work itself, and this is perhaps more reflective of our own desire to be outside, to escape the thicket of signs and symbols, than it is of anything else.

So let's try to think first about the work, and about the longing within and around the work, instead of about the biography. Because this longing, this organising of desire, is often at the heart of this work, and in the intense gravitational tug of this longing there is the palpable *counter-narrative* with respect to ideas of naturalist photography and documentary photography. The title of this exhibition is a fine indication of the issues orbiting this longing (as if we have an extant guide to the universe! to which there could be an alternative!) – a longing to be 'without fissure', which likewise seems to be at the centre of the work of these three artists.

For example: though Eugene Von Bruenchenhein also made paintings (some of them made, it is said, with paintbrushes fashioned from the hair of his wife's very head), we have here some of the many photographs he made of his wife Marie, somewhat in the style of pin-up photography but also with an interest in double-exposure and trick photography that suggests an intensive, if self-motivated, understanding of the furthest extremes of photographic history. Marie is so often photographed (there are over a thousand finished images) that, over the course of years, it's as if Von Bruenchenhein and Marie were almost exclusively engaged in this fanciful portraiture of their union.

What can we say of Marie? That she is beautiful, certainly, in a way that is believable, really, a way that is *of the world*. It is the artist's preoccupation with her beauty that animates the photographs, that extends the obsessiveness of the images and the great variety of milieux assembled for her. The half-smile is her most frequent

emotional contribution to the image, of which we cannot say with certainty that it has the ring of unalloyed commitment to the project, as it could easily be a constructed manifestation of Eugene Von Bruenchenhein's exacting standards. In the same vein, it is worth mentioning the infrequency of Marie's gazing upon the camera itself. Most often she looks off to the right or even upward, in a way that reminds one of the tendency of medieval and early Renaissance portrait subjects to gaze piously up at the heavens.

There is also her partial nudity, often a feature of the photos. This is in keeping with the occasionally lurid pin-up quality of her husband's attentions, and yet there is something confessional about the nudity, too. It doesn't always feel sexualised, it more often feels *true*; less like a centrefold and more like the insistences of, perhaps, an enthusiastic nudist.

And yet, to say this, that Marie is simply nude because nude is one thing a woman (a muse) might be, is to fail to account for the rest of each photograph. It is to fail to account, for example, for the profound variety of backdrops in Eugene Von Bruenchenhein's images. Often these photographs are interior scenes, something close to studio photographs because of their intimacy, their traces of the carnal and their obsessiveness, but Von Bruenchenhein is more than thorough about the ornamentation of his interiors. He is positively floral, seemingly comparing Marie to a great variety of ferns, flowers and plant life of all types. The comparison, for me – in the excess, the humour, the scale, the botanical efflorescences, and the barely concealed eroticism – is with Jean-Honoré Fragonard (1732–1806), who influenced a century of American chintz.[2]

There is one image of Marie sitting on a table with a television set, an early television set, we must suppose, from perhaps the late 1940s or early 1950s, showing just a little extra bit of leg, and with a stool under her feet, and the television set has a few figurines atop it, as though, in this rather humdrum American interior, Von Bruenchenhein cannot resist aestheticising, and the figurines are tiny versions of primitive sculptures, heroic figurines, to remind us of the greatness of the tradition in which he works – *the high art tradition*. But best of all is the portrait of Marie on the wall, behind the Marie in this photograph: a head shot, hanging in the rear of the photograph amid more leafy appurtenances. A little bit of recursiveness in what is already a reflexive image.

If Marie is a muse, what kind of a muse is she? A muse whose participation in the Von Bruenchenhein canon is complete, but whose rendering is somehow still mysterious. There's a way that the artist tries to possess his wife in all these reiterations of her, only to find that she resists being possessed – her elusive psychology, whether by intention or by happenstance, leaves an essence of her apart from the photographs, even in the rare instances when she gazes at the camera, as if part of the attempt in Von Bruenchenhein's photographs is to document exactly what, in a long marriage, the camera can never see.

Eugene Von Bruenchenhein
Untitled (Marie Crowned), 1940s

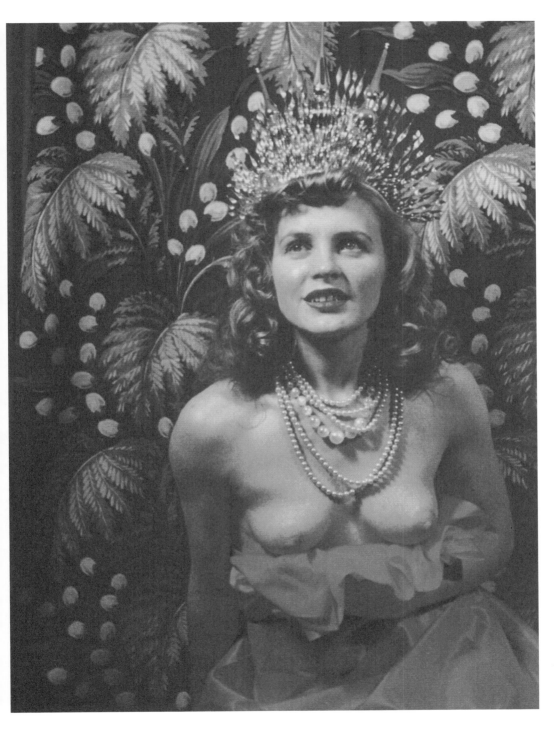

Morton Bartlett's orphanhood gets a lot of play in the psychologising of his art; the implication of being without family becomes the feature uppermost in the conjectured narrative, and in this way we can all flatter ourselves that the outlines of psycho-biography come into view, and the work is slotted into a convenient spot. That his dolls, the 15 that survive, with their detachable limbs (mix and match!), do not much resemble a conventional family, seems beyond doubt, though one cannot help but want to create an imaginary narrative for the part of the story that no one seems to address fully: the fact that the crisis of Bartlett's orphanhood took place when he was eight years old. If, as the Jesuits say, character is fully formed by the age of seven, then Bartlett was already the man he would become by the time his parents died, supposing that they died at the same time. Why is his early life missing from the story? Let's make it up! A parental crash in some primitive motor car? Or let's say his father was killed in First World War, and his mother simply could not take care of him (alcoholism! opiate addiction!). Let's say that like Little Orphan Annie (whose comic strip debuted about six years after Bartlett's adoption), Bartlett was from the wrong side of the tracks, from privation, from poverty and loss, and lucked out when he became part of the wealthier Bartlett family. The story doesn't much matter, because it quickly becomes an effect of the work, rather than vice versa.

The photographs of the dolls are where the dolls are made most animate (the photographs are lifelike; are, in their illusory way, three-dimensional, just like the sculptures themselves); they engage in a kind of paradoxical activity, because in the photographs the girls go about their business, their narrativity, in a society of girlhood (and boyhood, for there are three sculptures of boys, by some held to be autobiographical depictions of Bartlett himself). And in their society, their community of girlhood, there are, it's fair to say, moments of the frankly erotic, though perhaps less in their anatomically correct genitalia (some of the photos are nudes), than in gesture and posture. The girl with the tongue sticking out from the corner of her mouth, she is frankly erotic, as is the ballerina in sheer fabric, frankly erotic, but they are also more erotic when completely styled; the girls have the paradoxical effect that Nabokov's *Lolita* (1955) has – at first blush erotic, but, upon reflection, more about misconceptions of the erotic, and the amassing of misconstrued narratives of the romantic, because of the hard-to-parse and unsettling facial expressions, and our own tendencies to read into these.

If, as Bartlett said himself, the purpose of the sculptures and the photographs is 'to let out urges that do not find expression in other channels', then one of the urges that finds expression there is the urge to *arrest* the girls at a certain age.[3] The arrest of the girls, in the fact of the girls, seems to happen (on the basis of the work) at the time of life at which Bartlett was himself adopted, or just after (his eighth year), so as to memorialise that moment and the kind of perceptiveness that goes with sudden calamitous change. Or: one of the effects of post-traumatic thinking is vigilance – so that the girls memorialise the gaze of the orphan at the moment he is orphaned.

In the 26 years that Bartlett worked on the sculptures, and made his obsessively detailed girl costumes, and assembled the photographs, and implied the greater narrative of the dolls, an evolving debate about intergenerational love was taking place, of which Nabokov's *Lolita*, composed from tip to stern during Bartlett's active years, was also taking place, and it would be easy to consign the dolls to this evolving story (and to make Bartlett's work less complex than it is – more like, say, Jake and Dinos Chapman's), but the more interesting story is the evasive, paradoxical one, in which Bartlett doesn't seem to be a paedophile at all, and may have been fully informed about the art world happening around him, and may even have read *Lolita* (or seen the film, which was released very nearly in the year that he stopped working), in which story the work is a depiction of and resolution of a conflict that he had no intention of otherwise describing than he did. In this account, the photographs are not a depiction of libido, but are depictions of the conflict of libido. The incredibly complex faces of the girls, with their provocations, and their discontent, their girlishness, and their melancholy, make clear that there is never an easy answer with Bartlett. And that this is the complex reflection of life that Bartlett devoutly wished for.

Lee Godie's bus station photographs have overpowering and unnerving impact. They are almost too painful to gaze upon. They are remarkable not only for the fact that they exist, that a person living mainly on the street was cogent enough and resourceful enough to find 'publick cameras' and to compose for them. They are also remarkable for the light they shine on the depiction of self, and the way in which depictions of self proliferate even under challenging circumstances. Godie's conception of femininity, which seems to owe a great deal to a kind of mid-century feminine movie star – furs, lipstick, extended pinky – is a femininity *in extremis*, but it also represents an empowerment gambit of a startling and confident sort. No one, it seems, was going to tell Godie that the work did not constitute art, that it was not valid, that she should be doing something else with her time. And the market that sprang up for her work, both during her life (as subsidy) and since, is an indication that this was a prescient and accurate assessment of the context of her endeavours.

A related question, though, is whether or not Godie was equipped to accurately assess the truth value of her bus station images. Was she mentally ill? (The conventional wisdom is that Godie was never diagnosed, but there seems, from an exegetical standpoint, reason to suppose, while admitting to the uncertainties of time and distance.) If an artist is ill, can we assume that we are seeing the same work the artist saw? (A more recent example of this conundrum is to be found in the late images of De Kooning, produced when he was much impaired by late-onset dementia.) The issue is heightened by the use of photography here. Godie mugs for the camera, dresses, concocts signage for the bus station images, imitates head shots of the stars, and so on, and the camera is happy to oblige her. Her *de facto* critique of the mainstream of American culture is particularly acute, savage. The grimy, hilarious, off-the-grid street-dweller parodies the images of America's great beauties in a grungy, spirited way.

Did Godie know what she was doing? Did she know of Warhol's photo booth portraits? Did she know about all those kids in the malls making their little testaments to sisterhood in the photo booths, and did she know that she was using the medium for a much more interesting purpose? Did Godie mean to convey something accurate about herself in her self-portraits, or did she mean to convey that she had *no self*, in the conventional way, and that by refusing participation in the rigours of daily life, she had unselfed herself? Did she find comical and powerful the fact that despite the disregard of most her native Chicago she still managed to make work that was original and singular? Did she say she was an artist to close the sale? Did she feel artistic conviction? Of any conventional sort?

As with Bartlett and Von Bruenchenhein, Godie's refusal to evaluate her work at length (except for: 'I am much better than Cézanne'),[4] and the dearth of much biographical information about her, leaves us on our own in the matter of interpretation, and this is exactly her kind of liberty, the *total kind*. Godie's minor variations on a single harrowing, knowing, slightly sceptical smile in the photographs tells us as much about her as we really need to know. She was no fool, and she was willing to go a long way, across the river and into the woods, to live the untethered way she lived. The work is produced out of this wisdom, which is a wound, and a way to make a few bucks on the street. What a powerful smile that is.

Now a couple of final generalisations. First, in each case this is work about the feminine. Eugene Von Bruenchenhein's images of his 'muse' are idealisations of marriage in their obsessiveness by virtue of their highly decorative surface and by the sheer fact of their reiterations; Morton Bartlett's dolls, and the photographs thereof, are emblematic companions from some arrested community of girls that he saw around him, at a distance, at the moment of his own loss; and Lee Godie's bus station self-portraits are a profound, passionately narcissistic, and withering commentary on opportunities for a liberated womanhood in a capitalist economy. As such, we might ask: what is it about the feminine that makes it amenable to the tortured and structurally isolated work of artists who would, if we take the orthodox view, never have any truck with the academy?

I am reminded again of Nietzsche's famous formulation: 'Supposing truth is a woman – what then?'[5] By which I imagine Nietzsche to mean: supposing the truth were not the province of patriarchy, of the masculine, the linear, the ideological, the rhetorical, the logical, the tendentious, the unrelenting, the phallic, the traditional, the professional, the aggressive. Supposing the truth (and with it the 'real') were something else, supposing it were something more elusive and supple. Supposing that dialectical thinking, and theoretical rigour, and language itself, were all liable to fail to entrap *what is*. Traditional photography of the documentary sort has few traces of an oppositional feminine truth, this supple, annular, non-linear, counter-narrative of truth, because it already knows what the truth is, and how to depict

it, according to its somewhat theatrical legacy. But the best non-documentary work is all these things, often, and these artists seem consonant with that legacy. Supposing truth is not continuous, but is discontinuous, untrustworthy, mottled, pitted, full of irony, ambiguity, paradox, failure and instability? Then you might make photographs like the photographs of Eugene Von Bruenchenhein, Morton Bartlett or Lee Godie.

And: this work is work that was produced in the United States of America. While the US does not have a lock on the kinds of highly idiosyncratic and intuitive work that we associate with so-called 'outsider' artists, it certainly does contribute mightily to the tradition. We could easily confabulate a number of reasons for this rich contribution – a ramshackle apparatus for the treatment of mental health complaints, an economic system that disenfranchises very effectively and a significant national preoccupation with religiosity. Of this last we might say that religiosity in the United States of America now assumes many highly mutated and idiosyncratic forms. In fact, it's almost as if the US has as many religious alternatives as it has citizens. Many of these traditions, these highly imagined counter-narratives of religion, no longer seem to have anything to do with the divine at all (for example, the so-called 'Church' of Scientology).

But what does clearly remain of religion in the United States of America is a self-directed monastic tradition of reclusion and solitary petitioning. A country of religious pilgrims has become, in a way, a country of monks and nuns, each engaged in his or her self-guided search for the perfectly calibrated, highly individuated, carefully branded theology. The longing in these images, the longing of Von Bruenchenhein for his wife; the longing of Bartlett for a lost childhood and a lost childhood sexuality; the longing of Godie for the economic enfranchisement of the Hollywood star system, the counter-narrative of these images, seems to me to be heavily perfumed with an American mysticism, with a gnostic certainty about the individual's quest for spiritual meaning apart from the mainstream of society, with a sentimental belief in archetype and stereotype, especially as these are deployed talismanically in spiritual narratives, with a tolerance for the uncanny that we experience in the spiritual. We gaze on this tradition with fear and pity.

It's hard to imagine, at first glance, that photography would be exactly the form through which counter-narrativity, this sublime of the oppositional, would effectively take place, and yet it is the misconception of photography, its reputation for accuracy, that makes this powerful and individuated work not only likely, but necessary. Would that these photographers themselves did not have to suffer the rigours of reclusion that they sometimes did, in order to produce the work (as Freud once said of melancholies). But, on the other hand, these lessons, which are not at all from the *outside*, and not at all *other*, do tell us more about us than any documentary ever could.

JULIA
BRYAN-WILSON
ON ANA MENDIETA

Ana Mendieta:
Traces
2013

Ana Mendieta: Traces *was the first UK retrospective of Mendieta's provocative and radically inventive work. Spanning her entire career, the exhibition focused on the artist's main body of work, the* Siluetas *series, made using her own body, together with elemental materials such as earth, water, blood and fire. In addition to sculptures, films, photographs, drawings, personal writings and notebooks, the exhibition included an extensive research room with hundreds of photographic slides, which shed new light on the way that the artist worked, as well as the ways in which she documented her own practice. The accompanying catalogue featured texts by Adrian Heathfield and the exhibition's curator Stephanie Rosenthal, as well as the following essay by art historian Julia Bryan-Wilson, the Associate Professor of Modern and Contemporary Art at the University of California, Berkeley.*

AGAINST THE BODY: INTERPRETING ANA MENDIETA

LOOKING AT BLOOD

In 1973, Ana Mendieta had blood seep out of her apartment building onto a sidewalk in Iowa City; she then documented the responses of passers-by as they walked past this suggestion of domestic unrest. Her film captures a range of approaches towards the spilled, now-public mess: indifference, curiosity and – in a conclusion so logical it seems almost planned – as a problem to be solved. The final images in the sequence depict a man in striped worker's overalls and a painter's hat emerging from a door at the staged scene of the crime to sweep the debris into a cardboard box. While this act of careful workmanship unfolds, the other figure in the frame hurries on seemingly unawares, carrying the day's mail. *Moffitt Building Piece* (1973), an early work within Mendieta's archive, highlights her consistent interest in the charged properties of blood, with its corporeal and metaphoric associations with birth, love and death.[1] Not only that, but this piece points to the artist's lifelong interest in the terrain of temporality, the utilisation of spaces outside of traditional art sites, the primacy of documentation and the implication of audiences as witnesses after the fact.

With this piece, Mendieta created a situation that unfolded unpredictably over time, in which the bodies she shot were visibly marked by gender, race, age and class, even as the precise body of the hurt or wounded one that has presumably leaked these vital fluids, stays unknown and unknowable. Was the blood the product of children's play accident, or the result of an aggressive adult crime? It is not even clear if the bleeding being was a human or animal. What remains is, in fact, a remains: a leftover stain, unidentifiable by any axis of difference that might be mapped onto a physical form. Yet it has become commonplace within the literature on Mendieta to say that her work is about 'the body'; the very first sentence of the catalogue for her major retrospective at the Hirshhorn Gallery, entitled *Earth Body* (after the artist's own description of her work

as 'earth-body art'), states: 'Art made from, with, and of the body has an immediacy and directness that is ineluctable and familiar – virtually everyone can relate to it implicitly and emphatically because the body is the most fundamental aspect of human existence.'[2] This passage, from the foreword by museum director Ned Rifkin, summons 'the body' as a fundamental, even universal (uninflected, ungendered, unraced) body; but what 'body' is on display in a work like *Moffitt Building Piece*? It makes little sense to say of a work like this that it is about 'the body', as if 'the body' were a stable or monolithic category that transcends all difference; the bodies here are multiple and situational, put to work in diverse capacities. Mendieta's work dismantles, dismembers and decomposes the integrity of a singular 'body' by generating an array of corporeal forms, as well as by activating spectators whose bodies complete the circuit of viewing.

For Mendieta, who moved from Cuba to the United States when she was 12 and was involved in a range of activist efforts regarding the intersection of race, gender and nationality, 'the body' could never be one thing; bodies were porous, fragmented, constantly reconstituting themselves. In this essay, I examine how 'the body' in Mendieta's work – especially the female body – has become a lightning rod for her reception both within her lifetime and posthumously, specifically as it has been recruited for various feminist theories. Her work has been controversially taken up within competing feminist ideologies, ones that have shifted dramatically over time and have been received by what Miwon Kwon calls 'at least two seemingly irreconcilable "camps" […] At the crux of this distinction is the status of the body *in* representation and *as* representation. That is, the body as a transparent signifier of identity and self versus the body as a nexus of arbitrary conventions of meaning, the body as signature or sign'.[3] Which feminisms mattered for Mendieta? And which feminisms are at stake now as her legacy is being re-evaluated and reassessed in light of shifts within and around feminist politics regarding race, the environment and nation? Mendieta has become a lauded and widely recognised figure within feminist art histories; her work has been featured in many major exhibitions of women artists[4] and she has also been at the forefront of Latin American art history, with these two ostensibly distinct spheres sometimes coming together (as when her art was Included in the 1995 exhibition *Latin American Women Artists 1915–1985*). Mendieta has also been written about in many important volumes on women artists and feminist art.[5] Despite (or indeed because of) this curatorial and critical framing, some critics have questioned if feminist theories and politics indeed mattered much at all to Mendieta; writer and artist Luis Camnitzer has written, 'Her work was often seen as a programmatic expression of feminism enhanced by a US perception of mysterious exoticism. It was therefore also seen in the context of a superficial anthropologism prevalent in art. Some of her success within these perspectives can be attributed to a misunderstanding. Her work is not programmatic. It is, much more simply and modestly, a self-portrait'.[6] In Camnizter's view, 'the body' most convincingly examined by Mendieta was *her* body. How, then, are feminist theories relevant for understanding her work? With its ambivalent approach to figuration (and her sensationalised death), Mendieta has been made to speak for quite distinct, even competing, feminisms, especially as these feminisms articulate radically different approaches to 'the body'.

Mendieta first encountered the US feminist art movement at the University of Iowa, where she received her MFA in 1972 (she continued to live in Iowa until 1978, when she moved to New York City).[7] Though she began her studies as a painter, she moved to the university's Intermedia department chaired by Hans Breder to explore more multidisciplinary perspectives. Breder invited many visiting critics and artists to campus, including performance artist Vito Acconci and feminist conceptualist Martha Roser. In what would be a particularly formative encounter, Mendieta met art critic Lucy Lippard in 1975, after Lippard's guest lecture on women's work.[8] But even before her formal exposure to the rapidly expanding feminist art movement in the US, Mendieta had been pursuing issues of identity, including the malleability of gender, physical objection and violence – both regarding unspecified victims, as in *Moffitt Building Piece*, but also directly related to violence against women.

This concern found form in 1973 when Mendieta inaugurated a series of works in which she confronted the spectacularisation of violated female bodies, after a reported incident of violence against women on the Iowa campus. In *Rape Scene*, Mendieta had herself lied to a table in her apartment, her lower body naked and smeared with cow's blood in a terrifying durational event that was 'discovered' by friends and fellow artists. Feminist writers have pointed out that by making herself the object of both violence and the gaze, Mendieta complicates any simplistic idea of female victimhood.[9] In addition to this move of self-substitution or self-surrogacy, the piece has a distinctive collaborative aspect – she needed help to tie herself up in this fashion, and relied on – *depended on* – others to observe and document her in this state.

Ana Mendieta
Untitled (*Silueta* Series), 1978

In the rape pieces, Mendieta seems to be rehearsing various postures of female subjugation or submission, almost as if to exorcise them. They are extreme images of objectification, but hers is not the only body here; their production as art pieces immediately conjures up other bodies that are both explicit and implicit collaborators: those who roped her limbs together, those who photographed her, and those who viewed both the live event and, later, the documentation. A similar haunting of labouring figures occurs in other works, including *Sweating Blood* (1973), a short Super-8 film in which Mendieta's head fills the screen in a tight close-up, rivulets of blood dripping down her face. An assistant used a syringe to squirt blood onto Mendieta's scalp before the shot; the camera was stopped periodically so that fresh blood could be applied. While Mendieta's practice has largely been understood as solitary, the foundational inter-relationality proposed by pieces such as these serves as a counter-argument to Donald Kuspit's assertion that her work is pathologically self-absorbed, masturbatory and narcissistic.[10] Mendieta's work proposes not a 'narcissistic' attention to her own body, as Kuspit would have it, but rather a more ambivalently dialogical relationship to bodies (including those off-scene) as they form, deform and influence each other.

484 JULIA BRYAN-WILSON ON ANA MENDIETA

Kuspit's argument flies in the face of many feminist readings of Mendieta that insist upon her performances of gendered victimhood; yet to focus only on the female body narrows our understanding of how her work functions. *Rape* (1973) shows Mendieta outside splayed on her back, bent over a fallen log and bleeding, as if abandoned while grievously injured, or even dead. Who photographed this alarming situation? How are we rendered culpable as voyeurs? In *Rape*, Mendieta evinces one of her central concerns, which is the placement of a female form in the landscape, importantly located outside of an art context. The jolt of crisis that accompanies this atrocity document is escalated by the explicitly posed female body. Yet in perhaps her most well-known works, the *Silueta* series, living bodies have been evacuated, leaving only outlines or suggestions of shapes. In other works of this period, Mendieta produced interruptions within public space, startling unsuspecting viewers with her evocative and grotesque creations, as in *Suitcase Piece* (1973), where she placed blood and animal entrails in an open suitcase and left it in an Iowa City park. As she stated in a lecture at Alfred College, 'I work in public spaces […] unless it's a very restricted kind of area, I don't ask permission and it's always really interesting for me to have the reaction of the people around me'.[11] Instigating morbid interest if not horror, this suitcase recalls Brazilian artist Artur Barrio's gauze-wrapped 'bloody packages' left at sewage grate openings and in parks in the late 1960s. In

such pieces, Mendieta prompted a range of viewer responses to violence, including (but not limited to) violence against women; it is crucial to keep in focus how the bodies at stake were sometimes partial, contingent or otherwise unreadable.

Mendieta also explored the gendered associations of facial hair in the piece that became her Master's thesis, *Untitled (Facial Hair Transplant)* (1972), where she transferred her friend Morty Sklar's beard onto her own face. She later wrote: 'After looking at myself in a mirror, the beard became real. It did not look like a disguise. It became part of myself and not at all unnatural to my appearance.'[12] In truth, the result is closer to drag than to 'reality' – an exaggerated, playful artifice. She also engaged in a series of exercises distorting her appearance through wigs and make-up, in *Untitled (Facial Cosmetic Variations)* (1972); this piece bears a resemblance to Martha Wilson's later photographic diptych, *I make up the image of my perfection/I make up the image of my deformity* (1974). In fact, Wilson was one of the visitors to Iowa's Intermedia program. Significantly, Mendieta's investigations of this type relate to projects by other women of colour thinking through the imbrication of race and gender by transforming their visages, including Adrian Piper's nearly contemporaneous *Mythic Being* (1973–75), in which some audiences see Piper as a black male, triggering responses in public spaces; in this image, the artist is applying facial hair as one aspect of the preparation. Some years later, artist Howardena Pindell produced her video *Free, White and 21* (1980), also using make-up and multiple personae to visualise the ways in which femininity has been strongly associated with whiteness. These works resonate with Mendieta's interest in intersectionality, the multiplicity of bodies, the unfixed qualities of identity, and the performativity of gender and race.

It is crucial to our understanding of the response to Mendieta's work that the first writings about her to appear in major publications were within decidedly feminist contexts. Two early articles, both written by Lippard, focused on Mendieta's early work from Iowa, including *Rape*, within the larger rubric of women's role-playing, the instability of identity and conceptualism. The first, 'Transformation Art', which was published in *Ms.* magazine in 1975, discussed Mendieta's 'shocking, bloody rape "tableaux"' as one of many examples of work by artists including Piper, Wilson, Eleanor Antin and others who were interrogating questions of identity within conceptual frameworks.[13] As Lippard understood it, 'the turn of conceptual art toward behaviorism and narrative about 1970 coincided with the entrance of more women into its ranks, and with the turn of women's minds toward questions of identity raised by the feminist movement'.[14] In 'The Pains and Pleasures of Rebirth: European and American Women's Body Art', published in *Art in America* (1976), Lippard widens her scope to think about European artists like Marina Abramovic, Gina Pane and Ulrike Rosenbach alongside Mendieta and Piper, again as examples of what she calls 'the sexual and gender-oriented uses of the body in conceptual art by women artists'.[15] Though Mendieta is now understood as an artist who merged performance art with land art – as is signalled by her phrase 'earth-body art' –these articles remind us that she was initially viewed as a feminist *conceptual* artist, whose ephemeral medium was the transitory nature of flesh itself.

ACTIVISM, A.I.R. AND *HERESIES*

After Mendieta moved to New York in 1978, she became involved in a number of feminist organisations, including joining the A.I.R. gallery collective (in 1977, she had shown her work at A.I.R. in an exhibition called *Out of New York Invitational*). It is undeniable that Mendieta was active within A.I.R. for several years; however, her commitment to A.I.R.'s feminist politics is still somewhat contested.[16] A photo of the 'women of A.I.R.' places Mendieta in the front and just right of centre and, with her bright white blouse, open smile, and her direct eye contact, she is arguably the tokenised focal point of the image.

A.I.R. provided Mendieta with a platform to exhibit her work, as well as a crucial network of support for her artistic experimentation, and it was there that she had her first solo shows in New York. For these exhibits, she continued to make the work she is famous for, the *Silueta* series and was rapidly absorbed within a larger movement of white US feminism interested in reclaiming the historical importance of goddesses, one that was meant as a corrective to the naturalisation of patriarchal ideas of religion. But as Olga Viso has noted, Mendieta had already been exploring prehistoric art and multifaceted notions of spirituality within several ancient cultures; this interest predated her knowledge of the feminist reclamation of goddesses.[17]

In fact, the issue of goddesses and Mendieta would prove healed in the context of ideas about essentialism and fraught, 'innate' correspondences made between female bodies and nature.[18] Briefly, in the late 1970s and early 1980s Mendieta was viewed as one of many female artists seriously grappling with this subject. Her work appeared in the feminist publication *Heresies* in their 1978 special issue on 'The Great Goddess', in Gloria Feman Orenstein's 'The Reemergence of the Archetype of the Great Goddess in Art by Contemporary Women'.[19] Orenstein writes of Mendieta's *Silueta del Laberinto* (1974): 'In this piece someone traced her silhouette on the ground [...] Her image was imprinted upon the earth, suggesting that through a merging with the Goddess spirits are evoked that infuse the body and cause such occurrences as out-of-body journeys or astral travel.' Orenstein elides the collaborative aspect of her work – 'someone traced her silhouette' – and places Mendieta in a homogenising context in which all 'Goddess spirits' are more or less equivalent, collapsing the cultural specificities and historical differences that Mendieta was keen to emphasise.

Mendieta's relationship to goddesses was complex and volatile; she became resistant to having her work seen as another iteration of a trendy subtopic that became increasingly suffocating and rigid. She even drastically modified the aesthetics of her *Silueta* series to move them away from goddess associations, removing the arms from her torsos to make them into more open-ended forms. As she stated:

> The reason why I had the hands up was because it was like [...] a way of going into the earth. It didn't have any other kind of connotation but what I found happened was that some critics started writing about my

work very specifically, in terms of the Great Goddess, and I didn't want my work to be looked at in such a very specific kind of way. I want my work to be open because it's made in that kind of spirit. So later on I got rid of the arm.[20]

In fact, Mendieta always emphasised that she worked with 'real specific earth' rather than a generic idea of 'earth'; likewise, she was interested in specific goddesses not 'the Goddess'.[21] She fought hard to have her careful research into particular geographical contexts made legible rather than subsumed under the larger totalising rubric of undifferentiated 'Goddess spirits', as in her A.I.R. exhibition, *Ana Mendieta: Rupestrian Sculptures*, in which the gallery notes state: 'The works in this exhibition are named for goddesses from the Taino Culture indigenous to the Caribbean'. Jane Blocker describes how Mendieta differed from some of her contemporaries like Mary Beth Edelson, writing that when feminist critics 'appropriate Mendieta to a white goddess model and dis-locate her understanding of the earth from its origins in specific Cuban cultural traditions. It is difficult not to read this dis-location as a "whitening" of the image of the earth goddess, as a way of purifying it of its roots in African and indigenous cultures'.[22] Mendieta resisted being subsumed within a white feminist agenda that insisted upon the cross-historical and cross-cultural singularity of 'the goddess' or 'the female body', instead grounding herself more insistently in specific contexts and traditions, widening the spectrum of both goddesses and bodies.

Mendieta struggled to define herself and her work within the sexism and racism of the art world during the 1970s and 1980s. She was part of an A.I.R. task force on 'discrimination against women and minority artists', and became an active and vocal advocate for Cuban artists both male and female.[23] During this time, she participated in a wide number of New York art events dedicated to thinking about feminist art, and was on the editorial collective for the *Heresies* special issue on feminism and ecology, called 'Earthkeeping/Earthsaking'.[24] Within its pages appears Mendieta's project *La Venus Negra (The Black Venus)*; works such as these have inflected recent readings of Mendieta as an eco-feminist, a reading that was only preliminarily beginning to circulate in her lifetime.[25]

As she immersed herself in activist circles, Mendieta became dissatisfied with the A.I.R. collective and sought connections elsewhere, including within the Cuban exile community and within Third World feminist organisations. Though the *Heresies* collective had published an issue on 'Third World Women', Mendieta realised how deeply ingrained racism was within white US feminism. In this she was not alone; panellists at the Soho 20 Gallery in 1978 on 'Third-World Women Artists' – including Pindell, Faith Ringgold and Tomei Arai – discussed how 'individual encounters with the feminist movement had been keenly disappointing. Most of them had found white feminists incapable of comprehending the peculiar plight of non-white women – either because they were partners in the oppression or because they were too preoccupied with their own priorities to deal meaningfully with those of others'.[26]

Mendieta began to disidentify with the feminism practiced by the white majority of members in A.I.R.; in her curatorial introduction to an exhibition called *The Dialectics of Isolation: An Exhibition of Third World Women Artists of the United States*, she wrote: 'American feminism as it stands is basically a white middle-class movement. This exhibition points not necessarily to the injustice or incapacity of a society that has not been willing to include us, but more toward a personal will to continue being "other".'[27] Mendieta's identification as a 'Third World woman' is related to a much wider move for women of colour in the US to self-organise around this phrase.[28] Black women were among the first in the US to articulate this feminism; the Combahee River Collective began meeting in 1974, and issued 'A Black Feminist Statement' in 1977, later anthologised in the widely-read book, *All the Women Are White, All the Blacks Are Men, But Some of Us Are Brave* (1982).[29] Another influential text, *This Bridge Called My Back: Writings by Radical Women of Color*, edited by Cherríe Moraga and Gloria Anzaldúa, was published in 1981; it features an entire section dedicated to 'racism in the white women's movement', as well as one on 'the Third-World Woman Writer'.[30] The cover of the first edition of *This Bridge* features the schematic outline of a woman's body on all fours, and, though she is on her knees, she is clearly in motion, unburdened by any literal weight. Just at the time of this flurry of activity, Mendieta resigned from A.I.R. in 1982; she gave no reason in her official letter, instead letting her dissatisfaction and anger hover unspoken between the blank lines.[31]

MENDIETA'S FEMINIST RECEPTIONS

Mendieta's reception has been indelibly marked by her shocking death in 1955 and the uncertain circumstances that led to it, including the trial and acquittal of her husband, minimalist artist Carl Andre. Their relationship took on a lurid cast that has been called a 'Modernist martyrdom built on a foundation of Romantic myth'.[32] During the trial and its immediate aftermath, Mendieta was reduced to the status of victim, heroine or both.[33] A tell-all account, *Naked by the Window* (1990), by journalist Robert Katz, as well as a recent feminist graphic novel, *Who Is Ana Mendieta?* (2011), by Christine Redfern and Caro Caron, have circulated her biography to popular audiences.[34]

Beyond how her death has retroactively shaped our understanding of her life, Mendieta's work has undergone many shifting interpretations. One historiographic tale told is that, in the 1970s and early 1980s, she was understood as part of a larger essentialist feminist discourse, but this reading shifted along with the emergence of postmodern theories to focus on her transgressing artistic boundaries and a further attention to her status as an exile; the basic contours of these methodological divides and artistic movements are carefully laid out by Gill Perry.[35] Though the conflict of 'bad' or regressive 1970s essentialism versus 'good' or progressive 1980s–1990s anti-essentialism is often reduced to a false binary, there have been major divisions between these conflicting ideologies.[36]

Mendieta died just as the tensions between the two were coming to a head.[37] By the late 1980s, rather than dismiss Mendieta for her goddess titles and use of female forms, feminists became more interested in challenging presumptions of Mendieta's 'essentialism', emphasising instead qualities such as 'impermanence, distance, vulnerability and remoteness'. These later words are from Mira Schor from 1988, who wrote that Mendieta's work was easily 'criticised by contemporary feminist writers'.[38]

More recent feminist authors have more stridently defended Mendieta against charges of essentialism. Irit Rogoff writes, with some distaste: 'Lest all of this sound like an attempt at an archetypal "feminine" artistic practice, I hasten to say that Mendieta's work cannot be summed up as a representation of the dreaded biologically essentialist "feminine".'[39] Anne Raine states, 'I want to think of her work as inscribing not female or "natural" essences, but a gendered physicality, memory, desire and representation, across a concrete material terrain always already marked by politics and history'.[40] To avoid branding Mendieta with loaded words like 'nature' or 'biology', recent feminist authors use terms like alterity and fugitivity (Magdelena Maiz-Peña); exile and performativity (Jane Blocker); seriality and mimesis (Susan Best); trace and index (Joanna S. Walker); or 'spatialising and geographising gendered sites' (Rogoff).[41] In broad strokes, writers have turned to a few key themes that are consonant with poststructuralist feminism: Mendieta's persistent evacuation of the female body, the iterability and repetition within her practice and the levels of mediation introduced by her use of the document.[42] Some art historians take a more dialectical approach; Miwon Kwon, for instance, writes that 'especially the well-known projects from the 1970s, such as the *Silueta* series, *Fetish* series and *Rupestrian Sculptures* series, veer strongly toward the essentialist pole in both intention in and reception', yet at the same time acknowledges that Mendieta's works exceed those readings with their emphasis on enigma and absence.[43]

There have also been attempts to remove Mendieta from feminism altogether, as when Camnizter calls her work a self-portrait. Charles Merewether states: 'The question of naming has afflicted the scholarship and reception of Mendieta's work insofar as by naming it as Afro-Cuban, Mexican, even feminist, her work has been marginalised as peripheral to modernism, rather than central to the constitution of modernism itself.' [44] Merewether misapprehends how feminisms, far from marginal or limited, have been pivotal to the formation of contemporary art. But what are we to make of Mendieta's resignation from A.I.R. and reluctance to call herself a feminist? The current plurality of feminist thought has produced reflections on Mendieta's rejection of white feminism as itself a politic that might have grown with the times; as Esther Alder writes, 'In distancing herself from a feminist context, she was reacting to an increasingly simplified reading of her work. Feminist thought today, having evolved to embrace a broader and more complex range of cultural practices and experience, is a field that Mendieta would have perhaps found more accommodating'.[45]

In fact, the feminism that mattered the most to Mendieta – Third World feminism – had concerns quite distinct from the 'essentialism' and 'antiessentialism' debate, though its theorists and thinkers are largely absent from the Mendieta literature. This is a feminism that is powerfully committed to intersectionality, a feminism that views anti-racism, anti-capitalism and anti-sexism as interwoven, one that addresses questions of economic exploitation, access to health care, homophobia, poverty, workplace organisinga immigrant justice, environmental racism, the feminisation of labour, overconsumption, intimacy, cultural obliteration, decolonisation, etc. This is a feminism that sees spirituality as a political issue; that is unafraid to use the word 'faith'. As Cherríe Moraga writes in the preface to *This Bridge Called My Back*, 'I am not talking here about some lazy faith, where we resign ourselves to the tragic splittings in our lives with an upward turn of the hands or a vicious beating of our breasts. I am talking about believing that we have the power to actually transform our experience, change our lives, save our lives […] It is the faith of activists I am talking about'.[46] It is fitting, then, that the newly reissued version of *This Bridge* features a work by none other than Mendieta – *Rastros Corporales (Body Tracks)* – on its cover.

CODA: AFTERLIVES

As Mendieta's work is taken up in different contexts over time, it is inflected by contemporaneous feminist theories and activities. Her work is seen not only within catalogue exhibitions and art history journals, but in the many homages, artistic and otherwise, that have kept her memory alive. In 1992, members of the Women's Action Coalition staged a protest on the occasion of the opening of the Guggenheim SoHo, whose inaugural show featured four men, one of them Carl Andre. Their posters asked 'Where is Ana Mendieta?'. This was a highly publicised reassertion of how the artist has become, post-mortem, a feminist icon; indeed, this demonstration provides the opening (and title) for Blocker's monographic book. In a separate action, Cuban filmmaker Ela Troyano and Raquelín Mendieta, the artist's sister, placed photos of Mendieta's face on top of Andre's flat metal works: a moving evocation of loss and grief. For artist and writer Coco Fusco, Mendieta's multifaceted exilic poetics are somewhat eclipsed by a focus on her death, as the artist threatens to be reduced to 'a contemporary New York version of Frida Kahlo'.[47] In Fusco's words, 'scores of (mostly white) feminist artists have claimed affinities to Ana, and have invoked her name as a metaphor for female victimization', a reduction smacking of lightly veiled racist opportunism. Fusco states that 'there are more than a few of Ana's colleagues who, remembering her struggles to gain recognition […] find the current appropriation of her image painful and even exploitative'.[48]

One year after the Guggenheim protest, Nancy Spero (one of Mendieta's A.I.R. colleagues) performed her *Homage to Ana Mendieta* at the 1993 Whitney Biennial, a recreation of a piece by Mendieta that Spero had first performed in 1991 in a spontaneous act of commemoration.[49] Cuban artist Tania Bruguera produced a

series of reconstructions of Mendieta's work in her 11-year-long *Homenaje a Ana Mendieta* (1985–96); she undertook considerable archival research in preparation for these actions that were both a complex relocation of Mendieta back to the Cuban art context, as well as a personal incorporation of her influence.[50] Other artists have produced more allusive tributes. Regina José Galindo, an artist from Guatemala who has used her own body to think through cultural memory, state violence and crimes against women, sat in a public square under a device that dripped blood down her face, for a work called *The Weight of Blood* (2004) that recalls Mendieta's *Sweating Blood* (1973).

These diverse echoes of Mendieta remind us that, beyond the tired debate about essentialism versus anti-essentialism, her works remain powerfully current. Mendieta was dissatisfied with being reduced to one vision of feminism, or one articulation of identity; her work, likewise, resists any single template. Though she is a vital presence in the global contemporary art world, Cuban writer José Quiroga acknowledges how Mendieta's work also strategically calls to mind disappearance and the difficulty of remembering: 'the pieces […] incorporate feminism, anti-colonialism, earth art and the autobiography of exile. This makes the sculptures very specific but also allows them to cross over into distinct territories negotiated by the images themselves.'[51] Mendieta was deeply concerned with bodies, with their flesh and bones and fluids. Her work maintained some tether to the realm of representation, even as in its later years it became more abstract, such as *Arbol de la Vida* (*Tree of Life*) (1982) and *Furrows* (1984). In such works, the curved outlines have become disarticulated from any clear corporeality, rejecting self-containment. *Furrows*, in particular, with its ripples emerging from the grass, is barely recognisable as a coherent or closed figure. Radically simplified and structured around pre-existing elements, these works gesture out of themselves; they extend into space. Both are organised around a strong vertical line – the trunk of a tree and a footpath – that reads less as a spine than an indication that the form continues beyond the shape she has created. These pieces do not refuse to be gendered, but they refuse *only* to be gendered. One could say that in such work Mendieta moved *contra el cuerpo* ('against the body') – in the sense that a counter-attack is a redoubling of effort, and a counter-proposition does not negate the original but seeks to answer it. Just as there is no such thing as 'the earth' or 'the goddess', there is no such thing as 'the body' in Mendieta's work; she goes against 'the body' to reassert the existence of, and interdependency between, many bodies.

GEOFF DYER
ON DAYANITA SINGH

Dayanita Singh:
Go Away Closer
2013

Dayanita Singh: Go Away Closer was the first major UK retrospective of this artist's work. The exhibition brought together Singh's early works, artists' books and her 'portable museums', a major body of work that developed from her experiments in book-making, and which take the form of large wooden structures that hold 70 to 140 photographs that can be placed and opened in various configurations. Alongside an essay by novelist and photography historian Geoff Dyer – reproduced here – the exhibition's catalogue featured an in-depth interview with the artist by the show's curator Stephanie Rosenthal.

NOW WE CAN SEE

Arriving at Indira Gandhi International Airport in 2006, I was confronted by an unusually impressive advertisement. It featured a big and grainy black-and-white photograph of the tabla player Zakir Hussain and his dad Ustad Alla Rakha in concert, some time in the mid 1980s, I guessed. Zakir's dad is reaching over and patting his son's head, ruffling his hair as if to congratulate the puppy on having barked with such enthusiastic promise. But, with this loving gesture, the pre-eminent tabla player of one generation – in the famous Concert for Bangladesh it's the grinning Alla Rakha we see accompanying Ravi Shankar on sitar and Ali Akbar Khan on sarod – is also passing on the musical baton to the man Bill Laswell will later describe as 'the greatest rhythm player that this planet has ever produced'.[1] Quite a claim!

The picture turned out to be by Dayanita Singh, who, in one of the little home-made-looking photographic journals from the box set *Sent a Letter* (2008), has constructed a tribute to her mum: a passing back of something that was never quite a baton. The other six books in the set take their names from places in India – 'Calcutta', 'Bombay' and so on – whereas this one, with its slightly darker cover, is named after Dayanita's mother, Nony Singh. It's made up of either pictures Nony took or of ones she – Nony – found in her husband's cupboard. There are quite a few pictures of a little girl with a determined little pout or frowning smile who is clearly Dayanita.

Is that smile-pout a precocious sign of ambition? When the 18-year-old Dayanita first went to photograph Hussain at a concert the organisers tried to prevent her and she tripped over. Embarrassed but undeterred she called out 'Mr Hussain, I am a young student today, but someday I will be an important photographer, and then we will see'.[2] Mr Hussain liked this spirited response and allowed the student to travel with him and his fellow musicians, to document his life on the road and at home. The picture at Delhi airport was from *Zakir Hussain* (1986), the book that resulted from this – Dayanita's first.

Now that her injured boast has been made good, another kind of continuity can be seen. It too can be illustrated musically. Many of the greatest living female singers of

the Karnatic and Hindustani classical traditions are in their sixties or seventies. As they take slowly to the stage they look magisterial, imposing, grand – conscious of the immensity of their reputations. It can take them a while to get seated, cross-legged, but when these ladies start to sing the years fall away to reveal a lovely girlishness. A part of time has been stopped. Their voices are light-footed and graceful as the *gopis* spied upon by Krishna – but with the knowledge, wisdom and, often, sadness of age. Now look again at that box set of diaries, *Sent a Letter*: in its high-art-home-spun way, it's not unlike the kind of thing you might have tried to make as a kid in art classes – and it's as far removed from a super-sized Andreas Gursky or Thomas Struth as one could get. *Go Away Closer* (2007) looks like a school exercise book. The book of *Dream Villa* photographs (2010) – many of them printed quite large in exhibitions – seems intended to pass itself off as a pocket diary. This last, in my view, is a perverse decision and major aesthetic mistake – what is the gain in having the double-page, full-bleed spreads dominated by the gutter? – but the general point stands: playfulness, pleasure in the possibilities of the modest and the miniature, are not at odds with seriousness; they are part of what enabled Dayanita to become 'an important photographer'.

While it was perfectly natural for Zakir to become a tabla player – as Martin Amis says somewhere, there's nothing more normal than what your dad does – there were numerous obstacles to be overcome if the young student was to turn her mum's hobby into a vocation and profession. These were obstacles born of expectation: what was expected of young women in India and what was expected from Indian photographers and photographs of India generally. With Dayanita's work there is a subtle but clear break from the teeming streets of Raghu Rai and the crowd of colours associated with Raghubir Singh, in favour of a photography that is quiet, intimate, private, withdrawn: an art, increasingly, of absence.

In one of the pictures by her mum, the baby Dayanita is barely visible; in a couple of others she is entirely overlooked in favour of the splendid surroundings of a hotel room. The grown-up daughter has followed suit: her pictures are full of empty rooms, empty beds and what Billy Collins calls 'the chairs that no one sits in': 'where no one / is resting a glass or placing a book facedown'.[3] The poet is here thinking of permanently empty – rather than briefly vacated – chairs, but in photography, of course, even the momentary becomes permanent. And in photographic terms, these empty chairs have always been with us. Or at least, as John Szarkowski, former Director of Photography at MoMA, argues, they did not mean 'the same thing before photography as they mean to us now'.[4]

About half of the pictures in *Privacy* (2004) are portraits of people in their opulent homes – spacious rooms crowded with wealth and flesh. The effect of these is to make the other half, the empty interiors, seem… even emptier! And then there are the museum rooms of Anand Bhavan (now Swaraj Bhavan), the former Nehru family residence in Allahabad, where we get a redoubled, much-multiplied emptiness: unworn clothes hanging on the unopened doors of empty rooms. The glaring absence in these pictures, these rooms, is of the present (*as* symbolised by the stilled ceiling fan). This is what time looks like after history has moved on and left it for dead.

Referring to his own photographs of empty interiors, Walker Evans once said, 'I do like to suggest people sometimes by their absence. I like to make you feel that an interior is *almost* inhabited by somebody'.[5] The dominant suggestion in Dayanita's rooms is not so much of the absence of people so much as the *lack* of their absence: the idea of people, I mean, doesn't rush in to fill the vacancy. The wide-awake day-bed, the armchair never passing up a chance to take the weight off its feet, the books wanting nothing more than to curl up with a good book – all are perfectly content with the prospect of an evening on their own, undisturbed by human intrusion.

What Dayanita shares with Evans is the ability to suggest another, rarer, absence: that of the photographer. Making it seem that the room itself had done the photographing was Evans's paradoxical and signature gift: the air of anonymity – 'the non-appearance of author', as he put it – that enables us to identify an Evans *as* an Evans.[6] In this he both expressed an ideal – of the photographer disappearing into his photographs – and harked back to the dawn of the medium, to William Henry Fox Talbot's claim about an image made in 1835: 'this building I believe to be the first that was ever yet known *to have drawn its own picture*'.[7]

The silent atmosphere of places surveying themselves pervades Dayanita's rooms, corridors and halls. It's at its most extreme in a picture of (so extreme it seems more appropriate to write 'picture *by*') the library in Anand Bhavan (*Visitors at Anand Bhavan, Allahabad*, 2000). There *are* people in this photograph – visitors peering in through the glass that preserves and isolates the room – but the sense of latent sentience is so strong that a kind of role reversal occurs: as if the room itself is regarding a vitrine displaying these time-frozen specimens of life-sized humanity.

Installation view, *Dayanita Singh: Go Away Closer*, 2013

Elsewhere this sense is enhanced and signalled by the way that the rooms often contain other photographs, either actual ones – hanging on walls, propped on shelves – or, less tangibly, in the form of reflections: in shining floors and polished furnishings, in windows and mirrors. (It's often impossible, in photographs, to tell the difference between a mirror and a photo. In a photo, in fact, a mirror is automatically transformed *into* a photo. A photo, let's say, is a mirror with the time taken out of it.) The effect of these layers of self-seeing – inanimate, passive and abiding – is a cumulative laying bare of essence: the stillness of still photography. That's one way of seeing and putting it. Another, by a visitor to the 2007 exhibition of the *Go Away Closer* photographs, at the Kriti Gallery in Varanasi, was to copy into the visitors' book some lines in Urdu from a *ghazal* by Faiz Ahmad Faiz called 'Hum Dekhenge' ('We Will See'):

> All that will remain is Allah's name,
> He who is absent but present too,
> He who is the seer as well as the seen.

Light stares whitely through the windows: these windows reflect on the interiors – as we have seen – and provide visual access to the world outside. What happens when we gaze through them? What do we see?

To answer this we first have to re-familiarise ourselves with the terrain – get an overview of how the documentary impulse in early series such as *I Am As I Am* (started in 1999) and *Myself Mona Ahmed* (1989–2001) softens to something anchored less directly in place and time. Bear in mind, also, that the divisions between Dayanita's projects and books have never been absolute. A picture from *Go Away Closer* also appears in *Sent a Letter* and again in *Privacy*, and so on. The piles and shelves of documents in the recent *File Room* (2013) are prefigured by the libraries and piled-up books and lockers of *Privacy*. Effectively, then, the pictures are all the time overlooking each other, glancing over each other's shoulders. You can, in other words, glance out of the windows of a tower in Devi Garh and gaze down at Padmanabhapuram. Until recently, you could be fairly certain that the place you looked out from – and at – was somewhere in India, but that's no longer

the case. Come to think of it, a place might not even be a place – just a wall that's nowhere in particular with the image of a photographer drawn on it.

You can tell by the face of the woman in this mural – the photographic equivalent, surely, of Dayanita's tag – that this revealed and self-observing world is constantly surprising itself. Dayanita's work seems to advance by a series of rhythmic astonishments – 'Ooh, I wasn't expecting that!' – so calmly accepted that they appear almost to have been intended.

This is most noticeable in Dayanita's shift to colour. Colour photography famously got going in the West in the 1970s – 'the early Christian era of colour photography', as Joel Sternfeld fondly terms it.[8] For his part, Raghubir Singh wrote that if photography had been invented in India there would have been no need for all the theoretical hand-wringing and claims of heresy.[9] Dayanita, on the other hand, dutifully worked through black-and white – from documentary and reportage to the more elliptical style of *Go Away Closer* – before lurching accidentally into colour. *Blue Book* (2009) was the result of running out of black-and-white film on a shoot. No problem, she thought, just turn it into black-and-white later. Except this was daylight film (colour-adjusted to the intensity or 'colour temperature' of daylight), it was after sunset, and so the contacts came out blue. This blue period was short-lived – of stark, if limited, aesthetic usefulness – but the miscalibrated rainbow beckoned, and soon she was in the midst of exactly the kind of 'spontaneous colour experience' proclaimed by László Moholy-Nagy.[10] Having tumbled into colour as people stumble into darkness – now we shall see! – she glided into the gorgeous nocturnes of *Dream Villa*.

This move was both unexpected and unsurprising in equal measure. The very last words quoted by the tabla genius in *Zakir Hussain* look ahead to the colour-trance of Dayanita's tropical oneiric: 'Maybe it's a dream world, maybe it's make-believe, but it's beautiful.'[11] Either way, as Gillian Welch puts it, 'she showed me colours I'd never seen'.

So what makes a 'Dream Villa'? How does Dayanita know she's found one? The answer, surely, is that she doesn't, or, more accurately, that the question *is* the answer. The *Dream Villa* pictures are all uncaptioned because the places in them don't exist. Yes, they're out there in the world somewhere and she photographs them in that interrogative way of photographers, but it's only later, when they've stopped being places and become photographs, that it's possible to see if what was once reality – or a piece of real estate, at any rate – has acquired the ideal and elusive aura of the dream image.

The image that illustrates this most vividly is of a thin tree – more twig than tree – bathed in deep red light. Michael Ackerman's first book of photographs, *End Time City* (1999) was obviously about an actual place: Varanasi. But in his next book, *Fiction* (2001), Ackerman decided he 'no longer wanted to see any

information in [his] pictures'.[12] That's what we have here: a picture in which there is almost no information – just night, red light and trees. No before and no after, and therefore no narrative: the opposite, in a way, of an Edward Hopper painting. Wim Wenders said that Hopper always prompts us to construct little stories or movies – before-and-after scenarios: 'A car will drive up to a filling station, and the driver will have a bullet in his belly.'[13] It's not just that the *Dream Villa* pictures do not provoke a response of this kind; they make it seem entirely inappropriate. The red is presumably from a car's tail- or brake-lights, so a car has pulled up, but that's the full extent of the story. It does not make us curious about what the car is doing there, though it does suggest that the way to understand this picture is by reversing into it, as it were, by the *opposite* of story-telling – that our curiosity will not be satisfied in narrative terms. There's not even the potential mystery of the crime that may or may not be illusory in Michelangelo Antonioni's 1966 film *Blow-Up* (although the red glow of the ground is reminiscent of the safety light in David Hemmings's darkroom), a mystery that will be revealed if we scrutinise the picture closely enough. If there is intrigue here it is in the incidental cluster of lights in the distance and over to the right: what's going on over there? There is mystery in the foreground – there is nothing *but* mystery – but not the kind that seeks an answer beyond itself. This is mysteriousness not as a goad to solving and thereby bringing the mystery to an end, but mystery as a condition in which to reside (another reason for the lack of narrative, for the lack of desire *to move on*). So it's not just stylistic clumsiness on my part that has led to this infestation of 'nots'; what we see here is a demonstration of photography's ability to depict a state of negative capability.

You look at this picture without any irritable straining after truth, content in the permanence of the fleeting mystery depicted. And, when you do this, you realise that there *is* something there, in the middle of the picture. The ghost of a figure of some kind? Another tree? A mini-tornado touching harmlessly down? Just a trace of something, no more substantial than a smudge of smoke – so, perhaps, that mention of the darkroom in *Blow-Up* was not as parenthetical as it seemed. What we share here is the essential mystery – in danger of post-digital extinction – and excitement, of the photographer watching an image emerge in the red glow of the darkroom. A different kind of negative capability: one that might even be a synonym for photography itself.

The colourful dissolution of the external in the *Dream Villa* series was followed by what cries out to be described as Dayanita's most 'substantial' body of black-and-white work, *File Room* – a documentary record of documents! There's no room for emptiness here: sacks, cupboards, archives and cabinets are crammed full of books, papers and folders that have the weight and permanence of geological strata – minus, it goes without saying, the weight and permanence. That was an illusion – they're just pictures, after all – but how easily matters of fact become the stuff of fiction! So maybe it's not too deluded to think that if you pulled open enough drawers in one of the rooms you would find, neatly preserved and archived

in some Borgesian way, *Go Away Closer, House of Love* and all the earlier books, along with the prints and contact sheets. Certainly it seems safe to say that this, for the moment, is where Dayanita has ended up.

It's good to have things stored, stacked and available like this, to be able to go over to the shelves – organised and arranged according to some principle that only the custodian or owner understands – and pore over the relevant volumes. And then to return them, along with another more recent amendment and addition: this one.

ERIK DAVIS
ON THE INTERNET
OF THINGS

*Mark Leckey: The Universal
Addressability of Dumb Things*
2013

This Hayward Gallery Touring exhibition curated by Turner Prize-winning artist Mark Leckey explored the relationship between the digital and the physical worlds, and the extreme levelling effect that the internet has on our perception of objects, places and ideas. At the time of the exhibition, Leckey declared that: 'I think of this show as a work of fiction: a non-realist, anti-realist, magic-realist, speculative, slipstream fiction, a sort of sci-fi show.' Its title was taken from a term in computing that refers to 'a network of everyday objects, an Internet of Things'. Among the objects and artworks in the exhibition were a mummified cat, a mandrake root, a giant phallus from the set of A Clockwork Orange *and the helmet of a Cyberman from* Dr Who. *Erik Davis, American critic and commentator on technology, mysticism and the counterculture, contributed this essay to the accompanying catalogue, which also featured a text by medieval art historian Alixe Bovey.*

THE THING IS ALIVE

One of the recurring bits on the old kid's TV programme *Sesame Street* featured four objects, three of which formed a more or less obvious set. 'One of these things is not like the others', went the ditty. 'One of these things doesn't belong.' But what do we do with a collection where nothing – or everything – 'belongs'? Exploring Mark Leckey's curated assemblage, we confront a hugely heterogeneous collection, marvels at once archaic and utterly now: the clay idol of a car prototype, a hieratic uterine vase, a Chippewa political document that has the imaginative economy of a Paul Klee drawing. We sense that these objects belong together in some way, but how? We are certainly presented with some categories – sets of machines, beasts, human bodies – but these immediately begin to dissolve into one another. Nor do these catch-alls satisfy our deeper suspicion that a more enigmatic and urgent network of questions and concerns confronts us through and behind these particular images and objects. They are exemplars, but of what? Not themselves, certainly. Indeed, many if not most of Leckey's selections could have been substituted with some other wonder – an early Disney cartoon, a Renaissance automaton, a Cornell box – without disturbing the logic of sense engineered by the configurations and correspondences of Leckey's mash-up menagerie.

Back in the 1990s my fellow music journalists and I would often complain that 'everybody's a rock critic'. Nowadays, of course, everybody's a curator. The mediascape is choked with filters and selectors that provide us with an endless stream of playlists, YouTube channels, 'Top Ten' blogs, tweet feeds of filtered URLs, and celebrity mixtapes (even rock musicians are now rock critics, it seems). DJs, film programmers, even chefs, have been reframed as curators. With *The Universal Addressability of Dumb Things* Leckey now joins a handful of artists – including Mark Wallinger, Michael Craig-Martin and Tacita Dean – who have

curated exhibitions for Hayward Gallery Touring. Why this emphasis on curation – on gathering, filtering, selecting, framing, juxtaposing? Because curation is the native art of the network, and the network – digital, neural, bacterial, financial – now dominates our lives. It has become our latest implacable paradigm. Indeed, even the increasingly intelligent behaviour of the applications and processes we encounter on the Internet – Google searches, shopping recommendations, ads that follow us across multiple websites – reflect a kind of personalised curation carried out by algorithms acting on the copious crumbs of data our online doppelgängers leave behind them. Obviously, the rise of curation as a dominant and self-conscious cultural and political practice is an intelligent and creative response to the informational complexity and data overload of the world today. But it can also be seen as a belated and even parasitic symptom of archive fever and the anxieties of hyper-production, as we resort to glass bead games played not, as in Hermann Hesse's novel, out of serene spirituality and massive erudition, but as a sometimes playful and sometimes desperate reframing of the fact that, as far as the various networks that compose us are concerned, 'we' are already nothing more than nodes.[1] As an expression of twenty-first century omniculture, *The Universal Addressability of Dumb Things* also resonates with other eras when the shifting arts of curation and collection reflected epoch-making forces. For example, with its gathering of paintings and natural phenomena, of archaic exotica and visionary machines, Leckey's exhibition cannot help but call to mind the *Wunderkammer* of the early modern era. These well-known collections of natural oddities, mechanical toys, fossils, contemporary paintings, sculptures and colonised exotica allowed their owners to imaginatively seize a rapidly expanding world through an intermediation of unusual objects. The displays blended spectacle with the natural philosophy later called 'science', and their surrealistic air reflects profound fluctuations of cognitive categories and the emerging boundaries of modern knowledge – a particularly Leckeyesque example here would be the narwhal tusk often found in *Wunderkammer* collections, a natural oddity that was often framed as a unicorn relic. But the real magic of these collections lays not so much in the objects themselves, but in the crosstalk they established and the dynamic way they drew the observer into the conversation. As Barbara Stafford puts it, the cabinets did not present a static tableau but rather 'a drama of possible relationships to be explored'.[2]

As the organisation of knowledge changed in the early modern era, the drama of these relationships also changed, becoming less imaginative and more abstract and methodical. Even as they kept one foot in phantasmagoria, *Wunderkammern* also functioned as prototypes of the modern museum, whose encyclopaedic aims and organisational frameworks would help concretise the new conceptual universe of Enlightenment rationality.

Emerging during the Renaissance and carrying through the eighteenth and even nineteenth centuries, the *Wunderkammern* can therefore be seen as transitional object-assemblages that mediate between very different ways of organising, perceiving and understanding the world – conceptual paradigms that the early

Foucault called *epistemes*. Foucault drew a strong distinction between a Renaissance *episteme* based on resemblance, analogy and occult signatures, and a subsequent Enlightenment regime, which rejected that resonating mirror show of images for taxonomy, strict filiation and rationalised, abstractly-defined relationships.[3] This Enlightenment *episteme* transformed the organisation of knowledge – the order of things – but it also transformed the world, entering into the very folds of perception and experience. It did so by driving a wedge between things and meanings, establishing the schema that Bruno Latour characterised as fundamental to the logic of modernity.[4] Within the paradigm shift Latour describes, a radical distinction is drawn between natural objects and human culture, two domains that had formerly been braided into one resonating reality composed of hybrid objects that were at once natural and cultural. This was the old 'anthropological matrix' of fates and fetishes that modernity claimed to set itself resolutely against. No more unicorn tusks.

However, the older *episteme* did not disappear – it just fled to the margins, where it persisted and mutated inside the worlds of literature, popular entertainment, fringe science (and tech), 'madness' and the esoteric underground. Which brings us back to curation, and the art – rather than the science – of gathering together meaningful objects and images. Among the many modes of curation there is an enigmatic style whose orchestration of juxtapositions and resonances can lend an occult air of significance to the resulting collection, a kind of portmanteau discourse of visionary hybrids. Surrealists exploited this combinatory power to *détourne* consciousness in the direction of Freudian slip-knots and alchemical desire; personal altars and the bohemian art of thrift-store interior design are informal examples of such curated mysteries. Similarly, it is hardly accidental that the logic of dreams and esoteric correspondences runs so deep in the modern arts of collage and assemblage. Like Andy Holden's cosmic collage, such media gather objects and images – often quotidian or even corny on their own – into larger assemblages that both reflect on and intensify the essential enigma of things – like the possibility, Holden playfully suggests, that the universe is *looking back at us*. As if by magic, a gathering of objects calls forth a pattern that connects. The more heterogeneous the objects – in Leckey's show we have pop art canvases, Minotaur heads, car engines, canopic jars, Wurlitzer drum machines – the more feverish that linking pattern grows. Think of it as *object-oriented invocation*.

Installation view, *Mark Leckey: The Universal Addressability of Dumb Things*, The Bluecoat, Liverpool, 2013

In particular, Leckey wants to invoke the spectral and increasingly animated correspondences between beasts, machines and the human bodymind. Discourse is not necessary to tap into this invisible matrix of metamorphic figments – indeed, in some ways talking about it just gets in the way. Much may be gained from allowing yourself to daydream or divine your way through Leckey's labyrinth of phantom objects, to quiet your internal commentary enough to allow the objects themselves to provide their own oracular mumblings. Here the old paradigm of resemblances is

close at hand: a camera recalls a tribal fetish, books look like brains and a mandrake root naturally (magically?) forms a simulacrum of a man. Analogue chains of links and puns proliferate and circulate: the wooden model of a cat's reflex system invokes the Egyptian remains of a cat whose mummification calls up the CT scan – a 'CAT scan' we say – of a human mummy whose empty sockets demand, in turn, a procession of eyeballs: Toyen's *Object-fantom* and even the Sputnik model that returns to remind us, in a roundabout way, of the curious metallic peepers – jeepers creepers! – of the feline reflex model that began the chain. From this perspective, the show is a rebus whose solution is your own shifting consciousness.

At the same time, Leckey is also setting up a specifically *conceptual* assemblage, an analytical zeitgeist probe. With his characteristic informality and lack of pretension, Leckey is asking a question, or a set of questions, that happens to take the form of a gathering of symptoms that cross multiple levels of psyche, biology, art and apparatus.

At the heart of the question lies an observation, or a suspicion, that the science fiction writer Philip K. Dick once voiced in a prescient speech he delivered to the Vancouver Science Fiction Convention in 1972. Dick noted that our environment – by which he meant 'our man-made world of machines, artificial constructs, computers, electronic

systems, interlinking homeostatic components' – was coming to possess what the first peoples perceived in their environment: animation. Navigating a world of robots, non-player characters, talking technologies, self-improving algorithms and uncanny feedback arrays, we are increasingly hard-pressed to reject Dick's fundamental techno-animist claim: 'In a very real sense our environment is becoming alive, or at least quasi-alive.'[5]

The artefacts, images and moving pictures that Leckey has gathered might be said to ride the ambiguous, Möbius-strip surface of that 'quasi'. The Latin term, we should recall, means 'as if', and *as if* is perhaps the most fundamental strategy by which people today both experience and attempt to contain the tantalising and threatening re-enchantment of the world. As cultural commentators from Victoria Nelson to Christopher Partridge have shown us, subcultural enchantment is the fantastic flip side to Max Weber's famous assertion, not unrelated to Latour's critique, that the modern world is an iron cage that locks us inside a rationalised matrix, which exiles all the old spectres. Though figments of the anthropological matrix lurk perpetually at the margins of our minds – in dream leakages, odd hunches and the occasional mystic transport – the old enchantment is perhaps most visible in the tales told by our cultural artefacts. Fictions run on *as if*, of course – most obviously fantasy and science fictions, whose viewers and readers are called upon to not only suspend some of our underlying rules of reality but to allow other rules to temporarily take hold within a bounded space of possibility. As such, the *as if* operator also underlies the vast appeal of role-playing and massively multiplayer online games (MMOGs) and their compulsive elaborations of Science Fiction, occult, paranormal and fantasy rule-sets. Just as the philologist Max Müller once argued that human mythology is 'a disease of language', so the interactive fictions that glaze our objects – virtual and otherwise – might be seen as the emergent expressions of the re-engineered (or imagineered) codes and protocols that increasingly 'run' the real.

But, today, Dick's 'quasi' goes well beyond obvious fictions. As Michael Saler explains in his book *As If*, moderns have learned to inhabit an 'ironic imagination' that both indulges and disavows the world of enchantment.[6] This is the imagination that allows us to immerse ourselves in fantasies – especially like Sherlock Holmes or H.P. Lovecraft's, that play with their own possible reality – while ironically distancing any conflicts our imaginative assent might create with the rules of the iron cage. Today this mode – Saler calls it 'delight without delusion' – increasingly extends to the surfaces of our quotidian lives, albeit often in a less delightful vein.[7] Asking Siri a question *as if* the iPhone were intelligent, or modifying our social behaviour as *as if* were already being recorded, or following mainstream news stories into the hyperlinked labyrinths of conspiracy *as if* the truth was really out there, we discover that ironic imagination is no longer confined to obvious fictions but has become a handy rule of engagement with an environment where, as Dick foresaw, intelligence, responsiveness and something like life – or at least quasi-life – are increasingly distributed through the world of objects.

The problem with the *as if* approach to our increasingly animist experience of objects, though, is that it roots itself too resolutely in the modernist schema. This paradigm saps agency from natural and crafted objects and places it entirely on the human side of the equation. In this view, humans 'project' meanings onto objects in the environment; indeed the very concept of *environment* requires the absence of animating energies that would render the surrounding milieu too animate and even wilful for such abstract concepts. To some degree, of course, projection is the appropriate model, since the fluctuation of images through the network is part of the game. The belief that certain plants or mountains have a special occult power is partly related to the fact that some of their shapes – like the mandrake root in the show – elicit our own hard-wired tendency to find human faces and forms in the world around us. Similarly, we may recognise classic Disney animations as a return to animism, as the brilliant Russian filmmaker Sergei Eisenstein did in his writings on the Mouse ('*Bambi*', he notes, 'is already a shift towards ecstasy – serious, eternal'), but we also know that the film's mechanically projected 24 frames per second exploit our own perceptual machinery.[8]

That said, however, 'projection' alone will no longer suffice. The concept does not adequately account for the dynamic operations of the assemblage, which draws the human body and psyche into its mesh. Who is projecting *Bambi* anyway, the psyche or the film machine? Here we must recall Latour's core dictum that 'we have never been modern'. In other words, the radical distinction opened up between natural things and cultural meanings – the paradigm that gives us 'projection' – is an act of legerdemain by the magus modernity. In contrast, Latour argues that the emergence of nature-culture hybrids never actually ceased. Indeed, the sleight of hand of the modern schema encouraged the production of these meshed objects, so much so that today we have reached a point where hybrid networks of machines, biological forms and cognitive, cultural processes surround and implicate us so pervasively that they seem to compose us as well.[9] And so we sink back into the old anthropological matrix.

The Universal Addressability of Dumb Things is an index – an occult signature – of this shift. If the classic *Wunderkammer* can be seen as prologue to the modern order of things, Leckey's curated assemblage crawls out from the ruin of that order. It is common to note that the material things in our world are increasingly enmeshed in incorporeal matrixes established by 3D prototypes, imaging systems and an ecstasy of digital mediation. At the same time, however, objects are growing increasingly *demanding*. The peculiar presence of the things and images in Leckey's show – which both announce their significance and veil their meanings – is of a piece with what Latour's network-actor theory and a growing number of object-oriented thinkers recognise as the *agency of things*.[10] The new object is irreducibly real, but also elusive, uncanny. It has its own moves to make, its own alliances to establish, its own signs to emit. The demands of such a 'weird realism' surely block and obstruct the aspirations of modern human consciousness and its aspirations of autonomy, control and the cognitive correlations between mind and world.[11]

The newly awakened object can also be understood in terms of panpsychism – the argument, convincing even to a few hard-nosed neuroscientists, that a measure of mind or consciousness inheres in every single thing in the cosmos.[12] What Leckey shows us is that it doesn't matter whether these hybrid objects are opaque. Others or facets of cosmic consciousness, or both. Whether we are ready to embrace them or not, they are in some sense alive. Or, at least, quasi-alive. (Or maybe undead.) In any case, the return of the object is a return of animism of a sort, at least of a weird realism that undermines our blinkered passages through a merely human reality. Might as well meet the neighbours.

MARTIN HERBERT
ON CONTEMPORARY
FIGURATIVE
SCULPTURE

*The Human Factor: The Figure
in Contemporary Sculpture*
2014

This exhibition of contemporary sculpture brought together major works by 25 leading international artists whose work addressed the human form in new and challenging ways. Revisiting classical traditions of sculpture while drawing on representations of the human body in popular culture, the works in this exhibition – by artists including Ryan Gander, Rachel Harrison, Thomas Hirschhorn, Pierre Huyghe, Jeff Koons, Yinka Shonibare and Cathy Wilkes – encouraged visitors to change the way we think about, and perceive, one of art's oldest subjects. The exhibition's catalogue featured essays by Penelope Curtis, Lisa Lee, James Lingwood and Ralph Rugoff, as well as the following text by art critic and associate editor of ArtReview *Martin Herbert.*

POST-ABSTRACT AND DATA-MAPPED
THE CONDITIONS OF CONTEMPORARY FIGURE SCULPTURE

I n a 1964 conversation with Alberto Giacometti, David Sylvester reminded the artist of something strange he'd once said: that, while working on a standing figure, the more clay he took away, 'the bigger it gets'. After Giacometti acknowledged saying so, but added that he didn't know why it was, the critic hazarded a rationale: 'that when the thing is narrower, and therefore denser, it has more pent-up energy. And if this energy, this contained violence, goes on increasing, you have the impression that the sculpture dominates more space.'[1] In such a reading, there's an interpenetration of the sculpture and the very air around it. Relatedly, in his 2001 essay, 'Thinking of Sculpture as Shaped by Space', Charles Ray recalls reading an interview in which Giacometti noted that 'four beautiful women who had just entered the lobby could not be seen separately from the space the shiny marble floor generated between him and them. I think', Ray went on, 'Giacometti's sculptures somehow carry that space with them.'[2]

Such sculptural space is expansive and complexly tiered: it might, for example, be said to encompass time. But for the moment let's limit ourselves to physical dimensions. It's perhaps not wholly irrelevant to Sylvester's style of questioning, and Ray's later choice of what to highlight about Giacometti's work, that the 1960s was a period in which the relationship between a sculpture and the space around it was being revised and performed via minimalism. If the Italian sculptor's etiolated figures might be characterised as carved and compressed by the anxiety-creating world through which they move – this would be the approximate existentialist reading – then minimal artists more coolly asserted that sculpture, and reception, is indivisible from physical context. For all that the artistic results were typically geometric, this expansion was never wholly an act of abstraction, for minimal art was forever reminding' viewers of the presence of their own bodies in the room. 'The better new work', wrote Robert Morris in 'Notes on Sculpture, Part 1', 'takes relationships out of the work and makes them a function of space, light and the viewer's field of vision.'[3] When Sylvester interviewed Morris the following year, he

told the artist that what Morris's work most reminded him of in terms of physiological effect, were the carved figures from one wing of the Parthenon.

In Giacometti's work, the figure merges with abstraction, with an idea of what the world is and what being in it does to one. In minimalism, abstraction merges with the figure. Over the last quarter-century, while abstract sculpture has inevitably continued to be made, artists have returned to the sculpted human form. (Artists are intransigent, wilfully curious types: close a door and they'll try to pry it open.) They have done so, when intelligently, with no illusions about the possibility of a pre-modernist *tabula rasa*, yet also without being able to forget the past. If abstract sculptors could not shake off the figure, figurative sculptors cannot disregard the lessons of abstraction. The latter constitutes unerasable knowledge, and behoves them to operate somewhere in the overlap between two spheres.

Consider, for example, the first half-decade of Rebecca Warren's career. In the late 1990s, Warren first drew attention for working in unfired clay (at a point where her Young British Artist contemporaries were having their work commercially produced) and specifically for conjoining the iconographies of counterculture cartoonist Robert Crumb and photographer Helmut Newton in *Helmut Crumb* (1998), a pair of gate-like nested sculptures that reduced bodies to legs and vaginas. This work was in some sense already a dehumanising abstraction and, given Warren's gender, also a work of apparent feminist critique but all its parts were readable. By 2001, though, Warren was making works like the tartan-patterned, mutely featureless lump *Head*. And by 2003 she'd produced *Cube*, a rough-edged cuboid, sprayed gold, and a series of ungainly, womanly sculptures in which the human figure is dissolving and detaching in increasingly complicated ways, losing defining contours in a manner that reflected Warren's own thought process concerning the iconography she was using.

A, B

Teacher (M.B.) (2003) is one of a trio of works, along with *Teacher (R.)* and *Teacher (W.)*, that come with a fictional narrative attached: according to Warren, they've ostensibly been made by an art tutor, a sexually frustrated and rancorous one, at a regional English college. As in Crumb's notorious 1992 cartoon 'A Bitchin' Bod',[4] where the character Flaky Foont happily has sex with a headless woman, here the seat of thought is effectively obliterated, semi-abstracted, reduced to a grotesque, Gorgon-like snake-pit of hair. The figure also has only one monstrous breast and is clubfooted. It sits on a pair of trolleys, the square, skateboard-like sort that artists use to move works around their studios. Mobility is apropos. *Teacher (M.B.)* appears laceratingly critical of art's permissions of sexism, the cold male gaze sanctioned by exceptional skills such as Crumb's and Newton's (and Pablo Picasso's, for such a work also echoes his abstracting aggressions upon the female figure). But it also, Warren has said, reflects a conflicted, involuntary admiration of their ability. The sculpted woman is made of unfixed, unfired clay and is also on wheels. This all

makes sense, since what she represents for the artist – a swirl of mixed emotions regarding masters, teachers, predecessors – won't stay still.

C

A figurative sculpture today, *Teacher* admits, must productively acknowledge the multifarious weight of the past. Warren has never shied away from this; she has, rather, used the fact to generate zones of ethical ambiguity. Also in 2003 she produced *Pony*, a pneumatic take on Edgar Degas's small sculpture *Little Dancer Aged Fourteen* (1880–81, cast c.1922), a work the French artist kept, fetish-like, in his studio. His thought process regarding that work, and its model, is a black hole, a historical ingress that permits a proposal such as Ryan Gander's *I don't blame you, or, When we made love you used to cry and I love you like the stars above and I'll love you 'til I die* (2008). A bronze of a girl in a leotard sits propped against a white plinth, smoking, gazing at a small blue cube. The girl, in Gander's cosmology, is Degas's teenage model; and this is a moment we never saw – the *danseuse* off-duty, between poses, and, according to the title (which, we might think, is Degas's speech), snarled up in something more than a professional transaction. Times are tangled here, or time is curved. The dancer, taking a fag-break between big historical moments, seems to be contemplating the aesthetic world that will come out of Degas's early modernism – a floating offcut from De Stijl – but also the unknown. The blue cube is a mute thing, like a miniature obelisk dropped from the sky, and it reoccurs enigmatically in Gander's work. (Another one features in *The Artwork Nobody Knows*, [2011], where a tiny, immobilised model of Gander has fallen before it, as if overcome, from his wheelchair.)

Ryan Gander, *I don't blame you, or, When we made love you used to cry and I love you like the stars above and I'll love you 'til I die*, 2008. Installation view, *The Human Factor*, 2014

D

I don't blame you is turned playfully relativist by its title, which fast-forwards us into the 1980s (it is, in part, a lyric from Dire Straits's 'Romeo and Juliet' [1980], a song based on Shakespeare's 1597 play) while bending chronology to infer, perhaps, the timelessness of human desire and doomed love. Here, and in the companion work *Come up on different streets, they both were streets of shame Or Absinth blurs my thoughts, I think we should be moving on* (2009), again sporting a title partly taken from a 'Romeo and Juliet' lyric, where the girl stands on a larger blue cube to peer through the gallery window, there's an elastic sense of possibility in shuttling between time periods. If the monolithic weight of the aesthetic past derives in part from its being arranged, like standing stones, in a modernist timeline – development appearing to follow development with retrospectively crushing inevitability – then one way of treating it with liberating lightness might be to use it as an opportunity

MARTIN HERBERT ON CONTEMPORARY FIGURATIVE SCULPTURE

for recombinant fiction. And such fiction is necessarily subjective, so Gander's oeuvre as a whole has suggested since his early, dizzying lecture performances, by making lively, six-degrees-of-separation connections between disparate subjects. These, for all Gander's apparent mental agility, never let you forget that they're just one person's relativist take on the forbidding sprawl of knowledge. This isn't even his truth, just aw hand-cut path through the forest.

We might not, today, be able to think of *Romeo and Juliet* without a pop song springing to mind. (We might even prefer the pop song.) Picture a succession of doors slamming shut, over time: no return to purely figurative sculpture, no return to abstraction – which, as we've seen, was ghosted by the figure in any case – and, after pop art, perhaps no possibility of art as a discrete space where the barbarians can't get in. How to speak profoundly in a sullied language?

In Jeff Koons's *Bear and Policeman* (1988), from his *Banality* series, a smiling bear looms over an English policeman, or 'bobby', who gazes raptly into its eyes. The work, in polychromed wood, has a sweet 1950s feel that is a foil to its roiling psychosexual intent. The bear, in a semi-sexual and definitely dominating move, has grabbed the bobby's whistle, his symbol of authority and the thing that he uses

to maintain order, morality. Koons has suggested in several interviews that the creature represents art, which ought to be a powerful, challenging thing that vaults over petty aesthetic niceties; at the same time, though, Koons maintains (in classic Koonsian democratic-uplift style) that art ought not to act in its own interests but in those of the public. In the gaudy universe of his 1988 body of work, *Banality* – wherein Koons claimed he wanted to create art for the common person to recognise themselves rather than being cowed by oracular high art, an artwork (or artist) – art ought not to steal the whistle, act selfishly.

The irony-proofed blandishments of such work, and the unlikely intellectual challenge posed by Koons's apparent straight-talking and populist ambition, made clear at the time that it was possible to revisit wholly figure based sculpture without being *retardataire* or simplistic. (Indeed, it is Koons's transparency that turns out to be difficult.) Temporal, spatial, contextual displacement of the existing can be as eloquent as the invention of new forms. In Koons's recent *Gazing Ball* works, for example, the artist has rewound to antiquity, or something like it. There is a demotic cultural-mainstream vein running through these white plaster sculptures, each engaging with a blue ball; gazing balls, positioned like middle-class trophies in gardens, were a fixture from Koons's childhood. If the laser-cut figures of Aphrodite, Pan, etc. themselves recapitulate classical statuary, they are also tinted with popular culture: plaster casts were, Koons has also noted, very popular in the nineteenth century. And, undoing preconceptions again, for him there are verities in their iconography (sexuality, temptation) that still speak to modern reality, just as the figure of a nineteenth-century dancer might do, if we actually attend to their nuanced body language and altered context rather than merely classifying them.

E

So let the sculptural figure be, at least to some degree, the still point of a turning world. Antique stone newly set, or at least newly cut. Koons, these days, spends much of his time consulting with scientists over rarefied, submolecular developments in 3D printing, and he's far from the only sculptor awake to the widescreen horizons of the digital. Frank Benson's *Human Statue (Jessie)* (2011), though made of bronze, flaunts enough verisimilitude that, when it was installed on New York's High Line, some passers-by mistook it for a bronze-painted, stock-still 'human statue' performer. In actuality, *Human Statue (Jessie)* is an artefact of twenty-first century bleeding-edge tech. It derives from a 3D rendering of a photograph of Benson's friend, dancer and musician Jessie Gold, which was then 3D-printed using a compound technique called rapid prototyping, before the prints were cast in a New York foundry.

How technology is driving sculptural practice can be measured in the fact that Benson's sculpture is a sequel of sorts to *Human Statue* (2005), a silver-painted male figure who explicitly resembles one of those aforementioned frozen street performers, except that he's dissonantly nude. This work was made in a relatively

conventional, analogue way, casting a figure in fibreglass. The six years between the sculptures adumbrate a quantum leap in terms of representational control, since *Human Statue (Jessie)*'s techniques, which didn't exist in 2005, are sensitive enough to render veins in the feet. Reemphasising this technological dominion over the bodily, Benson plays with degrees of fidelity: some areas of the figure are unreally smooth, like an airbrushed magazine cover, others roughed up. But what the artist likes most about the work, he told the blog of the *New York Times*, is the fact that it is 'hard to place chronologically'.[5]

'Jessie's' body is *contrapposto*, a sculptural attitude that dates back to at least 480 BC. At the same time, she's wearing what looks like a sleek, synthetic, very modern black dress. While there's a shield at her feet, and a classical harmony between its shape and the bend of her arms, she sports an androgynous hairstyle and sunglasses that tie her to the 1980s. It's antiquity. It's that first age of retro, the Renaissance. And it's the 1980s that looked forward to *Blade Runner*'s 2019. It's the early 1990s of 'posthuman' sculpture. It's 2011, a moment not only of looking backward – when the specific 1980s fashions that Jessie wears were being revived on catwalks and are now already, doubly, retro again – but also of looking into an increasingly technologised future, predicated on mapping, observing, panoptic controlling: a decade after the sequencing of the human genome was completed, as CCTV cameras observe our every move, as Google Earth scours the globe. *Human Statue (Jessie)* thus registers, with spectral precision, not only a cultural obsession with glamour and surfaces, and something of end-of-empire decadence, but; more fundamentally, how we live now: strung between present, future and a myriad of pasts. (Even 3D printing has its roots in nineteenth-century methods of creating contour maps and the experimental technique of 'photosculpture'.[6])

One reason we don't have a fixed sense of the present, of course, is that we're now perpetually in the grip of imposed nostalgia cycles, past eras wheeled back onto catwalks and stages for commercial gain and recombined for creative frisson, particularly by the generation brought up with the Internet's opening up and flattening of the historical/cultural archive. Meanwhile, and ironically given the current mania for revivalism, certain things that it would be *useful* to bring back seem all but impossible to meaningfully resurrect. The present writer, for example, regularly finds himself in the studios of artists, hearing of their internal attitudes and watching them prowl embarrassedly around the word 'existentialism'. Sometimes they use it, usually they don't, because existentialism is a black-polo-necked, Gauloise-huffing, Camus-paperback-flaunting cliché. Still, it offers a useful, sincere vocabulary for dealing with human loneliness, the cruelty of the world, the brevity and possible pointlessness of life, where otherwise there's only religion. And some artists, if not many, do dare to engage with it.

Ugo Rondinone's 'nudes', a series of seven from 2010–11, look at once like they're posing for an artist, trying to get some needed rest and inwardly becalmed. The figures, in their facture, look back to classical techniques: they have nothing to

do with 3D printing, being cast from the body in wax mixed with earth pigments. They're emphatically unstable – the body parts are sectioned, composite, seamed and run to varied tones of earth, flesh and grey – and, in terms borderlines between being here and being taken apart, alive and inert, melancholic and relieved. Nudity, here, means allegorical exposure: defences and covers stripped back, reduced to primal being. (The press release for the work's first showing in New York didn't shy from using the word 'existential'.)

These are also perhaps works, though, to be seen in the context of Rondinone's formally diverse career as a whole. What they recall most insistently is his series, from 2001–02, of fibreglass clowns, also propped against gallery walls or laid flat. The clowns, at least, were wearing something, whether leotards or sackcloth or towelling; and the paint plastered over their faces resembled, naturally, greasepaint. Rondinone's nudes have lost even that protection. Off the pedestal and off their feet, they have little to do with the proud tradition of statuary; if, formally, they update anything from antiquity, it might be the ancient Roman *Dying Galatian* (220–30 BC), a portrait of a defeat. They are the human figure reduced to bare life.

As such they remind us that those ostensibly historical concerns animating Giacometti's art are not irrelevant, because the fundamental terms of being in the world have not changed. We have not become immortal, overcome war, collectively reanimated God, etc. What has changed is the texture of the space that surrounds the figure sculpture today. A la minimalism, the work is the sum of itself and its context. And what hangs invisible in the air around the sculpted figure, giving it 'pent-up energy', is the phantom continuum of the figurative sculptures, and also the abstractions, that preceded it. These at once make it difficult to make something new and, as we've seen, also offer opportunities for the inventive to engage the human body on the double-faced (forward-looking, backward-looking) terms of the present. The oldest figure sculpture is between 35,000 and 40,000 years old.[7] Between that point and the present there was a period of perhaps just 40 years when it was not particularly acceptable, and then only in the rarefied world of avant-garde art, to make such work. We want to see ourselves reflected, in the place we are now. If where we are now has never before had so much *then* in it, and nor, perhaps, so much scary and thrilling futurity, we'll see it in the images we build of our bodies and each other's before – à la Rondinone's nudes – our patchwork selves fall apart at the seams.

KENNETH GOLDSMITH
ON CONCRETE POETRY

The New Concrete
2015

The New Concrete, *produced by Hayward Gallery Publishing in partnership with the Southbank Centre's National Poetry Library, provided a survey of the rise of concrete poetry in the digital age. This illustrated publication featured the work of contemporary artists and poets working at the intersection of visual art and literature, and producing some of the most engaging and challenging work in either medium. The publication included essays by celebrated poets Victoria Bean and Chris McCabe, as well as the following essay by the American poet and critic Kenneth Goldsmith.*

MAKE IT NEW: POST-DIGITAL CONCRETE POETRY IN THE 21ST CENTURY

The documentary film *Helvetica* (2007) is about the ideological battles surrounding the classic typeface. On one side are the hardcore modernists who regard its clean lines and no-frills style as the apex of design. On the other is a group of mostly younger designers who, coming of age during and after the 1960s, reject the face as embodying the evils of the industrial-military complex, both politically and aesthetically. To them, Helvetica represents 'the man' in all his square, buttoned-down correctness. In order to counter the font's power, they create typefaces that are the exact opposite: expressive, hand-drawn and funky. To them, fonts and the way they are used are a political battlefield; Helvetica's monolith can be softened only by dousing it with raw emotion.

As a fan of typography, it's hard not to be sympathetic to both sides. Sure, Helvetica is pretty narrow in its worldview but nothing is more beautiful, elegant and clean, representing all that 'good design' should aspire to. Self-assured, it knows what it stands for and where it stands in the world. Yet precisely for these reasons, it doesn't fit into our time. Helvetica is an artefact born of the Cold War, powerfully expressing its binaries: black and white, old and new, us and them. Although it's a mid-twentieth-century font, it feels about as far away from the twenty-first century as the typographic ornaments, pen flourishes and swirly curls of Victorian typography. And our relationship to it is equally romantic. When we encounter it today, it's usually in scare quotes, found marching across the pages of catalogues selling mid-century-modern furniture replicas, the sort of stuff *Dwell* magazine might try to hawk you. Somehow, the one-dimensional simplicity and cleanliness of Helvetica doesn't quite jive with today's messy world.

The history of concrete poetry breaks down along similar lines, with the difference being that the same practitioners who advocated the strict use of Helvetica in the early 1950s were the same ones who broke with it in the 1970s for social, political and technological reasons. Charting a path from the utopian to the dystopian, you could say that there's a secret history of the second half of the twentieth century embedded in this little movement, one that parallels larger changes across cultural output. By the late 1970s, when concrete poetry collapsed into a smouldering heap, few could

have foreseen that it would arise as a digital phoenix in the computer age, presciently predicting the ways we would interact with language in the twenty-first century.

Sitting on my desk is a catalogue that was made to mark the half-century anniversary of the founding of the seminal Brazilian concrete poets known as the Noigandres group, consisting of the brothers Haroldo and Augusto de Campos, along with a fellow student named Décio Pignatari. They set out to change literature by creating a universal picture language, a poetry that could be read by all, regardless of what language they spoke. Letters would double as carriers of semantic content and as powerful visual elements in their own right. Often the poems – written in just about every language imaginable – came with a key so that, even if you didn't know, for example, Japanese, you could get the gist of what a handful of *kanji* compellingly strewn across a page added up to. Delightful to the eye, and political in its intent, their agenda was nothing short of revolutionary: to create a visual Esperanto that would ultimately dissolve linguistic – and thereby political – barriers between nations.

The movement, drawing from Poundian imagism and Joycean wordplay, dovetailed with the twentieth century's drive toward condensed languages as expressed in advertising slogans, logos and signage. By shedding all vestiges of historical connotation – including metaphor, lineation, spontaneous composition and organic form – concrete poetry planted itself firmly within the grand flow of modernism. These poems, to paraphrase Ezra Pound (a major influence for the group through his use and theories of ideograms), sought to literally 'make it new'.

In the black-and-white photographs of the period, the Noigandres group come off as 'serious' 1950s intellectuals, never smiling, dressed in thin-lapelled dark suits, crisp white shirts and skinny black ties. They look like tropical versions of 1920s Paris modernists, reminiscent of, say, Stravinsky peering over his thick glasses in his trademark double-breasted tweed suits. Their journal, which shared the group's name, further echoed European modernism, its design inspired by the look and feel of Éditions Gallimard. On the cover, crisp red typography, underscored by thick black rules, was surrounded by acres of creamy, off-white space. The journal was typeset entirely in the Futura font and the poems – elegant chunks of black-and-white phonemes – danced across the mostly empty pages. When colour did appear, it was often primaries, declaring these poems to be the linguistic cognate of Mondrian's paintings.

Alongside the group's own poetry, the journal published classic modernist poems and manifestos, many of which were presented in Brazil for the first time. Any given issue would include poems by Stéphane Mallarmé, Pound and e.e. cummings, alongside radical works by the Noigandres, Oswald de Andrade and João Cabral de Melo Neto. Entire issues were devoted to the idea of the poster-poem, meant to be pasted upon city walls, exploring 'renewed forms of sensibility in the urbano-industrial environment of a new society'[1] ideas that grew in tandem with the utopian construction of Brasília. The poems themselves were meant to invoke all the senses, bringing for the first time to poetry Anton Webern's idea of *Klangfarbenmelodie* (sound-colour-melody),

Pound's theory of *phanopoeia*, *melopoeia* and *logopoeia* (the play of image, music and meaning) and Joyce's neologistic notion of the *verbivocovisual*.

Voluminous correspondence with concrete poets from around the world led to a bona fide international movement with adherents from the UK, France, Germany, Portugal, Spain, Hungary, Canada, the United States and Japan, many of whom were published in the journal. By the 1960s, the concrete poets were honoured with two special editions of the *Times Literary Supplement*, several influential anthologies appeared and exhibitions of their works were mounted in galleries around the world. They were in sync with avant-garde ideas of their day, from Marshall McLuhan's media theories to the aleatory music of John Cage. In Brazil, they allied themselves with the youthful Tropicália movement – Caetano Veloso went on to set several of Augusto de Campos's poems to music – leading the poets to ride a global wave of pop. For a few short years, their revolution was a reality.

But political troubles in Brazil were brewing, beginning with the 1964 coup that overthrew President João Goulart. By 1968 the military dictatorial screws had tightened, to be followed by long years of authoritarianism. Writing about these dark years, Haroldo de Campos lamented:

> [It was] poetry in a time of suffocation. On the international level, the crises of ideologies went into overdrive, with imperial capitalism, savage and predatory, on the one hand and the bureaucratic state, repressive and uniforming, on the other, converting the revolutionaries of yesterday into the *apparatchik* of today and turning art into the squire of party-political dogma. Poetry was drained of its utopian function (despite, paradoxically, the advent of the new media created by electronic technology and the unprecedented possibilities they brought), as if putting flesh on the Benjaminian/Mallarméan prophecy of a universal picture language.[2]

De Campos referred to the next two decades of concrete poetic production not as 'post-modern' but 'post-utopian'. With ideology squashed, the poets swapped politics for visuality, using the 'electronic technology and the unprecedented possibilities they brought' to expand the formal parameters of their artistic practice. What had up until this time been a strict adherence to the rigours of modernism – produced mostly with type and paper – exploded into various forms of multimedia, from video environments to massive architecturally-based sculptures.

The apogee of this trend was a 1975 collaboration between Augusto de Campos and artist Julio Plaza called *Caixa Preta* (*Black Box*), which included everything from lavish construct-it-yourself die-cut paper sculptures to a Veloso 45rpm disc wrapped in a gorgeous sleeve designed by De Campos. With the increased availability of wild typefaces, De Campos dug right in, swapping sans-serif fonts for funky 1970s lettering that resembled disco typography or the opening credits of a porn film. It's a lot of fun and, in a way,

Bob Cobbing
Cygnet Ring, 1977

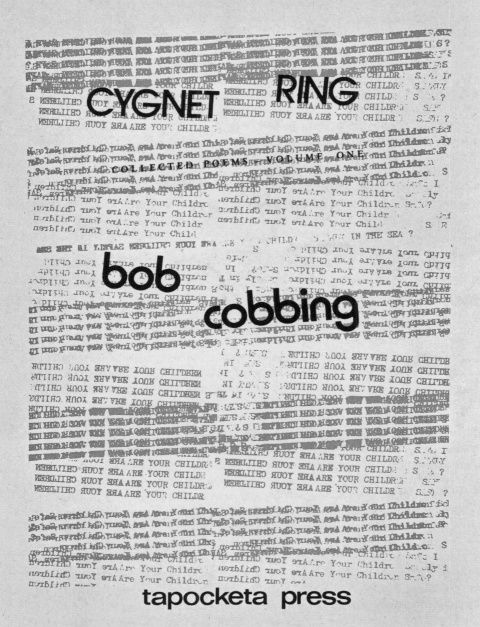

feels like a relief. De Campos freed himself from the straightjacket of modernism in the same way that the younger designers featured in *Helvetica* did. Even the photographs of the poets from this period bespeak a loosening up: their hair long and unkempt, sporting wrap-around aviator sunglasses, draped in floor-length black leather coats and festooned with thick jewellery; they're more Rainer Werner Fassbinder than Arnold Schoenberg.

As Haroldo de Campos remarked, similar changes were felt worldwide, expressing themselves in a variety of ways. In Canada and England, a second wave of concrete poets moved away from pure modernism by steering their production toward 'dirty concrete', where the 'noise' of the typewriter – misprints, ghost prints, overprints, doubling and wobbly lines – was purposely courted as evidence of the machine's presence during the writing of the poem. Whereas the earlier poetry required elaborate typesetting, there was something democratic about banging out poems on a typewriter: anyone could do it. The typewriter also changed the look of concrete poetry. The monospaced fonts and gridded movement of the carriage lent the poems a mechanised favour, echoing the minimalism raging through the art world at the time – Carl Andre's bricks and typings were but two sides of the same coin. And as there was only one font size available on the typewriter, the focus shifted from the individual letter to buzzy fields of hazy, swarming strokes.

The typewriter's democratisation imbued the poems with increased political awareness. The media archaeologist Lori Emerson notes that

> [dirty concrete] is commonly used to describe a deliberate attempt to move away from the clean lines and graphically neutral appearance of the concrete poetry from the 1950s and 1960s by [Eugen] Gomringer in Switzerland, the Noigandres in Brazil and Ian Hamilton Finlay in England [*sic*]. Such cleanliness was thought to indicate a lack of political engagement broadly speaking and, more specifically, a lack of political engagement with language and representation. As renowned French poet Henri Chopin wrote in 1969, a year after the failed worker/student protests in France: 1968 was the year when man really appeared. Man who is the streets, HIS PROPERTY, for he alone makes it [...] Yes, 1968 saw this. And for all these reasons, I was and am opposed to concrete poetry, which makes nothing concrete, because it is not active. It has never been in the streets, it has never known how to fight to save man's conquests: the street which belongs to us, to carry the word elsewhere than the printing press. In fact, concrete poetry has remained an intellectual matter. A pity.[3]

Legions of concrete poets heeded Chopin's clarion call for a less bourgeois poetry by purposely scumbling the surfaces of their poems using the typewriter or, in the case of someone like Bob Cobbing, exploiting the dirty, smudgy quality of mimeo and Xerox machines to 'court visual and linguistic nonlinearity and illegibility'.[4] This anti-aesthetic bled into punk zines and grunge culture in the following decades. By 1968, concrete poetry had, indeed, migrated off the page and exploded onto the streets in Paris, where Situationist-inspired graffiti doubled as poetry across the city's walls.

522

By the 1980s, the concrete poetry movement had pretty much collapsed, subsumed by larger trends, such as mail art, where one swapped concrete poems as readily as wobbly cassettes, postage-stamp-sized paintings, tabletop sculptures and folded-up posters. Concurrently, small press culture arose with its vast horizontal networks and voluminous production. Concrete poetry became a mere trickle of the torrent it once was, rendered nearly invisible as a minor note in a greatly expanded field.

There's a theory that the moment something verges on obsolescence, it's also on the cusp of revival, ready to reincarnate itself into new forms and uses. It's been noted, for example, that when the horse was rendered obsolete as a mode of transportation, it found a new role in recreation. Or, in a cellular age, that the availability of digital music on the smartphone or iPod has seen a steady rise in the sale of vinyl, now fetishised for its physicality.[5] While we used to get our information from magazines, today they resemble overproduced coffee-table books, more to be browsed than to be read.

And once concrete poetry had run its course, it too found a new and unexpected role in the digital world. In fact, many of concrete poetry's ideas about language's materiality have ended up being mirrored in our computational systems and processes. When our cursors interact with language, they do so in a physical way. Take, for instance, the computer's simple cut-and-paste function. When we highlight a word (note the word 'highlight') by moving our cursor over it and pressing down, we are literally picking up that word and moving it elsewhere. When we click on a link, we literally press down on a word. When, in the analogue age, did we ever press down on words? Similarly, we drag language from one place to another in our word-processing programmes. When we hit 'send' on an email, we are triggering a series of interactions that physically transfers language in the form of bytes from one computer to another, literally sending those words on a journey halfway around the world. In Photoshop, every time we work with text – stretching and sizing it – we are treating language materially. The Internet itself is entirely made up of alphanumeric language, the identical material that was used to make classic concrete poetry. What we take to be digital artefacts – our videos, photographs and music – are comprised of language posing as code (just think of when you've mistakenly received a .jpg in an email attachment that renders improperly as miles of code). The great dreams of the democratisation of concrete poetry by poets such as Henri Chopin have become embedded into our everyday activities. Haroldo de Campos's idea of universally readable visual languages floods our screens in the form of icons, emoticons and emojis.

Concrete poems being written in the twenty-first century have all been strained through the digital – and in some ways, have reacted to it; call it post-digital concretism. Even in cases where the poems might look similar to what was done in the last century, there's something different about them that responds to the digital in the ways they're produced, constructed, or distributed. Concrete poetry in the twenty-first century always winks at its twentieth-century precursors.

After years of poems laser-printed on vanilla A4 sheets or viewed as lo-res PDFs, we're seeing a fresh surge of poems printed on obscenely thick handmade paper, often swaddled in deluxe slipcase boxes. Books are more beautiful than they were before the digital age. Just walk through any number of art-book fairs popping up in cities around the world and the number of exquisitely-produced paperbound artefacts is overwhelming. Poets are migrating to print-on-demand systems as well, producing scads of lo-fi books more cheaply than ever, a return of the 'dirty concrete', punk, or grunge aesthetic, enabled by the digital. In the twenty-first century, poets have also rediscovered the sensuality of the typewriter and the expressive graphism of the handwritten word, resulting in new forms of asemic poetry, so unique that they can't be made by a computer. And even our cities are slathered with words. The walls of Paris '68 have evolved into the dynamic fields of graffiti and street art, marking the landscape with large, expressive hieroglyphs.

The content of post-digital concrete poetry seems to be influenced by the network as well. There's a lot of appropriated and remixed language, reflecting the cut-and-paste culture of the Web, as well as a gravitation toward erasure, perhaps a comment upon the fragility of cultural artefacts in the digital age. While concrete poetry has always been a fast poetry – purposely resistant to close reading – in the information age, it seems intentionally designed for short-attention spans. Influenced by 4chan image macros and the compressed language of Twitter, much of the new concrete poetry takes the form of snappy one-liners.

While visual artists such as Lawrence Weiner, Joseph Kosuth, Jenny Holzer and Barbara Kruger have worked with words for decades, a large number of young gallery-based artists are self-identifying not as 'text artists' but as 'visual poets'. In the same way that the art world has recently reimagined traditional, stagnant art forms such as dance and performance art, poetry is now receiving a similar treatment; last year's 89plus exhibition and workshop in Zurich, *Poetry Will Be Made By All!*, found dozens of poets under the age of 25 creating visual poetry in the gallery space, plastering the walls with word decals, aggressively pumping out poster-sized broadsides, doing daily webcast readings, tapping out smartphone poetry and publishing 1,000 print-on-demand books of poetry by young poets from around the world.

Concrete poetry's great gift was to demonstrate the multidimensionality of language, showing us that words are more than just words. What seemed like a marginal and boutique pursuit in the twentieth century has turned out to be prophetic in the twenty-first. Language is exploding around us in ways that the founders of the movement could never have predicted, but would be delighted by. Like Willem de Kooning's famous statement, 'history doesn't influence me. I influence it',[6] it's taken the Web to make us see just how prescient concrete poetics was in predicting its own lively reincarnation in the twenty-first century.

BIOGRAPHIES

DAWN ADES is a British art historian and curator. She is Professor Emeritus of Art History and Theory at the University of Essex, a Fellow of the British Academy and Professor of History of Art at the Royal Academy of Arts.

Ades has been responsible for several landmark exhibitions over the past 30 years, including the Hayward Gallery exhibitions *Dada and Surrealism Reviewed* (1978) and *Art in Latin America* (1989), the centenary exhibition of Salvador Dalí (Palazzo Grassi, Venice, 2004), *The Colour of My Dreams: The Surrealist Revolution in Art* (Vancouver Art Gallery, 2011) and *Dalí/Duchamp* (Royal Academy of Arts, London, 2017).

A leading voice on Dada, surrealism, abstraction and art from Latin America, she has published extensively on modernism, photomontage and artists including Leonora Carrington, Ithell Colquhoun, Hannah Höch, Linder and Gillian Wearing. In 2015 she published her collected essays, *Dawn Ades: Writings on Art and Anti-Art*.

RASHEED ARAEEN is a London-based artist and writer.

In 1964, Araeen moved to the UK from Pakistan, where he had trained as a civil engineer, and began his artistic career producing sculptural works based on geometry and symmetry. From the 1970s his work in performance, photography, painting and sculpture has challenged Eurocentrism within the British art establishment and championed the role of minority artists, especially those of Asian, African and Caribbean descent.

In addition to his artistic practice, Araeen founded the activist critical journal *Black Phoenix*, which was later relaunched as *Third Text*. Author of numerous essays and journals, he has written the autobiographical *Making Myself Visible* (1984) and *Art Beyond Art: Ecoaesthetics – A Manifesto for the 21st Century* (2010).

DORE ASHTON was a writer, critic and scholar on modern and contemporary art. She was Professor Emeritus of Art History at The Cooper Union for the Advancement of Science and Art, New York, and senior critic in painting and printmaking at Yale University.

Ashton embraced and championed the New York School, and made the case for abstract expressionism as the pre-eminent post-war art movement. Her many articles, exhibition catalogues, monographs and biographies include *The New York School: A Cultural Reckoning* (1972), *Abstract Expressionist Painting in America* (1983) and *Out of the Whirlwind: Three Decades of Arts Commentary* (1987). Her 1983 book *About Rothko* is still widely recognised as one of the key works on the artist.

HOMI K. BHABHA is the Anne F. Rothenberg Professor of the Humanities, Director of the Mahindra Humanities Center, and Senior Advisor to the President and Provost at Harvard University.

He is the author of numerous works exploring postcolonial theory, cultural change and power, contemporary art and cosmopolitanism, including *Nation and Narration* (1990) and *The Location of Culture* (1994).

He is a member of the Academic Committee for the Shanghai Power Station of Art, and the Mobilising the Humanities Initiating Advisory Board (British Council), an advisor on the Contemporary and Modern Art Perspectives (C-MAP) project at the Museum of Modern Art, New York, a Trustee of the UNESCO World Report on Cultural Diversity, and Curator in Residence at the Museum of Fine Arts, Boston. He holds honorary degrees from Université Paris 8, University College London and the Free University of Berlin. In 2012 he was conferred the Government of India's Padma Bhushan Presidential Award in the field of literature and education, and received the Humboldt Research Prize in 2015.

GUY BRETT is an art critic, curator and lecturer on art.

Brett was a key contributor to the development of European and Latin-American kinetic art during the 1960s. He has curated influential exhibitions such as *In Motion* (1966), an international survey of kinetic art for the Arts Council of Great Britain, *Hélio Oiticica* (Whitechapel Gallery, London, 1969) and *Force Fields: Phases of the Kinetic* (MACBA, Barcelona; Hayward Gallery, 2000).

Brett has written extensively for international periodicals including *Art in America*, *Artforum*, *Third Text*, *Studio International*, *Art Monthly*, *Black Phoenix* and *Parkett*, and is the author of monographic essays on Rasheed Araeen, Lygia Clark, Mona Hatoum, Susan Hiller and David Medalla, among others.

His books include *Kinetic Art: the Language of Movement* (1968), *Through Our Own Eyes: Popular Art and Modern History* (1986), *Carnival of Perception* (2004) and *Brasil Experimental: Arte/Vida Proposições e Paradoxos* (2005).

JULIA BRYAN-WILSON is a writer, critic and academic. She is Professor of Modern and Contemporary Art at the University of California, Berkeley.

Bryan-Wilson has published widely with a focus on post-war art in the US, Latin America and Europe, feminism and queer theory, performance, collaborative practice and theories of artistic labour.

Her criticism has appeared in numerous journals and magazines internationally, including *Afterall*, *Art Journal*, *Artforum*, *frieze*, *October* and *Parkett*. She is the editor of *OCTOBER Files: Robert Morris* (2013), and the author of *Art Workers: Radical Practice in the Vietnam War Era* (2009) and *Fray: Art and Textile Politics* (2017).

526 BIOGRAPHIES

ROGER CARDINAL is a writer and

curator. He is Emeritus Professor of Literary and Visual Studies at the University of Kent.

Credited with introducing the term 'outsider art', Cardinal has written widely on individual outsider artists and on architecture, prison art, autistic art and memory painting.

His publications include the influential *Outsider Art* (1972), the first English-language book on the subject, *Primitive Painters* (1978), *Figures of Reality* (1981), *Expressionism* (1986) and *Raw Creation: Outsider Art and Beyond* (2000). He has contributed essays to numerous art publications including *Inner Worlds Outside* (2006), *Kurt Schwitters: A Journey Through Art* (2010) and *The Alternative Guide to the Universe* (2013).

He is a contributing editor of *Raw Vision* magazine, and co-editor, with John Elsner, of *The Cultures of Collecting: Critical Views* (1994).

LYNNE COOKE is Senior Curator for

Special Projects in Modern Art at the National Gallery of Art, Washington, D.C.

Previously, she served as Chief Curator and Deputy Director of the Museo Nacional Centro de Arte Reina Sofía in Madrid (2008–12) and as Curator at Dia Art Foundation (1991–2008), where she organised monographic exhibitions on Jo Baer, Robert Irwin, Blinky Palermo and Bridget Riley, among others. She co-curated the 1986 Venice Biennale, the Carnegie International in 1991, and was Artistic Director of the 10th Biennale of Sydney in 1996.

Cooke has contributed numerous essays on the work of artists including Francis Alÿs, Alighiero Boetti, Joseph Beuys, Ann Hamilton, Roni Horn, On Kawara, Zoe Leonard, Sol Lewitt, Agnes Martin, Gerhard Richter and Rosemarie Trockel. Recently, she has published on self-taught artists, such as James Castle and Martín Ramírez. She has also written regularly for *Artforum*, *The Burlington Magazine* and *Parkett*.

ERIK DAVIS is an American writer, scholar

and journalist.

He is the author of several books, including *TechGnosis: Myth, Magic, and Mysticism in the Age of Information* (1998), *The Visionary State: A Journey through California's Spiritual Landscape* (2006) and *Nomad Codes: Adventures in Modern Esoterica* (2010).

His articles about art, music, technoculture and contemporary spirituality have appeared in a wide range of periodicals including *Bookforum*, *Arthur*, *Artforum*, *Slate*, *Salon*, *Gnosis*, *Rolling Stone*, *LA Weekly*, *Spin*, *Wired* and *Village Voice*.

Since 2010, he has hosted the podcast *Expanding Mind*, in which he explores the culture of consciousness, from magic and spirituality to psychology and technology.

TACITA DEAN is an artist working primarily

in film, but also in other mediums including drawing and photography. She studied at Falmouth School of Art (1985–88) and the Slade School of Fine Art, London (1990–92).

Solo exhibitions of Dean's work have been organised at the Tate Gallery (1996) and Tate Britain, London (1998 and 2001), Museum für Gegenwartskunst, Basel (2000), Hirshhorn Museum and Sculpture Garden, Washington, D.C. (2001), Musée d'Art Moderne de la Ville de Paris (2003), Schaulager, Basel (2006), the Solomon R. Guggenheim Museum, New York (2007), Dia: Beacon, New York (2008), Nicola Trussardi Foundation, Milan (2009), MUMOK, Vienna (2011), New Museum, New York (2012), Instituto Moreira Salles, Rio de Janeiro (2013), Fundación Botín, Santander (2013) and Museo Tamayo, Mexico City (2016).

Dean was nominated for the Turner Prize in 1998, and has been awarded the Hugo Boss Prize (2006) and the Kurt Schwitters Prize (2009), among others. She was artist in residence at The Getty Research Institute in Los Angeles (2014–15).

GEOFF DYER is a British writer, and a

Fellow of the Royal Society of Literature since 2005. He is currently Writer in Residence at the University of Southern California, Los Angeles.

His non-fiction includes *But Beautiful: A Book about Jazz* (1991), which won the Somerset Maugham Prize; *The Ongoing Moment* (2005), an idiosyncratic history of photography; and the essay collection *Otherwise Known as the Human Condition* (2011), which won the National Book Critics Circle Award for Criticism.

Dyer is the author of four novels: *The Colour of Memory* (1989), *The Search* (1993), *Paris Trance* (1999) and *Jeff in Venice, Death in Varanasi* (2009). He is also the editor of *John Berger: Selected Essays* (2001), and co-editor, with Margaret Sartor, of *What Was True: The Photographs and Notebooks of William Gedney* (2000).

His awards include the E.M. Forster Award from the American Academy of Arts and Letters, the International Center of Photography Infinity Award for writing on photography and, most recently, the Windham-Campbell Award for non-fiction.

DAVE EGGERS is an American writer,

editor and publisher, and a member of the American Academy of Arts and Letters.

He is the author of numerous books, including *The Circle* (2013); *Heroes of the Frontier* (2016), longlisted for the Dublin International Literary Award; *A Hologram for the King* (2012), a finalist for the National Book Award; and *What Is the What: The Autobiography of Valentino Achak Deng* (2006), a finalist for the National Book Critics Circle Award and winner of France's Prix Médicis étranger and the Dayton Literary Peace Prize.

His non-fiction and journalism has appeared in the *Guardian*, the *New Yorker*, the *Best American Travel Writing* and the *Best American Essays*.

Eggers is the founder of McSweeney's, the publishing company that distributes the *Voice of Witness* book series, which uses oral history to illuminate human rights crises around the world.

ADRIAN FORTY is Emeritus Professor

of Architectural History at The Bartlett School of Architecture, University College London, where he was the founder and director of the Master's programme in Architectural History.

Forty's main interest has been in architecture's social role. His research has ranged from the design of consumer goods, to verbal language in architecture, architecture and collective memory, and the 'material turn' in architecture.

He is the author of the influential *Objects of Desire: Design and Society since 1750* (1986), *Words and Buildings: A Vocabulary of Modern Architecture* (2000) and, more recently, *Concrete and Culture: A Material History* (2012).

In 2003, Forty was awarded the Sir Misha Black Award for Innovation in Design Education. He was President of the European Architectural History Network (EAHN) between 2010 and 2014.

MICHAEL FRIED is a poet, and an art

and literary critic and historian. He is currently the J.R. Herbert Boone Emeritus Professor of Humanities and Art History at the Johns Hopkins University, Baltimore.

Fried has been a highly influential voice in the debate over the origins and development of modernism, and has written extensively about minimalism, abstract painting and sculpture since the Second World War. He has also written about eighteenth- and nineteenth-century painting, and more recently on contemporary photography. His books include *Absorption and Theatricality: Painting and Beholder in the Age of Diderot* (1980), *Art and Objecthood: Essays and Reviews* (1998), *Why Photography Matters More Than Ever Before* (2008) and *Four Honest Outlaws: Sala, Ray, Marioni, Gordon* (2011).

Fried was awarded a Guggenheim Fellowship in 1973, and presented the Christian Gauss Seminars in Criticism at Princeton in 1975. In 2002, he delivered the Andrew Mellon Lectures in the Visual Arts at the National Gallery of Art in Washington, D.C.

KENNETH GOLDSMITH is an

American poet and critic. He is the Founding Editor of UbuWeb, an online resource for avant-garde poetry and media, and Senior Editor of PennSound, the online poetry archive at the University of Pennsylvania, where he teaches.

He has published ten books of poetry, among them *Fidget* (2000), *Soliloquy* (2001), *Day* (2003) and his American trilogy: *The Weather* (2005), *Traffic* (2007) and *Sports* (2008).

He is the author of a book of essays, *Uncreative Writing: Managing Language in the Digital Age* (2011), editor of *I'll Be Your Mirror: The Selected*

Andy Warhol Interviews (2004) and co-editor of *Against Expression: An Anthology of Conceptual Writing* (2011).

In 2011, Documenta 13 published Goldsmith's book *Letter to Bettina Funcke* as part of its *100 Notes – 100 Thoughts* series. In 2013, he was appointed the Museum of Modern Art's first Poet Laureate.

STUART HALL was a Jamaican-born

cultural theorist, political activist and sociologist. He was elected Fellow of the British Academy in 2005.

Hall played a pivotal role in the development of cultural studies in the UK and is widely known as the 'godfather of multiculturalism'. He was invited to join the Centre for Contemporary Cultural Studies at the University of Birmingham on the strength of his book *The Popular Arts* (1964, co-authored with Paddy Whannel). In 1968 he became Director of the Centre, where he stayed until 1979.

Founding Editor of the *New Left Review*, Hall wrote many influential articles including 'Situating Marx: Evaluations and Departures' (1972) and 'Encoding and Decoding in the Television Discourse' (1973). He is the author of *The Hard Road to Renewal: Thatcherism and the Crisis of the Left* (1988), and editor of *Formations of Modernity* (1992), *Questions of Cultural Identity* (1996) and *Cultural Representations and Signifying Practices* (1997).

Hall's posthumous memoir, *Familiar Stranger: A Life between Two Islands*, was published in 2017.

MARK HAWORTH-BOOTH is an

Honorary Research Fellow at the Victoria and Albert Museum (V&A), London and a Senior Fellow of the Royal College of Art (RCA), London.

Haworth-Booth was Senior Curator of Photographs at the V&A from 1970 to 2004, during which time he helped to build the museum's photography collection. He curated many exhibitions there, including *Photography: An Independent Art. Photographs from the Victoria and Albert Museum, 1839–1996* (1997) and *Things: A Spectrum of Photography, 1850–2001* (2004). In 2010 he curated *Camille Silvy: Photographer of Modern Life, 1834–1910*, a centenary retrospective of the pioneering photographer, produced by Jeu de Paume, Paris, and the National Portrait Gallery, London. He has published widely, contributing to major monographs on Lewis Baltz, Bill Brandt, Donald McCullin, Lee Miller and Curtis Moffat.

Haworth-Booth acted as a consultant on the BBC television series *The Genius of Photography* (2007) and was the first Visiting Professor of Photography at the University of the Arts London (2002–09).

MARTIN HERBERT is a writer and critic.

His critical writing appears regularly in art journals including *Artforum*, *frieze*, *Art Monthly* and *ArtReview*, where he is Associate Editor.

Herbert has contributed essays to numerous exhibition catalogues for, among others, the Museum of Modern Art, New York, and Tate Britain, Tate Modern, Hayward Gallery and the Serpentine Gallery, London. He is the author of *Mark Wallinger* (2011), *The Uncertainty Principle* (2014) and *Tell Them I Said No* (2016), and he is currently working on a book about the American artist Carol Bove. He lectures regularly in international art schools and was on the jury for the 2017 Turner Prize.

MATTHEW HIGGS is an artist, curator,
publisher and writer. Since 2004, he has been Director and Chief Curator of White Columns, New York's oldest alternative art space.

In 1993, Higgs founded his own press, Imprint 93, publishing a series of artists' editions and multiples, which included the work of Billy Childish, Martin Creed, Jeremy Deller, Peter Doig, Ceal Floyer, Hilary Lloyd, Paul Noble, Chris Ofili, Elizabeth Peyton, Bob and Roberta Smith, Jessica Voorsanger and Stephen Willats, among others.

He has curated many exhibitions over the past three decades, including *Protest and Survive*, with Paul Noble (Whitechapel Gallery, London, 2000) and *True Faith*, with Jon Savage and John Kugelberg (Manchester Art Gallery, 2017).

Higgs is also a prolific writer and editor, having contributed essays and interviews to numerous publications, exhibition catalogues and magazines including *Artforum*, *frieze*, *Afterall* and *Art Monthly*.

CHRISSIE ILES is the Anne and Joel
Ehrenkranz Curator at the Whitney Museum of American Art, New York. She is an adjunct professor at Columbia University, New York, and a member of the Graduate Committee at the Center for Curatorial Studies at Bard College.

Iles's curatorial practice focuses on the work of emerging artists and current issues in contemporary art, and the intersection of these with other periods in recent art history. She co-curated the 2004 and 2006 Whitney Biennials, and has curated a number of influential thematic exhibitions on the moving image, including *Into the Light: The Projected Image in American Art 1964–1977* (2001) and *Dreamlands: Immersive Cinema and Art 1905–2016* (2016), both at the Whitney Museum of American Art, New York.

She has written extensively on the work of contemporary artists and moving image from the 1960s and 1970s, including essays on Dora Budor, Ian Cheng, Anne Collier, Bruce Conner, Dan Graham, Robert Morris, Philippe Parreno and Hito Steyerl.

LEON KOSSOFF is a figurative painter.
Born in London to immigrant parents from Ukraine, he studied at Saint Martin's School of Art (1949–53) and the Royal College of Art (1953–56).

Kossoff and Frank Auerbach first met when they were students at Saint Martin's. They attended together David Bomberg's evening classes at the Borough Polytechnic and they worked in parallel in the early 1950s, painting building sites in post-war London. The city has remained a major subject in the work of both painters.

Kossoff has had major solo exhibitions at the Whitechapel Gallery, London (1972), Museum of Modern Art, Oxford (1981), Tate Gallery, London (1996), Louisiana Museum of Modern Art, Humlebaek, Denmark (2004) and the National Gallery, London (2007). He represented Great Britain in the 1995 Venice Biennale.

JAMES LINGWOOD is Co-Director
of Artangel. Among over 100 projects produced by Artangel since the early 1990s are *Rachel Whiteread: House* (1993–94), *Michael Landy: Break Down* (2001), *Jeremy Deller: The Battle of Orgreave* (2001), *Roger Hiorns: Seizure* (2008), *Inside: Artists and Writers in Reading Prison* (2016) and long-term projects with Roni Horn, Cristina Iglesias and Mike Kelley.

Lingwood has curated numerous exhibitions for international museums including surveys of the work of Bernd and Hilla Becher, Susan Hiller, Juan Muñoz, Thomas Schütte, Robert Smithson and Thomas Struth. At Hayward Gallery he curated, with Martin Caiger-Smith, *The Epic and the Everyday* (1994) and, with Fiona Bradley, *Douglas Gordon: What Have I Done* (2002). Most recently he has curated *Richard Hamilton: Serial Obsessions* (National Museum of Modern and Contemporary Art, Seoul, 2017) and *Luigi Ghirri: The Map and The Territory* (Folkwang Museum, Essen; Museo Nacional Centro de Arte Reina Sofía, Madrid; Jeu de Paume, Paris, 2018).

He has contributed essays to exhibition catalogues, including *Staging the Self: Self-Portrait Photography 1840s–1980s* (1986), *Thomas Struth: Photographs 1978–2010* (2010), *The Human Factor* (2014) and *Juan Muñoz: Double Bind & Around* (2015).

LUCY LIPPARD is an art writer, activist
and occasional curator.

She began writing criticism in 1964 and has since published 24 books, including *Six Years: The Dematerialization of the Art Object from 1966 to 1972* (1973), *From the Center: Feminist Essays on Women's Art* (1976), *Mixed Blessings: New Art in a Multicultural America* (1990), *The Lure of the Local: Senses of Place in a Multicentered Society* (1997) and *Undermining: A Wild Ride through Land Use, Politics and Art in the Changing West* (2014). She has also written extensively on the history and archaeology of the region where she lives in Galisteo, New Mexico.

MARCO LIVINGSTONE is an art
historian, writer and independent curator.

Livingstone has curated pop art exhibitions throughout Europe, Japan and Canada as well as numerous touring retrospectives devoted to the work of Jim Dine, David Hockney, Allen Jones,

R.B. Kitaj, Peter Phillips, Paula Rego, George Segal and Tom Wesselmann. He curated Patrick Caulfield's first retrospective exhibition, which opened at the Walker Art Gallery, Liverpool (1981), touring subsequently to the Tate Gallery, London.

His many publications include *David Hockney* (1981), the first monograph on the artist's work, tracing his career from the early 1960s to the 1980s; *Kitaj* (1985), a major monograph based on a series of interviews and letters between the artist and the author; *Pop Art: A Continuing History* (1990), a comprehensive international survey of pop art and its legacy; and *Peter Blake: One Man Show* (2009), an extensive study examining Blake's work across all mediums.

His substantial monograph *Patrick Caulfield: Paintings* (2005) was published shortly before the artist's death.

RICK MOODY is a novelist and short story writer.

Moody has published numerous books including *Garden Estate* (1992), *The Ice Storm* (1994), *Purple America* (1997), *On Celestial Music: And Other Adventures in Listening* (2012) and *Hotels of North America* (2015). He is also the author of a short story and novella collection, *The Ring of Brightest Angels Around Heaven* (1995) and the story collection *Demonology* (2001). With Darcey Steinke he co-edited *Joyful Noise: The New Testament Revisited* (1997), an omnibus of essays by various writers regarding faith and spirituality.

He has contributed fiction and essays to many major publications, including *The New Yorker*, *Harper's* magazine, the *New York Times* and *Esquire*.

He has won the Paris Review Aga Khan Prize (1994) and a Guggenheim Fellowship (2000). His memoir, *The Black Veil*, won the PEN/Martha Albrand Award in 2002.

SIMON NJAMI is a curator, writer and art critic. He is Director of AtWork, an itinerant educational project conceived to stimulate critical thinking through the creative process. He is also Artistic Director of the Donwahi Foundation, Abidjan, Côte d'Ivoire.

Njami has curated many pioneering exhibitions showcasing African contemporary artists on the international stage. He was Artistic Director of the Bamako Photography Biennale (2001–10) and co-curated the first African Pavilion at the 52nd Venice Biennale (2007). More recently he curated *The Divine Comedy: Heaven, Purgatory and Hell Revisited by Contemporary African Artists* (MMK Museum für Moderne Kunst, Frankfurt am Main; The SCAD Museum of Art, Savannah, Georgia; Smithsonian National Museum of African Art, Washington, D.C., 2014).

Previously, Njami was Co-Founder and Editor-in-Chief of the Paris-based journal *Revue Noire*. He was Artistic Director of Off Biennale (Cairo, 2015) and the Dak'Art Biennale (Dakar, 2016 and 2018).

GRAYSON PERRY CBE is an artist working with traditional mediums, including ceramics, cast iron, bronze, printmaking and tapestry. He graduated in Fine Arts at Portsmouth Polytechnic (1982), and undertook pottery classes at the Central Institute (1983). He has been a Royal Academician since 2012.

His works reference his own childhood and life as a transvestite while also engaging with wider social issues from class and politics, sex and religion, to contemporary issues such as Brexit and divided Britain.

Perry has exhibited nationally and internationally, with solo exhibitions held at Stedelijk Museum, Amsterdam (2002), Barbican, London (2002), 21st Century Museum of Contemporary Art, Kanazawa, Japan (2007), Turner Contemporary, Margate (2015), Museum of Contemporary Art, Sydney (2015); Bonnefantenmuseum, Maastricht (2016), Serpentine Galleries, London and Arnolfini, Bristol (both in 2017).

In 2003 Perry won the Turner Prize and in 2013 he delivered the Reith Lectures. In 2015 he was appointed Trustee of the British Museum and is currently Chancellor of the University of the Arts, London.

RICHARD J. POWELL is the John Spencer Bassett Professor of Art and Art History at Duke University, Durham, North Carolina.

Along with teaching courses in American art, the arts of the African diaspora and contemporary visual studies, he has written extensively on topics ranging from primitivism to postmodernism, including *Homecoming: The Art and Life of William H. Johnson* (1991), *Black Art: A Cultural History* (1997) and *Cutting a Figure: Fashioning Black Portraiture* (2008).

Powell has curated several major exhibitions including *The Blues Aesthetic: Black Culture and Modernism* (Washington Project for the Arts, 1989), *To Conserve a Legacy: American Art at Historically Black Colleges and Universities* (Addison Gallery of American Art, Andover, Massachusetts, 1999), *Back to Black: Art, Cinema and the Racial Imaginary* (Whitechapel Gallery, London, and the New Art Gallery Walsall, 2005), and *Archibald Motley: Jazz Age Modernist* (Nasher Museum of Art, Duke University, 2014).

JANE RENDELL is a writer, art critic, architectural historian and designer. She is Director of Architectural History and Theory at the Bartlett School of Architecture, where she is also Professor of Architecture and Art.

Rendell's writing explores interdisciplinary intersections between architecture, art, feminism and psychoanalysis. She is author of *The Pursuit of Pleasure* (2002), *Art and Architecture* (2006), and *Site-Writing: The Architecture of Art Criticism* (2010). She is co-editor of *Strangely Familiar* (1999), *Gender, Space, Architecture* (1999), *Intersections* (2000), *The Unknown City* (2001), *Spatial Imagination* (2005), *Critical Architecture* (2007) and *Pattern* (2007).

Rendell has taught at Chelsea College of Art and Design, Winchester School of Art and the University of Nottingham. She has been based at the Bartlett School of Architecture since 2000, where she was formerly Director of Architectural Research (2004–10) and Vice-Dean of Research (2010–13).

BRIDGET RILEY is a British painter.

She studied at Goldsmiths College, London (1949–52) and the Royal College of Art, London (1952–55).

Solo exhibitions of Riley's work have been organised at the Museum of Modern Art, New York (1966), accompanied by a US tour, Hayward Gallery (1971, 1992), Kunsthalle Nuremberg (1992), the Dia Center for the Arts, New York (2000), Tate Britain, London (2003), Musée d'Art Moderne de la Ville de Paris (2008) and the National Gallery, London (2010), among others.

She is also a highly perceptive writer on art. In 2009 her collected essays and interviews were published in *The Eye's Mind: Bridget Riley, Collected Writings 1965–2009*.

Riley has participated in numerous international group exhibitions including *The Responsive Eye* (Museum of Modern Art, New York, 1965), Documenta 4 (1968) and Documenta 6 (1977). She represented Great Britain in the 1968 Venice Biennale, where she was the first British contemporary painter, and the first woman, to be awarded the International Prize for Painting.

BRYAN ROBERTSON was a curator,

art gallery director and critic.

Director of the Whitechapel Gallery, London, from 1952 until 1968, Robertson transformed the gallery's profile, placing public education at its heart.

In 1956 he organised the seminal exhibition *This Is Tomorrow*, featuring artists associated with the Independent Group, such as Eduardo Paolozzi and Richard Hamilton. In the 1960s, Robertson curated two highly successful exhibitions of emerging British artists. *The New Generation: 1964* included paintings by Derek Boshier, David Hockney, John Hoyland and Bridget Riley. *The New Generation: 1965* showed the work of young sculptors, including Phillip King, Tim Scott and William Tucker. Robertson also curated the first British solo shows of Jackson Pollock (1958), Mark Rothko (1961), Robert Rauschenberg (1964) and Franz Kline (1965).

As an independent curator, he later curated important retrospectives of Ceri Richards at the Tate Gallery (1981) and *Raoul Dufy* at Hayward Gallery (1983).

STEPHANIE ROSENTHAL is

Director of the Martin-Gropius-Bau, Berlin.

Previously, Rosenthal was Chief Curator at Hayward Gallery from 2007 to early 2018, where she curated group exhibitions such as *Walking in My Mind* (2009) and *Art of Change: New Directions in China* (2012), as well as major mid-career retrospectives of Lee Bul, Ana Mendieta, Robin Rhode, Pipilotti Rist and Dayanita Singh. In her previous position as Curator at the Haus der Kunst in Munich, she staged exhibitions with a focus on performative art, featuring the work of artists such as Allan Kaprow, Paul McCarthy and Christoph Schlingensief.

In 2016, Rosenthal served as Artistic Director of the 20th Biennale of Sydney.

RALPH RUGOFF is Director of Hayward

Gallery.

Rugoff began writing on art in the mid 1980s and curated his first show, *Just Pathetic*, in 1990. Previously Director of the Wattis Institute for Contemporary Art in San Francisco, since his appointment at Hayward Gallery in 2006, he has curated numerous group exhibitions including *The Painting of Modern Life: 1960s to Now* (2007), *Psycho Buildings: Artists Take On Architecture* (2008), *Invisible: Art about the Unseen 1957–2012* (2012) and *The Infinite Mix* (2016), as well as monographic shows on Ed Ruscha, George Condo, Tracey Emin, Jeremy Deller, Carsten Höller and Andreas Gursky. In 2015 he curated the 13th Lyon Biennale, and he will curate the 58th Venice Biennale in 2019.

Rugoff has contributed articles and essays to a range of monographic books, catalogues, newspapers and art periodicals. He is author of *Circus Americanus* (1995), a collection of essays on popular visual culture and architecture.

In 2005 he won the inaugural Ordway Prize for Criticism and Curating from the Penny McCall Foundation.

JOHN RUSSELL CBE was a critic and

art historian.

In 1950 Russell became the art critic for the *Sunday Times* in London, where he championed emerging British artists including Lucian Freud, David Hockney, Howard Hodgkin and Bridget Riley.

Russell also organised exhibitions devoted to Amedeo Modigliani (1964), Georges Rouault (1966) and Balthus (1968) at the Tate Gallery and, with Suzi Gablik, curated a survey of pop art at Hayward Gallery (1969).

In 1974, Russell joined the *New York Times* where he was Chief Art Critic from 1982 until 1990. He is the author of monographs on Francis Bacon, Max Ernst, Henry Moore and Georges Seurat, and the comprehensive *The Meanings of Modern Art* (1981).

Russell won the Frank Jewett Mather award for Art Criticism from the College Art Association (1979), the Mitchell Prize for Art Criticism (1984) and the US Art Critics Award in 2006.

ADRIAN SEARLE is Chief Art Critic at

the *Guardian* newspaper.

Trained as a painter, Searle began writing art criticism in 1976 for *Artscribe* magazine. He has contributed articles to many art magazines, such as

Artforum, Parkett and *frieze*, and currently writes for *Fallon's Angler*. Searle has also contributed to publications including *Peter Doig* (2007) and *ON&BY: Luc Tuymans* (2013), and is the editor of *Juan Muñoz Writings* (2009).

Searle has also curated several exhibitions including *Unbound: Possibilities in Painting* (Hayward Gallery, 1994), *Lucia Nogueira* (Serralves Museum, Porto, 2007), *Julião Sarmento* (La Casa Encendida, Madrid, 2011), and two exhibitions of the work of Juan Muñoz (Marian Goodman Gallery, New York, 2006, and Frith Street Gallery, London, 2012).

He was a Turner Prize juror in 2004, and juror for the Schwitters Award, Hanover (2009–13). He has taught at numerous art schools in the UK and Europe.

WILL SELF is a novelist, journalist, broadcaster and academic.

ANNE SEYMOUR is an art historian and collector of modern and contemporary art.

A former curator at the Tate Gallery, Seymour was an early supporter of conceptual art, championing the work of artists including Art & Language, Gilbert & George, Richard Long and Bruce McLean. At Hayward Gallery, Seymour curated *The New Art* (1972) and *Richard Long: Walking in Circles* (1991).

She has contributed essays to numerous exhibition catalogues, including *Henry Moore to Gilbert & George: Modern British Art from the Tate Gallery* (1973), *Joseph Beuys: Drawings* (1983), *Anselm Kiefer: Watercolours 1970–1982* (1983) and *Beuys, Klein, Rothko: Transformation and Prophecy* (1991).

KAJA SILVERMAN is an art historian and critical theorist. She is currently the Keith L. and Katherine Sachs Professor of Contemporary Art at the University of Pennsylvania.

Silverman is the author of numerous books, including *The Subject of Semiotics* (1983), *The Acoustic Mirror: The Female Voice in Psychoanalysis and Cinema* (1988), *Male Subjectivity at the Margins* (1992), *Speaking About Godard* (1998, with Harun Farocki), *Flesh of My Flesh* (2009), and *The Miracle of Analogy, or The History of Photography, Part 1* (2015), a three-part revisionary history and theory of photography.

She was awarded a Guggenheim Fellowship in 2008, and a Distinguished Achievement Award by the Andrew H. Mellon Foundation in 2011.

ALI SMITH is an author, playwright, academic and journalist. Since 2007 she has been a Fellow of the Royal Society of Literature.

Smith is the author of nine novels, including *Hotel World* (2001) and *The Accidental* (2005), both shortlisted for the Booker Prize and the Orange Prize. Her 2014 novel *How to Be Both* won the Baileys Prize,

the Goldsmiths Prize and the Costa Novel Award, and was shortlisted for the Man Booker and the Folio Prize.

She has also published a series of short story collections, including *Free Love and Other Stories* (1995), which won the Saltire Society First Book of the Year Award and Scottish Arts Council Book Award, as well as a re-telling of the myth of Antigone for young children (*The Story of Antigone*, 2015).

She writes regularly for the *Guardian*, the *Scotsman* and the *Times Literary Supplement*.

DAVID SYLVESTER was an art critic and curator.

An influential figure in promoting modernism in Britain, Sylvester started writing for *Tribune* magazine in 1942. He was introduced to the work of Henry Moore, Graham Sutherland and a younger generation of London artists, including Lucian Freud and Francis Bacon. In 1945 he started working at Moore's studio, curating his first exhibition of work by the artist in 1951 (Tate Gallery, London), and writing his first book on the sculptor in 1968.

From the 1950s he became a personal friend of Francis Bacon. In 1975 their collected conversations on art were published as *Interviews with Francis Bacon*, recognised as an important document of the post-war period.

Sylvester curated several landmark exhibitions at Hayward Gallery, including *Miró Bronzes* (1972), *The Eastern Carpet and the Western World* (1983) and, with Sarah Whitfield, *Magritte* (1992). He also helped to select works for Hayward Gallery's opening exhibition *Matisse 1869–1954* (1968), was chairman of the organising committee for *Dada and Surrealism Reviewed* (1978), and was involved in the installation of *The Impressionists in London* (1973), *Edward Hopper 1882–1967* (1981), *Howard Hodgkin: Paintings* (1997), *The Drawings of Jasper Johns* (1991) and *Lucio Fontana* (2000), among others.

In 1993 Sylvester curated a show of Bacon's paintings for the Venice Biennale, which granted him the Golden Lion, the first time it had been given to a critic rather than an artist.

His other books include the acclaimed volume of essays *About Modern Art* (1996), the collections of conversations *Interviews with American Artists* (2001) and *London Recordings* (2003), and the short account of his early life, *Memoirs of a Pet Lamb* (2002).

JON THOMPSON was an artist, curator, writer and academic.

Thompson became Head of Fine Art at Goldsmiths College, London, in 1972. Subsequently he was appointed Principal of the School of Fine Art in 1973, and then Dean in 1980. His changes to the curriculum – which included abolishing the division between mediums – are credited with establishing Goldsmiths as a leading British art school and nurturing the generation of artists who became the Young British Artists (YBAs). Among his students were Damien Hirst, Gary Hume, Sarah Lucas, Steve McQueen and Mark Wallinger.

Among many other influential exhibitions, Thompson co-curated, with Barry Barker, *Falls the Shadow* (Hayward Gallery, 1986), which presented a range of significant European artists who were little known in Britain, including Lothar Baumgarten, Marcel Broodthaers, Rebecca Horn and Jannis Kounellis.

As an artist, his work moved from painting to conceptual photography and sculpture, and back to painting.

In 2006 Thompson published *How to Read a Modern Painting*. His collected writings were published in 2011.

DAVID TOOP is a composer, musician,
author and curator. He is Professor of Audio Culture and Improvisation at London College of Communication.

Toop has worked in many fields of sound art and music, including improvisation, sound installations, field recordings, pop music production and music for television, theatre and dance. In addition to *Sonic Boom* (Hayward Gallery, 2000), he has curated exhibitions such as *Playing John Cage* (Arnolfini, Bristol, 2005) and *Blow Up: Exploding Sound and Noise* (Flat Time House, London, 2010), and exhibited sound installations in Tokyo, Beijing and at the National Gallery, London.

Toop has written books on sound theory and music history, including *Rap Attack: African Jive to New York Hip Hop* (1984), *Ocean of Sound: Aether Talk, Ambient Sound and Imaginary Worlds* (1995) and *Sinister Resonance: The Mediumship of the Listener* (2010). The first of his two-volume book on free improvisation, *Into the Maelstrom: Improvisation, Music and the Dream of Freedom*, was published in 2016.

JAMES TURRELL is an American artist
working primarily with light and space. After a first degree in psychology,Turrell later enrolled on the Studio Art programme at University of California, Irvine (1966). He received a Master's in fine art from Claremont Graduate University (1973) and eight honorary doctorate degrees from various institutions.

Solo exhibitions have been held at the Stedelijk Museum, Amsterdam (1976), Whitney Museum of American Art, New York (1980), Israel Museum, Jerusalem (1982), Museum of Contemporary Art, Los Angeles (1984), MAK, Vienna (1998–99), and the National Gallery of Australia, Canberra (2015).

In 2013, four museums organised major retrospectives of his work: the Academy Art Museum, Easton, Maryland; Los Angeles County Museum of Art; Museum of Fine Arts, Houston; and Solomon R. Guggenheim Museum, New York.

Turrell has been working on *Roden Crater*, a major land art installation in northern Arizona, for over three decades.

ANTHONY VIDLER is Professor
of Architecture at the Irwin S. Chanin School of Architecture, The Cooper Union, New York and a Fellow of the American Academy of Arts and Sciences.

Exploring the history, theory and criticism of modern architecture and urbanism, Vidler's books include *The Writing of the Walls: Architectural Theory in the Late Enlightenment* (1987), *Claude-Nicolas Ledoux: Architecture and Social Reform at the End of the Ancien Régime* (1990), *The Architectural Uncanny: Essays in the Modern Unhomely* (1992), *Warped Space: Architecture and Anxiety in Modern Culture* (2000) and *The Scenes of the Street and Other Essays* (2011).

Vidler was a Getty Scholar at the Getty Center for the History of Art and the Humanities (1992–93) and a Senior Mellon Fellow at the Canadian Centre of Architecture, Montreal (2005). He received the architecture award from the American Academy of Arts and Letters in 2011.

ANNE WAGNER is an art historian, critic
and lecturer.

She is the author of several books including *Jean-Baptiste Carpeaux: Sculptor of the Second Empire* (1986), *Three Artists (Three Women): Modernism and the Art of Hesse, Krasner, and O'Keeffe* (1996), *Mother Stone: The Vitality of Modern British Sculpture* (2005) and *A House Divided: On Recent American Art* (2012). Her writing has appeared in *Art History, Sculpture Journal, October, London Review of Books* and *Artforum*.

Wagner was appointed The Henry Moore Foundation Research Curator at Tate Britain (2010–11), and was Visiting Professor at the Courtauld Institute of Art (2013–14), Visiting Distinguished Professor at the University of York (2010–13) and Mellon Residential Fellow in Arts Practice and Scholarship at the Richard and Mary L. Gray Center for the Arts and Inquiry at the University of Chicago (2012). With T.J. Clark, she curated *Lowry and the Painting of Modern Life* (Tate Britain, London, 2013) and *Pity and Terror: Picasso's Path to Guernica* (Museo Nacional Centro de Arte Reina Sofía, Madrid, 2017).

MARINA WARNER is a novelist, critic,
curator and cultural historian. She is a Professor of English and Creative Writing at Birkbeck College, University of London, a Professorial Research Fellow at the School of Oriental and African Studies (SOAS), London and in 2017 was elected President of the Royal Society of Literature.

Warner is the author of novels and children's books as well as non-fiction titles including *From the Beast to the Blonde: On Fairy Tales and Their Tellers* (1994), *Phantasmagoria: Spirit Visions, Metaphors, and Media* (2006), *Stranger Magic: Charmed States and the Arabian Nights* (2011) and *Once Upon a Time: A Short History of Fairy Tale* (2014).

She has curated exhibitions including *The Inner Eye: Art Beyond the Visible* (Hayward Touring, 1996), *Metamorphing: Transformations in Science, Art and Mythology* (Science Museum, London, 2002) and *Only Make-Believe: Ways of Playing* (Compton Verney Art Gallery, 2005).

A collection of her essays, *Forms of Enchantment: Writings on Art and Artists (1988–2017)*, will be published in 2018.

PETER WOLLEN is a film theorist and
filmmaker.

His early influential text *Signs and Meaning in the
Cinema* – originally published in 1969, with substantially
new editions in 1972, 1998 and 2013 – transformed
the discipline of film studies by incorporating the
methodologies of structuralism and semiotics.

Wollen co-wrote, with Mark Peploe, the screenplay
for Michelangelo Antonioni's *The Passenger* (1975)
and subsequently made five experimental feature
films in collaboration with Laura Mulvey, including
Riddles of the Sphinx (1977), and one solo feature,
Friendship's Death (1987).

Wollen took part in organising a number of art
exhibitions, including *Frida Kahlo and Tina Modotti*
(Whitechapel Gallery, London, 1982) and *On the
Passage of a Few People Through a Brief Moment in
Time: The Situationist International 1957–72* (Musée
National d'Art Moderne, Centre Georges Pompidou,
Paris; ICA, London; ICA, Boston, 1989). He contributed
essays to numerous exhibition catalogues, including
The Scene of the Crime (1997), as well as writing on
many topics for the *London Review of Books*.

NOTES

MICHAEL FRIED ON ANTHONY CARO
1. See the introductory essay for
Caro's exhibition at the Whitechapel
Gallery in September and October 1963.
Reprinted in *Art International*, Vll/7,
25 September 1963
2. Clement Greenberg, 'Anthony Caro',
in *Arts Yearbook*, No. 8, 1965, p. 106
3. Ibid.
4. Ibid.
5. For a discussion of theatricality in
relation to literalness, objecthood and
related concepts in the context of recent
modernist painting and sculpture, see
Michael Fried, 'Art and Objecthood', in
Artforum, Summer 1967
6. Robert Morris, 'Notes on Sculpture,
Part II', in *Artforum*, October 1966

ANNE SEYMOUR ON BRITISH CONCEPTUAL ART
Some of the quotations in this text come
from a day's conversation with Richard
Long in the summer of 1990.

DORE ASHTON ON AGNES MARTIN
1. Dore Ashton, 'Drawn from Nature',
in *New York Times*, 29 January 1959
2. Lin Yutang, *The Chinese Theory of
Art* (London, 1961), p. 63
3. Agnes Martin, notes given to the
Philadelphia Institute of Contemporary
Art, 1972
4. Paul Klee, *The Thinking Eye*
(London, 1961)
5. Lawrence Alloway, 'Introduction' to
Agnes Martin exh. cat., Philadelphia
Institute of Contemporary Art, January–
March 1973
6. Octavio Paz, *Children of the Mitre*
(Cambridge, MA, 1974), p. 67

LUCY LIPPARD ON GENDER AND CONTEMPORARY ART
1. A term used directly and indirectly
by Caroline Tisdall, Richard Cork and
Paul Overy and disputed by various
letters to the editors of their respective
papers.
2. From a statement by the selectors of
the 1978 Hayward Annual, as are other
quotations below.
3. *Women Artists: 1550–1950* was
accompanied by an extensive catalogue
and travelled to other US museums.
4. A cliché I will risk belabouring
with some of the British statistics
compiled by the selectors of *HAII:
British Sculpture, out of the Sixties*
at the ICA, 1970, 15 men, 1 woman;
Kinetics at Hayward Gallery 1971, 64
men, 3 women; *The New Art* at Hayward
Gallery, 1972, 15 men, 0 women; *British
Sculpture '72* at the Royal Academy,
24 men, 0 women; *Arte d'Oggi*, Milan,
1976, 45 men, 2 women; *The Condition*

of Sculpture at Hayward Gallery, 1975,
36 men, 4 women. Barbara Hepworth
had a one-artist show at the Tate over
a decade ago; no women have received
personal shows there since. Bridget
Riley had a one-artist show at the
Hayward in 1971.
5. The Whitney now holds a biennial
which is no longer attempting to be
representative of art being made across
the country.

**MARK HAWORTH-BOOTH ON
DAVID HOCKNEY'S PHOTOGRAPHY**
The first two epigraphs are from Marco
Livingstone's invaluable book on Hockney
published in 1981. The quotation from
Proust is taken from Roger Shattuck's
*Proust's Binoculars: A Study of Memory,
Time and Recognition in À la Recherche
du Temps Perdu* (New York, 1963) as
are, of course, the quotations later in
the introduction. 'Notes on Photography'
by Lady Eastlake and Jabez Hughes
are published in Beaumont Newhall's
Photography: Essays and Images
(New York, 1980).
 The best companion-guide to
the recent photographs is the book
Hockney Paints the Stage by Martin
Friedman, Stephen Spender, John Cox
and John Dexter (London, 1983). For
an assessment of Hockney's earlier
photography see Sally Eauclaire, *The
New Color Photography* (New York,
1981). *David Hockney Photographs*
(London/New York, 1982) was published
on the occasion of the Centre Georges
Pompidou exhibition.
 David Hockney, a South Bank Show
special presented by Melvyn Bragg
and directed by Don Featherstone,
contains Hockney's remarks on the
movies and television in relation to
his photo-collages and concludes with
a film 'joiner' by Hockney. Broadcast
13 November 1983 by London Weekend
Television.

ADRIAN FORTY ON LE CORBUSIER
1. Quoted in Reyner Banham, 'The Last
Formgiver', in *Architectural Review*,
Vol. 140, August 1966, p. 98, and also,
slightly differently, in Banham, *The New
Brutalism* (London, 1966), p. 86
2. Lionel Brett, 'The Space Machine',
in *Architectural Review*, Vol. 102,
November 1947
3. Sir Leslie Martin, 'An Architect's
Approach to Architecture', in *RIBA
Journal*, Vol. 74, May 1967
4. Sir Colin St John Wilson, 'The
Committed Architect', in *Society of
Architectural Historians' Journal*, Vol.
XXIV, No. 1, March 1965, p. 65

5. Ibid., p. 79
6. Peter and Alison Smithson, 'An
Urban Project', in *Architects' Year Book*,
No. 5, 1953
7. Peter and Alison Smithson, 'The
Built World – Urban Reidentification', in
Architectural Design, Vol. 25, June 1955
8. Peter and Alison Smithson, 'Cluster
City', in *Architectural Review*, Vol. 122
November 1957, p. 334
9. Smithson 1953
10. Alison Smithson (ed.), *The
Emergence of Team 10 out of CIAM*
(London, 1982), pp. 8–9
11. Smithson 1957, p. 366
12. On this aspect of English pop art
and the Smithsons's connection with
it, see Richard Morphet, *Richard
Hamilton*, exh. cat., Tate Gallery,
London, 1970, pp. 28–31, 48
13. For example in his speech accepting
the RIBA Gold Medal, reported in
The Architect's Journal, Vol. 117, 9 April
1953, p. 451
14. Smithson 1955
15. Alison Smithson 1982, pp. 58–59
16. Alison Smithson 1982, p. 87
17. James Gowan, 'Le Corbusier – His
Impact on Four Generations', in *RIBA
Journal*, Vol. 72, October 1965
18. James Stirling, 'Garches to Jaoul,
Le Corbusier as Domestic Architect in
1927 and 1953', in *Architectural Review*,
Vol. 118, September 1955
19. Ibid.
20. James Stirling, 'Ronchamp, Le
Corbusier's Chapel and the Crisis of
Rationalism', in *Architectural Review*,
Vol. 119, March 1956
21. Ibid.
22. See R.S. Haynes, 'Design and Image
in English Urban Housing 1945–1957',
MPhil. thesis, University College
London, 1976; Alexi F. Marmot,
'The Legacy of Le Corbusier and High
Rise Housing' in *Built Environment*,
Vol. 7, No. 2, 1981, pp. 82–95
23. LCC Architects' Department,
'Le Corbusier's Unité d'Habitation', in
Architectural Review, Vol. 109, May 1951
24. Reyner Banham, *Theory and
Design in the First Machine Age*
(London, 1960), pp. 329–30
25. Denys Hinton, letter, *The Architect's
Journal*, Vol. 142, 29 September 1965,
p. 721
26. The basis of this idea was presented
in the 'Introduction' of Charles Jencks,
Modern Movements in Architecture
(Harmondsworth, 1973) and developed
in his later writings
27. See for example the discussion of
Ronchamp by Edward Cullinan 'Nursed
by Experience', in Denys Lasdun (ed.),
*Architecture in an Age of Scepticism:
A Practitioners' Anthology* (New York,
1984), pp. 29–30

28. Sir John Summerson, 'Architecture, Painting and Le Corbusier', in *Heavenly Mansions and Other Essays on Architecture* (London, 1949), ch. 8; Sir John Summerson, 'Le Corbusier's Modulor', in *New Statesman*, Vol. 43, 23 February 1952; John Berger, 'The Only Machine for Living In', in *New Statesman*, Vol. 70, 8 October 1965

29. Conrad Jameson, 'Le Corbusier's Pessac: A Sociological Evaluation', in *Architectural Association Quarterly*, Vol. 4, No. 3, 1972. See also Martin Pawley, *Architecture Versus Housing* (London, 1971), pp. 89–91

30. *Building*, Vol. 223, 24 November 1972, p. 92

31. *Evening News*, 19 July 1976

32. See for example the various passages quoted by Anthony Sutcliffe in Russell Walden (ed.), *The Open Hand: Essays on Le Corbusier* (Cambridge, MA, 1977), pp. 232–33

33. Conrad Jameson, 'British Architecture: Thirty Wasted Years', in *Sunday Times Magazine*, 6 February 1977

34. Ibid.

35. Banham 1966, pp. 42, 132; and the review of it by Robin Middleton, 'The New Brutalism, or a Clean, Well-Lighted Place', in *Architectural Design*, Vol. 37, January 1967, p. 7

36. *Guardian*, 17 May 1986

37. Alice Coleman, *Utopia on Trial: Vision and Reality in Planned Housing* (London, 1985), p. 105

38. See Brian Anson, 'Don't Shoot the Graffiti Man', in *The Architect's Journal*, 2 July 1986, pp. 16–17; Bill Hiller, 'City of Alice's Dreams', in *The Architect's Journal*, 9 July 1986, pp. 39–41; Alice Coleman, 'Utopia Debate', in *The Architect's Journal* 6 August 1986, pp. 16–17; B. Heaven, 'Comeback on Coleman', in *The Architect's Journal*, 3 September 1986, pp. 32–33

LYNNE COOKE ON TONY CRAGG

1. See Interview with Lynne Cooke, p. 16

2. In philosophy the term materialism covers an ill-defined group of doctrines, central to which is the idea that whatever exists is either matter, or entirely dependent on matter for its existence. This notion of matter need not preclude developments in subatomic physics for matter can be seen as simply the basic stuff or raw material from which the diverse elements of the world are composed, that is, something analogous to the traditional craftsman's wood or clay.

3. The notion of science employed here is akin to Nelson Goodman's usage: 'The difference between art and science is not that between feeling and fact, intuit ion and inference, delight and deliberation, synthesis and analysis, passion and action, mediacy and immediacy, or truth and beauty, but rather a difference in domination of certain specific characteristics of symbols.' Nelson Goodman, *Languages of Art: An Approach to a Theory of Symbols* (Brighton, 1981 (1976)), p. 264

4. Cragg studied sciences at school, at the urging of his father, then spent a year as an assistant in a biochemistry laboratory. He maintains his interest in these fields by reading widely. A distinction should be drawn between Cragg's responses to the kinds of scientific information recently made available and that to which Moore and other artists of his age may have responded, perhaps through the intermediary of a book like D'Arcy Wentworth Thompson's seminal *On Growth and Form* (1917). In his study of the relationship between science and recent art Jack Burnham claims: 'In a very real sense *On Growth and Form* stands on the threshold between the world of natural forms which is still accessible to the sculptor, and that world of molecular bonds and protein chains completely out of his reach. Herbert Read and other essayists have repeatedly referred to Thompson's analysis of cellular formations, evolutionary form developments, tissue structure as a function of magnitude, the shaping of bones, differentials in growth rates, the mathematics of spiral growth, and the development of hollow three-dimensional bone trusses, so as to parallel the vitalist sculptor's forms with the products of nature...' D'Arcy Thompson has alluded (Thompson 1917, p. 10) to a morality implicit in natural forms. Very much like Louis Sullivan's dictum that all trees grow naturally, it recognises that man seeks and finds a positive moral position in the earth-born phenomena around him, as a kind of stabilising factor for his powers of cognition and creativity. This seems to be a fundamental reaction to the industrial age. Thompson also refers to the fact that the analysis of natural effects for the physicist constitutes just so many problems of a mechanical or mathematical nature, but, as to relationships of nature, '...it is on another plane of thought from the physicist's that we contemplate their intrinsic harmony and perfection and "see that they are good"'. Jack Burnham, *Beyond Modern Sculpture* (New York, 1982 (1968)), pp. 77, 100. No such separation exists in Cragg's thinking.

5. That there is but a single reference to astrology in Cragg's oeuvre to date is indicative of the materialist bias in his thinking; the lone work incorporated a meteor. When asked about astrology he replied that there was nothing to get a grip on.

6. Tony Cragg, unpublished interview with Rod Stoneman and Lewis Biggs, 1985

7. Although attentive to the distinctive qualities and character of plastic Cragg tried rigorously to avoid becoming identified with it or any other single material. It was only recently that he first read Roland Barthes's short essay on plastic which he admires, especially such passages as the following: '...until now imitation materials have always indicated pretension, they belonged to the world of appearances, nor of actual use [...] plastic [...] is a household material. It is the first magical substance which consents to be prosaic [...] And as an immediate consequence, the age-old function of nature is modified; it is no longer the Idea, the pure Substance to be regained or imitated; an artificial Matter, more bountiful than all the natural deposits, is about to replace her, and to determine the very invention of forms [...] The hierarchy of substances is abolished: a single one replaces them all: the whole world can be plasticized, and even life itself since, we are told, they are beginning to make plastic aortas.' Barthes's tongue-in-cheek enthusiasm has its counterpart in the insouciant brashness with which Cragg has at times presented this derided material. See Roland Barthes, 'Plastic', in *Mythologies* (London, 1985 (1973)), pp. 98–99

8. See, for example his exhibition in Limoges in 1982, with its diverse range of works in wood. Nonetheless, a certain degree of sympathy for this position is suggested by Cragg's emphasis on mediated images in his statement for Documenta 7: 'The images. Celluloid wildlife, video landscapes, photographic wars, Polaroid families, offset politics, quick change, something new on all channels. Always a choice of second-hand images. Reality can hardly keep up with its marketing image.' Reprinted in *Découpage/Collage: à propos de Tony Cragg* (Limoges, 1982), p. 24

9. Some of these recurrent image/objects include the bottle, in various forms, and a long series of permutations on the subject of wood/tree/leaves; images were inscribed on wooden surfaces, or cut out from wood, or elements were laid out on the ground in the appropriate shape, or made in the right colour (green) but from the 'wrong' material (plastic) etc.

10. Rudolf Arnheim, *Entropy in Art* (Los Angeles, 1971), pp. 1–3. I am grateful to Lewis Biggs for bringing this essay to my attention.

11. In his distaste for abstract theorising and in his emphasis on the eye as the primary tool for understanding and making thinking models of the world, Cragg has much in common with other artists who have been fascinated by science, amongst whom Leonardo is pre-eminent. In a lecture delivered in 1938 to a group of bio-chemists, the renowned art historian Fritz Saxl praised the Italian master for the singularity of his involvement at the same time that he acknowledged 'Leonardo's influence on science has not become as overwhelming as we should have expected. The explanation lies in the fact that he approached all problems with the eye, by way of the image, and in this approach scientists would not follow him.' Although Saxl affirmed that in modern science the mathematical model predominates, and quoted 'one of the great modern physicists' to the effect that 'It is much easier […] to establish exact physical laws if the senses are ignored and attention is concentrated on events outside the senses', he nonetheless concluded, 'The great thinkers of today are looking for a means of bridging the gap between the picturable world and the scientific model which can no longer be represented by pictures'. Fritz Saxl, 'Science and Art in the Renaissance', in *Last Lectures*, 1957, pp. 122, 124. Art in the form of 'thinking models' as conceived by Cragg may be one answer.
12. Quoted in *Sonsbeek 86, International Sculpture Exhibition* (Utrecht, 1986) p. 300
13. Quoted in 'Preconditions', in *Tony Cragg*, exh. cat., Kestner-Gesellschaft, Hannover, 20 December 1985–9 February 1986, p. 37
14. Quoted in 'Tony Cragg Talking about Axehead 1982', in *Tony Cragg's 'Axehead'*, Tate Gallery, London, 1984, p. 12
15. Quoted in catalogue for Documenta 7; reprinted in *Découpage/Collage*, 1982, p. 24
16. That for Cragg abstract values along with additional levels of meaning are incipient in the most mundane and ordinary artefacts may be gauged from the following statement: 'Furniture is an example of a group of several objects against which human scale becomes very dear: the scale in which human beings are in the world. Furniture exemplifies processes which in an elementary way make apparent the manner in which human beings modify their environment. Furniture is an extension of human beings and reflects their activities. Today we have developed high technology for the processing of minerals, wood

and other materials in order to change the world to accommodate ourselves. At the same time they reveal political values (King Arthur's Round Table), social functions (the 250 flying chairs in an aeroplane) and personal function (my table, my armchair and my bed). The vacant furniture betrays the user.' *Die sich Verselbständigenden Möbel, Objekte und Installationen von Künstlern*, exh. cat., Von der Heydt Museum Wuppertal, 24 March–30 April 1985 (artist's translation).
17. Quoted in *True et Troc: Leçon des Choses*, exh. cat., ARC, Musée d'Art Moderne de la Ville de Paris, 27 January–6 March 1983, p. 32
18. Karl R. Popper, *Objective Knowledge: An Evolutionary Approach* (Oxford, 1972 (1973)), p. 266
19. My italics. Quoted in Documenta 7 catalogue. Reprinted in *Découpage/Collage*, 1982, p. 24

GUY BRETT ON LATIN AMERICAN ART
1. I do not mean by this to deny the great and continuing significance of popular expression on the Latin American continent.
2. Quoted in José Balza, *Alejandro Otero* (Milan, 1977), p. 48
3. José Joaquín Brunner, 'Cultura y Sociedad en Chile', in *Chile Vive*, exh. cat., Círculo de Bellas Artes, Madrid, 1987
4. Jesús Soto, in conversation with the author, Caracas, May 1988
5. This description is not so true of Fontana, who was most conscious of the Futurist legacy, or of Camargo, at one time a student of Fontana's in Buenos Aires, who felt closer to Brancusi than to constructive or concrete artists.
6. There are more artists of significance than it is possible to discuss here: indeed the 'neo-concrete' movement in Latin America deserve an exhibition to themselves.
7. See Fontana's 'Manifesto Blanco' translated in *Art in Latin America: The Modern Era, 1820–1980*, exh. cat., South Bank Centre, London, 1989, pp. 331–34
8. Alejandro Otero, interview with Rachel Adler, in *Alejandro Otero, A Retrospective Exhibition*, exh. cat., University of Texas, Austin, 1975, p. 18
9. Lygia Clark, quoted in Lucia Rito, 'Sensação em dose dupla', in *Veja*, December 1986, p. 34
10. Lygia Clark, 'Writings', in *Signals: Newsbulletin of the Centre for the Advanced Creative Study*, London, Vol. 1, No. 7, April–May 1965, pp. 2–3
11. Haroldo de Campos, interview with Leonora de Barros, in *Lygia Clark e Hélio Oiticica* (Rio de Janeiro, 1986), p. 54

12. Ronaldo Brito 'A Ordem e a Loucura da Ordem', preface to *Sergio Camargo*, exh. cat., Museu de Arte Moderna do Rio de Janeiro, 1975
13. Mira Schendel, letter to the author, 24 November 1965
14. The phrase is Haroldo de Campos', from an unpublished poem written in homage to Mira Schendel, April 1966
15. Bertolt Brecht, 'Sur la Peinture Chinoise', in *Sur le Réalisme* (Paris, 1970), pp. 68–69
16. Quoted in Olivia Zuñiga, *Mathias Goeritz* (Mexico City, 1963)
17. To build the Guri Dam, two communities of Pemon Indians were forcibly removed from their land and relocated in new villages built by the government, an experience which has left them far from happy. Brazil has recently seen Indians protests against hydro-electric projects in the Amazon, saying they 'do not benefit local people, only business interests.'
18. Hélio Oiticica, *Aspiro ao Grande Labirinto* (Rio de Janeiro, 1986), p. 79

RASHEED ARAEEN ON THE OTHER STORY
1. Edward Said, 'Opponents, Audience, Constituencies and Community', in Hal Foster (ed.), *The Anti-Aesthetic: Essays on Postmodern Culture* (Port Townsend, WA, 1983), p. 158
2. Quoted in Partha Miller, *Much Maligned Monsters: A History of European Reactions to Indian Art* (Oxford, 1977), ch. IV
3. Ibid., ch. V
4. Hugh Honour and John Fleming, *A World History of Art* (London, 1984)
5. E.H. Gombrich, *The Story of Art* (Oxford, 1950)
6. See back cover of *Honour and Fleming* 1984
7. See *Magiciens de la Terre*, exh. cat., Centre Georges Pompidou, Paris, 1989; and the special edition of *Third Text*, No. 6, which includes all the articles from *Les Cahiers du Musée National d'Art Moderne*, and which was published to coincide with the exhibition, as well as *Third Text's* critique of the exhibition.
8. Abigail Solomon-Godeau, 'Going Native', in *Art in America* (The Global Issue), July 1989
9. Quoted in Jag Mohen, *Souza in the Forties* (New Delhi, 1983), p. 13
10. Senake Bandaranayake, 'Ivan Peries (Painting 1939–69): The Predicament of the Bourgeois Artist in the Societies of the Third World', in *Third Text*, No. 2, Winter 1987–88, p. 90
11. Quoted in K.G. Subramanyan, *Moving Focus: Essays on Indian Art* (New Delhi, 1978), p. 19

538 NOTES

12. Homi K. Bhabha, 'The Other Question', in *Screen*, Vol. 24, No. 6, November/December 1983
13. Quoted in Edwin Mullins, *Souza* (London, 1962)
14. W.G. Archer, 'Pictures from a Wider World', in *Sunday Telegraph*, 15 April 1962
15. Norbert Lynton, catalogue introduction to an exhibition of Iqbal Geoffrey, Alfred Brad Galleries, London, August 1962
16. It is interesting to note that Afro-Asian artists were ignored during Norbert Lynton's tenure as the Arts Council's Exhibitions Director in the 1970s, and when his book *The Story of Modern Art* came out in 1982 it comprised only white/European artists.
17. The Tate Gallery does not, for example, recognise the independent development of minimalist sculpture in Britain in the 1960s.

JON THOMPSON ON POST-MINIMALIST SCULPTURE

1. Rosalind E. Krauss, *Passages in Modern Sculpture* (New York, 1977)
2. See Lucy Lippard (ed.), *Art News*, September 1966
3. See Joseph Beuys in *Düsseldorf 1962–1987: Punt de Confluència*, exh. cat., Centre Cultural de la Fundació Caixa de Pensions, Barcelona, 1988
4. See Piero Gilardi, 'Foreword' to *Op Losse Schroeven*, exh. cat., Stedelijk Museum, Amsterdam, 1969
5. See Germano Celant, *Arte Povera* (Milan, 1969)
6. See Barbara Rose (ed.), 'Readings in American Art', in *Painting in America since 1900* (New York, 1968)
7. See Max Kozloff, 'American Panting During the Cold War' (1975), in Francis Frascina (ed.), *Pollock and After: The Critical Detail* (New York, 1985)
8. Harold Rosenberg, 'The American Action Painters', in *Art News*, December 1952
9. Kozloff 1975
10. Krauss 1977
11. Ibid.
12. Clement Greenberg, in *Partisan Review*, 1949. See Clement Greenberg, *The Collected Essays and Criticism, Vol. 2, Arrogant Purpose 1945–1949* (Chicago, 1986)
13. Clement Greenberg, *Modernist Painting*, 1965. See Frascina (ed.) 1985
14. Stephen W. Melville, *Philosophy Beside Itself: On Deconstruction and Modernism* (Minnesota, 1986)
15. Adrian Stokes, *Stones of Rimini* (1935); *Part II: 'Stones and Clay'*. See Lawrence Gowing (ed.), *The Critical Writings of Adrian Stokes* (London, 1978).
16. Adrian Stokes, 'Cézanne', 1947, in ibid.
17. One complete set of the 'Nu de Dos'

is in the permanent collection of the Tate Gallery.
18. Krauss 1977
19. Michael Fried, *Absorption and Theatricality: Painting and Beholder in the Age of Diderot* (California, 1980). The most pertinent essay, 'Art and Objecthood', was first published in *Artforum*, Vol. V, 1967
20. It is usual to list Richard Serra amongst the minimalists, but the way in which he uses material to evoke a strong sense of 'bodiliness' in the viewer would seem to set him apart from the other artists listed.
21. Fried 1967
22. Ibid.
23. Immanuel Kant, *Critique of Pure Reason*, 2nd edn., (London, 1933)
24. T.J. Clark, 'Arguments about Modernism: A Reply to Michael Fried', in *The Politics of Interpretation* (Chicago, 1983)
25. Ibid.
26. Melville 1986
27. Clark 1983
28. T.J. Clark, 'Clement Greenberg's Theory of Art', in *Critical Inquiry*, Vol. 4, 1982
29. Michael Fried, 'How Modernism Works: A Response to T.J. Clark', *Critical Inquiry*, Vol. 9, 1982
30. Umberto Eco, 'Openness, Information, Communication', in David Robey (ed.), *The Open Work* (London, 1989)
31. Eco, in Robey (ed.) 1989
32. Eco's first book on semiotics, *A Theory of Semiotics*, was published in 1976.
33. Introduction to Robey (ed.) 1989
34. Eco, in Robey (ed.) 1989
35. Ibid.
36. The Gruppo 63 was founded in 1963 in Palermo, Sicily.
37. Umberto Eco, 'The death of the Gruppo 63', in *Quindici*, 1969; this was the final publication of Gruppo 63
38. Claude Levi-Strauss, *The Raw and the Cooked* (London, 1971)
39. Umberto Eco, *La Struttura Assente* (Milan, 1968)
40. Ibid.
41. Antonio Gramsci, *Selection from the Prison Notebooks* (New York, 1971)
42. Germano Celant, 'Arte Povera: Notes for a Guerrilla War' (1968)
43. Krauss 1977

ADRIAN SEARLE ON PAINTING

1. The critic Clement Greenberg asked whether a stretched-up canvas already existed as a picture (and if it did, whether it could be a successful one) in his essay 'After Abstract Expressionism' (1962), while Michael Fried, in his 1967 essay 'Art and Objecthood' replied that it couldn't conceivably be one. The discussion

is repeated in Francis Frascina (ed.), *Pollock and After, The Critical Debate* (London, 1985), pp. 68–66
2. From 'Painting: the Task of Mourning', in Yve-Alain Bois, *Painting as Model* (Cambridge, MA, 1990)
3. The relative modernity of the idea of painting for oneself is discussed, in relation to Goya's *Black Paintings*, in the essay 'Goya in His Hell' by Rafael Argullol in José Miguel G. Cortes (ed.), *Words and Images [Las Imágenes y las Palabras (Arte y Literatura)]* (Valencia, 1992), pp. 11–23, 143–54
4. Dan Cameron, 'Ode to Discernment', in *frieze*, No. 14, 1994, p. 36
5. Jessica Stockholder, *Installations 1983–1991* (Chicago/Rotterdam, 1991), p. 5
6. Ibid.
7. Thomas McEvilley's 'L'Exposition Imaginaire – The Art of Exhibiting in the Eighties' in José Miguel G. Cortez/Juan Vicente Aliaga (eds.), *Sacred Time: The Myth of Contemporary Art [El Tiempo Segrado: la Mitificación del Arte Contemporáneo]* (Valencia, 1991)
8. Rainer Crone/David Moos, *Jonathan Lasker: Telling the Tales of Painting* (Stuttgart, 1993), pp. 11–12
9. From 'The Technique of Painting' in *The Memoirs of Giorgio de Chirico* (Milan, 1962/London, 1971), pp. 231–32

JAMES LINGWOOD ON CONTEMPORARY PHOTOGRAPHY

1. Introduction to Fernand Braudel, *On History* (London, 1980), p. 4
2. Braudel, 'History and the Social Sciences', in ibid., p. 26
3. Braudel, 'The Situation in History' in ibid., p. 10
4. Preface to Michel de Certeau, *The Practice of Everyday Life* (Los Angeles, 1984)
5. Mikhail Bakhtin, 'Epic and Novel', in Michael Holquist (ed.), *The Dialogic Imagination* (Austin, 1981), p. 7. I am also indebted to Jerry Zaslove's illuminating discussion of Bakhtin in the context of Jeff Wall's work, in 'Faking Nature and Reading History', in *Jeff Wall*, 1990 (Vancouver, 1990), pp 64–102
6. Ibid., p. 30
7. Walter Benjamin, 'The Storyteller' (1936), in *Illuminations* (London, 1973), p. 90
8. See Dennis Longwell (ed.), 'A Collective Interview with Garry Winogrand', in *Image*, Vol. 15., No. 2, July 1972
9. Benjamin Buchloh, in *Thomas Struth Photographs* (Chicago, 1991)
10. Braudel 1980, p. 37
11. Bakhtin, 'Forms of Time and of the Chronotope in the Novel', in Bakhtin 1981, p. 84

12. Bakhtin 1981, p. 31
13. Preface to Joseph Conrad, *The Nigger of the 'Narcissus'* (London, 1897)
14. Robert Smithson, 'A Tour of the Monuments of Passaic' (1966), in Nancy Holt (ed.), *The Writings of Robert Smithson* (New York, 1979)
15. Jeff Wall, interview with Els Barents in *Transparencies* (Munich, 1987), pp. 95–104
16. Bakhtin 1981, p. 84
17. De Certeau, ibid., p. 93
18. Bakhtin, ibid., p. 250

DAWN ADES ON ART AND POWER

1. Rivera's mural was dismantled and stored; it was installed in its present location, the Theater of the City College, San Francisco, in 1961.
2. Serge Guilbaut, *How New York Stole the Idea of Modern Art* (Chicago/London, 1983), p. 41
3. Ibid.
4. Clement Greenberg, 'Avant-Garde and Kitsch', in *Partisan Review*, Fall 1939; Greenberg's 'Towards a Newer Laocoön', in *Partisan Review*, July–August 1940, in defence of abstract art, marked a shift away from the 1939 text which maintained that a living, avant-garde culture depended for its survival on socialism. See Clement Greenberg, *The Collected Essays and Criticism 1939–1944*, ed. John O'Brian (Chicago, 1988).
5. During the war in Britain, propaganda posters appeared calling on the people to 'defend your country and your homes'; all over the land the 'y' was swiftly scratched out to give 'our country and our homes'. This relatively trivial incident reveals a profound shift in popular political perceptions and attitudes to authority.
6. V.I. Lenin, 'Decree: On the Monuments of the Republic, 12 April 1918', in Lenin, *On Literature and Art* (London, 1967), p. 245
7. Ibid., p. 247. These included Karl Marx, Mikhail Bakunin, Henri de Saint-Simon, Robert Owen, Aleksandr Pushkin, Andrei Rublëv, Mikhail Vrubel and Frédéric Chopin.
8. N.N. Punin, 'The Monument to the Third International' (1920), trans. Christina Ladder, in *Modern Art and Modernism, Supplementary Documents (Blocks VIII–IX)* (The Open University, 1983), p. 6
9. Ibid.
10. Robert Desnos, 'Pygmalion et le Sphinx', in *Documents*, Vol. 2, No. 1, 1930, p. 36
11. Witness the furore provoked in Britain by the statue of Churchill in Parliament Square, which offended because it had swung too far towards

naturalism and away from dignity, and more recently by the statue of Air Chief Marshal 'Bomber' Harris in the Strand, which was seen as a remarkably insensitive way of marking D-Day. This sculpture, interestingly, does what Desnos recommended, standing on the ground without a pedestal.
12. Craig Owens, 'The Allegorical Impulse: Towards a Theory of Postmodernism', in *October*, No. 12, Spring 1980; reprinted in Charles Harrison/Paul Wood (eds.), *Art in Theory 1900–1990* (Oxford, 1992), p. 1052
13. See Hanne Bergius/Norbert Miller/Karl Riha (eds.), *Johannes Baader Oberdada* (Lahn-Giessen, 1977), p. 187; and Kate Winskell, 'Dada, Russia and Modernity, 1915–1922', doctoral dissertation, Courtauld Institute of Art, London, April 1995, p. 67
14. Christian Zervos, 'Réflexions sur la tentative d'Esthétique dirigée du IIIe Reich', in *Cahiers d'Art*, Vol. 11, Nos. 8–10, 1936, p. 212
15. Greenberg 1988, p. 6
16. Owens 1980
17. Punin 1983, p. 6
18. 'Manifesto of the Union of Mexican Workers, Technicians, Painters and Sculptors', in *El Machete* (Mexico City, 1923), trans. Polyglossia, in Dawn Ades, *Art in Latin America*, exh. cat., Hayward Gallery (London, 1989), p. 324
19. Siqueiros, who remained a member of the Communist Party, was an influential figure in Eastern Europe after the war. Among those who collaborated with him in the 1930s on mural projects such as the Electricians' Union in Mexico City was Josep Renau, who was responsible for the graphic material of the Spanish pavilion at the 1937 Paris International Exhibition.
20. André Masson, letter to André Breton, 29 June 1938, in *André Breton: La Beauté Convulsive*, exh. cat., Centre Georges Pompidou, Paris, 1991, p. 239
21. Ibid.
22. See, for example, André Breton, 'Position Politique du Surréalisme', in *La Bibliothèque Volante*, No. 2, 1971; and André Breton, *What is Surrealism?: Selected Writings*, ed. F. Rosemom (London, 1978).
23. André Breton, 'Souvenir du Mexique', in *Minotaure*, Vol. 6, Nos. 12–13, May 1919, pp. 30–52
24. Leon Trotsky, 'Art and Politics: a Letter to the Editors of *Partisan Review*', in *Partisan Review*, 1918, p. 8
25. 'Manifesto for an Independent Revolutionary Art', in Breton 1978, p. 184
26. Ibid., p. 186
27. Mario Sironi, 'Manifesto of Mural Painting' (1933), in Harrison/Wood 1992, p. 408

28. P. Sacerdoti, in *Le Pavillon Italien, Exposition de Paris* (Paris, 1973), p. 77
29. Fernand Léger, 'Le Mur, l'Architecte, le Peintre' (1933) in Léger, *Fonctions de la Peinture* (Utrecht, 1965), p. 120
30. Fernand Léger, 'De la Peinture Murale' (1952), in ibid., p. 111
31. Carlos Monsivais, 'La Hora Cívica: De Monumentos Cívicos y sus Espectadores', in Carlos Monsivais, *Los Rituales del Caos* (Mexico City, 1995), p. 149
32. See *Kunst und Diktatur*, Vol. 2, exh. cat., Künstlerhaus, Viena, 1994, pp. 842–45

RICHARD J. POWELL ON THE HARLEM RENAISSANCE

1. Jean Toomer, *Cane* (New York, 1969 (1923)), p. 21
2. Mary Schmidt Campbell, *Harlem Renaissance: Art of Black America* (New York, 1987).
3. John Hope Franklin, 'A Harlem Renaissance', in *From Slavery to Freedom: A History of American Negroes* (New York, 1956 (1947)), pp. 489–511
4. Langston Hughes, from 'Dream Variations', in Alain Locke (ed.), *The New Negro* (New York, 1980 (1925)), p. 15
5. Joseph A. Young, *The Black Novelist as White Racist: The Myth of Black Inferiority in the Novels of Oscar Micheaux* (New York, 1989).
6. Charles S. Johnson, 'The New Frontage on American Life', in Locke (ed.) 1980, p. 285
7. Rudolph Fisher, 'The City of Refuge' in Locke (ed.) 1980, pp. 57–74; Jon Michael Spencer, 'The Mythology of the Blues', in *Blues and Evil* (Knoxville, 1993), pp. 1–34; and Thomas Johnson/Philip Dunn, *A True Likeness: The Black South of Richard S. Roberts, 1920–1936* (Chapel Hill, NC, 1986).
8. Wallace Thurman, *The Blacker the Berry* (New York, 1996 (1929))
9. Alain Locke, 'The Legacy of the Ancestral Arts', in Locke (ed.) 1980, p. 264; and Richard J. Powell, 'Ethiopia: Reborn and Re-Presented', in *Black Art and Culture in the 20th Century* (London, 1997), pp. 41–50
10. Nancy Cunard, 'Harlem Reviewed', in *Negro: An Anthology* (New York, 1970 (1933)), pp. 47–55
11. Ann Douglas, *Terrible Honesty: Mongrel Manhattan in the 1920s* (New York, 1995)
12. Robert Goldwater, *Primitivism in Modern Painting* (1938), reprinted as *Primitivism in Modern Art* (Cambridge, MA, 1986); Abraham A. Davidson, *Early American Modernist*

Painting, 1910–1915 (New York, 1981); William Rubin/Kirk Varnadoe (eds.), 'Primitivism', in Twentieth Century Art: Affinity of the Tribal and Modern, 2 vols (New York, 1984); and George Hutchinson, 'Cultural Nationalism and the Lyrical Left', in The Harlem Renaissance in Black and White (Cambridge, MA, 1995), pp. 94–124

13. Alain Locke, 'The New Negro', in Locke (ed.) 1980, p. 6

14. Aaron Douglas, letter to Langston Hughes, 21 December 1925. Langston Hughes Papers, James Weldon Johnson Memorial Collection of Negro Arts and Letters, Beinecke Rare Book and Manuscript Library, Yale University, New Haven, Connecticut

15. W.C. Handy, 'St. Louis Blue', in Blues: An Anthology (New York, 1990 (1926)), pp. 82–83

16. Lucia Garcia-Noriega y Nieto (ed.), Miguel Covarrubias: Homenaje (Mexico, DF, 1987)

17. Richard J. Powell (ed.), The Blues Aesthetic: Black Culture and Modernism (Washington, D.C., 1989); and Jessie Fauset, 'The Gift of Laughter', in Locke (ed.) 1980, p. 166

18. See Richard J. Powell, 'Art History and Black Memory: Towards a Blues Aesthetic', in Robert G. O'Meally/ Genevieve Fabre (eds.), History and Memory in African American Culture (New York, 1994), pp. 228–43

19. Paul Morand, Black Magic (New York, 1929), pp. v–vi

20. Louis Achille, 'The Negroes and Art', in La Revue du Monde Noir, No. 1, 1931, pp. 28–31; and William H. Johnson, quoted in Thomasis, 'Dagens Interview: Med Indlaner-og Negerblod I Aarene. Chinos-Maleren William H. Johnson fortaeller lidt om sin Afrikarejse, primitiv Kunst, m.m.', in Fyns Stiftstidende, 27 November 1932, p. 3

21. James A. Porter, 'The New Negro Movement', in Modern Negro Art (Washington, D.C., 1992 (1943)), pp. 99–100; and Richard J. Powell, 'The Cult of the People', in Powell 1997, pp. 67–85

22. 'Baltimore Museum becomes the first in the South to stage large show of Negro art', in Newsweek, No. 13, 6 February 1939, p. 26

23. Vachel Lindsay, 'The Congo: A Study of the Negro Race', in Collected Poems (New York, 1969 (1925)); Richard Bruce Nugent, 'Sahdji' and Countee Cullen, 'Heritage', in Alain Locke (ed.) 1980, pp. 113–114, 250–53

24. Marius De Zayas, 'Preface', in Charles Sheeler, African Negro Sculpture (New York, privately

printed, 1918), n.p.; James Johnson Sweeney, African Negro Art (New York, 1935); and Alain Locke, 'The Legacy of Ancestral Arts', in Locke (ed.) 1980, pp. 254–267

25. Herman Lebovics, True France: The War over Cultural Identity, 1900–1945 (Ithaca, NY, 1992); Whitney Chadwick, 'Fetishizing Fashion/Fetishizing Culture: Man Ray's Noire et Blanche', in The Oxford Art Journal, No. 18, 1995, pp. 3–17; Alvia J. Wardlaw (ed.), Black Art/Ancestral Legacy: The African Impulse in African American Art (New York, 1989)

26. Georges-Marie Haardt/Louis Audouin-Dubreuil, La Croisière Noire (Paris, 1927); and Malvina Hoffman, Heads and Tales (New York, 1936)

27. Tritobia Hayes Benjamin, The Life and Art of Loïs Mailou Jones (San Francisco, CA, 1994); and Michel Fabre, 'From the New Negro to Negritude: Encounters in the Latin Quarter', in From Harlem to Paris: Black American Writers in France, 1840–1980 (Urbana, 1991), pp. 146–59

28. Alain Locke, 'The Negro: "New" or Newer: A Retrospective Review of the Literature of the Negro for 1938', in Jeffrey C. Stewart (ed.), The Critical Temper of Alain Locke (New York, 1983), pp. 271–83

29. David Levering Lewis, 'It's Dead Now', in When Harlem Was in Vogue (New York, 1981), pp. 282–307; and Jervis Anderson, 'The Depression and the Arts', in This Was Harlem (New York, 1981), pp. 272–84

30. Eugene O'Neill, Plays: The Emperor Jones, Gold, The First Man, & The Dreamy Kid (New York, 1925)

31. Laënnec Hurbon, 'American Fantasy and Haitian Vodou', in Donald Cosentino (ed.), Sacred Arts of Haitian Vodou (Los Angeles, CA, 1995), pp. 181–97

32. Jacob Lawrence, 'Biographical Sketch', 12 November 1940, Downtown Gallery Papers, Archives of American Art, Smithsonian Institution, Washington, D.C.; and Marvel Cooke, 'Pictorial History of Haiti Set on Canvas', in New York Amsterdam News, 3 June 1939, p. 3

33. W.E.B. DuBois, 'The Negro Mind Reaches Out', in Locke (ed.) 1980, pp. 385–414; and Houston Baker, Modernism and the Harlem Renaissance (Chicago, 1987), p. 37

HOMI K. BHABHA ON ANISH KAPOOR

1. I borrow this epigraph from Adam Phillips, On Kissing, Ticking and Being Bored (London, 1994), p. 75

2. Jacques-Alain Miller (ed.), The Seminar of Jacques Lacan. Book VII – The Ethics of Psychoanalysis 1959–1960, trans. Dennis Porter (New York, 1986), p. 140

3. From conversations between Anish Kapoor and Homi K. Bhabha, 1998 (hereafter 'Conversations').

4. Conversations

5. Yves-Alain Bois and Rosalind E. Krauss, Formless – A User's Guide (New York, 1997), p. 16

6. Conversations

7. Hannah Arendt, The Human Condition (Chicago, 1958), p. 210

8. John O'Brian (ed.), Clement Greenberg: The Collected Essays and Criticism, Vol. 4, Modernism with a Vengeance, 1957–1969 (Chicago, 1986), p. 251

9. Ibid., p. 254

10. Sherry Gaché, 'Interview – Anish Kapoor', in Sculpture, February 1996, p. 22

11. David Farrell Krell (ed.), Martin Heidegger – Basic Writings (San Francisco/New York, 1993)

12. Emmanuel Lévinas, Collected Philosophical Papers (Dordrecht, 1986), p. 4

13. I owe this distinction to Philip B. Wagoner, 'Selfborn' and 'Man-made': Architecture, Aesthetics, and Power at Vijayanagara, MS (a paper presented at the South Asian Regional Studies Seminar, University of Pennsylvania, 5 November 1997)

14. Ibid., p. 8

15. Krell 1993, p. 105

16. Martin Heidegger, Poetry, Language, Thought, trans. Albert Hofstadter (New York, 1975), p. 172

17. Miller 1986, p. 120

18. Gaché 1996

19. Ibid.

20. Conversations

21. Conversations

22. Conversations

23. Conversations

24. Miller 1986, p. 118

25. Conversations

26. Richard Serra, Writings/Interviews (Chicago, 1994), p. 100

27. D.W. Winnicott, Playing and Reality (New York, 1982), pp. 96–97

28. Rosalind E. Krauss, The Optical Unconscious (Cambridge, MA, 1993), p. 217

29. Nicholas Abraham/Maria Torok, The Shell and The Kernel, Vol. 1, trans. Nicholas T. Rand (Chicago, 1994), p. 113 [author's emphasis]

30. Miller 1986

31. Gaché 1996, p. 23

32. Conversations

33. Michael Fried in Charles Harrison/ Paul Wood (eds.),

Art in Theory, 1900–1990 (Oxford, 1992), p. 832. In putting together these phrases from Fried, I have stayed true to the spirit of his argument.

34. Emmanuel Lévinas, *Time and the Other*, trans. Richard A. Cohen (Pittsburgh, 1987), pp. 134, 137 [author's interpolations]

35. C.H. Dodd, *Interpretation of the Fourth Gospel* (Cambridge, 1953), p. 430

36. Conversations

37. My account of the narrative of Thomas in the wider context of Johannine Theology is largely based on Dodd 1953, pp. 431–32, 442–43, and Rudolf Bultmann, *The Gospel of John – A Commentary*, ed. R.W.N. Hoare/J.K. Riches, trans. G.R. Beasley-Murray (Oxford, 1971), pp. 693–97.

PETER WOLLEN ON ART AND FASHION

1. Diana de Marly, *Worth: Father of Haute Couture* (New York, 1990 (1980))
2. Kirk Varnedoe, *Vienna 1900: Art, Architecture & Design*, exh. cat., The Museum of Modern Art, New York, 1986
3. Anne Hollander, *Sex and Suits* (New York, 1994)
4. Elsa Schiaparelli, *Shocking Life* (New York, 1954)
5. Hollander 1994

MARCO LIVINGSTONE ON PATRICK CAULFIELD

1. I covered much of this background in detail in my introduction to *Patrick Caulfield: Paintings 1963–81*, exh. cat., Walker Art Gallery, Liverpool, 22 August–4 October 1981, and Tate Gallery, London, 27 October 1981–3 January 1982
2. Some of these studies are reproduced in *The Art of Drawing: Selected from the Collection of the St John Wilson Trust*, exh. cat., Pallant House, Chichester, 22 April–21 June 1997, pl. 2 and back cover. Though he came from a prosperous middle-class family and was the son of a banker, Cézanne nevertheless remains 'bohemian' in the popular imagination.
3. For more on Caulfield's interest in the work of Juan Gris, see the 1981 exh. cat., pp. 15–19, 29
4. Caulfield had never seen the original painting nor even a colour reproduction of it, preferring to invent the colours that he thought appropriate to it from the black-and-white illustration that he had to hand. See the discussion about *Greece Expiring* in the 1981 exh. cat., pp. 16–17
5. In fact, it was characteristically from a rather unlikely source that Caulfield developed the practice of outlining his forms in black: he had noticed that such a technique was used to strengthen the

forms on postcard reproductions of Minoan frescoes that he had purchased on visits to Crete in 1961 and 1963. See the 1981 exh. cat., p. 14
6. Caulfield took the image of the stove, as well as the title and subject of the picture, from Eugene Delacroix's *Coin d'Atelier – Le Poêle*, c.1830 (Louvre, Paris).
7. The specific sources for these and other paintings of this type are given in the 1981 exh. cat.; see in particular pp. 34–35, n. 37–41, 43, 47
8. *Forrest Gump* is a film starring Tom Hanks, released by Paramount Pictures in 1994
9. See *Braque: The Late Works*, exh. cat., Royal Academy of Arts, London, 23 January–6 April 1987, cat. nos. 19–24. They are discussed in Sophie Bowness's notes on pp. 72–85 and pp. 8–10 of John Golding's introductory essay. The lamp is prominent in *Atelier II*, 1949 (Kunstsammlung Nordrhein-Westfalen, Dusseldorf), cat. no. 19, reproduced in colour on p. 75. Golding, p. 9, quotes Braque's comments from the late 1950s on the "'metamorphic' confusion' that he sought in his representation of objects. It is typical of Caulfield's contrary sense of humour that although he, too, frequently plays on such ambiguous identities he should choose to represent the motif of the lamp which he associates with Braque in such an assertively literal way.
10. The artist's remarks about this painting are from a conversation with the author on 22 September 1998.
11. For a detailed analysis of these and related paintings, see my essay 'Rooms Ready for Habitation', in *Patrick Caulfield: New Paintings*, exh. cat., Waddington Galleries, London, 26 March–26 April 1997, pp. 5–11

MATTHEW HIGGS ON 1990s BRITISH ART

1. The best of which include Matthew Collings's urban and criminally underrated *Blimey! From Bohemia to Britpop: The London Artworld from Francis Bacon to Damien Hirst* (Cambridge, 1997); Julian Stallabrass's pointed *High Art Lite* (London/New York, 1999); Patricia Bickers's valuable and early account of the international reception of British art, *The Brit Pack: Contemporary British Art, the View from Abroad* (Manchester, 1995); David Burrows's edited collection *Who's Afraid of Red White & Blue: Attitudes to Popular and Mass Culture, Celebrity, Alternative & Critical Practice & Identity Politics in Recent British Art* (Birmingham, 1998); and Duncan McCorquodale/Naomi Siderfin/Julian Stallabrass (eds.), *Occupational

Hazard: Critical Writing on Recent British Art (London, 1998)
2. Conceived and curated by Damien Hirst in 1988, *Freeze* presented works by Steven Adamson, Angela Bulloch, Mat Collishaw, Ian Davenport, Dominic Denis, Angus Fairhurst, Anya Gallacio, Damien Hirst, Gary Hume, Michael Landy, Abigail Lane, Sarah Lucas, Lala Meredith-Vula, Richard Patterson, Simon Patterson, Stephen Park and Fiona Rae.
3. David Rimanelli, *Artforum*, December 1999, p. 122. The 'scandal' to which Rimanelli refers was the furore surrounding the inclusion of Chris Ofili's 1996 painting *The Holy Virgin Mary* at the Brooklyn Museum's display of *Sensation* and New York's Mayor Giuliani's subsequent attempts to withdraw funding from the museum on the grounds that Ofili's work was offensive to the Catholic faith.
4. Ed Ruscha, *Los Angeles County Museum on Fire*, 1965–68. Collection Hirschhorn Museum and Sculpture Garden, Smithsonian Institution, Washington, D.C.
5. Others such as Peter Doig and Jenny Saville have largely avoided being associated with the YBA phenomenon.
6. The most significant of which include *General Release: Young British Artists at Scuola di Pasquale*, Venice, 1995; *Brilliant!: New Art From London*, Walker Art Center, Minneapolis, 1996; *Live/Life: La Scène Artistique au Royaume-Uni en 1996 de Nouvel les Aventures*, Musée d'Art Moderne de la Ville de Paris, 1996; *Pictura Britannica: Art from Britain*, Museum of Contemporary Art, Sydney, 1997; and *Real/Life: New British Art*, Tochigi Prefectural Museum of Fine Arts, Japan, 1998–99
7. Manifesta 2 included amongst its 40-plus European artists only two British artists, Richard Wright and Christine Borland, both Glasgow-based. Documenta 10 (Kassel, 1997) included a number of senior British practitioners, including Richard Hamilton, Art & Language, Alison and Peter Smithson, and Archigram. The younger British artists represented there did not conform to received notions surrounding the YBAs: they included Liam Gillick, Heath Bunting, Steve McQueen and Adam Page. Harald Szeemann's 1999 Venice exhibition *APERTO over ALL* included work by only two British amongst its 100-plus artists: Douglas Gordon and Roderick Buchanan, again both Glasgow-based.
8. Recently opened or about to open venues include the re-built Ikon Gallery in Birmingham; Cardiff's Centre for

Visual Arts; Dundee Contemporary Arts; the Milton Keynes Gallery; Baltic, Gateshead; the New Art Gallery, Walsall; The Dean Gallery, Edinburgh; and Tate Modern, London.
9. Amanda Foreman, 'Uncommon Touch', in *Guardian*, 9 July 1999, p. 2
10. The works referred to are Damien Hirst, *The Physical Impossibility of Death in the Mind of Someone Living*, 1991; Marc Quinn, *Self*, 1991; and Tracey Emin, *My Bed*, 1999.
11. *Young British Art: The Saatchi Decade* (London, 1999)
12. Quoted in Matthew Slotover's review of *Young British Art: The Saatchi Decade*, in *frieze*, No. 47, June–August 1999, p. 112

BRIDGET RILEY ON PAUL KLEE
1. Paul Klee, *The Thinking Eye* (London, 1961), p. 169
2. Ibid., p. 72
3. Ibid., p. 49
4. Ibid., p. 76
5. Ibid., p. 454

MARINA WARNER ON ART AND ILLUSION
1. Plato, *The Republic* (c.306 BC), trans. Benjamin Jowett (1894), Book X. 602 c, d
2. Robert Smithson, *The Collected Writings*, ed. Jack Flam (Berkeley, 1996), p. 132
3. Hippolytus, *The Refutation of All Heresies*, trans. Rev. J.H. MacMahon (Edinburgh, 1868), pp. 103–08
4. William Shakespeare, *The Winter's Tale*, 3.3.37
5. Athanasius Kircher, *Ars Magna Lucis et Umbrae* (Rome, 1646)
6. Claudia Swan, 'Eyes Wide Shut: Early Modern Imagination, Demonology, and the Visual Arts', in *Zeitsprünge*, 2003, pp. 560–81
7. Aristotle, *De Anima III*, Vii:15, trans. W.S. Hett (Cambridge, MA/London, 1936), pp. 176–77
8. Robert Fludd, *Utriusque Cosmi (Of This World and the Others)* (Oppenheim, 1617–19)
9. René Descartes, 'La Dioptrique', in *Discourse VI*, in *Philosophical Works*, ed. E. Haldane (Cambridge, 1911), p. 253
10. David Hockney has argued that this was in widespread use; see *Secret Knowledge: Recovering the Lost Techniques of the Old Masters* (London, 2001)
11. Leonardo da Vinci, *Treatise on Painting*, ed. and trans. Philip McMahon (Princeton, 1956), Vol. 1, p. 59; Vol. 2, p. 33, v., para. 93
12. See A.P. Oppé, Alexander and John Robert Cozens, which includes A. Cozens,

A New Method for Assisting the Invention of Drawing Original Compositions of Landscape (London, 1952)
13. Wilhelm von Kaulbach, *Kaffee-Klexbilder*, 1885
14. See Bruno Klopfer/Douglas McGlashan Kelley, *The Rorschach Technique: A Manual for a Projective Method of Personality Diagnosis* (Yonkers-on-Hudson, New York, 1942); Sina Najafi, 'Bats and Dancing Bears: An Interview with Eric Zillman', in *Cabinet*, No. 5, Winter 2001, pp. 84–90; Frederick C. Crews, 'Out, Damned Blot!', in *New York Review of Books*, 15 July 2004, pp. 23–25
15. Lewis Carroll, *Through the Looking Glass* (London, 1998), pp. 239–40
16. Slavoj Žižek, *Welcome to the Desert of the Real* (London, 2002)
17. The Hoogstraten peepshow is 58 x 88 x 63.5 cm and is in the National Gallery, London
18. Jurgis Baltrušaitis, *Anamorphic Art*, trans, W.J. Strachan (Cambridge, 1977), pp. 79–86
19. See Lyle Massey, 'Anamorphosis through Descartes or Perspective Gone Awry', in *Renaissance Quarterly*, No. 50, 1997, pp. 1148–89
20. See Sir David Brewster, *Letters on Natural Magic* (London, 1832)
21. See Jim Steinmeyer, *Hiding the Elephant: How Magicians Invented the Impossible and Learned to Disappear* (New York, 2003)
22. I am grateful to Andrew Johnson, manager of the *camera obscura*, for his help with its history.
23. Hippolyte Baraduc, *L'Ame Humaine, ses Mouvements, ses Lumières* (Paris, 1896)
24. The whole fairytale vision was installed in the Musée Grevin six years later. I saw it four years ago and it was still a wonder of wonders, infinite sparkling reflections playing in a complex mirrored vault to create an infinite scintillating empyrean. This quintessentially modern urban spectacle is now unfortunately closed.
25. Lucy Fischer, 'The Lady Vanishes: Women, Magic and the Movies', in John L. Fell (ed.), *Film Before Griffith* (Berkeley, 1983), pp. 339–54
26. Terry Ramsaye, 'Robert Paul and the Time Machine', in Harry M. Geduld (ed.), *The Definitive Time Machine* (Bloomington, 1987), pp. 196–203
27. Camille Flammarion, *Récits de l'Infini. Lumen: Histoire d'un Comète: Dans l'Infini* (Paris, 1873); *Lumen*, trans. A.A.M./R.M. (London, 1897)
28. Paul demonstrated it on 2 February 1896 at Finsbury Technical College, and eight days later in the library of the Royal Institution.

29. Valerie Smith (ed.), *Joan Jonas: Works*, exh. cat., Queens Museum of Art, New York, 2003
30. Wallace Stevens, 'Angel Surrounded by Paysans', in *Selected Poems* (London, 1965), pp. 141–42

SIMON NJAMI ON CONTEMPORARY AFRICAN ART
1. Convened by the German Chancellor Otto von Bismarck in 1884, the Berlin Conference agreed a final carve-up between European powers of those parts of Africa which remained uncolonised.
2. Meeting of 29 African and Asian countries, held in the Indonesian city of Bandung in 1955, with the aim of promoting economic and cultural co-operation and of opposing colonialism (South Africa was not invited to the conference.)
3. The German anthropologist Leo Frobenius (1873–1938) was one of the first anthropologists to make Africa his special field of study. See Leo Frobenius, *Prehistoric Rock Pictures in Europe and Africa* (Ayer Co Pub, 1972 (1937)); Leo Frobenius and Douglas C. Fox, *African Genesis* (New York, 1976 (1938)).
4. Michel Leiris (1901–90), French anthropologist, poet and novelist; his journal was published as *L'Afrique Fantôme* (Paris, 1934).
5. Presidents: Léopold Sédar Senghor, Senegal (1960); Kwame Nkrumah, Ghana (1960); Antonio Agostinho Neto, Angola (1975); Gamal Abdel-Nasser, United Arab Republic (1954); Thomas Sankara, Burkina Faso (1983); Modibo Keita, Mali (1960); Anwar Sadat, United Arab Republic (1970); Nelson Mandela, South Africa (1994). Steve Biko was a South African black consciousness leader, born 1947, murdered in custody in 1977.
6. Self-evident truth, obvious remark, truism (after Jacques de La Palice, 1470–1525).
7. Sahel is a 'one-million-square mile area reaching from Senegal in the west to the Horn of Africa in the east, which contains Burkina Faso, Chad, Mali, Mauritania, Niger and Senegal'. E.L. Bute/H.J.P. Harmer, *The Black Handbook: The People, History and Politics of Africa and the African Diaspora* (London/Washington, D.C., 1997), p. 98
8. Frantz Fanon, *The Wretched of the Earth*, trans. Constance Farrington (London, 2001 (1961))
9. Léopold Sédar Senghor, see note 5. Aimé Césaire was a writer and politician in Martinique, and co-founder in 1934 of *L'Étudiant Noir*, a magazine supporting *négritude*.

10. Ernst Bloch, *The Spirit of Utopia: Meridian Crossing Aesthetics*, trans. Anthony A. Nassar (Stanford, CA, 2000 (1919)) p. 3
11. Afrocentrism is an intellectual and ideological movement composed mostly of African Americans who believe that the world has too long been dominated by a Eurocentric viewpoint. The movement supports an African-centred worldview with positively expressed African values.
12. Bloch 2000, p. 10

TACITA DEAN ON CURATING
1. Paul Nash, *Country Life*, 1 May 1937

ANTHONY VIDLER ON ANTONY GORMLEY
1. F.W.J. von Schelling, *Philosophie der Mythologie* (Darmstadt, 1996 (1842)), Vol. 2, p. 654
2. Jacques Lacan, *The Four Fundamental Concepts of Psychoanalysis*, ed. J.A. Miller, trans. A. Sheridan (New York, 1978), p. 96
3. Jacques Derrida, *Archive Fever: A Freudian Impression*, trans. E. Prenowitz, (Chicago, 1996), p. 46

KAJA SILVERMAN ON PAINTING FROM PHOTOGRAPHS
1. Gerhard Richter, *The Daily Practice of Painting: Writings, 1962–1993*, trans. David Britt (Cambridge, MA, 1995), p. 146. The parts of this essay that are devoted to Richter are part of a larger argument that forms the concluding chapter of my forthcoming book, *Flesh of My Flesh*.
2. For the sake of consistency, I am referring to the device with which Richter works over the wet paint of his photo paintings as a 'squeegee'. In fact, though, it is only one of a range of implements deployed for this purpose.
3. Richter 1995, p. 38
4. Several other writers have also identified analogy as one of the organising principles of Richter's work. See Dietmar Elger, 'Landscape as a Model', in *Gerhard Richter: Landscapes* (Ostfildern-Ruit, 1998), p. 8–38; and Richard Cork, 'Through a Glass Darkly: Reflections on Gerhard Richter', in *Gerhard Richter: Mirrors*, exh. cat., Anthony d'Offay Gallery, London, 1991, pp. 11, 15
5. Richter 1995, pp. 119, 121
6. André Bazin, 'The Ontology of the Photographic Image', trans. Hugh Gray, in *What Is Cinema?* (Berkeley, 1967), Vol. 1, pp. 9–22; and Roland Barthes, *Camera Lucida: Reflections on Photography*, trans. Richard Howard (New York, 1981)

7. This account of photography is by now so firmly entrenched that it belongs at the same time to everyone, and no one. Therefore, rather than attempting to document its sources, I will simply quote from a text in which it is presented with particular lucidity. 'Photography captures an aspect of reality which is only ever the result of an arbitrary selection, and, consequently, of a transcription', Pierre Bourdieu writes in 'The Social Definition of Photography', '...among all of the qualities of the object, the only ones retained are the visual qualities which appear for a moment and from one sole viewpoint; these are transcribed in black and white, generally reduced in scale and always projected onto a plane. In other words, photography is a conventional system which expresses space in terms of the law of perspective (or rather of one perspective)... Photography is considered to be a perfectly realistic and objective recording of the visible world because (from its origin) it has been assigned social uses that are held to be "realistic" and "objective".' *Photography: A Middle-Brow Art*, trans. Shaun Whiteside (Stanford, 1990), pp. 73–74
8. Ibid., p. 33. One of the reasons the photograph is invisible is that it has been subsumed since the moment of its invention to the index, and treated as a form of evidence.
9. 'Photographs... drop onto our doormats, almost as uncontrived as reality, but smaller', Richter told an interviewer in 1989, in the middle of a discussion of the images that gave rise to *October 18, 1977*. See Richter 1995, p. 187
10. For a discussion of the dialectical image, see Walter Benjamin, 'On the Concept of History', in Walter Benjamin, *Selected Writings, Vol. 4*, ed. Michael W. Jennings (Cambridge, MA, 2003), pp. 389–400; and Walter Benjamin, *The Arcades Project*, trans. Howard Eiland/Kevin McLaughlin (Cambridge, MA, 1999), pp. 456–75
11. This metaphor was inspired by the following passage from Walter Benjamin: 'One can read the real like a text. And that is how the nineteenth century will be treated here. We will open the book of what happened.' (Benjamin 1999, p. 464)
12. Ibid., p. 474
13. Benjamin 2003, p. 390
14. Freud introduces the notion of a death drive in 'Beyond the Pleasure Principle', in *The Standard Edition of the Complete Psychological Works, Vol. 18*, trans. James Strachey (London, 1955), pp. 7–64. It casts a long shadow over all of his later works.

15. Richter 1995, p. 125. Freud's *Civilization and its Discontents*, which is included in Vol. 21 of *The Standard Edition of the Complete Psychological Works*, is full of similar passages: see, for instance, pp. 111–12
16. Barthes 1981, p. 15
17. 'Vija Celmins Interviewed by Chuck Close at her New York Loft on September 26 and 27, 1991', in *Vija Celmins* (New York, 1992), p. 8
18. Ibid., p. 12
19. 'Robert Gober in Conversation with Vija Celmins', in Vija Celmins (London, 2004), pp. 13–14
20. *Vija Celmins* 1992, p. 26
21. Lane Relyea, 'Vija Celmins's Twilight Zone', in *Vija Celmins* 2004, p. 51
22. I am in the middle of writing a book about photography called *The Miracle of Nature*. The phrase comes from Marcel Proust, who uses it in *Time Regained*.
23. Andy Warhol, *The Philosophy of Andy Warhol: From A to B and Back Again* (London, 1977), p. 69
24. Ibid., pp. 100–01
25. Ibid., pp. 121–23
26. Ibid., p. 123

JANE RENDELL ON ART AND ARCHITECTURE
1. In developing the concept of critical spatial practice in art, I discuss the difference between the terms space, place and site. See Jane Rendall, *Art and Architecture: A Place Between* (London, 2006). In my forthcoming book *Site-Writing: The Architecture of Art Criticism*, I explore criticism itself as a critical spatial practice, where interaction between the critic and the work operates as a form of setting. See also Miwon Kwon, *One Place After Another: Site-Specific Art and Locational Identity* (Cambridge, MA, 2002); and the discussion of place in Claire Doherty (ed.), *Thinking of the Outside: New Art and the City of Bristol* (Bristol, 2005), pp. 9–10
2. Robert Morris, 'Notes on Sculpture 1–3', in Charles Harrison/Paul Wood (eds.), *Art in Theory 1900–1990: An Anthology of Changing Ideas* (Oxford, 1992), p. 81. Part 1 was first published in *Artforum*, February 1966, pp. 42–44
3. See David Antin, 'What is an Environment?', in *Art News*, April 1966, referenced in Suzaan Boettger, *Earthworks: Art and the Landscape of the Sixties*, (Los Angeles, 2002), p. 211
4. David Bourdon, 'The Razed Sites of Carl Andre', in Gregory Battcock (ed.), *Minimalism: A Critical Anthology* (Berkeley/Los Angeles, 1995), pp. 103–08. Reprinted from *Artforum*, October 1966, pp. 103–10
5. Germano Celant, *Dennis Oppenheim* (Milan, 1997), p. 29

6. Morris, p. 816. Part 2 was first published in *Artforum*, October 1966, pp. 20–23

7. Claire Bishop argues that the sensorial experience of Tropicália has to be understood as 'activated spectatorship' in relation to the oppressive Brazilian regime of the mid 1960s onwards. See Claire Bishop, *Installation Art: A Critical History* (London, 2005). Her point can be extended to suggest that the various kinds of spatial experience involved in installation art need to be understood within their specific historical and cultural context.

8. See for example, Dan Graham, *Pavilions*, Kunsthalle Bern, 1983; Dan Graham, *Pavilions*, Kunstverein München, 1988; and Martin Köttering and Roland Nachtigäller (eds.), *Dan Graham: Two-Way Mirror Pavilions 1989–1996*, Städtische Galerie Nordhorn, 1996

9. The park includes a pavilion designed by the artist Dan Graham in collaboration with architects Moji Baratloo and Clifton Balch and a video salon with a coffee bar showing work selected by the artist. See leaflet published by Dia Center for the Arts, Dan Graham, 'Rooftop Urban Park Project', long-term installation, consisting of Dan Graham 'Two-Way Mirror Cylinder Inside Cube', 1981–91, and Design Collaboration, Baratloo-Balch architects, 'Video Salon'.

10. Hal Foster, *The Return of the Real: The Avant-Garde at the End of the Century* (Cambridge, MA, 2001), p. 38

11. Ibid., p. 43

12. Robert Smithson, 'Interview with Robert Smithson for the Archive of American Art/Smithsonian Institution' (1972), in Jock Flam (ed.), *Robert Smithson: The Collected Writings* (Berkeley/Los Angeles, 1966), p. 296

13. See Robert Smithson, 'Entropy and New Monuments' (1966), in ibid., pp. 10–23, and Robert Smithson, 'A Tour of the Monuments of Passaic, New Jersey' (1967), in ibid., pp. 68–74

14. See Robert Smithson quoted in Neville Wakefield, 'Yucatan is Elsewhere: On Robert Smithson's *Hotel Palenque*', in *Parkett*, No. 43, 1995, p. 133. See http://www.robertsmithson.com/essays/palenque.htm

15. For specific descriptions of his site/non-site dialectic see Robert Smithson, 'Towards the Development of an Air Terminal Site' (1967), in *Flam*, 1966, p. 291, Robert Smithson, '"Earth" (1969) Symposium at White Museum, Cornell University', ibid., p. 178, and Robert Smithson, 'The Spiral Jetty' (1972), ibid., pp. 152–53

16. See for example Benjamin H.D. Buchloh (ed.), *Michael Asher, Writings*

1973–1983 on Works 1969–1979 (Los Angeles, 1984), pp. 76–81

17. See Kirsi Peltomäki, 'Affect and Spectatorial Agency: Viewing Institutional Critique in the 1970s', in *Art Journal*, Winter 2007

18. See Bishop 2005, pp. 6–13

19. Walter Benjamin, 'The Work of Art in the Age of Mechanical Reproduction', completed in 1936 and translated by Harry Zohn, in Hannah Arendt (ed.), *Illuminations* (London, 1992), pp. 231, 233

20. See for example http://www.merzbau.org/Schwitters.html

21. Ilya Kabakov, On the *'Total' Installation* (Bonn, 1995), p. 273

22. See for example http://www.ptproject.net/introduction.php

23. See for example Sandra Sider, 'Womanhouse: Cradle of Feminist Art', in Art Spaces Archive Project, http://as-ap.org/sider

24. Umber to Eco, 'The Poetics of the Open Work' (1962), in Claire Bishop (ed.), *Participation: Documents of Contemporary Art* (London/Cambridge, MA, 2006), pp. 20–40

25. Sigmund Freud, 'On Beginning the Treatment (Further Recommendations on the Technique of Psycho-Analysis I)' (1913), in *The Standard Edition of the Complete Psychological Works of Sigmund Freud, Volume XII (1911–1913): The Case of Schreber, Papers on Technique and Other Works*, pp. 121–44, 126, 133

26. Luciana Nissin Momigliano, 'The Analytic Setting: Theme with Variations', in *Continuity and Change in Psychoanalysis: Letters from Milan* (London/New York, 1992), pp. 33–61, 33–34

27. José Bleger, 'Psycho-Analysis of the Psycho-Analytic Frame', in *International Journal of Psycho-Analysis*, 1967, 48, pp. 511–19, 518

28. The French term used is 'baquet'. See Jean Laplanche, 'Transference: Its Provocation by the Analyst', in *Essays on Otherness* (London, 1999), pp. 214–33, 226, note

29. The French word used is 'écrin'. See André Green, *Key Ideas for a Contemporary Psychoanalysis: Misrecognition and Recognition of the Unconscious* (London, 2005), p. 33, note

30. 'Dialogues with André Green', in Gregorio Kohon (ed.), *The Dead Mother: The Work of André Green* (London, 1999), p. 29

31. André Green, 'The Analyst, Symbolization and Absence in the Analytic Setting (On Changes in Analytic Practice and Analytic Experience) – In Memory of D.W. Winnicott', in *International Journal of Psycho-Analysis*, No. 56, 1975, pp. 1–22, 12

32. André Green, 'Potential Space in Psychoanalysis: The Object in the Setting', in Simon A. Grolnick and Leonard Barkin (eds.), *Between Reality and Fantasy: Transitional Objects and Phenomena* (New York/London, 1978), pp. 169–89, 180

STEPHANIE ROSENTHAL ON PERFORMANCE ART

1. William Forsythe, 'Choreographic Objects', in *Suspense*, exh. cat., Ursula Blickle Stiftung, Kraichtal, 2008, p. 6

2. See, for example, *Tanz in der Moderne*, exh. cat., Haus der Kunst, Munich, 1996; *Tanzen. Sehen.*, exh. cat., Museum für Gegenwartskunst, Siegen, 2007; *Dance with Camera*, Institute of Contemporary Art, Philadelphia, 2009

3. Allan Kaprow, 'The Legacy of Jackson Pollock', in *Allan Kaprow, Essays on the Blurring of Art and Life*, ed. Jeff Kelley (Berkeley/Los Angeles, 1996), p. 6

4. Forsythe 2008

5. Both pieces were part of *Five Dance Constructions and Some Other Things*, which Forti staged in a 1961 concert series at the Yoko Ono Studios organised by La Monte Young.

6. Simone Forti, *Handbook in Motion* (Halifax, 1974) p. 39

7. Ibid., p. 56

8. For more on the Judson Dance Theater, see Sally Banes, *Democracy's Body: Judson Dance Theater 1962–1964* (Ann Arbor, MI, 1980)

9. Sabine Huschka, *Merce Cunningham und der Moderne Tanz: Körperkonzepte, Choreographie und Tanzästhetik* (Würzburg, 2000), p. 35

10. See Yvonne Rainer's tally of the similarities between minimal sculpture and dance: 'A quasi survey of some "minimalist" tendencies in the quantitatively minimal dance activity midst the plethora, or an analysis of Trio A', in Gregory Battcock (ed.), *Minimal Art: A Critical Anthology* (Berkeley, 2009 (1962)), p. 263

11. Deborah Hay, *Will They or Won't They?*, 1963 (performed by Barbara Dilley, Alex Hay, Deborah Hay, Robert Rauschenberg); Robert Rauschenberg, *Map Room II*, 1965 (performed by Alex Hay, Deborah Hay, Steve Paxton, Robert Rauschenberg).

12. For a more detailed discussion of these works, see Carrie Lambert-Beatty, *Being Watched: Yvonne Rainer and the 1960s* (Cambridge, MA, 2007), p. 75, as well as Noel Carrol, 'Yvonne Rainer and the recuperation of the everyday life', in *Yvonne Rainer: Radical Juxtaposition 1961–2002*, exh. cat., Rosenwald-Wold Gallery, The University of the Arts, Philadelphia, 2002, pp. 75–125

13. Yvonne Rainer in Battcock (ed.) 2009, p. 269

14. Kaprow 1996, p. 7

15. See also Allan Kaprow, 'The Education of the Un-Artist, Part I' (1971) in ibid., pp. 97–109

16. For a continuation of this quote, please see p. 392–93 of this volume

17. *Trisha Brown: Dance and Art in Dialogue*, 1961–2001, exh. cat., Addison Gallery of American Art, Phillips Academy, Andover, MA, 2002, p. 307

18. 'On the conviction that Rainer's area of exploration was not exactly "things in themselves" but things-in-themselves to watch. Eyeing this difference, I have come to see Rainer as not only a shaper of dances and mover of bodies but a sculptor of spectatorship. Seen this way, Rainer's work becomes a – perhaps the – bridge between key episodes in post-war art. For this was a period in which issues of spectatorship came to the fore everywhere, in both literal and theoretical ways.' Lambert-Beatty 2007, p. 9

19. Letter to Michael Compton, 19 January 1971, about his exhibition at the Tate Gallery, London

20. Morris in an interview with Simon Grant, in *Tate Etc.*, No. 14, Autumn 2008.

21. Many artists who would later be important choreographers in New York had been Halprin's students. Her work championed improvisation in dance and emphasised the physical self-discovery of her students.

22. Forti 1974, p. 31

23. For a more detailed discussion of these works, see *Robert Morris: The Mind/Body Problem*, exh. cat., Solomon R. Guggenheim Museum, New York, 1994, pp. 158–59, 168–69

24. Robert Morris, 'Notes on Dance', in *The Tulane Drama Review*, Vol. 10, No. 2, Winter 1965, pp. 179–86, p. 179

25. Richard Serra, 'Interview with Lynne Cook and Michael Govan', in *Richard Serra: Torqued Ellipses* (New York, 1997), p. 28. Quoted in Lambert-Beatty 2007, p. 4

26. Bruce Nauman, 'Interview mit Willoughby Sharp,' in Christine Hoffmann (ed.), *Bruce Nauman: Interviews 1967–1988* (Amsterdam, 1996), p. 49

27. Ibid.

28. Bruce Nauman, 'Interview mit Lorraine Sciarra', in Hoffmann (ed.) 1996, pp. 79–80

29. Nauman, 'Interview mit Willoughby Sharp', in Hoffmann (ed.) 1996, p. 15

30. 'Because an interesting thing was happening. A lot of people had taken a lot of trouble educating the public to participate – if I put this stuff out here, you were supposed to participate. And certain kinds of clues were taken that

certain sculptures were participatory.' Ibid., p. 82

31. Nauman, 'Interview mit Lorraine Sciarra', in Hoffmann (ed.) 1996, p. 82

32. With its discovery of mirror neurons, neuroscience has demonstrated that the same neurons in the brain are activated whether we perform an activity ourselves or merely observe it without performing it.

33. Graham himself mentioned Forti as one of the most important influences on his work of the late 1960s. See *Tanzen. Sehen.*, exh. cat., 2007, p. 123

34. For a more detailed discussion, see ibid., p. 122

35. Morris interview, *Tate Etc.*, Autumn 2008

36. See Robert Morris, 'Notes on Sculpture', in Battcock (ed.) 2009, pp. 222–35

37. Michael Fried, 'Art and Objecthood', in ibid., pp. 116–47

38. Letter to Michael Compton, March 1971, Tate Archive

39. Lygia Clark, in *Lygia Clark*, exh. cat., Fundació Antoni Tàpies, Barcelona, 1997, p. 227

40. Ibid., p. 242

41. Guy Brett in ibid., p. 22

42. Forsythe 2008, p. 7

43. Rudolf Laban, *The Language of Movement: A Guidebook to Choreutics* (Boston, MA, 1978), p. 3. Quoted in Huschka 2000, p. 92

44. Letter to Michael Compton, 19 January 1971, about his exhibition at the Tate Gallery, London

45. Maurice Merleau-Ponty, *Phänomenologie der Wahrnehmung* (Berlin, 1966), p. 103

46. Ibid., p. 174

47. Ibid., p. 176

48. 'I read a book called *Gestalt Therapy* that was important because it has to do with awareness of your body and a way of thinking about it.' Bruce Nauman, 'Interview with Lorraine Sciarra', in Hoffmann (ed.) 1996, p. 79. Perls, too, was a member of Halprin's circle.

49. Dorothea von Hantelmann, *How to Do Things with Art. Zur Bedeutsamkeit der Performativität von Kunst* (Zurich, 2007), p. 170

50. Alva Noë, *Action in Perception* (Cambridge, MA), 2004, p. 1

51. Ibid., p. 73

52. Andrew Hewitt, *Social Choreography: Ideology as Performance in Dance and Everyday Movement* (Durham, NC/London, 2005), p. 14

53. Mike Kelley in John Welchman (ed.) *Mike Kelley: Minor Histories, Statements, Conversations, Proposals* (Cambridge, MA, 2004), p. 139.

Education is only one among many factors that shape out development. 'My education must have been a form of mental abuse, of brainwashing. How else could I have engaged for so long in activity that pointed so overtly toward my own repressed abuse without consciousness of it?' (p. 320) For a more detailed discussion of 'Educational Complex', see *Educational Complex Onwards, 1995–2008*, exh. cat., Wiels, Brussels, Zurich, 2009.

54. Pablo Bronstein, in 'Interview between Pablo Bronstein and Rebecca May Marston', 4 November 2007, New York. See http://07.performa-arts.org

55. Ibid.

56. Pablo Bronstein in *Displayer*, p. 44

57. Bronstein in Marston 2007

58. See Julienne Lorz's text on João Penalva's *Widow Simone* (1996) in *Move: Choreographing You: Art and Dance since the 1960s*, exh. cat., Hayward Gallery, London, 2010, pp. 82–85

59. See Helen Luckett's essay on Isaac Julien, ibid., pp. 114–17

60. See André Lepicki's detailed discussion of La Ribot in ibid., pp. 60–63

61. For a more detailed discussion of this work, see Hantelmann 2007, p. 153

62. Ibid., p. 146

63. Bruce Nauman, 'Dance Piece', in *Bruce Nauman*, exh. cat., Museum fur Neue Kunst MNK, ZKM Karlsruhe, 1999, p. 61

64. Hantelmann 2007, p. 151

65. Ibid., p. 152

66. Tino Sehgal quoted in ibid., p. 171

67. Ibid., p. 192

68. See www.corpusweb.net/answers-4349.html

69. For a more detailed discussion of Lydia Clark's 'communal body', see *Move: Choreographing You*, exh. cat., 2010

70. Michael Kliën, *Book of Recommendations* (Limerick, 2008), p. 24

71. Hantelmann 2007, p. 175

72. Tino Sehgal quoted in ibid., p. 190

ALI SMITH ON TRACEY EMIN

1. Gertrude Stein, *Look at Me Now and Here I Am: Writings and Lectures 1909–45* (New York, 1971)

2. W.G. Sebald, *Campo Santo* (London/New York, 2005), p. 67

3. Jennifer Doyle, 'The Effect of Intimacy: Tracey Emin's Bad-Sex Aesthetics', in Mandy Merck/Chris Townsend (eds.), *The Art of Tracey Emin* (London, 2002)

4. Tracey Emin/Carl Freedman, *Tracey Emin: Works 1963–2006* (New York, 2006), p. 327

5. Neal Brown, *Tracey Emin* (London, 2006), p. 53

CHRISSIE ILES ON PIPILOTTI RIST
1. Rosalind Krauss/Yve-Alain Bois, *Formless: A User's Guide* (New York, 1997), p. 32
2. Rosalind Krauss, 'Where's Poppa?', in Thierry de Duve (ed.), *The Definitively Unfinished Marcel Duchamp* (Cambridge, MA, 1993), p. 474
3. David Joselit, *Infinite Regress: Marcel Duchamp 1910–1941* (Cambridge, MA, 1998), pp. 39–40
4. Carolee Schneemann, *More than Meat Joy: Complete Performance Works & Selected Writings* (Kingston, New York, 1979), p. 9
5. Ibid.
6. Conversation with Richard Julin, trans. Matthew Partridge, in *Pipilotti Rist – Congratulations!* (Baden, 2007), p. 21
7. Robert L. Schwarz, 'Body, Space and Idea' in Ric Allsopp/Scott deLahunta (eds.), *The Connected Body: An Interdisciplinary Approach to the Body and Performance* (Amsterdam, 1996), p. 79
8. Julin 2007, p. 43
9. Julin 2007, p. 57
10. Gene Youngblood, *Expanded Cinema* (New York, 1970), p. 351
11. Tom Wolfe, *The Electric Kool-Aid Acid Test* (New York, 1968), p. 206
12. Marshall McLuhan/Quentin Fiore, *The Medium Is the Message* (New York, 1967), p. 24
13. Ibid., p. 125
14. Leah Dickerman, 'Dada Gambits', in *October*, Vol. 105, Summer 2003, p. 12

WILL SELF ON GEORGE CONDO
1. I am grateful to Dr Matthew Beaumont for illuminating G.K. Chesterton's response to impressionism for me in his essay 'The Man Who Was Thursday' (published as the introduction to the Penguin Classics edition).
2. Respectively: the statue of the Madonna atop the Basilica of Albert that early in the war was tipped to the horizontal by shellfire, and remained that way for three years, seemingly about to cast away the infant Jesus held in her arms; the 'vision' that British troops were said to have experienced during the Battle of Mons of an angelic reinforcement; and the widespread myth that the German troops had used their bayonets to crucify a Canadian prisoner.
3. Richard Hunter/Ida Macalpine, *Psychiatry for the Poor: 1851 Colney Hatch Asylum – Friern Hospital 1973: A Medical and Social History* (London, 1974).

STUART HALL ON JEREMY DELLER
1. All quotes are taken from a conversation with the artist, 25 July 2011, unless otherwise stated.
2. Jeremy Deller, *The English Civil War Part II: Personal Accounts of the 1984–85 Miners' Strike* (London, 2002)
3. Jeremy Deller, 'Foreword', in *It Is What It Is* (New York, 2011)
4. Ibid., p. 1
5. Ibid.
6. Ibid.
7. Guy Debord, *Society of the Spectacle* (Detroit, 1984)
8. Henri Lefebvre, *Critique of Everyday Life*, trans. John Moore, 3 vols. (London, 2008 (1947))
9. Jeremy Millar, 'Poets of Their Own Affairs: A Brief Introduction to Folk Archive', in Jeremy Deller/Alan Kane, *Folk Archive: Contemporary Popular Art from the UK* (London, 2005), p. 149
10. Ibid., p. 150. *Citing Design and Workmanship in Printing* (London, 1915); Barbara Jones, *Black Eyes and Lemonade*, exh. cat., Whitechapel Art Gallery, London, 1951; Barbara Jones, *The Unsophisticated Arts* (London, 1951); Margaret Lambert/Enid Marx, *English Popular Art* (London, 1951)
11. Ibid.
12. Jeremy Deller, *Procession* (Manchester, 2010), p. 3
13. William Cobbett, *Rural Rides* (London, 2005 (1830))
14. Ibid.
15. Jeremy Deller/Alan Kane, *Folk Archive: Contemporary Popular Art from the UK* (London, 2005), p. 3

RALPH RUGOFF ON INVISIBLE ART
1. Quoted in Sidra Stich, *Yves Klein* (Stuttgart, 1994), p. 139, p. 9
2. Both quotes from Yoko Ono are found in the statement accompanying her 1966 exhibition at Indica Gallery, London.
3. Sergiusz Michalski, *Public Monuments: Art in Political Bondage 1870–1997* (London, 1998), p. 172
4. Michael Baldwin, 'Remarks on Air-Conditioning', in *Arts*, November 1967, p. 22
5. Quoted in Robert Pincus-Witten, *Postminimalism into Maximalism: American Art 1966–1986*, (Ann Arbor, 1987), p. 135
6. Holger Weh, 'Robert Barry, Die Einladung als Medium' (interview with Robert Barry), in *Kunstforum*, January–February 1994
7. Arthur R. Rose (pseud.), 'Interview with Robert Barry', in *Arts*, February 1969, p. 22
8. Barry's *Telepathic Piece* appeared in the catalogue for an untitled exhibition organised by Seth Siegelaub

at the Center for Communication and the Arts, Simon Fraser University, Burnaby, British Columbia, Canada, 19 May–19 June, 1969.
9. Reprinted in Lucy Lippard (ed.), *Six Years: The Dematerialisation of the Art Object from 1966 to 1972* (New York, 1973), p. 113
10. According to the gallery's press release, the first part of Byars's exhibition, entitled *Shutting Up Genie*, consisted of 'sealing Eugenia Butler off from the Gallery exhibition space. Her name comes down from the front of the building, and "Shutting Up Genie" is lettered in red on the wall directly behind the Gallery window, visible from the street. Eugenia Butler is forbidden by the artist to enter the gallery exhibition space during the five-day period.'
11. Gustav Metzger, 1974 statement from *Art into Society/Society into Art*, exh. cat., Institute of Contemporary Art, London, 1974

ANNE WAGNER ON ART AND LIGHT
1. Readers are referred to the invaluable exhibition catalogue, *Light Art from Artificial Light: Light as a Medium in 20th and 21st Century Art*, ed. Peter Weibel/Gregor Jansen, ZKM/Museum für Neue Kunst, Karlsruhe, 2006, whose many contributors together survey the topic in its multiple dimensions.
2. Marshall McLuhan, first in *The Gutenberg Galaxy* (1962) and then in *Understanding Media* (1964), became the great theorist of these changes.
3. 'From Pigment to Light' in Richard Kostelanetz (ed.), *Moholy-Nagy: An Anthology* (New York, 1970). Or, as the artist put it in the introduction to *Painting, Photography, Film* (Cambridge, MA, 1969 (1925)), 'Chiaroscuro in place of pigment'. 'The New Vision', Moholy-Nagy's coinage, was a term in general use to describe German photography of the period.
4. The word is a neologism derived from telegram, another coinage prompted by modern technology. The Oxford English Dictionary, q.v. 'telegram', locates its first usage in 1852, and points to the initial dispute among scholars over the failure to follow the Greek analogy suggested by tele; had it done so, such messages would have been named *telegraphemes*, as indeed they are in modern Greek. The photogram deploys what might be called a pre-photographic technique, in use since the discovery of the photosensitivity of chemically coated paper. While William Fox Talbot (1800–77) called the result a photogenic drawing, in the

first decades of the twentieth century the name of the individual artist using it (the Schadograph for works made by Christian Schad, the Rayograph for those produced by Man Ray) was routinely deployed. Moholy-Nagy's is the first term for this technique to make clear its hybrid relationship to current technologies of communication.

5. The earlier replica (1970) is at the Van Abbemuseum, Eindhoven; the later one, which was manufactured for inclusion in a 2009 exhibition at Tate Modern, is now in the collection of the Harvard University Art Galleries.

6. These effects, which according to Oliver Botar included 'multiple exposures, negative sequences and doubling, as well as light modulating properties such as transparency and translucency', were clearly chosen to strengthen and supplement the 'natural' workings of the Prop. See Botar's 2008 review of several recent books on Moholy-Nagy's films, 'Films by László Moholy-Nagy', in *Journal of the Society of Architectural Historians*, Vol. 67, No. 3, November 2008, p. 461

7. Botar attributes this information to the American scholar Linda Dalrymple Henderson. See ibid., p. 462, n. 7

8. The opening lines of David Cronenberg's film *Videodrome* (1983) are said by a man's voice coming from a television set: 'Civic TV; the one you take to bed with you.' Cronenberg both wrote and directed the film. Since it appeared, mobile phones and tablets have, of course, been added to the list.

9. The titles mentioned refer to shows held at the Stedelijk Van Abbemuseum, Eindhoven, the Walker Art Center, Minneapolis, and the Whitney Museum of American Art, New York, respectively.

10. The catalogue, one in the series of exhibitions now dubbed 'numbers shows', is part of the topic of Cornelia Butler et al., *From Conceptualism to Feminism: Lucy Lippard's Numbers Shows, 1969–74* (London, 2012)

11. Serra's handwritten list is now in the collection of the Museum of Modern Art, New York. Richard Serra, *Verb List*, 1967–68, graphite on paper, two sheets, each 25.4 x 20.3 cm. Gift of the artist in honour of Wynn Kramarsky.

12. This brief paragraph relies on material discussed at greater length in my essay 'Flavin's Limited Light' in J. Weiss (ed.), *Dan Flavin: New Light* (New Haven/London, 2006), pp. 108–32

13. As a teacher at the Bauhaus, Moholy-Nagy knew both Kazimir Malevich and El Lissitzky, each of whom produced costume designs for the work.

14. In his essay 'Tate Modern's Turbine Hall and the Unilever series,' Wouter

Davidts cites a Tate Modern press release made public immediately following the work's closure and giving the attendance figure of what remains a high for this particular space. See Christopher R. Marshall (ed.), *Sculpture and the Museum* (London, 2011), p. 213, n. 5

RICK MOODY ON OUTSIDER PHOTOGRAPHY

1. For example, see Glyn Daly, 'Slavoj Žižek: Risking the Impossible', in http://www.lacan.com/zizek-primer.htm

2. See, for example, *The Swing* (1767)

3. From Bartlett's notes, in the *25th Anniversary Report* of the Harvard class of 1932 (1957)

4. https://web.archive.org/web/20130717101331/http://www.art.org/2008/09/finding-beauty-the-art-of-lee-godie/

5. Friedrich Nietzsche, *Beyond Good and Evil: Prelude to a Philosophy of the Future*, trans. Walter Kaufmann (New York, 1966), p. 1

JULIA BRYAN-WILSON ON ANA MENDIETA

1. Mendieta's early work has been helpfully catalogued in Olga Viso, *Unseen Mendieta: The Unpublished Works of Ana Mendieta* (Munich/New York, 2008)

2. Ned Rifkin, foreword, in Olga Viso, Ana Mendieta, *Earth Body: Sculpture and Performance 1972–1985* (Washington, D.C., 2004), p. 11

3. Miwon Kwon, '"Bloody Valentines": Alterimages by Ana Mendieta', in M. Catherine de Zegher (ed.), *Inside the Visible: An Elliptic Traverse of Twentieth-Century Art in, of, and from the Feminine* (Cambridge, MA, 1996), pp. 165–66

4. Such exhibits include the following touchstones: *Making Their Mark: Women Artists Move into the Mainstream* (Pennsylvania Academy of Fine Arts, Philadelphia, 1989); *Féminin-Masculin: Le Sexe de l'Art* (Centres Georges Pompidou, Paris, 1995); *Inside the Visible: An Elliptical Traverse of Twentieth-Century Art, in, of, and from the Feminine* (Institute of Contemporary Art, Boston, 1996); *Sexual Politics: Judy Chicago's Dinner Party in Feminist Art History* (curated by Amelia Jones at the Hammer Museum, Los Angeles, 1996); and *WACK!: Art and the Feminist Revolution* (organised by Connie Buller for the Los Angeles Museum of Contemporary Art, 2007). This is by no means a comprehensive list, but it points to how Mendieta's work has been curated into avowedly feminist contexts as well as seen in relation to other

female artists in shows that do not have an explicit feminist lens.

5. For example, Whitney Chadwick, *Women, Art and Society* (New York, 1990), Norma Broude/Mary D. Garrard, *The Power of Feminist Art: The American Movement of the 1970s, History and Impact* (New York, 1994), and Connie Buller/Alexandra Schwartz (eds.), *Modern Women: Women Artists at the Museum of Modern Art* (New York, 2010). Again this list is partial.

6. Luis Camnitzer, *New Art of Cuba* (Austin, 1994), p. 93. Camnitzer was a close friend of Mendieta's, and dedicated this book to her.

7. See Julia Herzberg, 'Ana Mendieta's Iowa Years, 1970–1980', in Viso, *Ana Mendieta, Earth Body*, pp. 136–79

8. Lucy Lippard, 'Who is Ana Mendieta? Nobody Else', in Christine Redfern/Cora Caron (eds.), *Who Is Ana Mendieta?* (New York, 2011), p. 6; see also Viso, *Ana Mendieta, Earth Body*, p. 46

9. Kaira M. Cabañas, 'Ana Mendieta: "Pain of Cuba, Body I Am"', in *Woman's Art Journal*, Spring–Summer 1999, pp. 12–17. See also Hanna Kruse 'A Shift in Strategies: Depicting Rape in Feminist Art', in *The Subject of Rape* (New York, 1993)

10. Donald Kuspit, 'Ana Mendieta, Autonomous Body', in Gloria Moure (ed.), *Ana Mendieta* (Santiago de Compostela, 1996), pp. 35–82

11. Mendieta, Transcription of slide lecture at Alfred University, 1981, from the Mendieta archive

12. Mendieta, MA Thesis statement (Iowa City, 1972)

13. Lucy Lippard, 'Making Up: Role-Playing and Transformation in Women's Art', in *The Pink Glass Swan: Selected Essays on Feminist Art* (New York, 1995), pp. 89–98

14. Ibid., p. 91

15. Lippard, 'The Pains and Pleasures of Rebirth: European and American Women's Body Art', in *The Pink Glass Swan*, pp. 99–116

16. Raquelín Mendieta states that she joined A.I.R. primarily because she failed to find commercial gallery representation in New York; communication with the author, July 2013

17. Viso, *Ana Mendieta, Earth Body*, p. 45

18. Jennie Klein has delved into this complex issue with more detail than can be accommodated here; see her 'Goddess: Feminist Art and Spirituality in the 1970s', in *Feminist Studies*, Vol. 35, No. 3, Fall 2009, pp. 575–602

19. Gloria Feman Orenstein, 'The Re-emergence of the Archetype of the Great Goddess in Art by Contemporary Women', in *Heresies: Great Goddess*, No. 5, 1978, pp. 74–84. It is important

to recognise that many differences are quite alive within the Heresies special issue (if not necessarily in Orenstein's article); the publication includes pieces by artists not commonly associated with goddess discourse, such as Mierle Laderman Ukeles.

20. Alfred University lecture

21. Ana Mendieta, interview with Joan Marter (1 February 1985), from the Mendieta archive

22. Jane Blocker, *Where Is Ana Mendieta?: Identity, Performativity, Exile* (Minneapolis, 1999), p. 19. The goddesses that Mendieta referenced were not at all uniformly Cuban, or Latin American, or African, or indigenous, as she explicitly drew on Etruscan and early Roman references as well. We must be attentive to her wide-ranging curiosity and not force onto her simplistic presumptions of her 'Latin American' content, for that impulse has its own essentialising undertones. It is also troubling when Mendieta's interest in a range of sacred and spiritual traditions is collapsed into the syncretic Cuban religion Santeria; for one reading that is overly reliant on a framework of Santeria, see Mary Jane Jacobs, *Ana Mendieta: The 'Silueta' Series, 1973–1980* (New York, 1991).

23. Laura Roulet, 'Ana Mendieta as a Cultural Connector with Cuba', in *American Art*, Vol. 26, No. 2, Summer 2012, pp. 21–27

24. Heresies, Vol. 4, No. 1, issue 13 (1981)

25. See, for instance, the reproduction of a piece by Mendieta on the cover of environmental studies scholar and feminist theorist Stacy Alaimo's book *Undomesticated Ground: Recasting Nature as Feminist Space* (Ithaca, NY, 2000)

26. Lowery Stokes Sims, quoted in Judy Seigel (ed.), *Mutiny and the Mainstream: Talk That Changed Art, 1975–1990* (New York, 1932), p. 105

27. Quoted in Viso, *Ana Mendieta, Earth Body*, p. 73

28. Within the art world. Michele Wallace was a major figure within black feminism; her article 'Anger in Isolation: A Black Feminist's Search for Sisterhood' was published in *Village Voice*, 28 July 1975; reprinted in Manning Marable/Leith Mullings, *Let Nobody Turn Us Around: Voices of Resistance, Reform, and Renewal: An African American Anthology* (New York, 2000), pp. 520–23. See also Wallace's ground-breaking *Black Macho and the Myth of the Superwoman* (New York, 1979)

29. The Combahee River Collective. 'A Black Feminist Statement' (1977), in Gloria T. Hull/Patricia Bell Scott/Barbara Smith (eds.), *All the Women Are White, All the Blacks Are Men, But Some of Us Are Brave: Black Women's Studies* (New York, 1952), pp. 13–22

30. Cherrie Moraga/Gioro Anzaldúa, *This Bridge Called My Back: Writings by Radical Women of Color* (Watertown, MA, 1981)

31. Though not stated in her letter, some of Mendieta's reasons for resigning include: an imminent move to Rome; other emerging opportunities to show her work; and her anger over the fact that her proposal lo sponsor a Brazilian artist to take her place in the A.I.R. cooperative had been turned down.

32. Joanna Frueh, 'Making a Mess: Women's Bane, Women's Pleasure', in Katy Deepwell (ed.), *Women Artists and Modernism* (Manchester, 1988), p. 147

33. As Irit Rogoff notes of the trial: 'Her feminist activism, her co-founding of *Heresies*, her third world politics, the constant contact with Cuba, her promotion of Cuban artists in the United States, none of these were mentioned.' *Terra Infirma: Geography's Visual Culture* (London/ New York, 2000), p. 133. (To be clear, Mendieta was not a co-founder of *Heresies*, but, as mentioned above, was on its editorial collective for one issue.)

34. Robert Katz, *Naked by the Window: The Fatal Marriage of Carl Andre and Ana Mendieta* (New York, 1990); Redfern/Caron

35. Gill Perry, 'The Expanding Field: Ana Mendieta's *Silueta* Series', in Jason Gaiger (ed.), *Frameworks for Modern Art* (New Haven, 2003), pp. 153–205

36. See Helen Molesworth, 'Cleaning Up in the 1970s: The Work of Judy Chicago, Mary Kelly and Mierle Laderman Ukeles', in Michael Newman/Jon Bird, *Rewriting Conceptual Art* (London, 1999), pp. 107–22

37. Directly addressing this conflict, Mira Schor wrote about a panel at the New Museum of Contemporary Art held in December 1957 called 'The Great Goddess Debate – Spirituality vs. Social Practice in Recent Feminist Art', featuring Nancy Spero, Lyn Blumenthal, Arlene Raven, Kate Linker, Helen Deutsch and Judith Williamson. She recounts: 'The debate exposed a major rift within feminism itself [...] Deutsch and Linker could scarcely conceal their contempt for [Spero's] depictions of women, including ancient goddesses, for the relatively handmade look of her work, and for her identification with 1970s activist feminist art [...] Their words, by logical extension, could be seen as possible attacks on the work of Ana Mendieta, given that the debate took place during the New Museum's Mendieta retrospective exhibition.' Mira Schor, 'Backlash and Appropriation', in Broude/Garrard, p. 254

38. Mira Schor, 'Ana Mendieta', in *Sulfur*, No. 22, 1988; republished in Mira Schor, *Wet: On Painting, Feminism, and Art Culture* (Durham, NC, 1997), p. 66

39. Rogoff, p. 175

40. Anne Raine, 'Embodied Geographies: Subjectivity and Materiality in the Work of Ana Mendieta', in Griselda Pollock (ed.), *Generations and Geographies in the Visual Arts: Feminist Readings* (London/New York, 1996), pp. 228–49

41. Magdalena Maiz-Peña, 'Body Tracks: Dis/locaciones, Corporeidad y Estética Fílmica de Ana Mendieta', in *Letras Femeninas*, Vol. 33, No. 1, Summer 2007, pp. 175–92; Blocker; Susan Best, 'The Serial Spaces of Ana Mendieta', in *Art History*, Vol. 30, No. 1, February 2007, pp. 57–82; Joanne S. Walker, 'The Body Is Present Even if in Disguise: Tracing the Trace in the Artwork of Nancy Spero and Ana Mendieta', in *Tate Papers*, No. 11, April 2009; Rogoff

42. Some authors have gone back and focused on her early student work, with its grotesque performances, to rescue her from charges of essentialism: see Kelly Baum, 'Shapely Shapelessness: Ana Mendieta's *Untitled (Glass on Body Imprints: Face)*, 1972', in *More than One: Photographs in Sequence* (Princeton, 2008), pp. 80–93. Others have asserted that Mendieta was working within the more tactical realm of strategic essentialism advocated by feminist thinkers like Diana Fuss; see Michelle Hudson, 'Beyond Self: Strategic Essentialism in Ana Mendieta's *La Maja de Yerba*', MA Design Thesis, Georgia State University, 2011

43. Kwon, p. 167

44. Charles Merewether, 'From Inscription to Dissolution: An Essay on Expenditure in the Work of Ana Mendieta' in Gloria Moure (ed.), *Ana Mendieta*, p. 148, n. 12

45. Esther Adler, 'Ana Mendieta', in Buller/Schwartz, p. 391

46. Moraga, 'Preface', in Moraga/Anzaldúa, p. xviii

47. Coco Fusco, 'Traces of Ana Mendieta: 1988–1993', in *English Is Broken Here: Notes on Cultural Fusion in the Americas* (New York, 1995), p. 125

48. Fusco, p. 125

49. For more on Spero's re-performance, see Walker

50. Gerardo Mosquera, 'Cuba in Tania Bruguera's Work: The Body Is the Social Body', in *Tania Bruguera: On the Political Imaginary* (Milan, 2009), pp. 23–35; Gerardo Mosquera, 'Resucitando a Ana Mendieta', in *Poliéster*, Vol. 4, No. 11, Winter 1995, pp. 52–55

51. José Quirago, 'Still Searching For Ana Mendieta', in *Cuban Palimpsests* (Minneapolis, 2005), p. 189

GEOFF DYER ON DAYANITA SINGH

1. Quoted by Peter Lavezzoli in *The Dawn of Indian Music in the West* (New York, 2006), p. 350
2. Dayanita Singh, *Privacy* (Göttingen, 2004), n.p.
3. Billy Collins, *Aimless Love: New and Selected Poems* (New York, 2013), p. 149
4. John Szarkowksi, *Atget* (New York, 2000), p. 176
5. Quoted by Belinda Rathbone in *Walker Evans: A Biography* (London, 1995), p. 252
6. Jerry L. Thompson, *Walker Evans at Work* (London, 1984), p. 70
7. William Henry Fox Talbot, 'Some Account of the Art of Photogenic Drawing' (1839) in Vicki Goldberg (ed.), *Photography in Print* (Albuquerque, 1981), p. 46
8. Quoted in *Sunday Telegraph Magazine*, 28 March 2004, p. 29
9. Raghubir Singh, *River of Colour: The India of Raghubir Singh* (London, 1998), p. 8
10. László Moholy-Nagy, 'Pigment to Light' (1936) in Goldberg 1981, p. 342
11. Quoted by Dayanita Singh in *Zakir Hussain* (New Delhi, 1986), p. 75
12. Michael Ackerman, *Fiction* (Paris, 2001), n.p.
13. Wim Wenders, *The Act of Seeing: Essays and Conversations* (London, 1996), p. 137

ERIK DAVIS ON THE INTERNET OF THINGS

1. Hermann Hesse, *Magister Ludi (The Glass Bead Game)* (New York, 1970). For a grimmer take on nodal games, see Jean Baudrillard, 'The Ecstasy of Communication', in Hal Foster (ed.), *The Anti-Aesthetic: Essays on Postmodern Culture* (Port Townsend, WA, 1983), pp. 126–34
2. Barbara Stafford, *Devices of Wonder: From the World in a Box to Images on a Screen* (Los Angeles, 2001), p. 6
3. Michel Foucault, *The Order of Things: An Archaeology of the Human Sciences* (New York, 1994), esp. pp. 17–45
4. Bruno Latour, *We Have Never Been Modern*, trans. Catherine Porter (Cambridge, MA, 1993), pp. 13–48
5. Philip K. Dick, 'The Android and the Human', http://1999pkdweb. philipkdickfans.com/The%20 Android%20and%20the%20 Human.htm. Compare with Latour's concept of 'quasiobject'.
6. Michael Saler, *As If: Modern Enchantment and the Literary Prehistory of Virtual Reality* (Oxford, 2012)
7. Ibid., p. 56
8. S.M. Eisenstein, *Eisenstein on Disney*, ed. Jay Leyda, trans. Alan Upchurch (Calcutta,1986), p. 63
9. Latour 1993
10. See, for example, Graham Harman's object-oriented interpretation of Latour's sociology in his *Prince of Networks: Bruno Latour and Metaphysics* (Melbourne, 2009).
11. See, especially, Graham Harman, *Weird Realism: Lovecraft and Philosophy* (Alresford, 2012).
12. See Christof Koch, *Consciousness: Confessions of a Romantic Reductionist* (Cambridge, MA, 2012).

MARTIN HERBERT ON CONTEMPORARY FIGURATIVE SCULPTURE

1. 'Interview', in David Sylvester, *Looking at Giacometti* (London, 1994), pp. 215–16
2. Charles Ray, 'Thinking of Sculpture as Shaped by Space', in *New York Times*, 7 October 2001
3. Robert Morris, 'Notes on Sculpture, Part 1', in *Artforum*, February 1966, pp. 41–44
4. R. Crumb, 'A Bitchin' Bod', in *HUP*, No. 4, 1992
5. 'Visiting Artists: Frank Benson', in nytimes.com, 9 September 2011
6. See NSF JTEC/WTEC: 'Rapid Prototyping in Europe and Japan', p. 22: http://www.wtec.org/loyola/rp/toc.htm
7. The oldest verifiable sculpture of a human figure is the Venus of Hohle Fels discovered in Schelklingen, Germany, in 2008 and currently being researched at the University of Tübingen.

KENNETH GOLDSMITH ON CONCRETE POETRY

1. João Bandeira/Lenora de Barros (eds.), *Poesia Concreta: O Projeto Verbivocovisual* (São Paulo, 2008), p. 30
2. Ibid. p. 136
3. Lori Emerson, *Reading Writing Interfaces: From the Digital to the Bookbound* (Minneapolis, 2014), pp. 99–100
4. Ibid., p. 100
5. Although this might be changing with the introduction of the Apple Watch in 2015
6. Morton Feldman, 'The Anxiety of Art' (1965) in B.H. Friedman (ed.), *Give My Regards to Eighth Street* (Cambridge, MA, 2000), p. 32

550

Published in 2018 by
Hayward Gallery Publishing
Southbank Centre
Belvedere Road
London SE1 8XX
UK
www.southbankcentre.co.uk

Art Publisher **Rebecca Fortey**
Project Manager **Diana Adell**
Sales Manager **Alex Glen**
Publication design **Robert Boon**
at Inventory Studio
Printed in Croatia by **Zrinski**
Introductory texts written and
compiled by **Lucy Biddle**
Author biographies compiled by
Diana Adell

HAYWARD
GALLERY
PUBLISHING

Distributed in North America,
Central America and South America by
ARTBOOK I D.A.P.
75 Broad Street, Suite 630
New York, NY 10004
tel: +1 212 627 1999
www.artbook.com

Distributed in the UK and Europe
by Cornerhouse Publications
HOME, 2 Tony Wilson Place
Manchester, M15 4FN
tel: +44 (0)161 212 3466
www.cornerhousepublications.org